# Microscope Image Processing

# Microscope Image Processing

Qiang Wu
Fatima A. Merchant
Kenneth R. Castleman

AMSTERDAM • BOSTON • HEIDELBERG • LONDON
NEW YORK • OXFORD • PARIS • SAN DIEGO
SAN FRANCISCO • SINGAPORE • SYDNEY • TOKYO
Academic Press is an imprint of Elsevier

Academic Press is an imprint of Elsevier

30 Corporate Drive, Suite 400, Burlington, MA 01803, USA
525 B Street, Suite 1900, San Diego, California 92101-4495, USA
84 Theobald's Road, London WC1X 8RR, UK

⊗ This book is printed on acid-free paper.

**Library of Congress Cataloging-in-Publication Data**
Application submitted.

**British Library Cataloguing-in-Publication Data**
A catalogue record for this book is available from the British Library.

ISBN: 978-0-12-372578-3

For information on all Academic Press publications
visit our Web site at www.books.elsevier.com

Printed and bound by CPI Group (UK) Ltd, Croydon, CR0 4YY
Transferred to digital print 2013

# Contents

**8 Morphological Image Processing**      **113**

*Roberto A. Lotufo, Romaric Audigier, André V. Saúde,*
*and Rubens C. Machado*

**9 Image Segmentation** — **159**

*Qiang Wu and Kenneth R. Castleman*

# Foreword

**Brian H. Mayall**

Microscope image processing dates back a half century when it was realized that some of the techniques of image capture and manipulation, first developed for television, could also be applied to images captured through the microscope. Initial approaches were dependent on the application: automatic screening for cancerous cells in Papanicolaou smears; automatic classification of crystal size in metal alloys; automation of white cell differential count; measurement of DNA content in tumor cells; analysis of chromosomes; etc. In each case, the solution lay in the development of hardware (often analog) and algorithms highly specific to the needs of the application. General purpose digital computing was still in its infancy. Available computers were slow, extremely expensive, and highly limited in capacity (I still remember having to squeeze a full analysis system into less than 10 kilobytes of programmable memory!). Thus, there existed an unbridgeable gap between the theory of how microscope images could be processed and what was practically attainable.

One of the earliest systematic approaches to the processing of microscopic images was the CYDAC (CYtophotometric DAta Conversion) project [1], which I worked on under the leadership of Mort Mendelsohn at the University of Pennsylvania. Images were scanned and digitized directly through the microscope. Much effort went into characterizing the system in terms of geometric and photometric sources of error. The theoretical and measured system transfer functions were compared. Filtering techniques were used both to sharpen the image and to reduce noise, while still maintaining the photometric integrity of the image. A focusing algorithm was developed and implemented as an analog assist device. But progress was agonizingly slow. Analysis was done off-line, programs were transcribed to cards, and initially we had access to a computer only once a week for a couple of hours in the middle of the night!

The modern programmable digital computer has removed all the old constraints—incredible processing power, speed, memory and storage come with any consumer computer. My ten-year-old grandson, with his digital camera and access to a lap-top computer with processing programs such as i-Photo and Adobe Photoshop, can command more image processing resources than were

available in leading research laboratories less than two decades ago. The challenge lies not in processing images, but in processing them correctly and effectively. *Microscope Image Processing* provides the tools to meet this challenge.

In this volume, the editors have drawn on the expertise of leaders in processing microscope images to introduce the reader to underlying theory, relevant algorithms, guiding principles, and practical applications. It explains not only what to do, but also which pitfalls to avoid and why. Analytic results can only be as reliable as the processes used to obtain them. Spurious results can be avoided when users understand the limitations imposed by diffraction optics, empty magnification, noise, sampling errors, etc. The book not only covers the fundamentals of microscopy and image processing, but also describes the use of the techniques as applied to fluorescence microscopy, spectral imaging, three-dimensional microscopy, structured illumination and time-lapse microscopy. Relatively advanced techniques such as wavelet and morphological image processing and automated microscopy are described in intuitive and comprehensive manner that will appeal to readers, whether technically oriented or not. The summary list at the end of each chapter is a particularly useful feature enabling the reader to access the essentials without necessarily mastering all the details of the underlying theory.

*Microscope Image Processing* should become a required textbook for any course on image processing, not just microscopic. It will be an invaluable resource for all who process microscope images and who use the microscope as a quantitative tool in their research. My congratulations go to the editors and authors for the scope and depth of their contributions to this informative and timely volume.

## Reference

1. ML Mendelsohn, BH Mayall, JMS Prewitt, RC Bostrum, WG Holcomb. "Digital Transformation and Computer Analysis of Microscopic Images," *Advances in Optical and Electron Microscopy*, **2**:77–150, 1968.

# Preface

The digital revolution has touched most aspects of modern life, including entertainment, communication, and scientific research. Nowhere has the change been more fundamental than in the field of microscopy. Researchers who use the microscope in their investigations have been among the pioneers who applied digital processing techniques to images. Many of the important digital image processing techniques that are now in widespread usage were first implemented for applications in microscopy. At this point in time, digital image processing is an integral part of microscopy, and only rarely will one see a microscope used with only visual observation or photography.

The purpose of this book is to bring together the techniques that have proved to be widely useful in digital microscopy. This is quite a multidisciplinary field, and the basis of processing techniques spans several areas of technology. We attempt to lay the required groundwork for a basic understanding of the algorithms that are involved, in the hope that this will prepare the reader to press the development even further.

This is a book about techniques for processing microscope images. As such it has little content devoted to the theory and practice of microscopy or even to basic digital image processing, except where needed as background. Neither does it focus on the latest techniques to be proposed. The focus is on those techniques that routinely prove useful to research investigations involving microscope images and upon which more advanced techniques are built.

A very large and talented cast of investigators has made microscope image processing what it is today. We lack the paper and ink required to do justice to the fascinating story of this development. Instead we put forward the techniques, principally devoid of their history. The contributors to this volume have shouldered their share of their creation, but many others who have pressed forward the development do not appear.

# Acknowledgments

Each of the following contributors to this volume has done important work in pushing forward the advance of technology, quite in addition to the work manifested herein.

*Romaric Audigier*
Centre de Morphologie Mathématique
Fontainebleau, France

*Alan Bovik*
Department of Electrical and Computer Engineering
The University of Texas at Austin
Austin, Texas

*Hyohoon Choi*
Sealed Air Corp.
San Jose, California

*Oleh Dzyubachyk*
Biomedical Imaging Group Rotterdam
Erasmus MC—University Medical Center Rotterdam
Departments of Medical Informatics and Radiology
Rotterdam, The Netherlands

*Ilya Goldberg*
Image Informatics and Computational Biology Unit
Laboratory of Genetics
National Institute on Aging—NIH/IRP
Baltimore, Maryland

*Myung Kim*
Department of Physics
University of South Florida
Tampa, Florida

**Acknowledgments**

*Leo Krzewina*
Saint Leo University
San Leo, Florida

*Roberto Lotufo*
School of Electrical and Computer Engineering
University of Campinas—UNICAMP
Campinas SP, Brazil

*Rubens Machado*
Av Jose Bonifacio
Campinas SP, Brazil

*Tomasz Macura*
Image Informatics and Computational Biology Unit
Laboratory of Genetics
National Institute on Aging—NIH/IRP
Baltimore, Maryland

*Erik Meijering*
Biomedical Imaging Group Rotterdam
Erasmus MC—University Medical Center Rotterdam
Departments of Medical Informatics and Radiology
Rotterdam, The Netherlands

*Jean-Christophe Olivo-Marin*
Quantitative Image Analysis Unit
Institut Pasteur
Paris, France

*Ammasi Periasamy*
Keck Center for Cellular Imaging
Department of Biology
University of Virginia
Charlottesville, Virginia

*Andre Saude*
Department de Ciência da Computação
Universidade Federal de Lavras
Lavras/MG, Brazil

*Shishir Shah*
Department of Computer Science
University of Houston
Houston, Texas

*Ihor Smal*
Biomedical Imaging Group Rotterdam
Erasmus MC—University Medical Center Rotterdam
Departments of Medical Informatics and Radiology
Rotterdam, The Netherlands

*James Thigpen*
Department of Computer Science
University of Houston
Houston, Texas

*Yu-Ping Wang*
School of Computing and Engineering
University of Missouri—Kansas City
Kansas City, Missouri

*Ian T. Young*
Quantitative Imaging Group
Department of Imaging Science and Technology
Faculty of Applied Sciences
Delft University of Technology
Delft, The Netherlands

In addition to those who contributed full chapters, the following researchers responded to the call for specific figures and examples taken from their work.

*Gert van Cappellen*
Erasmus MC—University Medical Center Rotterdam
Rotterdam, The Netherlands

*José-Angel Conchello*
Molecular, Cell, and Developmental Biology
Oklahoma Medical Research Foundation, Oklahoma City, Oklahoma
Program in Biomedical Engineering
University of Oklahoma, Norman, Oklahoma

*Jeroen Essers*
Erasmus MC—University Medical Center Rotterdam
Rotterdam, The Netherlands

*Niels Galjart*
Erasmus MC—University Medical Center Rotterdam
Rotterdam, The Netherlands

*William Goldman*
Washington University
St Louis, Missouri

*Timo ten Hagen*
Erasmus MC—University Medical Center Rotterdam
Rotterdam, The Netherlands

*Adriaan Houtsmuller*
Erasmus MC—University Medical Center Rotterdam
Rotterdam, The Netherlands

*Deborah Hyink*
Department of Medicine
Division of Nephrology
Mount Sinai School of Medicine
New York, New York

*Iris International, Inc.*
Chatsworth, California

*Erik Manders*
Centre for Advanced Microscopy
Section of Molecular Cytology
Swammerdam Institute for Life Sciences
Faculty of Science, University of Amsterdam
Amsterdam, The Netherlands

Finally, several others have assisted in bringing this book to fruition. We wish to thank Kathy Pennington, Jamie Alley, Steve Clarner, Xiangyou Li, Szeming Cheng, and Vibeesh Bose.

Many of the examples in this book were developed during the course of research conducted at the company known as Perceptive Systems, Inc., Perceptive Scientific Instruments, and later as Advanced Digital Imaging Research, LLC. Much of that research was supported by the National Institutes of Health, under the Small Business Innovative Research program. A large number of employees of that company played a role in bringing together the knowledge base from which this book has emerged.

*Qiang Wu*
*Fatima A. Merchant*
*Kenneth R. Castleman*
*Houston, Texas*
*October 2007*

# 1

# Introduction

Kenneth R. Castleman and Ian T. Young

## 1.1 The Microscope and Image Processing

Invented over 400 years ago, the optical microscope has seen steady improvement and increasing use in biomedical research and clinical medicine as well as in many other fields [1]. Today many variations of the basic microscope instrument are used with great success, allowing us to peer into spaces much too small to be seen with the unaided eye. More often than not, in this day and age, the images produced by a microscope are converted into digital form for storage, analysis, or processing prior to display and interpretation [2–4]. Digital image processing greatly enhances the process of extracting information about the specimen from a microscope image. For that reason, digital imaging is steadily becoming an integral part of microscopy. Digital processing can be used to extract quantitative information about the specimen from a microscope image, and it can transform an image so that a displayed version is much more informative than it would otherwise be [5, 6].

## 1.2 Scope of This Book

This book discusses the methods, techniques, and algorithms that have proven useful in the processing and analysis of digital microscope images. We do not attempt to describe the workings of the microscope, except as necessary to outline its limitations and the reasons for certain processes. Neither do we spend

time on the proper use of the instrument. These topics are well beyond our scope, and they are well covered in other works. We focus instead on *processing* microscope images in a computer.

Microscope imaging and image processing are of increasing interest to the scientific and engineering communities. Recent developments in cellular-, molecular-, and nanometer-level technologies have led to rapid discoveries and have greatly advanced the frontiers of human knowledge in biology, medicine, chemistry, pharmacology, and many related fields. The successful completion of the human genome sequencing project, for example, has unveiled a new world of information and laid the groundwork for knowledge discovery at an unprecedented pace.

Microscopes have long been used to capture, observe, measure, and analyze the images of various living organisms and structures at scales far below normal human visual perception. With the advent of affordable, high-performance computer and image sensor technologies, digital imaging has come into prominence and is replacing traditional film-based photomicrography as the most widely used method for microscope image acquisition and storage. Digital image processing is not only a natural extension but is proving to be essential to the success of subsequent data analysis and interpretation of the new generation of microscope images. There are microscope imaging modalities where an image suitable for viewing is *only* available after digital image processing. Digital processing of microscope images has opened up new realms of medical research and brought about the possibility of advanced clinical diagnostic procedures.

The approach used in this book is to present image processing algorithms that have proved useful in microscope image processing and to illustrate their application with specific examples. Useful mathematical results are presented without derivation or proof, although with references to the earlier work. We have relied on a collection of chapter contributions from leading experts in the field to present detailed descriptions of state-of-the-art methods and algorithms that have been developed to solve specific problems in microscope image processing. Each chapter provides a summary, an in-depth analysis of the methods, and specific examples to illustrate application. While the solution to every problem cannot be included, the insight gained from these examples of successful application should guide the reader in developing his or her own applications.

Although a number of monographs and edited volumes exist on the topic of computer-assisted microscopy, most of these books focus on the basic concepts and technicalities of microscope illumination, optics, hardware design, and digital camera setups. They do not discuss in detail the practical issues that arise in microscope image processing or the development of specialized algorithms for digital microscopy. This book is intended to

complement existing works by focusing on the computational and algorithmic aspects of microscope image processing. It should serve the users of digital microscopy as a reference for the basic algorithmic techniques that routinely prove useful in microscope image processing. The intended audience for this book includes scientists, engineers, clinicians, and graduate students working in the fields of biology, medicine, chemistry, pharmacology, and other related disciplines. It is intended for those who use microscopes and commercial image processing software in their work and would like to understand the methodologies and capabilities of the latest digital image processing techniques. It is also for those who desire to develop their own image processing software and algorithms for specific applications that are not covered by existing commercial software products.

In summary, the purpose of this book is to present a discussion of algorithms and processing methods that complements the existing array of books on microscopy and digital image processing.

## 1.3   Our Approach

A few basic considerations govern our approach to discussing microscope image processing algorithms. These are based on years of experience using and teaching digital image processing. They are intended to prevent many of the common misunderstandings that crop up to impair communication and confuse one seeking to understand how to use this technology productively. We have found that a detailed grasp of a few fundamental concepts does much to facilitate learning this topic, to prevent misunderstandings, and to foster successful application. We cannot claim that our approach is "standard" or "commonly used." We only claim that it makes the job easier for the reader and the authors.

### 1.3.1   The Four Types of Images

To the question "Is the image analog or digital?" the answer is "Both." In fact, at any one time, we may be dealing with four separate images, each of which is a representation of the specimen that lies beneath the objective lens of the microscope. This is a central issue because, whether we are looking at the pages of this book, at a computer display, or through the eyepieces of a microscope, we can see only images and not the original object. It is only with a clear appreciation of these four images and the relationships among them that we can move smoothly through the design of effective microscope image processing algorithms. We have endeavored to use this formalism consistently throughout this book to solidify the foundation of the reader's understanding.

### 1.3.1.1 *Optical Image*

The optical components of the microscope act to create an optical image of the specimen on the image sensor, which, these days, is most commonly a charge-coupled device (CCD) array. The *optical image* is a continuous distribution of light intensity across a two-dimensional surface. It contains some information about the specimen, but it is not a complete representation of the specimen. It is, in the common case, a two-dimensional projection of a three-dimensional object, and it is limited in resolution and is subject to distortion and noise introduced by the imaging process. Though an imperfect representation, it is what we have to work with if we seek to view, analyze, interpret, and understand the specimen.

### 1.3.1.2 *Continuous Image*

We can assume that the optical image corresponds to, and is represented by, a continuous function of two spatial variables. That is, the coordinate positions $(x, y)$ are real numbers, and the light intensity at a given spatial position is a nonnegative real number. This mathematical representation we call the *continuous image*. More specifically, it is a real-valued analytic function of two real variables. This affords us considerable opportunity to use well-developed mathematical theory in the analysis of algorithms. We are fortunate that the imaging process allows us to assume analyticity, since analytic functions are much more well behaved than those that are merely continuous (see Section 1.3.2.1).

### 1.3.1.3 *Digital Image*

The *digital image* is produced by the process of digitization. The continuous optical image is sampled, commonly on a rectangular grid, and those sample values are quantized to produce a rectangular array of integers. That is, the coordinate positions $(n, m)$ are integers, and the light intensity at a given integer spatial position is represented by a nonnegative integer. Further, random noise is introduced into the resulting data. Such treatment of the optical image is brutal in the extreme. Improperly done, the digitization process can severely damage an image or even render it useless for analytical or interpretation purposes. More formally, the digital image may not be a faithful representation of the optical image and, therefore, of the specimen. Vital information can be lost in the digitization process, and more than one project has failed for this reason alone. Properly done, image digitization yields a numerical representation of the specimen that is faithful to the original spatial distribution of light that emanated from the specimen.

What we actually process or analyze in the computer, of course, is the digital image. This array of sample values (pixels) taken from the optical image,

however, is only a relative of the specimen, and a rather distant one at that. It is the responsibility of the user to ensure that the relevant information about the specimen that is conveyed by the optical image is preserved in the digital image as well. This does not mean that *all* such information must be preserved. This is an impractical (actually impossible) task. It means that the information required to solve the problem at hand must not be lost in either the imaging process or the digitization process.

We have mentioned that digitization (sampling and quantization) is the process that generates a corresponding digital image from an existing optical image. To go the other way, from discrete to continuous, we use the process of *interpolation*. By interpolating a digital image, we can generate an approximation to the continuous image (analytic function) that corresponds to the original optical image. If all goes well, the continuous function that results from interpolation will be a faithful representation of the optical image.

### 1.3.1.4 Displayed Image

Finally, before we can visualize our specimen again, we must display the digital image. Human eyes cannot view or interpret an image that exists in digital form. A digital image must be converted back into optical form before it can be seen. The process of displaying an image on a screen is also an interpolation action, this time implemented in hardware. The display spot, as it is controlled by the digital image, acts as the interpolation function that creates a continuous visible image on the screen. The display hardware must be able to interpolate the digital image in such a way as to preserve the information of interest.

## 1.3.2 The Result

We see that each image with which we work is actually four images. Each optical image corresponds to both the continuous image that describes it and the digital image that would be obtained by digitizing it (assuming some particular set of digitizing parameters). Further, each digital image corresponds to the continuous function that would be generated by interpolating it (assuming a particular interpolation method). Moreover, the digital image also corresponds to the displayed image that would appear on a particular display screen. Finally, we assume that the continuous image is a faithful representation of the specimen and that it contains all of the relevant information required to solve the problem at hand. In this book we refer to these as the optical image, the continuous image, the digital image, and the displayed image. Their schematic relationship is shown in Fig. 1.1.

This leaves us with an option as we go through the process of designing or analyzing an image processing algorithm. We can treat it as a digital image

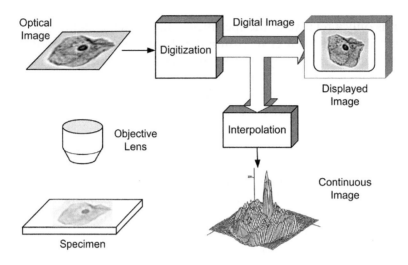

**FIGURE 1.1**    The four images of digital microscopy. The microscope forms an optical image of the specimen. This is digitized to produce the digital image, which can be displayed and interpolated to form the continuous image.

(which it is), or we can analyze the corresponding continuous image. Both of these represent the optical image, which, in turn, represents the specimen. In some cases we have a choice and can make life easy on ourselves. Since we are actually working with an array of integers, it is tempting to couch our analysis strictly in the realm of discrete mathematics. In many cases this can be a useful approach. But we cannot ignore the underlying analytic function to which that array of numerical data corresponds. To be safe, an algorithm must be true to both the digital image and the continuous image. Thus we must pay close attention to both the continuous and the discrete aspects of the image. To focus on one and ignore the other can lead a project to disaster.

In the best of all worlds, we could go about our business, merrily flipping back and forth between corresponding continuous and digital images as needed. The implementations of digitization and interpolation, however, do introduce distortion, and caution must be exercised at every turn. Throughout this book we strive to point out the resulting pitfalls.

### 1.3.2.1 Analytic Functions

The continuous image that corresponds to a particular optical image is more than merely continuous. It is a real-valued *analytic* function of two real variables. An analytic function is a continuous function that is severely restricted in how "wiggly" it can be. Specifically, it possesses all of its derivatives at every point. This restriction is so severe, in fact, that if you know the value of an

analytic function and all of its (infinitely many) derivatives at a single point, then that function is unique, and you know it everywhere. In other words, only one analytic function can pass through that point with those particular values for its derivatives. To be dealing with functions so nicely restricted relieves us from many of the worries that keep pure mathematicians entertained.

As an example, assume that an analytic function of one variable passes through the origin where its first derivative is equal to 2, and all other derivatives are zero. The analytic function $y = 2x$ uniquely satisfies that condition and is thus that function. Of all the analytic functions that pass through the origin, only this one meets the stated requirements.

Thus when we work with a monochrome image, we can think of it as an analytic function of two dimensions. A multispectral image can be viewed as a collection of such functions, one for each spectral band. The restrictions implied by the analyticity property make life much easier for us than it might otherwise be. Working with such a restricted class of functions allows us considerable latitude in the mathematical analysis that surrounds image processing algorithm design. We can make the types of assumptions that are common to engineering disciplines and actually get away with them.

The continuous and digital images are actually even more restricted than previously stated. The continuous image is an analytic function that is band-limited as well. The digital image is a band-limited, sampled function. The effects created by all of these sometimes conflicting restrictions are discussed in later chapters. For present purposes it suffices to say only that, by following a relatively simple set of rules, we can analyze the digital image as if it were the specimen itself.

### 1.3.3 The Sampling Theorem

The theoretical results that provide us with the most guidance as to what we can get away with when digitizing and interpolating images are the Nyquist sampling theorem (1928) and the Shannon sampling theorem (1949). They specify the conditions under which an analytic function can be reconstructed, without error, from its samples. Although this ideal situation is never quite attainable in practice, the sampling theorems nevertheless provide us with means to keep the damage to a minimum and to understand the causes and consequences of failure, when that occurs. We cannot digitize and interpolate without the introduction of noise and distortion. We can, however, preserve sufficient fidelity to the specimen so that we can solve the problem at hand. The sampling theorem is our map through that dangerous territory. This topic is covered in detail in later chapters. By following a relatively simple set of rules, we can produce usable results with digital microscopy.

## 1.4  The Challenge

At this point we are left with the following situation. The object of interest is the specimen that is placed under the microscope. The instrument forms an optical image that represents that specimen. We assume that the optical image is well represented by a continuous image (which is an analytic function), and we strive, through the choices available in microscopy, to make this be the case. Further, the optical image is sampled and quantized in such a way that the information relevant to the problem at hand has been retained in the digital image. We can interpolate the digital image to produce an approximation to the continuous image or to make it visible for interpretation. We must now process the digital image, either to extract quantitative data from it or to prepare it for display and interpretation by a human observer. In subsequent chapters the model we use is that the continuous image is an analytic function that represents the specimen and that the digital image is a quantized array of discrete samples taken from the continuous image. Although we actually process only the digital image, interpolation gives us access to the continuous image whenever it is needed.

Our approach, then, dictates that we constantly keep in mind that we are always dealing with a set of images that are representations of the optical image produced by the microscope, and this, in turn, represents a projection of the specimen. When analyzing an algorithm we can employ either continuous or discrete mathematics, as long as the relationship between these images is understood and preserved. In particular, any processing step performed upon the digital image must be legitimate in terms of what it does to the underlying continuous image.

## 1.5  Nomenclature

Digital microscopy consists of theory and techniques collected from several fields of endeavor. As a result, the descriptive terms used therein represent a collection of specialized definitions. Often, ordinary words are pressed into service and given specific meanings. We have included a glossary to help the reader navigate a pathway through the jargon, and we encourage its use. If a concept becomes confusing or difficult to understand, it may well be the result of one of these specialized words. As soon as that is cleared up, the path opens again.

## 1.6  Summary of Important Points

1. A microscope forms an optical image that represents the specimen.

2. The continuous image represents the optical image and is a real-valued analytic function of two real variables.

3. An analytic function is not only continuous, but possesses all of its derivatives at every point.

4. The process of digitization generates a digital image from the optical image.

5. The digital image is an array of integers obtained by sampling and quantizing the optical image.

6. The process of interpolation generates an approximation of the continuous image from the digital image.

7. Image display is an interpolation process that is implemented in hardware. It makes the digital image visible.

8. The optical image, the continuous image, the digital image, and the displayed image each represent the specimen.

9. The design or analysis of an image processing algorithm must take into account both the continuous image and the digital image.

10. In practice, digitization and interpolation cannot be done without loss of information and the introduction of noise and distortion.

11. Digitization and interpolation must both be done in a way that preserves the image content that is required to solve the problem at hand.

12. Digitization and interpolation must be done in a way that does not introduce noise or distortion that would obscure the image content that is needed to solve the problem at hand.

# References

1. DL Spector and RD Goldman (Eds.), *Basic Methods in Microscopy*, Cold Spring Harbor Laboratory Press, 2005.
2. G Sluder and DE Wolf, *Digital Microscopy*, 2nd ed., Academic Press, 2003.
3. S Inoue and KR Spring, *Video Microscopy*, 2nd ed., Springer, 1997.
4. DB Murphy, *Fundamentals of Light Microscopy and Electronic Imaging*, Wiley-Liss, 2001.
5. KR Castleman, *Digital Image Processing*, Prentice-Hall, 1996.
6. A Diaspro (ed.), *Confocal and Two-Photon Microscopy*, Wiley-Liss, 2001.

# 2

# Fundamentals of Microscopy

Kenneth R. Castleman and Ian T. Young

## 2.1 Origins of the Microscope

During the 1st century AD, the Romans were experimenting with different shapes of clear glass. They discovered that by holding over an object a piece of clear glass that was thicker in the middle than at the edges, they could make that object appear larger. They also used lenses to focus the rays of the sun and start a fire. By the end of the 13th century, spectacle makers were producing lenses to be worn as eyeglasses to correct for deficiencies in vision. The word *lens* derives from the Latin word *lentil*, because these magnifying chunks of glass were similar in shape to a lentil bean. In 1590, two Dutch spectacle makers, Zaccharias Janssen and his father, Hans, started experimenting with lenses. They mounted several lenses in a tube, producing considerably more magnification than was possible with a single lens. This work led to the invention of both the compound microscope and the telescope [1].

In 1665, Robert Hooke, the English physicist who is sometimes called "the father of English microscopy," was the first person to see cells. He made his discovery while examining a sliver of cork. In 1674 Anton van Leeuwenhoek, while working in a dry goods store in Holland, became so interested in magnifying lenses that he learned how to make his own. By carefully grinding and polishing, he was able to make small lenses with high curvature, producing magnifications of up to 270 times. He used his simple microscope to examine blood, semen, yeast, insects, and the tiny animals swimming in a drop of water. Leeuwenhoek became quite involved in science and was the first person to describe cells and bacteria.

Because he neglected his dry goods business in favor of science and because many of his pronouncements ran counter to the beliefs of the day, he was ridiculed by the local townspeople. From the great many discoveries documented in his research papers, Anton van Leeuwenhoek (1632–1723) has come to be known as "the father of microscopy." He constructed a total of 400 microscopes during his lifetime. In 1759 John Dolland built an improved microscope using lenses made of flint glass, greatly improving resolution.

Since the time of these pioneers, the basic technology of the microscope has developed in many ways. The modern microscope is used in many different imaging modalities and has become an invaluable tool in fields as diverse as materials science, forensic science, clinical medicine, and biomedical and biological research.

## 2.2    Optical Imaging

### 2.2.1    Image Formation by a Lens

In this section we introduce the basic concept of an image-forming lens system [1–7]. Figure 2.1 shows an optical system consisting of a single lens. In the simplest case the lens is a thin, double-convex piece of glass with spherical surfaces. Light rays inside the glass have a lower velocity of propagation than light rays in air or vacuum. Because the distance the rays must travel varies from the thickest to the thinnest parts of the lens, the light rays are bent toward the optical axis of the lens by the process known as *refraction*.

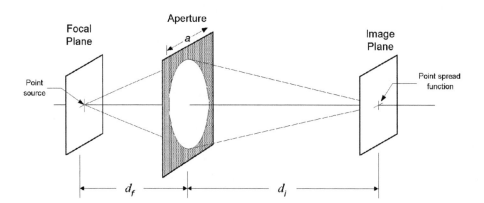

**FIGURE 2.1**    An optical system consisting of a single lens. A point source at the origin of the focal plane emits a diverging spherical wave that is intercepted by the aperture. The lens converts this into a spherical wave that converges to a spot (i.e., the point spread function, psf) in the image plane. If $d_f$ and $d_i$ satisfy Eq. 2.1, the system is in focus, and the psf takes on its smallest possible dimension.

### 2.2.1.1 *Imaging a Point Source*

A diverging spherical wave of light radiating from a point source at the origin of the focal plane is refracted by a convex lens to produce a converging spherical exit wave. The light converges to produce a small spot at the origin of the image plane. The shape of that spot is called the *point spread function* (psf).

**The Focus Equation** The point spread function will take on its smallest possible size if the system is in focus, that is, if

$$\frac{1}{d_f} + \frac{1}{d_i} = \frac{1}{f} \tag{2.1}$$

where $f$ is the *focal length* of the lens. Equation 2.1 is called the *lens equation*.

### 2.2.1.2 *Focal Length*

Focal length is an intrinsic property of any particular lens. It is the distance from the lens to the image plane when a point source located at infinity is imaged in focus. That is,

$$d_f = \infty \;\Rightarrow\; d_i = f$$

and by symmetry

$$d_i = \infty \;\Rightarrow\; d_f = f$$

The *power* of a lens, $P$, is given by $P = 1/f$; if $f$ is given in meters, then $P$ is in diopters. By definition, the *focal plane* is that plane in object space where a point source will form an in-focus image on the image plane, given a particular $d_i$. Though sometimes called the *object plane* or the *specimen plane*, it is more appropriately called the *focal plane* because it is the locus of all points that the optical system can image in focus.

**Magnification** If the point source moves away from the origin to a position $(x_o, y_o)$, then the spot image moves to a new position, $(x_i, y_i)$, given by

$$x_i = -Mx_o \qquad y_i = -My_o \tag{2.2}$$

where

$$M = \frac{d_i}{d_f} \tag{2.3}$$

is the *magnification* of the system.

Often the objective lens forms an image directly on the image sensor, and the pixel spacing scales down from sensor to specimen by a factor approximately equal

to the objective magnification. If, for example, $M = 100$ and the pixel spacing of the image sensor is 6.8 μm, then at the specimen or focal plane the spacing is 6.8 μm/100 = 68 nm. In other cases, additional magnification is introduced by intermediate lenses located between the objective and the image sensor. The microscope eyepieces, which figure into conventional computations of "magnification," have no effect on pixel spacing. It is usually advantageous to measure, rather than calculate, pixel spacing in a digital microscope. For our purposes, pixel spacing at the specimen is a more useful parameter than magnification.

Equations 2.1 and 2.3 can be manipulated to form a set of formulas that are useful in the analysis of optical systems [8]. In particular,

$$f = \frac{d_i d_f}{d_i + d_f} = \frac{d_i}{M+1} = d_f \frac{M}{M+1} \tag{2.4}$$

$$d_i = \frac{f d_f}{d_f - f} = f(M+1) \tag{2.5}$$

and

$$d_f = \frac{f d_i}{d_i - f} = f \frac{M+1}{M} \tag{2.6}$$

Although it is composed of multiple lens elements, the objective lens of an optical microscope behaves as in Fig. 2.1, to a good approximation. In contemporary light microscopes, $d_i$ is fixed by the optical tube length of the microscope. The mechanical tube length, the distance from the objective lens mounting flange to the image plane, is commonly 160 mm. The optical tube length, however, varies between 190 and 210 mm, depending upon the manufacturer. In any case, $d_i \gg d_f$ and, $M \gg 1$, except when a low-power objective lens (less than 10×) is used.

### 2.2.1.3  Numerical Aperture

It is customary to specify a microscope objective, not by its focal length and aperture diameter, but by its magnification (Eq. 2.3) and its *numerical aperture*, NA. Microscope manufacturers commonly engrave the magnification power and numerical aperture on their objective lenses, and the actual focal length and aperture diameter are rarely used. The NA is given by

$$\text{NA} = n \sin(\alpha) \approx n(a/2d_f) \approx n(a/2f) \tag{2.7}$$

where $n$ is the refractive index of the medium (air, immersion oil, etc.) located between the specimen and the lens and $\alpha = \arctan(a/2d_f)$ is the angle between the optical axis and a marginal ray from the origin of the focal plane to the edge of the aperture, as illustrated in Fig. 2.1. The approximations in Eq. 2.7 assume

small aperture and high magnification, respectively. These approximations begin to break down at low power and high NA, which normally do not occur together. One can compute and compare $f$ and $a$, or the angles $\arctan(a/2d_f)$ and $\arcsin(\text{NA}/n)$ to quantify the degree of approximation.

### 2.2.1.4 Lens Shape

For a thin, double-convex lens having a diameter that is small compared to its focal length, the surfaces of the lens must be spherical in order to convert a diverging spherical entrance wave into a converging spherical exit wave by the process of *diffraction*. Furthermore, the focal length, $f$, of such a lens is given by the *lensmaker's equation*,

$$\frac{1}{f} = (n-1)\left(\frac{1}{R_1} + \frac{1}{R_2}\right) \tag{2.8}$$

where $n$ is the refractive index of the glass and $R_1$ and $R_2$ are the radii of the front and rear spherical surfaces of the lens [4]. For larger-diameter lenses, the required shape is aspherical.

## 2.3 Diffraction-Limited Optical Systems

In Fig. 2.1, the lens is thicker near the axis than near the edges, and axial rays are refracted more than peripheral rays. In the ideal case, the variation in thickness is just right to convert the incoming expanding spherical wave into a spherical exit wave converging toward the image point. Any deviation of the exit wave from spherical form is, by definition, due to *aberration* and makes the psf larger.

For lens diameters that are not small in comparison to $f$, spherical lens surfaces are not adequate to produce a spherical exit wave. Such lenses do not converge peripheral rays to the same point on the $z$-axis as they do near-axial rays. This phenomenon is called *spherical aberration*, since it results from the (inappropriate) spherical shape of the lens surfaces. High-quality optical systems employ aspherical surfaces and multiple lens elements to reduce spherical aberration. Normally the objective lens is the main optical component in a microscope that determines overall image quality.

A *diffraction-limited* optical system is one that does produce a converging spherical exit wave in response to the diverging spherical entrance wave from a point source. It is so called because its resolution is limited only by diffraction, an effect related directly to the wave nature of light. One should understand that a diffraction-limited optical system is an idealized system and that real optical systems can only approach this ideal.

### 2.3.1   Linear System Analysis

It should be clear that increasing the intensity of the point source in Figure 2.1 causes a proportional increase in the intensity of the spot image. It follows that two point sources would produce an image in which the two spots combine by addition. This means that the lens is a two-dimensional *linear system* [8]. For reasonably small off-axis distances in well-designed optical systems, the shape of the spot image undergoes essentially no change as it moves away from the origin. Thus the system can be assumed to be *shift invariant* (ignoring magnification effects), or, in optics terminology, *isoplanatic*, as well as linear. The psf is then the *impulse response* of a shift-invariant, linear system. This implies that the imaging properties of the system can be specified by either its psf or its *transfer function* [4, 8]. The *optical transfer function* is the Fourier transform of the psf. The field of linear system analysis is quite well developed, and it provides us with very useful tools to analyze the performance of optical systems. This is developed in more detail in later chapters.

## 2.4   Incoherent Illumination

Incoherent illumination may be viewed as a distribution of point sources, each having a random phase that is statistically independent of the other point sources [2, 5–7]. Under incoherent illumination, an optical system is linear in light intensity. The light intensity is the square of the amplitude of the electromagnetic waves associated with the light [2]. In the following, we assume narrow-band light sources. In general, light is a collection of different wavelengths, and modern microscopy makes extensive use of wavelengths between 350 nm (ultraviolet) and 1100 nm (near infrared). The term *narrow-band* implies using only a small range of wavelengths, perhaps 30 nm wide around some center wavelength.

### 2.4.1   The Point Spread Function

The spot in the image plane produced by a point source in the focal plane is the psf. For a lens with a circular aperture of diameter $a$ in narrow-band, incoherent light having center wavelength $\lambda$, the psf has circular symmetry (Fig. 2.2) and is given by

$$\text{psf}(r) = h(r) = \left[ 2 \frac{J_1\left(\pi\left[\frac{r}{r_o}\right]\right)}{\pi\left[\frac{r}{r_o}\right]} \right]^2 \tag{2.9}$$

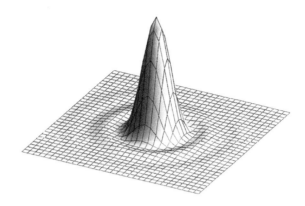

**FIGURE 2.2** The incoherent point spread function. A focused diffraction-limited system produces this psf in narrow-band incoherent light.

where $J_1(x)$ is the first-order Bessel function of the first kind [4]. The intensity distribution associated with this psf is called the *Airy disk pattern*, after G.B. Airy [9, 10], and is shown in Fig. 2.2. The constant, $r_o$, a dimensional scale factor, is

$$r_o = \frac{\lambda d_i}{a} \tag{2.10}$$

and $r$ is radial distance measured from the origin of the image plane, that is,

$$r = \sqrt{x_i^2 + y_i^2} \tag{2.11}$$

## 2.4.2 The Optical Transfer Function

Since the imaging system in Fig. 2.1 is a shift-invariant linear system, it can be specified either by its impulse response (i.e., the psf ) or by the Fourier transform of its psf, which is called the *optical transfer function* (OTF). For a lens with a circular aperture of diameter $a$ in narrow-band incoherent light having center wavelength $\lambda$, the OTF (Fig. 2.3) is given by [4]

$$\text{OTF}(q) = F\{h(r)\} = H(q) = \begin{cases} \dfrac{2}{\pi - 2}\left\{\cos^{-1}\left[\dfrac{q}{f_c}\right] - \sin\left[\cos^{-1}\left(\dfrac{q}{f_c}\right)\right]\right\} & q \le f_c \\ 0 & q \ge f_c \end{cases} \tag{2.12}$$

where $q$ is the spatial frequency variable, measured radially in two-dimensional frequency space. It is given by

$$q = \sqrt{u^2 + v^2} \tag{2.13}$$

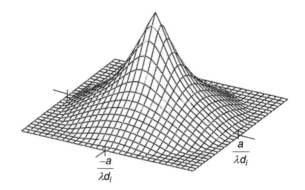

**FIGURE 2.3**    The incoherent OTF. This is the frequency response of a focused diffraction-limited system in narrow-band incoherent light.

where $u$ and $v$ are spatial frequencies in the $x$ and $y$ directions, respectively. The parameter $f_c$, called the *optical cutoff frequency*, is given by

$$f_c = \frac{1}{r_o} = \frac{a}{\lambda d_i} \tag{2.14}$$

## 2.5    Coherent Illumination

Some microscopy applications require the use of coherent light for illumination. Lasers, for example, supply coherent illumination at high power. Coherent illumination can be thought of as a distribution of point sources whose amplitudes maintain fixed phase relationships among themselves. Diffraction works somewhat differently under coherent illumination, and the psf and OTF take on different forms. Under coherent illumination, an optical system is linear in complex amplitude as opposed to linear in light intensity, as in the incoherent case.

### 2.5.1    The Coherent Point Spread Function

For a lens with a circular aperture of diameter $a$ in coherent light of wavelength $\lambda$, the psf has circular symmetry (Fig. 2.4) and is given by

$$h(r) = 2\frac{J_1[\pi(r/r_o)]}{\pi(r/r_o)} \tag{2.15}$$

where $r_o$ is from Eq. 2.10 and $r$ is from Eq. 2.11.

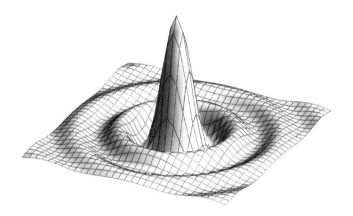

**FIGURE 2.4** The coherent point spread function. A focused diffraction-limited system produces this psf in coherent light.

## 2.5.2 The Coherent Optical Transfer Function

For a lens with a circular aperture of diameter $a$ in coherent light of wavelength $\lambda$, the OTF (Fig. 2.5) is given by [4]

$$H(q) = \Pi\left(q\frac{\lambda d_i}{a}\right) \tag{2.16}$$

where $q$ is from Eq. 2.13 and

$$\Pi(q) = \begin{cases} 1 & |q| < \dfrac{1}{2} \\ 0 & |q| > \dfrac{1}{2} \end{cases} \tag{2.17}$$

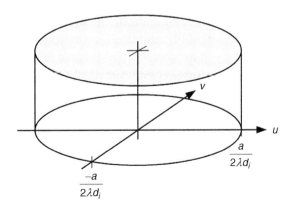

**FIGURE 2.5** The coherent OTF. This is the frequency response of a focused diffraction-limited system in coherent light.

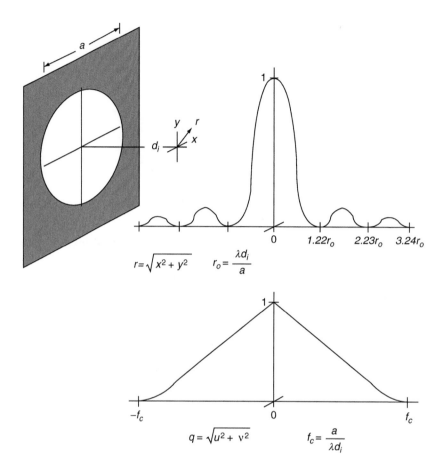

**FIGURE 2.6**    The incoherent point spread function and transfer function. This shows how the psf and OTF depend on wavelength and aperture diameter for a diffraction-limited optical system with a circular aperture.

Notice that, under coherent illumination, the OTF is flat out to the cutoff frequency, while under incoherent illumination it monotonically decreases. Notice also that the cutoff frequency in incoherent light is twice that of the coherent case. Fig. 2.6 illustrates the relationships between the incoherent point spread function and transfer function of diffraction-limited optical systems with circular exit pupils.

## 2.6    Resolution

One of the most important parameters of a microscope is its *resolution*, that is, its ability to reproduce in the image small structures that exist in the specimen. The optical definition of resolution is the minimum distance by which two point sources must be separated in order for them to be recognized as separate. There is no unique way to establish this distance. The psfs overlap gradually as the

points get closer together, and one must specify how much contrast is required if the two objects are to be recognized as distinct. There are, however, two commonly used criteria for comparing the resolving power of optical systems.

### 2.6.1  Abbe Distance

To a good approximation, the half-amplitude diameter of the central peak of the image plane psf is given by the *Abbe distance* (after Ernst Abbe [11]),

$$r_{\text{Abbe}} = \frac{1}{M}\lambda\frac{d_i}{a} = \lambda\frac{d_f}{a} \approx \frac{\lambda}{2\text{NA}} = 0.5\left(\frac{\lambda}{\text{NA}}\right) \tag{2.18}$$

### 2.6.2  Rayleigh Distance

For a lens with a circular aperture, the first zero of the image plane psf occurs at a radius

$$r_{\text{Airy}} = 1.22r_o = 0.61\left(\frac{\lambda}{\text{NA}}\right) \tag{2.19}$$

which is called *the radius of the Airy disk*. According to the *Rayleigh criterion of resolution* (after Lord Rayleigh [12]), two point sources can be just resolved if they are separated, in the image, by the distance $\delta = r_{\text{Airy}}$. (See Fig. 2.7.) In the terminology of optics, the Rayleigh distance defines circular *resolution cells* in the image, since two point sources can be resolved if they do not fall within the same resolution cell.

### 2.6.3  Size Calculations

In microscopy it is convenient to perform size calculations in the focal plane, rather than in the image plane as previously, since that is where the objects of

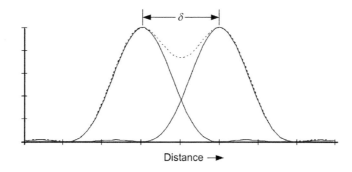

FIGURE 2.7  The Rayleigh criterion of resolution. Two point sources can be just resolved if they are separated, in the image, by the Airy distance.

interest actually reside. The projection implemented by the lens involves a $180°$ rotation and a scaling by the factor $M$ (Eq. 2.3). The pixel spacing and resolution can then be specified in units of micrometers at the specimen. Spatial frequencies can be specified in cycles per micrometer in the focal plane.

Since $d_f \approx f$ for high-magnification lenses (Eq. 2.6), the resolution parameters are more meaningful if we scale them to the focal (specimen) plane rather than working in the image plane. For a microscope objective, the incoherent optical cutoff frequency in the focal plane coordinate system is

$$f_c = \frac{Ma}{\lambda d_i} = \frac{a}{\lambda d_f} = \frac{2\text{NA}}{\lambda} \tag{2.20}$$

the Abbe distance is

$$r_{\text{Abbe}} = \frac{1}{M}\lambda\frac{d_i}{a} = \lambda\frac{d_f}{a} \approx \frac{\lambda}{2\text{NA}} = 0.5\left(\frac{\lambda}{\text{NA}}\right) \tag{2.21}$$

and the Rayleigh distance (resolution cell diameter) is

$$\delta_{\text{Rayleigh}} = 1.22r_o = 0.61\left(\frac{\lambda}{\text{NA}}\right) \tag{2.22}$$

For $\lambda = 0.5\,\mu\text{m}$ (green light) and an NA of 1.4 (high-quality, oil-immersion lens), we have $f_c = 5.6\,\text{cycles}/\mu\text{m}$, $r_{\text{Abbe}} = 0.179\,\mu\text{m}$, and $\delta_{\text{Rayleigh}} = 0.218\,\mu\text{m}$.

The foregoing approximations begin to break down at low power and high NA, which normally do not occur together. Again, one can compute and compare $f$ and $a$, or the angles $\arctan(a/2d_f)$ and $\text{arcsine}(\text{NA}/n)$, to quantify the degree of approximation.

## 2.7   Aberration

Real lenses are never actually diffraction limited, but suffer from aberrations that make the psf broader, and the OTF narrower, than they would otherwise be [2, 6, 7]. An example is spherical aberration, mentioned earlier. Aberrations in an optical system can never increase the magnitude of the optical transfer function, but they can drive it negative.

## 2.8   Calibration

Making physical size measurements from images is very often required in the analysis of microscope specimens. This can be done with accuracy only if the

pixel spacing at the focal plane is known. Making brightness measurements in the image is also useful, and it requires knowledge of the relationship between specimen brightness and gray levels in the digital image.

## 2.8.1 Spatial Calibration

The pixel spacing can be either calculated or measured. Calculation requires knowledge of the pixel spacing at the image sensor and the overall magnification of the optics (recall Eq. 2.3). Often it can be calculated from

$$\delta x = \frac{\Delta x}{M_o M_a} \qquad (2.23)$$

where $\delta x$ and $\Delta x$ are the pixel spacing values at the specimen and at the image sensor, respectively, and $M_o$ is the magnification of the objective. $M_a$ is the magnification imposed by other optical elements in the system, such as the camera adapter. Usually this is quoted in the operator's manual for the microscope or the accessory attachment. The image sensor pixel spacing is quoted in the camera manual.

Too often, however, the numbers are not available for all the components in the system. Pixel spacing must then be measured with the aid of a calibrated target slide, sometimes called a *stage micrometer*. This requires a computer program that can read out the $(x, y)$ coordinates of a pixel in the digital image. One digitizes an image of the calibration target and locates two pixels that are a known distance apart on the target. Then

$$\delta x = \frac{D}{\sqrt{(x_2 - x_1)^2 + (y_2 - y_1)^2}} \qquad (2.24)$$

where $\delta x$ is the pixel spacing, $D$ is the known distance on the calibration target, and $(x_1, y_1)$ and $(x_2, y_2)$ are the locations of the two pixels in a recorded image. For precision in the estimate of $\delta x$, the two points should be as far apart as possible in the microscope field of view.

## 2.8.2 Photometric Calibration

Photometric properties that can be measured from a microscope image include transmittance, optical density, reflectance, and fluorescence intensity. Optical density calibration, as well as that for reflectance, requires a calibration target. The procedure is similar to that for spatial calibration [8]. Fluorescence intensity calibration techniques are covered in Chapter 12.

## 2.9   Summary of Important Points

1. Lenses and other optical imaging systems can, in most cases, be treated as two-dimensional, shift-invariant, linear systems.

2. The assumptions involved in the use of linear analysis of optical systems begin to break down as one moves far off the optical axis, particularly for wide-aperture, low-magnification systems.

3. Under coherent illumination, an optical system is linear in complex amplitude.

4. Under incoherent illumination, an optical system is linear in intensity (amplitude squared).

5. An optical system having no aberrations is called *diffraction-limited* because its resolution is limited only by the wave nature of light (diffraction effects). This is an ideal situation that real systems can only approach.

6. A diffraction-limited optical system transforms a diverging spherical entrance wave into a converging spherical exit wave.

7. The point spread function of an optical system has a nonzero extent because of two effects: the wave nature of light (diffraction) and aberrations in the optical system.

8. The optical transfer function is the Fourier transform of the point spread function.

9. The point spread function is the inverse Fourier transform of the optical transfer function.

10. For a circularly symmetric lens, the incoherent point spread function is given by Eq. 2.9.

11. For a circularly symmetric lens, the incoherent optical transfer function is given by Eq. 2.12.

12. For a circularly symmetric lens, the coherent point spread function is given by Eq. 2.15.

13. For a circularly symmetric lens, the coherent transfer function is given by Eq. 2.16.

# References

1. WJ Croft, *Under the Microscope: A Brief History of Microscopy*, World Scientific Publishing Company, 2006.
2. M Born and E Wolf, *Principles of Optics: Electromagnetic Theory of Propagation, Interference and Diffraction of Light*, 7th ed., Cambridge University Press, 2000.
3. EL O'Neill, *Introduction to Statistical Optics*, Courier Dover Publications, 2004.
4. JW Goodman, *Introduction to Fourier Optics Third Edition*, Roberts and Company, 2005.
5. C Scott, *Introduction to Optics and Optical Imaging*, IEEE Press, 1998.
6. E Hecht, *Optics*, 4th ed., Addison-Wesley, 2002.
7. DJ Goldstein, *Understanding the Light Microscope*, Academic Press, 1999.
8. KR Castleman, *Digital Image Processing*, Prentice-Hall, 1996.
9. GB Airy "The Diffraction of an Annular Aperture," *Philos. Mag. Ser.*, 1841.
10. GB Airy, "On the Diffraction of an Object-Glass with Circular Aperture," SPIE milestone series, Society of Photo-optical Instrumentation Engineers, 2007.
11. E Abbe, *Archiv. Mikroskopische Anat.* **9**:413–468, 1873.
12. L Rayleigh, "On the Theory of Optical Images, with Special Reference to the Microscope," *Philosophical Magazine,* **42**(5):167, 1896.

# 3

# Image Digitization

Kenneth R. Castleman

## 3.1 Introduction

As mentioned in Chapter 1, digitization is the process that generates a digital image, using the optical image as a guide. If this is done properly, then the digital image can be interpolated (again, if done properly) to produce a continuous image that is a faithful representation of the optical image, at least for the content of interest. In this chapter we address the factors that must be considered in order to make this faithful representation happen.

In this day and age, many high-quality commercial image digitizing components are available. It is no longer necessary to build an image digitizing system from scratch. The design of a digital microscope system thus mainly entails selecting a compatible set of components that are within budget and adequate for the work to be done. A properly designed system, then, is well balanced and geared to the tasks at hand. That is, no component unduly restricts image quality, and none is wastefully overdesigned.

The various components of the imaging system (optics, image sensor, analog-to-digital converter, etc.) act as links in a chain. Not only is the chain no stronger than its weakest link, but the sum is actually less than any of its parts (Section 3.8.1). In this chapter we seek to establish guidelines that will lead to the design of well-balanced systems.

The primary factors that can degrade an image in the digitizing process are (1) loss of detail, (2) noise, (3) aliasing, (4) shading, (5) photometric nonlinearity, and (6) geometric distortion. If the level of each of these is kept low enough, then the digital images obtained from the microscope will be usable for their

intended purpose. Different applications, however, require different levels of accuracy. Some are intrinsically more prone to noise and distortion than others. Thus the design of a system must begin with a list of the planned applications and their requirements in these five areas. In this chapter we discuss these five topics individually before addressing them collectively.

This chapter addresses the various sources of degradation and how to quantify them and the system design factors that affect overall performance. Other chapters present image processing techniques that can be used to correct these degradations. The principal goals are to preserve a suitably high level of detail and signal-to-noise ratio while avoiding aliasing and to do so with acceptably low levels of shading, photometric nonlinearity, and geometric distortion.

## 3.2   Resolution

The term *resolution* is perhaps the most abused word in all of digital microscopy. It is sometimes used to describe pixel spacing (e.g., 0.25 microns between adjacent pixel centers), digital image size (e.g., 1024 × 1024 pixels), test target size (e.g., 1-micron bars), and grayscale depth (e.g., 8 bits, or 256 gray levels). One must pay careful attention to context in order to know which definition is in use. Otherwise considerable confusion will result.

In this book we adhere to the definition from the field of optics. *Resolution* is a property of an imaging system. Specifically, it refers to the ability of the system to reproduce the contrast of objects of different size. Notice that an object necessarily must reside on a background. It is visible because it differs in brightness from that background; that difference in brightness is its *contrast*. Smaller objects normally are reproduced with lower contrast than larger objects. Below some limiting size, objects are imaged totally without contrast, and they disappear. Resolution refers to the smallest size an object can have and still be *resolved* (seen to be separate from other objects in the image). This loss of contrast with decreasing size, however, is a gradual phenomenon, so it is impossible to specify uniquely the size of the smallest objects that can be imaged. Instead we must adopt some criterion of visibility to specify the smallest resolvable object size.

At high magnification, in a well-designed system, it is normally the optical components (principally the objective lens) that determine overall system resolution. At low magnification, however, other components, such as the image sensor array, may set the limit of resolution.

The optical transfer function (OTF) is a plot of the reproduced contrast of an imaged object versus object size [1]. Here object size is specified as the frequency of a pattern of bars with sinusoidal profile. In Fig. 3.1 we see such a test pattern and note that the contrast of the imaged bars decreases with increasing frequency. A plot showing this decrease is the OTF.

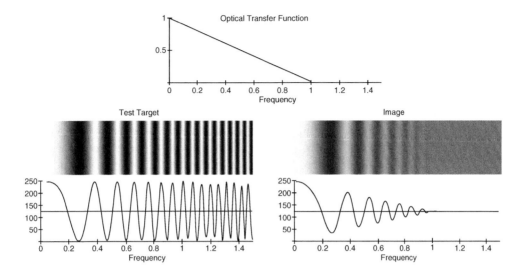

**FIGURE 3.1** The optical transfer function (OTF). The OTF specifies how the contrast of sinusoidal structures of different frequencies is reduced by the imaging process.

Much to our good fortune, the OTF is the Fourier transform of the point spread function (psf), which is discussed in Chapter 2. Thus having either of these functions makes available the other, and either one is sufficient to specify the resolution of the system or of one of its components. Here we are making the assumption that the imaging components under consideration can be modeled as shift-invariant linear systems [1, 2].

While the OTF and, equivalently, the psf are complete specifications of the system's imaging capability, they are curves, and it is often desirable to have a single number as a specification of resolution. Several of these are used, such as the frequency at which the OTF drops to 10% of its zero-frequency value. More common is the Rayleigh resolution criterion [1, 3]. It states that two point objects can be just resolved if they are separated by a distance equal to the radius of the first minimum of the psf, commonly called the *Airy disk*.

## 3.3 Sampling

The digitization process samples the optical image to form an array of sample points. These are most commonly arranged on a rectangular sampling grid. The image intensity is averaged over a small local area at each sample point. This process can be modeled as convolution with the psf of the system. Further, the image intensity is quantized at each sample point to produce an integer. This rather brutal treatment is necessary to produce image data that can be processed in a computer. If it is done properly, however, the important components of the image will pass through undamaged.

The Shannon sampling theorem [1, 4, 5] states that a continuous function can be reconstructed, without error, from evenly spaced sample points, provided that two criteria are met. First the function must be band-limited. That means that its Fourier spectrum is zero for all frequencies above some cutoff frequency, which we call $f_c$. This means the function can have no sinusoidal components of frequency greater than $f_c$. Second, the sample spacing must be no larger than $\Delta x = 1/2f_c$. This means there will be at least two sample points per cycle of the highest-frequency sinusoidal component of the function. If these two criteria are met, the function can be recovered from its samples by the process of interpolation, if that is properly done.

If $\Delta x < 1/2f_c$, then we have a smaller sample spacing than necessary, and the function is said to be *oversampled*. The major drawbacks of oversampling are increased file size and increased equipment cost, but reconstruction without error is still possible. If $\Delta x = 1/2f_c$ we have *critical sampling*, also known as sampling at the *Nyquist rate* [1]. If $\Delta x > 1/2f_c$, then we have a larger sample spacing than that required by the sampling theorem, and the function is said to be *undersampled*. In this case interpolation cannot reconstruct the function without error if it contains sinusoidal components of frequency up to $f_c$ (see Section 3.3.2).

## 3.3.1  Interpolation

As a further requirement for perfect reconstruction of a sampled function, the interpolating function must also be band-limited [6]. By the similarity theorem of the Fourier transform [1, 2, 7, 8], a narrow function has a broad spectrum, and vice versa. This means that any suitable interpolating function (such as $\sin(x)/x$) will extend to infinity in both positive and negative $x$ and $y$. Clearly we cannot implement that digitally, so we are constrained to work with truncated interpolation functions. This means that perfect reconstruction remains beyond our grasp, no matter how finely we sample. However, we can usually get close enough, and oversampling is a key to that.

Figure 3.2 shows the results of interpolating a sampled cosine function with the often-used Gaussian interpolation function, shown at the upper left. Even though the sampling theorem is satisfied (i.e., $\Delta x < 1/2f$) in all seven cases, the inappropriate interpolation function creates considerable reconstruction error. As the sampling becomes finer, the results of interpolation, while still imperfect, are seen to improve. The lesson is that, even though we are constrained to use inappropriate interpolation functions, judicious oversampling can compensate for much of that inadequacy.

Figure 3.3 shows interpolation with a truncated version of the sinc function. Here the interpolation process is more complicated than with the Gaussian, but good results are obtained, all the way up to the sampling limit of $\Delta x = 1/2f$.

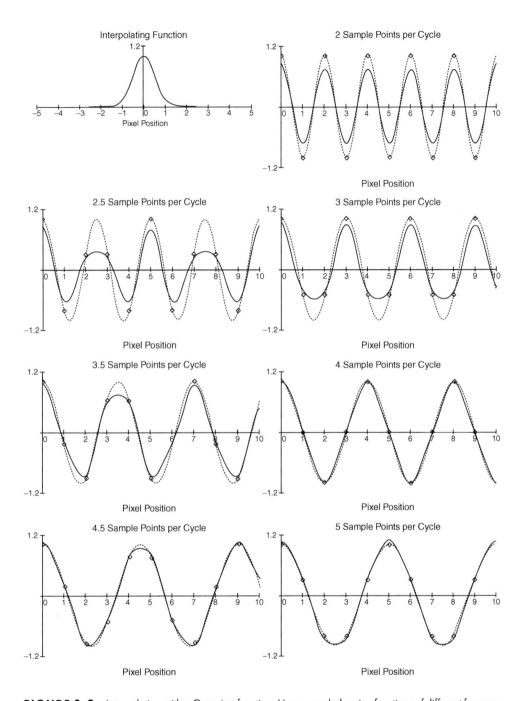

**FIGURE 3.2** Interpolation with a Gaussian function. Here, sampled cosine functions of different frequencies are interpolated by convolution with the commonly used Gaussian function shown at the upper left. In each case, the original function appears as a dashed line and the reconstructed function as a solid line. The sample points appear as diamonds. Notice that the inappropriate shape of the interpolation function gives rise to considerable reconstruction error and that the amount and nature of that error varies with frequency. In general, however, the amount of interpolation error decreases as the sample spacing becomes smaller in relation to the period of the cosine. This phenomenon argues that oversampling tends to compensate for our having to use a truncated interpolation function.

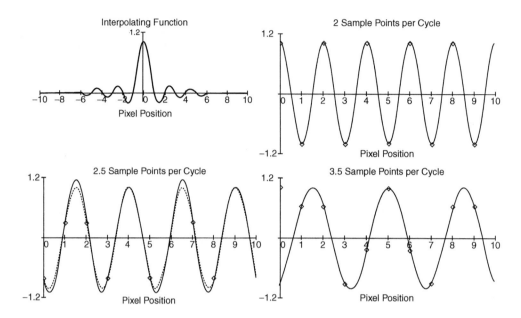

**FIGURE 3.3**   Interpolation with a truncated sinc function. Sampled cosine functions of different frequencies are interpolated by convolution with the truncated sinc function, shown in the upper left. In each case, the original function is shown as a dashed line and the reconstructed function as a solid line. The sample points appear as diamonds. Notice that the more appropriate shape of the interpolation function gives rise to considerably less reconstruction error than that apparent in Fig. 3.2.

This means that the continuous image is truly available to us if we implement digital interpolation using a decent approximation to the sinc function.

## 3.3.2   Aliasing

*Aliasing* is the phenomenon that occurs when an image is sampled too coarsely, that is, when the pixels are too far apart in relation to the size of the detail present in the image [1, 5, 6, 9]. It introduces a very troublesome type of low-frequency noise. Aliasing can be a significant source of error when images contain a strong high-frequency pattern, but it can be, and should be, avoided by proper system design.

If the sample spacing, $\Delta x$, is too large (i.e., $\Delta x > 1/2f$), then a sinusoid of frequency $f$ is undersampled and cannot be reconstructed without error. When it is interpolated, even with an appropriate interpolation function, the phenomenon of aliasing introduces noise that resembles a Moiré pattern. Aliasing poses a particular problem in images that contain a high-contrast, high-frequency parallel-line pattern. Most images have little contrast at the highest frequencies, so there is less of a visible effect.

Figure 3.4 illustrates aliasing. In the upper left, the cosine is oversampled and is reconstructed exactly by interpolation with the sinc function. In the other

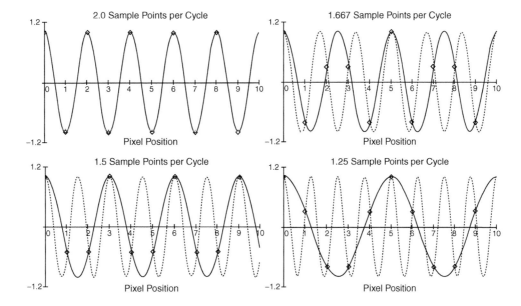

**FIGURE 3.4** Aliasing. Here cosine functions of different frequencies are sampled and then interpolated by convolution with the (untruncated) sinc function. In each case, the original function is shown as a dashed line and the reconstructed function as a solid line. The sample points appear as diamonds. Notice that violation of the sampling theorem (i.e., $\Delta x > 1/2f$) gives rise to a peculiar form of reconstruction error. In each case a cosine of unit magnitude is reconstructed, so amplitude and waveshape are preserved but frequency is not. The reconstructed cosines are reduced in frequency. This phenomenon affects all sinusoidal components having frequency greater than half the sampling frequency. Notice that the reconstructed function, although of the wrong frequency, still passes through all of the sample points.

three panels, the cosine is undersampled, and, though a cosine is reconstructed, it has the wrong frequency. Aliasing reduces the frequency of sinusoidal components in an image. This can be quite troublesome and should be avoided by maintaining $\Delta x < 1/2f_c$.

We mentioned in Chapter 2 that the OTF of a microscope objective lens (Eq. 2.12) goes to zero for all frequencies above the optical cutoff frequency $f_c = \lambda/2\text{NA}$ (Eq. 2.14). Thus the optics provide a built-in antialiasing filter, and we can be content simply to design for $\Delta x < 1/2f_c$, at least as far as aliasing is concerned. However, since we cannot interpolate with the sinc function, as contemplated by the sampling theorem, we must compensate for this shortcoming by oversampling. Thus it is good practice to set the sample spacing well below the aliasing limit.

## 3.4  Noise

The term *noise* is generally taken to mean an undesired additive component of an image. It can be random or periodic. The most common noise component is

the random noise generated by the amplifier circuitry in the camera. Periodic noise can result from stray periodic signals finding their way into the camera circuits. Quantization noise results from conversion of the continuous brightness values into integers. As a rule of thumb, the overall noise level will be the root sum square of the various noise source amplitudes. One can control quantization noise by using enough bits per pixel. Generally quantization noise can be, and should be, kept below the other noise sources in amplitude. Eight-bit digitizers are quite common, and this puts the quantization noise level (1/256) below 0.5 percent of the total dynamic range. Some applications, however, require the more expensive 10-bit or 12-bit digitizers.

## 3.5 Shading

Ideally the contrast of an object would not change as it moved around within the image. Neither would the gray level of the background area where no objects reside. This is never the case. An empty field will usually show considerable variation in brightness, typically as a slowly varying pattern that becomes darker toward the periphery of the field of view. This is called *additive shading* because brightness is added to (or subtracted from) the true brightness of the object at different locations in the image. Careful adjustment of the microscope (e.g., lamp centering, condenser focusing) can minimize, but not remove, this effect. More subtle but equally important is *multiplicative shading*. Here the contrast of the object (brightness difference from background) varies with position. The gray level is multiplied by a factor that varies with position.

Fortunately, both additive and multiplicative shading usually remain constant from one image to the next, until the microscope configuration (e.g., objective power) is changed. Thus one can usually record the shading pattern at the beginning of a digitizing session and remove it from each captured image by subsequent digital processing (see Chapter 12). Nevertheless, steps taken in the design phase to reduce inherent shading will reap generous rewards later.

## 3.6 Photometry

Ideally the gray levels should be linearly related to some photometric property of the specimen, just as the pixel position (row and column) in the digital image is related to $(x, y)$ position in the specimen. Then the recorded digital image describes the specimen and not the system that imaged it. The photometric property can be transmittance, optical density, reflectance, fluorescence intensity, etc. If the image sensor array is not linear in the desired photometric property, then a grayscale transformation (Chapter 6) may be required to bring about the

desired linear relationship. Special calibration targets containing objects of known brightness are commonly used to determine the relationship. Step wedge targets and fluorescent beads of known size and brightness are often useful.

## 3.7 Geometric Distortion

Geometric distortion is an unwanted "warping" of the image that distorts the spatial relationship among the objects in the image. It can change the apparent size and shape of objects and the spacing between them. Geometric distortion can undermine the accuracy of spatial measurements, such as length, area, perimeter, shape, and spacing.

Most modern microscope imaging systems use solid-state image sensor arrays. The pixel geometry is carefully controlled in the manufacturing process, and geometric distortion from this source is negligible. Other components, however, can disturb the geometrical relationships. The imaging optics, for example, can introduce geometric distortion.

One can reduce the effects of geometric distortion by first measuring and characterizing it and then correcting it in software after the images have been digitized. Measurement requires a suitable test target of known geometry, such as a rectangular grid pattern. Correction requires a suitably defined geometric operation (see Chapter 5).

To a first-order approximation, geometric distortion is invariant from one image to the next. This means we can measure it once and for all and correct the images as a batch process. Changing the microscope configuration (e.g., the objective lens), of course, will change the distortion pattern, and separate correction is required for each different setup.

## 3.8 Complete System Design

No one component single-handedly determines the quality of the images obtained from a digital microscope. It is the interaction of all components that establishes image quality.

### 3.8.1 Cumulative Resolution

Each component in the imaging chain (objective, relay lens, camera, etc.) contributes to the overall resolution of the system. If each of these is a shift-invariant linear system, then their cumulative effect can be summarized as the system psf. The overall system psf is simply the convolution of all of the component psfs. The problem with this is that each convolution broadens the psf. Thus the system psf will be broader than any of the component psfs. Looking at

the problem in the frequency domain, the overall system transfer function (TF) is the product of the transfer functions of all of the components. Since they all typically decay with increasing frequency, the system TF will be narrower than any component TF. The result of all this is that we might assemble a system with components, each of which has adequate resolution, only to find that the system itself does not. Searching for a single offending component will be futile, since this chain is weaker than any of its links. Thus we must select components based on overall, not individual, performance requirements.

## 3.8.2   Design Rules of Thumb

Here we discuss some principles that can be used to guide the design of a system, even when this consists mainly of component selection.

### 3.8.2.1   Pixel Spacing

The cutoff frequency of the objective lens OTF sets the maximum sample spacing, but one is always wise to oversample generously. One should select the pixel spacing not only to avoid aliasing for any configuration (objective power, etc.), but also to make subsequent processing more reliable. Low-magnification configurations deserve special consideration since the objective lens may not provide an antialiasing filter, and aliasing becomes more likely.

### 3.8.2.2   Resolution

Although each component contributes, the numerical aperture (NA) of the objective lens generally establishes the resolution of the system. For high-quality lenses, one can assume the diffraction-limited form of the OTF (Eq. 2.12). A measured OTF is better, however, especially for lower-quality optics, which may not live up to their full potential. The objective lens OTF should pass the highest frequencies expected to be present in the specimens of interest. Stated another way, the psf (Eq. 2.9) should be less than half the size of the smallest objects of interest to be imaged.

### 3.8.2.3   Noise

The overall noise level is approximately the square root of the sum of squares of the individual noise sources in the system. Quantization noise should be less than half the root mean square (RMS) noise level due to all other noise sources.

### 3.8.2.4   Photometry

One can measure the photometric linearity of a particular microscope configuration using a suitable calibration target (step wedge, fluorescent beads, etc.).

If there is significant nonlinearity, it can be corrected with a suitable grayscale transformation (Chapter 6). This can be done as a batch job after the digitizing session is finished.

### 3.8.2.5 Distortion

The degree of geometric distortion in a particular microscope configuration can be measured with a calibration grid target. If it is significant, one can use a geometric transformation to correct it in each digitized image (Chapter 5). This can be done as a batch job after the digitizing session is complete.

## 3.9 Summary of Important Points

1. Aliasing results when the sample spacing is greater than one-half the period of a sinusoidal component.

2. Aliasing reduces the frequency of sinusoidal components.

3. The system OTF sets an upper limit on the frequencies that can be present in an image.

4. The system OTF can act as an antialiasing filter.

5. One can set the sampling frequency to be at least twice the OTF cutoff frequency to avoid aliasing.

6. A band-limited interpolation function is required for recovery without error of a sampled function.

7. A truncated sinc function is better for interpolation than a nonnegative pulse.

8. Oversampling tends to compensate for the use of a truncated interpolation function.

9. Oversampling tends to make subsequent quantitative image analysis more accurate.

## References

1. KR Castleman, *Digital Image Processing*, Prentice-Hall, 1996.
2. RN Bracewell, *The Fourier Transform and Its Applications*, McGraw-Hill, 2000.
3. JW Goodman, *Introduction to Fourier Optics*, *Third Edition*, Roberts and Company, 2005.
4. CE Shannon, "A Mathematical Theory of Communication," *The Bell System Technical Journal*, **27**(3):379–423, 1948.

5. AB Jerri, "The Shannon Sampling Theorem—Its Various Extensions and Applications: A Tutorial Review," *Proceeding of the IEEE*, 1565–1596, 1977.

6. A Kohlenberg, "Exact Interpolation of Bandlimited Functions," *Journal of Applied Physics*, 1432–1436, 1953.

7. JW Goodman, *Introduction to Fourier Optics Third Edition*, Roberts and Company, 2005.

8. EO Brigham, *The Fast Fourier Transform and its Applications*, Prentice-Hall, 1988.

9. RR Legault, "The Aliasing Problems in Two-Dimensional Sampled Imagery," in *Perception of Displayed Information*, LM Biberman, ed., Plenum Press, 1973.

# 4

# Image Display

Kenneth R. Castleman

## 4.1  Introduction

In some cases a digitized microscope image may be analyzed quantitatively, and
the resulting numerical data is all that is required for the project. In many other
cases, however, a processed image must be displayed for interpretation. Indeed,
more actual scientific discovery is based on viewing images than on observing
data. Even in clinical applications, one usually wishes to see the specimen, if only
to understand and confirm the accompanying numerical data.

Image display is the opposite of digitization. It converts a digital image back
into visible form. It does so by an interpolation process that is implemented in
hardware. Just as image digitization must be done with attention to the elements
that affect image quality, high-quality image displays do not happen by accident
either. In this chapter we discuss processing steps that can help ensure that
a display system presents an image in its truest or most interpretable form.
Image display technologies fall outside our scope and are covered elsewhere
[1–7]. Here we focus on how to prepare digital image data for display.

The primary job of a display system is to recreate, through interpolation, the
continuous image that corresponds to the digital image that is to be displayed.
Recall from Chapter 1 that any digital image is a sampled function that corres-
ponds uniquely to a particular analytic function. The task of the display system
is to produce that analytic function as a pattern of light on a screen, a pattern of
ink on a page, or an image on film. We wish that presentation to be as accurate
as possible or at least good enough to serve the needs of the project.

Normally a display system produces an analog image in the form of a rectangular array of display pixels. The brightness of each display pixel is controlled by the gray level of the corresponding pixel in the digital image. However, the primary function of the display is to allow the human observer to understand and interpret the image content. This introduces a subjective element, and it is helpful to match the display process to the characteristics of the human eye. For example, the human eye has considerable acuity in discriminating fine detail (high-spatial-frequency information), but is not particularly sensitive to low-frequency (slowly varying) image information [8]. Some images may be more easily understood if they are displayed indirectly, using contour lines, shading, color, or some other representation. Examples of such displays appear throughout this book.

# 4.2   Display Characteristics

In this section we discuss those characteristics that, taken together, determine the quality of a digital image display system and its suitability for particular applications. The primary characteristics of interest are the image size, the photometric and spatial resolution, the low-frequency response, and the noise characteristics of the display.

## 4.2.1   Displayed Image Size

The image size capability of a display system has two components. First is the physical size of the display itself, which should be large enough to permit convenient examination and interpretation of the displayed images. For example, a larger screen is required for group viewing. The second characteristic is the size of the largest digital image that the display system can handle. The native displayed image size must be adequate for the number of rows and columns in the largest image to be displayed. The trend is toward processing larger images, and inadequate display size can reduce the effectiveness of an image processing system.

## 4.2.2   Aspect Ratio

Ideally the vertical and horizontal pixel spacings will be equal in the image digitizing camera and in the display device. This situation is referred to as *square pixels*. In many cases, however, the vertical and horizontal pixel spacings will be different, most likely in the display. An example of the effect of this is readily seen when a standard 4:3 video image is displayed on a high-definition 16:9

television screen. The image becomes stretched, in this case, horizontally. Round objects become oval. While this may not be of critical importance in the entertainment industry, it can be problematical in science, where quantification is more important.

Modern image display devices are often capable of operating in several different aspect ratio modes, and one can often select a mode that minimizes distortion. Software is readily available that can stretch an image horizontally or vertically by a specified amount (see Chapter 5). A simple test is to generate a digital image that contains a square object and measure the height and width of its displayed image.

### 4.2.3 Photometric Resolution

For display systems, *photometric resolution* refers to the accuracy with which the system can produce the correct brightness value at each pixel position. Of particular interest is the number of discrete gray levels that the system can produce. This is partially dependent on the number of bits used to control the brightness of each pixel.

Some older displays were capable of handling only 4-bit data, therefore producing only 16 distinct shades of gray, while modern units commonly handle 8-bit data, for 256 gray levels. However, it is one thing to design a display that can accept 8-bit data and quite another to produce a system that can reliably display 256 distinct shades of gray. The effective number of gray levels is never more than the number of gray levels in the digital data, but it may well be less.

If electronic noise generated within the display system occupies more than one gray level, then the effective number of gray levels is reduced. As a rule of thumb, the RMS noise level represents a practical lower limit for grayscale resolution. For example, if the RMS noise level is 1% of the total display range from black to white, then the display can be assumed to have a photometric resolution of 100 shades of gray. If the display system accepts 8-bit data, it still has only 100 effective gray levels. If it is a 6-bit display system, then it has 64 gray levels. The RMS noise level is a convenient measure to use. If the noise can be assumed to have a normal distribution, then it will stay within $\pm 1$ standard deviation about 68% of the time.

A useful tool for determining the grayscale capability of a display system is the *step target* (Fig. 4.1). This is a rectangular arrangement of squares of each different gray level. If all of the boundaries between steps can be seen clearly, then the display is doing its job well. One often finds that the darkest few steps and the lightest few are indistinguishable, indicating saturation at the black and/or white end of the grayscale.

**FIGURE 4.1**    A gray-level step target.

## 4.2.4  Grayscale Linearity

Another important display characteristic is the *linearity* of the grayscale. By this we mean the degree to which the displayed brightness is proportional to input gray level. Any display device has a transfer curve of input gray level to output brightness. For proper operation, this curve should be reasonably linear and constant from one use to the next.

Fortunately perhaps, the human eye is not a very accurate photometer [8]. Slight nonlinearities in the transfer curve, as well as 10–20% intensity shading across the image, are hardly noticed. If the transfer curve has a definite shoulder or toe at one end or the other, however, information may be lost or degraded in the light or dark areas.

## 4.2.5  Low-Frequency Response

In this section, we consider the ability of a display system to reproduce large areas of constant gray level ("flat fields"). Since our goal is to minimize the visible effects of digital processing, we prefer flat fields to be displayed with uniform intensity.

### 4.2.5.1  Pixel Polarity

A flat field can, of course, be displayed at any shade of gray between black and white. On a monitor display, for example, a high-intensity pixel is displayed as

a bright spot on an otherwise dark screen. Zero-intensity pixels leave the screen in its intrinsic dark state. In a printer or film recorder, a high-intensity pixel leaves a black spot on otherwise white paper or transparent film. Zero-intensity pixels leave the paper white or the film transparent. Thus any display system has a characteristic pixel polarity. No matter what the display polarity, zero-intensity flat fields are displayed uniformly flat. Thus flat-field performance becomes an issue only at intermediate and high gray levels, and these may be either black or white, depending on the display system polarity.

### 4.2.5.2  Pixel Interaction

Flat-field performance depends primarily on how well the pixels "fit together." Flat panel displays, such as liquid crystal display (LCD) or thin-film transistor (TFT) units, use rectangular arrays of rectangular pixels [6, 7]. Their flat-field performance is affected by the size of the gaps between pixels. Cathode ray tube (CRT) devices, which are becoming less common for digital image display, use a rectangular array of circular spots [9–20]. For either type of display device, close inspection will reveal pixelization (the appearance of pixels) in bright, flat areas of the displayed image.

## 4.2.6  High-Frequency Response

How well a display system can reproduce fine detail again depends on display spot shape and spacing. The ideal $\sin(x)/x$ spot shape is unattainable, so compromise is unavoidable. Processing steps that can improve the rendering of detail in displayed images are discussed in Section 4.4.

## 4.2.7  The Spot-Spacing Compromise

The goals of field flatness and high-frequency response place conflicting constraints on the selection of spot spacing. The best compromise depends on the relative importance of high- and low-frequency information in each individual image. While spot spacing can be considered a display variable that must be tailored to the image processing application, it is usually left to the manufacturer of the display equipment.

## 4.2.8  Noise Considerations

Random noise in the intensity channel can produce a salt-and-pepper effect that is particularly visible in flat fields. The previously stated rule of thumb indicates that the effective quantizing level is roughly equal to the RMS noise amplitude. If the noise is periodic and of reasonably high intensity, it can produce a

herringbone pattern superimposed on the displayed image. If the noise is periodic and synchronized with the horizontal or vertical deflection signals, it can produce a pattern of bars. The general display quality is adequate if all noise, random and periodic, is kept at or below one gray level in amplitude. In many systems, it is actually somewhat worse than that. Preprocessing is not effective at eliminating noise introduced by the display system. Only repair or replacement will improve the situation.

## 4.3 Volatile Displays

The most common types of volatile display are the LCD and the TFT flat panel monitor [6, 7], although CRT monitors are still common [10–15]. Plasma displays are made by sandwiching a fine mesh between two sheets of glass, leaving a rectangular array of cells containing an ionizable gas [21]. By means of coincident horizontal and vertical addressing techniques, the cells can be made to glow under the influence of a permanent sustaining electrical potential.

The monitor is usually driven by a display card in the computer that transfers the image data to the monitor in the proper format. Monitors come with various native image sizes and aspect ratios, and the physical aspect ratio often does not match the pixel ratio. These "nonsquare pixel" displays introduce geometric distortion by stretching the digital image vertically or horizontally to fill the screen. The 4:3 aspect ratio is a holdover from television broadcast technology and is still quite common for digital image display monitors. The more modern 16:9 aspect ratio is becoming popular as well. Note that a 4:3 image displayed on a 16:9 monitor will be distorted. Table 4.1 shows some commonly used 4:3 image display formats.

**TABLE 4.1**  Display formats

| Format | Image Size |
| --- | --- |
| VGA | $640 \times 480$ |
| SVGA | $800 \times 600$ |
| XGA | $1024 \times 768$ |
| XGA | $1152 \times 864$ |
| XGA | $1280 \times 960$ |
| XGA | $1400 \times 1050$ |
| XGA | $1600 \times 1200$ |
| XGA | $1856 \times 1392$ |
| XGA | $1920 \times 1440$ |
| XGA | $2048 \times 1536$ |

Displayed grayscale formats range from 8-bit monochrome to 16-bit (64 thousand colors) and 24-bit color (16.7 million colors). The *contrast ratio* is the ratio of the intensity of the brightest white to pure black, under ambient illumination. Values of 500 to 5,000 are typical. Refresh rates vary from 30 to 120 Hz. The display can be either progressive, which scans line by line, or interlaced. Interlaced scanning is a holdover from early television design [10–18]. In order to reduce perceived flicker, the odd-numbered lines and even-numbered lines are scanned alternately. Usually a high-refresh-rate progressive scan is preferred.

The past decade has seen remarkable developments in image display technology. High-quality display equipment is now available at reasonable cost. The trend is toward physically larger displays with more pixels.

## 4.4 Sampling for Display Purposes

We have mentioned that displaying a digital image is actually a process of interpolation, in that it reconstructs a continuous image from a set of discrete samples. We also know, from the sampling theorem, that the proper interpolation function (i.e., display spot shape) has the form $\text{sinc}(\alpha x) = \sin(\alpha x)/\alpha x$, which is, in fact, quite different from the shape of most display pixels.

The solid line in Fig. 4.2 shows, in one dimension, the example of a cosine function that is sampled at a rate of 3.3 sample points per cycle. That is, the sample spacing is 30% of the period of the cosine. This sample spacing is small enough to preserve the cosine, and proper interpolation will reconstruct it from its samples without error. When this sampled function is interpolated with

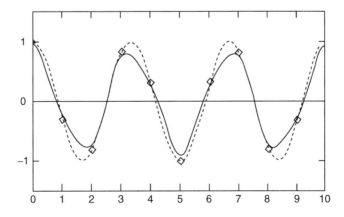

**FIGURE 4.2** Interpolation with a Gaussian function. The original cosine is shown as a dashed line, the sample points as squares, and the interpolated function as a solid line. In this case the sample spacing is 30% of the period of the cosine. The distortion of the reconstructed function results from the inappropriate shape of the interpolation function.

a Gaussian display pixel, however, the distorted waveform (solid line) in Fig. 4.2 results. This illustrates that the display process itself can degrade an image, even one that has survived digitization and processing without damage.

The difficulties encountered in the foregoing sections illustrate that image display using a physical display spot is a suboptimal process. While it is impractical to implement display devices with $\sin(\alpha x)/\alpha x$–shaped display spots, there are things that can be done to improve the situation.

## 4.4.1  Oversampling

The inappropriate shape of the display spot has less effect when there are more sample points per cycle of the cosine. Thus one can improve the situation by arranging to have many pixels that are small in relation to the detail in the image. This is called "oversampling" and is discussed in Chapter 3. It requires more expensive cameras and produces more image data than other system design considerations would dictate.

## 4.4.2  Resampling

Another way to improve the appearance of a displayed image is by *resampling*. This is the process of increasing the size of the image via digitally implemented interpolation done prior to display. For example, a $512 \times 512$ image might be interpolated up to $1024 \times 1024$ prior to being displayed. If the interpolation is done properly, the result will be more satisfactory. Note that this interpolation adds no new information to the image, but it does help overcome inadequacies in the display process.

Figure 4.3 shows what happens when two extra sample points are inserted between each pair in Fig. 4.2. The value at each new sample point is determined by placing a $\sin(\alpha x)/\alpha x$ function at each of the original sample points and summing their values at each new sample position. Here $\alpha = \pi/\tau$, where $\tau$ is the original sample spacing. This is digitally implemented interpolation using the correct interpolation function. Fig. 4.3 shows that when the new (three times larger) sampled function is interpolated with a Gaussian display spot, the result is more satisfactory.

Resampling a digital image by a factor of 2 or 3 increases its size by a factor of 4 or 9, respectively, and this requires a display device that can accommodate the resulting larger image size. It only needs to be done as the last step prior to display, however, so the burden is not felt until that stage. If the digital image size is smaller than the inherent size of the display, most modern display systems use built-in resampling. Since this algorithm is implemented in hardware, it often lacks sophistication. A more satisfactory result can often be obtained by first resampling the image up to a size that matches the native pixel resolution of the display device.

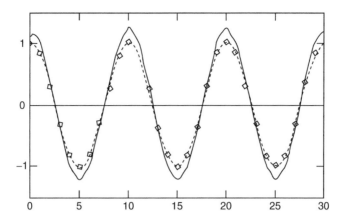

**FIGURE 4.3** Interpolation after resampling. The sample points in Fig. 4.2 were interpolated to place two new points between each existing pair. The sinc(x) function was used in that digitally implemented interpolation process. The resulting (more dense) sample points were then interpolated, as in Fig. 4.2, with a Gaussian function. The result is a better reconstruction of the original cosine. Again the original cosine is a dashed line, the sample points are squares, and the interpolated function is a solid line.

## 4.5  Display Calibration

On both display monitors and hard-copy printers, the transfer curve depends, in part, on the brightness and contrast settings. Sometimes these also include a "gamma" setting that affects the shape of the nonlinear transfer curve. Thus it is possible for the user to alter the transfer curve to suit a particular image or personal taste. In most cases, however, it is most satisfactory to allow the image processing to be done by the software and not the display system, which should merely present the digital image to the operator without additional "enhancement."

A simple calibration procedure can ensure that the display renders the digital image properly. A grayscale test target, such as that in Fig. 4.1, is displayed on the monitor or sent to the image printer. Then the various adjustments are set so that the full range of brightness is visible, with no loss of gray levels at either end. When an image processing system is in proper calibration, a print from the hard-copy recorder looks just like the image displayed on the screen, and this in turn is an accurate rendering of the digital image data.

## 4.6  Summary of Important Points

1. Image display is a process of interpolation done in hardware.

2. The ideal display spot for interpolation without error has the form $\sin(x)/x$.

3. Physical display spots differ significantly from the ideal.

4. Display quality can be improved by resampling the image prior to display.

5. The horizontal and vertical pixel spacing should be equal, and the aspect ratio of the display should match that of the image, in order to avoid distortion.

6. Simple image processing software can be used to prepare an image for display so as to avoid distortion.

# References

1. JI Pankove (ed.), *Display Devices* (Topics in Applied Physics Series, Vol. 40), Springer-Verlag, 1980.
2. H Poole, *Fundamentals of Display Systems*, Macmillan, 1966.
3. HR Luxenberg and RL Kuehn (eds.), *Display Systems Engineering*, McGraw-Hill, 1968.
4. A Cox and R Hartmann (eds.), *Display System Optics*, SPIE Press, 1987.
5. HM Assenheim (ed.), *Display System Optics II*, SPIE Press, 1989.
6. W den Boer, *Active Matrix Liquid Crystal Displays: Fundamentals and Applications*, Newnes, 2005.
7. P Yeh, *Optics of Liquid Crystal Displays*, Wiley-Interscience, 1999.
8. B Julesz, *Foundations of Cyclopean Perception*, University of Chicago Press, 1971.
9. KR Castleman, *Digital Image Processing*, Prentice-Hall, 1996.
10. KB Benson, *Television Engineering Handbook: Featuring HDTV Systems*, rev. ed., McGraw-Hill, 1992.
11. DG Fink (ed.), *Television Engineering Handbook*, McGraw-Hill, 1984.
12. AF Inglis, *Video Engineering: NTSC, EDTV, & HDTV Systems*, McGraw-Hill, 1992.
13. W Wharton, S Metcalfe, and GC Platts, *Broadcast Transmission Engineering Practice*, Focal Press, 1992.
14. KB Benson and DG Fink, *HDTV: Advanced Television for the 1990s*, McGraw-Hill, 1991.
15. JC Whitaker and KB Benson, *Standard Handbook of Video and Television Engineering*, Blair, 2000.
16. KB Benson, *Television Engineering Handbook*, McGraw-Hill, 1992.
17. AC Bovik and JD Gibson (eds.), *Handbook of Image and Video Processing*, Academic Press, 2000.
18. AF Inglis and AC Luther, "Video Engineering," *Communications Magazine*, IEEE Press, 1996.
19. DG Fink and D Christiansen, *Electronics Engineer's Handbook*, McGraw-Hill, 1989.

20. G Hutson, P Shepherd, and J Brice, *Colour Television Theory: System Principles, Engineering Practice and Applied Technology*, McGraw-Hill, 1990.

21. TJ Nelson and JR Wullert, *Electronic Information Display Technologies*, World Scientific Publications, 1997.

# 5

# Geometric Transformations

Kenneth R. Castleman

## 5.1 Introduction

Geometric operations are those that distort an image spatially and change the physical relationships among the objects in an image [1–10]. This includes simple operations like translation, rotation, and scaling (magnification and shrinking) as well as more generalized actions that warp the image and move things around within it. In general, a geometric operation is simply an image copying process, because the gray-level values of pixels are not changed as they move from input image to output image. The difference is that the gray levels are copied into different pixel locations. The general definition of a geometric operation is

$$g(x, y) = f[a(x, y), b(x, y)] \qquad (5.1)$$

where $f(x, y)$ is the input image and $g(x, y)$ is the output image. The spatial transformation functions $a(x, y)$ and $b(x, y)$ specify the physical relationship between points in the input image and corresponding points in the output image. This, in turn, determines the effect the operation will have on the image. For example, if

$$g(x, y) = f[x + x_0, y + y_0] \qquad (5.2)$$

then $g(x, y)$ will be a translated version of $f(x, y)$. The pixel at $(x_0, y_0)$ moves to the origin, and everything in the image moves down and to the left by the amount $\sqrt{x_0^2 + y_0^2}$. Thus it is the spatial mapping functions, $a(x, y)$ and $b(x, y)$ that define a particular geometric operation.

*Microscope Image Processing*
Copyright © 2008, Elsevier Inc. All rights reserved.
ISBN: 978-0-12-372578-3

The implementation of a geometric operation requires two separate algorithms. One is the algorithm that defines the spatial transformation itself, that is, $a(x, y)$ and $b(x, y)$. This specifies the "motion" as each pixel "moves" from its original position in the input image to its final position in the output image. The pixels in a digital image reside on a rectangular grid with integer coordinates, but the spatial transformation generates noninteger pixel locations. Recall from Chapter 1 that the continuous image, an analytic function that corresponds to the digital image, can be generated by interpolation. This problem, then, is solved by a gray-level interpolation algorithm.

## 5.2   Implementation

The output image is generated pixel by pixel, line by line. For each output pixel $g(x, y)$, the spatial transformation functions $a(x, y)$ and $b(x, y)$ point to a corresponding location in the input image. In general, this location falls between four adjacent pixels (Fig. 5.1). The gray level that maps into the output pixel at $(x, y)$ is uniquely determined by interpolation among these four input pixels. Some output pixels may map to locations that fall outside the borders of the input image. In this case a gray level of zero is usually stored.

## 5.3   Gray-Level Interpolation

There is a trade-off between simplicity of implementation and quality of results when selecting a technique for gray-level interpolation.

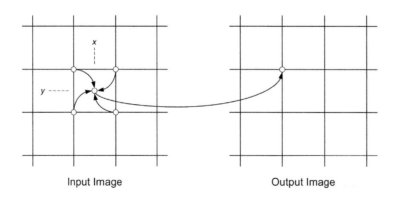

Input Image                                    Output Image

**FIGURE 5.1**   Pixel mapping. The gray level for a particular output pixel is determined by interpolating among four adjacent input pixels. The geometric mapping specifies where in the input image the point $(x, y)$ falls. Normally $x$ and $y$ take on noninteger values.

### 5.3.1  Nearest-Neighbor Interpolation

The simplest way to fill the output pixel is just to use the gray level of the input pixel that falls closest to the mapped position, $(x, y)$. However, this technique is seldom used because it creates a ragged effect in areas of the image containing detail such as lines and edges.

### 5.3.2  Bilinear Interpolation

In many cases bilinear interpolation offers the best compromise between processing speed and image quality. It is a direct 2-D generalization of linear interpolation in one dimension. Figure 5.2 shows four adjacent pixels and a fractional location, $(x, y)$, among them. We first use linear interpolation horizontally to find the values of the continuous image at $(x, 0)$ and $(x, 1)$. We then interpolate vertically between those two points to find its value at $(x, y)$.

Bilinear interpolation actually approximates the continuous image by fitting a hyperbolic paraboloid through the four points. The hyperbolic paraboloid surface is given by

$$f(x, y) = ax + by + cxy + d \qquad (5.3)$$

where $a$, $b$, $c$, and $d$ are parameters determined by the interpolation process. In particular,

$$f(x, y) = [f(1, 0) - f(0, 0)]x + [f(0, 1) - f(0, 0)]y$$
$$+ [f(1, 1) + f(0, 0) - f(0, 1) - f(1, 0)]xy + f(0, 0) \qquad (5.4)$$

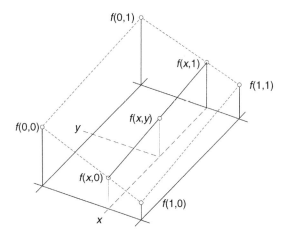

**FIGURE 5.2**  Bilinear interpolation. We use linear interpolation first to find $f(x, 0)$ and $f(x, 1)$ and then between those points to find $f(x, y)$.

Bilinear interpolation can be implemented with only three multiplication and six add/subtract operations per pixel and thus is only slightly more computationally expensive than nearest-neighbor interpolation [1]. It guarantees that the interpolated function will be continuous at the boundaries between pixels, but it does not avoid slope discontinuities. In many cases this is not a serious flaw.

### 5.3.3   Bicubic Interpolation

With bicubic interpolation, the interpolated surface not only matches at the boundaries between pixels, but has continuous first derivatives there as well. The formula for the interpolated surface is

$$p(x, y) = \sum_{i=0}^{3} \sum_{j=0}^{3} a_{ij} x^i y^j \tag{5.5}$$

The 16 coefficients $a_{ij}$ are chosen to make the function and its derivatives continuous at the corners of the four-pixel square that contains the point $(x, y)$. This is done by solving 16 equations in the 16 unknown coefficients at each point. The equations are derived by setting the function and its three derivatives to their known values at the four corners. Since estimating the derivatives at a pixel requires at least a $2 \times 2$ pixel neighborhood, bicubic interpolation is done over a $4 \times 4$ or larger neighborhood surrounding the point $(x, y)$.

### 5.3.4   Higher-Order Interpolation

In addition to slope discontinuities at pixel boundaries, bilinear interpolation has a slight smoothing effect on the image, and this becomes particularly visible if the geometric operation involves magnification. Stated differently, bilinear interpolation does not precisely reconstruct the continuous image that corresponds to the digital image. Bicubic interpolation does a better job, and so it is becoming the standard for image processing software packages and high-end digital cameras. But even this is still imperfect. We know from the sampling theorem that the proper form for the interpolating function is $\operatorname{sinc}(\alpha x) = \sin(\alpha x)/(\alpha x)$. Thus an interpolation technique that better approximates that function will yield better results.

Higher-order interpolation uses a neighborhood that is larger than $4 \times 4$ to determine the gray-level value at a fractional pixel position. An interpolation function that approximates a truncated $\operatorname{sinc}(x)$ function is fitted through the larger neighborhood. The additional complexity is justified by improved performance in some applications, particularly if the geometric operation has the effect of magnifying the image.

Notice that the hyperbolic paraboloid has four parameters and can be made to fit through all four points in the neighborhood of Fig. 5.2. Similarly, the bicubic function has 16 parameters and can fit all 16 points in a 4 × 4 neighborhood. If a higher-order interpolating function has the same number of coefficients as the neighborhood has points, then the interpolating surface can likewise be made to fit at every point. However, if there are more points in the neighborhood than there are coefficients, then the surface cannot fit all the points, and a curve-fitting or error-minimization procedure must be used. Higher-order interpolating functions that are widely used include cubic splines, Legendre centered functions, and the truncated sinc($x$) function itself.

# 5.4 Spatial Transformation

Equation 5.2 specifies the translation operation. Using

$$g(x, y) = f\left[x/M_x, y/M_y\right] \tag{5.6}$$

will scale (magnify or shrink) the image by the factor $M_x$ in the $x$ direction and $M_y$ in the $y$ direction. Rigid rotation about the origin through an angle $\theta$ is given by

$$g(x, y) = f[x \cdot \cos(\theta) - y \cdot \sin(\theta), x \cdot \sin(\theta) + y \cdot \cos(\theta)] \tag{5.7}$$

To rotate about another point, one would first translate that point to the origin, then rotate the image about the origin, and finally translate back to its original position. Translation, rotation, and scaling can be combined into a single operation [1].

## 5.4.1 Control-Grid Mapping

For warpings too complex to be defined by an equation, it is convenient to specify the operation using a set of *control points* [1]. This is a list of certain pixels whose positions in the input and output images are specified. The displacement values for the remaining unspecified pixels are determined by interpolation among those that have been specified. Figure 5.3 shows how four control points that form a quadrilateral in the input image map to the vertices of a rectangle in the output image. Displacement values for points inside the rectangle can be determined with bilinear interpolation. A set of contiguous quadrilaterals that span the input image (a *control grid*) can be mapped into a set of contiguous rectangles in the output image. The specification of the transformation, then, consists of the coordinates of the rectangle vertices, along with the *x, y* displacement (to the corresponding control-grid vertex) of each.

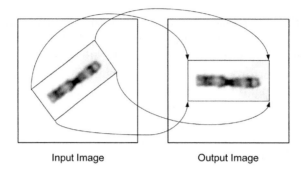

Input Image                    Output Image

**FIGURE 5.3**   Control point mapping. The four corners of an arbitrarily shaped quadrilateral in the input image map to the four corners of a rectangle in the output image. The mapping of the corners is specified, and the mapping of interior points is determined by interpolation.

# 5.5   Applications

Geometric operations are useful in microscopy in several ways. A few of those are mentioned here.

## 5.5.1   Distortion Removal

Microscope images are sometimes affected by geometric distortion due to the optics or due to the specimen preparation. Optical distortion is usually constant from image to image and can be removed with batch processing. Physical distortion of specimens, such as that induced by slicing on a microtome, must be corrected on an image-by-image basis.

## 5.5.2   Image Registration

It is often necessary to align multiple images of the same specimen, as in optical sectioning (Chapter 14) and time-lapse microscopy (Chapter 15). Geometric operations are useful for these tasks [11]. Cross-correlation (see Chapter 14) is useful for determining the translation required for alignment.

## 5.5.3   Stitching

Often it is impossible to get an entire specimen to fit within a single field of view. Here multiple images of the specimen can be combined into a mosaic image by the process called *stitching*. Geometric operations are usually necessary to make the images match in their regions of overlap. Cross-correlation can be used in the local region of a control point to determine the displacement values for a control grid [12]. In areas where images overlap it is useful to blend them

together to smooth out the transition from one to the next [13]. Blending can be done using a weighted average in the overlapping areas, where the weights taper off to zero at the image borders [14]. This produces a more seamless appearance and makes the images easier to interpret. Geometric and radiometric corrections applied to the input images make automatic mosaicing possible [15].

## 5.6  Summary of Important Points

1. Geometric operations warp an image, changing the positions of the objects within.

2. Geometric operations include translation, rotation, and scaling as well as more general transformations.

3. A geometric transformation can be specified by a formula or by a control grid.

4. Geometric operations are implemented by mapping output pixel positions back into the input image.

5. Since output pixels map to noninteger positions in the input image, gray-level interpolation is used to estimate the underlying continuous image.

6. Bilinear interpolation is more accurate than nearest-neighbor interpolation and simpler than higher-order interpolation.

7. Higher-order interpolation techniques fit an approximation of the truncated $\text{sinc}(x)$ function through a neighborhood larger than $2 \times 2$ pixels.

8. Geometric operations are useful for distortion correction, registration, and stitching.

## References

1. KR Castleman, *Digital Image Processing*, Prentice-Hall, 1996.
2. G Wolberg, *Digital Image Warping*, IEEE Computer Society Press, 1994.
3. JD Foley and A van Dam, *Fundamentals of Interactive Computer Graphics*, Addison-Wesley, 1982.
4. WM Newman and RF Sproul, *Principles of Interactive Computer Graphics*, 2nd ed., McGraw-Hill, 1979.
5. DH Ballard and CM Brown, *Computer Vision*, Prentice-Hall, 1982.
6. R Nevatia, *Machine Perception*, Prentice-Hall, 1982.
7. WK Pratt, *Digital Image Processing*, John Wiley & Sons, 1991.

8. RC Gonzales and RE Woods, *Digital Image Processing*, Prentice-Hall, 2002.

9. WH Press, SA Teukolsky, WT Vetterling, and BP Flannery, *Numerical Recipes in C*, 2nd ed., Cambridge University Press, 1992.

10. CA Glasbey and KV Mardia, "A Review of Image-Warping Methods," *Journal of Applied Statistics*, **25**(2):155–171, 1998.

11. LG Brown, "A Survey of Image Registration Techniques," *ACM Computing Surveys*, **24**(4):325–376, 1992.

12. SK Chow et al., "Automated Microscopy System for Mosaic Acquisition and Processing," *Journal of Microscopy*, **222**(2):76–84, 2006.

13. V Rankov et al., "An Algorithm for Image Stitching and Blending," *Proceedings of the SPIE*, **5701**:190–199, 2005.

14. BW Loo, W Meyer-Ilse, and SS Rothman, "Automatic Image Acquisition, Calibration and Montage Assembly for Biological X-Ray Microscopy," *Journal of Microscopy*, **197**(2): 185–201, 2000.

15. C Sun et al., "Mosaicing of Microscope Images with Global Geometric and Radiometric Corrections," *Journal of Microscopy*, **224**(2):158–165, 2006.

# Image Enhancement

Yu-Ping Wang, Qiang Wu, and Kenneth R. Castleman

## 6.1 Introduction

Images that come from a variety of microscope technologies provide a wealth of information. The limited capacity of optical imaging instruments and the noise inherent in optical imaging make image enhancement desirable for many microscopic image processing applications. *Image enhancement* is the process of enhancing the appearance of an image or a subset of the image for better contrast or visualization of certain features and to facilitate subsequently more accurate image analysis. With image enhancement, the visibility of selected features in an image can be improved, but the inherent information content cannot be increased. The design of a good image enhancement algorithm should consider the specific features of interest in the microscopic image and the imaging process itself. In microscopic imaging, the images are often acquired at different focal planes, at different time intervals, and in different spectral channels. The design of an enhancement algorithm should therefore take full advantage of this multidimensional and multispectral information.

A variety of image enhancement algorithms have previously been developed and utilized for microscopy applications. These algorithms can be classified into two categories: spatial domain methods and transform domain methods. The spatial domain methods include operations carried out on a whole image or on a local region selected on the basis of image statistics. Techniques that belong to this category include histogram equalization, image averaging, sharpening of important features such as edges or contours, and nonlinear filtering. The transform domain enhancement methods manipulate image information in

transform domains, such as Fourier and wavelet transforms. Often, interesting image information cannot be separated out in the spatial domain but can be isolated in the transform domain. For example, one can amplify certain coefficients in the Fourier domain and then recover the image in the spatial domain to highlight interesting image content. The wavelet transform is another powerful tool that has been developed in recent years and used for image enhancement.

In the following discussion we focus on the enhancement of two-dimensional (2-D) gray-level and color microscope images. Processing of multispectral and three-dimensional (3-D) microscope images is discussed in other chapters of the book (Chapters 13 and 14).

## 6.2 Spatial Domain Methods

Given a gray-level image with the intensity range $[0, L]$, a *global operation* on the image refers to an image transform, $T$, that maps the image, $I$, to a new image, $g$, according to the following equation:

$$g = T(I) \tag{6.1}$$

There are many examples of this type of image transform, such as contrast stretching, clipping, thresholding, grayscale reversal, and gray-level window slicing [1]. If the operation results in fractional (noninteger) values, they must be rounded to integers for the output image.

### 6.2.1 Contrast Stretching

Display devices commonly have a limited range of gray levels over which the image features are most visible. One can use global methods to adjust all the pixels in the image so as to ensure that the features of interest fall into the visible range of the display. This technique is also called *contrast stretching* [2]. For example, if $I_1$ and $I_2$ define the intensity range of interest, a scaling transformation can be introduced to map the image intensity $I$ to the image $g$ with the range of $I_{\min}$ to $I_{\max}$ as

$$g = \frac{(I - I_1)}{I_2 - I_1}(I_{\max} - I_{\min}) + I_{\min} \tag{6.2}$$

This mapping is a liner stretch. A number of nonlinear monotonic pixel operations exist [2, 3]. For example, the following transform maps the gray level of the image according to a nonlinear curve

$$g = \left(\frac{I - I_1}{I_2 - I_1}\right)^{\alpha}(I_{\max} - I_{\min}) + I_{\min} \qquad 0 < \alpha < \infty \tag{6.3}$$

where $\alpha$ is an adjustable parameter. This image intensity scaling is usually used for contrast stretching, clipping, display calibration, etc.

## 6.2.2 Clipping and Thresholding

Image clipping is a special case of contrast stretching that is useful in noise reduction when the input image, $f$, is known to lie in the range of 0 to $L$. The transform is defined in the equation

$$g = \begin{cases} 0 & 0 \leq f < a \\ \alpha I & a \leq f < b \\ L & f \geq b \end{cases} \qquad (6.4)$$

where $a$ and $b$ are usually obtained from the histogram of the image and they specify the valley between the peaks of the histogram (see Fig. 6.1). When $a = b$, the transform is called *thresholding*, and the output is a binary image.

## 6.2.3 Image Subtraction and Averaging

When more than one image of a stationary object is available, averaging over $N$ images is a simple way to improve the signal-to-noise ratio by $\sqrt{N}$. In microscopic imaging, multiple images are often obtained. For microscopic video imaging, frames from the same scene are acquired sequentially. These multiple images, if properly registered, can then be averaged to reduce noise. Registration may be required if the images are not already aligned.

*Image subtraction* is usually performed when two images of the same object are obtained under different conditions [3]. The image subtraction will highlight whatever has changed between the two images. Another application is *background correction*. In microscopic imaging the image is often affected by a slowly varying background shading pattern. One can move the microscope stage to an

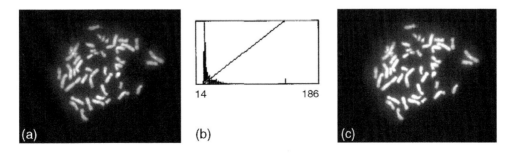

(a)          (b)          (c)

**FIGURE 6.1**   Image enhancement using a contrast stretch. The image in (c) is obtained from (a) through a mapping defined in (b).

empty field and acquire an image of the background. When the background image is subtracted from the image containing the specimen, it removes the shading (see Chapter 12).

### 6.2.4   Histogram Equalization

The gray-level histogram of an image is the probability of occurrence of each gray level in the image. The goal of histogram equalization is to remap the image gray levels so as to obtain a uniform (flat) histogram [2]. If no prior information is available about the gray-level distribution, it is often useful to distribute the intensity information uniformly over the available intensity levels. Also it is easier to compare two images taken under different conditions if their histograms match.

Mathematically, the normalized histogram $h(r_i)$ can be expressed as $h(r_i) = n_i/n$, where $r_i$ is the $i$th gray level in an image having a total of $L$ values, $n_i$ is the number of occurrences of gray level $r_i$ in the image, and $n$ is the total number of pixels in the image. We can use the transformation $T(r)$ to map the original gray levels $r_i$ of the input image into new gray levels $s_i$, such that, for the output image,

$$s_i = T(r_i) = \sum_{j=0}^{i} h(r_j) = \sum_{j=0}^{i} \frac{n_i}{n}, \qquad i = 0, 1, \ldots, L-1 \qquad (6.5)$$

where the transformation $T$ is the cumulative distribution function of the image gray levels, which is always monotonically increasing. The resulting image will have a histogram that is "flat" in a local sense, since there is only a finite number of gray levels available (see Fig. 6.2).

Local histogram equalization is a variant of the histogram equalization operation described earlier. It applies histogram equalization to small, overlapping areas of the image [4] that contain local features. This nonlinear operation can significantly increase the visibility of subtle features in the image. However, because histogram equalization is carried out in local areas, it is computationally intensive, and the complexity increases with the size of the local area used in the operation. There is also a number of other variations in image histogram transformations that take into account local image properties, such as the local standard deviation [5].

### 6.2.5   Histogram Specification

More generally, histogram specification allows us to modify an image so that its histogram takes on a specific shape. Assume that $f(x, y)$ is the input image having histogram $h_1(r_i)$ and that $g(x, y)$ is the output image with the target

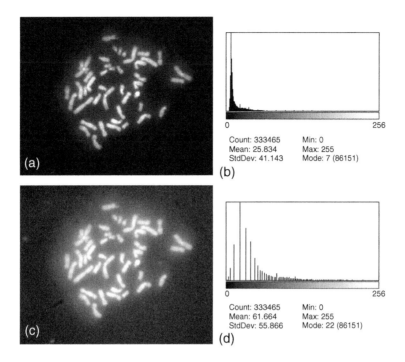

**FIGURE 6.2** The image in (c) is obtained from the image in (a) by histogram equalization. The histograms of the images in (a) and (c) are shown in (b) and (d), respectively.

histogram $h_2(z_i)$. The input image can be modified according to the equalization transformation, $T$, given in Eq. 6.5, to produce a flat histogram. Further, the transformation, $V$, will give the target image a flat distribution if

$$V(z_i) = \sum_{j=0}^{i} h_2(z_j) \quad \text{and} \quad T(r_i) = \sum_{j=0}^{i} h_1(r_j) \quad i = 0, 1, \ldots, L-1 \quad (6.6)$$

Then the output image, $g(x, y)$, can be computed from the input image, $f(x, y)$, using the following cascaded transformation:

$$g(x, y) = V^{-1}[T(f(x, y))] \quad (6.7)$$

This transformation enables us to obtain an output image with the desired gray-level distribution, $h_2(z_i)$.

## 6.2.6 Spatial Filtering

Spatial filtering involves the convolution of an image with a specific kernel operator. The gray level of each pixel is replaced with a new value that is the weighted average of neighboring pixels that fall within the window of the kernel.

In the continuous form, the output image $g(x, y)$ is obtained as the convolution of the image $f(x, y)$ with the filter kernel $w(x, y)$ as follows:

$$g(x, y) = f(x, y) * w(x, y) \qquad (6.8)$$

where the convolution is performed over all values of $(x, y)$ in the defined region of operation in the image.

In the discrete form, convolution becomes $g_{i, j} = f_{i, j} * w_{i, j}$, and the spatial filter $w_{i, j}$ takes the form of a weight mask. Table 6.1 shows several commonly used discrete filters.

In general, an image can be enhanced by the following sharpening operation:

$$g(x, y) = f(x, y) + \lambda e(x, y) \qquad (6.9)$$

where $\lambda > 0$ and $e(x, y)$ is a high-pass filtered version of the image, which usually corresponds to some form of the derivative of an image. The operation can be accomplished, for example, by adding gradient information to the image. A well-known gradient filter is the *Sobel* filter pair that can be used to compute an estimate of the gradient in both the $x$ and the $y$ directions. Other commonly used derivative filters include the Laplacian filter [1], which is defined as

$$e(x, y) = \nabla^2 f(x, y) = \left( \frac{\partial^2}{\partial x^2} + \frac{\partial^2}{\partial y^2} \right) f(x, y) \qquad (6.10)$$

In the discrete form, the operation can be implemented as

$$\nabla^2 f_{i, j} = \left[ f_{i+1, j} - 2f_{i, j} + f_{i-1, j} \right] + \left[ f_{i, j+1} - 2f_{i, j} + f_{i, j-1} \right] \qquad (6.11)$$

The kernel mask used in the foregoing discrete Laplacian filtering is shown in Table 6.1.

To sharpen a noisy image, a Laplacian of Gaussian (LoG) filter is useful. The LoG filter first smoothes the image with a Gaussian low-pass filtering, followed by the high-pass Laplacian filtering. The LoG filter is defined as

$$\nabla^2 G(x, y) = \left( \frac{\partial^2}{\partial x^2} + \frac{\partial^2}{\partial y^2} \right) G_\sigma(x, y) \qquad (6.12)$$

**TABLE 6.1**    Examples of discrete kernel masks for spatial filtering

| Low-Pass Filter | High-Pass Filter | Laplacian Filter |
|---|---|---|
| $w_{i, j} = \dfrac{1}{10} \begin{bmatrix} 1 & 1 & 1 \\ 1 & 2 & 1 \\ 1 & 1 & 1 \end{bmatrix}$ | $w_{i, j} = \begin{bmatrix} -1 & -1 & -1 \\ -1 & 9 & -1 \\ -1 & -1 & -1 \end{bmatrix}$ | $w_{i, j} = \begin{bmatrix} 0 & 1 & 0 \\ 1 & -4 & 1 \\ 0 & 1 & 0 \end{bmatrix}$ |

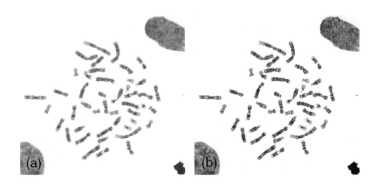

**FIGURE 6.3**    The image in (b) is obtained by sharpening the image in (a) using a Laplacian of Gaussian operation.

where

$$G_\sigma(x, y) = \frac{1}{\sqrt{2\pi}\,\sigma} \exp\left(-\frac{x^2 + y^2}{2\sigma^2}\right)$$

is the Gaussian function with variance $\sigma$, which determines the size of the filter. A larger size of the filter results in more smoothing of the noise. A discrete form of the LoG filter is given in [2]. Figure 6.3 shows the result of sharpening an image using a LoG operation. More examples of medical image enhancement using local derivative filtering can be found in [6–8].

Image filtering operations are most commonly done globally, that is, over the entire image. However, because image properties may vary throughout the image, it is often useful to perform spatial filtering operations in local neighborhoods.

## 6.2.7   Directional and Steerable Filtering

Many images contain edge features in various orientations. Directional filters, such as the steerable filters [9], are used to enhance image features that lie in a particular direction. The filtering effect in regard to orientation can be evaluated by computing an *orientation map*, which is the squared filter response as a function of filter orientation [1, 6, 10, 11]. The concept of steerable filters [12] is based on an *oriented filter*, which is constructed from a linear combination of a set of directionally oriented basis filters. Here the weighting factors determine the directionality of the filter. Basis filters can be derived from directional derivatives of Gaussians and used to compute local orientation maps.

The simplest example of a steerable filter is the partial derivative of a two-dimensional Gaussian. In polar coordinates, the horizontal and vertical derivatives are written as

$$G_1^{(0)}(r,\,\theta) = \cos(\theta)\left(-re^{-r^2/2}\right) \tag{6.13}$$

and

$$G_1^{(\pi/2)}(r,\,\theta) = \sin(\theta)\left(-re^{-r^2/2}\right) \tag{6.14}$$

where the subscript denotes the order of derivative and the superscript denotes the direction of the derivative. $G_1(r,\,\theta)$, at any orientation $\theta$, can be synthesized by taking a linear combination of $G_1^{(0)}$ and $G_1^{(\pi/2)}$ as follows:

$$G_1^{(\theta)}(r,\,\theta) = \cos(\theta)G_1^{(\pi/2)}(r,\,\theta) + \sin(\theta)G_1^{(\pi/2)}(r,\,\theta) \tag{6.15}$$

This equation implies the steerability of these functions. The directional derivative, $G_1$, can be generated at any arbitrary orientation using a linear combination of the basis filters $G_1^{(0)}$ and $G_1^{(\pi/2)}$ with coefficients $\cos(\theta)$ and $\sin(\theta)$ as the weighting functions, also known as the *interpolation functions*. Therefore filtering an image with an arbitrarily oriented filter can be accomplished using a proper linear combination of the image convolved with the two basis filters.

Steerability can be extended to the higher-order derivatives. The general steerability condition, for functions that are polar separable, is expressed as

$$f^\alpha(r,\,\phi) = h(\phi - \alpha)g(r) = \sum_{n=1}^{\hat{N}} k_n(\alpha)h(\phi - \alpha_n)g(r) \tag{6.16}$$

where $h(\phi)$ is the angular portion of the steerable filter, $g(r)$ is the radial portion, $k_n(\alpha)$ are interpolation functions, and $\alpha_n$ are a fixed set of $\hat{N}$ orientations. This equation can be satisfied by all functions with angular components that are band-limited to contain no more than $\hat{N}/2$ harmonic terms [12]. Examples of steerable filter sets consisting of higher-order directional derivatives of a Gaussian, along with steerable approximations to their Hilbert transforms, can be found in [12]. Orientation maps can be computed as the sum of squared responses of these filters.

Steerable filters have been used to generate multiscale, self-inverting pyramid decompositions of images [12] that have the desirable properties of shift and rotation invariance. By analyzing and selectively processing the transform coefficients, image feature detection and enhancement can be achieved with designed flexibility in scale, orientation, and degree of enhancement [9].

Traditional techniques based on conventional convolution filtering and contrast stretching are limited in what they can do. By decomposing the image into several differently oriented bases at multiple scales using the steerable pyramid transform, it becomes easier selectively to detect and enhance certain

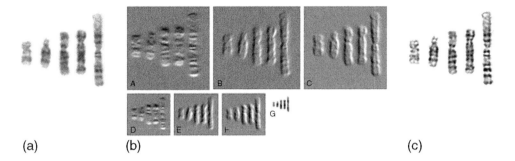

(a)                    (b)                                                      (c)

**FIGURE 6.4** (a) An image of five human chromosomes in upright orientation. (b) The steerable pyramid transform of the image in (a). Three levels of decomposition are performed. A, B, and C show the three bandpass-filtered images at decomposition level 2, while D, E, and F show them at decomposition level 3, respectively. Image G shows the down-sampled low-pass image at decomposition level 3. (c) The result of image enhancement.

image features that correspond to important object structures at a particular scale, location, and orientation. Figure 6.4 shows the result of chromosome image enhancement based on a steerable pyramid transform and selective processing of the transform coefficients [9].

## 6.2.8 Median Filtering

The median filter is a commonly used nonlinear operator that replaces the original gray level of a pixel by the median of the gray levels of the pixels in a specified neighborhood. The median filter is a type of *ranking filter* [3], because it is based on the statistics derived from rank-ordering the elements of a set. This filter is often useful because it can reduce noise without blurring edges in the image [1]. The noise-reducing effect of the median filter depends on two factors: (1) the spatial extent of its neighborhood and (2) the number of pixels involved in the median calculation. Figure 6.5 shows an example of salt-and-pepper noise

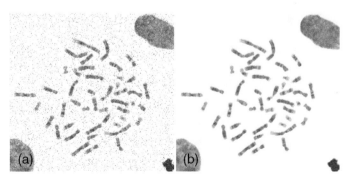

**FIGURE 6.5** As shown in image (b), salt-and-pepper noise in image (a) is removed by a 4 × 4 median filter.

removal using median filtering. This type of noise otherwise cannot be removed by conventional convolution filtering.

## 6.3    Fourier Transform Methods

In many cases, frequency domain filtering is more effective than its spatial domain counterpart because noise can be more easily separated from the objects in the frequency domain. When an image is transformed into the frequency domain, low-frequency components correspond to smooth regions or large structures in the image; medium-frequency components correspond to image features; and high-frequency components are dominated by noise. Hence one can design filters, using the knowledge of the frequency components, to sharpen the image while suppressing noise [13, 14]. A noise-reducing enhancement filter, for example, seeks to boost the amplitude of mid-frequency components and to attenuate the high frequencies at the same time.

### 6.3.1    Wiener Filtering and Wiener Deconvolution

The Wiener filter is known to be optimal, in the minimum mean square error (MSE) sense, for recovering a signal that is embedded in noise [1, 3, 14]. The observed image, $g(x, y)$, is assumed to be resulting from the sum of the original image, $f(x, y)$, and stationary noise, $n(x, y)$; that is,

$$g(x, y) = f(x, y) + n(x, y) \tag{6.17}$$

where the noise is spectrally white, with zero mean and variance $\sigma^2$. The transfer function of the Wiener filter is given by [2]

$$H(u, v) = \frac{P_f(u, v)}{P_f(u, v) + \sigma^2} \tag{6.18}$$

where $P_f(u, v)$ is the power spectrum of the signal. The conventional Wiener filter has certain limitations. For instance, the minimum MSE criterion often provides more smoothing than the human eye would like. The Wiener filter is often outperformed by nonlinear estimators [3].

A number of variants of the Wiener filter consider the spatially variant characteristics of signals and noise [2]. One approach to making the filter spatially variant is to allow the noise parameter $\sigma_n$ to vary spatially, and to change the filter from one pixel to the next. Another variant is the noise-adaptive Wiener filter [15], which models the signal as a locally stationary process. Image recovery using noise-adaptive Wiener filtering is given by

$$\tilde{f}(x, y) = m_f(x, y) + \frac{\sigma_f^2(x, y)}{\sigma_f^2(x, y) + \sigma_n^2(x, y)} \left( g(x, y) - m_f(x, y) \right) \qquad (6.19)$$

where $m_f$ is the local mean of the signal $f$ and $\sigma_f^2$ is the local signal variance.

Another limitation of the Wiener filter is that it only accounts for the second-order statistics of an input image. However, by incorporating nonlinearity into the processing, this limitation can be overcome. A modified adaptive filter can be constructed as a linear combination of the stationary Wiener filter $H$ and an identity operation [16]:

$$H_\alpha = H + (1 - \alpha)(1 - H) \qquad (6.20)$$

The modified adaptive filter equals the Wiener filter when $\alpha = 1$, whereas when $\alpha = 0$ it becomes the identity (null) transformation. Based on a study of human vision system, an anisotropic component was introduced to improve the preceding filter [17]:

$$H_{\alpha,\gamma} = H + (1 - \alpha)\left(\gamma + (1 - \gamma)\cos^2(\varphi - \theta)\right)(1 - H) \qquad (6.21)$$

where the parameter $\gamma$ controls the degree of anisotropy, $\varphi$ is the angular direction of the filter, and $\theta$ defines the orientation of the local image structure. In this way, the more dominant the local orientation is, the smaller the $\gamma$ value and the more anisotropic the filter. The local direction and level of anisotropy can be estimated using three oriented Hilbert transform pairs. The weighting function $\cos^2(\varphi - \theta)$ was imposed by its ideal interpolation properties. The directed anisotropy filter can also be implemented as a steerable filter [12].

Figure 6.6 shows an example of image deblurring using conventional Wiener deconvolution.

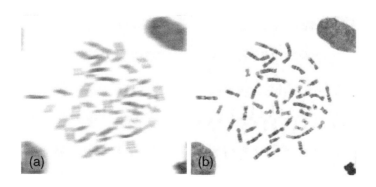

**FIGURE 6.6** Deblurring of the image in (a) to obtain the image in (b) by applying the conventional Wiener deconvolution.

## 6.3.2  Deconvolution Using a Least-Squares Approach

The observed image, $g$, can be expressed in a matrix form as

$$\mathbf{g} = \mathbf{Hf} + \mathbf{n} \qquad (6.22)$$

where $\mathbf{g}$, $\mathbf{f}$, and $\mathbf{n}$ are $N^2 \times 1$ column vectors, $\mathbf{H}$ is an $N^2 \times N^2$ matrix, $\mathbf{f}$ is the original image, $\mathbf{n}$ is the noise, and $\mathbf{H}$ stands for blurring. When the blurring is shift-invariant, the matrix $\mathbf{H}$ becomes a block-circulant matrix. If $\mathbf{n} = 0$, we can find the approximate solution by minimizing the mean square error

$$e(\hat{\mathbf{f}}) = \|\mathbf{g} - \mathbf{H}\hat{\mathbf{f}}\|^2 = \left(\mathbf{g} - \mathbf{H}\hat{\mathbf{f}}\right)^t \left(\mathbf{g} - \mathbf{H}\hat{\mathbf{f}}\right) \qquad (6.23)$$

by setting the derivative of $e\left(\hat{\mathbf{f}}\right)$ in respect to $\hat{\mathbf{f}}$ to zero:

$$\frac{\partial e\left(\hat{\mathbf{f}}\right)}{\partial \hat{\mathbf{f}}} = -2\mathbf{H}^t\left(\mathbf{g} - \mathbf{H}\hat{\mathbf{f}}\right) = 0 \qquad (6.24)$$

The solution for $\hat{\mathbf{f}}$ becomes

$$\hat{\mathbf{f}} = (\mathbf{H}^t\mathbf{H})^{-1}\mathbf{H}^t\mathbf{g} = \mathbf{H}^{-1}\mathbf{g} \qquad (6.25)$$

If $\mathbf{n}$ is nonzero, the problem can be formulated as one of constrained optimization:

$$e\left(\hat{\mathbf{f}}\right) = \|\mathbf{Q}\hat{\mathbf{f}}\|^2 + \lambda\left(\|\mathbf{g} - \mathbf{H}\hat{\mathbf{f}}\|^2 - \|\mathbf{n}\|^2\right) \qquad (6.26)$$

where the first term is a regularization term, such that the solution is smooth, and the matrix $\mathbf{Q}$ is usually taken to be the first or second difference operation on $\hat{\mathbf{f}}$. $\lambda$ is a constant called the *Lagrange multiplier*. Similarly, we can set the derivative of $e\left(\hat{\mathbf{f}}\right)$ in respect to $\hat{\mathbf{f}}$ to zero, as follows,

$$\frac{\partial e\left(\hat{\mathbf{f}}\right)}{\partial \hat{\mathbf{f}}} = 2\,\mathbf{Q}^t\mathbf{Q}\hat{\mathbf{f}} - 2\,\lambda\mathbf{H}^t\left(\mathbf{g} - \mathbf{H}\hat{\mathbf{f}}\right) = 0 \qquad (6.27)$$

and find the solution for $\hat{\mathbf{f}}$:

$$\hat{\mathbf{f}} = \left(\mathbf{H}^t\mathbf{H} + \frac{1}{\lambda}\mathbf{Q}^t\mathbf{Q}\right)^{-1}\mathbf{H}^t\mathbf{g} \qquad (6.28)$$

It turns out this solution is the general form of solution for the deconvolution problem.

### 6.3.3   Low-Pass Filtering in the Fourier Domain

Since a low-pass filter can suppress noise in an image, an alternative to spatial domain filtering is to implement the low-pass filtering in the Fourier domain. To accomplish this, a 2-D low-pass filter transfer function $H(u, v)$ is multiplied by the Fourier transform $G(u, v)$ of the image

$$\hat{F}(u, v) = H(u, v)G(u, v) \tag{6.29}$$

where $\hat{F}(u, v)$ is the Fourier transform of the filtered image $f(x, y)$ that we wish to recover. $f(x, y)$ can be obtained by taking the inverse Fourier transform.

An ideal low-pass filter is designed by assigning a frequency cutoff value

$$H(u, v) = \begin{cases} 1 & \text{if } D(u, v) \leq D_0 \\ 0 & \text{otherwise} \end{cases} \tag{6.30}$$

where $D(u, v)$ is the distance of a point from the origin in the Fourier domain. However, since the rectangular pass-band in the ideal low-pass filter causes ringing artifacts in the spatial domain, usually filters with smoother roll-off characteristics are used instead. For example, the following Butterworth low-pass filter of $n$th order is often used for this purpose:

$$H(u, v) = \frac{1}{1 + [D(u, v)/D_0]^{2n}} \tag{6.31}$$

When the order, $n$, increases, the roll-off characteristics of the bandpass filter become more prominent. Hence a first-order Butterworth filter provides the least amount of ringing artifacts in the filtered image.

### 6.3.4   High-Pass Filtering in the Fourier Domain

Whereas a low-pass filter can suppress noise and smooth an image, a high-pass filter can accentuate edge information and sharpen the image. An ideal high-pass filter with cutoff frequency $D_0$ is given by

$$H(u, v) = \begin{cases} 1 & \text{if } D(u, v) \geq D_0 \\ 0 & \text{otherwise} \end{cases} \tag{6.32}$$

Similar to the ideal low-pass filter discussed earlier, the sharp cutoff characteristics of a rectangular window function in the frequency domain can cause the ringing artifacts in the filtered image. Therefore, we can also make use of a filter with smoother roll-off characteristics, such as

$$H(u,\ v) = \frac{1}{1 + [D_0/D(u,v)]^{2n}} \qquad (6.33)$$

which represents a Butterworth high-pass filter of $n$th order. Note that Eq. 6.33 has the same form as Eq. 6.31, except the terms $D_0$ and $D(u,\ v)$ in the denominator are interchanged.

## 6.4   Wavelet Transform Methods

Human visual perception is known to function at multiple scales. Wavelet transforms were developed for the analysis of multiscale image structures [18]. Unlike traditional transform domain methods, such as the Fourier transform, wavelet-based methods not only dissect signals into their component frequencies but also enable the analysis of the component frequencies across different scales. As a result these methods are more suitable for such applications as image data compression, noise reduction, and edge detection.

### 6.4.1   Wavelet Thresholding

The application of wavelet-based methods to image enhancement has been studied extensively. A widely used technique known as *wavelet thresholding* performs enhancement through the manipulation of wavelet transform coefficients so that object signals are boosted while noise is suppressed. Wavelet transform coefficients are modified using a nonlinear mapping. Hard-thresholding and soft-thresholding functions [12] are representative of such nonlinear mapping functions. For example, the soft-thresholding function is given by

$$\theta(x) = \begin{cases} x - T & \text{if } x > T \\ x + T & \text{if } x < -T \\ 0 & \text{if } |x| \leq T \end{cases} \qquad (6.34)$$

Small coefficients (below threshold $T$ or above $-T$) normally correspond to noise and are reduced to a value near zero. Usually, the thresholding operation of Eq. 6.34 is performed in the orthogonal or biothorgonoal wavelet transform domain (see Chapter 7). A translation-invariant wavelet transform may be more appropriate in some cases [19]. Enhancement schemes based on nonorthogonal wavelet transforms are also used [10, 20, 22]. Nonlinear mapping functions can be used in these schemes to accomplish multiscale image sharpening.

## 6.4.2 Differential Wavelet Transform and Multiscale Pointwise Product

Since edge sharpening is an essential part of image enhancement and edges can be detected and characterized by differential operators, a particular family of differential wavelets has been used for this purpose [11, 22]. In this case the approximation and detail coefficients of the differential wavelet transform of an image $f$ are defined as $S_{2^j}f$ and $W_{2^j}f$, and the wavelet transform is computed using the following equations:

$$\begin{cases} S_{2^j}f = S_{2^{j-1}}f * h_{\uparrow 2^{j-1}} \\ W_{2^j}f = S_{2^{j-1}}f * g_{\uparrow 2^{j-1}}, \end{cases} \quad 1 \le j \le J \qquad (6.35)$$

where $h$ and $g$ are the low-pass and high-pass filters, respectively, and $\uparrow 2^{j-1}$ is the up-sampling operation by putting $2^{j-1} - 1$ zeros between each pair of adjacent samples in the filter [11]. This differential wavelet transform facilitates a desirable image representation for the extraction of edges at multiple scales. Since edge patterns are correlated spatially across multiple scales, one can take advantage of this property during the identification of the edges and subsequent enhancement. A *multiscale pointwise product* (MPP) can be employed to measure the cross-scale correlation of the differential wavelet transform coefficients [22]. The MPP is defined as

$$P_k(n) = \prod_{j=1}^{k} W_{2^j}f(n) \qquad (6.36)$$

where $\{W_{2^j}f\}$ are the detail coefficients defined in Eq. 6.35. Because the maxima of $W_{2^j}f(n)$ represent edges in the signal and tend to propagate across scales whereas the maxima of $W_{2^j}f(n)$ caused by noise do not, $P_k(n)$ reinforces the responses from edges rather than from noise. Experimental observation of edge patterns shows that the MPP has a built-in ability to suppress isolated and narrow impulses while preserving edge responses across different scales [22].

Based on the foregoing consideration, the following nonlinear mapping function $\theta(x)$ can modify the wavelet coefficient $x$ subject to the MPP criterion [22]:

$$\theta(x) = \begin{cases} \lambda x & \text{if } |P_k(n)| \ge \mu \\ 0 & \text{otherwise} \end{cases} \qquad (6.37)$$

where $\lambda$ is an adjustable constant associated with the degree of enhancement desired. The threshold parameter, $\mu$, can be empirically determined. A larger value of $\mu$ results in a higher denoising effect, and vice versa. The choice of $\mu$

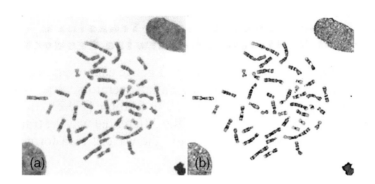

**FIGURE 6.7**   Enhancement of chromosomal banding patterns in the left image based on the differential wavelet transform and applying the MPP criterion. The enhanced image is shown on the right.

also depends on the noise level in the image [22]. Figure 6.7 shows an example of chromosomal banding pattern enhancement using this approach.

## 6.5   Color Image Enhancement

Color image processing in microscopy applications usually deals with the tricolor images acquired with modern color imaging devices. This topic is discussed in more detail in Chapter 13, which addresses the more general subject of multispectral image processing. Among many color coordinate systems, the *RGB* and *HSI* are two commonly used formats. The RGB format is most straightforward because it deals directly with the red, green, and blue images that are closely associated with the human visual system. The HSI (hue, saturation, intensity) format [21] is a system popularly used among artists. Hue and saturation can best be described by the use of a color circle [8]. The hue of a color refers to the spectral wavelength that it most closely matches. The saturation is the radius of the point from the origin of the color circle and represents the purity of the color. The RGB and HSI formats can be easily converted from one to the other [8]. One can also convert a color image to a monochrome image by averaging the RGB components together, which discards all chrominance information during the conversion.

When processing the components of a color image, one must exercise caution to avoid changing the color balance improperly. Essentially all of the image enhancement techniques discussed previously can be applied to the intensity component of an image in HSI format, since this component encodes contrast and edge information. The color information, on the other hand, is encoded in the hue and saturation components of the image. Enhancement of these color components should be approached with great caution because they are likely to upset the color balance.

### 6.5.1 Pseudo-Color Transformations

A pseudo-color image transformation involves a mapping from a single-channel (monochrome) image to a three-channel (color) image. It is used primarily as a display technique to aid human visualization and interpretation of grayscale images, since humans can discern the combinations of hue, saturation, and intensity much better than shades of gray alone. The technique of intensity slicing and color coding is a simple example of pseudo-color image processing. If an image is interpreted as a 3-D terrain model, this method can be viewed as one of painting each elevation with a different color. Pseudo-color techniques are useful for projecting multispectral image data down to three channels for display purposes.

### 6.5.2 Color Image Smoothing

The difference between color and gray-level image smoothing is that for color processing the smoothing is performed in each of the three RGB channels using conventional grayscale neighborhood processing [17], as shown in Eq. 6.38, where $S_{xy}$ denotes the neighborhood of a pixel at $(x, y)$. Equivalently, if the HSI color format is used, one need apply the smoothing operation only to the intensity image:

$$\tilde{f}_c(x, y) = \begin{bmatrix} \dfrac{1}{N} \sum\limits_{(x, y) \in S_{xy}} f_R(x, y) \\ \dfrac{1}{N} \sum\limits_{(x, y) \in S_{xy}} f_G(x, y) \\ \dfrac{1}{N} \sum\limits_{(x, y) \in S_{xy}} f_B(x, y) \end{bmatrix} \qquad (6.38)$$

### 6.5.3 Color Image Sharpening

Similar to the gray-level counterpart, color image sharpening is accomplished by extracting and accentuating edge information of an image. The Laplacian operator provides an example. For a three-component color vector $f_c(x, y) = (f_R(x, y), f_G(x, y), f_B(x, y)^t)$, the Laplacian of a vector is defined as a vector whose components are equal to the Laplacian of each of the individual scalar components of the input vector. Specifically, the Laplacian of the vector $f_c(x, y)$ is given by

$$\nabla^2 f_c(x, y) = \begin{bmatrix} \nabla^2 f_R(x, y) \\ \nabla^2 f_G(x, y) \\ \nabla^2 f_B(x, y) \end{bmatrix} \qquad (6.39)$$

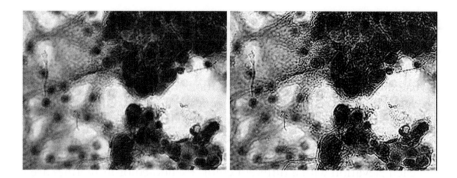

**FIGURE 6.8** The right image is the result of applying color image sharpening to the left image. This figure may be seen in color in the four-color insert.

which means that one can compute the Laplacian of an RGB color image by simply computing the Laplacian of each component image separately [17]. Likewise, applying the Laplacian operator only to the intensity component of the image under the HSI format accomplishes the same objective. Figure 6.8 shows an example of applying a Sobel edge enhancement operator to the RGB channels of a color image for sharpening.

## 6.6   Summary of Important Points

1. Image enhancement is the process of enhancing the appearance of an image or a subset of the image for better contrast or visualization of image features and to facilitate more accurate subsequent image analysis.

2. Image enhancement can be achieved using computational methods either in the spatial domain or in the transform domain.

3. The spatial domain methods accomplish image enhancement using either global operations on the whole image or local operations on a neighborhood region of each pixel.

4. The operations used to increase contrast in the image include contrast stretching, clipping and thresholding, image subtraction and averaging, and histogram equalization and specification.

5. The operations used to sharpen image features and reduce noise include spatial bandpass filtering, directional and steerable filtering, and median filtering.

6. If image noise is a random stationary process, variants of the Wiener filter can be used to reduce the noise effectively.

7. Nonlinear filters, such as the median filter, can reduce noise without blurring edges.

8. Transform domain methods accomplish image enhancement based on computations performed in a transform domain, such as the Fourier or wavelet transform. Often, salient image features can be more easily isolated and extracted in the transform domain than in the spatial domain.

9. Commonly used Fourier domain image enhancement methods include Wiener filtering, least-squares deconvolution, and bandpass filtering. The Wiener filter is optimal for noise removal in the sense of minimum mean square error.

10. Wavelet domain image enhancement methods leverage the advantages of multiscale image representation and nonlinear filtering. Since image edges tend to correlate spatially across multiple scales whereas noise does not, one can exploit this property and use nonlinear filtering to accentuate edge structures effectively while suppressing noise in the image.

11. Essentially all of the techniques developed for the enhancement of monochrome images can be applied to enhance color images by performing the operations on their intensity or luminance component, where image contrast and edge information is encoded.

# References

1. AK Jain, *Digital Image Processing*, Prentice-Hall, 1989.
2. R Fisher et al., *Hypermedia Image Processing Reference*, http://homepages.inf.ed.ac.uk/rbf/HIPR2/, 2003.
3. DA Agard et al., "Fluorescence Microscopy in Three Dimensions," *Methods in Cell Biology*, **30**:353–377, 1989.
4. RB Paranjape, "Fundamental Enhancement Techniques," in *Handbook of Medical Imaging*, IN Bankman, ed., Academic Press, 2000.
5. A Laine and W Huda, "Enhancement by Multiscale Nonlinear Operators," in *Handbook of Medical Imaging*, IN Bankman, ed., Academic Press, 2000.
6. A Polesel, G Ramponi, and VJ Mathews, "Image Enhancement via Adaptive Unsharp Masking," *IEEE Transactions on Image Processing*, **9**(3):505–510, 2000.
7. Y Xu et al., "Wavelet Domain Filters: A Spatial Selective Noise Filtration Technique," *IEEE Transactions on Image Processing*, **3**(11):747–757, 1994.
8. KR Castleman, *Digital Image Processing*, Prentice-Hall, 1996.

9. Q Wu, MA Schulze, and KR Castleman, "Steerable Pyramid Filters for Selective Image Enhancement Applications," *Proceedings of ISCAS*, 1998.

10. BM Sadler and A Swami, "Analysis of Multiscale Products for Step Detection and Estimation," *IEEE Transactions on Information Theory*, **45**(3):1043–1051, 1999.

11. Y Wang, "Image Representations Using Multiscale Differential Operators," *IEEE Transactions on Image Processing*, **8**(12):1757–1771, 1999.

12. WT Freeman and EH Adelson, "The Design and Use of Steerable Filters," *IEEE Transactions on Pattern Analysis and Machine Intelligence*, **13**(9):891–806, 1991.

13. A Beghdadi and AL Negrate, "Contrast Enhancement Technique Based on Local Detection of Edges," *Computer Vision and Graphical Image Processing*, **46**:162–174, 1989.

14. W Carrington, "Image Restoration in 3D Microscopy with Limited Data," *Proceedings of IEEE*, **1205**: 72–83, 1990.

15. AP Dhawan, *Medical Image Analysis*, John Wiley & Sons, 2003.

16. S Mallat and S Zhong, "Characterization of Signals from Multiscale Edges," *IEEE Transactions on Pattern Analysis and Machine Intelligence*, **14**(7):710–732, 1992.

17. RC Gonzalez and RE Woods, *Digital Image Processing*, 2nd ed., Prentice-Hall, 2002.

18. H Knutsson, R Wilson, and GH Granlund, "Anisotropic Non-Stationary Image Estimation and Its Applications, Part I, Restoration of Noisy Images," *IEEE Transactions on Communications*, **31**(3):388–397, 1983.

19. JS Lee, "Digital Image Enhancement and Noise Filtering by Local Statistics," *IEEE Transactions on Pattern Analysis and Machine Intelligence*, **2**:165–168, 1980.

20. RR Coifman and DL Donoho, "Translation-Invariant De-Noising," in *Wavelets and Statistics*, A Antoniadis and G Oppenheim, eds., Springer-Verlag, 1995.

21. AH Munsell, "A Pigment Color System and Notation," *American Journal of Psychology*, **23**:236–244, 1912.

22. Y Wang et al., "Chromosome Image Enhancement Using Multiscale Differential Operators," *IEEE Transactions on Medical Imaging*, **22**(5):685–693, 2003.

# 7

# Wavelet Image Processing

Hyohoon Choi and Alan C. Bovik

## 7.1  Introduction

Multiresolution image representations using wavelet transforms have become quite popular in recent years, owing to their effectiveness in a very broad array of applications [1]. In essence, wavelets made it possible to formalize the general concept of multiresolution processing that was being used, for example, in the computer vision field to enable to detection, analysis, and recognition of image features and objects over varying ranges of scales. Such important image processing tasks as segmentation require that the image be analyzed over neighborhoods of varying sizes in order to capture salient image features and properties that occur at different scales.

The concept of multiresolution wavelets first emerged about two decades ago in the signal processing subfield known as filter bank or sub-band filter theory. At about the same time came the introduction and development of the *continuous wavelet transform* (CWT) in applied mathematics. Discrete signal transforms that derive from a unification of these approaches have collectively become known as *discrete wavelet transforms* (DWTs). Today, in an amazing variety of image processing applications, the discrete wavelet transform has become the indispensable formal mathematical tool for creating and manipulating multiresolution representations [2].

This chapter introduces the basic concepts and properties of wavelet transforms. It begins with a review of the basic tools of linear transformations and the classical Fourier transform. This is followed by a discussion of the important relationships between the CWT, DWT, multiresolution processing, and filter

banks. We also discuss a number of topics, such as compactly supported wavelets, biorthogonal wavelets, and wavelet lifting schemes, because they are useful in applications. The concepts are first introduced in the context of one-dimensional (1-D) signals and then extended to two-dimensional (2-D) signals and images.

## 7.1.1   Linear Transformations

Linear system theory plays an important role in wavelet theory. A signal or function $f(x)$ can often be better described, analyzed, or compressed if it is transformed into another domain using a linear transform such as the Fourier transform or a wavelet transform [3]. A signal $f(x)$ can be expressed as a linear combination of a set of *basis functions*:

$$f(x) = \sum_j c_j \psi_j(x) \tag{7.1}$$

where $j$ is an integer index, $c_j$ are expansion coefficients, and $\{\psi_j(x)\}$ form a basis if the coefficients are unique for every signal. If the basis functions are orthonormal

$$\langle \psi_j(x)\psi_k(x)\rangle = \int \psi_j(x)\psi_k(x)dx = \begin{cases} 1; j = k \\ 0; j \neq k \end{cases} \tag{7.2}$$

then the coefficients are expressed as inner products of the signal with the corresponding basis function,

$$c_j = \langle f(x), \psi_j(x)\rangle = \int f(x)\psi_j(x)dx \tag{7.3}$$

Thus, in orthonormal linear transformations, signals are decomposed, as in Eq. 7.3, and reconstructed, as in Eq. 7.1, using the same set of basis functions.

If there exists a set of functions $\tilde{\psi}_k(x)$ that are linearly independent and not orthonormal but are orthonormal with respect to another set of basis functions $\psi_j(x)$

$$\langle \psi_j(x), \tilde{\psi}_k(x)\rangle = \delta(j - k) \tag{7.4}$$

then these two sets of functions form the basis for a *biorthogonal transformation*. In biorthogonal transformations, one set of functions is used for the decomposition and the other for reconstruction.

Linear transformations of discrete signals can be expressed in linear algebraic forms, where the signals are considered as vectors and the transformations as matrix–vector multiplications. The sampled signal, $f(x)$, can be written as

an $N \times 1$ column vector, $\mathbf{f}$. The discrete linear transformation of $\mathbf{f}$ can be expressed as

$$c_j = \sum_{k=0}^{N-1} f_k \psi_{j,k} \qquad \text{or} \qquad \mathbf{c} = \mathbf{\Psi f} \qquad (7.5)$$

where $\mathbf{\Psi}$ is an $N \times N$ kernel matrix and $\mathbf{c}$ is an $N \times 1$ vector of transform coefficients. Each row of the kernel matrix is a basis vector, and the rows are orthonormal:

$$\mathbf{\Psi \Psi}^t = \mathbf{I} \qquad (7.6)$$

where $t$ indicates the transpose. The vector $\mathbf{f}$ is reconstructed using the same set of basis functions by

$$\mathbf{f} = \mathbf{\Psi}^t \mathbf{c} \qquad (7.7)$$

that is, by summing the basis functions, which are weighted in amplitude by the coefficients.

There are many useful linear transformations that map an $N \times 1$ vector to another $N \times 1$ vector using $N \times N$ kernel matrices. The Fourier transform is a classic example of such a linear transformation, where the orthonormal basis is composed of sinusoidal functions.

## 7.1.2 Short-Time Fourier Transform and Wavelet Transform

The Fourier series representation of a $2\pi$-periodic function is defined as

$$f(x) = \sum_{n=-\infty}^{\infty} c_n e^{inx} \qquad (7.8)$$

where $i = \sqrt{-1}$ and the Fourier coefficients $c_n$ are given by

$$c_n = \frac{1}{2\pi} \int f(x) e^{-inx} dx \qquad (7.9)$$

A Fourier series decomposes a periodic signal into sinusoidal components by using a complex sinusoidal basis. It is useful to observe that the frequency components in Eq. 7.9 are generated by scaling, that is, by expanding or shrinking, the same basis function along the $x$-axis. This is a theme that is explored later in the context of the wavelet transform. The Fourier series and Fourier transform are the cornerstones of classic linear system theory, and they remain as powerful tools for signal and image analysis. Yet it has long been

recognized that classical Fourier theory has limited utility as a tool for analyzing local, transient, and time-varying signal properties.

Conceptually, each coefficient of a linear transformation can be regarded as a measure of the degree of similarity between the input signal and that particular basis function [5]. Thus, if a signal is composed of a few sinusoids, then all but a few the Fourier coefficients will be zero. Therefore the signal can be compactly represented by a few nonzero coefficients. In this way a highly efficient (highly compressed) representation is achieved. However, digital images, such as those taken through a microscope, contain a great diversity of structures that exhibit, for example, sharp localization (e.g., abrupt edges and lines), spatial transience (noise or artifacts), and nonstationarity (many textures). The classical Fourier basis functions resemble such components poorly and thus are not effective in compressing and analyzing signals and images containing such components.

Moreover, the Fourier bases are eternally oscillating functions, and hence they are difficult to adapt for analyzing local temporal or spatial phenomena in signals or images. One solution to this problem is to employ a window. The local frequency components of that portion of the signal located around $b$, as isolated by a window function $g(x - b)$, are analyzed. The window is translated by $b$ to enable localized Fourier analysis over all of space or time. This approach, called the *short-time Fourier transform* (STFT), was first developed by Gabor [6], who used Gaussian functions as windows. The STFT yields a two-dimensional (time–frequency) or four-dimensional (space–frequency) representation of one-dimensional temporal signals or two-dimensional spatial signals, respectively.

The choice of window size in the STFT determines the time–frequency resolutions that are obtained. Using a small window yields good time resolution but poor frequency resolution, and vice versa. For analyzing slowly varying components, such as low-frequency components or large image structures, a large window should be used, while a small window is better suited for analyzing short-duration transient components. A limitation of the STFT is that it uses a fixed-size window for a given signal. The ability to use multiple windows with variable sizes or scales is the basic conceptualization of multiresolution (or multiscale) signal and image analysis.

In order optimally to represent and analyze signals and images containing transient and time-varying components, new classes of basis functions have been developed that are localized simultaneously in time (or space) and frequency. Many of these have the appearance of short-duration waves or tapered sinusoids, hence the term *wavelets*. Wavelets that satisfy certain admissibility conditions may be used to define wavelet transforms, as will be shown shortly. The basis functions of wavelet transforms have an infinite variety of shapes, unlike those of the Fourier transform, which take a specific form. Figure 7.1 depicts examples of wavelet basis functions.

**FIGURE 7.1** Examples of wavelets.

# 7.2 Wavelet Transforms

First we define some notation that is used in this chapter. Let **R** and **Z** denote the set of integers and real numbers, respectively. Further, let $L^2(\mathbf{R})$ denote the vector space of all real one-dimensional square-integrable functions having finite energy; e.g., $f \in L^2$ means

$$\int \left| f(x) \right|^2 dx < +\infty$$

## 7.2.1 Continuous Wavelet Transform

The one-dimensional continuous wavelet transform (CWT), also called *integral wavelet transform*, was introduced by Grossman and Morlet [7]. The CWT maps a function of a single continuous variable to a function of two continuous variables using wavelets $\psi(x)$. If $\psi(x)$ satisfies the admissibility condition

$$C_\psi = \int_{-\infty}^{\infty} \frac{|\Psi(\omega)|^2}{|\omega|} d\omega < \infty \tag{7.10}$$

then $\psi(x)$ is called a *basic wavelet* (also called *mother wavelet*), where $\Psi(\omega)$ is the Fourier transform of $\psi(x)$. Note that $C_\psi$ is finite only if $\Psi(0) = 0$, that is,

$$\int_{-\infty}^{\infty} \psi(x)dx = 0 \tag{7.11}$$

The so-called first-generation wavelet basis functions are generated by scaling and translating the basic wavelet:

$$\psi_{a,b}(x) = \frac{1}{\sqrt{a}} \psi\left(\frac{x-b}{a}\right) \tag{7.12}$$

where $a > 0$ and $b$ are real numbers. The factor $1/\sqrt{a}$ is used to maintain the norm. The variables $a$ and $b$ specify scaling and translation, respectively. For small $a$, $\psi_{a,b}(x)$ is narrow (high frequency); for large $a$, $\psi_{a,b}(x)$ is broad (low frequency). Then the CWT of $f(x)$ is [8]

$$W_f(a, b) = \int_{-\infty}^{\infty} f(x)\psi_{a,b}(x)dx \tag{7.13}$$

This representation provides the time–frequency localization, but the representation is highly redundant or overcomplete. Note that as the wavelet becomes broader, the time resolution becomes worse while the frequency resolution improves. Conversely, as the wavelet becomes narrower, the time resolution improves but the results of frequency analysis become less certain. Discretization of $a$, $b$ and special choices of $\psi(x)$ lead to wavelet orthonormal bases, or wavelet series expansions.

## 7.2.2 Wavelet Series Expansion

The wavelet series expansion is analogous to the Fourier series, in that both methods represent continuous-time signals with a series of discrete coefficients. A set of basis functions is formed by scaling and translating the basic wavelet, $\psi(x)$, but the scaling and translation takes only discrete values.

A set of wavelet basis functions that constitute an orthonormal basis for $L^2(\mathbf{R})$ is given by

$$\psi_{j,k}(x) = 2^{j/2}\psi(2^j x - k), \qquad j, k \in \mathbf{Z} \tag{7.14}$$

Observe that $\psi(2^j x - k)$ is obtained from a basic wavelet $\psi(x)$ by a binary dilation by a factor $2^j$, that is, by shrinking it by factor that is a power of 2, and a dyadic translation by $k/2^j$. The dyadic translation is a shift by the amount of the width of the wavelet, which is proportional to $2^j$. Thus, high-frequency wavelets are translated by small steps, whereas low-frequency wavelets translate by larger steps [2].

In order for $\psi_{j,k}(x)$ to be an orthonormal basis, it must satisfy

$$\langle \psi_{j,k}(x), \psi_{l,m}(x) \rangle = \delta(j - l)\delta(k - m) \tag{7.15}$$

where $\delta(\cdot)$ is the Kronecker delta function. Any function $f \in L^2(\mathbf{R})$ can then be expressed

$$f(x) = \sum_{j,k=-\infty}^{\infty} c_{j,k}\psi_{j,k}(x) \tag{7.16}$$

where $c_{j,k}$ are the *wavelet coefficients* and are computed by

$$c_{j,k} = \left\langle f(x), \psi_{j,k}(x) \right\rangle = \int_{-\infty}^{\infty} f(x)\psi_{j,k}(x)dx \tag{7.17}$$

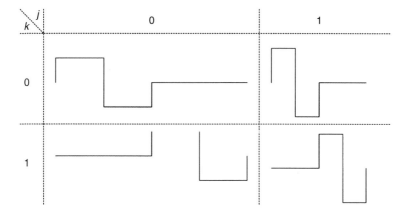

**FIGURE 7.2**   Haar wavelets $\psi_{j,k}(x)$. The oldest orthonormal wavelet basis. Index $j$ is the scale and $k$ is the translation.

Equations 7.17 and 7.16 are called the *analysis* and *synthesis formulae*, respectively. These terms are used because the forward expansion coefficients are useful for analyzing the signal or image in some tasks, while the reverse formula synthesizes the signal from the coefficients.

### 7.2.3   Haar Wavelet Functions

The oldest example of an orthonormal wavelet basis is the Haar function,

$$\psi(x) = \begin{cases} 1 & 0 \le x < \dfrac{1}{2} \\ -1 & \dfrac{1}{2} \le x < 1 \\ 0 & \text{otherwise} \end{cases} \qquad (7.18)$$

The Haar function can constitute an orthonormal basis for $L^2(\mathbf{R})$ by iteratively dilating (or narrowing) and translating the basis function. Note that it has compact support in time but $1/\omega$ decay in frequency, and thus it has good time localization but poor frequency localization. Figure 7.2 shows the Haar wavelets, $\psi_{j,k}(x)$. As defined in Eq. 7.14, the basic wavelet is narrowed iteratively by a factor of 2 and translated by its width at any given scale $j$. It is easy to see from the figure that the basis functions are orthogonal to each other, since there is no nonzero overlap among them.

## 7.3   Multiresolution Analysis

The preceding section developed the basic idea of wavelets. This section discusses how multiresolution fits into the wavelet framework. Multiresolution analysis is a powerful tool that enables improved performance in a variety of

computer vision and image processing applications, such as image segmentation, object recognition, compression, and noise reduction. The concept of multiresolution also provides a solid mathematical framework for forming interpretations of wavelet bases.

## 7.3.1  Multiresolution and Scaling Function

In a multiresolution analysis, a signal $f(x)$ is decomposed into an "approximation" and "residual details" at a given resolution. The approximation is further decomposed into another approximation and residual details at a smaller resolution [1] (see Fig. 7.3). This process is iterated toward successively finer resolutions.

The vector space that contains the set of all possible approximations of $f(x)$, at the resolution $j$, is denoted as $V_j$, which is a subspace of $L^2(\mathbf{R})$, or $V_j \subset L^2(\mathbf{R})$. At different resolutions, the spaces are nested as $V_j \subset V_{j+1}$ for all $j \in \mathbf{Z}$,

$$\cdots \subset V_{-1} \subset V_0 \subset V_1 \subset V_2 \subset \cdots \subset L^2 \tag{7.19}$$

with $V_\infty = L^2(\mathbf{R})$ and $V_{-\infty} = \{0\}$. If an approximation function $\phi(x)$ is in $V_j$, then the scaled approximation function, $\phi(2x)$, is in $V_{j+1}$, and, by Eq. 7.19, $\phi(x) \in V_{j+1}$. This means that all lower-resolution spaces are scaled versions of a higher-resolution space and can be derived from it.

The approximation function $\phi(x)$ is called a *scaling function*, and the set of scaling functions obtained by binary dilations and dyadic translations is an orthonormal basis for the subspace:

$$\phi_{j,k}(x) = 2^{j/2}\phi(2^j x - k) \tag{7.20}$$

is an orthonormal basis of $V_j$.

The differences between the spaces $V_j$ and $V_{j+1}$ are denoted as $W_j$ [3]. Thus the space $V_{j+1}$ is composed of $V_j$ (approximations) and $W_j$ (details):

$$V_{j+1} = V_j \oplus W_j, \qquad j \in \mathbf{Z} \tag{7.21}$$

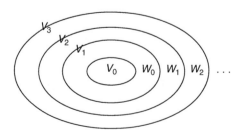

**FIGURE 7.3**    Multiresolution representation of the vector space (after [3]).

Figure 7.3 illustrates the nesting space of $L^2$. While the set of scaling functions $\phi_{j,k}(x)$ is the basis for $V_j$, the set of wavelet functions $\psi_{j,k}(x)$ discussed earlier is the basis for $W_j$. The subspaces $V_j$ and $W_j$ are orthogonal to each other, and the intersection of the subspaces $V_j$ is the null space $\{0\}$. Thus the basis functions in both spaces should be orthogonal,

$$\langle \phi_{j,k}(x), \psi_{k,l}(x) \rangle = \int \phi_{j,k}(x)\psi_{k,l}(x)dx = 0, \qquad j,k,l \in \mathbf{Z} \qquad (7.22)$$

The entire space can be written as

$$L^2 = V_0 \oplus W_0 \oplus W_1 \oplus W_2 \oplus \cdots \qquad (7.23)$$

or it can be written without the scaling space at $j = -\infty$

$$L^2 = \cdots \oplus W_{-2} \oplus W_{-1} \oplus W_0 \oplus W_1 \oplus W_2 \oplus \cdots \qquad (7.24)$$

which is the expansion using the wavelet basis as in Eq. 7.17.

## 7.3.2 Scaling Functions and Wavelets

Using the multiresolution structure, a scaling function $\phi(x)$ in $V_0$, which is also in $V_1$, can be expressed in terms of the basis in $V_1$:

$$\phi(x) = \sum_n h_0(n)\phi_{1,n}(x) \qquad (7.25)$$

where

$$h_0(n) = \langle \phi(x), \phi_{1,n}(x) \rangle \qquad \text{and} \qquad \sum_n \left| h_0(n) \right|^2 = 1 \qquad (7.26)$$

Equation 7.25 can be rewritten

$$\phi(x) = \sqrt{2} \sum_{n \in \mathbf{Z}} h_0(n)\phi(2x - n) \qquad (7.27)$$

where the coefficients $h_0(n)$ are the *scaling function coefficients*.

The same idea can be applied to the wavelet function $\psi(x) \in W_0 \subset W_1$, where $\psi(x)$ can also be expressed in terms of the basis in $V_1$:

$$\psi(x) = \sum_n h_1(n)\phi_{1,n}(x) \qquad (7.28)$$

which can be rewritten as

$$\psi(x) = \sqrt{2} \sum_{n \in \mathbf{Z}} h_1(n)\phi(2x - n) \qquad (7.29)$$

Equations 7.27 and 7.29 suggest that one can construct all of the scaling functions and wavelets starting from only one scaling function.

A scaling function is an approximation function, which means that the scaling functions are useful for analyzing general trends in the signal, whereas the details in the signal are analyzed using the wavelets. Thus, any low-pass filter that satisfies certain conditions can become a scaling function. The simplest scaling function is the Haar scaling function,

$$\phi(x) = \begin{cases} 1 & \text{if } 0 < x < 1 \\ 0 & \text{otherwise} \end{cases}$$

whose filter coefficients are $h_0(n) = [1/\sqrt{2}, 1/\sqrt{2}]$, which is an average filter. Due to the orthogonality between the wavelet and the scaling functions, $h_1(n)$ and $h_0(n)$ are related as

$$h_1(n) = (-1)^n h_0(1 - n) \tag{7.30}$$

The wavelet satisfying conditions Eq. 7.29 and Eq. 7.30, using the Haar scaling function, is the Haar wavelet shown in Eq. 7.18 and Fig. 7.2, whose filter coefficients are $h_1(n) = [1/\sqrt{2}, -1/\sqrt{2}]$, which is a differential (differencing) filter. While the Haar scaling filter is a low-pass filter, the Haar wavelet filter is a high-pass filter. For a finite even-length $h_0(n)$, $h_1(n) = (-1)^n h_0(N - n)$, where $N$ is an odd number; i.e., the high-pass filter $h_1$ is found by reversing the order and alternating the signs of the low-pass filter $h_0$.

## 7.4   Discrete Wavelet Transform

This section examines how this multiresolution analysis structure can be used to formulate the discrete wavelet transform (DWT).

### 7.4.1   Decomposition

At resolution $j$, Eq. 7.27 can be written

$$\phi(2^j x - k) = \sum_n h_0(n)\sqrt{2}\phi(2^{j+1}x - 2k - n) \tag{7.31}$$

After a change of variables $m = 2k + n$, Eq. 7.31 becomes

$$\phi(2^j x - k) = \sum_m h_0(m - 2k)\sqrt{2}\phi(2^{j+1}x - m) \tag{7.32}$$

Similarly, Eq. 7.29 can be expressed at resolution $j$ as

$$\psi(2^j x - k) = \sum_m h_1(m - 2k)\sqrt{2}\phi(2^{j+1}x - m) \tag{7.33}$$

Using the multiresolution space defined in Eq. 7.23, a function, $f(x)$, can be expressed

$$f(x) = \sum_k c_0(k)\phi(x - k) + \sum_k \sum_{j=0}^{\infty} d_j(k)2^{j/2}\psi(2^j x - k) \tag{7.34}$$

where $c_0(k)$ are the approximation coefficients at resolution $j = 0$ and $d_j(k)$ are the details at resolution $j \geq 0$. That is, any signal in $L^2$ can be constructed, starting from its coarse approximation, by progressively adding the finer details.

It is also convenient to represent the signal $f(x)$ starting from a high resolution, say, $j + 1$, as

$$f(x) = \sum_k c_{j+1}(k)2^{(j+1)/2}\phi(2^{j+1}x - k) \tag{7.35}$$

At one-scale-lower resolution, using Eq. 7.21, $c_{j+1}(k)$ is decomposed into an approximation and detail as

$$f(x) = \sum_k c_j(k)2^{j/2}\phi(2^j x - k) + \sum_k d_j(k)2^{j/2}\psi(2^j x - k) \tag{7.36}$$

and $c_j(k)$ can be further iteratively decomposed. The approximation coefficient $c_j$ is expressed by the inner product,

$$c_j(k) = \langle f(x), \phi_{j,k}(x) \rangle = \int f(x)2^{j/2}\phi(2^j x - k)dx \tag{7.37}$$

By taking the inner products of $f(x)$ with both sides of Eq. 7.32, we obtain

$$\langle f(x), \phi_{j,k}(x) \rangle = \sum_m h_0(m - 2k)\langle f(x), \phi_{j+1}(x) \rangle \tag{7.38}$$

which is

$$c_j(k) = \sum_m h_0(m - 2k)c_{j+1}(m) \tag{7.39}$$

Similarly, $d_j$ can be written as

$$d_j(k) = \sum_m h_1(m - 2k)c_{j+1}(m) \tag{7.40}$$

Equations 7.39 and 7.40 tell us that it is not necessary to know the scaling functions and wavelets in order to compute the approximations and details, provided that $h_0(n)$ and $h_1(n)$ are given.

Now denote $x(n)$ as the output of a convolution between a filter $h(n)$ and $c_{j+1}(n)$:

$$x(n) = \sum_m h(m - n)c_{j+1}(m)$$

Then the *down-sampled* (by a factor of 2) version of $x(n)$ is

$$x(2n) = \sum_m h(m - 2n)c_{j+1}(m).$$

Equations 7.39 and 7.40 mean that the scaling and wavelet coefficients are computed by the convolution with finite-length discrete filters or finite–impulse response (FIR) filters, $h_0(n)$ and $h_1(n)$, and followed by down-sampling by a factor of 2 (retaining only the even-indexed samples).

Figure 7.4 shows the decomposition (or analysis) procedure, or the forward discrete wavelet transform. The low-pass filtered and down-sampled signal, $c_j$, is further decomposed into an approximation and a detail. This process repeats on the approximation coefficients, producing one coarse approximation and details at each decomposition level. For example, $c_{j+1}$ can be represented by $c_{j-2}$, $d_{j-2}$, $d_{j-1}$, and $d_j$ when a three-level decomposition is performed.

It is interesting to observe how the multiresolution analysis divides the frequency domain. The frequency responses of the analysis filters $h_0(n)$ and $h_1(n)$ can be computed using the discrete-time Fourier transform (DTFT), given by

$$H(\omega) = \sum_{n=-\infty}^{\infty} h(n)e^{-i\omega n} \tag{7.41}$$

where $i = \sqrt{-1}$ and $n \in \mathbf{Z}$. This transforms a discrete function $h(n)$ to the $2\pi$-periodic continuous representation $H(\omega)$. The frequency responses of the analysis filters are shown in Fig. 7.5. The convolution processes in Eqs. 7.39 and 7.40 imply products between the frequency components of $c_{j+1}$ and $H_0(\omega)$ and $H_1(\omega)$, which divides $c_{j+1}$ into low- and high-frequency components, or frequency bands. The low-frequency component, $c_j$, is further decomposed into low-low- ($V_{j-1}$) and low-high- ($W_{j-1}$) frequency components, where the low-low component is computed by convolving $c_{j+1}$ twice with $h_0(n)$ and the low-high component is convolved with $h_0(n)$ and then once with $h_1(n)$. Thus the

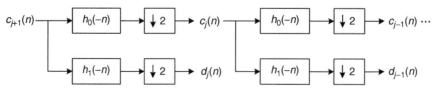

**FIGURE 7.4** Forward discrete wavelet transform.

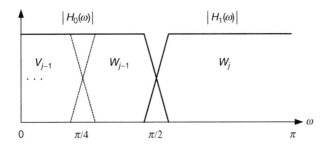

**FIGURE 7.5** Frequency responses of the analysis filters, and spectrum division by multiresolution analysis.

details (high-frequency components) are computed by convolving $c_{j+1}$ with $h_0(n)$ multiple times and then once with $h_1(n)$. Since large structures are composed of low-frequency components, dividing the spectrum into subbands actually separates different scaling components in the signal. The concept of spectrum division greatly facilitates understanding of filter banks.

In practice, signals and images are recorded in discrete and finite form. At each decomposition, the number of coefficients in $c_j(n)$ becomes half the number of samples in $c_{j+1}(n)$. Thus, the decomposition can repeat until only one approximation coefficient is left. The maximum number of decomposition is $J$ when the number of samples in $c_{j+1}(n)$ is $N = 2^J$. Obviously, the decomposition begins at the finest level. Starting from the coarsest approximation, we can iteratively add finer details. But there also is a limit beyond which no more fine detail is available using the discrete representation. The computational complexity of the DWT is $O(N)$ for a signal of length $N$, given that the filter length is negligible.

## 7.4.2 Reconstruction

The reconstruction of $c_{j+1}$ can be done by reversing the decomposition process. By taking inner products on both sides of Eq. 7.36 with $\phi_{j+1,k}$, we get

$$\langle f(x),\phi_{j+1,k}\rangle = \sum_m c_j(m)\langle\phi_{j,m},\phi_{j+1,k}\rangle + \sum_m d_j(m)\langle\psi_{j,m},\phi_{j+1,k}\rangle \qquad (7.42)$$

which can be rewritten after using Eq. 7.32 and Eq. 7.33,

$$c_{j+1}(k) = \sum_m c_j(m)h_0(k-2m) + \sum_m d_j(m)h_1(k-2m) \qquad (7.43)$$

Equation 7.43 implies that $c_j$ and $d_j$ are first up-sampled by a factor of 2 (inserting zeros at every odd index) and then filtered with $h_0(n)$ and $h_1(n)$, and

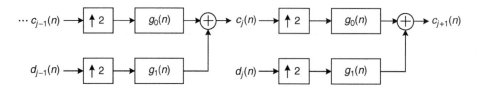

**FIGURE 7.6**   Inverse discrete wavelet transform.

the results are then added to reconstruct $c_{j+1}$. Figure 7.6 illustrates this reconstruction (synthesis) procedure, or the inverse DWT.

As is seen from Eq. 7.43, the same digital filters used in the analysis are used for the synthesis, since we have defined orthonormal scaling and wavelet functions. This type of transformation is known as an *orthogonal* (or, more specifically, *orthonormal*) *discrete wavelet transform*. If the analysis and synthesis filters are different but the transform is invertible, then the transform is known as a *biorthogonal wavelet transform*, as explained later in this chapter. Due to this orthonormality, $g_0(n) = h_0(-n)$ and $g_1(n) = h_1(-n)$, and $h_1(n)$ can be expressed in terms of $h_0(n)$, as shown in Eq. 7.30. Thus, a carefully designed low-pass filter, $h_0(n)$, is what is needed to compute the orthogonal discrete wavelet transform [5]. The computational procedure defined in this section and shown in Figs. 7.5 and 7.6 is known as *Mallat's algorithm* [1].

## 7.4.3   Filter Banks

The structure of multiresolution analysis is closely related to filter bank theory and subband coding [4, 9, 10, 11, 19]. In subband coding, the input signal $f(n)$, a sequence of samples, is decomposed into $M$ subbands by convolving the signal with a set of $M$ bandpass filters, followed by down-sampling each result by a factor of $M$. The down-sampled subband signals represent the input data without redundancy, which means that the total number of coefficients in the transform domain is equal to the number of input samples. Each subband contains different frequency components or, equivalently, different scale components [12]. To reconstruct the original signal, the subband signals are up-sampled and convolved with a set of filters, and the resulting signals are then added together. The analysis and synthesis filters are specifically designed to recover the original signal without error.

### 7.4.3.1   Two-Channel Subband Coding

In a two-channel subband coding scheme, the signal is filtered by one low-pass and one high-pass filter and down-sampled by a factor of 2, which is identical to the one-level decomposition in the DWT. Figure 7.7 is a schematic diagram of

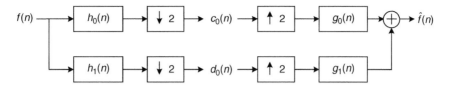

**FIGURE 7.7** Two-channel filter bank. The analysis filters, $h_0(n)$ and $h_1(n)$, are the low-pass and high-pass filters, respectively.

a two-channel filter bank. The DWT is achieved by repeating the decomposition on the low-pass filtered result using a two-channel filter bank.

Subband coding was originally developed for compressing digital audio signals [9, 10]. Using a set of bandpass filters, an audio signal would be decomposed into multiple spectral bands. If the filters were designed to resemble important features in the signal, then the coefficients in the subbands would have a compact representation, resulting in effective coding. Furthermore, those frequency bands to which the human ear is more sensitive can be coded with more bits, while less salient bands could be discarded.

If we want the transform to be invertible using two channels, then ideally the spectrum might be split at the mid-frequency point, without a gap. However, the ideal "brick wall" low-pass and high-pass filters yield poor time localization, since their impulse responses are of infinite extent. To achieve good temporal localization, the frequency responses of the filters must be smooth if the filter impulse responses are to be of finite extent. This introduces spectral overlap between the filters, or *subband aliasing*. This aliasing can be canceled during the reconstruction stage, as discussed next.

### 7.4.3.2 Orthogonal Filter Design

To find the conditions on these filters for alias canceling and perfect reconstruction, $z$-notation is convenient. The $z$-transform of a sequence $x(n)$ is defined as $X(z) = \sum_n x(n)z^{-n}$, where $z = e^{i\omega}$.

When a sequence $x(n)$ is down-sampled by a factor of 2, the $z$-transform of $v(n) = x(2n)$ is written as [13]

$$V(z) = \frac{1}{2}[X(z^{1/2}) + X(-z^{1/2})] \tag{7.44}$$

If $v(n)$ is up-sampled by a factor of 2, $u(n) = v(2n)$ has a $z$-transform

$$U(z) = \frac{1}{2}[X(z) + X(-z)] \tag{7.45}$$

Thus, the decomposition results $c_0(n)$ and $d_0(n)$ in Fig. 7.7 can be rewritten

$$C_0(z) = \frac{1}{2}[H_0(z^{1/2})F(z^{1/2}) + H_0(-z^{1/2})F(-z^{1/2})]$$

$$D_0(z) = \frac{1}{2}[H_1(z^{1/2})F(z^{1/2}) + H_1(-z^{1/2})F(-z^{1/2})]$$

(7.46)

The reconstruction process should return the original signal perfectly up to a delay: $\hat{f}(n) = f(n-l)$ or $\hat{F}(z) = z^{-l}F(z)$. The reconstructed signal $\hat{f}(n)$ is

$$\hat{F}(z) = C_0(z^2)G_0(z) + D_0(z^2)G_1(z)$$

(7.47)

which can be expanded as

$$\hat{F}(z) = \frac{1}{2}[H_0(z)G_0(z) + H_1(z)G_1(z)]F(z) + \frac{1}{2}[H_0(-z)G_0(z) + H_1(-z)G_1(z)]F(-z)$$

(7.48)

Perfect reconstruction using a two-channel filter bank is obtained when the filters satisfy

$$H_0(z)G_0(z) + H_1(z)G_1(z) = 2z^{-l}$$

(7.49)

$$H_0(-z)G_0(z) + H_1(-z)G_1(z) = 0$$

(7.50)

Since $F(-z)$ is the aliased version of the input signal, Eq. 7.50 is the necessary condition for removing the aliasing. One solution to remove aliasing, proposed by Esteban and Galand [16] is

$$H_1(z) = H_0(-z),$$
$$G_0(z) = H_0(z),$$
$$G_1(z) = -H_1(z) = -H_0(-z).$$

(7.51)

This solution obviously satisfies Eq. 7.50, and substituting the solution into Eq. 7.49 gives

$$H_0^2(z) - H_0^2(-z) = 2z^{-l}$$

(7.52)

Since $H_1(z)$ is the mirrored version of $H_0(z)$ with respect to $\omega = \pi/2$ and both filters are squared, the filters satisfying Eq. 7.51 are called *quadrature mirror filters* (QMFs). There exist no FIR filters that satisfy condition Eq. 7.52 exactly except for the Haar filter. However, there are many ways to design QMFs that make the reconstructed signal approximate the input closely [2].

Another solution, known as *conjugate quadrature filters* (CQFs) [10], is

$$H_1(z) = z^{-1}H_0(-z^{-1})$$
$$G_0(z) = H_0(z^{-1}) \qquad\qquad (7.53)$$
$$G_1(z) = H_1(z^{-1}) = zH_0(-z)$$

which implements the orthogonal FIR filters. Again, using Eq. 7.53, the alias term, Eq. 7.50, becomes zero, and the distortion term, Eq. 7.49, becomes

$$H_0(z)H_0(z^{-1}) + H_0(-z)H_0(-z^{-1}) = 2z^{-l} \qquad (7.54)$$

Since the filters have real values, using $H(e^{j\omega}) = H(e^{-j\omega})$, Eq. 7.54 can be written as

$$\left|H_0(e^{j\omega})\right|^2 + \left|H_0(-e^{j\omega})\right|^2 = \left|H_0(\omega)\right|^2 + \left|H_0(\omega + \pi)\right|^2 = 2 \qquad (7.55)$$

In this case, there do exist filters $h_0(n)$ that satisfy Eq. 7.55, and thus perfect reconstruction can be realized using two-channel filter banks. It is apparent from Eq. 7.53 that $h_1(n) = (-1)^n h_0(1 - n)$, since $H(z^{-1})$ implies time reversal $h(-n)$, while $H(-z)$ implies sign alternation $(-1)^n h(n)$. The orthogonal wavelet transform is achieved using these orthogonal FIR filters. Therefore, the orthogonal wavelet transform only requires the design of the scaling vector, $h_0(n)$, having *compact support* (a small number of nonzero coefficients), and all other filters are then derived from it. For example, if $h_0(n) = [a, b, c, d]$, then $h_1(n) = [d, -c, b, -a]$, $g_0(n) = [d, c, b, a]$, and $g_1(n) = [-a, b, -c, d]$.

## 7.4.4 Compact Support

A function has compact support if it is nonzero over only a small region of its range. Representing an image or a signal with a small number of large coefficients is important not only for data compression but also for noise removal [14]. At certain locations, such as singularities in a signal or lines or edges in an image, using widely supported wavelet filters will generate many coefficients of various magnitudes. In order to achieve a local representation of the signal, using an efficient, small number of large-magnitude coefficients, the support size (non-zero portion) of the basis functions should be small. Thus, compact support is important for achieving efficient representations while providing time or space localization and faster computation.

Daubechies constructed orthonormal wavelets having a minimum support size given the number of vanishing moments [15]. A wavelet function $\psi(x)$ has $M$ vanishing moments if

$$\int_{-\infty}^{\infty} t^k \psi(x)dx = 0, \qquad \text{for } 0 \leq k < M \qquad (7.56)$$

The orthonormal wavelets, $\psi$, are constructed starting with the $2\pi$-periodic function $H(\omega)$, which is the frequency response of

$$h(n) = \sqrt{2} \int \phi(x)\phi(2x - n)dx \qquad (7.57)$$

If $\phi$ has compact support, then $h(n)$ has a finite number of nonzero moments. By Eqs. 7.29 and 7.30, $\psi$ also has compact support. The orthogonality of $h(n)$ implies that $H(\omega)$ should satisfy Eq. 7.55.

The number of vanishing moments is related to the *regularity,* which describes the smoothness of $\phi$ and $\psi$. The regularity is defined by the factorization of $H(\omega)$ as a trigonometric polynomial,

$$H(\omega) = \sqrt{2}\left(\frac{1 + e^{j\omega}}{2}\right)^{M} R(\omega) \qquad (7.58)$$

which means that $H(\omega)$ has $M$ zeros at $\omega = \pi$. By the orthogonality of $\phi$ and $\psi$, it also follows that $G(\omega)$ has $M$ zeros at $\omega = 0$. It was proved [2] that given $M$ vanishing moments, $h(n)$ has at least $N$ nonzero coefficients, where $N \geq 2M$. Daubechies' orthonormal wavelet filters have the minimum support size of $2M$ [2, 15]. Interestingly, when $M = 1$, the Haar wavelet is the solution for the Daubechies wavelet system.

The smoothness of the wavelet function greatly affects the visual quality of a reconstructed image. When the wavelet coefficients are processed in some manner that produces loss or error of coefficients, such as thresholding or quantization, then the reconstructed image will differ from the original image. The differences are usually less noticeable when the images are processed with continuously differentiable wavelets rather than with discontinuous wavelets, such as Haar wavelets [14].

Table 7.1 shows the Daubechies scaling function coefficients for $M = 2, 3, 5,$ and 9. Their corresponding scaling and wavelet functions are shown in Fig. 7.8. Notice that the regularity increases as the support size increases.

## 7.4.5  Biorthogonal Wavelet Transforms

For orthonormal wavelets, the analysis filters and synthesis filters are basically the same, except they are time-reversed versions of each other. Requiring orthogonality greatly limits the degrees of freedom, often resulting in complicated design equations and preventing linear phase analysis [3]. Except for Haar wavelets, linear phase (or even complete symmetry) is not achievable using compactly supported orthonormal wavelets. However, by using two different wavelet basis sets, $\psi_{j,k}(x)$ and $\tilde{\psi}_{j,k}(x)$, satisfying

**TABLE 7.1**   Coefficients of Daubechies scaling function $h_0(n)$ for $M = 2, 3, 5$ and 9

| $n$ | $M = 2$ | $M = 3$ | $M = 5$ | $M = 9$ |
|---|---|---|---|---|
| 0 | 0.48296 | 0.33267 | 0.16010 | 0.03808 |
| 1 | 0.83652 | 0.80689 | 0.60383 | 0.24383 |
| 2 | 0.22414 | 0.45988 | 0.72431 | 0.60482 |
| 3 | −0.12941 | −0.13501 | 0.13843 | 0.65729 |
| 4 | | −0.08544 | −0.24229 | 0.13320 |
| 5 | | 0.03523 | −0.03224 | −0.29327 |
| 6 | | | 0.07757 | −0.09684 |
| 7 | | | −0.00624 | 0.14854 |
| 8 | | | −0.01258 | 0.03073 |
| 9 | | | 0.00333 | −0.06763 |
| 10 | | | | 0.00025 |
| 11 | | | | 0.02236 |
| 12 | | | | −0.00472 |
| 13 | | | | −0.00428 |
| 14 | | | | 0.00185 |
| 15 | | | | 0.00023 |
| 16 | | | | −0.00025 |
| 17 | | | | 0.00004 |

$$\langle \psi_{j,k}(x) \tilde{\psi}_{l,m}(x) \rangle = \delta(j - l)\delta(k - m) \tag{7.59}$$

it is possible to obtain symmetrical wavelet representations or linear phase with compact support [17]. These wavelets are called *biorthogonal wavelets*.

Biorthogonal expansions can be expressed as

$$f(x) = \sum_{j,k \in \mathbb{Z}} \langle \psi_{j,k}(x), f(x) \rangle \tilde{\psi}_{j,k}(x) = \sum_{j,k \in \mathbb{Z}} \langle \tilde{\psi}_{j,k}(x), f(x) \rangle \psi_{j,k}(x) \tag{7.60}$$

Thus, either wavelet can be used for the decomposition, given that the other is used for the reconstruction.

### 7.4.5.1   Biorthogonal Filter Banks

The two-channel filter banks shown in Fig. 7.7 also implement the biorthogonal wavelet transform. In this case, we need to choose a pair of low-pass filters, $h_0(n)$ and $g_0(n)$, and derive high-pass filters from them. Using the multiresolution definition of the scaling functions, an infinite cascade of low-pass filters generates two scaling functions,

$$\phi(x) = \sqrt{2} \sum_n h_0(n)\phi(2x - n) \quad \text{and} \quad \tilde{\phi}(x) = \sqrt{2} \sum_n g_0(n)\tilde{\phi}(2x - n) \tag{7.61}$$

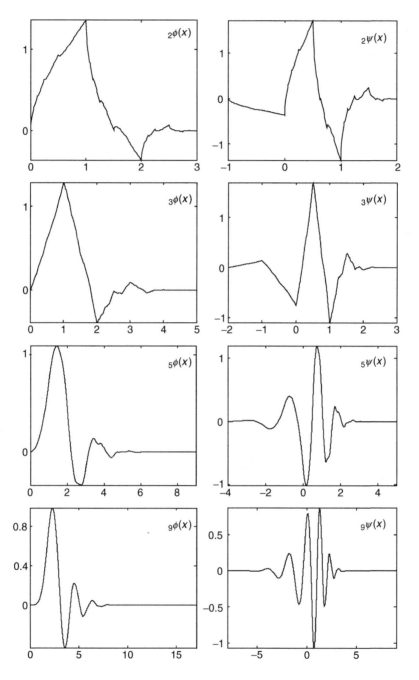

**FIGURE 7.8**  Daubechies' compactly supported orthonormal scaling functions $_M\phi(x)$ and wavelets $_M\psi(x)$ for vanishing moments $M = 2, 3, 5,$ and $9$ [2].

whose Fourier transforms are

$$\Phi(2\omega) = \frac{1}{\sqrt{2}} H_0(\omega)\Phi(\omega) = \frac{1}{\sqrt{2}} \prod_{k=0}^{\infty} H_0(\omega/2^k)$$

and

$$\tilde{\Phi}(2\omega) = \frac{1}{\sqrt{2}} G_0(\omega)\tilde{\Phi}(\omega) = \frac{1}{\sqrt{2}} \prod_{k=0}^{\infty} G_0(\omega/2^k)$$

Perfect reconstruction using analysis and synthesis low-pass filters should satisfy

$$G_0(\omega)H_0(\omega) + G_0(\omega + \pi)H_0(\omega + \pi) = 2 \qquad (7.62)$$

where

$$G_0(\pi) = H_0(\pi) = 0$$

$$G_0(0) = \sum_n g_0(n) = \sqrt{2}$$

$$H_0(0) = \sum_n h_0(n) = \sqrt{2}$$

While the filter lengths must be even in orthogonal systems (or frequency information is lost at mid-frequencies), the lengths of the low-pass filters can be either both even or both odd in biorthogonal systems. The high-pass filters are generated from the low-pass filters as

$$h_1(n) = (-1)^n h_0(1 - n) \qquad \text{and} \qquad g_1(n) = (-1)^n g_0(1 - n) \qquad (7.63)$$

The wavelets are then defined by

$$\psi(x) = \sqrt{2} \sum_n h_1(n)\phi(2x - n) = \sqrt{2} \sum_n (-1)^n h_0(1 - n)\phi(2x - n)$$

and

$$\tilde{\psi}(x) = \sqrt{2} \sum_n g_1(n)\tilde{\phi}(2x - n) = \sqrt{2} \sum_n (-1)^n g_0(1 - n)\tilde{\phi}(2x - n).$$

### 7.4.5.2 Examples of Biorthogonal Wavelets

Designing biorthogonal wavelets requires developing appropriate $h_0(n)$ and $g_0(n)$ that have compact support. There are many methods for the design of biorthogonal wavelets [11, 17, 18]. Cohen, Daubechies, and Feauveau [17] used splines as scaling functions to construct biorthogonal wavelets. Their family of biorthogonal wavelets is probably the most widely used biorthogonal wavelets [3].

**TABLE 7.2** Cohen–Daubechies–Feauveau 9/7 wavelets

| $n$ | $h_0(n)$ | $g_0(n)$ |
|---|---|---|
| 0 | 0.852698679 | 0.788485616 |
| 1,−1 | 0.377402855 | 0.418092273 |
| 2,−2 | −0.110624404 | −0.040689417 |
| 3,−3 | −0.023849465 | −0.064538882 |
| 4,−4 | 0.037828845 | |

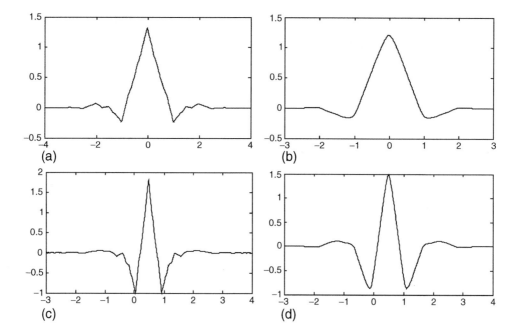

**FIGURE 7.9** Scaling functions and wavelets of Cohen–Daubechies–Feauveau 9/7 biorthogonal wavelets. (a) and (c) are analysis scaling function and wavelet, and (b) and (d) are synthesis scaling function and wavelet, respectively.

For example, one family of biorthogonal wavelets, known as the *Cohen–Daubechies–Feauveau 9/7 wavelets*, is used in the FBI fingerprint compression standard and in the JPEG 2000 image compression standard as well. Table 7.2 shows their coefficients and Fig. 7.9 shows their scaling functions and wavelets.

## 7.4.6 Lifting Schemes

### 7.4.6.1 Biorthogonal Wavelet Design

There is another method of designing biorthogonal wavelets, called *lifting schemes* [18, 20]. Using lifting, new sets of compactly supported biorthogonal

wavelets are constructed from a set of biorthogonal wavelets. Unlike traditional methods, where wavelets are constructed in the frequency domain with the help of Fourier transform, lifting schemes can build wavelets and scaling functions in the spatial domain [18]. Lifting also yields a faster implementation of the DWT.

Given an initial set of finite biorthogonal dual filters $(h_0, h_1, g_0, g_1)$, a new set of finite biorthogonal filters $(\tilde{h}_0, h_1, g_0, \tilde{g}_1)$ are constructed with [20]

$$\tilde{H}_0(\omega) = H_0(\omega) + H_1(\omega)S^*(2\omega) \tag{7.64}$$

$$\tilde{G}_1(\omega) = G_1(\omega) - G_0(\omega)S(2\omega) \tag{7.65}$$

where $S(\omega)$ is a trigonometric polynomial and * indicates the complex conjugate. These equations allow the formulation of the lifting scheme. Given an initial set of biorthogonal scaling functions and wavelets $(\phi, \psi, \tilde{\phi}, \tilde{\psi})$ associated with the filters $(h_0, h_1, g_0, g_1)$, a new set of biorthogonal scaling functions and wavelets $(\phi^l, \psi^l, \tilde{\phi}, \tilde{\psi}^l)$ can be found [18]:

$$\phi^l(x) = \sqrt{2} \sum_{n=-\infty}^{\infty} h_0(n)\phi^l(2x - n) + \sum_{n=-\infty}^{\infty} s(-n)\psi^l(x - n) \tag{7.66}$$

$$\psi^l(x) = \sqrt{2} \sum_{n=-\infty}^{\infty} h_1(n)\phi^l(2x - n) \tag{7.67}$$

$$\tilde{\psi}^l(x) = \tilde{\psi}(x) - \sum_{n=-\infty}^{\infty} s(n)\tilde{\phi}(x - n) \tag{7.68}$$

where $s(n)$ is a finite sequence. These equations allow for the custom design of biorthogonal wavelets. The number of vanishing moments or the shape of the wavelets, for example, can be determined by the choice of $s(n)$.

### 7.4.6.2 Wavelet Transform Using Lifting

Lifting schemes also implement the DWT with less computation than the standard filter bank implementation. Figure 7.10 shows the forward wavelet transform using lifting. First the signal is split into even and odd samples (also called *polyphase components*) by the lazy wavelet transform. Then the odd samples are predicted using even samples. This step is called *dual lifting*. If the signal is slowly varying, then the even and odd samples are highly correlated; thus, given one set, predicting the other is reasonably accurate. In dual lifting, a filter is applied to the even samples and the result is subtracted from the odd samples. Finally the update stage, called *lifting*, ensures that the coarser signal has the same average value as the original signal.

Figure 7.11 shows the inverse wavelet transform using lifting. First the even samples are recovered by undoing the update, then the prediction is added to the

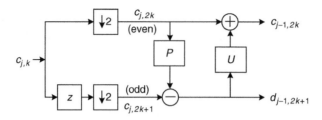

**FIGURE 7.10**  The forward wavelet transform using lifting. The first step is to split the signal into even and odd samples by lazy wavelet transform. Then the odd samples are predicted using even samples. Finally the update stage ensures that the coarser signals have the same average value as the original signal.

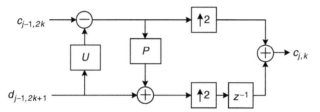

**FIGURE 7.11**  The inverse wavelet transform using lifting. First, undoing the update recovers the even samples, then the prediction is added to the even samples to recover the odd samples, and finally the original signal is recovered by merging them.

even samples to recover the odd samples, and finally the original signal is recovered by merging them.

Lifting provides many benefits. Lifting steps can be calculated in place, which means prediction and update results at one stage can be replaced with the results at the next stage, which can be important for memory-limited systems. Lifting also permits an integer transform by rounding off the result of the filter ($P$ or $U$) right before adding or subtracting [21], and the system remains invertible.

Another method of invertible integer wavelet transform uses modular arithmetic to fix the dynamic range [22]. For example, if the input is an 8-bit image, then all the wavelet coefficients are 8 bits as well. However, due to the modular arithmetic, this method causes the large coefficients to become small, which complicates analysis of the coefficients.

# 7.5   Two-Dimensional Discrete Wavelet Transform

## 7.5.1   Two-Dimensional Wavelet Bases

The notion of multiresolution with orthogonal subspaces for one-dimensional signals can be extended easily to two-dimensional signals [14]. The approximation

subspace for an image at resolution $j$ is denoted $V_j^2$, which is in $L^2(\mathbf{R}^2)$, and its orthogonal complement subspace is denoted $W_j^2$. As with one-dimensional multiresolution spaces, the sum of the subspaces $V_j^2$ and $W_j^2$ forms the finer approximation space $V_{j+1}^2$; that is,

$$V_{j+1}^2 = V_j^2 \oplus W_j^2 \tag{7.69}$$

To construct two-dimensional wavelet bases, we first consider the separable basis, which is obtained by applying the same filters developed for one-dimensional signals to each dimension separately. In vector spaces, the separable two-dimensional multiresolution space is defined by the tensor product of one-dimensional multiresolution spaces,

$$V_j^2 = V_j \otimes V_j \tag{7.70}$$

Thus the separable two-dimensional scaling function can be written as

$$\phi(x, y) = \phi(x)\phi(y) \tag{7.71}$$

which means that one can compute the two-dimensional approximation coefficients by convolving the one-dimensional scaling filter $h_0(n)$ along each dimension of the image separately.

Using Eqs. 7.69 and 7.70, the detail space can be written as

$$W_j^2 = (V_j \otimes W_j) \oplus (W_j \otimes V_j) \oplus (W_j \otimes W_j) \tag{7.72}$$

which shows that three wavelets form the orthonormal basis of $W_j^2$. Thus the separable two-dimensional orthonormal wavelets are

$$\psi^1(x, y) = \phi(x)\psi(y), \qquad \psi^2(x, y) = \psi(x)\phi(y), \qquad \psi^3(x, y) = \psi(x)\psi(y) \tag{7.73}$$

The family of wavelets in Eq. 7.73 forms the orthonormal basis of $W_j^2$ and thus of $L^2(\mathbf{R}^2)$. Again, the detail coefficients are computed by convolving $h_0(n)$ and $h_1(n)$ in each dimension separately.

## 7.5.2 Forward Transform

The forward transform procedure is shown in Fig. 7.12. At each decomposition, the approximation coefficients $c_{j+1}(n, m)$ are decomposed into one set of approximation $c_j(n, m)$ and three sets of detail coefficients, $d_j^1(n, m)$, $d_j^2(n, m)$, and $d_j^3(n, m)$. In order to compute $c_j(n, m)$, for example, as shown in Fig. 7.12, the rows of $c_{j+1}(n, m)$ are convolved with $h_0(-n)$ and column-wise down-sampled (retain every even-numbered column). Then the output is convolved column-wise with the same filter and down-sampled row-wise. Since the filtering is

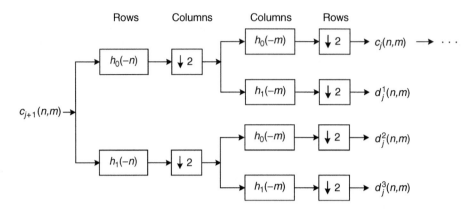

**FIGURE 7.12** The decomposition procedure for the two-dimensional DWT. The one-dimensional analysis filters are used to convolve rows and columns of an image. $c_j$ is the coarse approximation and $d_j^1$, $d_j^2$, and $d_j^3$ are the details of $c_{j+1}$.

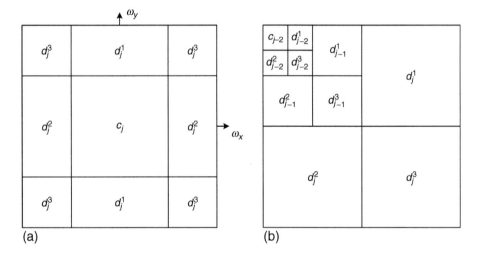

**FIGURE 7.13** (a) The decomposition of the frequency domain by the two-dimensional discrete wavelet transform. (b) A typical arrangement of the wavelet coefficients when a three-level decomposition is performed.

performed horizontally and vertically, the wavelet decomposition emphasizes oriented frequency components. That is, $d_j^1$, $d_j^2$, and $d_j^3$ contain horizontal edge (vertical high frequencies), vertical edge (horizontal high frequencies), and diagonal edge information, respectively. Figure 7.13a shows how the frequency information of $c_{j+1}$ is split by the decomposition. Due to the orthogonality, the total number of wavelet coefficients is the same as the number of pixels in the input image. This is called a *complete representation*. Figure 7.13b shows a typical arrangement of the wavelet coefficients.

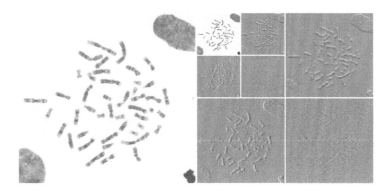

**FIGURE 7.14** The two-dimensional discrete wavelet transform of an image. The left image is decomposed up to two levels.

Figure 7.14 shows an example of the two-dimensional DWT of an image. Since the sum of all of the coefficients in each detail set is zero, the average value (which is zero) is adjusted to 128 (medium gray), and the dynamic range is adjusted to fit the 8-bit grayscale, for ease of visualization. Notice that the detail coefficients (high-frequency subbands) have large magnitudes near edges and details in the image and small magnitudes at locations where no prominent high-frequency features reside. This sparse representation, also known as *energy compaction,* is quite useful for many applications, especially image compression. Notice also that the edges at different orientations take large values in each subband. As the image is decomposed, only major, large-scale structures remain. This multiresolution representation makes it possible to analyze structures that appear at different scales in a natural way.

### 7.5.3 Inverse Transform

Reconstruction of the input image is achieved by reversing the decomposition process. As shown in Fig. 7.15, at each decomposition level the wavelet coefficients are first up-sampled in columns. Then the rows are convolved with $g_0$ or $g_1$, which are $h_0(m)$ and $h_1(m)$ in the orthogonal case. The four convolution outputs are added together in pairs. Then the two resulting outputs are up-sampled in rows and then the columns are convolved with $g_0$ or $g_1$. The sum of the two outputs yields the finer approximation. By repeating this process for the number of decomposition levels, the input image $c_{j+1}(n, m)$ is reconstructed.

### 7.5.4 Two-Dimensional Biorthogonal Wavelets

The forward and inverse two-dimensional wavelet transforms using orthogonal wavelets are easily extended to biorthogonal wavelets. Again, we consider the

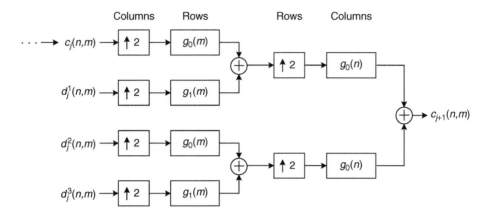

**FIGURE 7.15**    Reconstruction from the two-dimensional DWT.

separable case. For the forward transform, the biorthogonal wavelets are given by Eq. 7.73. The dual wavelets for the inverse transform are

$$\tilde{\psi}^1(x) = \tilde{\phi}(x)\tilde{\psi}(y), \qquad \tilde{\psi}^2(x) = \tilde{\psi}(x)\tilde{\phi}(y), \qquad \tilde{\psi}^3(x) = \tilde{\psi}(x)\tilde{\psi}(y)$$

## 7.5.5   Overcomplete Transforms

One of the few drawbacks of the DWT is that the transformation is not invariant to shifts of position in the input signals or images. That is, the DWT coefficients of a signal and a shifted version of that signal are different and do not have a simple relationship between them. Thus, if the coefficients are processed (e.g., thresholded for denoising), then different signals are reconstructed for different amounts of shift. The shift variance of the DWT sometimes causes unwanted visual artifacts in the neighborhood of discontinuities [23]. A solution to this problem is the use of an undecimated wavelet transform (UDWT) filter bank or a redundant DWT [23, 24]. For denoising, all translations of a signal are estimated, and the resulting signals of the inverse transform after thresholding are averaged [23]. The forward and inverse DWT filter banks can be modified by removing the down-sampling and up-sampling operators to achieve UDWT. Since the number of coefficients computed by UDWT is larger than the size of the input image, the overcomplete representation is not useful for compression. However, it has been shown that the UDWT produces superior results for denoising, as compared to the orthogonal DWT. The benefit comes at the price of increased computational complexity, which is $O(N \log_2 N)$ for a signal of length $N$ and is the same as the FFT's complexity. For an $N \times M$ image, the computational complexity of an overcomplete expansion is $O(NM \log_2 (NM))$, while it is only $O(NM)$ for DWT.

# 7.6 Examples

Wavelets have been used in countless applications, including many in the field of biomedical image processing [27]. Using compactly supported wavelets that best approximate the signal, the DWT provides a high-energy compaction relative to other, traditional transform-based methods. Along with the energy compaction property, the statistical properties of wavelet coefficients between scales or within each subband [1, 28] provide objectively and visually superior results in many applications, such as image compression, denoising, and image fusion.

## 7.6.1 Image Compression

Image compression is one of the most successful applications of the DWT. The operation of a transform-based coder can be summarized in three steps. First an image is transformed to have a compact representation, then the coefficients are quantized, and finally the quantization result is entropy coded. The decomposition of an image using the DWT produces three orientation components in multiple resolutions. Because of the compact representation of the DWT, the histograms of these detail coefficients have a unique shape, which has a narrow peak centered at zero and long tails away from zero. When the coefficients are quantized, many of the small coefficients will be set to zero value, leaving only a small number of nonzero coefficients to be encoded. This is one of the main reasons that the wavelet transform is effective for image compression.

Wavelet-compressed images have been decisively shown to produce fewer visual artifacts at the same bit rate relative to other coding methods. As the regularity of the wavelets increases, the visible artifacts are reduced, but the support size increases, which, in turn, reduces compression. It has been shown that the 9/7 biorthogonal wavelets yield an excellent trade-off between support size and regularity, and they deliver the best compression performance [14].

## 7.6.2 Image Enhancement

The quality of images often degrades when, for example, transmitted through a band-limited channel, compressed, or obtained through a system that has various types of noise [29]. The compact representation of the wavelet transform is also useful for denoising. *Wavelet shrinkage* [25, 26] is a technique for denoising in which detail coefficients smaller than a threshold are set to zero while large coefficients are unchanged. This nonlinear process is far more effective than methods based on frequency filtering. Since the large coefficients correspond to edges, using wavelet shrinkage preserves the sharp edges, while the noise is reduced. However, thresholding wavelet coefficients often produces undesirable

artifacts on the reconstructed images. This drawback can be alleviated using a shift-invariant wavelet transform, such as the undecimated DWT [23].

### 7.6.3   Extended Depth-of-Field by Wavelet Image Fusion

Wavelet image fusion is a technique of combining, in the wavelet domain, information from multiple registered images to form a single image. Image fusion techniques have been particularly popular in medical imaging, where different modalities are used to capture different information, and in multi-spectral imaging for remote sensing. When imaging a specimen that is thicker than the depth-of-field (DOF) of a microscope, only a portion of the specimen is in focus at any one time, while other areas are blurred because of the point spread function. To image the whole specimen, a series of images (*optical sections*) are often acquired at different depths. However, since analyzing a stack of images is difficult, a system with extended DOF is desired. What is needed is one image that shows the entire specimen in focus. The extended DOF can be achieved by fusing a stack of images in the wavelet domain.

Large wavelet coefficients correspond to the salient objects in the image. By taking the maximum-amplitude coefficients at each pixel from multiple transformed images, the resulting composite image will contain all of the salient objects collected from all of the images. Another interesting observation is that the coefficients corresponding to the true signal are highly correlated across scale, whereas the coefficients corresponding to the noise are less correlated across scale. An overcomplete representation is best suited for observing this effect. Based on these ideas, the extended DOF for microscope images is achieved by wavelet image fusion [30]. An example of this process is shown in Fig. 7.16. Detailed discussion about extended DOF techniques for microscope imaging can be found in Chapter 16.

## 7.7   Summary of Important Points

1. Wavelets are short-duration waves whose spectrum resembles the transfer function of a bandpass filter.

2. A basic wavelet is dilated and translated to form a set of basis functions for the wavelet transform.

3. While the Fourier transform has only sinusoids as basis functions, many different wavelets can be used as the basic wavelet to form different bases for the wavelet transform.

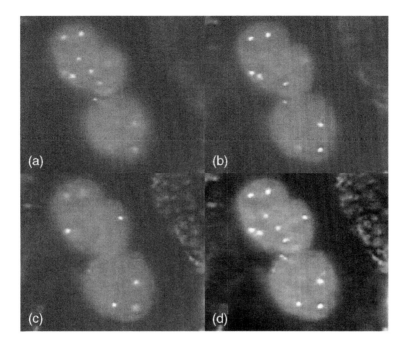

**FIGURE 7.16** Extended depth-of-field is achieved through a wavelet image fusion technique. Images (a), (b), and (c) are optical sections taken at different depths, and (d) is the fusion result. Images (a), (b), and (c) have been deblurred (Chapter 14) prior to the image fusion [30]. This figure may be seen in color in the four-color insert.

4. The continuous wavelet transform provides time-scale analysis for a signal. Images are represented as a function of three variables: two for spatial locations and one for scale.

5. Transient components such as lines, edges, or discontinuities are better represented using wavelets than waves. Thus, in general, the wavelet transform yields a compact representation or energy compaction of signals or images.

6. The DWT can be computed by iterating two-channel filter banks or by using lifting schemes.

7. The Haar wavelet is the oldest and simplest of orthonormal wavelets.

8. Wavelets that are more regular are smoother but have larger support size than less regular wavelets.

9. The two-dimensional DWT can be implemented using two-channel filter banks with separable filters.

10. Biorthogonal wavelets yield invertible transforms and perfect reconstruction.

11. Nonlinear operations, such as rounding, can be used in lifting, and the system remains invertible. Lifting also provides a way of constructing biorthogonal wavelets.

# References

1. S Mallat, "A Theory for Multiresolution Signal Decomposition: The Wavelet Representation," *IEEE Transactions on Pattern Recognition and Machine Intelligence*, **11**(7): 674–693, 1989.
2. I Daubechies, *Ten Lectures on Wavelets*, SIAM, 1992.
3. CS Burrus, RA Gopinath, and H Guo, *Introduction to Wavelets and Wavelet Transforms: A Primer*, Prentice-Hall, 1998.
4. M Vetterli, "Filter Banks Allowing Perfect Reconstruction," *Signal Processing*, **10**(3): 219–244, 1986.
5. KR Castleman, *Digital Image Processing*, Prentice-Hall, 1996.
6. D Gabor, "Theory of Communication," *IEEE Proceedings*, **93**:429–441, 1946.
7. A Grossman and J Morlet, "Decomposition of Hardy Functions into Square Integrable Wavelets of Constant Shape," *SIAM Journal of Mathematics*, **15**:723–736, 1984.
8. CK Chui, *An Introduction to Wavelets*, Academic Press, 1992.
9. MJT Smith and TP Barnwell III, "A Procedure for Designing Exact Reconstruction Filter Banks for Tree-Structured Subband Coders," *Proceedings of the IEEE International Conference on Acoustics, Speech, and Signal Processing*, 1984.
10. MJ Smith and TP Barnwell III, "Exact Reconstruction Techniques for Tree-Structured Subband Coders," *IEEE Transactions on Acoustics, Speech, and Signal Processing*, **34**:434–441, 1986.
11. M Vetterli and C Herley, "Wavelets and Filter Banks: Theory and Design," *IEEE Transactions on Signal Processing*, **40**(9):2207–2232, 1992.
12. EP Simoncelli and EH Adelson, "Subband Transforms," in *Subband Image Coding*, John Woods, ed., Kluwer Academic, 1990.
13. G Strang and T Nguyen, *"Wavelets and Filter Banks,"* Wellesley-Cambridge, 1996.
14. S Mallat, *"A Wavelet Tour of Signal Processing,"* Academic Press, 1998.
15. I Daubechies, "Orthogonal Bases of Compactly Supported Wavelets." *Communications on Pure and Applied Mathematics*, **41**:909–996, 1988.
16. D Esteban and C Galand, "Application of Quadrature Mirror Filters to Split-band Voice Coding Schemes," *Proceedings of the IEEE International Conference of Acoustics, Speech, and Signal Processing*, 191–195, 1977.
17. AI Cohen, I Daubechies, and JC Feauveau, "Biorthogonal Bases of Compactly Supported Wavelets," *Communications on Pure and Applied Mathematics*, **45**:485–560 (1992).
18. W Sweldens, "The Lifting Schemes: A Custom-Design Construction of Biorthogonal Wavelets," *Applied Computer and Harmonic Analysis*, **3**(2):186–200, 1996.

19. M Vetterli and J Kovacevic, *Wavelets and Subband Coding*, Prentice-Hall, 1995.

20. C Herley and M Vetterli, "Wavelets and Recursive Filter Banks," *IEEE Transactions on Signal Processing*, **41**(8):2536–2556, 1993.

21. AR Calderbank et al., "Wavelet Transforms That Map Integers to Integers," *Applied Computer and Harmonic Analysis*, **5**:332–369, 1998.

22. H Chao and P Fisher, "An Approach to Fast Integer Reversible Wavelet Transform for Image Compression," in *Advances in Computational Mathematics*, Zhongying Chen et al., eds., CRC Press, 1998.

23. RR Coifman and DL Donoho, "Translation-Invariant Denoising," in *Wavelets and Statistics*, A Antoniadis and G Oppenheim, eds., 125–150, 1995.

24. M Lang et al., "Noise Reduction Using an Undecimated Discrete Wavelet Transform," *IEEE Signal Processing Letters*, **3**(1):10–12, 1996.

25. DL Donoho, "Denoising by Soft-Thresholding," *IEEE Transactions on Information Theory*, **41**:613–627, 1995.

26. DL Donoho and IM Johnstone, "Ideal Spatial Adaptation via Wavelet Shrinkage," *Biometrika*, **81**:425–455, 1994.

27. M Unser and A Aldroubi, "A Review of Wavelets in Biomedical Applications," *Proceedings of the IEEE*, **84**:626–638, 1996.

28. J Portilla et al., "Image Denoising Using Scale Mixtures of Gaussians in the Wavelet Domain," *IEEE Transactions on Image Processing*, **12**(11):1338–1351, 2003.

29. D Wei, U Rajashekar, and AC Bovik, "Wavelet Denoising for Image Enhancement," in *Handbook of Image and Video Processing*, 2nd ed., 2005.

30. H Choi et al., "Extended Depth-of-Field Using Adjacent Plane Deblurring and MPP Wavelet Fusion for Microscope Images," *IEEE Symposium on Biomedical Imaging: from Nano to Macro*, 2006.

# Morphological Image Processing

Roberto A. Lotufo, Romaric Audigier,
André V. Saúde, and Rubens C. Machado

## 8.1 Introduction

This chapter presents the main concepts of morphological processing (MP) for
the microscope image analyst. Morphological processing has applications in
such diverse areas of image processing as filtering, segmentation, and pattern
recognition, to both binary and grayscale images. One of the advantages of MP
is its being well suited for discrete image processing, because its operators can be
implemented in digital computers with complete fidelity to their mathematical
definitions. Another advantage of MP is its inherent building block structure,
where complex operators can be created by the composition of a few primitive
operators. Further, each of these primitive operators has an intuitive physical
analogy that greatly aids understanding the effects it can produce in an image.

Although MP is based on strong mathematical concepts, there are only a few
references that describe the MP operators with stress on intuitive concepts or
implementation, presumably because of the risk of weakening the mathematical
formalism. This chapter introduces the most commonly used concepts as they
are applied to real situations in microscopy imaging, with explanations that
appeal to one's intuition whenever possible. Despite the lack of full details, this
chapter remains true to the underlying mathematical theory. The motivated
reader can investigate the many texts where these details and formalisms are
treated in depth [1–2]. This chapter gives the main mathematical equations and
several algorithms, even though they are not necessarily the ones that produce

the most efficient implementations. Source codes of implementations of these equations are available on the Internet site of the SDC Morphology Toolbox [3].

Despite the power and general applicability of MP operators, few existing software packages implement a wide range of operators, such as the grayscale operators that are based on morphological reconstruction. This chapter illustrates how to solve image analysis problems using a combination of the primitive MP operators that are implemented. Morphological image processing is based on probing an image with a *structuring element* and either filtering or quantifying the image according to the manner in which the structuring element fits (or does not fit) within the image. A binary image is made up of foreground and background pixels, and connected sets of foreground pixels make up the objects in the image. In Fig. 8.1 we see a binary image and a circular structuring element (probe) that is placed in two different positions. In one location it fits within the object, but in the other it does not. By marking those locations at which the structuring element does fit within the object, we derive structural information about that image. This information depends on both the size and shape of the structuring element. Although this concept is rather simple, it is the basis of the majority of the operations presented in this chapter—erosion, dilation, opening, closing, morphological reconstruction, etc.—as they are applied to both binary and grayscale images. Common measurements that can be derived from this concept are the largest disk that fits inside the object and the area of the object.

In this chapter, only symmetrical structuring elements are used. When the structuring element is not symmetrical, care must be taken, because only some properties are valid for a reflected structuring element. Four structuring element types are used in the illustrations throughout this chapter: (1) the *elementary cross*, a 3 × 3 structuring element with the central pixel and its direct four neighbors; (2) the *elementary box*, which has the central pixel and its eight neighbors; (3) the *disk* of a given radius; and (4) the *linear structuring element* of a given length and orientation.

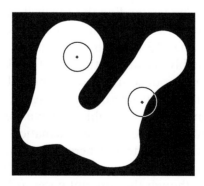

**FIGURE 8.1**    Probing an image with a structuring element.

# 8.2 Binary Morphology

A binary image is one having only two gray levels, 0 and 1. We refer to pixels with gray level 0 as "background pixels" and gray level 1 pixels as "interior pixels." A connected set of interior pixels forms an "object" in the binary image. Some of these objects will correspond to physical structures on the microscope slide. Others may be due to artifacts or noise. Image segmentation (Chapter 9) is the process of delineating the actual structures in the image, and binary morphological processing can be very useful in that endeavor.

## 8.2.1 Binary Erosion and Dilation

The basic fitting operation of morphology is the *erosion* of an image by a structuring element. Erosion is done by scanning the image with the structuring element. When the structuring element fits completely inside the object, the probe position is marked. The erosion result consists of all scanning locations where the structuring element fits inside the object. The eroded image is usually a shrunken version of the image, and the shrinking effect is controlled by the structuring element size and shape. The erosion of set $A$ by set $B$ is defined by

$$A \ominus B = \{x : B_x \subset A\} \tag{8.1}$$

where $\subset$ denotes the subset relation and $B_x = \{b + x : b \in B\}$ is the *translation* of set $B$ by a point $x$.

A *binary image* consists of foreground and background pixels. In morphology, for every operator that changes the foreground in a particular way, there is a *dual operator* that changes the background in the same way. The *complement* of an image is formed by reversing the foreground and background pixels. The dual of the erosion operator is the *dilation* operator. Dilation involves fitting a probe into the complement of the image. Thus it represents a filtering on the outside of the object, whereas erosion represents a filtering on the inside of the object, as depicted in Fig. 8.2. Formally, the dilation of set $A$ by $B$ is defined by

$$A \oplus B = (A^c \ominus \check{B})^c \tag{8.2}$$

where $A^c$ denotes the complement of $A$ and $\check{B} = \{-b : b \in B\}$ is the *reflection* of $B$, that is, a $180°$ rotation of $B$ about the origin.

The foreground is usually labeled with white color, while the background is labeled black, but the inverse convention is sometimes used.

An alternative way to compute dilation is by "stamping" the structuring element on the location of every foreground pixel in the image. For instance, Fig. 8.14d was obtained by stamping small arrows (the structuring element) on the centroids of the detected spots in Fig. 8.14c.

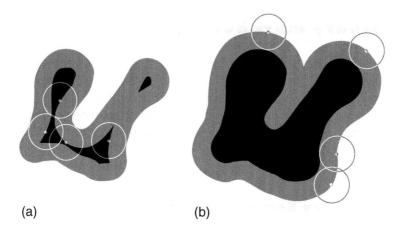

(a)                                    (b)

**FIGURE 8.2** Erosion and dilation. (a) Input object in black and gray and erosion in black (region where the probe can fit). (b) Input object in black and dilation in black and gray.

Formally, the dilation can be defined by

$$A \oplus B = \bigcup_{a \in A} B_a \qquad (8.3)$$

Dilation has the effect of expanding the object, filling small holes in and intrusions into the object (Fig. 8.2b), while erosion has a shrinking effect, enlarging holes and eliminating small extrusions (Fig. 8.2a).

Since dilation by a disk expands an object and erosion by a disk shrinks an object, they can be combined to find object boundaries in binary images. The three possibilities are: (1) the *external boundary* (dilation minus the image), (2) the *internal boundary* (the image minus the erosion), and (3) the *morphological gradient* (dilation minus erosion), which is the boundary that straddles the actual boundary. The morphological gradient is often used as a practical way of displaying the boundary of segmented objects, as in Fig. 8.23f.

## 8.2.2 Binary Opening and Closing

Besides the two primary operations of erosion and dilation, two more important operations play key roles in morphological image processing: *opening* and its dual, *closing*.

The opening of an image $A$ by a structuring element $B$, denoted by $A \circ B$, is the union of all the structuring elements that fit inside the image, as depicted in Fig. 8.3a.

$$A \circ B = \bigcup \{B_x : B_x \subset A\} \qquad (8.4)$$

Figures 8.5c through 8.5f show how the result of opening depends on the structuring element when using different linear structuring elements to open the same image. The opening is also defined by

$$A \circ B = (A \ominus B) \oplus B \tag{8.5}$$

The dual of opening is closing, which is defined by

$$A \bullet B = (A^c \circ \breve{B})^c$$
$$A \bullet B = (A \oplus B) \ominus B \tag{8.6}$$

Figure 8.3b shows an example of closing. Note that, whereas the position of the origin relative to the structuring element has a role in both erosion and dilation, it plays no role in opening or closing.

Opening and closing have two important properties [4]. First, once an image has been opened (or closed), successive openings (or closings) using the same structuring element produce no further effect. Second, an object in an opened image is contained in the original object, which, in turn, is contained in the closed image, as illustrated in Fig. 8.3.

As a consequence of this property, we can consider the subtraction of the opening from the input image, called the *opening top-hat* operation, and the subtraction of the image from its closing, called *closing top-hat* operation, respectively, defined by

$$A \,\hat{\circ}\, B = A - (A \circ B)$$
$$A \,\hat{\bullet}\, B = (A \bullet B) - A \tag{8.7}$$

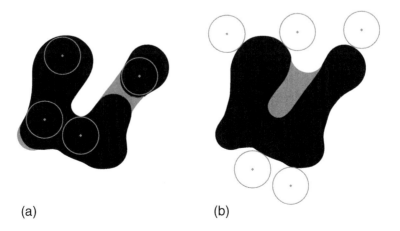

(a)  (b)

**FIGURE 8.3** Opening and closing. (a) Input image in black and gray and opening in black (region where the probe fits). (b) Input image in black and closing in black and gray.

The opening top-hat and closing top-hat results correspond to the gray parts of Figs. 8.3a and 8.3b, respectively.

As a filter, opening can clean the boundary of an object by eliminating small extrusions, but it does this in a much finer manner than erosion. The net effect is that the opened image is a much better replica of the original than the eroded image (compare Fig. 8.3a with Fig. 8.2a). Analogous remarks apply to closing and the filling of small intrusions (compare Fig. 8.3b with Fig. 8.2b).

Binary images can have both additive noise (extraneous foreground pixels in the background) and subtractive noise (extraneous background pixels in the foreground). One strategy for correcting this is to open the image to eliminate additive noise and then to close it to fill subtractive noise.

The open–close strategy works when noise components are small, but it fails when attempts to remove large noise components destroy too much of the original object. In this case, a better strategy is to employ an *alternating sequential filter* (ASF). Here open–close (or close–open) filters are performed iteratively, beginning with a very small structuring element and then proceeding with ever-larger structuring elements.

$$\text{ASF}_{co}^{n}(S) = (((((S \bullet B) \circ B) \bullet 2B) \circ 2B) \ldots \bullet nB) \circ nB \tag{8.8}$$

$$\text{ASF}_{oc}^{n}(S) = (((((S \circ B) \bullet B) \circ 2B) \bullet 2B) \ldots \circ nB) \bullet nB \tag{8.9}$$

### 8.2.3 Binary Morphological Reconstruction from Markers

One of the most important operations in morphological image processing is *reconstruction from markers*. The basic idea is to mark certain image components and then to reconstruct that portion of the image that contains the marked components.

#### 8.2.3.1 Connectivity

A region (set of pixels) is said to be *connected* if any two pixels in the set can be linked by a sequence of neighbor pixels also in the set. If the region is *4-connected*, the linking involves only vertically and horizontally adjacent pixels. If the region is *8-connected*, the linking involves diagonally adjacent pixels as well.

Every binary image can be expressed as the union of connected regions. A region is *maximally connected* if it is not a proper subset of a larger connected region in the image. The maximally connected regions are called the *connected*

*components* of the image. A connected object has only one component. The union of all connected components $C_k$ recovers the input image $A$ and the intersection of any two connected components is empty:

$$A = \bigcup_{k=1}^{n} C_k \tag{8.10}$$

To find all the connected components of an image, one can iteratively (1) find any foreground pixel of the image as a starting point, (2) use it to reconstruct its connected component, (3) remove that component from the image, and (4) iteratively repeat the same extraction until no more foreground pixels are found in the image. This operation, called *labeling*, decomposes an image into its connected components (objects). These can be numbered sequentially as they are found. The result of the labeling operation can be conveniently stored as a grayscale image ("object membership map") in which the gray level of each pixel is its object number. An example of labeling can be seen in Fig. 8.6c.

### 8.2.3.2 Markers

The *morphological reconstruction* of an image $A$ from a *marker M* (a subset of $A$) is denoted by $A\Delta M$ and defined as the union of all connected components of image $A$ that intersect marker $M$. This filter is also called a *component filter*:

$$A\Delta_E M = \bigcup \{C_k : C_k \cap M \neq \varnothing\} \tag{8.11}$$

The reconstruction operation requires the input image, the marker, and a selection of the type of connectivity. The marker specifies which component of the input image is to be extracted. The result of the reconstruction depends on the connectivity, $E$, used.

An example of reconstruction from markers using 8-connectivity is shown in Fig. 8.4. Figure 8.4a is the input image, which is a collection of grains. Figure 8.4b is the marker image, that is, a central vertical line intersecting the grains. Figure 8.4c shows the reconstruction from the markers, which extracts the three central components from the original image.

There are typically three ways to select the marker placement for the component filter: (a) a priori selection, (b) selection from the opening, and (c) selection by means of some more complex operation.

An example of reconstruction from an a priori marker can be seen in Fig. 8.27d, where the background component, in black, was selected by placing a marker at the top left of the image in Fig. 8.27c. In this case, we work on the complement of the image. This dual reconstruction has the overall effect of filling in bounded regions.

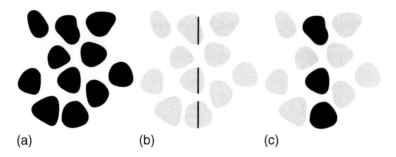

(a)          (b)          (c)

**FIGURE 8.4**   Reconstruction from markers. (a) Input image. (b) Marker image. (c) Reconstructed image.

### 8.2.3.3 *The Edge-Off Operation*

The *edge-off* operation, particularly useful for removing objects that touch the image border, combines reconstruction and top-hat concepts. The objects touching the border are selected by reconstructing the image using its border as an a priori marker. The objects not connected to the image frame are then selected by subtracting the reconstructed image from the input image. The result is an image containing only those objects that do not touch the border.

Figure 8.22 illustrates a variant of the edge-off operation applied to grain boundaries. Here we want to keep only the boundaries of those grains that do not touch the image border in Fig. 8.22f. The boundaries connected to the border cannot simply be removed, because that would also remove the boundaries of the neighboring grains that do not directly touch the border. So the strategy is first to fill in all the bounded grains that do not directly touch the border by reconstruction of the border from the complement of the image in Fig. 8.22f (see Fig. 8.22g). Then we remove the thin grain boundaries that do touch the border by applying an opening. The final result, in Fig. 8.22h, is obtained by intersecting the remaining inner grains and the boundaries in Fig. 8.22f.

## 8.2.4 Reconstruction from Opening

With marker selection by opening, the marker is found by opening the input image with a particular structuring element. The result of the reconstruction detects all of the connected components into which that structuring element fits.

By using the mechanism of reconstruction from the opening to detect objects with particular geometric features, one can design more complex techniques to find the markers from combined operators. At the last step, the reconstruction reveals those objects that exhibit those geometric features.

The biomedical application illustrated in Fig. 8.5 detects overlapping human chromosomes by using the intersection of four reconstructions from openings.

Because chromosome length is highly variable, the structuring element, length, is a critical parameter for good filter performance. A length of 30 pixels was used in this example.

To identify overlapping chromosomes, as shown in Fig. 8.5b, only the objects (connected components) into which all four of the linear structuring elements can fit are chosen. This is achieved by performing four reconstructions from opening operations and intersecting them. The four linear structuring elements used are vertical, horizontal, and $\pm 45°$ (Figs. 8.5c to 8.5f).

The top-hat concept can be applied to reconstruction by opening, producing the *reconstruction from opening top-hat* operation. This is the image minus its reconstruction. In this case the operator reveals the objects that do not exhibit a specified fitting criterion. For instance, to detect thin objects, one can use a disk of diameter larger than the thickest of those objects. Then only objects too thin to contain the disk remain.

These operations are not restricted to openings. Analogous dual operations can be developed to form *sup-reconstruction from closing* and *sup-reconstruction from closing top-hat* respectively.

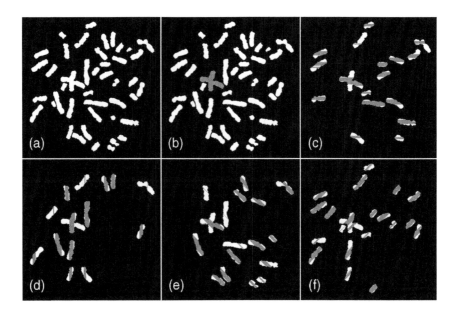

**FIGURE 8.5** Detecting overlapping chromosomes. (a) Input image. (b) Intersection (in gray) of four reconstructions from openings. (c) Opening (in gray) by horizontal line and its reconstruction. (d) Opening (in gray) by vertical line and its reconstruction. (e) Opening (in gray) by a 45° line and its reconstruction. (f) Opening (in gray) by −45° line and its reconstruction.

## 8.2.5  Area Opening and Closing

Another common criterion for selection of connected components is area. This is achieved by an *area opening*, which removes all connected components $C_i$ with area less than a specified value $\alpha$:

$$A \circ (\alpha)_E = \bigcup \{C_i, \operatorname{area}(C_i) \geq \alpha\} \tag{8.12}$$

E denotes the connectivity used. Figure 8.23e shows how the area opening can behave as a filter to remove small artifacts from the image in Fig. 8.23d and select only the large objects (epithelial cells) having area greater than 1000 pixels.

The next demonstration targets cytogenetic images of human metaphase cells. This is a classical application of area opening. The task is to preprocess the image by segmenting out the chromosomes from the nuclei, stain debris, and the background. Figure 8.6 shows the input image (a), the thresholded (binary) image (b), the labeling (c) of the identified connected components, and the result (d), with the components classified by area. The components with area less than 100 pixels are background noise, those with area greater than 10,000 pixels are nuclei (shown in dark gray), and the rest are the chromosomes, shown in light gray.

The dual operation, called *area closing*, is also useful in many applications.

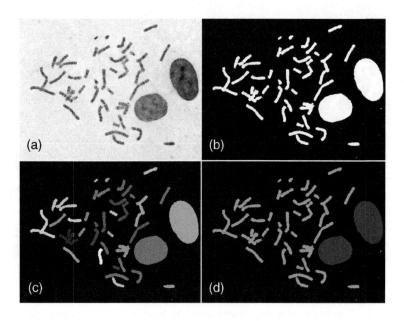

**FIGURE 8.6**  Preprocessing chromosome spreads using area opening. (a) Input image. (b) Thresholded image. (c) Labeled (grayscaled) image. (d) Objects classified by area: residues in white (area < 100 pixels), chromosomes in light gray (area between 100 and 10,000 pixels), and nuclei in dark gray (area > 10,000 pixels).

Figure 8.23d shows how area closing can be used to fill small aggregate holes with area less than 200 pixels (c) that are specific to a texture, to form significant clusters of interest. Similarly, small holes in Fig. 8.30g, having area less than 100 pixels, are closed and merged to recover the objects of interest (Fig. 8.30h).

In this section, we have introduced several component filters, their duals, and their top-hat versions. That is, filters that do not introduce false edges because they are able to select out (entirely) certain connected components of the image, the selection being based on an area or shape fitting criterion.

## 8.2.6 Skeletonization

A standard problem in image processing is finding a thinned replica of a binary image to use either in a recognition algorithm or for data compression. A commonly employed thinning procedure is *skeletonization*, which is based on the concept of maximal disks. In microscopy images, skeletons have been successfully used for feature extraction for classification purposes.

Given a point interior to an object in a binary image, there exists a largest disk having the point at its center and also lying within the object. Regarding the largest disk at a point, there are two possibilities: Either there exists another disk lying within the object and properly containing the given disk, or there does not exist another disk within the object properly containing the given disk. Any disk satisfying the second condition is called a *maximal disk*. The centers of all maximal disks comprise the *medial axis* of the image. As an illustration, consider the isosceles triangle in Fig. 8.7, whose skeleton is depicted in part (a) of the figure. Part (b) shows a maximal disk $D(x)$ situated at point $x$ so that $x$ lies on the skeleton. In part (c), $D(w)$ is the largest disk centered at $w$; however, it is not maximal, since it is properly contained in $D_P$, which itself lies within the triangle. Thus, $w$ does not lie in the skeleton.

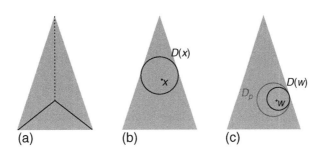

(a)  (b)  (c)

**FIGURE 8.7** Triangle medial axis. (a) Medial axis. (b) Maximal disk $D(x)$ for skeleton point $x$. (c) $w$ is not a skeleton point because $D(w)$ is contained in disk $D_p$.

As might be expected, adaptation of the skeleton to the digital setting requires some care, since Euclidean disks are defined in a continuous space. Efficient algorithms for the Euclidean medial axis in discrete spaces now exist, but implementations based on discrete disks are still widely used. We begin with some "disklike" digital primitive, and the actual skeleton obtained depends on the choice of that primitive. For the moment, let $B$ denote the $3 \times 3$ square structuring element, and let $nB$ be defined by the iterated dilation of Eq. 8.13,

$$nB = B \oplus B \oplus \cdots \oplus B \qquad (8.13)$$

where $n$ is any positive integer. Equation 8.13 implies that $2B = B \oplus B$, $3B = B \oplus B \oplus B$, and so on. The notion of maximal disk is put into the digital setting by considering "disks" chosen from among $0B$, $B$, $2B$, $3B$, $\ldots$, where $0B$ is simply the origin. The discrete skeleton can be characterized morphologically. Let $S$ be the set of object pixels, for $n = 0, 1, \ldots$, and we define the *skeletal subset* Skel($S; n$) to be the set of all pixels $x$ in $S$ such that $x$ is the center of a maximal disk $nB$. Then it is evident, from the definition of the skeleton, that the skeleton is the union of all skeletal subsets:

$$\text{Skel}(S) = \bigcup_{n=0}^{\infty} \text{Skel}(S;n) \qquad (8.14)$$

It can be shown that the skeletal subsets are given by

$$\text{Skel}(S;n) = (S \ominus nB) - [(S \ominus nB) \circ B] \qquad (8.15)$$

Together Eqs. 8.14 and 8.15 yield *Lantuejoul's formula* for the skeleton:

$$\text{Skel}(S) = \bigcup_{n=0}^{\infty} (S \ominus nB) - [(S \ominus nB) \circ B] \qquad (8.16)$$

The drawbacks of such discrete skeletons are illustrated further, in a comparison with Euclidean skeletons. Lantuejoul's formula is not applicable to Euclidean disks, but there are efficient algorithms for Euclidean skeletons available, and we can define such skeletons. We denote by $d(x, y)$ the Euclidean distance between points $x$ and $y$. The usual definition of an $n$-dimensional discrete Euclidean disk of radius $R$ and center point $x$ is the set $DE(x, R)$ given by

$$DE(x, R) = \{y \in \mathbb{Z}^n, d(x, y) < R\} \qquad (8.17)$$

The *discrete Euclidean medial axis* is thus defined by the same terms as its continuous counterpart, but with discrete Euclidean disks. Similarly to the continuous medial axis, each maximal disk that composes the discrete medial axis can be reconstructed from its center and its radius, and the original object can be reconstructed by the union of all such disks. However, topology preservation is no longer

guaranteed. For instance, the discrete medial axis of a single connected set may be composed of many disconnected subsets. This problem is solved by the combination of the discrete medial axis with a topology-preserving thinning process.

A basic topology-preserving thinning process is based on the notion of a *simple point*. A simple point is a point that can be removed from the object without changing its topology. The sequential removing of simple points from the object, with the constraint of not removing points of the object's medial axis, constitutes a thinning process that preserves object topology and guarantees object reconstruction. To preserve some characteristics of the object's geometry, the thinning process can be guided by a *priority function* based on geometric information. Later we present the algorithm of a thinning process guided by the Euclidean distance transform. In a binary image, the *distance transform* is defined for any point in a given set as the distance from this point to the complement of the set. In a guided thinning, when the thinned object has no simple point, the process stops and the resulting subset is called the *Euclidean skeleton*.

For skeleton analysis, one may need to prune spurious branches that result from boundary irregularities and noise. There are many thinning and pruning algorithms described in the literature.

The following function computes the Euclidean skeleton.

```
Function sk = EuclSkel(f,T)

    f: input image
    T: threshold value for pruning the medial axis

  1. Medial axis extraction and pruning
      M <- discrete medial axis of f, with all disks radii
      pM <- x in M, x is center of a disk with R > T

  2. Initialize guided thinning
      DT <- distance transform of f
      for all x in DT
        if DT(x) = 1 then inHFQ(x,DT(x))

  3. Propagation
      while HFQ is not empty:
          p <- outHFQ
          for each q neighbor of p:
              inHFQ(q,DT(q))
          if p is simple and M(p) = 0 (p not in the medial axis)
          then
              f(p) <- 0 (p is deleted)
```

In this function, the hierarchical FIFO queue (HFQ) includes the following operations: inHFQ($p,v$), insert pixel $p$ with priority $v$; outHFQ, remove the pixel with the lowest priority with the FIFO policy for pixels at the same priority.

The detection of overlapping chromosomes, performed earlier by other means, can now be done by detecting crossing points in the chromosomes' skeletons. In the following, we illustrate the skeletons of overlapping chromosomes. In order to detect crossing points, a further mask-matching operation must be performed.

In Fig. 8.8 we compare the Euclidean skeleton with the discrete skeleton $nB$. Figure 8.8a shows the Euclidean skeleton, obtained by a topology-preserving thinning process guided by the Euclidean distance, with the constraint of not removing the points of the exact Euclidean medial axis. The skeleton presented in Fig. 8.8b has been obtained by a topology-preserving thinning process guided by the 8-neighbor distance, with the constraint of not removing the points of the exact medial axis with $nB$ disks. Despite the presence of many branches in the Euclidean skeleton, the number of branches on the skeleton in Fig. 8.8b is greater, showing how the discrete skeleton $nB$ is more sensitive to noisy boundaries.

The effect of skeleton pruning is shown in Fig. 8.9, where different skeletons based on Euclidean disks are superimposed on the chromosomes. The exact Euclidean medial axis is presented in Fig. 8.9a. In the medial axis, some isolated points are due to the noisy chromosome boundaries and may be discarded without affecting the quality of the resulting skeleton. In Fig. 8.9b the points that represent centers of maximal disks with (squared) radii less than 36 are removed from the medial axis. The filtering of small-radius disks is one of the simplest skeleton-pruning techniques. With the constraint of not removing the points of the pruned medial axis, we perform a topology-preserving thinning process guided by the Euclidean distance, and we obtain the Euclidean skeleton of Fig. 8.9c. Finally, the reverse process (reconstruction of the object) is

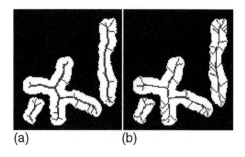

(a)                              (b)

**FIGURE 8.8**  Comparison of skeletons. Skeletons superimposed on the original chromosomes: (a) Euclidean skeleton with topology preservation, containing the exact Euclidean medial axis; (b) discrete skeleton with topology preservation, containing the exact medial axis by $nB$ disks.

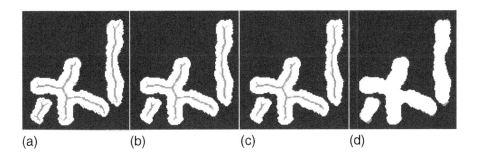

**FIGURE 8.9** Skeletonization and pruning. The skeletons are superimposed on the original chromosomes. (a) The exact Euclidean medial axis (center of maximal discrete Euclidean disks); (b) Pruned medial axis, disks with (squared) radius less than 36 have been removed; (c) Euclidean skeleton with topology preservation, containing the pruned medial axis shown in (b); (d) points on the boundaries that could not be reconstructed by the reverse process of the pruned skeleton.

performed on the pruned skeletons, and Fig. 8.9d shows the details of the boundaries that could not be reconstructed.

## 8.3 Grayscale Operations

It is useful to look at a grayscale image as a surface. Figure 8.10 shows a grayscale image made of three Gaussian-shaped peaks of different heights

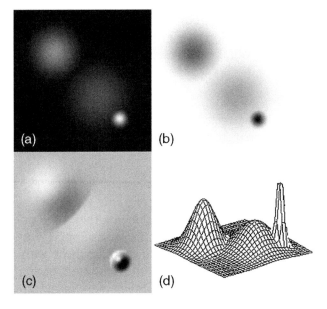

**FIGURE 8.10** Graphical representations of a grayscale image. (a) Grayscale mapping: zero is dark and 255 is bright. (b) Reverse grayscale mapping: zero is bright and 255 is dark. (c) Top-view shaded surface. (d) Surface mesh plot.

and widths. The image is depicted in four different graphical representations: (a) the pixel values mapped in gray levels (low values are dark and high values are bright gray tones); (b) the pixel values also mapped in grayscale but in a reverse order; (c) the same image but as a top view of a shaded surface; and (d) a mesh plot of the same surface.

## 8.3.1  Threshold Decomposition

The *threshold sets* of a grayscale image contain all the pixels of the binary objects obtained by thresholding the image at all (e.g., 256) gray levels. *Threshold decomposition* of a grayscale image is the process that creates the threshold sets. A *level component* in a grayscale image is defined as a connected set of pixels in a threshold set of the image at a particular gray level. A grayscale image, then, can be thought of as a *cardboard landscape model*, that is, a stack of thin, flat pieces of cardboard. The cardboard is first cut into the shape of each binary object (level component) from the threshold sets, and then the pieces are stacked up to form the topography. Each cardboard piece, then, corresponds to a level component of one threshold set for that grayscale image. The image can be characterized uniquely by its threshold sets. Recovering an image from its threshold sets is called *stack reconstruction*. Note that, for stack reconstruction to be possible, the threshold sets must satisfy the *stack property*. This means that each level component at a gray level must contain the level component above it and must be contained in the level component below.

The threshold decomposition of a grayscale image, $f$, is the collection of all the threshold sets, $X_t(f)$, obtained at each gray level $t$:

$$X_t(f) = \{z : f(z) \geq t\} \tag{8.18}$$

The image can be characterized uniquely by its threshold decomposition. The image can be recovered from its threshold sets by stack reconstruction:

$$f(x) = \max \{t : x \in X_t(f)\} \tag{8.19}$$

In all the grayscale morphological operations presented here, we use *flat structuring elements*, that is, structuring elements that have no grayscale variation and that are the same as those used in the case of binary images. We use the term *flat structuring elements* so as not to confuse them with their grayscale analogs. This restriction greatly simplifies the definition, characterization, and use of grayscale operators as an extension of the binary case. Care must be taken, however, when using a non-flat grayscale structuring element, because the erosion (dilation) is not a moving-minimum (moving-maximum) filter anymore, the threshold decomposition property does not hold for the primitive operators,

nor does it hold for grayscale morphological reconstruction. As mentioned earlier, only symmetrical structuring elements are discussed in this chapter.

## 8.3.2 Erosion and Dilation

*Grayscale erosion* (*dilation*) of an image, *f*, by a flat structuring element *D* is equivalent to a moving-minimum (moving-maximum) filter over the window defined by the structuring element. Thus, erosion $f \ominus D$ and dilation $f \oplus D$ in this case are simply special cases of order-statistic filters:

$$
\begin{aligned}
(f \ominus D)(x) &= \min\{f(z) : z \in D_x\} \\
(f \oplus D)(x) &= \max\{f(z) : z \in D_x\}
\end{aligned}
\tag{8.20}
$$

An example of erosion by a disk on a grayscale image is shown in Fig. 8.11. The two images on the left, input and eroded, are represented in grayscale, and the two on the right are the same images represented as top-view surfaces. Note how well the term *erosion* fits this example. The eroded surface appears to have been created by a pantograph engraving machine equipped with a flat disk milling cutter. The pantograph follows the original surface while shaping the eroded surface with the flat disk milling cutter.

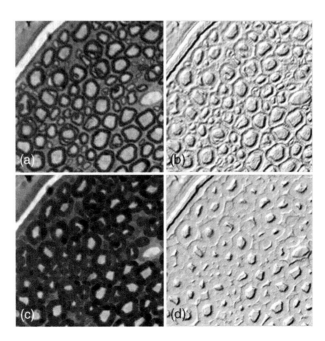

**FIGURE 8.11** Illustration of grayscale erosion. (a) Input image. (b) Surface view of the input image. (c) Erosion by a disk. (d) Surface view of the eroded image.

The intuitive interpretation for grayscale erosion is the following: Slide the structuring element along beneath the surface, and at each point record the highest altitude to which the structuring element can be translated while still fitting beneath the surface. Alternatively, one can simply compute the erosion (dilation) of a grayscale image by computing the threshold decomposition of the image, applying binary erosion (dilation) to the threshold sets, and following up with stack reconstruction.

Figure 8.12 illustrates grayscale erosion by means of threshold decomposition. At the right of the grayscale images (original (a) and eroded (e)) are three threshold sets, at gray levels 80, 120, and 180, respectively. Note that the binary images shown in (f), (g), and (h) are eroded versions of the binary images shown in (b), (c), and (d).

The filters that can be implemented by threshold decomposition are called *stack filters*. A stack filter can be built from any binary filter as long as the stack property is satisfied. Dilation and erosion by a flat structuring element are, in this sense, stack filters. So, too, is the median filter. A practical characteristic of a stack filter is that it stores all results of filtering the input thresholded images. So when dealing with stack filters, instead of thresholding the image and then applying the filter, it is better first to apply the filter, keeping the image in grayscale, and to threshold the result later. That is, put the parametric operation at the end of the procedure.

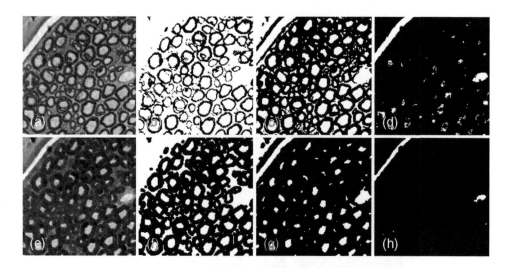

**FIGURE 8.12**    Illustration of grayscale erosion by means of threshold decomposition. (a) The input image. (e) The eroded grayscale image. (b), (c), and (d) show the input image thresholded at gray levels 80, 120, and 180, respectively. (f), (g), and (h) show the eroded image thresholded at gray levels 80, 120, and 180, respectively.

### 8.3.2.1  Gradient

Observe that the morphological gradient (dilation minus erosion), previously described for binary pictures, is extensible directly to grayscale morphology if grayscale erosions and dilations are used. At each point the morphological gradient yields the difference between the maximum and minimum values, over the neighborhood, at the point determined by the flat structuring element.

The grayscale morphological gradient is often used as one step of a more complex process, such as segmentation. For instance, Fig. 8.31b shows the gradient of the yeast cells in Fig. 8.31a that we wish to segment. The segmentation of urology specimens in Fig. 8.30a and the chromosomes in Fig. 8.27a also use gradient computation (Fig. 8.30b and Fig. 8.27b, respectively).

## 8.3.3  Opening and Closing

As an extension of the binary case, *grayscale opening* (*closing*) can be achieved simply by threshold decomposition, followed by binary opening (closing) and stack reconstruction. Grayscale opening and closing have the same properties as their binary equivalents [4]. The intuitive interpretation for opening is the following: Slide the structuring element beneath the surface and, at each point, record the maximum altitude to which the structuring element can be translated while still fitting beneath the surface. The position of the origin relative to the structuring element is irrelevant. Note the slight difference between the opening and the erosion. While in the opening, the maximum altitude is recorded for all points of the structuring element; in the erosion, only the location of the structuring element is recorded.

Figure 8.26b shows the grayscale opening of the input image (a) by a disk of radius 20. Note the manner in which the white dots are removed and the image is filtered from the bottom in accordance with the shape of the structuring element.

An intuitive interpretation of closing can be seen from the duality relation. Opening filters the image from below the surface, whereas closing filters it from above. By duality, closing is an opening of the negated image. Hence, to apply closing, simply flip the image upside down (invert), filter by the opening, and then flip it back. The filtering effect of closing is illustrated in Fig. 8.30c, which shows the closing of image (b) by a $7 \times 7$ box structuring element.

### 8.3.3.1  Top-Hat Filtering

The top-hat concept is also valid for grayscale images. *Grayscale opening top-hat* is the subtraction of the opened image from the input image, and *grayscale closing top-hat* is the subtraction of the image from its closing. By choosing an appropriately sized structuring element, one can use the top-hat transform to mark narrow peaks while not marking wider peaks in the image. In some

applications it is impossible to separate desirable from undesirable bright spots simply by using an appropriately sized structuring element, but it is possible to separate them by an appropriately chosen threshold.

The following application illustrates the use of grayscale closing and grayscale closing top-hat (Fig. 8.13). The input is a grayscale image of a microelectronic circuit. The relevant objects in this image are vertical metal stripes. Irregularities in these stripes are to be detected. This procedure uses the grayscale closing top-hat, followed by filtering (by size threshold) of the residues. The top part of Fig. 8.13 shows the grayscale images, while the lower part shows their surface views. The input image is shown in (a); its closing by a vertical line of length 25 pixels, is shown in (b). Then the top-hat result is the subtraction of the original from the closing (c), revealing dark defects in the metal stripes. It shows the discrepancies of the image where the structuring element cannot fit the surface from above. In this case, it highlights vertical depressions longer than 25 pixels. Thresholding the top-hat image, followed by the elimination of small objects by an area opening of 5 pixels, results in the detected regions with irregularities, which are shaded in black in the original image (d).

*Open top-hat* is very useful as a preprocessing step to correct uneven illumination (see Chapter 12) before applying a threshold, thereby implementing an adaptive thresholding technique (see Chapter 9). The following application illustrates this.

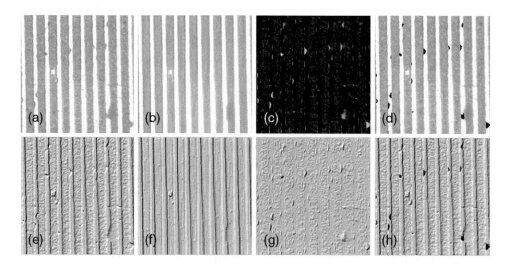

**FIGURE 8.13** Illustration of grayscale closing and closing top-hat. (a) Input image. (b) Closing by a vertical structuring element. (c) Closing top-hat. (d) Thresholded top-hat (black areas) overlaid on original. (e)–(h) Surface view of the corresponding images above.

For a real-world biological application, we consider fluorescent in situ hybridization (FISH) imaging, which is discussed in Chapter 12. A DNA probe labeled with a fluorophore hybridizes to a matching sequence of DNA in the cell, and the dye fluoresces at some particular color when excited by illumination in a microscope.

Figure 8.14 shows the open top-hat transform applied to a FISH image: (a) the FISH image; (b) open top-hat of the FISH image by a disk of radius 4; (c) binary image resulting from thresholding the top-hat image at a gray level of 50; and (d) final result with an arrow indicating the position of each detected spot. Due to noise, the top-hat methodology typically yields a number of very small extraneous spots in the thresholded top-hat image. These can be eliminated by filtering image with a grayscale area opening operation of two pixels. The arrows were overlaid automatically by a dilation of the centroids of the detected spots with an arrow-shaped structuring element having its origin translated slightly from the arrow tip so as not to disturb the visualization of the original spots in the image.

An illustration of the detection of thin structures using the closing top-hat can be seen in Figs. 8.22c–d. In (c) we see crystals surrounded by a dark contour and a bright oriented shade. The application of a closing top-hat by a disk with diameter larger than the thickness of the dark contours (see Fig. 8.22c) removes the bright shade and enhances the contours of the crystals.

To detect both peaks and valleys, one can apply the open top-hat transform, threshold to find peak markers, apply the close top-hat transform, threshold to find valley markers, and then form the union of the two marker images.

### 8.3.3.2 Alternating Sequential Filters

Grayscale opening can be employed to filter positive noise spikes from an image, and closing can remove negative noise spikes. Typically one encounters both, and, as long as the noise spikes are sufficiently well separated, they can be suppressed by an opening and closing or by a closing and opening operation. However, selection of an appropriate structuring element size is crucial. If the

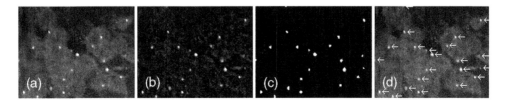

**FIGURE 8.14** Grayscale open top-hat example. (a) Input image. (b) Opening top-hat by a disk of radius 4. (c) Thresholded area open (by 2 pixels). (d) Dilation of centroids by arrow, for illustration, overlaid on original.

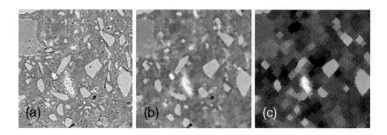

**FIGURE 8.15** Grayscale alternating sequential filtering. (a) Input image. (b) Close–open by an elementary cross; (c) ASF close–open with three stages.

spacing between noise spikes is uneven and they are not sufficiently separated, one can employ an *alternating sequential filter* (ASF). This is a sequence of alternating opening and closing operations with increasingly larger structuring elements.

Figure 8.15 shows an example of grayscale image filtering using ASF. A single-stage close–open filter (shown in (b)) is the result of the closing followed by an opening using a $3 \times 3$ diamond-shaped structuring element. For the second stage, another close–open operation is concatenated using a $5 \times 5$ diamond structuring element. In (c) a three-stage ASF was applied, with the last stage being processed by a $7 \times 7$ diamond structuring element.

For correction of uneven illumination, the background can be estimated by an ASF filter. An example of this technique appears in Fig. 8.22. Part (a) is the input image, which shows a strong, uneven illumination component; in part (b) the background is estimated by a 10-stage close–open ASF using a family of different-size octagonal disks.

## 8.3.4 Component Filters and Grayscale Morphological Reconstruction

The concept of a connected component filter, which was introduced in Section 8.2.3, on binary morphology, can be extended to grayscale morphology. Such a filter can be constructed from (1) reconstruction from markers operations, (2) reconstruction from opening operations, and (3) area-opening operations. These grayscale operators can be constructed from their corresponding binary counterparts by using threshold decomposition, described earlier (Section 8.3.1). A grayscale component filter is an operator that removes only a few level components (cardboard pieces) in such a way that the stack reconstruction property is not violated. That is, a level component is removed only if all the level components above it are also removed. One important property of a component filter is that it never introduces a false edge, so it is one of a family of edge-preserving smoothing filters. Recall that the definition of

component filters requires the specification of a connectivity convention, which can be either 4- or 8-neighbor connectivity.

### 8.3.4.1 Morphological Reconstruction

Morphological reconstruction is one of the most used tools for building component filters [5–7]. As with binary reconstruction, grayscale reconstruction proceeds from markers. As with the binary case, in the morphological reconstruction from markers, there are mainly three ways to design the marker image: (a) with a priori selection, (b) using selection from opening (grayscale reconstruction from opening, see Section 8.3.4.2) [9], and (c) determination from more complex processing (see Section 8.3.4.4).

The morphological reconstruction of an image from a marker can be obtained by (1) threshold decomposition of the image and the marker, followed by (2) binary reconstruction from markers done at each gray level and (3) stack reconstruction of the results. This can be interpreted intuitively by using the cardboard landscape model of the image. Imagine that the cardboard pieces are stacked but not glued. The markers are seen as needles that pierce the model from bottom to top. If one shakes the model while holding the needles, those cardboard pieces not pierced by the needles will be lost. The remaining cardboard pieces constitute a new model, possibly with fewer objects, and that corresponds to the final result of grayscale morphological reconstruction. Note that the marker can be a grayscale image, with the pixel gray level corresponding to the height that the needles reach as they pierce the model. This process is also called *inf-reconstruction*. By duality, the *sup-reconstruction* works in the same manner on the complemented image.

### 8.3.4.2 Alternating Sequential Component Filters

An important class of component filters is composed of those generated from alternating reconstructions from openings and closings. These are called *alternating sequential component filters* (ASCFs). Figure 8.16 shows two examples of a grayscale ASCF, using, as input, the image shown in Fig. 8.15. A three-stage close–open filter (shown in (b)) is the result of the sup-reconstruction from closing followed by an inf-reconstruction from opening using a $3 \times 3$, $5 \times 5$, and $7 \times 7$ diamond structuring element in the first, second, and last stage, respectively. One can compare the fidelity of the edges between the results of this component filter and the results of the ASF filters shown in Fig. 8.15.

### 8.3.4.3 Grayscale Area Opening and Closing

Grayscale area opening is another type of component filter [8]. It is defined analogously to the binary case. The size-*a* area opening of a grayscale image can

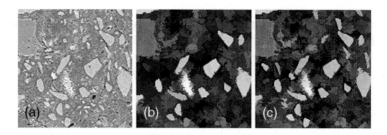

**FIGURE 8.16**   Grayscale alternating sequential component filtering. (a) Input image. (b) Reconstructive close–open by a 3 × 3 diamond structuring element of stage 3. (c) Area close–open with area parameter of 30 pixels.

be modeled as a stack filter in which, at each level, only level components containing at least *a* pixels are retained. This operation removes all cardboard pieces whose area is less than *a*. An area closing is the same operation performed on the complement image.

In Fig. 8.16c an area close–open operation is applied using 30 pixels as the area parameter.

### 8.3.4.4  Edge-Off Operator

The grayscale edge-off operator can easily be derived from the binary case, and it is very useful in many situations. As with the binary case, the edge-off operator is the top-hat of the reconstruction from a marker placed at the image border (i.e., an example of the case where the marker is placed a priori). In the cardboard landscape model (threshold decomposition), all the cardboard pieces that touch the image border are removed, leaving only those cardboard pieces that form domes inside the image.

The following application illustrates the use of an area close–open filter as a preprocessing filter followed by the edge-off operator to enhance pollen grains. It is known a priori that the pollen grains have areas ranging from 5000 to 150,000 pixels at the resolution of these images. Figure 8.17a shows the input image containing two grains. Figure 8.17b is the area close–open ASCF result. It was used with an area parameter of 1500 pixels, first filling holes of less than this size and then removing level components with area less than 1500 pixels. Note that there are deep, dark areas around the pollen grains, and these make it useful to apply the edge-off operator, shown in Fig. 8.17c. The process of enhancing the pollen grain images was done entirely in the grayscale domain. Finally, a segmentation can be obtained by thresholding Fig. 8.17c at a gray level of 5 (Fig. 8.17d).

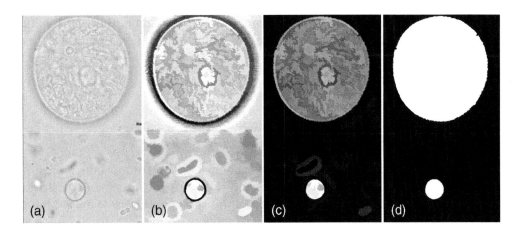

**FIGURE 8.17** Segmenting pollen grains with grayscale component filters. (a) Input image. (b) Area close–open ASCF. (c) Edge-off operation. (d) Thresholding.

### 8.3.4.5 *h*-*Maxima and h-Minima Operations*

The reconstruction of an image $f$ after subtracting $h$ from itself is called the *h-maxima* operation:

$$\text{HMAX}_{h,E}(f) = f \; \Delta_E \; (f - h) \tag{8.21}$$

This is a component filter that removes any object with height less than or equal to $h$, and it decreases the height of the other objects by $h$. The intuitive interpretation of the *h*-maxima operation based on the threshold decomposition concept is that the height attribute associated with a particular level component (cardboard piece) is one plus the maximum number of levels that exist above it in that object. The *h*-maxima filter removes all the cardboard pieces with height attribute less than or equal to $h$. The dual operator of *h*-maxima is called *h-minima*, $\text{HMIN}_{h,E}(f)$. It fills in any basin with depth less than $h$ and decreases the depth of the other basins by $h$.

### 8.3.4.6 *Regional Maxima and Minima*

Considering the threshold decomposition of a grayscale image, *regional maxima* are level components with height attribute equal to 1; i.e., there are no other level components above them. These are the cardboard pieces at the top of their respective peaks. For instance, Fig. 8.29c shows the regional maxima of the image in Fig. 8.29b. All regional maxima can be found by subtracting the *h*-maxima with $h = 1$ from its original image, $f$:

$$\text{RMAX}_E(f) = f - \text{HMAX}_{1,E}(f) \tag{8.22}$$

By duality, a *regional minimum* is a flat connected region that is at the bottom of a basin. Regional maxima and minima are generically called *extrema* of the image.

$$\mathrm{RMIN}_E(f) = \mathrm{HMIN}_{1,E}(f) - f \qquad (8.23)$$

### 8.3.4.7  Regional Extrema as Markers

The watershed transform, described in Section 8.4, is an important morphological segmentation process. One of the crucial steps in watershed transform segmentation is marker extraction. A marker must be placed inside every object that needs to be extracted. The regional maxima (minima) can be used as markers for watershed segmentation. Marker finding, using the regional maxima, is most effective when done on filtered images. One advantage of this method is its independence of any grayscale thresholding values.

Typically, an image presents a large number of regional maxima because of noise inherent in the acquisition process. If the regional maximum operator is applied to a gradient image, then the situation is even worse. Filtering the image can remove small regional maxima, which are likely due to noise. This is usually accomplished using (1) opening, (2) reconstruction from opening, (3) area opening, (4) *h*-maxima, or combinations thereof. The choice of filter to use is a part of the design strategy.

Figure 8.18 shows the regional maxima of an input image following four different filters: (a) input image; (b) regional maxima without filtering; (c) regional maxima following opening by a disk of radius 3; (d) regional maxima following reconstruction from opening by the same disk; (e) regional maxima following area opening; and (f) regional maxima following an *h*-maxima operation. Note how the oversegmentation (excessive number of separate markers) produced by the direct regional maxima in (b) is reduced by the subsequent filtering.

In the next section these markers are used to segment an image using the watershed transform (see Fig. 8.21). Analogously, in Figs. 8.23c and 8.22e, the *h*-minima operator is used to filter minima in the images of Figs. 8.23b and 8.22d, respectively, prior to the watershed transform.

## 8.4  Watershed Segmentation

The watershed transform is a key building block for morphological segmentation of images [10]. The watershed segmentation method has become highly developed to deal with numerous real-world contingencies, and a number of algorithms have been implemented [11–12].

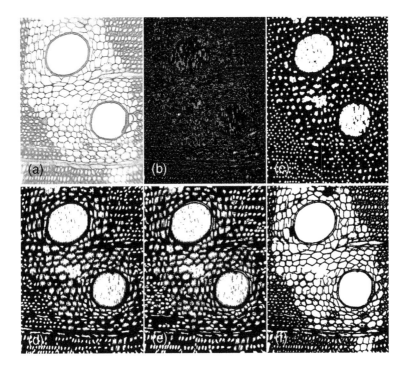

**FIGURE 8.18** Regional maxima of a filtered image. (a) Input image. (b) Regional maxima. (c) Regional maxima after opening by a disk of radius 3. (d) Regional maxima after reconstruction from opening by the same disk. (e) Regional maxima after an area opening of 100 pixels. (f) Regional maxima after *h*-maxima filtering with $h = 20$.

## 8.4.1 Classical Watershed Transform

The most intuitive description of the *watershed transform* is based on a flooding simulation. Consider the input grayscale image as a topographic surface (recall Fig. 8.10). The goal is to produce the watershed lines on this surface. To do so, holes are punched at each regional minimum in the image. The topography is slowly flooded from below by allowing water to rise from each regional minimum at a uniform rate across the image. When the rising water coming from two distinct minima is about to merge, a dam is built to prevent the merging. The flooding will eventually reach a stage when only the tops of the dams are visible above the water surface, and these correspond to the *watershed lines*. The final segmented regions arising from the various regional minima are called *catchment basins*.

Figure 8.19 illustrates this flooding process on a one-dimensional signal with four regional minima generating four catchment basins. The figure shows some steps of the process: (a) input image, (b) holes punched at minima and initial flooding, (c) dam created when waters from different minima are about to merge, and (d) final flooding, yielding three watershed lines and four catchment basins.

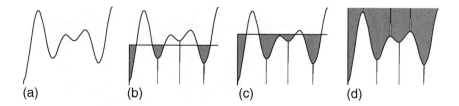

**FIGURE 8.19** Flooding simulation of the watershed transform. (a) Input signal. (b) Punched holes at minima and initial flooding. (c) A dam is created when waters from different minima are about to merge. (d) Final flooding, with three watershed lines and four catchment basins.

For image segmentation, the watershed is usually, but not always, applied to a gradient image. Since real digitized images present many regional minima in their gradients, this typically results in an excessive number of catchment basins, the result being called *watershed oversegmentation*. We now address how to prevent this.

## 8.4.2 Filtering the Minima

One solution to cope with oversegmentation is to filter the image to reduce the number of regional minima, creating fewer catchment basins. Figure 8.20 shows the application of the classical watershed transform. The input image (a) is a small synthetic image with three different-size Gaussian peaks. Part (b) shows its morphological gradient using a $3 \times 3$ box-structuring element. Part (c) shows a typical watershed result with oversegmentation due to spurious regional minima, each one generating a catchment basin. By filtering the gradient image with the *h*-minima operator, with $h = 9$, the watershed gives the desired result, shown in Fig. 8.20d. This kind of filtering is very subtle to the eye because the spurious regional minima that are eliminated are quite small and difficult to see.

Figure 8.21 illustrates reducing oversegmentation of the watershed algorithm by filtering the minima in the input image with several different filters.

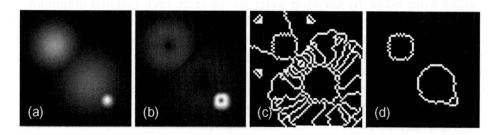

**FIGURE 8.20** Classical watershed segmentation with regional minimum filtering. (a) Small synthetic input image ($64 \times 64$). (b) Morphological gradient. (c) Watershed on the morphological gradient. (d) Watershed on the *h*-minima ($h = 9$) filtered morphological gradient.

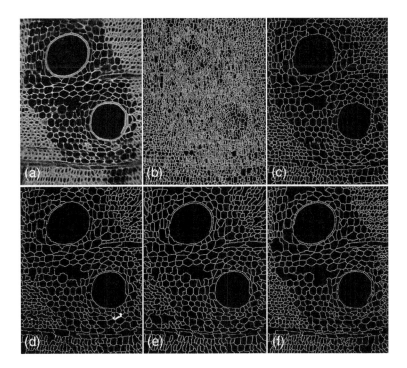

**FIGURE 8.21** Regional maxima of filtered image. (a) Input image. (b) Watershed of the input image. (c) Watershed of the input image after closing with a disk of radius 3. (d) Watershed of the input image after sup-reconstruction from closing by the same disk. (e) Watershed of the input image after area closing of 100 pixels. (f) Watershed of the input image after $h$-minima filtering with $h = 20$.

In (a) is the input image; (b) is the watershed of (a) without filtering; (c) is when filtered with a closing operation with a disk of radius 3; (d) is when filtered with sup-reconstruction from closing with the same disk; (e) is when filtered with area closing; and (f) is when filtered with the $h$-minima operator. This example is equivalent to the regional maxima simplification shown in Fig. 8.18. If we compute the regional minima in the filtered images, we get the same results as in that figure. Note that to filter regional minima, we use filters that operate on the valleys, such as closings and $h$-minima operators. Applying filters that operate on peaks does not reduce the number of minima or the number of catchment basins found by the watershed algorithm.

The next application we consider deals with an electron micrograph of silver halide T-grain crystals embedded in emulsion. Automated crystal analysis involves segmentation of the grains for size measurement. This segmentation problem looks simple at first, but the image has several things that make segmentation difficult. The image has a strong illumination gradient, the interior gray-level values for the crystal grains are the same as the background, the image has strong white "shadow" noise, it has a wide range of grain sizes, and there are

overlapping and touching grains. Despite all these problems, watershed segmentation can produce very good results. The two key points here are the background correction and the enhancement of the dark contours using a close top-hat operation with a disk diameter larger than the thickness of these contours. The crystals are surrounded by dark contour lines that are to be used for the watershed-based segmentation. The preprocessing stage is intended to enhance only these lines.

The input image is shown in Fig. 8.22a. The illumination gradient is estimated with a 10-stage alternating sequential filtering using an octagon structuring element in (b). The input image is then divided by this background estimate, normalized by its minimum value in (c). This division ensures that the dark contours have the same depth; so in the dark regions of the image, the depths of the dark contours are increased by this procedure. This is necessary to yield uniform segmentation when applying the $h$-minima filtering later. A classical closing top-hat filter detects the dark contours in (d). The size of the structuring

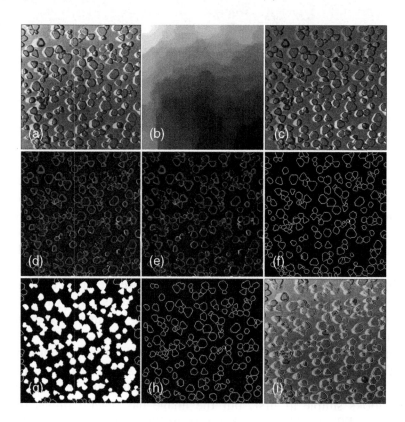

**FIGURE 8.22**  Silver halide T-grain crystal segmentation. (a) Input image. (b) Alternating sequential filter applied. (c) Input image divided by (b). (d) Contour enhancement. (e) $h$-minima filter. (f) Watershed. (g) Removal of grains touching the border. (h) Watershed lines not touching the border. (i) Final result.

element must be larger than the thickness of the dark contours. Note that the white areas of the image do not affect the detection of the dark contours.

The watershed transform detects the dividing lines between the dark regions. In this case, it is not necessary to compute the gradient, since the contour lines have already been enhanced. We apply an area closing followed by an $h$-minima operation in (e). The choices of parameters for the filters used in this example are crucial, and they have been found by trial and error. Application of the watershed on the simplified contour image gives the watershed lines shown in (f). Grains connected to the image border are removed in (g). After that, the intersection of the watershed lines and the grains not connected to the image border gives the final boundaries of grains not touching the border in (h). For display purposes, the contours are overlaid on the original image (i).

### 8.4.3  Texture Detection

Oversegmentation, usually seen as a drawback of the watershed transform, can be useful to separate homogeneous from textured regions of an image. Indeed, the watershed transform will create large catchment basins in rather homogeneous regions and very small catchment basins in textured regions.

The following example, illustrated in Fig. 8.23, finds the segmentation of epithelial cells from monochrome images. Because the cells are nearly transparent,

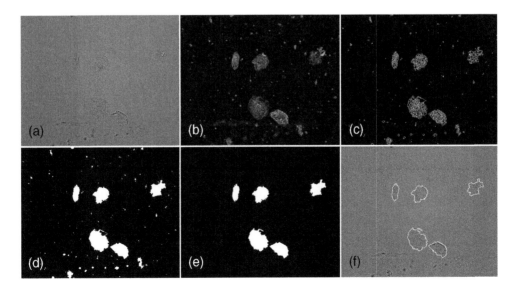

**FIGURE 8.23**  Epithelial cell segmentation. (a) Original image. (b) Morphological gradient. (c) Watershed lines (with oversegmentation) on $h$-minima ($h = 6$) filtered gradient. (d) Area closing to merge small catchment basins. (e) Area opening to select only the large objects. (f) Outline (in white) of the segmented objects.

the idea is to use the watershed to detect small catchment basins due to the texture present in the interior of these cells. The catchment basins are area-closed and then opened to remove noise. Although the oversegmentation of the watershed algorithm is desirable, a component filtering operation is still required to detect only those catchment basins inside the cells. An *h*-minima operation on the gradient is used. In Fig. 8.24, (a) is the original image containing the almost-transparent target cells; (b) is the morphological gradient; (c) shows the watershed lines of the *h*-minima filtered gradient; (d) shows the merging of small catchment basins by area closing; (e) is the result of the area opening to detect large objects; and in (f) the contours (gradient) of segmented objects are overlaid on the input image.

The example that follows shows an image analysis technique for detecting anhydrous phase and aggregate in a polished concrete section, imaged by the scanning electron microscope (SEM) in Fig. 8.24a as homogeneous white and medium-gray grains, respectively.

The steps in this analysis are: (1) anhydrous detection by automatic threshold analysis, (2) homogeneous grain detection using the watershed technique, and (3) identification of aggregates as homogeneous grains that are not from the anhydrous phase. The automatic threshold analysis is done using one-dimensional morphological processing of the gray-level histogram with the watershed algorithm.

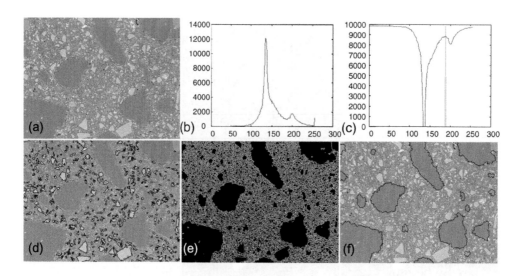

**FIGURE 8.24** Aggregate and anhydrous phase extraction from a concrete section imaged by a SEM. (a) Input image. (b) Gray-level histogram. (c) Automatic threshold from histogram using watershed. (d) Contour (in black) of the anhydrous regions from automatic thresholding. (e) Watershed lines from filtered regional minima of the gradient. (f) Contour (in black) of the aggregate regions obtained from area open–close of the watershed.

The histogram in Fig. 8.24b has a small peak in the white region due to the anhydrous phase. The threshold value is automatically determined with the 1-D watershed technique. This is done by computing the one-dimensional watershed on the filtered, negated histogram. The filter is based on a closing of 5 points followed by an $h$-minima operation with $h = 10$ (see Fig. 8.24c). The threshold parameter is taken as the position of the watershed point.

Anhydrous regions are detected by applying the automatic threshold and by removing objects with area less than 20 pixels. Their contour, computed from the gradient, is overlaid (in black) on the input image in Fig. 8.24d. Figure 8.24e shows the watershed applied on the filtered gradient of the input image. The filter is the $h$-minima with $h = 10$. The larger catchment basin regions are the aggregate and the anhydrous. These regions are filtered out using an area opening of 300 pixels followed by an area closing of 50 pixels to eliminate small holes. The aggregate, contoured in black in (f), is obtained by removing the anhydrous phase already computed.

## 8.4.4   Watershed from Markers

The *watershed from markers* technique is a very effective way to reduce over-segmentation if one can place markers within the objects to be segmented. The watershed from markers can also be described as a flooding simulation process. In this case, holes are punched at the marker regions. Each marker is associated with a color. The topography is flooded from below by letting colored water rise from the hole associated with its color, this being done for all holes at a uniform rate across the entire image. If the water reaches a catchment basin with no marker in it, then the water floods that catchment basin without restriction. However, if the rising waters of distinct colors are about to merge, then a dam is built to prevent the merging. The colored regions are the catchment basins associated with the various markers. To differentiate these catchment basins from the ones obtained with the classical watershed transform, we call the latter *primitive catchment basins.*

Figure 8.25 illustrates the flooding of the watershed from markers in one dimension. There are markers placed into the two rightmost primitive catchment basins. Part (a) shows the two holes punched at the markers and some initial flooding. When the water rises, a primitive catchment basin without a marker is flooded without creating a dam, as shown in part (b). In part (c), a dam is built to prevent the merging of waters coming from the two markers. Finally, part (d) shows the final flooding, with only one watershed line separating the two marked regions.

The classical watershed transform can be constructed using the watershed from markers technique, and vice versa. If we place the markers at all regional minima of the input image, then the watershed from markers technique gives the

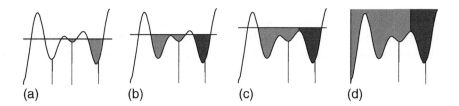

**FIGURE 8.25**   Flooding simulation of the watershed from markers. (a) Punched holes at markers and initial flooding. (b) Flooding a primitive catchment basin without a marker. (c) A dam is created when waters coming from different markers are about to merge. (d) Final flooding, only one watershed line.

classical watershed transform result. To obtain the watershed from markers result from the standard watershed transform, we must apply the classical watershed transform to the sup-reconstruction of the image from the markers.

## 8.4.5   Segmentation of Overlapped Convex Cells

Application of the watershed transform often involves a certain spatial decomposition. Given a set of isolated points (grains) in a binary image, its *Voronoi diagram* is composed of lines that partition the plane into regions, each consisting of the points that are closest to one particular grain. More generally, the grains can consist of connected components of arbitrary sets, instead of isolated points. In this case, the Voronoi regions are called *influence zones*, and the Voronoi diagram is called a *skeleton by influence zones* (SKIZ).

In a binary image, the *distance function*, or *distance transform*, is defined, for any point inside an object, as the distance from that point to the nearest point outside the object. The watershed transform is a useful method for computing the Voronoi diagram and the SKIZ. The idea is to compute the classical watershed transform of the distance transform of the background of the objects. The catchment basins are the influence zones, and the watershed lines compose the SKIZ.

This concept can address one of the earliest uses of the watershed transform, the problem of binary-image segmentation of images with touching and overlapping objects. For instance, in Fig. 8.26c, seven cells appear to be overlapping to form a single connected component. Our goal is to segment that component in a manner consistent with the integrity of each cell. A key to this problem, and with many segmentation problems, is to find markers for each of the objects.

In Fig. 8.26, after the input image (a) is filtered using an opening with a disk (b), the image is thresholded in (c). Using the watershed transform to segment the overlapped cells works in the following way. The distance transform is computed on the binary image, and one marker is required for each cell. In the case of rounded cells, these markers can be extracted from the regional

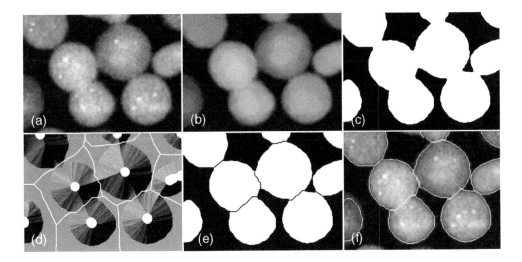

**FIGURE 8.26** Segmentation of overlapping convex cells. (a) Input image. (b) Preprocessing by opening with a disk of radius 20. (c) Threshold of the preprocessed image. (d) Distance transform of complement image (in gray) overlaid by marker (white) and watershed lines (white). (e) Watershed lines used to cut the binary overlapped cells. (f) Cell boundaries overlaid on the input image.

maxima of the distance function. Depending on the difficulty of this extraction, it may require filtering the distance function. This can be done via an opening according to the methodology of marker extraction using regional maxima, which is discussed in Section 8.3.4.7. In this case the distance function was filtered by an opening with a disk of radius 15. The lines from the watershed transform on the negated distance function from the markers are used to cut the input binary image (e). The shaded distance function, displayed in part (d) of Fig. 8.26, is overlaid with the marker (in white) and the watershed lines (in white). In part (f), the input image is overlaid by the morphological gradient of the binary image.

Overlapping cells may appear in complex images, such as cytogenetic specimens prepared with FISH techniques. Figure 8.27 illustrates such an application, where the task is to find and segment chromosomes, interphase cell nuclei, and DNA-probe dots in the images. (a) is the blue channel; (b) is the morphological gradient; (c) is the watershed transform calculated on (b), after an $h$-minima filtering with height 7; in (d), the objects are filled out using reconstruction; in (e) cut nucleus cells have been filtered from reconstruction from open by a circle; nuclei and chromosomes have been segmented in (f) and (g) respectively; (h) is the red channel image; in (i), spots were detected by thresholding the $h$-maxima; Note the classical binary-image segmentation problem in (e), where the touching round nuclei are separated.

We now discuss the other operations that were performed in this application. The sup-reconstruction of the watershed result, which selects the whole

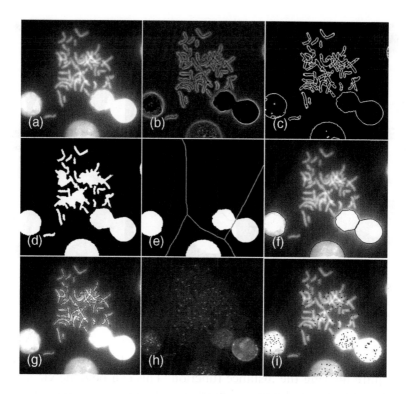

**FIGURE 8.27**    Fluorescence in situ hybridization image. (a) Blue channel. (b) Morphological gradient. (c) Watershed calculated on (b), after an *h*-minima filtering with height 7. (d) Objects filled out using reconstruction. (e) Cut nucleus cells filtered with reconstruction from open by a circle. (f) Outline (in black) of the segmented nuclei overlaid on the blue channel. (g) Outline (in black) of the detected chromosomes overlaid on the blue channel. (h) Red channel image. (i) Spots (in black) detected by thresholding *h*-maxima and overlaid on the blue channel.

components from (d), is tricky: The marker of the sup-reconstruction is a white image with a single black point. To detect the red dots from the original color image, the red channel is selected, and a simple *h*-maxima filter, with a high dynamics parameter (e.g., 20), selects the red dots. The *dynamic* of a regional maximum is the height we must climb down from that maximum in order to reach another maximum of higher elevation [13]. Similarly, the dynamic of a minimum is the minimum height we must climb from that regional minimum in order to reach a lower regional minimum.

## 8.4.6   Inner and Outer Markers

A typical watershed-based segmentation problem is to segment cell-like objects in a grayscale image. The general approach commonly used to solve these problems is threefold: (1) preprocessing using a smoothing filter, (2) extraction of object markers (inner markers) and background markers (outer markers),

and (3) obtaining watershed lines of the morphological gradient from the markers. Usually the most critical part is the extraction of object markers, since an object not marked properly will be missed in the final segmentation.

Figure 8.28 shows a typical application of the watershed from markers technique using inner and outer markers. The input image for this example is the same one used in Fig. 8.20. Parts (a), (b), and (c) are the same images presented in the illustration of the classical watershed in Fig. 8.20. In this case, however, oversegmentation is avoided by using the inner and outer markers concept applied to the watershed from markers technique. The inner markers are detected from the regional maxima of the input image opened with a small disk (see part (d) ). For the outer markers, we first negate the input image (e) and then compute the watershed transform on it. In the negated input image, the peaks become basins, and taking the watershed transform of the inner markers yields the skeletons of the influence zones of the basins. These compose the background (outer) marker (f). Care is required in combining both markers because they can touch each other at some points. We first label the inner markers with integers and then label the outer marker with 1 greater than the maximum inner-marker label. In (g) the different markers are painted with different colors. The final segmentation is in (h).

To illustrate watershed segmentation using inner and outer markers, we consider the poor-quality microscopic image of a cornea tissue shown in Fig. 8.29a. The cell markers are extracted as the regional maxima of the opening

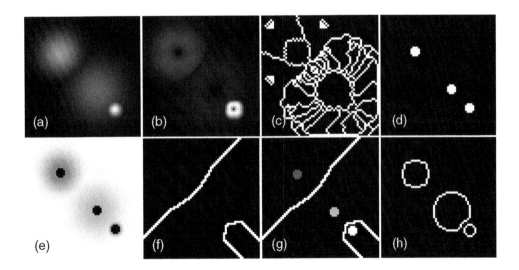

**FIGURE 8.28** Watershed from markers. (a) Small synthetic input image (64 × 64). (b) Morphological gradient. (c) Oversegmentation using watershed on the morphological gradient. (d) Detection of inner markers. (e) Inner markers overlaid on negated input image. (f) Outer marker as the watershed from markers. (g) Inner and outer markers (labeled). (h) Watershed from markers applied to the morphological gradient.

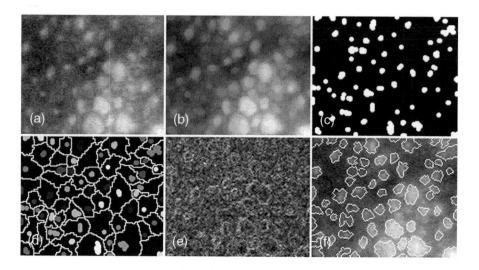

**FIGURE 8.29**   Segmentation of cornea cells from a noisy image. (a) Input image. (b) Filtered by an opening operation. (c) Regional maxima of the opening (inner markers). (d) Inner and outer markers (watershed lines of the negated input image from the inner markers). (e) Morphological gradient of the original image. (f) Final watershed lines overlaid on the input image.

with a disk operation performed on the input image. The criterion used with regional maxima is mainly topological. We can model each cell as a small hill, and we want to mark the top of each hill that has a base larger than the disk used in the opening. Parts (b) and (c) of the figure show the opened image and its regional maxima, respectively. The inner and outer markers (d) are detected by the same procedure as in Fig. 8.28. The regional maxima constitute the inner markers, and the outer markers are obtained by a watershed transform on the negated input image. After labeling the markers, the morphological gradient is computed in (e). Although it is a very noisy gradient, the final watershed lines, which are overlaid on the input image in (f), provide a satisfactory segmentation.

The watershed transform is most often applied to a gradient image, a top-hat image, or a distance function image, but in other cases the input image itself is suitable for application of the watershed transform. Figure 8.30 illustrates this on a brightfield image of a urology specimen. The task is to find the boundaries of the low-contrast objects in the image. The idea is to segment the low-contrast structures in (a) by a watershed from markers operation applied directly to the input image, because the input image already has a gradient-like structure. For this to work, it is necessary to detect the markers only on the urology specimens. So the first step is to find a mask image roughly larger than the specimens. We achieve this by thresholding the filtered gradient image. Part (b) shows the gradient of the input image, and part (c) is the closing of the gradient by a box of size $7 \times 7$, followed by an area opening of 120 pixels in (d). These parameters

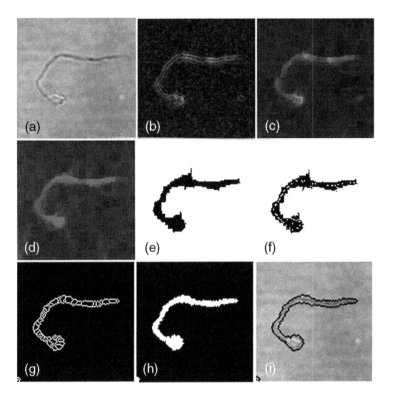

**FIGURE 8.30** Segmentation of a urology specimen. (a) Input image. (b) Gradient. (c) Closing with a box of size 7 × 7. (d) Area opening by 120 pixels. (e) Thresholding (presegmentation). (f) Markers given by the regional minima of the input image, masked by the presegmentation. (g) Watershed from markers of the input image. (h) Area closing. (i) Contour (gradient) overlaid on the input image.

were chosen based on the thickness of the objects. Part (e) is the thresholding of the filtered image, which, after a union operation with the regional minima of the input image, forms the markers for the watershed, as seen in (f). The result of the watershed from markers is seen in (g). An area closing fills in the catchment basins, as seen in (h), and the contours computed from the gradient of part (h) are overlaid on the input image in (i).

## 8.4.7 Hierarchical Watershed

A *hierarchical*, or *multiscale*, *watershed* (MSW) transform creates a set of nested partitions. The multiscale watershed presented here can be obtained by applying the watershed from markers technique to a decreasing set of markers.

The watershed at scale 1 (finest partitioning) is the classical watershed, made up of the primitive catchment basins, and perhaps with oversegmentation. As the scale increases, fewer markers are involved, and the coarsest partition is the entire image, obtained from a single marker at the regional minimum of largest dynamic.

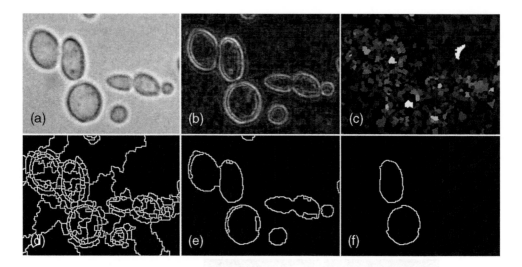

**FIGURE 8.31** Multiscale watershed transform. (a) Original image. (b) Morphological gradient. (c) Mosaic image. (d) Markers as the regional minima with dynamics above 3. (e) Markers as the regional minima with dynamics above 8. (f) Markers as the regional minima with dynamics above 15.

Figure 8.31 illustrates the multiscale watershed transform applied to a real image. The decreasing sets of markers are obtained by applying the $h$-minima filter; that is, the dynamics of the minima are used. We show a mosaic image where the primitive catchment basins of the gradient are displayed with gray level proportional to the dynamics of their regional minima. Then we show three levels in the hierarchy, with markers taken as the regional minima with dynamics above 3, 8, and 15. In Fig. 8.31, (a) is the input image, (b) is the morphological gradient, (c) is the mosaic image, and (d), (e), and (f) show the results of the watershed transform from the markers taken as the regional minima having dynamics greater than 3, 8 and 15, respectively. Note that the highest dynamic corresponds to the background, the second highest dynamic corresponds to the largest circular cell, and the third highest corresponds to the elongated cell lying above it. This observation is confirmed by the two most prominent objects on the background in (f).

## 8.4.8  Watershed Transform Algorithms

There are many watershed transform algorithms in the literature, and this can be quite confusing. Two types of algorithms are the most important. One is based on *immersion simulation* and the other is based on *minimum-cost paths*. We present an algorithm based on the minimum-cost path for the watershed-from-markers transform, in which the definition and implementation are consistent. The classical watershed transform is obtained when the markers are the regional minima of the image.

The image is modeled as a graph, and each pixel is a node. The minimum-path cost between two pixels, $p$ and $q$, in the graph is given by the minimal cost of all the paths connecting $p$ and $q$:

$$C^*(p, q) = \min_i \{C(\pi_i(p \to q))\}$$

where $\pi_i(p \to q)$ denotes a path from $p$ to $q$. The cost of a simple connected path from $p \to q$ is given by a lexicographic cost $C(p)$, where the first component, $C^1(p)$, is the maximum pixel value in the path and the second component, $C^2(p)$, is the number of times the first component cost is the same before arriving at $p_n$:

$$
\begin{aligned}
C(p_1, p_2, \ldots, p_n) &= \left[C^1(p_n), C^2(p_n)\right] \\
C^1(p_1) &= 0 \\
C^1(p_n) &= \max\{C^1(p_1), f(p_2), \ldots, f(p_n)\}, \quad \textit{for } n > 1 \\
C^2(p_n) &= \max\{j: C^1(p_n) = C^1(p_{n-j})\}, \quad j = 0, 1, \ldots, n-1
\end{aligned}
$$

(8.24)

Here $f$ is the input image and $C^1(p_n)$ is the maximum pixel value of $f(p_i)$, where $p_i$ is in the path $p_1 \to p_n$.

The catchment basin $\text{CB}_k$ associated with the marker $L_k$ is defined by those nodes $p$ having a path cost from this marker that is less than or equal to the path cost from any other marker; that is,

$$\text{CB}_k = \{p: C^*(L_k, p) \le C^*(L_j, p), j \ne k\}$$

(8.25)

where $C^*(L, p)$ is the minimum-cost path from region $L$ to pixel $p$, and this is the minimum-cost path from any pixel of region $L$ to $p$, that is,

$$C^*(L, p) = \min\{C^*(l, p): l \in L\}$$

A simple but efficient implementation of this watershed definition is the following algorithm, $cb(f, L)$, where $f$ is the input image, $L$ is a labeled image where nonmarker pixels have the value 0, and the output of the algorithm is $L$, which shows the final catchment basin regions.

```
Function L = cb (f, L)
    f: input image
    L: labeled image (input and output)

    1. Initialization
        for L(p) != 0:
            inHFQ(p, 0)
```

*(Continued)*

```
2. Propagation
    while HFQ is not empty:
        p <- outHFQ
        for each non-labeled q neighbor of p:
            L(q) <- L(p)
            inHFQ(q, f(q))
```

In this function, the hierarchical FIFO queue (HFQ) has the following operations: inHFQ($p$, $v$)—insert pixel $p$ with priority $v$; outHFQ—remove the pixel with the lowest priority, with the FIFO policy for pixels at the same priority. This FIFO policy implements intrinsically the second component of the lexicographic cost of Eq. 8.24.

Two points are worth mentioning in the formulation of the catchment basins given in Eq. 8.25. First, watershed lines are not defined by this algorithm. Second, many optimal solutions are possible. This is because the criterion for a pixel's belonging to a particular catchment basin is merely that its cost relative to that basin marker be less than or equal to its cost relative to any other basin marker. Thus watershed lines can be assigned to pixels that have the same minimal cost relative to more than one marker. With this approach, the watershed lines can be thick. If one wants one-pixel-thick watershed lines, a thinning can be used.

# 8.5  Summary of Important Points

1. Morphology processing has to do with the fitting, or not fitting, of a structuring element inside the objects in an image.

2. Morphology processing can be directly and efficiently applied to discrete images.

3. Morphology processing can be applied to both binary and grayscale images.

4. Morphology algorithm design is based on a building block concept, where complex operators are built up from sequences of simple ones.

5. Erosion and dilation are primitive operators of morphology processing, and they are duals.

6. The erosion of an image consists of all locations where the structuring element fits inside an object.

7. Opening and closing are created from the composition of erosion and dilation. They are dual operations.

8. An image contains its opening, whereas it is contained by its closing.

9. The opening of an image by a structuring element is the union of all the structuring elements that fit inside the objects. It is a way of marking objects that have certain specified morphological properties.

10. An alternating sequential filter combines openings and closings with increasing structuring element sizes to filter out iteratively both additive and subtractive noise components.

11. The top-hat concept consists of subtracting the input image from the output image of a morphological filter, or the inverse.

12. The labeling process decomposes an image into its connected components.

13. The morphological reconstruction of an image from a marker is the union of all connected components of the image that intersect that marker.

14. The area-opening operation removes all connected components with area less than a specified value.

15. Skeletonization is a classic tool for image processing that shrinks an object's boundaries to thin lines. It has been widely used in microscopy, primarily for segmentation and shape analysis.

16. Grayscale erosion (or dilation) by a flat structuring element is equivalent to a moving-minimum (moving-maximum) filter over the window defined by the structuring element.

17. The morphological gradient is defined as the subtraction of the erosion from the dilation.

18. When a flat structuring element is used, grayscale erosion, dilation, opening, closing, ASF, morphological reconstruction, alternating sequential component filters, area opening, and closing are stack filters. They can be implemented by operating on the threshold sets with their binary-equivalent operator, followed by stack reconstruction.

19. The $h$-maxima operator is a component filter that removes any peaks with height less than or equal to $h$ and decreases the height of the remaining peaks by $h$. The $h$-minima operator is its dual.

20. A regional maximum (or minimum) is a flat connected region that is on top of a peak (or at the bottom of a basin).

21. Intuitively, the watershed transform is a flood simulation, where the watershed lines separate waters flooded in from different regional minima of the image.

22. Normally, the watershed is computed on the image gradient to detect contour lines around homogeneous regions.

23. In noisy images there are normally too many minima, resulting in a watershed oversegmentation effect.

24. Watershed oversegmentation is effectively eliminated by filtering the image with closing, area-closing, or *h*-minima operators.

25. The watershed oversegmentation phenomenon can be useful to separate homogeneous from textured regions.

26. Another way to eliminate watershed oversegmentation is by using the watershed from markers technique, where water can flood only from markers instead of from all regional minima.

27. The watershed-based segmentation from markers technique typically requires inner markers for the objects and outer markers for the background.

28. The classical watershed transform can be constructed using the watershed from markers technique, and vice versa.

29. A multiscale watershed transform creates a set of nested partitions.

# References

1. E Dougherty and R Lotufo. *Hands-on Morphological Image Processing*. SPIE, 2003.
2. P Soille. *Morphological Image Analysis: Principles and Applications*, 2nd ed., Springer-Verlag, 2003.
3. SDC Morphology Toolbox for MATLAB or Python. URL: <www.mmorph.com>
4. J Serra, "Morphological Filtering: An Overview," *Signal Processing*, **38**:3–11, 1994.
5. P Salembier, A Oliveras, and L. Garrido, "Anti-extensive Connected Operators for Image and Sequence Processing." *IEEE Transactions on Image Processing*, 7:555–570, 1998.
6. P. Salembier and J. Serra, "Flat Zones Filtering, Connected Operators and Filter by Reconstruction," *IEEE Transactions on Image Processing*, **3**(8):1153–1160, 1995.
7. L Vincent, "Morphological Grayscale Reconstruction in Image Analysis: Efficient Algorithms and Applications," *IEEE Transactions on Image Processing*, 2:176–201, 1993.
8. L Vincent, "Grayscale Area Openings and Closings, Their Efficient Implementation and Applications," in *Mathematical Morphology and Its Applications to Signal Processing*, J Serra and P Salembier, eds., pp. 22–27. UPC Publications, 1993.
9. EJ Breen and R Jones, "Attribute Openings, Thinnings and Granulometries," *Computer Vision and Image Und.*, **64**(3):377–389, 1996.

10. S Beucher and F Meyer, "The Morphological Approach to Segmentation: The Watershed Transformation," in *Mathematical Morphology in Image Processing*, ER Dougherty, ed., Marcel Dekker, 1993.

11. R Lotufo and A Falcão, "The Ordered Queue and the Optimality of the Watershed Approaches," in *Mathematical Morphology and Its Application to Image and Signal Processing*, J Goutsias, L Vincent, and D Bloomberg, eds., Kluwer Academic, 2000.

12. L Vincent and P Soille, "Watersheds in Digital Spaces: An Efficient Algorithm Based on Immersion Simulations," *IEEE Transactions on Pattern Analysis and Machine Intelligence*, **13**:583–598, 1991.

13. M Grimaud, "New Measurement of Contrast: Dynamics," in *Image Algebra and Morphological Image Processing*, P Gader, E Dougherty, and J Serra, eds., SPIE-1769, 1992.

# 9

---

# Image Segmentation

Qiang Wu and Kenneth R. Castleman

## 9.1 Introduction

Image segmentation is a task of fundamental importance in digital image analysis. It is the process that partitions a digital image into disjoint (nonoverlapping) regions, each of which typically corresponds to one object. Once isolated, these objects can be measured and classified, as discussed in Chapters 10 and 11, respectively. Unlike human vision, where image segmentation takes place without effort, digital processing requires that we laboriously isolate the objects by breaking up the image into regions, one for each object [1]. Errors in the segmentation process almost certainly lead to inaccuracies in any subsequent analysis. Further, the exact location of object boundaries is subject to interpretation, and different segmentation algorithms often produce different, though not erroneous, results.

In this chapter we describe a number of techniques for locating and isolating objects in a digital image. We focus the discussion on the segmentation of 2-D gray-level images, but most of the techniques can be extended to multispectral images (see Chapter 13) and 3-D images (see Chapter 14). Segmentation is also treated in Chapter 8, for it is a major application of morphological image processing.

Image segmentation is usually approached from one of two different but complementary perspectives, by seeking to identify either the *regions* or the *boundaries* of objects in the image [2, 3]. A region is a connected set of (adjacent) pixels. In the *region-based approach*, we consider each pixel in the image and assign it to a particular region or object. In the *boundary-based approach*, either

we attempt to locate directly the boundaries that exist between the regions or we seek to identify edge pixels and then link them together to establish the required boundaries. Segmentations resulting from the two approaches may not be exactly the same, but both approaches are useful to understanding and solving image segmentation problems, and their combined use can lead to improved performance [2–4]. Real-world applications in digital microscopy often pose very challenging segmentation problems. Variations and combinations of the basic techniques presented here often must be tailored to the specific application to produce acceptable results.

### 9.1.1   Pixel Connectivity

Before introducing various methods for image segmentation, it is important to understand the concept of connectivity of pixels in a digital image (see also Chapters 8 and 14). In a set of connected pixels, all the pixels are adjacent or touching [5]. Between any two pixels in a connected set there exists a connected path wholly within the set. A *connected path* is one that always moves between neighboring pixels. Thus, in a connected set, one can trace a connected path between any two pixels without ever leaving the set.

There are two rules of *connectivity*. If only laterally adjacent pixels (up, down, right, left) are considered to be connected, we have "4-connectivity," and the objects are "4-connected." Thus a pixel has only four neighbors to which it can be connected. If diagonally adjacent (45° neighbor) pixels are also considered to be connected, then we have "8-connectivity," the objects are "8-connected," and each pixel has eight neighbors to which it can be connected. Either connectivity rule can be adopted as long as it is used consistently. Any region that is 4-connected is also 8-connected, but the converse is not necessarily true. Overall, 8-connectivity is more commonly used, and it produces results that are closer to one's intuition.

## 9.2   Region-Based Segmentation

Region segmentation methods partition an image by grouping similar pixels together into identified regions. Image content within a region should be uniform and homogeneous with respect to certain attributes, such as intensity, rate of change in intensity, color, and texture. Regions are important in interpreting an image because they typically correspond to objects or parts of objects in a scene. In this section we discuss a number of widely used techniques that fall into this category.

### 9.2.1   Thresholding

Thresholding is an essential region-based image segmentation technique that is particularly useful for scenes containing solid objects resting on a contrasting

background. It is computationally simple and never fails to define disjoint regions with closed, connected boundaries. The operation is used to distinguish between the objects of interest (also known as the *foreground*) and the background on which they lay. The output is either the label "object" or "background," which can be represented as a Boolean variable. In general, a gray-level thresholding operation can be described as

$$G(x, y) = \begin{cases} F, & \text{if } I(x, y) \geq T \\ B, & \text{if } I(x, y) < T \end{cases} \tag{9.1}$$

where $I(x, y)$ is the original image, $T$ is the threshold, $G(x, y)$ is the thresholded image, and $F$ corresponds to the foreground labeled with either a designated gray-level value or the original gray level, $I(x, y)$. Thus all pixels at or above the threshold are assigned to the foreground and all pixels below the threshold are assigned to the background, which is labeled $B$. The boundary is then that set of interior points, each of which has at least one neighbor outside the object. It should be noted that the given formulation assumes we are interested in high gray-level objects on a low gray-level background. For the converse, one can simply invert the image and the discussion here is still applicable.

Thresholding works well if the objects of interest have uniform interior gray level and rest on a background of unequal but uniform gray level. If the objects differ from the background by some property other than gray level (color, texture, etc.), one can first use an operation that converts that property to gray level. Then gray-level thresholding can segment the processed image. Thresholding can also be generalized to multivariate classification operations, in which the threshold becomes a multidimensional discriminant function classifying pixels based on several image properties. Readers interested in multivariate image thresholding and clustering are referred to [6–8] for details.

### 9.2.1.1 Global Thresholding

In the simplest implementation of thresholding, the value of the threshold gray level is held constant throughout the image. If the background gray level is reasonably constant over the image and if the objects all have approximately equal contrast above the background, then the gray-level histogram is bimodal, and a fixed global threshold usually works well, provided that the threshold, $T$, is properly selected. In most cases the threshold is determined from the gray-level histogram of the image to be segmented. In general, the choice of the threshold, $T$, has considerable effect on the boundary position and overall size of segmented objects. This, in turn, affects the values obtained from subsequent object measurement. For this reason, the value of the threshold must be determined carefully.

### *9.2.1.2 Adaptive Thresholding*

Due to uneven illumination and other factors, the background gray level and the contrast between the objects and the background often vary within the image. In such cases, global thresholding is unlikely to produce satisfactory results, since a threshold that works well in one area of the image might work poorly in other areas. To cope with this variation, one can use an adaptive, or variable, threshold that is a slowly varying function of position in the image [9].

One approach to adaptive thresholding is to partition an $N \times N$ image into nonoverlapping blocks of $n \times n$ pixels each ($n < N$), analyze gray-level histograms of each block, and then form a thresholding surface for the entire image by interpolating the resulting threshold values determined from the blocks. The blocks should be of proper size so that there is a sufficient number of background pixels in each block to allow reliable estimation of the histogram and setting of a threshold [10].

Adaptive thresholding can also be implemented as a two-pass operation [10, 11]. Before the first pass, a threshold is computed based on the histogram of each block by choosing, for example, the value located midway between the background and object peaks. Blocks containing unimodal histograms can be ignored. In the first pass, the object boundaries are defined using a gray-level threshold that is constant within each block but differs for the various blocks. The objects so defined are not extracted from the image, but the interior mean gray level of each object is computed. On the second pass, each object is given its own threshold that lies midway between its interior gray level and the background gray level of its principal block.

Figure 9.1 shows an example of applying thresholding for segmentation of human chromosomes in a microscope image. In this example, the background gray level varies due to nonuniform illumination, and contrast varies from one chromosome to the next. In Fig. 9.1a, a global threshold has been used on the

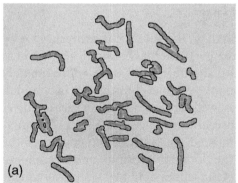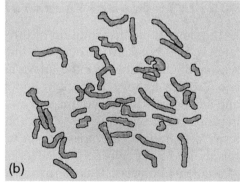

(a)                                   (b)

**FIGURE 9.1**    The results of global (a) and adaptive (b) thresholding for chromosome segmentation.

image to isolate the chromosomes. Each isolated chromosome is displayed with a boundary. In Fig. 9.1b, an adaptive threshold has been used instead. This results in fewer segmentation errors, that is, cases where multiple chromosomes are stuck together. The accuracy of the area measurement for chromosomes is improved by adaptive thresholding as well [10, 12].

### 9.2.1.3 Threshold Selection

The selection of the threshold value is crucial to the success of a thresholding operation. Unless the object in the image has very steep sides, any variation in threshold value can significantly affect the boundary position and thus the overall size of the extracted object. This means that subsequent object measurements, particularly the area measurement, are quite sensitive to the threshold value. While no universal methodology for threshold selection works on all kinds of images, a wealth of techniques have been developed to facilitate the determination of threshold values under different circumstances [13, 14].

An image containing an object on a contrasting background normally has a bimodal gray-level histogram (Fig. 9.2). The two peaks correspond to the relatively large numbers of pixels that belong to the object and to the background. The dip between the peaks corresponds to the relatively few pixels around the edge of the object. When a threshold value, $T$, is chosen, the area of the object is given by

$$\text{area} = \int_0^T H(I)dI \tag{9.2}$$

where $H(I)$ is the gray-level histogram of the image. Notice in Fig. 9.2 that increasing the threshold from $T$ to $T + \Delta T$ causes only a slight change in area if the threshold is placed at the dip in the histogram; hence the threshold chosen at or near the dip minimizes the sensitivity of the object area measurement to small variations in threshold value.

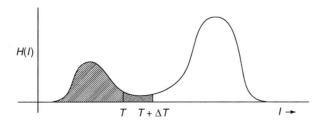

**FIGURE 9.2** A bimodal histogram. The shaded areas show the effect of threshold variation on the area of the object.

**Histogram Smoothing**  If the region of the image containing the object is small and noisy, the histogram itself will be noisy. Unless the dip is unusually sharp, the noise can make its location obscure and unreliable. This can be overcome to some extent by smoothing the histogram using either a convolution filter or a curve-fitting procedure.

A simple yet effective smoothing operation is the convolution of the input histogram with a moving-average filter, also known as a *box filter*:

$$H_{\text{output}}(i) = \frac{1}{W} \sum_{j=-(W-1)/2}^{(W-1)/2} H_{\text{input}}(i-j) \tag{9.3}$$

where $W$ is an odd number, typically chosen to be 3 or 5. This operation is designed to reduce small fluctuations without shifting the peak positions. If the two peaks are unequal in size, smoothing may tend to shift the position of the dip in the histogram, making it difficult to locate uniquely. The peaks, however, are easy to locate and relatively stable under reasonable amounts of smoothing. Therefore, placing the threshold at some designated position relative to the two peaks can be more reliable than trying to place it at the dip. In this section we introduce several methods based on different threshold selection criteria.

**The Isodata Algorithm**  The *isodata algorithm* is an iterative threshold selection technique [15]. Initially, the histogram is divided into two parts using a starting threshold, $T^{(0)}$, placed midway between the maximum and minimum gray level. Next we compute the sample mean, $\mu_F^{(0)}$, of the gray-level values associated with the foreground pixels and the sample mean, $\mu_B^{(0)}$, of the gray-level values associated with the background pixels, respectively. A new threshold value, $T^{(1)}$, is then obtained as the average of these two sample means. This process is repeated using the new threshold, until the threshold value no longer changes; that is,

$$T^{(k)} = \frac{\mu_F^{(k-1)} + \mu_B^{(k-1)}}{2}, \qquad \text{until } T^{(k)} = T^{(k-1)}, \quad k > 0 \tag{9.4}$$

**The Background Symmetry Algorithm**  The *background symmetry algorithm* works under the assumption that there is a dominant background peak in the histogram, and it is symmetrical about its maximum [16]. Preprocessing the histogram with a smoothing operation may help improve the performance of this algorithm. The position of the peak maximum, $I_{\text{max}}$, is determined by searching the entire histogram. After that, the algorithm searches on one side of the background peak that is farther away from the foreground

to locate a certain percentile point, $I_p$. Using the symmetry assumption, the threshold value is then selected on the other side of the background peak at an equal displacement from the background peak; that is,

$$T = I_{max} - (I_p - I_{max}) \tag{9.5}$$

This algorithm can easily be adapted to the case where the object peak dominates instead of the background peak and is approximately symmetrical.

**The Triangle Algorithm**   The *triangle algorithm* is known to be particularly effective when the object pixels produce a weak peak in the histogram [17], as illustrated in Fig. 9.3, where low gray-level objects reside on a high gray-level background. One first finds the maximum peak of the histogram. A line is then constructed to connect the maximum peak point $[I_{max}, H(I_{max})]$ to the lowest point $[I_{lowest}, H(I_{lowest})]$ in the histogram. This is followed by the computation and comparison of the distances between that line and all the histogram points $H(I)$, with $I$ ranging from $I_{lowest}$ to $I_{max}$. The threshold value, $T$, is taken as the value of $I$ where this distance is greatest.

**Gradient-Based Algorithms**   A variant of the preceding methods is the construction of a histogram of only those pixels having relatively high gradient magnitude [18]. This eliminates a large number of interior and exterior pixels from consideration, which may make the dip in the histogram easier to locate [19]. One can also divide the histogram by the average gradient of pixels at each gray level to enhance the dip further [18], or average the gray level of high-gradient pixels to determine a threshold [19].

### 9.2.1.4   Thresholding Circular Spots

In many important cases it is necessary to find objects that are roughly circular in shape. Suppose an image $I(x, y)$ contains a single spot. By definition, this

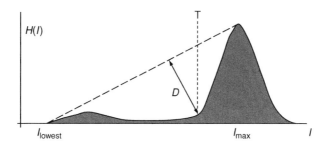

**FIGURE 9.3**   Illustration of the triangle algorithm.

image contains a point $(x_0, y_0)$ of maximum gray level. With polar coordinates centered on $(x_0, y_0)$, the image can be represented as $I(r, \theta)$ and we have

$$I(r_1, \theta) \geq I(r_2, \theta), \qquad r_2 > r_1 \tag{9.6}$$

for all values of $\theta$. If equality is not allowed in Eq. 9.6, $I(x, y)$ is a *monotone spot*. An important special case occurs if all contours of a monotone spot are circles centered on $(x_0, y_0)$. Such a special case is referred to as a *concentric circular spot* (CCS). To a good approximation, this model can be used to represent the noise-free images of certain types of cells in a microscope. For a CCS, the function $I(r, \theta)$ is independent of $\theta$, and it serves as the 1-D spot profile function. This function is useful for threshold selection. For example, one can locate the inflection point and select the gray-level threshold to place the boundary at the point of maximum slope. Other unique points on the profile, such as the maximum magnitude of the second derivative [19], can also be used. If we threshold a monotone spot at a gray level $T$, we define an object with a certain area and perimeter. As we vary $T$ throughout the range of gray levels, we generate the threshold area function, $A(T)$, and the perimeter function, $P(T)$. Both of these functions are unique for any spot. They are both continuous for monotone spots, and either is sufficient to specify a CCS completely. If two spots have identical perimeter functions or identical histograms, they are known as p-equivalent or h-equivalent, respectively. It turns out that h-equivalent spots have identical threshold area functions [19].

Analytical expressions relating the profile function to the threshold area function and the perimeter function of a CCS can be derived to guide the selection of threshold. The radius of the circular object obtained by thresholding a CCS at gray level $T$ is

$$r(T) = \left[ \frac{1}{\pi} A(T) \right]^{1/2} = \left[ \frac{1}{\pi} \int_0^T H(I) dI \right]^{1/2} \tag{9.7}$$

For a monotone spot, the histogram $H(I)$ is nonzero between its minimum and maximum gray levels. This means that the area function $A(T)$ is monotonically increasing, and so is $r(T)$. Thus the inverse function of $r(T)$ exists, and it is the spot profile. Thus we can compute the area-derived profile of a CCS by integrating the histogram to obtain the area function, followed by taking the square root and then the inverse function. Similarly, the profile may also be obtained from the perimeter function through the relationship

$$r(T) = \frac{1}{2\pi} P(T) \tag{9.8}$$

### 9.2.1.5 Thresholding Noncircular and Noisy Spots

For an image containing a noise-free CCS, we can easily obtain the profile simply by taking the gray levels along the scan line that contains the peak. Even for near-circular spots and noisy spots that analysis can still be useful. For example, one can use the histogram of a near-circular spot to obtain the profile of the h-equivalent CCS and select the threshold gray level that maximizes the slope at the boundary. On the other hand, it is useful to measure the perimeter function and determine the profile of the p-equivalent CCS. Either technique could be used to select thresholds suitable for the image under consideration. In some microscope images the noise level is so high that differentiating a single scan line cannot reliably identify the inflection point on the profile. Nonetheless, since the area-derived and perimeter-derived profiles are computed using most or all of the edge pixels in the object, the noise is reduced inherently in the process by averaging.

Further noise reduction can be achieved by smoothing the histogram or perimeter function before profile computation or by smoothing the profile function itself. The area-derived profile is easier to compute, and it has a greater noise reduction effect. Random noise in the image usually makes the spot boundary jagged. While this may have little effect on the area function, it tends to make the perimeter function erroneously large. Even though the error can be reduced by boundary smoothing built into the perimeter measurement routine, the area-derived profile clearly has the advantage of computational simplicity.

In the study described in [19], nine methods of threshold selection were compared, including two based on the area-derived profile (maximum magnitudes of the first and second derivatives) for measuring the diameter of fluorescent microspheres. Generally the method based on maximum magnitude of second derivative was found to be the most accurate of the nine for spheres of different sizes and intensities. It also performed well for cells in culture [19, 20]. Other methods tended to underestimate object size.

**Noncircular Spots**  For highly noncircular spots, the h-equivalent and p-equivalent CCS profiles may no longer be acceptable for placing the gray-level threshold. For objects of arbitrary shape, we can examine the average gradient around the boundary as a function of the threshold gray level that defines the boundary [10]. Suppose a noncircular monotone spot is thresholded at gray levels of $I$ and $I + \Delta I$, as shown in Fig. 9.4. At some point $a$ on the outer boundary, $\Delta r$ is the perpendicular distance to the inner boundary. Since $\Delta r$ is perpendicular to a contour line, it lies in the direction of the gradient vector at

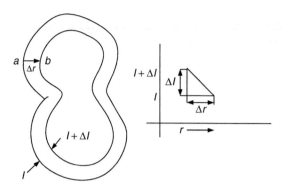

**FIGURE 9.4**    Threshold selection for a noncircular object. (After [2].)

point $a$. The magnitude of the gradient vector at point $a$ on the outer boundary is given by

$$|\nabla I| = \lim_{\Delta I \to 0} \frac{\Delta I}{\Delta r} \qquad (9.9)$$

To obtain the average gradient around the boundary, we can simply average $|\nabla I|$ around the outer boundary. If $\Delta r$ is small compared to the perimeter, the area between the two boundaries is approximately

$$\Delta A = P(I)\overline{\Delta r} \qquad (9.10)$$

where $\overline{\Delta r}$ is the average perpendicular distance from the outer to the inner boundary and $P(I)$ is the perimeter function. To obtain the average gradient around the boundary, we substitute $\overline{\Delta r}$ for $\Delta r$ in Eq. 9.9 and get

$$|\nabla I| = \lim_{\Delta I \to 0} \frac{\Delta I}{\Delta A} \cdot P(I) = \frac{P(I)}{H(I)} \qquad (9.11)$$

Hence the average boundary gradient turns out to be the ratio of the perimeter function to the histogram. This function is not difficult to compute, and it readily identifies the threshold gray level that maximizes the slope at the boundary. For noisy images, it may be beneficial to smooth the perimeter function and the histogram before this computation.

**Objects of General Shape**    Objects of arbitrary shape that are nonmonotonic and relatively flat on top (without a unique peak) usually have sides that slope uniformly down toward the background. The point spread function of microscope optical systems forbids sides of infinite slope

in real images. On the sides of the objects, the contour lines are closed and generally convex curves, but they may have local concavities. We can assume that each threshold gray level defines a single closed contour for each object. Under these conditions we need to consider only the range of gray levels corresponding to the sloping sides of the object, and the ways to establish the maximum slope threshold can be summarized as follows:

1. Select $T$ at a local minimum in the histogram. This is the easiest technique, and it minimizes the sensitivity of the area measurement to small variations in $T$.

2. Select $T$ corresponding to the inflection point in the h-equivalent CCS profile function. This is a simple computation, and it involves considerable averaging for noise reduction.

3. Select $T$ to maximize the average boundary gradient. This involves computing the perimeter function but requires no approximation regarding equivalent spot images.

4. Select $T$ corresponding to the inflection point in the p-equivalent CCS profile function.

For large-scale studies, one may use one of these methods to characterize the objects under study. Then a shortcut method can be implemented for efficiency. If a profile analysis shows, for example, that the optimal threshold gray level for isolated cells in microscope images occurs midway between the peak and the background gray level, then this simplified technique can be employed for routine use.

## 9.2.2 Morphological Processing

After thresholding, a given image is segmented into a binary image of object (foreground) and background. If this initial segmentation is not satisfactory, a set of morphological operations or the procedures based on these operations and their variants can be utilized to improve the segmentation results. The techniques of morphological processing provide versatile and powerful tools for image segmentation. The design of particular algorithms involves using one's knowledge of what effect each of the primitive operations has on an image and combining them appropriately to obtain the desired result. For a more thorough discussion of morphological operations, see Chapter 8.

Many of the binary morphological operations can be implemented as $3 \times 3$ neighborhood operations. In a binary image, any pixel, together with its eight neighbors (assuming 8-connectivity), represents 9 bits of information.

Thus there are only 512 possible configurations for a $3 \times 3$ neighborhood in a binary image. Convolution of a binary image with the $3 \times 3$ kernel

$$\begin{bmatrix} 1 & 2 & 4 \\ 8 & 16 & 32 \\ 64 & 128 & 256 \end{bmatrix}$$

generates a 9-bit (512-gray-level) image, in which the gray level uniquely specifies the configuration of the $3 \times 3$ binary neighborhood centered on that pixel. Neighborhood operations thus can be implemented with a 512-entry lookup table with 1-bit output. Whether the operation is implemented in software or in specially designed hardware, it is often much more efficient to use a lookup table for fast "pipeline processing" [21–23] than other ways of implementation.

In the general case, morphological image processing operates by sliding a structuring element over the image, manipulating a square of pixels at a time similar to convolution (Fig. 9.5). Like the convolution kernel, the structuring element can be of any size, and it can contain any complement of 1's and 0's. At each position, a specified logical operation is performed between the structuring element and the underlying binary image. The binary result of that logical operation is stored in the output image at that pixel position. The effect created depends on the size and content of the structuring element and on the nature of the logical operation.

*Binary erosion* is the process of eliminating all the boundary points from an object, leaving it smaller in area by one pixel all around the perimeter. By definition, a boundary point is a pixel that is located inside the object but that has at least one neighbor outside the object. If the object is circular, its diameter decreases by two pixels with each erosion. If it narrows to less than three pixels thick at any point, it will become disconnected (into two objects) at

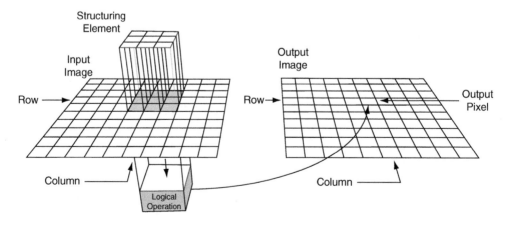

**FIGURE 9.5**   Implementation of morphological image processing operation. (After [2].)

that point. Objects no more than two pixels thick in any direction are eliminated. Binary erosion is useful for removing from a thresholded image objects that are too small to be of interest.

Conversely, *binary dilation* is the process of incorporating into the object all the background points that touch the object, leaving it larger in area by that amount. If the object is circular, its diameter increases by two pixels with each dilation. If two objects are separated by less than three pixels at any point, they will become connected (merged into one object) at that point.

### 9.2.2.1 Hole Filling

Dilation-based propagation (also known as *reconstruction*) can be used, for example, to fill interior holes of segmented objects in a thresholded image. Figure 9.6 shows an example of such a procedure. Starting from the binary segmented image of the object shown in Fig. 9.6a, one inverts this image to create a mask. Then the border of the image is used as the marker of a propagation (reconstruction) inward toward the mask. This generates the image shown in Fig. 9.6b. Inverting this propagated image produces the desired result, which contains the object with all interior holes filled (Fig. 9.6c).

### 9.2.2.2 Border-Object Removal

Another useful procedure is the removal of border-touching objects. In quantitative microscopy the objects that are connected to the image border are partially obscured and usually not suitable for subsequent analysis. In such cases one can use the procedure illustrated in Fig. 9.7 to eliminate border-touching objects. Here the binary thresholded image (in Fig. 9.7a) is used as the mask, and the border of the image is used as the marker. A propagation from the border inward toward the mask generates the image shown in Fig. 9.7b. Then computing the logical exclusive OR (XOR) operation of the propagated image and the mask image produces the image shown in Fig. 9.7c.

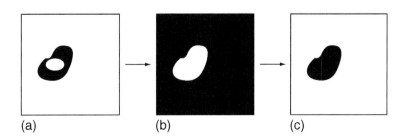

(a)                    (b)                    (c)

**FIGURE 9.6**    Filling interior holes of segmented objects using binary morphological operations.

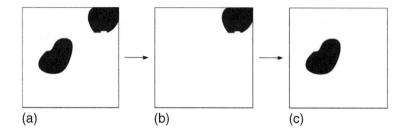

(a)                    (b)                    (c)

**FIGURE 9.7**   Removing border objects using binary morphological operations.

### 9.2.2.3  *Separation of Touching Objects*

Binary morphological processing can also be used to separate slightly touching objects that result from the segmentation process. As illustrated in Fig. 9.8, the procedure works as follows. Starting from a binary segmented image (Fig. 9.8a), compute a few erosions that are enough to separate the touching objects (Fig. 9.8b). Invert the resulting image and compute the skeleton (Fig. 9.8c). This is known as the *exoskeleton* because it is the skeleton of the background outside the objects [16]. It is then followed by computing the logical operation AND of the original binary image and the inverted skeleton image. The final result is shown in Fig. 9.8d, where the touching objects are separated.

### 9.2.2.4  *The Watershed Algorithm*

Perhaps the best-known morphological processing technique for image segmentation is the watershed algorithm. This topic is discussed extensively in Chapter 8. Figure 9.9 shows a 1-D illustration of how this approach works. For this example we assume the objects are of low gray level, on a high-gray-level background. Figure 9.9 shows the gray levels along one scan line that cuts through two objects lying close together. The image is initially thresholded at a low gray level, one that segments the image into the proper number of objects.

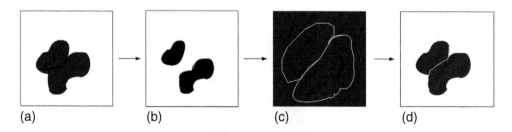

(a)                (b)                (c)                (d)

**FIGURE 9.8**   Illustration of separating touching objects. (a) A binary segmented image. (b) After a few erosions and inversion. (c) The exoskeleton. (d) Separated objects resulting from applying AND between the images in (a) and (c).

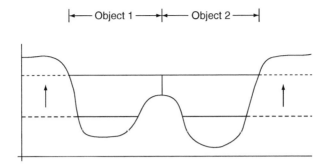

**FIGURE 9.9** Illustration of the watershed algorithm. (After [2].)

Then the threshold is raised gradually, one gray level at a time. The object boundaries will expand as the threshold increases. When they touch, however, they are not allowed to merge. Thus these points of first contact become the final boundaries between adjacent objects. The process is terminated before the threshold reaches the gray level of the background.

Rather than simply thresholding the image at the optimum gray level, the watershed approach begins with a threshold that is low enough to isolate the individual objects properly. Then the threshold is gradually raised to the optimum level, but merging of objects is not allowed. This can solve the problem posed by objects that are either touching or too close together for global thresholding to work. The final segmentation will be correct if and only if the segmentation at the initial threshold isolates the individual objects correctly. Both the initial and final threshold gray levels must be well chosen. If the initial threshold is too low, objects will be oversegmented and low-contrast objects will be missed at first and then merged with nearby objects as the threshold increases. If the initial threshold is too high, objects will be merged from the start. The final threshold value determines how well the final boundaries fit the objects. The threshold selection methods discussed in this chapter can be useful in setting these two values.

## 9.2.3 Region Growing

The fundamental limitation of histogram-based region segmentation methods, such as thresholding, is that the histograms describe only the distribution of gray levels without providing any spatial information. *Region growing* [4, 24–26] is an approach that exploits spatial context by grouping adjacent pixels or small regions together into larger regions. Homogeneity is the main criterion for merging the regions. With this approach, one begins by dividing an image into many small regions. These initial regions can be small neighborhoods or even individual pixels known as the *seeds*. In each region one computes suitably defined

functions of image property parameters that reflect on its membership in an object. The parameters that distinguish different objects may include average gray level, texture, color, etc. Thus the first step assigns to each region a set of parameters whose values reflect the object to which it belongs. Next, all boundaries between adjacent regions are examined. A measure of boundary strength is computed utilizing the differences of the parameters of the adjacent regions. A given boundary is strong if the parameters differ significantly on either side of that boundary, and it is weak if they do not. Strong boundaries are allowed to stand; weak boundaries are dissolved and the adjacent regions merged. This process is iterated by alternately recomputing the object membership parameters for the enlarged regions and once again dissolving weak boundaries, until it reaches a point where no boundaries are weak enough to be dissolved.

Region-growing methods often produce good segmentation results that correspond well to the visually apparent edges of objects in the image. Observing this procedure gives one the impression that regions in the interior of an object are growing and merging until their boundaries reach the edge of the object. Although region-growing algorithms are computationally more expensive than the simpler techniques, the methods are able to utilize several image parameters directly and simultaneously in determining the final boundary location.

Figure 9.10 shows four stages in the region-growing process for the nucleus of a squamous epithelial cell on a microscope slide. In this example, gray-level was the sole region membership parameter. Part (d) shows the final region. Note that two starting regions eventually merge into one.

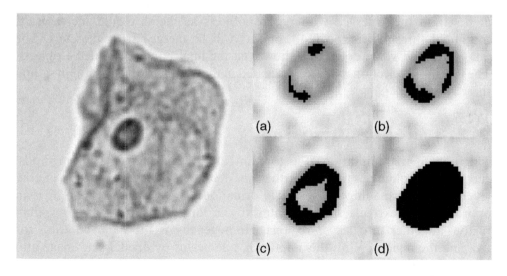

(a)          (b)

(c)          (d)

**FIGURE 9.10**    Example of region growing.

## 9.2.4   Region Splitting

Opposite to the "bottom-up" approach of region growing, region splitting is a "top-down" operation. The basic idea of region splitting is to break the image into disjoint regions within which the pixels have similar properties. In a sense, the morphological procedures discussed earlier, such as the exoskeleton and watershed algorithms, can be viewed as region-splitting methods since they work to separate touching objects. However, morphological techniques are generally more suitable for segmenting regularly shaped objects and for those cases where there are distinct bottleneck connections between touching objects.

Region splitting usually starts with the whole image as a single initial region. It first examines the region to decide if all pixels contained in it satisfy certain homogeneity criteria of image properties. Region-splitting methods generally use homogeneity criteria similar to those that region-growing methods use, and they differ only in the direction of application. In region splitting, if the criterion is met, then the region is considered homogeneous and hence left unmodified in the image. Otherwise the region is split into subregions, and each of the subregions, in turn, is considered for further splitting. This recursive process continues until no further splitting occurs.

The most commonly used region-splitting algorithms employ a pyramid image representation known as the *quadtree*. Regions are square-shaped and correspond to the nodes of the quadtree. After region splitting, the resulting segmentation may contain neighboring regions that have identical or similar image properties. Hence a merging process can be used after each split to compare adjacent regions and merge them if necessary. Such combined operations lead to the methods known as *region-splitting and -merging algorithms*, which exploit the advantages of both approaches [27]. Figure 9.11 illustrates the basic idea of these methods. We use **F** to denote the whole image (Fig. 9.11a) and suppose that not all the pixels in **F** meet the chosen criterion of homogeneity. Thus the region is split as in Fig. 9.11b. We then assume that all pixels within regions **F1**, **F2**, and **F3** are homogeneous, respectively, but that those in **F4**

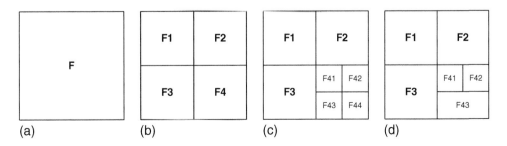

**FIGURE 9.11**   Example of region splitting and merging. (a) Whole image. (b) First split. (c) Second split. (d) Merge.

are not. Hence **F4** is split next, as in Fig. 9.11c. Now, if we assume that all pixels within each resulting region are homogeneous with respect to that region and that, after comparing all the regions, regions **F41** and **F42** are found to be identical or similar. These regions are therefore merged, as in Fig. 9.11d.

# 9.3   Boundary-Based Segmentation

The region-based methods discussed in the previous section aim to segment an image by partitioning the image into sets of interior and exterior pixels according to the similarity of certain image properties. Boundary-based techniques, on the other hand, seek to extract object boundaries directly, based on identifying the edge pixels located at the boundaries in the image. In this section we discuss a number of methods in this category.

## 9.3.1   Boundaries and Edges

In the simplest cases, for scenes containing isolated solid objects on a contrasting background, image segmentation can be readily done by thresholding. To obtain the boundaries of these objects, one can perform a dilation and an erosion of the binary segmented image separately. Then subtracting the eroded image from the dilated one will result in the object boundaries. In practice, however, input images are less ideal, and the localization of object boundaries requires more sophisticated gray-level computation.

In general, edges correspond to those points in an image where gray level changes sharply. Such sharp changes or discontinuities usually occur at object boundaries. Pixels exhibiting the characteristics of an edge can be detected and used to establish the boundaries of the objects. One can locate these pixels by computing the derivatives of the image. This is illustrated for the one-dimensional case in Fig. 9.12. Theoretically, we can detect edges either by applying a high-pass frequency filter in the Fourier domain or by convolving the image with an appropriate derivative operator in the spatial domain. In practice, however, edge detection is usually performed in the spatial domain, because it is

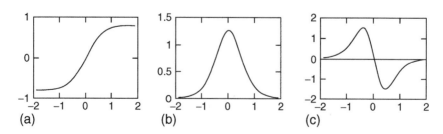

**FIGURE 9.12**    An edge and its first and second derivatives. (After [2].)

computationally less expensive and often yields better results. There are many derivative operators designed for 2-D edge detection, most of which can be categorized as gradient-based or Laplacian-based methods. The gradient-based methods detect the edges by looking for the maximum in the first derivative of the image. The Laplacian-based methods search for zero-crossings in the second derivative of the image to find edges.

## 9.3.2 Boundary Tracking Based on Maximum Gradient Magnitude

Because object or region boundaries are associated with high gradient magnitudes, one can track the boundaries based on the information in a gradient magnitude image. Suppose a gradient magnitude image is computed from a noise-free input image that contains a single object on a contrasting background. We can start the boundary tracking on this image from the highest-gray-level pixel as the first boundary point, since it is certainly on the boundary. If several points have the maximum gray level, then we choose arbitrarily. Next we search the $3 \times 3$ neighborhood centered on the first boundary point and take the neighbor with the maximum gray level as the second boundary point. If two neighbors have the same maximum gray level, we choose arbitrarily. From this point on, we begin the iterative process of finding the next boundary point, given the current and last boundary points. Working in the $3 \times 3$ neighborhood centered on the current boundary point, we examine the neighbor diametrically opposite the last boundary point and the neighbors on either side of it (Fig. 9.13a). The next boundary point is one of those three that has the highest gray level. If all three or two adjacent boundary points share the highest gray

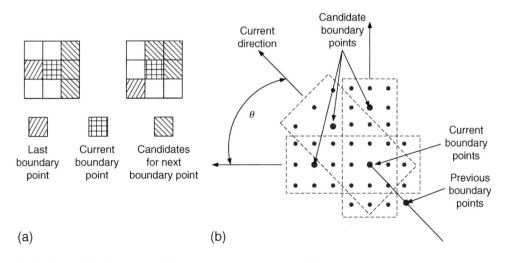

(a)                              (b)

**FIGURE 9.13**  Illustration of the boundary-tracking process. (After [2].)

level, then we choose the middle one. If the two nonadjacent points share the highest gray level, we choose arbitrarily.

With the assumption of a noise-free image of a monotone spot, this algorithm will trace out the maximum gradient boundary nicely. However, if noise is present, the tracking is likely to go away from the boundary. Noise effects can be reduced by smoothing the gradient image before tracking or by implementing a *tracking bug*, which works as follows. First a rectangular averaging window, usually having uniform weights, is defined to embody the bug (Fig. 9.13b). The last two or last few boundary points define the current boundary direction. The rear portion of the bug is centered on the current boundary point, with its axis oriented along the current direction. The bug is subsequently oriented at an angle $\theta$ to either side, looking for direction, and the average gradient under the bug is computed for each position. The next boundary point is then taken as one of the pixels under the front portion of the bug when it is in the highest average gradient position.

Essentially, the tracking bug is a spatially larger implementation of the boundary-tracking procedure described earlier. The larger size of the bug implements smoothing of the gradient image and makes it less susceptible to noise. It also limits how sharply the boundary can change directions. The size and shape of the bug may be adjusted for best performance. The "inertia" of the bug can be increased by reducing the side-looking angle $\theta$.

In practice, boundary tracking on gradient magnitude images is useful only in low-noise cases. The tracking algorithms do not guarantee closed boundaries, and they can even get lost in cases where the noise level is high.

### 9.3.3 Boundary Finding Based on Gradient Image Thresholding

If we threshold a gradient image at moderate gray level, we find both object and background below threshold and most edge points above (Fig. 9.14). Kirsch's

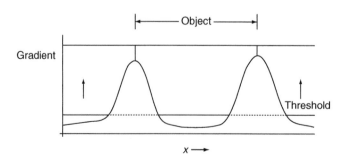

**FIGURE 9.14** One-dimensional illustration of gradient image thresholding using Kirsch's algorithm. (After [2].)

segmentation method makes use of this phenomenon [28]. In this technique, one first thresholds the gradient at a moderately low level to identify the object and the background, which are separated by bands of edge points that are above threshold. Then the threshold is gradually increased. This causes both the object and the background to grow. When they touch, they are not allowed to merge; rather, the points of contact define the boundary. This is essentially an application of the watershed algorithm to the gradient image.

While this method is computationally more expensive than thresholding, it tends to produce maximum gradient boundaries, and it avoids many of the problems of gradient tracking. For multiple object images, the segmentation is correct if and only if it is done accurately by the initial thresholding step. Smoothing the gradient image beforehand may help produce smoother boundaries.

## 9.3.4  Boundary Finding Based on Laplacian Image Thresholding

The Laplacian is a scalar second-derivative operator for 2-D images. It is defined as

$$\nabla^2 I(x, y) = \frac{\partial^2}{\partial x^2} I(x, y) + \frac{\partial^2}{\partial y^2} I(x, y) \qquad (9.12)$$

and can be implemented digitally by any of the following convolution kernels:

$$l_1 = \begin{bmatrix} 0 & -1 & 0 \\ -1 & 4 & -1 \\ 0 & -1 & 0 \end{bmatrix}, \qquad l_2 = \begin{bmatrix} -1 & -1 & -1 \\ -1 & 8 & -1 \\ -1 & -1 & -1 \end{bmatrix}, \qquad l_3 = \begin{bmatrix} 1 & -2 & 1 \\ -2 & 4 & -2 \\ 1 & -2 & 1 \end{bmatrix}$$

$$(9.13)$$

The Laplacian has the advantage that it is an isotropic measure of the second derivative. The edge magnitude is independent of the orientation and can be obtained by convolving the image with only one kernel. As a second-derivative operator, the Laplacian produces an abrupt zero-crossing at an edge that is easy to find in a noise-free image. Thresholding a Laplacian filtered image at zero gray level may produce closed connected contours at the boundaries of objects. The presence of noise, however, imposes a requirement for a smoothing operation prior to using the Laplacian. Usually, a Gaussian filter is chosen for this purpose. Since convolution is associative, we can combine the Gaussian and Laplacian into a single *Laplacian of Gaussian* (LoG) kernel [29, 30]:

$$\text{LoG}(x, y) = -\nabla^2 \frac{1}{2\pi\sigma^2} e^{-\frac{x^2+y^2}{2\sigma^2}} = \frac{1}{\pi\sigma^4} \left[ 1 - \frac{x^2 + y^2}{2\sigma^2} \right] e^{-\frac{x^2+y^2}{2\sigma^2}} \qquad (9.14)$$

This LoG filter is also known as the *Mexican hat* filter, since it has the shape of a positive peak in a negative dish. It is separable in the $x$ and $y$ directions and thus can be implemented efficiently. The parameter $\sigma$ controls the width of the peak, which is related to the amount of smoothing. The edge positions can be determined by the zero-crossings in the LoG-filtered image.

## 9.3.5   Boundary Finding Based on Edge Detection and Linking

As discussed earlier, edges are closely associated with the boundaries of objects in an image. Pixels exhibiting the required characteristics are known as *edge points*. Edge points can be detected and used to establish the boundaries. We can examine each of these pixels and its immediate neighborhood to determine if it is, in fact, on the boundary of an object. Due to noise and shading effects, edge points seldom form closed connected boundaries that are required for image segmentation. Thus a linking process is usually required to fill in the gaps and associate nearby edge points so as to create a closed connected boundary.

### 9.3.5.1   Edge Detection

The goal of edge detection is to mark the pixels in an image at which the gray level changes sharply. The two parameters of interest are the slope and direction of the transition. An image in which gray level reflects how strongly each pixel meets the requirements of an edge point is called an *edge map*, whereas an image that encodes the direction of the edge instead of the magnitude is known as a *directional edge map*. An example pair of edge map and directional edge map is the magnitude and direction of the gradient vector of an image. Edge detection operators examine each pixel neighborhood and quantify the slope (and often the direction as well) of the gray-level transition. Most of these operators perform a 2-D spatial gradient measurement on an image $I(x, y)$ using convolution with a pair of horizontal and vertical derivative kernels, $g_x$ and $g_y$. Each pixel in the image is convolved with both kernels, one estimating the gradient in the $x$ direction and the other in the $y$ direction. These kernels are designed to respond maximally to edges running horizontally and vertically relative to the pixel grid. The output of these two convolutions can be combined to form the estimated absolute magnitude of the gradient $|G|$ and its orientation $\theta$ at each pixel. This gradient magnitude is computed by taking the square root of the sum of the squares of the output from the two orthogonal kernels; that is,

$$|G| = \sqrt{G_x^2 + G_y^2} \qquad (9.15)$$

where $G_x$ and $G_y$ are the output of the estimated derivative function in the $x$ and $y$ directions, respectively,

$$G_x = I(x.y) * g_x, \qquad G_y = I(x.y) * g_y \qquad (9.16)$$

Likewise, the gradient direction can be computed from the ratio of $G_y$ and $G_x$ by

$$\theta = \arctan\left(\frac{G_y}{G_x}\right) \qquad (9.17)$$

In practical implementations, an approximation to the gradient magnitude is often used instead, for faster computation. It is given by

$$|G| = |G_x| + |G_y| \qquad (9.18)$$

In the following, we discuss several sets of widely used derivative-based kernels for edge detection.

**The Roberts Edge Detector**   The Roberts operator represents one of the earliest methods of finding edges in an image using small convolution kernels to approximate the first derivative of the image [31]. It uses the following $2 \times 2$ derivative kernels:

$$g_x = \begin{bmatrix} 1 & 0 \\ 0 & -1 \end{bmatrix}, \qquad g_y = \begin{bmatrix} 0 & 1 \\ -1 & 0 \end{bmatrix} \qquad (9.19)$$

**The Sobel Edge Detector**   The Sobel operator is characterized by the following pair of $3 \times 3$ convolution kernels [32]:

$$g_x = \begin{bmatrix} 1 & 0 & 1 \\ -2 & 0 & 2 \\ -1 & 0 & 1 \end{bmatrix}, \qquad g_y = \begin{bmatrix} -1 & -2 & -1 \\ 0 & 0 & 0 \\ 1 & 2 & 1 \end{bmatrix} \qquad (9.20)$$

Compared with the Roberts operator, the Sobel operator is a little slower to compute, but its larger convolution kernels smooth the image to a greater extent, making it less sensitive to noise. It also generally produces considerably higher output values for similar edges [32].

***The Prewitt Edge Detector*** The Prewitt operator is related to the Sobel operator and uses slightly different kernels [33]:

$$g_x = \begin{bmatrix} 1 & 0 & -1 \\ 1 & 0 & -1 \\ 1 & 0 & -1 \end{bmatrix}, \qquad g_y = \begin{bmatrix} -1 & -1 & -1 \\ 0 & 0 & 0 \\ 1 & 1 & 1 \end{bmatrix} \tag{9.21}$$

This operator produces results similar to those of the Sobel operator, but it is not as isotropic in its response.

***The Canny Edge Detector*** Generally, edge detection based on the aforementioned derivative-based operators is sensitive to noise. This is because computing the derivatives in the spatial domain corresponds to high-pass filtering in the frequency domain, thereby accentuating the noise. Furthermore, edge points determined by a simple thresholding of the edge map (e.g., the gradient magnitude image) is error-prone, since it assumes all the pixels above the threshold are on edges. When the threshold is low, more edge points will be detected, and the results become increasingly susceptible to noise. On the other hand, when the threshold is high, subtle edge points may be missed. These problems are addressed by the Canny edge detector, which uses an alternative way to look for and track local maxima in the edge map [34].

The Canny operator is a multistage edge-detection algorithm. The image is first smoothed by convolving with a Gaussian kernel. Then a first-derivative operator (usually the Sobel operator) is applied to the smoothed image to obtain the spatial gradient measurements, and the pixels with gradient magnitudes that form local maxima in the gradient direction are determined. Because local gradient maxima produce ridges in the edge map, the algorithm then performs the so-called *nonmaximum suppression* by tracking along the top of these ridges and setting to zero all pixels that are not on the ridge top. The tracking process uses a dual-threshold mechanism, known as *thresholding with hysteresis*, to determine valid edge points and eliminate noise. The process starts at a point on a ridge higher than the upper threshold. Tracking then proceeds in both directions out from that point until the point on the ridge falls below the lower threshold. The underlying assumption is that important edges are along continuous paths in the image. The dual-threshold mechanism allows one to follow a faint section of a given edge and to discard those noisy pixels that do not form paths but nonetheless produce large gradient magnitudes. The result is a binary image where each pixel is labeled as either an edge point or a nonedge point.

### 9.3.5.2 Edge Linking and Boundary Refinement

An edge map characterizes the objects in an image with edge points. If the edges are strong enough and the noise level is low, one can threshold an edge map and thin the resulting binary image down to single-pixel-wide closed connected boundaries. Under less than ideal conditions, however, the edge points seldom form closed connected boundaries required for image segmentation. Hence another step is usually required to complete the delineation of object boundaries before object extraction can be performed. *Edge linking* is the process of associating nearby edge points so as to create a closed connected boundary. This process fills in the gaps in the edge map that are often caused by noise and shading in the image.

Generally, edge linking for small gaps can be accomplished by searching a neighborhood around an endpoint for other endpoints and then filling in boundary pixels as required to connect them. Typically this neighborhood is a square region of $5 \times 5$ or larger. In complex scenes with dense edge points, however, this can oversegment the image. To avoid oversegmentation, one can require that the two endpoints agree in gradient magnitude and orientation to within specified tolerances before they are allowed to be connected.

**Heuristic Search**  For those boundary gaps in an edge map that are too wide to fill accurately with a straight line, one can establish, as a quality measure, a function that can be computed for every connected path between the two endpoints, which we denote as A and B. This edge quality function may, for example, be defined to be the average of the gradient magnitudes of the points, minus some measure of their average disagreement in orientation angles [35, 36].

The search starts by evaluating the neighbors of endpoint A as the candidates for taking the first step toward B. Normally only the neighbors that lie in the general direction of endpoint B would be considered. The one that maximizes the edge quality function from A to that point is selected. Then it becomes the starting point for the next iteration. When the linking finally reaches B, the edge quality function over the newly created path is compared to a threshold. If the newly created edge is sufficiently strong, it is accepted. Otherwise it is discarded.

Heuristic search techniques usually perform well in relatively simple images, but they do not necessarily converge to the globally optimal path between endpoints. They become computationally expensive if the gaps to be traversed are numerous and wide, in which case complicated edge quality functions must be used.

**Curve Fitting**  So far, we have discussed edge linking using searching or tracking methods. All of these require the existence of a continuous path of edge points. If the edge points are so sparse that few connected or even nearby edge

points are available, it might be desirable to fit a piecewise linear or higher-order spline curve through them to establish a boundary suitable for object extraction. For example, one can use a piecewise linear method called *iterative endpoint fitting* [37] for this purpose. Suppose there is a group of edge points lying scattered between two particular edge points A and B and that a subset of these are to be selected to form the nodes of a piecewise linear path from A to B. We start by establishing a straight line from A to B, and we continue by computing the perpendicular distance from that line to each of the remaining edge points. The furthermost one becomes the next node on the path, which now has two branches. This process is repeated on each new branch of the path until no remaining edge point lies more than a specified distance away from the nearest branch. When this type of fitting is done all around the object, it produces a polygonal approximation to the boundary.

**Hough Transform**    The Hough transform [38, 39] can detect shapes and establish object boundaries in an image by recognizing evidence in a transformed parameter space. Because the transform requires the data points to be specified in some parametric form, the technique is most commonly used to detect curves of regular shape, such as lines, circles, and ellipses. It is particularly useful when the input image is noisy and the data points are sparse.

Given an equation for a parameterized 2-D curve

$$f(x, y, t_1, \ldots, t_n) = 0 \qquad \text{where} \quad n \geq 2 \tag{9.22}$$

which defines the curve in the $(x, y)$ plane, and $t_1, \ldots, t_n$ are the parameters, one can first select a candidate set of points from the image, such as those points that have high probability of being located on object boundaries. In the $n$-dimensional parameter space, a histogram is constructed to quantify the strength of evidence with respect to different parameter values. Each edge point that satisfies Eq. 9.22 is transformed into a curve in the parameter space, and the histogram bins that lie along this curve are incremented. In this way, each edge point in the image votes for the parameterized curve it fits best, and the histogram distribution characterizes the relative strength of evidence that the curves with parameter values $t_1, \ldots, t_n$ are detected in the image.

As an example, a straight line $y = kx + b$ can be expressed in polar coordinates as [37]

$$\rho = x \cos(\theta) + y \sin(\theta) \tag{9.23}$$

where $\rho, \theta$ defines a vector from the origin to the nearest point on that line (Fig. 9.15a). This vector will be perpendicular to the line. One can consider a two-dimensional parameter space defined by $\rho$ and $\theta$. Any line in the $x, y$ plane

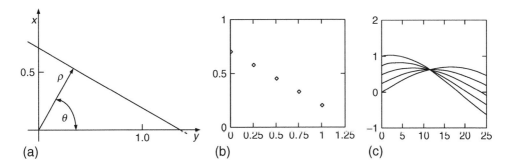

**FIGURE 9.15** Illustration of the Hough transform. (a) A straight line and its polar coordinate. (b) Sample edge points in $x$, $y$ space. (c) The sinusoids (corresponding to the edge points) in $\rho$, $\theta$ space. (After [2].)

corresponds to a point in the parameter space. Thus the Hough transform of a straight line in image space is a point in the $\rho$, $\theta$ space.

Now consider a particular point $x_1$, $y_1$ in the $x$, $y$ plane. There are many straight lines that pass through the point $x_1$, $y_1$, and each of these corresponds to a point in the $\rho$, $\theta$ space. These points, however, must satisfy Eq. 9.23 with $x_1$ and $y_1$ as constants. Thus the locus of all such lines in the $x$, $y$ space is a sinusoid in the parameter space, and any point in the $x$, $y$ space (Fig. 9.15b) corresponds to a sinusoidal curve in the $\rho$, $\theta$ space (Fig. 9.15c).

If a set of edge points $x_i$, $y_i$ lie on a straight line with parameters $\rho_0$, $\theta_0$, then each edge point corresponds to a curve in the $\rho$, $\theta$ space. However, all these curves must intersect at the point $\rho_0$, $\theta_0$, since this is a line they all have in common (Fig. 9.15c).

Thus, to find the straight-line segment on which the edge points fall, one can set up a two-dimensional histogram in the $\rho$, $\theta$ space. For each edge point $x_i$, $y_i$, all the histogram bins in the $\rho$, $\theta$ space that lie on the sinusoid curve for that point are incremented. When this is done for all the edge points, the bin containing $\rho_0$, $\theta_0$ will be a local maximum. One can then search the histogram in the $\rho$, $\theta$ space for local maxima and obtain the parameters of linear boundary segments.

Similarly, one can detect and establish boundaries of circular objects using the Hough transform. In this case the parametric equation is

$$(x - a)^2 + (y - b)^2 = r^2 \tag{9.24}$$

where $a$ and $b$ are the coordinates of the center of the circle and $r$ is its radius. Notice that the computational complexity begins to increase, because there are now three variables in the parameter space, and hence a 3-D histogram must now be constructed. In general, the computational complexity of the transform increases substantially with the number of parameters required to represent the curve. Hence, the Hough transform described here is practical only for curves

for which simple analytic parameterizations exist. Nonetheless, the advantages of the technique are the tolerance of gaps in data points and relatively robust performance when image noise is present.

**Active Contours**   Because the shape of many natural objects cannot be described accurately by rigid graph representations, such as polygons and circles, edge linking based on the techniques discussed so far often results in only coarsely delineated object boundaries. The *active contour*, or *snake*, is a boundary refinement technique [40]. The active-contour model allows a simultaneous solution for both the segmentation and tracking problems and has been applied successfully in a number of ways [41, 42]. The model uses a set of connected points (called a *snake*), which can move around so as to minimize an energy function formulated for the problem at hand. The curve formed by the connected points delineates the active contour. Properties of the image (e.g., gray level, gradient) contribute to the energy of the snake, as do constraints on the continuity and curvature of the contour itself. In this way, the snake contour can react to the image and move in a continuous manner, ensuring continuity and smoothness as it locates the desired object boundary. Furthermore, the iterative nature of the algorithm allows active adjustment of the weights employed in the energy function to affect the dynamic behavior of the active contour. Processing time is consumed mostly by the first iteration, and subsequent iterations require little additional computation time.

A number of different implementations of active contour have been described in the literature. The first seminal approach was developed using variational calculus and spline models [40]. Other approaches include dynamic programming [43], neural networks [44], and "greedy" algorithms [45]. There are various advantages and disadvantages to each approach. Since dynamic programming and neural network approaches are known to be computationally intensive, variational calculus and greedy algorithms are often preferred. Their main advantages are relative algorithmic simplicity and computational efficiency. The main disadvantage is the extremely local nature of the decision criteria used.

The crucial part of active-contour methodology is the formulation of the energy minimization function. Following the notation in [40], given a parametric representation of the snake, $v(s) = (x(s), y(s))$, where $s \in [0, 1]$, the energy function can be written as

$$
\begin{aligned}
E^*_{\text{snake}} &= \int_0^1 [E_{\text{snake}}(v(s))]\,ds \\
&= \int_0^1 \left[ E_{\text{int}}(v(s)) + E_{\text{image}}(v(s)) + E_{\text{const}}(v(s)) \right] ds
\end{aligned}
\qquad (9.25)
$$

This is simply an integration of energy along the length of the contour, which in the discrete greedy model would correspond to summing the energy of all the points on the contour after one iteration of the snake. In the greedy implementation, this integration is not actually performed. The greedy nature of the algorithm assumes that local greedy decisions at each contour point automatically result in a tendency toward a global minimum of this function. The energy terms in Eq. 9.25 correspond, respectively, to (1) internal forces between points of the contour (analogous to tension and rigidity), (2) image forces such as gradient magnitude and gray-level magnitude, and (3) external constraints. Note that each term in the energy function, $E$, once computed, must be normalized and weighted in the following manner

$$E = \omega \cdot \left[ \frac{(\min - \varepsilon)}{(\max - \min)} \right] \qquad (9.26)$$

where $\varepsilon$ is the energy term, $\omega$ is a contribution weight, and min and max are the minimum and maximum energy computations, respectively, in the search neighborhood of a contour point. The internal energy is modeled using two terms, a continuity term (tension) and a curvature term (rigidity); that is,

$$E_{\text{int}} = E_{\text{cont}} + E_{\text{curv}} \qquad (9.27)$$

Often, the continuity term is made proportional to the distance between the point being examined and the previous point on the contour. This, however, causes the snake either to contract or to expand, depending on the sign of the contribution weight. Because the snake boundary is expected to remain close to the original initialized boundary, the continuity term will be made proportional to the difference between that distance and the average interpoint distance for the snake; i.e.,

$$\varepsilon_{\text{cont}} = \bar{d} - \|v_i - v_{i-1}\| \qquad (9.28)$$

where $v_i$ denotes the coordinates of the $i$th contour point and $\bar{d}$ is the average interpoint distance, calculated at the end of each snake iteration. This will not only encourage equal spacing of points but cause the snake to contract if the interpoint distance is larger than the average and expand if it is smaller. The energy associated with the curvature at a point is approximated by taking the square of the magnitude of the difference between two adjacent unit tangent vectors,

$$\varepsilon_{\text{curv}} = \left\| \frac{\vec{u}_{i+1}}{\|\vec{u}_{i+1}\|} - \frac{\vec{u}_i}{\|\vec{u}_i\|} \right\|^2 \qquad (9.29)$$

where $\vec{u}_i = v_i - v_{i-1}$ and $\frac{\vec{u}_i}{\|\vec{u}_i\|}$ is a discrete approximation to the unit tangent at $u_i$. This gives a quick and reasonable estimate of local curvature and, in general, has the effect of causing the contour to straighten, thus favoring smoother outlines. The contributing measurement for the image energy term can be, for example, the result of a Sobel gradient operator; that is,

$$\varepsilon_{\text{image}} = \sqrt{G_x^2 + G_y^2} \qquad (9.30)$$

Note that the normalization causes the snake to be affected by relative local gradients, regardless of the strength of the gradient. This may be especially effective in localizing the characteristically low contrast cell boundaries that are often found in microscope images.

The term $E_{\text{const}}$ corresponds to external constraints that can be modeled with prior knowledge, such as the shape of the objects. For example, one can investigate the use of shape constraints to aid in the segmentation of cells with indistinct overlapping boundaries. A shape bias contributing to the energy of the snake can act as a guiding force to prevent the boundary from taking on an impossible shape.

Figure 9.16 shows an example of applying the active contour method to the delineation of cell boundary in a fluorescence microscope image. After 15 iterations of energy function minimization, the improvement in the accuracy of boundary delineation is clearly noticeable.

## 9.3.6   Encoding Segmented Images

After image segmentation, sometimes it is not necessary to extract the objects from the original image if only gross measurements (e.g., area) of each object are required. In other cases, however, it may be desirable to compose a new image

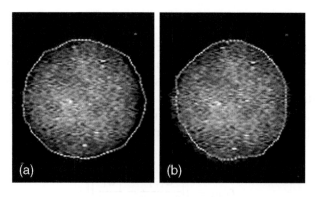

(a)

(b)

**FIGURE 9.16**   (a) A cell image with the boundary delineated after initial segmentation. (b) The same cell image with improved boundary delineation after 15 iterations of active contour computation.

showing the objects extracted or to display each object in a separate image. One may also wish to perform further measurement or other processing on each of the individual objects. Hence, encoding a segmented image in a convenient format facilitates subsequent measurement and processing of the individual objects. Usually, each object in an image is assigned a sequence number as it is found. This object number can be used to identify and track the individual objects in the image.

### 9.3.6.1 Object Label Map

From the segmented regions in an image, one can generate a separate image of size equal to the original, to encode object membership on a pixel-by-pixel basis. In the object label map, the gray level of each pixel encodes the sequence number of the object to which the corresponding pixel in the original image belongs. For instance, all pixels belonging to the 11th object in the image will have a gray level of 11 in the label map.

The object label map is not a particularly compact approach to storing segmentation information because it requires an additional full-size image to encode object membership, even when the image contains only one small object. However, images of this type of can be compressed quite significantly, since they normally contain large areas of constant gray level. If only object size and shape are of interest for subsequent analysis, the original image may be discarded after segmentation. Further data reduction is possible when there is only one object or if the objects need not be differentiated. In this case the label map becomes a binary image.

In some cases, the computation requirements of an image segmentation algorithm dictate that the process be carried out in several passes over the image data. A binary or multilevel label map is often useful as an intermediate data representation in a multiple-pass image segmentation procedure.

### 9.3.6.2 Boundary Chain Code

The boundary chain code (BCC) is another well-known technique often used to encode the results of image segmentation. Compared with the object label map, it is a more compact way to store the image segmentation information [46]. With such an approach, only the boundary is required to define an object, and therefore it is not necessary to store the location of interior pixels. Furthermore, the boundary chain code exploits the fact that boundaries are connected paths; hence, highly efficient data encoding, with little redundancy, becomes possible.

The chain code starts by specifying an arbitrarily selected starting point with coordinate $(x, y)$ located on the boundary of the object. This point has eight neighbors. At least one of these must also be a boundary point. The boundary

**FIGURE 9.17**   Boundary direction codes.

chain code specifies the direction in which a step must be taken to go from the present boundary point to the next. Figure 9.17 shows the eight directions of the neighboring pixels. The eight possible directions can be represented by three bits. Thus the boundary chain code consists of the coordinates of the starting point, followed by a sequence of direction codes that specify the path around the boundary.

With the boundary chain code, encoding the segmentation of an object requires only one $(x, y)$ coordinate and then three bits for each boundary point. This is considerably less data than that required for the object label map. When a complex scene is segmented, the program can encode each object boundary as a single record consisting of the object number, the perimeter (number of boundary points), and the chain code. Several size and shape features can also be computed directly from the chain code. If needed, even the object label map can be constructed from the boundary chain code by filling the enclosed region with the object number using a region-filling algorithm [47].

Generation of the boundary chain code usually requires random access to the input image because the boundary must be tracked through the image. The operation is a natural adjunct to the boundary-tracking and -refinement procedures of image segmentation. When further processing of individual object images is required, the chain code becomes less useful, since the interior points of objects must be accessed and computed.

## 9.4   Summary of Important Points

1.  Image segmentation is the process that partitions an image into disjoint regions consisting of connected sets of pixels. These regions correspond to either the background or the objects in the image.

2.  Region-based and boundary-based methods are different but complementary approaches to image segmentation.

3. Region-based techniques partition the image into sets of interior and exterior pixels according to similarity of image properties.

4. Boundary-based techniques establish object boundaries by detecting edge pixels that are associated with differences in image properties.

5. Gray-level thresholding is a simple region-based segmentation technique.

6. Unless the background gray level and object contrast are relatively constant, it is usually necessary to vary the threshold within the image. This is adaptive thresholding.

7. The selection of the threshold value is crucial and can significantly affect the boundaries and areas of segmented objects.

8. For images of simple objects on a contrasting background, placing the threshold at the dip of the bimodal histogram minimizes the sensitivity of object area measurement to threshold variation.

9. Both the profile function of a concentric circular spot and the average gradient around a contour line can be derived from the histogram or from the perimeter function of its image.

10. Morphological processing can improve the initial segmentation results from thresholding by using procedures such as separation of touching objects and filling of internal holes.

11. Unlike thresholding, region growing and splitting techniques exploit the spatial context in complex scenes.

12. Region growing combines adjacent regions into larger regions, within which the pixels have similar properties.

13. Region splitting partitions larger regions into smaller adjacent regions, within which the pixels have different properties.

14. Edges correspond to the image points where gray level changes abruptly, and they usually occur on object boundaries. Edge points can be detected and used to establish the boundaries of objects.

15. Gradient-based methods detect edges by looking for the pixels with large gradient magnitude.

16. Laplacian-based methods search for zero-crossings in the second derivative of the image to find edges.

17. Object boundaries can be established by thresholding either the gradient image or the Laplacian image if edges are strong and the noise level is low.

18. The detected edge points seldom form closed connected boundaries that are required for image segmentation. Therefore edge linking and boundary refinement are usually performed to complete the object boundary delineation process.

19. The Hough transform can fit a parameterized boundary function to a scattered set of edge points.

20. Active contours can be used to refine boundaries that have been found by other methods.

21. The result of image segmentation can be encoded and stored conveniently either as an object label map or as a boundary chain code.

# References

1. E Davies, *Machine Vision*, Academic Press, 1990.
2. KR Castleman, *Digital Image Processing*, Prentice-Hall, 1996.
3. R Gonzales and R Woods, *Digital Image Processing*, Addison-Wesley, 1992.
4. AK Jain, *Fundamentals of Digital Image Processing*, Prentice-Hall, 1989.
5. A Rosenfield, "Connectivity in Digital Pictures," *Journal of the ACM*, **17**:146–160, 1970.
6. JM Prats-Montalbán, A Ferrer, "Integration of Colour and Textural Information in Multivariate Image Analysis: Defect Detection and Classification Issues," *Journal of Chemometrics*, **21**(1):10–23, 2007.
7. E Bala and A Ertuzun, "A Multivariate Thresholding Technique for Image Denoising Using Multiwavelets," *EURASIP Journal on Applied Signal Processing*, **8**:1205–1211, 2005.
8. JC Noordam, WHAM van den Broek, and LMC Buydens, "Multivariate Image Segmentation with Cluster Size Insensitive Fuzzy C-means," *Chemometrics and Intelligent Laboratory Systems*, **64**(1):65–78, 2002.
9. F Liu et al., "Adaptive Thresholding Based on Variational Background," *Electronics Letters,* **38**(18):1017–1018, 2002.
10. RJ Wall, "The Gray Level Histogram for Threshold Boundary Determination in Image Processing to the Scene Segmentation Problem in Human Chromosome Analysis," PhD thesis, University of California at Los Angeles, 1974.
11. KR Castleman and R. Wall, "Automatic Systems for Chromosome Identification," in *Nobel Symposium 23—Chromosome Identification*, T Caspersson, ed., Academic Press, 1973.
12. KR Castleman and J Melnyk, "An Automated System for Chromosome Analysis: Final Report," Document No. 5040-30, Jet Propulsion Laboratory, Pasadena, CA, 1976.
13. PK Sahoo, S Soltani, and KC Wong, "A Survey of Thresholding Techniques," *Computer Vision Graphics and Image Processing*, **41**:233–260, 1988.

14. CA Glasbey, "An analysis of Histogram-Based Thresholding Operations," *Computer Graphics and Image Processing*, **55**:532–537, 1993.

15. TW Ridler and S Calvard, "Picture Thresholding Using an Iterative Selection Method," *IEEE Transactions on Systems, Man, and Cybernetics*, **8**(8):630–632, 1978.

16. IT Young, JJ Gerbrands, and LJ van Vliet, eds., *Image Processing Fundamentals*, online book at http://www.qi.tnw.tudelft.nl/Courses/FIP/noframes/fip.html.

17. GW Zack, WE Rogers, and SA Latt, "Automatic Measurement of Sister Chromatid Exchange Frequency," *Journal of Histochemistry & CytoChemistry*, **25**(7):741–753, 1977.

18. J Weszka, "A Survey of Threshold Selection Techniques," *Computer Graphics and Image Processing*, **7**:259–265, 1978.

19. ME Sieracki, SE Reichenbach, and KL Webb, "Evaluation of Automated Threshold Selection Methods for Accurately Sizing Microscopic Fluorescent Cells by Image Analysis," *Applied and Environmental Microbiology*, **55**(11):2762–2772, 1989.

20. CL Viles and ME Sieracki, "Measurement of Marine Picoplankton Cell Size by Using a Cooled, Charge-Coupled Device Camera with Image-Analyzed Fluorescence Microscopy," *Applied and Environmental Microbiology*, **58**(2):584–592, 1992.

21. SR Sternberg, "Parallel Architectures for Image Processing," *Proceedings of the 3rd International IEEE COMPSAC*, 1981.

22. SR Sternberg, "Biomedical Image Processing," *IEEE Computer*, **16**(1):22–34, 1983.

23. RM Lougheed and DL McCubbrey, "The Cytocomputer: A Practical Pipelined Image Processor," *Proceedings of the 7th Annual International Symposium on Computer Architecture*, 1980.

24. Y Tuduki et al., "Automated Seeded Region Growing Algorithm for Extraction of Cerebral Blood Vessels from Magnetic Resonance Angiographic Data," *Proceedings of the International Conference of the IEEE Engineering in Medicine and Biology Society*, **3**:1756–1759, 2000.

25. T Pavlidis and YT Liow, "Integrating Region Growing and Edge Detection," *IEEE Transactions on Pattern Analysis and Machine Intelligence*, **12**(3):225–233, 1990.

26. S Zucker, "Region Growing: Childhood and Adolescence," *Computer Graphics and Image Processing*, **5**:382–399, 1976.

27. S Chen, W Lin, and C Chen, "Split-and-Merge Image Segmentation Based on Localized Feature Analysis and Statistical Tests," *Computer Graphics and Image Processing*, **53**(5): 457–475, 1991.

28. RA Kirsch, "Computer Determination of the Constituent Structure of Biological Images," *Computers in Biomedical Research*, **4**:315–328, 1971.

29. D Marr and E Hildreth, "Theory of Edge Detection," *Proceedings of the Royal Society of London,* B **207**:187–217, 1980.

30. D Marr, *Vision*, Freeman, 1982.

31. JK Aggarwal, RO Duda, and A Rosenfeld, eds., *Computer Methods in Image Analysis*, IEEE Press, 1977.

32. LS Davis, "A Survey of Edge Detection Techniques," *Computer Graphics and Image Processing,* **4**:248–270, 1975.

33. J Prewitt, "Object Enhancement and Extraction," in *Picture Processing and Psychopictorics*, B. Lipkin and A., Rosenfeld, eds., Academic Press, 1970.

34. J Canny, "A Computational Approach to Edge Detection," *IEEE Transactions on Pattern Analysis and Machine Intelligence*, **8**:679–714, 1986.

35. R Nevatia, "Locating Object Boundaries in Textured Environments," *IEEE Transactions on Computers*, **25**:1170–1180, 1976.

36. JM Lester et al., "Two Graph Searching Techniques for Boundary Finding in White Blood Cell Images," *Computers in Biology and Medicine*, **8**:293–308, 1978.

37. RO Duda, PE Hart and D Stork, *Pattern Classification*, Wiley, 2001.

38. D Ballard and C Brown, *Computer Vision*, Prentice-Hall, 1982.

39. D Ballard, "Generalizing the Hough Transform to Detect Arbitrary Shapes," *Pattern Recognition*, **13**(2):111–122, 1981.

40. M Kass, A Witkin, and D Terzopoulos, "Snakes: Active Contour Models," *Proceedings of the First International Conference on Computer Vision*, pp. 259–269, 1987.

41. P Fua and AJ Hanson, "An Optimization Framework of Feature Extraction: Applications to Semiautomated and Automated Feature Extraction," *Proceedings of the DARPA Image Understanding Workshop*, pp. 676–694, 1989.

42. C Garbay, "Image Structure Representation and Processing: A Discussion of Some Segmentation Methods in Cytology," *IEEE Transactions on Pattern Analysis and Machine Intelligence*, **8**:140–146, 1986.

43. A Amini, S Tehrani, and TE Weymouth, "Using Dynamic Programming for Minimizing the Energy of Active Contours in the Presence of Hard Constraints," *Proceedings of the Second International Conference on Computer Vision*, pp. 95–99, 1988.

44. CT Tsai, YN Sun, and PC Chung, "Minimizing the Energy of Active Contour Model Using a Hopfield Network," *IEEE Proceedings*, **140**(6):297–303, 1993.

45. DJ Williams and M Shah, "A Fast Algroithm for Active Contours," *Computer Graphics and Image Processing*, **55**(1):14–26, 1992.

46. H Freeman, "Boundary Encoding and Processing," in *Picture Processing and Psychopictorics*, B. Lipkin and A. Rosenfeld, eds., Academic Press, 1970.

47. T Pavlidis, "Filling Algorithms for Raster Graphics," *Computer Graphics and Image Processing* **10**:126–141, 1979.

# 10

# Object Measurement

Fatima A. Merchant, Shishir K. Shah, and Kenneth R. Castleman

## 10.1 Introduction

Providing objectivity for any image processing task requires quantitative measurement of an area of interest extracted from an image or the image as a whole. In Chapter 9 we discussed methods for segmenting or extracting objects from an image. In this chapter we discuss the problem of measuring each of the segmented objects so that a quantitative measurement can be associated with the extracted image region. Measuring object properties has been a subject of study since the early 1970s and is considered to be the culmination of considerable development [1–6].

The basic objectives of object measurement are application dependent. It can be used simply to provide a measure of the object morphology or structure by defining its properties in terms of area, perimeter, intensity, color, shape, etc. It can also be used to discriminate between objects by measuring and comparing their properties. In this chapter we introduce the basic concepts of object measurement. For a more detailed treatment of the subject matter, the reader should consult the broader image analysis literature [7–11].

An image that has undergone segmentation and perhaps morphological postprocessing will clearly define objects from which measurements can be computed. The extracted objects can be treated either as binary objects or as gray-level objects. In either case, the object of interest is presented with an object label map (Chapter 9). Binary objects are typically represented such that pixels belonging to the object take a value of "1," and the remaining pixels are "0."

Object measurements can be broadly classified as (1) geometric measures, (2) ones based on the histogram of the object image, and (3) those based on the intensity of the object. Geometric measures, including those that quantify object structure, can be computed for both binary and grayscale objects. In contrast, histogram- and intensity-based measures are applicable to grayscale objects. Another category of measures, which are distance based, can be used for computing the distance between objects or between two or more components of objects. In the rest of this chapter we discuss some common measurements for both binary and gray-level objects.

## 10.2   Measures for Binary Objects

A binary object can be described in terms of its size, shape, or distance to other objects. Some common measures are presented in this section.

### 10.2.1   Size Measures

The size of an object can be defined in terms of its area and its perimeter. Area is a convenient measure of overall size. Perimeter is particularly useful for discriminating between objects with simple shapes and those with complex shapes. Compared to irregular objects that have complex structures, a regular object with a simple shape requires less perimeter to enclose its area. Both area and perimeter measurements can be performed during the extraction of an object from a segmented image.

#### 10.2.1.1   Area

Consider the function $I_n(i, j)$ described for an object label map of an $N \times N$ image (i.e., the result of segmentation as described in Chapter 9):

$$I_n(i, j) = \left\{ \begin{array}{ll} 1 & \text{if } I(i, j) = n^{\text{th}} \text{ object number} \\ 0 & \text{otherwise} \end{array} \right\} \tag{10.1}$$

The area in pixels of the $n^{\text{th}}$ object is then given by

$$A_n = \sum_{i=0}^{N-1} \sum_{j=0}^{N-1} I_n(i, j) \tag{10.2}$$

#### 10.2.1.2   Perimeter

The simplest measure of perimeter is obtained by counting the number of boundary pixels that belong to an object. This can be obtained by counting the number

of pixels that take a value of "1" and that have at least one neighboring pixel with a value of "0." The neighborhood of a pixel is normally defined in terms of either its 4-connectivity or 8-connectivity (Chapter 8). Due to the discrete spatial arrangement of pixels, counting boundary pixels is normally biased, since small changes in curvature of the boundary will result in a number of 45° or 90° turns. This produces an exaggerated estimate of the perimeter. Unbiased estimators of perimeter based on boundary pixel count using either 4-connectivity or 8-connectivity have been formulated assuming a uniform distribution of orientation changes that occur in the boundary [7, 12]. This is given as [12]

$$\frac{N_4}{1.273} \quad \text{and} \quad \frac{N_8}{0.900} \qquad (10.3)$$

where $N_4$ and $N_8$ are the boundary pixel counts using 4-connectivity and 8-connectivity, respectively.

Another concern in computing the perimeter is differentiating between the internal and external perimeter of an object. It is generally understood that the true vertex point of a boundary pixel lies at the center of that pixel. Using the location of the boundary pixels for measuring the perimeter yields the internal perimeter; using the boundary of the background pixels surrounding the object yields the external perimeter. A simple solution to this is to add $\pi$ to the internal perimeter measurements [12]. More complicated methods resulting in better estimates of perimeter measurement have been developed as well [13–15].

### 10.2.1.3 Area and Perimeter of a Polygon

Without loss of generality, we can assume any object to be a polygon. Mathematically, there is a simple way to compute both the area and the perimeter of a polygon in a single traversal of its boundary [11]. The area of a polygon can be measured as the sum of areas of all triangles formed by lines that connect the vertices of the polygon to an arbitrary point $(x_0, y_0)$. Let us assume that point to be the origin, as shown in Fig. 10.1. Consider Fig. 10.2, which shows a single triangle having a vertex at the origin. As seen in the figure, the region is divided into rectangles by the horizontal and vertical lines such that some of the rectangles have sides of the triangle as their diagonals. Thus half of each such rectangle is outside the triangle. By inspection of Fig. 10.2 we can write [11]

$$dA = x_1 y_2 - \frac{1}{2} x_2 y_2 - \frac{1}{2} x_1 y_1 - \frac{1}{2}(x_1 - x_2)(y_2 - y_1) \qquad (10.4)$$

This expression simplifies to

$$dA = \frac{1}{2}(x_1 y_2 - x_2 y_1) \qquad (10.5)$$

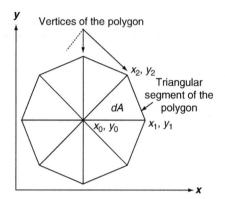

**FIGURE 10.1**    Computing the area of a polygon. (After [11].)

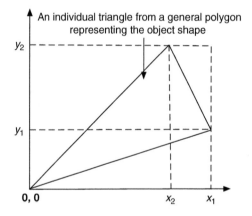

**FIGURE 10.2**    Area measurement for a triangle. (After [11].)

and the total area can be written as

$$A = \frac{1}{2} \sum_{i=1}^{N_b} [x_i y_{i+1} - x_{i+1} y_i] \qquad (10.6)$$

where $N_b$ is the total number of boundary points.

Note that, if the origin falls outside the object, an area that is not within the polygon can be included in any particular triangle. Note also that depending on the direction in which the boundary is being traversed, the area of a particular triangle can be either positive or negative. By the time a complete traversal around the boundary is complete, the area that falls outside the object has been subtracted out.

Another approach is to use Green's theorem. This says that the area enclosed by a closed curve in the $x$-, $y$-plane is given by the contour integral [11]

$$A = \frac{1}{2} \int (x\, dy - y\, dx) \tag{10.7}$$

where the integration is carried out around the closed curve. We can discretize Eq. 10.7, yielding [11]

$$A = \frac{1}{2} \sum_{i=1}^{N_b} [x_i(y_{i+1} - y_i) - y_i(x_{i+1} - x_i)] \tag{10.8}$$

and manipulate this expression into the form of Eq. 10.6. The corresponding perimeter is the sum of the side lengths of the polygon. Side lengths can easily be calculated from the boundary chain code (Chapter 9). If all boundary points are used as vertices, the perimeter will simply be the sum of lateral and diagonal steps, written as [11]

$$P = N_e + \sqrt{2}N_o \tag{10.9}$$

where $N_e$ is the number of even and $N_o$ the number of odd steps in the boundary chain code.

## 10.2.2 Pose Measures

The *pose* of an object is typically defined by its location and orientation. Measuring its centroid can indicate the location of an object. Object orientation is normally measured by computing the angle subtended by its major axis.

### 10.2.2.1 Centroid

Following the definition of Eq. 10.1, the center of the $n^{\text{th}}$ object, $(i_n^c, j_n^c)$, can be given as

$$i_n^c = \frac{1}{A_n} \sum_{i=0}^{N-1} \sum_{j=0}^{N-1} i I_n(i, j)$$

$$j_n^c = \frac{1}{A_n} \sum_{i=0}^{N-1} \sum_{j=0}^{N-1} j I_n(i, j) \tag{10.10}$$

where $A_n$ is the area of that object. Since $i$ and $j$ index the image space, the center so computed will be relative to the image coordinate space. Thus, the location of the object determined is within the two-dimensional image plane. The same measurement can also be obtained using moments and is described in Section 10.2.3.5.

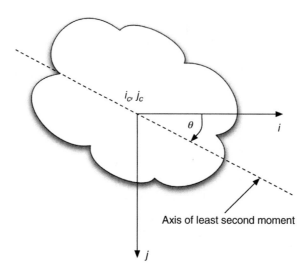

**FIGURE 10.3**    Axis of least inertia for an arbitrary shaped object. (After [18].)

### 10.2.2.2 Orientation

One method of measuring the orientation of an object is based on computing the axis of the least second moment [16]. Intuitively, this defines the axis of least inertia that can be rotated to align it with the $x$-axis. Consider the arbitrary shape shown in Fig. 10.3. If we define the orientation of least inertia for this $n^{\text{th}}$ object as $\theta_n$, it can be calculated as [11]

$$\tan(2\theta_n) = \frac{2\displaystyle\sum_{i=0}^{N-1}\sum_{j=0}^{N-1} ijI_n(i,j)}{\displaystyle\sum_{i=0}^{N-1}\sum_{j=0}^{N-1} i^2I_n(i,j) - \sum_{i=0}^{N-1}\sum_{j=0}^{N-1} j^2I_n(i,j)} \tag{10.11}$$

### 10.2.3 Shape Measures

Shape measures are increasingly used as features in object-recognition and -classification applications to distinguish objects of one class from other objects. Shape features are generally invariant to translation, rotation, and scaling. These features can be used independent of, or in conjunction with, area and perimeter measurements. In this section, we consider some commonly used shape parameters.

### 10.2.3.1 Thinness Ratio

Thinness is typically used to define the regularity of an object. Having computed the area $A$ and perimeter $P$ of an object, we can define the thinness ratio as

$$T = 4\pi \left( \frac{A}{P^2} \right) \tag{10.12}$$

This measure takes a maximum value of 1 for a circle. The same measure can also be used to quantify the roundness of an object, and it is referred to as the *compactness ratio*. Objects of regular shape have a higher thinness ratio than similar irregular ones.

### 10.2.3.2 Rectangularity

The rectangularity of an object can be measured with the rectangle fit factor [11]

$$R = \frac{A}{A_R} \tag{10.13}$$

This is simply the ratio of the object's area to the area of its *minimum enclosing rectangle* (MER), $A_R$. The MER for an object is defined as its bounding box aligned such that it encloses all the points in the object with the area minimized. To determine the MER, the object boundary is rotated through 90° in steps of ~3°. Following each stepwise rotation, a horizontally aligned bounding box is fit to the object boundary, and the minimum and maximum $x$ and $y$ values of the rotated boundary points are recorded. At a particular angle, the area of the bounding box is minimized, and this defines the MER.

The rectangle fit factor represents how well an object fills its minimum enclosing rectangle. This parameter takes on a maximum value of 1 for rectangular objects. It is bounded between 0 and 1, taking the value $\pi/4$ for circular objects and smaller values for slender, curved objects.

Another related shape measure is the aspect ratio, computed as [17]

$$\text{Aspect} = \frac{W}{L} \tag{10.14}$$

It is the ratio of the width to the length of the minimum enclosing rectangle, and it is used to distinguish slender objects from roughly square or circular objects.

### 10.2.3.3 Circularity

Circularity is a shape feature, which is minimized by the circular shape. Typically used to reflect the complexity of the object boundary, it can be written as [11]

$$C = \frac{P^2}{4\pi A} \tag{10.15}$$

which is the ratio of the perimeter squared to the area. Circular shapes yield the minimum circularity value of 1.0, and the value increases for complex shapes. Notice that it is the reciprocal of thinness ratio, defined earlier.

Another shape measure that is related to circularity is the boundary energy [4]. Consider an object with perimeter $P$. We can measure the distance around the boundary starting at some point $p$. Then at any instance, the radius of the circle tangent to the boundary at that point defines its radius of curvature, $r(p)$, as shown in Fig. 10.4. The curvature function, $K(p)$, which is periodic with period $P$ at point $p$, is written as [11]

$$K(p) = \frac{1}{r(p)} \tag{10.16}$$

The average energy per unit length of boundary is given by [11]

$$E = \frac{1}{P} \int_0^P |K(p)|^2 dp \tag{10.17}$$

The circle has, for fixed area, minimum boundary energy, given by [11]

$$E_0 = \left(\frac{2\pi}{P}\right)^2 = \left(\frac{1}{R}\right)^2 \tag{10.18}$$

where $R$ is the radius of the circle. Curvature and boundary energy can be computed from the chain code (see Chapter 9) [4, 5]. It has been shown that the boundary energy reflects the boundary complexity better than the circularity measure of Eq. 10.15 [4].

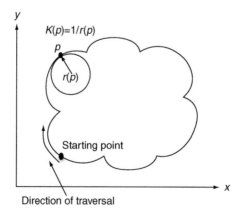

**FIGURE 10.4**  Circularity computation and radius of curvature. (After [11].)

### **10.2.3.4** **Euler Number**

For an image, the Euler number is defined as the number of objects minus the holes [19]. For an extracted object, the Euler number is used to represent the completeness of that object, and it corresponds to the number of closed curves contained within the object [20]. The determination of the number of objects and holes in an image was described earlier, in Chapters 8 and 9.

### **10.2.3.5** **Moments**

The moments of a function, which originate from probability theory [21, 22], can be used to define a group of shape features that have several desirable properties [23, 24]. For a bounded function $f(x,y)$, the set of moments of two variables is defined by [11]

$$M_{jk} = \int_{-\infty}^{\infty} \int_{-\infty}^{\infty} x^j y^k f(x, y) dx\, dy \qquad (10.19)$$

where $j$ and $k$ take on all nonnegative integer values and they generate an infinite set of moments. The set of moments, $\{M_{jk}\}$, is sufficient to specify the function $f(x, y)$ completely and is unique for the function, such that only $f(x, y)$ has that particular set of moments.

If $f(x, y)$ takes on the value 1 inside the object and 0 elsewhere, it represents a silhouette function, which ignores internal gray-level details and reflects only the shape of the object. This function can be used as a shape descriptor, such that every unique shape corresponds to a unique silhouette and the corresponding unique set of moments. The order of the moment is given by $j + k$. There is only one zero-order moment, and it gives the area of the object as

$$M_{00} = \int_{-\infty}^{\infty} \int_{-\infty}^{\infty} f(x, y) dx\, dy \qquad (10.20)$$

There are two first-order moments and correspondingly more moments of higher orders. All the higher-order moments can be normalized to be invariant to object size, by dividing them by $M_{00}$.

**Central Moments**  The so-called *central moments* are computed using the center of gravity as the origin and hence are location invariant. The coordinates of the center of gravity of the object are given by [11]

$$\mu_{10} = \frac{M_{10}}{M_{00}} \qquad \text{and} \qquad \mu_{01} = \frac{M_{01}}{M_{00}} \qquad (10.21)$$

Moments of higher order, where $j + k > 1$, are normally defined in terms of the object's location. This leads to a more generalized mathematical definition for central moments, given as

$$\mu_{jk} = \int_{-\infty}^{\infty} \int_{-\infty}^{\infty} (x - \mu_{10})^j (y - \mu_{01})^k f(x, y) dx\, dy \qquad (10.22)$$

**Object Dispersion**   The three second-order moments provide a measure of how dispersed the pixels in an object are with respect to its centroid. They correspond to $j + k = 2$ and are written as

$$\mu_{20} = M_{20} - \frac{M_{10}^2}{M_{00}}, \qquad \mu_{02} = M_{02} - \frac{M_{01}^2}{M_{00}}, \qquad \text{and}$$

$$\mu_{11} = M_{11} - \frac{M_{10} M_{01}}{M_{00}} \qquad (10.23)$$

These are proportional to the object's spread over the $x$-axis, over the $y$-axis, and in both orientations, respectively.

**Rotationally Invariant Moments**   While central moments are location invariant, they are not rotationally invariant. This means that, given a change in an object's orientation, the central moments will yield different measures. The angle of rotation $\theta$ that causes the second-order central moment to vanish can be obtained from Eq. 10.11. Then, the principal axes $x'$, $y'$ of an object are at an angle $\theta$ from the $x$-, $y$-axes. If the moments are computed relative to the principal axes or if the object is rotated through $\theta$ before the moments are computed, then the moments are rotation invariant. In general, it is desirable that object measures be invariant under simple transformations such as translation, rotation, and scale. The area-normalized central moments computed relative to the principal axis are translation, rotation, and scale invariant. Rotationally invariant moments, which are functions of the second-order moments [25], are given by

$$\mu_{20} + \mu_{02} \qquad \text{and} \qquad (\mu_{20} - \mu_{02})^2 + 4\mu_{11}^2 \qquad (10.24)$$

The magnitude of the invariant moments can be used as shape features in pattern recognition.

**Zernike Moments**   Zernike moments are derived from a complex polynomial that forms an orthogonal set from a unit circle as its domain [26]. The set of these polynomials $\{Z_{mn}(x, y)\}$ are of the form [26]

$$Z_{nm}(x, y) = Z_{nm}(\rho, \theta) = R_{nm} \exp(jm\theta) \qquad (10.25)$$

where $n \geq 0$, $m$ is an integer subject to the constraints that $n - |m|$ must be even and $|m| \leq n$, $\rho$ is the length of the vector from the origin to $(x, y)$, and $\theta$ is the angle between the vector $\rho$ and the $x$-axis in the counterclockwise direction. $R_{nm}(\rho)$ in Eq. 10.25 is a radial polynomial defined as [26]

$$R_{nm}(\rho) = \sum_{s=0}^{n-|m|/2} (-1)^s \cdot \frac{(n-s)!}{s!\left(\frac{n+|m|}{2} - s\right)!\left(\frac{n-|m|}{2} - s\right)!} \rho^{n-2s} \tag{10.26}$$

The Zernike moment of order $n$, with repetition $m$, for a continuous image function $I(x, y)$ that vanishes outside the unit circle is [26]

$$A_{nm} = \frac{n+1}{\pi} \iint_{x^2 + y^2 \leq 1} I(x, y)Z_{nm}^*(\rho, \theta)dx \, dy \tag{10.27}$$

which is the projection of the image function onto the orthogonal basis functions given in Eq. 10.25. Discretizing the integrals in Eq. 10.27, we have [26]

$$A_{nm} = \frac{n+1}{\pi} \sum_x \sum_y I(x, y)Z_{nm}^*(\rho, \theta) \qquad x^2 + y^2 \leq 1 \tag{10.28}$$

If $A_{nm}$ represents the moments associated with an image, and $A_{nm}^r$ represents the moments of the same image rotated by an angle $\phi$, then

$$A_{nm}^r = A_{nm} \cdot \exp(-jm\phi) \tag{10.29}$$

The magnitude of the Zernike moments is therefore invariant to rotation. On the other hand, they are not translation and scale invariant. Nonetheless, translation invariance can be achieved by moving the origin of the image to the centroid of the object. In typical applications requiring object shape measurements, up to eight orders of Zernike moments are used. Only moments of order 2 to 8 are relevant for discrimination purposes, since, after object normalization for scale and translation invariance, moment $|A_{00}|$ is constant and moment $|A_{11}|$ is zero [27]. Since the Zernike moments themselves are complex numbers and are sensitive to rotation of the image, typically the magnitudes of the moments (i.e., $|A_{nm}|$) are used as shape features [28].

### 10.2.3.6 Elongation

A measure used frequently to describe the shape of an object is elongation. One way of calculating this measure is by taking the ratio of an object's length to its breadth

$$El = \frac{\text{length}}{\text{breadth}} \tag{10.30}$$

Another way of defining the same thing is based on computing the bounding rectangle for the object and taking the ratio of the long side to the short side. An easy away to approximate this is by scanning the object image and finding the maximum and minimum values along the spatial indices. The ratio can then by given by

$$El = \frac{j_{max} - j_{min} + 1}{i_{max} - i_{min} + 1} \qquad (10.31)$$

The same measure can be calculated as the ratio of second-order moments of the object defining its major and minor axes. Elongation in this case would be given by

$$El = \frac{\lambda_1}{\lambda_2} \qquad (10.32)$$

where

$$\lambda_1 = \mu_{20} \sin^2 \theta + \mu_{02} \cos^2 \theta + 2\mu_{11} \sin \theta \cos \theta$$
$$\lambda_2 = \mu_{20} \cos^2 \theta + \mu_{02} \sin^2 \theta - 2\mu_{11} \sin \theta \cos \theta \qquad (10.33)$$

where $\theta$ is the angle of rotation, described in Eq. 10.11. All of the preceding measures of elongation provide similar but not necessarily identical results.

## 10.2.4   Shape Descriptors

A shape descriptor is another way of describing an object's shape. It provides a more detailed description of shape than that offered by the single parameter shape measures described earlier. Shape descriptors also allow a more compact representation of shape than what is reflected by the object image itself.

### 10.2.4.1   Differential Chain Code

The most common shape descriptors include the *boundary chain code* (BCC) and its derivative known as the *differential chain code* (DCC) [14, 29, 30]. As discussed in Chapter 9, the BCC represents the boundary tangent angles as a function of distance around the object. For a simple polygon, Fig. 10.5 shows the associated BCC and DCC. The DCC reflects the curvature of the object's boundary. Convexities and concavities in the boundary show up as peaks and valleys, respectively, in the differential chain code. Both of these functions can be analyzed further to obtain shape measures.

### 10.2.4.2   Fourier Descriptors

Fourier descriptors exploit the periodicity in the BCC representation of the boundary [31]. The complex boundary function is defined as $B(p) = x(p) + jy(p)$,

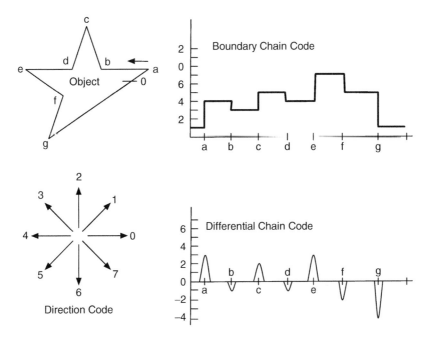

**FIGURE 10.5** The chain code and its derivative for an arbitrary shape. (After [11].)

where $x(p)$ and $y(p)$ are the coordinates of the $p^{th}$ boundary point, measured from an arbitrary starting point, and $j$ is the imaginary unit. $B(p)$ is a complex-valued periodic function with period $P$, and thus its Fourier series can be computed [11]. It is the low-frequency components in this Fourier series expansion that represent the basic shape of the object. These components are inherently shift invariant, and their complex magnitudes are rotation invariant and independent of the starting point as well. Thus they can be used as shape descriptors.

### 10.2.4.3 Medial Axis Transform

*Medial axis transformation* (MAT) is another data reduction technique that is used as a shape descriptor (Chapter 8) [11, 32]. The medial axis of an object is a set of points inside the object such that each point is the center of a circle that is tangent to the boundary at two nonadjacent points. Normally a value is associated with each point on the medial axis, and it is the minimum distance to the object boundary from that point.

The simplest technique to find the medial axis is by erosion (Chapter 8). By successively removing the outer perimeter of points, one can detect the point whose removal would disconnect the object. That point is then considered to be on the medial axis. Its associated value is simply the number of layers removed or the number of erosion iterations required. The MAT is a useful descriptor for long, narrow, and curved objects. In some applications, the medial axis is used

only as a graph, ignoring the associated values. In others, the graph is used to derive additional shape measures, such as the number of branches and the total length [33].

### 10.2.4.4   Graph Representations

Graphs have been used as a tool for translation- and rotation-invariant representation of object shapes [34]. These are descriptors that define the structure among a set of points located on the boundary of an object [35]. The two graphs used most often are the minimum spanning tree (MST) and the Delaunay triangulation (DT).

**Minimum Spanning Tree**   Consider an arbitrary shaped object as shown in Fig. 10.6a, with a set of points $n$ given by $P = \{p_1, p_2, \ldots, p_n\}$ located on the boundary. A tree is constructed by connecting pairs of points from the set so as to form a tree structure that "spans" the set of points. There are many ways to draw this tree, but if the sum of branch lengths for a particular tree is less than the sum of branch lengths for any other spanning tree, then that tree is called the *minimum spanning tree* (MST), as shown in Figure 10.6b. The MST is a type of skeleton of the object, and it can give rise to a number of shape descriptors, such as total, average, and standard deviation of branch length, average

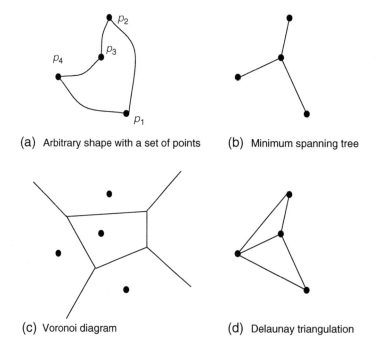

(a)  Arbitrary shape with a set of points      (b)  Minimum spanning tree

(c)  Voronoi diagram      (d)  Delaunay triangulation

**FIGURE 10.6**   An object represented with a set of boundary points and its associated graphs.

branching angle, and number of nodes. These descriptors have been used in numerous applications [36, 37].

**Delaunay Triangulation**    In representing an object using Delaunay triangulation (DT), edges are formed by joining pairs of points from the set $P = \{p_1, p_2, \ldots, p_n\}$ in such a way that as many triangles as possible are generated, but without any crossing lines. DT is a specific triangulation based on locally equiangular triangles [38] and is normally derived from the Voronoi partitioning of the object shape [39, 40]. The Voronoi diagram partitions the object into disjoint regions such that each region $R_i$ is composed of a subset of points $p_i$ and is defined as

$$R_i = \left\{ x \colon E_d(x, p_i) < E_d(x, p_j) \right\} \qquad \text{for all } j \neq i \qquad (10.34)$$

where $E_d$ is the Euclidean distance (described shortly in Section 10.3.1). The partitioning of the example object is shown in Fig. 10.6c. The DT is now defined by joining two points, $p_i$ and $p_j$, if and only if their corresponding regions share a side. The resulting triangulation is shown in Fig. 10.6d. Once the triangulation is defined for the object, it can be characterized by the same measures as the MST.

# 10.3   Distance Measures

Measures of distance provide a way to compute the separation between two points in an image [3, 41]. These can be two points within the same object (such as points on the major and minor axes) or points on two different objects. The three most common ways of measuring distance are presented here.

## 10.3.1   Euclidean Distance

Euclidean distance, by far the most commonly used measure of distance, is given by

$$D_e = \sqrt{(i - k)^2 + (j - l)^2} \qquad (10.35)$$

where the two points have spatial indices $(i, j)$ and $(k, l)$, respectively.

## 10.3.2   City-Block Distance

City-block distance is an approximation to the Euclidean measure that is computationally faster. It is also called *Manhattan distance* or the *absolute value metric*. It is written as [12]

$$D_m = |i - k| + |j - l| \qquad (10.36)$$

### 10.3.3  Chessboard Distance

The chessboard distance measure is the maximum separation in either the $x$ or $y$ direction between the two points. Also known as the *maximum value metric*, it is written as [12]

$$D_c = \max(|i - k|, |j - l|) \tag{10.37}$$

## 10.4  Gray-Level Object Measures

Object measurements derived as a function of the intensity distribution of the object are called *gray-level object measures*. Most of the measures defined earlier for binary objects can also be used for gray-level objects. There are three main categories of gray-level object measurements. Intensity and histogram measures are normally defined as first-order measures of the gray-level distribution, whereas texture measures quantify second- or higher-order relationships among gray-level values.

### 10.4.1  Intensity Measures

Images most often contain regions that show heterogeneous intensity distributions. Intensity-based measures can be used to quantify intensity variations across and between objects. Some of the commonly used measures are described next.

#### 10.4.1.1  Integrated Optical Intensity

The integrated optical density (IOD) is the sum of the gray levels of all pixels in the object [8–11]. It reflects the "mass" or "weight" of the object and is numerically equal to the area multiplied by the mean interior gray level. Consider for an object, if $(i, j)$ are the spatial indices, $I(i, j)$ represents the gray level, and $A$ is the area of the object, then

$$\text{IOD} = \sum_{i,j \in A} I(i, j) \tag{10.38}$$

#### 10.4.1.2  Average Optical Intensity

The average optical density (AOD) is merely IOD divided by area [8–11]. The total number of object pixels is the simplest measure of an object's area. Thus, the AOD of an $M \times N$ image can be calculated by

$$\text{AOD} = \frac{1}{A} \sum_{i=1}^{M} \sum_{j=1}^{N} I(i, j) \tag{10.39}$$

where $A = M \times N$ is the area of the image. For an object, the summations are taken over all pixels inside the object.

### 10.4.1.3 Contrast

A measure of contrast of an object is the brightness (AOD) difference between the object and the surrounding background.

## 10.4.2 Histogram Measures

The histogram of the image of an object provides a description of the distribution of intensity values within the object. When normalized by the size of the object, the histogram is the probability density function (pdf) of the gray levels. Thus, measures derived from the normalized histogram of the object image provide statistical descriptors characterizing the gray-level distribution of the object [8–11]. Common first-order measures calculated on the histogram include mode, mean, standard deviation, skew, energy, and entropy. Second-order measures are based on joint distribution functions and are representative of the texture of the object [42]. Consider the gray-level probability density function given as

$$P(g) = \frac{h(g)}{M} \tag{10.40}$$

where $h(g)$ is the number of pixels with gray level $g$ and $M$ is the total number of pixels in the image. Each of the first-order measures can be calculated from the pdf.

### 10.4.2.1 Mean Gray Level

Mean gray level provides a measure of the average intensity of the image. It can be calculated as

$$\bar{g} = \sum_{g=0}^{L-1} P(g) \cdot g \tag{10.41}$$

where $L$ is the number of gray levels present in the image. Note that this is the same as AOD.

### 10.4.2.2 Standard Deviation of Gray Levels

Standard deviation is a measure that provides an understanding of the spread of intensities across the image. This is also an indicator of contrast in the image. Standard deviation is measured by

$$\sigma_g = \sqrt{\sum_{g=0}^{L-1} (g - \bar{g})^2 \cdot P(g)} \tag{10.42}$$

### *10.4.2.3  Skew*

Skew measures the asymmetry in the image's intensity distribution. We can calculate skew by

$$\kappa = \frac{1}{\sigma_g^3} \sum_{g=0}^{L-1} (g - \bar{g})^3 \cdot P(g) \tag{10.43}$$

### *10.4.2.4  Entropy*

Entropy provides a measure of an image's smoothness in terms of gray-level values. The higher the entropy, the more gray levels are present in the image. Entropy can be calculated by

$$\text{Entropy} = - \sum_{g=0}^{L-1} P(g) \cdot \log_2 [P(g)] \tag{10.44}$$

### *10.4.2.5  Energy*

Energy is another measure that shows how the gray-level values are distributed within the image. It has an inverse relation to entropy, in that the energy of an image is highest if it has only one gray-level value. The more gray levels present in an object, the lower its energy. We can calculate energy as

$$\text{Energy} = \sum_{g=0}^{L-1} [P(g)]^2 \tag{10.45}$$

### **10.4.3  Texture Measures**

The word *texture* originally referred to the appearance of fabric. A general definition is "the arrangement or characteristics of the constituent elements of anything, especially as regards to surface appearance or tactile qualities" [43]. A more relevant definition for image analysis is "an attribute representing the spatial arrangement of the gray levels of pixels in a local region" [44]. In the current context, we are specifically concerned with the measurement of the texture of an object in an image. Perception of texture is scale dependent. For example, in viewing an image of a tiled floor from a distance, texture would be perceived as the repetition observed in tile placement. By contrast, observing an individual tile on the tiled floor may lead to perceiving the texture within that tile. Broadly speaking, we can define texture as patterns of local variations in image intensity that are too fine to be distinguished as separate objects at the observed resolution [18].

Electronic noise induced by a camera is an example of a *random texture*. Here the gray-level variation exhibits no recognizable repeating pattern. Cross-hatching, by contrast, is a *pattern texture* that does exhibit a visible regularity. Statistical properties such as standard deviation of gray level (i.e., texture amplitude) and autocorrelation width (i.e., texture size) are commonly used to characterize random textures. Similarly, pattern textures can be characterized by measurements that quantify the nature and directionality of the pattern, if it has any.

A *texture feature* quantifies some characteristic of the gray-level variation within an object. It is normally independent of object position, orientation, size, shape, and average brightness. Presented here are some of the more common methods for computing *texture features*.

### 10.4.3.1 Statistical Texture Measures

Statistical measures of intensity variation include standard deviation, variance, and skew. These can be computed as moments of the gray-level histogram, $H$, of the object. Similarly, a feature referred to as the *module* can be computed as [45]

$$I = \sum_{i=1}^{N} \frac{H_i - M/N}{\sqrt{\frac{H_i(1-H_i/M)+M(1-1/N)}{N}}} \tag{10.46}$$

where $M$ is the number of pixels in the object and $N$ is the number of gray levels in the grayscale. Although the human eye is insensitive to textural differences of order higher than second (i.e., the variance), texture features such as the "module" often rely on quantifiable differences, where they exist.

**Gray-Level Co-occurrence Matrix**   The gray-level co-occurrence matrix (GLCM) provides a number of second-order statistics relating to the gray-level relationships in a neighborhood around a pixel [42, 46, 47]. Computation of GLCM features is a two-step process. The GLCM is created as the first step, then it is used to compute a number of statistics, and those are the texture features.

The GLCM, $\mathbf{P}_d$, is a 2-D histogram that specifies how often two gray levels occur in pairs of pixels separated by a particular offset distance. First, one must pick the offset distance and direction. Then each entry, $(i, j)$, in $\mathbf{P}_d$ corresponds to the number of occurrences of the gray levels $i$ and $j$, in pairs of pixels that are separated, in the image, by the chosen distance and direction. Once the GLCM is formed, one can compute specific statistical values from it (see below). Selecting a different offset direction and distance gives rise to a new GLCM.

Several widely used statistical and probabilistic features can be derived from the GLCM [48, 49]. Examples include *entropy*, given by

$$H = - \sum_{i,j} \mathbf{P}_d(i,j) \log(\mathbf{P}_d(i,j)) \qquad (10.47)$$

*inertia*, which is

$$I = \sum_{i,j} (i-j)^2 \mathbf{P}_d(i,j) \qquad (10.48)$$

*energy*, defined as

$$E = \sum_{i,j} [\mathbf{P}_d(i,j)]^2 \qquad (10.49)$$

*maximum probability*, given as

$$P = \max_{i,j} \mathbf{P}_d(i,j) \qquad (10.50)$$

*inverse differential moment* (IDM), defined by

$$\text{IDM} = \sum_{i,j(i \neq j)} \frac{\mathbf{P}_d(i,j)}{(i-j)^2} \qquad (10.51)$$

and *correlation*, denoted by

$$C = \frac{1}{\sigma_i \sigma_j} \sum_{i,j} (i - \mu_i)(j - \mu_j) \mathbf{P}_d(i,j) \qquad (10.52)$$

Some co-occurrence matrix-based texture features correspond to characteristics that can be recognized by the eye [50], but many do not. In general one must determine experimentally which of these features have discriminating power.

### 10.4.3.2  Power Spectrum Features

Power spectrum features are measures of texture that are derived from the Fourier transform of the object image. The power spectrum, defined as the magnitude squared of the 2-D Fourier spectrum, gives rise to a set of texture measures. These measures can be defined by averaging the power spectrum in annular rings to produce a 1-D function that ignores directionality or by averaging along radial lines to produce a 1-D function that shows only the directionality. These one-dimensional functions of frequency (or angle) can be further reduced to single measurement values that reflect salient characteristics of the texture pattern.

# 10.5  Object Measurement Considerations

Image analysis can provide several measures of an object's structure by defining its characteristics in terms of area, perimeter, elongation, compactness, contrast, and texture, as shown in Table 10.1. The table shows object measures computed for different particle types from the urinary sediment, including, red blood cells (RBC), calcium oxalate crystals (CAOX), white blood cells (WBC), bacteria (BACT), granular casts (GRAN), cellular cast (CCST), squamous epithelial cells (SQEP), sperm (SPRM), and hyphae yeast (HYST). It is clear that size measures such as area and perimeter can be used to distinguish smaller particles, such as RBC, from the larger cells types, such as SQEP. Similarly, the elongation and compactness measures readily differentiate the circular shaped cells (e.g., RBC, WBC, and SQEP) from the elongated cells (e.g., SPRM and HYST). Finally, intensity-based measures such as contrast and texture measures can be used to differentiate between low-contrast objects (e.g., SPRM, SQEP, and HYST) and high-contrast objects, such as crystals (e.g., CAOX, RBC, and WBC) and between objects with textured interiors (e.g., SPRM, SQEP, and HYST) and relatively untextured objects (e.g., CAOX, RBC, and WBC).

In computing measurements of an object, it is important to keep in mind the specific application and its requirements. A critical factor in deciding which object measurement to use is its robustness, that is, its ability to provide consistent results in different applications. For example, if we wish to design a system that can differentiate between types of cells under different illumination conditions, we may not want to use an intensity measure, such as average optical density, as the only measurement made on the object. This would provide inconsistent results due to lighting changes that will alter the measured AOD of cells. Instead, we may wish to measure cell area. Another important consideration is the invariance of the measurement under rotation, translation, and scale. When deciding on the set of object measures to use, these considerations should guide one in identifying a suitable choice.

# 10.6  Summary of Important Points

1. Object measurements are normally computed from the binary representation of a segmented object or the gray-level intensity distribution within the object boundary.

2. Measurements of an object can be based on either its size, its shape, or its intensity values.

**TABLE 10.1**  Measurements of object structure for a variety of particle types

| Cell Type | | $A$ (µm$^2$) | $P$ (µm) | Elongation | Compactness | Contrast | Texture |
|---|---|---|---|---|---|---|---|
| | | | | | Object Measures | | |
| RBC | | 56.16 | 22.8 | 1.123 | 1.142 | 0.4874 | 127.4 |
| CAOX | | 236.16 | 50.4 | 1.034 | 1.065 | 0.8083 | 106.5 |
| WBC | | 390.24 | 63.6 | 1.119 | 1.242 | 0.5081 | 73.8 |
| BACT | | 146.88 | 49.2 | 2.429 | 1.17 | 0.1189 | 122.9 |
| GRAN | | 1121.76 | 145.2 | 2.373 | 1.451 | 0.3202 | 192.6 |
| CCST | | 1882.08 | 205.2 | 3.158 | 1.411 | 0.4852 | 183.6 |
| SQEP | | 5127.84 | 256.8 | 1.139 | 1.355 | 0.1422 | 275.2 |
| SPRM | | 416.16 | 146.4 | 2.629 | 3.680 | 0.0275 | 346.0 |
| HYST | | 918.72 | 225.6 | 3.933 | 2.670 | 0.2900 | 344.8 |

3. Area, length, width, and perimeter are common measures of object size.

4. Object shape can be captured by measures of circularity, rectangularity, moments, and Euler number, among other features.

5. Histogram measures capture the statistics of an object's gray levels.

6. Texture measures capture the statistics of an object's gray-level structure.

7. Objects can be described using compact descriptors such as a chain codes, the medial axis transform, and graphs.

# References

1. K Fukunaga, *Introduction to Statistical Pattern Recognition*, Academic Press, 1972.

2. H Blum, "Biological Science and Visual Shape (Part I)," *Journal of Theoretical Biology,* **38**:205–287, 1973.

3. RO Duda and PE Hart, *Pattern Classification and Scene Analysis*, Wiley-Interscience, 1973.

4. IT Young, JE Walker, and JE Bowie, "An Analysis Technique for Biological Shape (I)," *Information and Control*, **25**:357–370, 1974.

5. JE Bowie and IT Young, "An Analysis technique for biological shape (II)," *Acta Cytology*, **21**(3):455–464, 1977.

6. JE Bowie and IT Young, "An Analysis Technique for Biological Shape (III)," *Acta Cytology*, **21**(6):739–746, 1977.

7. L Dorst, *Discrete Straight Lines: Parameters, Primitives and Properties*, Delft University of Technology, 1986.

8. TY Young and K Fu, *Handbook of Pattern Recognition and Image Processing*, Academic Press, 1986.

9. AK Jain, *Fundamentals of Digital Image Processing*, Prentice-Hall, Englewood Cliffs, 1989.

10. R Gonzales and R Woods, *Digital Image Processing*, Addison-Wesley, 1992.

11. KR Castleman, *Digital Image Processing*, Prentice-Hall, 1996.

12. CA Glasbey and GW Horgan, *Image Analysis for Biological Sciences*, John Wiley & Sons, 1995.

13. L Dorst and AM Smeulders, "Best Linear Unbiased Estimator for Properties of Digitized Straight Lines," *IEEE Transactions on Pattern Analysis and Machine Intelligence*, **8**:276–282, 1986.

14. J Koplowitz and AM Bruchstein, "Design of Perimeter Estimators for Digitized Planar Shapes," *IEEE Transactions Pattern Analysis and Machine Intelligence*, **11(6)**:611–622, 1989.

15. L Dorst and AM Smeulders, "Length Estimators for Digitized Contours," *Computer Vision, Graphics and Image Processing*, **40**:311–333, 1987.

16. SE Umbaugh, *Computer Vision and Image Processing: A Practical Approach Using CVIPtools*, 1st ed., Prentice-Hall, 1998.
17. S Petitjean, S Ponce, and DJ Kriegman, "Computing Exact Aspect Graphs of Curved Objects: Algebraic Surfaces," *International Journal on Computer Vision*, **9**(3):231–255, 1992.
18. R Jain, R Kasturi, and BG Schunk, *Machine Vision*, McGraw-Hill, 1995.
19. SE Umbaugh, *Computer Imaging: Digital Image Analysis and Processing*, CRC Press, 2005.
20. JR Munkers, *Element of Algebraic Topology*, Perseus Press, 1993.
21. E Kreyzig, *Introductory Mathematical Statistics,* John Wiley & Sons, 1970.
22. A Papoulis, *Probability, Random Variables, and Stochastic Processes*, McGraw-Hill, 1965.
23. CH Teh and RT Chen, "On Image Analysis by the Method of Moments," *IEEE Transactions on Pattern Analysis and Machine Intelligence*, **10**:496–513, 1988.
24. FL Alt, "Digital Pattern Recognition by Moments," *Journal of ACM*, **9**:240–258, 1962.
25. MK Hu, "Visual Pattern Recognition by Moment Invariants," *IEEE Transactions on Information Theory,* **8**(2):179–187, 1962.
26. A Khotanzad and YH Hong, "Invariant Image Recognition by Zernike Moments," *IEEE Transactions on Pattern Analysis and Machine Intelligence*, **12**:489–497, 1990.
27. Y Abu-mostafa and D Psaltis, "Image Normalization by Complex Moments," *IEEE Transactions on Pattern Analysis and Machine Intelligence*, **7**(1):46–55, 1985.
28. MV Boland, MK Markey, and RF Murphy, "Automated Recognition of Patterns Characteristic of Subcellular Structures in Fluorescence Microscopy Images," *Cytometry*, **33**:366–375, 1998.
29. A Rosenfeld, "Survey: Image Analysis and Computer Vision," *Computer Vision and Image Understanding*, **66**(1):33–93, 1977.
30. DH Ballard and CM Brown, *Computer Vision*, Prentice-Hall, 1982.
31. CT Zahn and RZ Roskies, "Fourier Descriptors for Plane Closed Curves," *IEEE Transactions on Computers, C-***21**:269–281, 1972.
32. RJ Wall, A Kilnger, and S Harami, "An Algorithm for Computing the Medial Axis Transform and Its Inverse," in *Workshop on Picture Data Description and Management*, IEEE Computer Society, 1977.
33. RM Haralick, SR Sternberg, and X Zhuang, "Image Analysis Using Mathematical Morphology," *IEEE Transactions on Pattern Analysis and Machine Intelligence*, **9**:532–550, 1987.
34. GT Toussaint, "The Relative Neighborhood Graph of a Finite Planar Set," *Pattern Recognition*, **12**:261–268, 1980.
35. CT Zahn, "Graph-Theoretical Methods for Detecting and Describing Gestalt Clusters," *IEEE Transactions on Computers*, **20**:68–86, 1971.
36. B Rosenberg and DJ Langridge, "A Computational View of Perception," *Perception*, **2**(4):415–424, 1973.

37. B Weyn et al., "Computer-Assisted Differential Diagnosis of Malignant Mesothelioma Based on Syntactic Structure Analysis," *Cytometry*, **35**(1):23–29, 1999.

38. R Sibson, "Locally Equiangular Triangulation," *Computer Journal*, **21**:243–245, 1978.

39. BA Lewis and JS Robinson, "Triangulation of Planar Regions with Applications," *Computer Journal*, **21**:324–332, 1978.

40. PJ Green and R Sibson, "Computing Dirichlet Tessalations in the Plane," *Computer Journal*, **21**(2):168 173, 1978.

41. RO Duda, PE Hart, and DG Stork, *Pattern Classification*, John Wiley & Sons, 2001.

42. RM Haralick, "Statistical and Structural Approaches to Texture," *Proceedings of IEEE*, **67**(5):786–804, 1979.

43. SI Landau, *Webster Illustrated Contemporary Dictionary*, Doubleday, 1982.

44. IEEE Standard 601.4-1990, *IEEE Standard Glossary of Image Processing and Pattern Recognition Terminology*, IEEE Press, 1990.

45. GE Lowitz, "Can a Local Histogram Really Map Texture Information?," *Pattern Recognition*, **16**(2):141–147, 1983.

46. SH Peckinpaugh, "An Improved Method for Computing Gray-Level Co-occurence Matrix–Based Texture Measures," *Computer Vision, Graphics and Image Processing*, **53**(6):574–580, 1991.

47. P Kruzinga and N Petkov, "Nonlinear Operator for Oriented Texture," *IEEE Transactions on Image Processing*, **8**(10):1395–1407, 1999.

48. M Tuceryan and AK Jain, "Texture Analysis," in *Handbook of Pattern Recognition and Computer Vision*, CH Chen, LF Pau, and PP Wang, eds., World Scientific, 1993.

49. RM Haralick and LG Shapiro, *Computer and Robot Vision*, Addison-Wesley, 1992.

50. H Tamura, S Mori, and T Yamawaki, "Texture Features Corresponding to Visual Perception," *IEEE Transactions on Systems, Man and Cybernetics*, **8**:460–473, 1978.

# 11

# Object Classification

Kenneth R. Castleman and Qiang Wu

## 11.1 Introduction

Classification is the step that tells us what is in the image. Assuming the objects in the image have been segmented and measured, classification identifies them by assigning each of them to one of several previously established categories or classes. There are several mathematical approaches that can be taken to address the classification problem, and a complete coverage is beyond our scope. Here we illustrate the process of classification with the very useful maximum-likelihood method. This technique is widely used because it minimizes the probability of making an incorrect assignment. More specifically, we present the minimum Bayes risk classifier, assuming Gaussian statistics, along with several of its interesting special cases. We also address other classification strategies.

## 11.2 The Classification Process

When we encounter an object in a microscopic image, we know three things about it. First, we know the *a priori probability* that it belongs to each of the classes. For example, if we are attempting to separate abnormal from normal cells, we might know from past experience that 90% of all cells encountered are normal. Thus the a priori probability for class 1 (normal) is 0.9, while for class 2 (abnormal) it is 0.1:

$$P(C_1) = 0.9 \quad \text{and} \quad P(C_2) = 0.1 \quad (11.1)$$

This knowledge applies to all of the objects. Quite a large sample size may be required to estimate the a priori probabilities [1]. Second, we know the object's measured feature values. This is the quantitative data that is unique to that particular object. Third, we know the probability density function (pdf) of those features for each of the classes. This specifies what is known about each class. Given these three pieces of knowledge, we seek to make an optimal assignment of that object to a class. For the moment we take the probability of error as the performance criterion, and we seek to minimize it.

## 11.2.1  Bayes' Rule

We now consider how to combine the three things we know about an object to find its most likely class. After an object has been measured, we should be able to use the measurement data and the class-conditional pdfs to improve our knowledge of the object's most likely class membership. The *a posteriori probability* that the object belongs to class *i* is given by Bayes' theorem; that is,

$$P(C_i|x) = \frac{P(C_i)p(x|C_i)}{p(x)} \tag{11.2}$$

where $P(C_i)$ is the a priori probability of class *i*, $p(x|C_i)$ is the pdf of the feature *x* for class *i*, and

$$p(x) = \sum_{i=1}^{N} p(x|C_i)P(C_i) \tag{11.3}$$

is the normalization factor that is required to make the set of a posteriori probabilities sum to unity. Bayes' theorem, then, allows us to combine the a priori probabilities of class membership with the measurement data and the class-specific pdf to compute the probability that the measured object belongs to each class. Given this information, we can assign each object to its most likely class.

## 11.3  The Single-Feature, Two-Class Case

To illustrate the classification process, we first consider the simple case where two types of objects must be sorted on the basis of a single measurement. For this example, assume we are attempting to separate abnormal from normal cells on the basis of nuclear diameter alone. This means that the cells encountered belong either to class 1 (normal) or to class 2 (abnormal). For each cell,

we measure one property, nuclear diameter, and this is the feature we call $x$. It may be that the pdf of the diameter measurement, $x$, is already known for one or both classes of cells. If not, we would have to estimate it by measuring a large number of normal and abnormal cells and plotting histograms of their nuclear diameters. After normalization to unit area and perhaps some smoothing, these histograms can be taken as estimates of the corresponding pdfs. If the histogram fits the Gaussian form, to a reasonable approximation, we can compute the mean, $\mu$, and variance, $\sigma$, and use the parametric representation for the normal distribution

$$p(x) = \frac{1}{\sqrt{2\pi}} e^{-\frac{(x-\mu)^2}{2\sigma^2}} \tag{11.4}$$

There are other standard statistical distributions for the pdf that might fit the histograms if the Gaussian does not. If we use the Gaussian, then only the mean and variance are required to completely specify the pdf for a class.

## 11.3.1 A Priori Probabilities

The a priori probabilities represent our knowledge about an object before it has been measured. In this example, we assume that an unmeasured cell has a 9:1 chance of being normal (Eq. 11.1).

## 11.3.2 Conditional Probabilities

Figure 11.1 shows what the two pdfs might look like. We denote the conditional pdf for normal cell diameter as $p(x|C_1)$, which can be read as "the probability

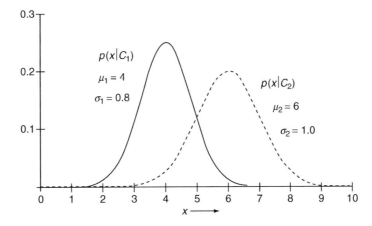

**FIGURE 11.1** Probability density functions for a two-class problem.

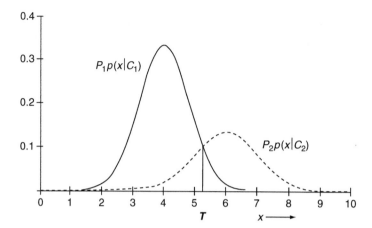

**FIGURE 11.2**  Probability density functions for a two-class problem, scaled by the a priori probabilities.

that diameter $x$ will occur, given that the cell belongs to class 1." Similarly, $p(x|C_2)$ is the probability that diameter $x$ will occur, given cell class 2 (abnormal).

If we scale each of the pdfs by the a priori probability of its class, as in Figure 11.2, we get a better picture of the error situation. We could establish a decision rule by setting a threshold value, $T$, on the nuclear diameter and classifying cells normal if they fall below that and abnormal if they fall above it. The area under the dotted curve, to the left of the threshold, is proportional to the probability of calling an abnormal cell normal. Similarly, the area under the solid curve, to the right of the threshold, is proportional to the probability of misclassifying a normal cell.

## 11.3.3  Bayes' Theorem

Before a cell has been measured, our knowledge of it consists of only the a priori probabilities of class membership. After measurement, however, we can use the measurement and the conditional pdfs to improve our knowledge of the cell's class membership. After measurement, the a posteriori probability that the object belongs to class $i$ is given by Bayes' theorem [2–5]

$$P(C_i|x) = \frac{P(C_i)p(x|C_i)}{p(x)} \tag{11.5}$$

where $P(C_i)$ is the a priori probability of class $i$, $p(x|C_i)$ is the pdf of the feature $x$ for class $i$, and

$$p(x) = \sum_{i=1}^{N} p(x|C_i)P(C_i) \tag{11.6}$$

is a normalization factor that is required to make the set of a posteriori probabilities sum to unity. Bayes' theorem, then, allows us to combine the

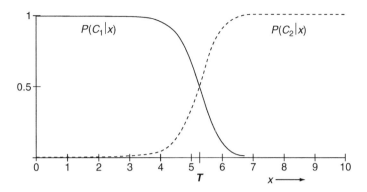

**FIGURE 11.3** A posteriori probabilities for the two-class problem.

a priori probabilities of class membership with the measurement and the class-specific pdf to compute the probability that the measured object belongs to each class. Figure 11.3 shows the a posteriori probabilities for this example. For any nuclear diameter $x$, the solid curve gives the probability that a cell having that diameter belongs to class 1. The dotted curve gives the probability that the cell belongs to class 2.

In our cell-sorting example, we would assign the object to class 1 (i.e., call it normal) if

$$P(C_1|x) > P(C_2|x) \tag{11.7}$$

and assign it to class 2 (abnormal) otherwise. At the decision threshold, $T$, where equality holds in Eq. 11.7, we may assign arbitrarily. The classifier defined by this decision rule is called a *maximum-likelihood classifier* because it maximizes the probability of a correct assignment. Note in Fig.11.3 that cells with nuclear diameter less than 4 micrometers can be confidently assigned to class 1, while cells larger than 6 micrometers easily can be called abnormal. It is for cells with nuclear diameter near 5 micrometers that one would expect misclassification errors to occur.

# 11.4 The Three-Feature, Three-Class Case

We next consider the case where there are three types of objects and three measurements are made on each. The particular example we use here is the classification of pixels in a color image. The three measurements made on each

pixel are the red, green, and blue intensity values. We assume that each pixel belongs to one of three classes: the interior of a normal cell, the interior of an abnormal cell, or the background.

Each pixel can be considered to represent a point in three-dimensional color space. Thus each of the different-colored objects in the image will correspond to a "cloud" of points in color space, and segmentation becomes the task of isolating these clusters. More specifically, we wish to define a set of decision surfaces that carve up the space into three disjoint regions, one for each class.

## 11.4.1 Bayes Classifier

One straightforward and quite powerful approach is the use of the Bayes maximum-likelihood classifier. It generates second-order surfaces that partition the color space into disjoint regions, one for each object type (i.e., for each color of pixel). Assuming Gaussian distributions for the clusters of points in color space, the Bayes classifier maximizes the probability that each pixel will be assigned correctly.

We illustrate the use of the Bayes classifier with a simple example. We assume that a three-color RGB (red, green, blue) system is used to digitize a fluorescent microscope image. The vector of gray levels at a single pixel location is

$$\mathbf{x} = [x_j] = \begin{bmatrix} x_1 \\ x_2 \\ x_3 \end{bmatrix} \tag{11.8}$$

where

$$j = \begin{cases} 1 & \Rightarrow & \text{red} \\ 2 & \Rightarrow & \text{green} \\ 3 & \Rightarrow & \text{blue} \end{cases}$$

We further assume that the images contain two types of objects, normal and abnormal cells. Both types of cells bind the blue fluor, the normals also bind the green fluor, but the abnormals pick up the red fluor instead. One would expect a three-dimensional histogram (scatter plot) of the color space to show three clusters of points, one each for background, normal cells, and abnormal cells. Since the background is dark, its cluster will fall near the origin of color space. The normal cells will give rise to a cloud of points near the cyan corner, while the abnormals will fall near the magenta corner, as in Fig. 11.4.

### 11.4.1.1 Prior Probabilities

Let us assume that the area of a typical image is 90% occupied by background and 10% by cells. Further assume that, overall, only 10% of the cells are abnormal.

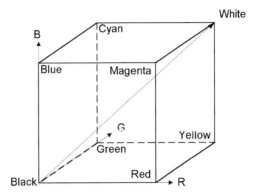

**FIGURE 11.4** The three-dimensional RGB color space.

Thus the vector of prior probabilities, where $P_i = P\{\text{pixel belongs to class } i\}$, is

$$\mathbf{P} = \begin{bmatrix} 0.90 \\ 0.09 \\ 0.01 \end{bmatrix} \tag{11.9}$$

where

$$i = \begin{cases} 1 & \Rightarrow & \text{background} \\ 2 & \Rightarrow & \text{normal} \\ 3 & \Rightarrow & \text{abnormal} \end{cases}$$

### 11.4.1.2  Classifier Training

The first step is to train the classifier to recognize the three types of pixels. For this we require a training set containing pixels that are known to fall in the background, inside normal cells, and inside abnormal cells. It is the statistics of these training set pixels that constitute the knowledge the classifier has about the problem. Estimating these statistics is the process of classifier training.

### 11.4.1.3  The Mean Vector

Using the training set, we calculate, for each class $i$, the mean pixel brightness in each color $j$. That is,

$$\mu_{ij} = \frac{1}{N_i} \sum_{k=1}^{N_i} x_{ijk} \tag{11.10}$$

where $N_i$ is the number of pixels in class $i$ and $x_{ijk}$ is the value, in color $j$, of pixel $k$ in class $i$ of the training set. The mean vector for class $i$ is

$$\boldsymbol{\mu}_i = \begin{bmatrix} \mu_{i1} \\ \mu_{i2} \\ \mu_{i3} \end{bmatrix} \tag{11.11}$$

This vector, the mean vector of the training set, is an estimate of the mean of the entire population of class $i$ pixels. If the training set is both adequately large and representative of the population, it will be a good estimate. Otherwise, it will be a poor estimate, and classifier accuracy will suffer, as will our ability to predict how well it will work.

### 11.4.1.4  Covariance

We calculate the covariance matrix for each class [2, 3, 6] as

$$\mathbf{S}_{ij_1j_2} = \frac{1}{N_i - 1} \left[ \sum_{k=1}^{N_i} x_{ij_1k} x_{ij_2k} - N_i \mu_{ij_1} \mu_{ij_2} \right] \tag{11.12}$$

### 11.4.1.5  Variance and Standard Deviation

The diagonal elements of a covariance matrix are the variances of the features for that class. The variance is the square of the standard deviation. That is,

$$\sigma_{ij}^2 = S_{ijj} \qquad \text{and} \qquad \sigma_{ij} = \sqrt{S_{ijj}} \tag{11.13}$$

### 11.4.1.6  Correlation

From the covariance matrix we can compute the correlation matrix for each class [2, 3, 6]. For class $i$, this is

$$\mathbf{C}_{ij_1j_2} = \frac{\mathbf{S}_{ij_1j_2}}{\sigma_{ij_1} \sigma_{ij_2}} \tag{11.14}$$

The elements of the correlation matrix are bounded by $\pm 1$. A correlation of 1 means the corresponding two features are proportional to each other. A correlation of $-1$ means each is proportional to the negative of the other. A correlation of zero means the two features are uncorrelated. Using highly correlated features is not only redundant, but it can actually degrade classifier accuracy. One can either combine highly correlated features (by averaging, for example) or simply discard all but one of them. In this example we assume the features are not highly correlated.

### 11.4.1.7  The Probability Density Function

The probability density function for class $i$ is

$$p_i(\mathbf{x}) = \frac{1}{\sqrt{(2\pi)^n |\mathbf{S}_i|}} \exp\left[-\frac{1}{2}\left|(\mathbf{x} - \boldsymbol{\mu}_i)^T \mathbf{S}_i^{-1}(\mathbf{x} - \boldsymbol{\mu}_i)\right|\right] \qquad (11.15)$$

where $\mathbf{x}$ is the vector of RGB values for a pixel, as in Eq. 11.8, and $n = 3$ is the number of features in use. The superscript $T$ indicates the matrix transpose, and $\mathbf{S}_i^{-1}$ is the inverse of the covariance matrix for class $i$. Equation 11.15 is the multidimensional generalization of Eq. 11.4.

### 11.4.1.8  Classification

Each class of pixels is now characterized by its prior probability, mean vector, and covariance matrix. The classifier has been trained. We now have enough statistical information about the problem to begin classifying pixels. By Bayes' rule, the likelihood that an unknown pixel having color vector $\mathbf{x}$ belongs to class $i$ is

$$L_i = P_i \frac{pdf_i(\mathbf{x})}{p(\mathbf{x})} \qquad \text{where} \qquad p(\mathbf{x}) = pdf_1(\mathbf{x}) + pdf_2(\mathbf{x}) + pdf_3(\mathbf{x}) \qquad (11.16)$$

or

$$L_i = \frac{P_i}{p(\mathbf{x})\sqrt{(2\pi)^3 |\mathbf{S}_i|}} \exp\left[-\frac{1}{2}\left|(\mathbf{x} - \boldsymbol{\mu}_i)^T \mathbf{S}_i^{-1}(\mathbf{x} - \boldsymbol{\mu}_i)\right|\right] \qquad (11.17)$$

Thus we can compute the three likelihoods (one for each class) and assign the pixel to the most likely (largest likelihood) class. If the pdfs are, as we have assumed, Gaussian (normal) density functions, then no other partitioning of color space will result in lower overall error rates [2].

### 11.4.1.9  Log Likelihoods

Since the logarithm is a monotonic function, we can take the log of both sides of Eq. 11.17 and use the resulting value for classification purposes. Equation 11.17 then becomes

$$\begin{aligned}
\ln(L_i) = \ln(P_i) - \frac{1}{2}\left|(\mathbf{x} - \boldsymbol{\mu}_i)^T S_i^{-1}(\mathbf{x} - \boldsymbol{\mu}_i)\right| \\
- \frac{3}{2}\ln(2\pi) - \frac{1}{2}\ln(|\mathbf{S}_i|) - \ln\big(p(\mathbf{x})\big)
\end{aligned} \qquad (11.18)$$

The third and fifth terms are constants and, for classification purposes, can be dropped, leaving

$$LL_i = \ln(P_i) - \frac{1}{2}\left|(\mathbf{x} - \boldsymbol{\mu}_i)^T S_i^{-1}(\mathbf{x} - \boldsymbol{\mu}_i)\right| - \frac{1}{2}\ln(|\mathbf{S}_i|) \qquad (11.19)$$

The first term accounts for the prior probabilities, while the third term accounts for the within-class scattering of the features. The larger this variation, the less confidently one can assign the pixel to that class. The second term is the square of the *Mahalanobis distance*. It represents the variance-normalized distance, in feature space, from the unknown color to the class mean.

### 11.4.1.10  Mahalanobis Distance Classifier

We can simplify the Bayes classifier further by computing only the Mahalanobis distance from an unknown pixel to each class mean,

$$D_i = \sqrt{\frac{1}{2}\left|(\mathbf{x} - \boldsymbol{\mu}_i)^T S_i^{-1}(\mathbf{x} - \boldsymbol{\mu}_i)\right|} \qquad (11.20)$$

and assigning each pixel to the class having the nearest mean. This results in what is called a *Mahalanobis distance classifier*. It corresponds to the special case where the prior probabilities are equal among the classes, and likewise for the within-class variations. This distance classifier is sometimes used when the prior probabilities are unknown and the covariance matrix cannot be estimated accurately, due to limited training set size. Distance in feature space can be computed in other ways as well (e.g., Euclidean), and this gives rise to other types of distance classifiers.

### 11.4.1.11  Uncorrelated Features

While 30 or so pixels per class in the training set might be sufficient to estimate the feature means and variances, considerably more might be required to estimate the off-diagonal elements of the covariance matrix. If the training set is necessarily small, one solution is to set the off-diagonal elements to zero. This is equivalent to assuming that the features are uncorrelated. Under pressure of limited training set size, this can yield a more stable and better-performing classifier than one designed around inadequately estimated covariances. Using a distance classifier, which automatically assumes uncorrelated features, results in an even simpler classifier. Since there are so many pixels in an image, however, it is possible to accumulate quite large training sets, and covariances could be estimated quite accurately in this example.

## 11.4.2 A Numerical Example

To illustrate the operation of the three-class Bayes classifier, we include a numerical example having six pixels from each class in the training set. While this is hopelessly inadequate for any real case, it serves to illustrate the calculations. This example will permit readers who choose to implement a Bayes classifier to check their implementation for numerical accuracy.

Assume the training set is

$$\begin{bmatrix} 33 & 31 & 46 & 57 & 18 \\ 42 & 10 & 24 & 38 & 56 \\ 62 & 50 & 34 & 21 & 33 \end{bmatrix} \begin{bmatrix} 6 & 28 & 47 & 21 & 58 \\ 96 & 116 & 126 & 84 & 73 \\ 70 & 82 & 96 & 117 & 90 \end{bmatrix} \begin{bmatrix} 78 & 115 & 122 & 76 & 134 \\ 12 & 52 & 34 & 70 & 22 \\ 81 & 100 & 146 & 78 & 70 \end{bmatrix} \quad (11.21)$$

for the RGB color values of six pixels each of background, normal cells, and abnormal cells, respectively. The mean vectors for the three classes are then

$$\boldsymbol{\mu}_1 = \begin{bmatrix} 37 \\ 34 \\ 40 \end{bmatrix} \qquad \boldsymbol{\mu}_2 = \begin{bmatrix} 32 \\ 99 \\ 91 \end{bmatrix} \qquad \boldsymbol{\mu}_3 = \begin{bmatrix} 105 \\ 38 \\ 95 \end{bmatrix} \quad (11.22)$$

The covariance matrices are

$$\mathbf{S}_1 = \begin{bmatrix} 223.5 & -79 & -112.25 \\ -79 & 310 & -58.5 \\ -112.25 & -58.5 & 257.5 \end{bmatrix} \qquad \mathbf{S}_2 = \begin{bmatrix} 428.5 & -24 & 86.25 \\ -24 & 482 & -79.75 \\ 86.25 & -79.75 & 306 \end{bmatrix}$$

$$\mathbf{S}_3 = \begin{bmatrix} 700 & -154.5 & 265.75 \\ -154.5 & 542 & 21.5 \\ 265.75 & 21.5 & 934 \end{bmatrix} \quad (11.23)$$

from which the standard deviations (square roots of diagonal elements) are

$$\boldsymbol{\sigma}_1 = \begin{bmatrix} 15.0 \\ 17.6 \\ 16.0 \end{bmatrix} \qquad \boldsymbol{\sigma}_2 = \begin{bmatrix} 20.7 \\ 22.0 \\ 17.5 \end{bmatrix} \qquad \boldsymbol{\sigma}_3 = \begin{bmatrix} 26.5 \\ 23.3 \\ 30.6 \end{bmatrix} \quad (11.24)$$

the correlation matrices (Eq. 11.14) are

$$\mathbf{C}_1 = \begin{bmatrix} 1 & -.300 & -.468 \\ -.300 & 1 & -.207 \\ -.468 & -.207 & 1 \end{bmatrix} \quad \mathbf{C}_2 = \begin{bmatrix} 1 & -.053 & .238 \\ -.053 & 1 & -.208 \\ .238 & -.208 & 1 \end{bmatrix}$$

$$\mathbf{C}_3 = \begin{bmatrix} 1 & -.251 & .329 \\ -.251 & 1 & .030 \\ .329 & .030 & 1 \end{bmatrix} \tag{11.25}$$

and the determinants of the covariance matrices are

$$|\mathbf{S}_1| = 1.053 \times 10^7 \qquad |\mathbf{S}_2| = 5.704 \times 10^7 \qquad |\mathbf{S}_3| = 2.917 \times 10^8 \tag{11.26}$$

Suppose we have an unknown pixel having color vector

$$\mathbf{x} = \begin{bmatrix} 38 \\ 80 \\ 78 \end{bmatrix} \tag{11.27}$$

The three likelihoods (from Eq. 11.17) are

$$L = \begin{bmatrix} 0.000015 \\ 0.088083 \\ 0.000213 \end{bmatrix} \tag{11.28}$$

and the pixel would be assigned to class 2. The log likelihoods, with constant terms dropped (Eq. 11.19), are

$$\mathbf{LL} = \begin{bmatrix} -20.9 \\ -12.3 \\ -18.3 \end{bmatrix} \tag{11.29}$$

Again the pixel would be assigned to class 2. The Mahalanobis distances to the class means (Eq. 11.20) are

$$\mathbf{D} = \begin{bmatrix} 3.57 \\ 0.97 \\ 1.99 \end{bmatrix} \tag{11.30}$$

This pixel would be assigned to class 2 by a distance classifier as well, since it is the closest.

## 11.5  Classifier Performance

Once a classifier has been designed and trained, it is necessary to test it to establish its accuracy. This is usually done by classifying a test set of known objects and

tabulating the number of errors. If the test set is the same as the training set, the performance estimates will be optimistically biased. If it includes none of the training data, they will be pessimistically biased. If the test set is large, the effects of this bias will be slight. If the number of available preclassified objects is small, one can use the "round robin" or "leave one out" method. Here the classifier is trained on all but one of the objects and tested on the remaining object. This process is repeated until every object has been used for testing. The results of the various experiments are then averaged together to estimate the error rates.

## 11.5.1 The Confusion Matrix

A very handy tool for specifying the accuracy of a multiclass classifier is the confusion matrix. This is an $N \times N$ matrix, $\mathbf{C}$, where $N$ is the number of classes. The columns of $\mathbf{C}$ correspond to the classes to which objects actually belong, while the rows of $\mathbf{C}$ correspond to the classes to which objects can be assigned. Thus the element $c_{ij}$ corresponds to the situation of an object that belongs to class $j$ being assigned to class $i$. That is, true class $= j$, assigned class $= i$.

One can set up the confusion matrix to summarize the results of a classifier test in several ways. A *raw confusion matrix* results when the value of each element is simply set to the number of times the corresponding situation occurred in a particular test of the classifier. Other values, however, may be more useful. For example, *sensitivity* is defined, for each class, as the probability that an object belonging to that class will be correctly assigned. We obtain an estimate of the sensitivity matrix by dividing the raw confusion matrix elements by the total number of objects in the true class. Each element, then, shows what percentage of the objects that actually belong to that class are assigned to that class. The columns of the sensitivity matrix sum to unity.

*Specificity*, for a particular class, is defined as 1 minus the ratio of the number of objects incorrectly assigned to the class to the total number of objects not in that class. Specificity is seldom a very useful parameter because it almost always takes on values quite close to unity. A more useful specification is *positive predictive value* (PPV). This is the probability that an object assigned to a class actually belongs to that class. The PPV matrix is estimated by dividing the elements in each row of the raw confusion matrix by the total number of objects assigned to that class. In this case the rows sum to unity.

When analyzing the performance of a classifier, one finds the sensitivity matrix and the PPV matrix to be very useful. In short, the sensitivity matrix tells you where each type of object is going, while the PPV matrix tells you what is going into each of the classes. Studying these two matrices can yield considerable insight into the strengths and weaknesses of a particular classifier.

As an example, consider the sensitivity matrix and PPV matrix shown in Fig. 11.5. They correspond to the three-class pixel classifier example

| Sens | True Class | | |
|---|---|---|---|
| Assigned Class | | 1 | 2 | 3 |
| | 1 | 98% | 2% | 1% |
| | 2 | 1% | 96% | 9% |
| | 3 | 1% | 2% | 90% |

| PPV | True Class | | |
|---|---|---|---|
| Assigned Class | | 1 | 2 | 3 |
| | 1 | 98% | 1% | 1% |
| | 2 | 2% | 96% | 2% |
| | 3 | 2% | 7% | 91% |

**FIGURE 11.5**  Confusion matrices.

mentioned earlier. We see from Fig. 11.5 that this classifier has two problems. First, 9% of the pixels in abnormal cells are being called normal. This could lead to abnormal cells being missed. Second, 7% of the pixels that are called abnormal are actually normal. This could lead to false-positive errors. We would conclude that this classifier needs to be improved in its ability to discriminate between pixels in the normal and abnormal classes.

# 11.6  Bayes Risk

We now introduce a generalization of the maximum-likelihood Bayes classifier that allows one to bias the classifier so as to reduce the occurrence of certain costly types of misclassification errors, in exchange for making more of other, less serious errors [2, 3]. Our three-class example had nine elements in the confusion matrix. Three correspond to correct decisions, while the remaining six represent different types of errors. Suppose that it is considered to be more serious to confuse a pixel that falls inside an abnormal with one from a normal cell, or to call a normal pixel abnormal, than it is to make any of the four other possible errors. The minimum Bayes risk classifier allows us to account for this.

## 11.6.1  Minimum-Risk Classifier

We begin by setting up a *cost matrix*. It has the same format as the confusion matrix, except its elements represent the "cost" of that situation's occurring. Specifically, $C_{ij}$ represents the cost of assigning to class $j$ a pixel that actually belongs to class $i$. If $i = j$, this corresponds to a correct classification, and a cost of zero might be assigned to those elements. If all misclassification errors are equally unfortunate, then 1's could be placed in all of the off-diagonal elements. In this case a maximum-likelihood classifier results. However, larger values can be assigned to cost matrix elements that correspond to the more serious errors. A possible cost matrix for our three-class example is

$$\mathbf{C} = \begin{bmatrix} 0 & 1 & 1 \\ 1 & 0 & 4 \\ 1 & 2 & 0 \end{bmatrix} \qquad (11.31)$$

Here we have said that (1) correct classifications cost nothing, (2) calling an abnormal pixel normal has a cost of 4, (3) calling a normal pixel abnormal has a cost of 2, and (4) the four remaining errors have unit cost. Note that the actual cost values are unitless, and their values are relevant only in relation to one another.

Given a cost matrix, we can set up the Bayes classifier to minimize its long-term cost of operation. The Bayes risk for assignment to a particular class is the cost of each outcome times the likelihood of that outcome, summed over all possible assignments to that class. It can be computed, for the unknown pixel of Eq. 11.27, as

$$R_i = \sum_{j=1}^{3} C_{i,j} L_j \qquad \mathbf{R} = \begin{bmatrix} 0.0883 \\ 0.0009 \\ 0.1762 \end{bmatrix} \qquad (11.32)$$

In this example, the unknown pixel would be assigned to Class 2 because the risk is lowest there.

## 11.7 Relationships Among Bayes Classifiers

Note that the minimum-risk classifier is the most general Bayes classifier. The maximum-likelihood classifier is a special case, namely when all costs are set to be equal. Further reductions in generality result when the a priori probabilities are assumed to be equal, or the off-diagonal covariances are assumed to be zero. The minimum-distance classifier is a further restricted special case that results when both the a priori probabilites and the within-class variation are ignored. In this example, all three forms of the Bayes classifier, the minimum-risk, maximum-likelihood, and minimum-distance classifiers, assigned the unknown pixel to the same class. This will not be the case in general, as objects that fall near the decision boundaries will be assigned differently by the different classifiers. Objects that fall near the class mean will be classified correctly by any of the classifiers.

## 11.8 The Choice of a Classifier

If a considerable amount of training data is available, one can simply estimate the required pdfs and use those estimates in the classification process. Such classifiers are called *nonparametric*. Often, however, it is difficult to obtain large numbers of preclassified objects. In that case one can

assume a particular functional form for the pdf (the Gaussian, for example) and use the training data only to estimate the parameters. This gives rise to a *parametric classifier*. Considerably less training data is then required for training, and one benefits from the powerful mathematics that have been developed for those cases.

It is often useful to begin a classifier design effort with a classical Bayes classifier, as described earlier. At the very least this establishes a baseline of performance against which other types of classifiers can be tested and evaluated. Further, if the underlying assumptions are met, the Bayes classifier, assuming Gaussian statistics, may well perform as well as or better than any other classifier.

Problems arise when the underlying pdfs do not fit the assumed form. The classifier's performance and one's predictions of its accuracy are only as good as the underlying assumptions. It is rather difficult to prove that a population of objects actually fits, for example, a Gaussian distribution. As a rule of thumb, if the marginal distributions (one-dimensional histograms) are unimodal and symmetrical, one can often assume Gaussian statistics (although there are no guarantees, and notable exceptions exist). Even if they are not unimodal and symmetrical, one can do things to make them unimodal and symmetrical.

## 11.8.1   Subclassing

If the feature histograms of a class are multimodal (i.e., they have two or more peaks), one would suspect that two or more distinct subclasses exist within the class. By subdividing the class, one can often achieve unimodal pdfs, but with a larger number of classes. This is a fair trade if it justifies the assumption of Gaussian statistics. An example is shown in Fig. 11.6. This is the single-feature, two-class example used earlier in this chapter. Here the nuclear diameter histogram of normal cells is unimodal, but that of the abnormals is bimodal.

If we reexamine the training set, we may find that two distinct populations of cells exist within the abnormal class. In this case we can establish a new class called "atypical" and assign some of the previously "abnormal" cells to it, based on their morphology. The result is a three-class problem where the feature histograms are unimodal (Fig. 11.7). This is a very profitable trade if it permits the use of the assumption of Gaussian statistics.

## 11.8.2   Feature Normalization

An asymmetrical or non-Gaussian pdf often can be corrected by a suitably designed nonlinear transformation of the feature values [3]. A feature histogram

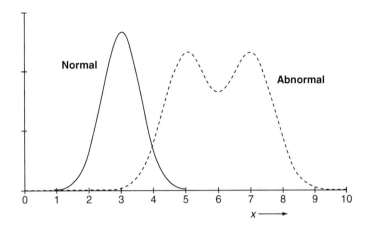

**FIGURE 11.6** A two-class problem with a bimodal pdf.

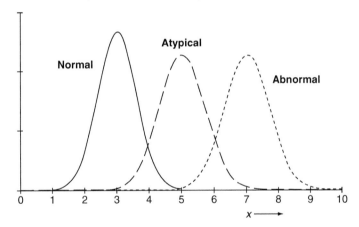

**FIGURE 11.7** The use of subclassing to eliminate a bimodal pdf. The result is a three-class problem with unimodal pdfs.

normalized to unit area is an estimate of the pdf of that feature. The *cumulative distribution function* (CDF) is the integral of the pdf; that is,

$$P(x) = \int_0^x p(u)du = \frac{1}{A_o} \int_0^x H(u)du \qquad (11.33)$$

where $H(x)$ is the histogram, $p(x)$ is the pdf, $P(x)$ is the CDF, and $A_o$ is the area under the histogram. The CDF is quite a well-behaved function, increasing monotonically from zero to 1. If it is used to transform feature $x$ into a new feature, $y$, that is, $y = P(x)$, then feature $y$ will have a flat histogram (uniform

distribution). As a special case, the CDF corresponding to a Gaussian pdf will transform a feature with a Gaussian pdf into one with a flat histogram. It follows that the inverse function of the Gaussian CDF will transform a feature with a flat histogram into one with a Gaussian histogram. Thus we can transform a feature so that it has a Gaussian histogram by concatenating two nonlinear transformations:

$$y = P_2\big(P_1(x)\big) \tag{11.34}$$

where $P_1(x)$ is the CDF of the feature and $P_2(x)$ is the inverse of the CDF of a Gaussian. $P_1(x)$ makes the pdf uniform, and $P_2(x)$ makes it Gaussian.

Note that, in a multifeature classification problem, transforming the individual features to have Gaussian pdfs does not guarantee that the overall multivariate pdf will be Gaussian. As a practical matter, however, such a transformation can make the assumption of Gaussian statistics much less of an approximation. Feature normalization works best in the commonly occurring case where the raw feature histograms are not radically different from a Gaussian to begin with.

## 11.9  Nonparametric Classifiers

If the functional form of the pdfs of the classes is unknown, then the parametric approach cannot be used. In this case one must estimate the pdfs directly from the training data [2]. This generally requires a much larger training set. However, the maximum-likelihood and minimum-risk formulations still apply.

The basic problem of nonparametric pdf estimation is straightforward: Given a set of training samples, model the pdf of the data without making any assumptions about the form of the distribution. Suppose we have $N_j$ training samples from class $j$. To estimate the pdf, the $L$-dimensional feature space can be partitioned into small regions that are $L$-dimensional hypercubes, with volume $V = h^L$, where $h$ is the bin size. Let $\mathbf{R}$ be such a region and $k_j$ be the number of samples from class $j$ falling into $\mathbf{R}$, with $k_j \leq N_j$. A straightforward estimate of the pdf can be expressed as

$$\hat{p}(\mathbf{x}|C_j) = \frac{k_j/N_j}{V} \tag{11.35}$$

This basic estimator corresponds to an $L$-dimensional histogram. Essentially, the feature space is divided into a finite number of hypercube bins, and the probability density at the center of each hypercube is estimated by the fraction of samples in the training set that fall into that hypercube bin. The bin size, $h$, and the starting position of the first bin are two "parameters" that determine the shape of the histogram.

The histogram is a simple and effective form of pdf estimation, but it has several drawbacks. The shape of the estimate is affected by both the bin size and the starting point of the bins. The discontinuities of the estimate are not due to the underlying probability density but are caused, rather, by the particular choice of bin locations. A more serious problem is the curse of dimensionality, since the number of bins grows exponentially with the number of dimensions. In high dimensions we would require a very large number of training samples, or else most of the bins would be empty.

A more advanced nonparametric pdf estimation method makes use of the so-called *Parzen window* for a unit hypercube centered at the origin:

$$\psi(\mathbf{v}) = \begin{cases} 1, & |v_q| \le \dfrac{1}{2}, \ q = 1, 2, \ldots, L \\ 0 & \text{otherwise} \end{cases} \tag{11.36}$$

Hence $\psi((\mathbf{x} - \mathbf{x}_i)/h)$ equals unity if $\mathbf{x}_i$ is within the hypercube at $\mathbf{x}$ and is zero elsewhere. The number of training samples that fall into this hypercube can be written as

$$k = \sum_{i=1}^{N_j} \psi((\mathbf{x} - \mathbf{x}_i)/h)$$

Substituting it in Eq. 11.35, we have

$$\hat{p}(\mathbf{x}|C_j) = \frac{1}{N_j} \sum_{i=1}^{N_j} \frac{1}{V} \psi((\mathbf{x} - \mathbf{x}_i)/h) \tag{11.37}$$

Notice that the Parzen window density estimate resembles the histogram, except the hypercube locations are determined by the training sample points rather than by the histogram bins. The expression in Eq. 11.37 shows that the estimate $\hat{p}(\mathbf{x}|C_j)$ is made of an average of functions of $\mathbf{x}$ and the samples $\mathbf{x}_i$. Based on the foregoing formulation, we can adopt two basic approaches. We can choose a fixed value of $k$ and determine the corresponding volume $V$ from the training samples. This gives rise to the so-called *k nearest neighbor* (kNN) approach. We can also choose a fixed value of the volume $V$ and determine $k$ from the samples. This leads to the methods commonly referred to as kernel density estimation (KDE).

## 11.9.1 Nearest-Neighbor Classifiers

The kNN is a very intuitive nonparametric approach that classifies unknown objects based on their similarity to the samples in the training set. For an unknown object $\mathbf{x}$, it finds the $k$ "nearest" samples $x_i$ in the training set and assigns $\mathbf{x}$ to the class that appears most frequently among the $k$ nearest samples. A great

advantage with the kNN approach is that no estimation of the pdf is required because the function is only approximated locally, and all computation is deferred until the classification stage. However, the disadvantages are the memory requirement to store training samples and the computational complexity required to search for the $k$ nearest samples during the classification of each unknown object.

On the other hand, with the KDE methods one can generalize the hypercube Parzen window with a smooth nonnegative kernel function $\psi(\mathbf{x})$ that satisfies the condition $\int \psi(\mathbf{x})\, d\mathbf{x} = 1$. Just as the Parzen window estimate can be considered a sum of boxes centered at the samples, the smooth kernel estimate is a sum of "bumps" placed at the samples, and the kernel function determines the shape of the bumps. Usually $\psi(\mathbf{x})$ is chosen to be a radially symmetric, unimodal pdf, such as the multivariate Gaussian. The kernel function is used essentially for interpolation, and each sample contributes to the estimate according to its distance from $\mathbf{x}$.

It can be shown [2] that both of these approaches converge to the true pdf as $N_j \to \infty$, that is, $\lim_{N_j \to \infty} \hat{p}(\mathbf{x}|C_j) = p(\mathbf{x}|C_j)$, provided that $V$ shrinks with $N_j$ and that $k$ grows with $N_j$ properly. For applications with high-dimensional feature space, the curse of dimensionality affects all classifiers, without exception. The available training samples are usually inadequate to obtain an accurate estimation in these cases. One solution to the problem is to choose independent features so that $p(\mathbf{x}|C_j) = \prod_{i=1}^{L} p(x_i|C_j)$, by mapping the original features using a proper subspace transformation such as independent component analysis (ICA) [7]. Thus the problem of estimating an $L$-dimensional multivariate pdf $p(\mathbf{x}|C_j)$ is reduced to that of estimating multiple one-dimensional univariate pdfs $p(x_i|C_j)$, $i = 1, 2, \ldots, L$. This way the training set size requirement becomes much easier to meet.

## 11.10   Feature Selection

Ideally one would prefer to use a rather small number of highly discriminating, uncorrelated features. Increasing the number of features increases the dimensionality and hence the volume of the feature space [8–10]. This, in turn, increases the requirements for training set and test set size [2–4]. Adding features that have poor discrimination or are highly correlated with the other features can actually degrade classifier performance [2].

### 11.10.1   Feature Reduction

There are well-developed mathematical procedures for reducing a large number of features down to a smaller number without severely limiting the discriminating

power of the set. *Principal component analysis* (PCA) [6] and *linear discriminant analysis* (LDA), also known as *Fisher discriminant analysis* (FDA) [11], discussed later, are among the best-known subspace methods that can be used for this purpose. Both generate a new set of features, each of which is a linear combination of the original features. In both cases the new features are ranked so that one can select only a few of the most useful ones, thereby reducing the number of features.

### 11.10.1.1 Principal Component Analysis

In general, suppose $\mathbf{x}$ is an $L$-dimensional feature vector and $\mathbf{W}$ is a $Q \times L$ matrix, then

$$y_i = \sum_{j=1}^{L} w_{i,j} x_j, \qquad i = 1, 2, \ldots, Q, \qquad \text{or} \qquad \mathbf{y} = \mathbf{W}\mathbf{x} \qquad (11.38)$$

defines a linear transformation of the vector $\mathbf{x}$. The result is a $Q \times 1$ vector $\mathbf{y}$, which is a projection of $\mathbf{x}$ onto a linear subspace defined by the transform matrix $\mathbf{W}$. Each element $y_i$ is the inner product of a basis vector, which is made up of the $i$th row of $\mathbf{W}$, with the input vector $\mathbf{x}$. Consider a set of $L$-dimensional sample feature vectors $\mathbf{x}_1, \mathbf{x}_2, \ldots, \mathbf{x}_M$. Without loss of generality, we can assume these are zero-mean vectors, since we can always redefine $\mathbf{x} = \mathbf{x}' - \boldsymbol{\mu}$, where $\boldsymbol{\mu}$ is the mean vector of all these samples. Then $\mathbf{X}$ is an $L \times M$ data matrix whose columns comprise the $M$ sample vectors $\mathbf{x}_1, \mathbf{x}_2, \ldots, \mathbf{x}_M$, and $\mathbf{S}_t = \mathbf{X}\mathbf{X}^T$ is defined as the total scatter matrix of the sample vectors. The aim of PCA is to find the transform matrix of a subspace whose basis vectors correspond to the maximum-scatter directions in the original $L$-dimensional feature space. Therefore the PCA transform matrix, $\mathbf{W}_{\text{PCA}}$, is chosen to maximize the determinant of the total scatter matrix of the projected samples

$$\mathbf{W}_{\text{PCA}} = \arg\max_{\mathbf{W}} |\tilde{\mathbf{S}}_t| \qquad (11.39)$$

where $\tilde{\mathbf{S}}_t = \mathbf{W}\mathbf{S}_t\mathbf{W}^T$. The solution to this equation is the transformation matrix $\mathbf{W}$, constructed so that its row vectors are the eigenvectors, $\mathbf{w}_j$, of the scatter matrix, $\mathbf{S}_t$, arranged in the order of decreasing magnitude of the corresponding eigenvalues $\lambda_j$, that is,

$$\mathbf{S}_t\mathbf{w}_j = \lambda_j\mathbf{w}_j, \qquad j = 1, 2, \ldots, Q \qquad (11.40)$$

where the $\lambda_j$ are nonzero eigenvalues associated with the eigenvectors $\mathbf{w}_j$, $Q$ denotes the rank of $\mathbf{S}_t$, and it cannot exceed the lesser of $L$ and $M$.

Because of the maximum-scatter projection, PCA provides an optimal transformation for representing the original data vector, $\mathbf{x}$, from a lower-dimensional subspace in terms of minimum mean square error (MSE) [2]. Let

$\hat{\mathbf{W}}_{\text{PCA}}$ be the $R \times L$ matrix ($R < L$) formed by discarding the lower $L - R$ rows of $\mathbf{W}_{\text{PCA}}$. Then the transformed $R \times 1$ vector $\hat{\mathbf{y}}$ is given by $\hat{\mathbf{y}} = \hat{\mathbf{W}}_{\text{PCA}}\mathbf{x}$. The $\mathbf{x}$ vector can still be reconstructed as $\hat{\mathbf{x}} = \hat{\mathbf{W}}_{\text{PCA}}^T\hat{\mathbf{y}}$, with approximation error given by MSE $= \sum_{k=R+1}^{L} \lambda_k$. Overall, PCA uncorrelates the new features and maximizes their variance. The number of new PCA features is equal to the number of original features, and one can decide how many of them to use.

### 11.10.1.2   Linear Discriminant Analysis

Unlike PCA, LDA seeks a linear subspace that best discriminates among object classes rather than the one that represents samples with the least MSE. Specifically, LDA selects the transform matrix $\mathbf{W}_{\text{LDA}}$ in such a way that the ratio of the between-class scatter and within-class scatter is maximized [11]. If we define the between-class scatter matrix as

$$\mathbf{S}_b = \sum_{i=1}^{c} M_i(\boldsymbol{\mu}_i - \boldsymbol{\mu})(\boldsymbol{\mu}_i - \boldsymbol{\mu})^T \tag{11.41}$$

and the within-class scatter matrix as

$$\mathbf{S}_w = \sum_{i=1}^{c} \sum_{j=1}^{M_i} \left(\mathbf{x}_j - \boldsymbol{\mu}_i\right)\left(\mathbf{x}_j - \boldsymbol{\mu}_i\right)^T \tag{11.42}$$

where $M_i$ is the number of samples in class $i$, $c$ is the number of object classes, $\boldsymbol{\mu}_i$ is the mean of type $i$ sample vectors, and $\boldsymbol{\mu}$ is the total mean of sample vectors of all classes. The optimization criterion here is to maximize the determinant ratio of between-class and within-class scatters of the projected samples

$$\mathbf{W}_{\text{LDA}} = \arg\max_{\mathbf{W}} \left\{ \frac{|\tilde{\mathbf{S}}_b|}{|\tilde{\mathbf{S}}_w|} \right\} \tag{11.43}$$

where $\tilde{\mathbf{S}}_b = \mathbf{W}\mathbf{S}_b\mathbf{W}^T$ and $\tilde{\mathbf{S}}_w = \mathbf{W}\mathbf{S}_w\mathbf{W}^T$. It has been proven [11] that if $\mathbf{S}_w$ is nonsingular, the determinant ratio in Eq. 11.43 is maximized when the row vectors of the transform matrix, $\mathbf{W}$, are the generalized eigenvectors of $\mathbf{S}_w^{-1}\mathbf{S}_b$ corresponding to

$$\mathbf{S}_w^{-1}\mathbf{S}_b\mathbf{w}_i = \lambda_i\mathbf{w}_i, \qquad i = 1, 2, \ldots, m \tag{11.44}$$

where $\lambda_i$, $i = 1, 2, \ldots, m$ are the generalized eigenvalues and $m$ is the number of nonzero generalized eigenvectors, $m \leq c - 1$. Notice that the dimensionality of the LDA subspace is upper-bounded by $c - 1$, meaning that the total number

of LDA features is 1 less than the number of classes. This is because $\mathbf{S}_b$ is of rank $c - 1$ or less. Also, since the rank of $\mathbf{S}_w$ is at most $M - c$, $M$ must be greater than or equal to $L + c$ in order to ensure that $\mathbf{S}_w$ does not become singular.

In summary, since LDA maximizes the ability of the new features to discriminate among the classes, it is generally considered to be more effective than PCA for feature reduction prior to classification.

# 11.11  Neural Networks

A completely different approach to classification is the use of artificial neural networks (ANNs) [5]. Here a network is composed of one or more layers of interconnected processing elements (PEs). Each PE creates its output as a weighted sum of its inputs (see Fig. 11.8). The feature values are the inputs to the first layer, and the output values of the final layer are used to assign the object to a class.

The ANN is trained by adjusting the weighting factors in each of its PEs. A large training set of preclassified objects is presented to the network repeatedly and in random order. Each time, the weights are adjusted to bring the output

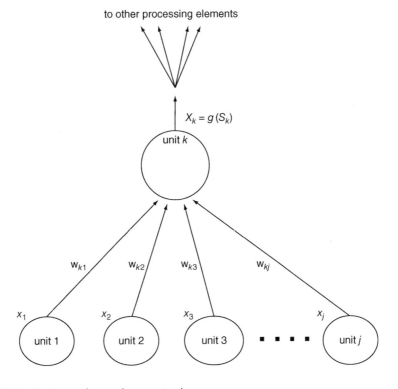

**FIGURE 11.8**  A neural network processing layer.

value toward its correct value. The training process is continued until the error rate stops declining.

The computation performed by such a PE is a function of a dot product,

$$O = g(\mathbf{X} \cdot \mathbf{W}) = g\left[\sum_{i=1}^{N} x_i w_i\right] = g(S) \tag{11.45}$$

where $O$ is the (scalar) output, $\mathbf{X}$ is the input vector, and $\mathbf{W}$ is the weight vector associated with that processing element. The weights are adjusted during the training process, and they remain fixed during ordinary usage.

The weighted sum is subjected to a nonlinear transformation by the *activation function*, $g(S)$, which has a sigmoid (S-curve) shape. It is monotonically increasing and differentiable, and it asymptotically approaches 0 and 1 at large negative and positive values of its argument, respectively. An example is

$$g(S) = \frac{1}{1 + e^{-S}} \tag{11.46}$$

The primary purpose of the activation function is to limit the output of the PE to the range [0, 1]. By convention, outputs are all positive, but interconnection weights can be either positive or negative.

One advantage of the ANN is that it is not necessary to know the statistics (i.e., pdfs) of the features in order to develop a functioning classifier. Further, the decision surfaces that the ANN can implement in feature space are more complex than the second-order surfaces that the parametric Bayes classifier, for example, generates. This can be helpful when the pdfs are multimodal.

A disadvantage of the ANN, as compared to the statistical classifiers previously discussed, is that it is a "black box," and one is hard pressed to understand or explain its behavior. It also lacks the rich analytical underpinning of the classical approach that provides guidance in the design and development process. This makes it difficult to prove optimality or to predict error rates. Further, if the training is not done properly, on representative training sets of sufficient size, then the net can overfit, or "memorize the training set," that is, perform well on the training set but not generalize to objects not previously seen.

## 11.12  Summary of Important Points

1. A well-trained Bayes classifier can be quite effective at multiclass, multifeature classification, even in the presence of considerable noise.

2. One should pay particular attention to numerical precision issues since some of the parameters in the probability calculations can become quite large or quite small.

3. If the marginal distributions are unimodal and symmetrical, it may be useful to assume Gaussian statistics (multivariate normal pdfs).

4. A nonlinear transformation can make a feature's pdf symmetrical.

5. A multimodal pdf suggests the presence of subclasses. Judicious use of subclassing and feature transformations can often make the Gaussian assumption work.

6. When a particular functional form for the pdf (the Gaussian, for example) is known, less training data is required since it is used only to estimate the parameters. This gives rise to a parametric classifier.

7. If the functional form of the pdf is not given or it is known to be non-Gaussian, one must estimate the pdfs directly from the training data. Such classifiers are nonparametric, and they usually require considerably more training data.

8. When available training samples are inadequate to estimate the pdfs accurately, one can choose independent features by mapping the original features using a proper transformation such as independent component analysis. With this method the problem of estimating a multivariate pdf is simplified to that of estimating multiple univariate pdfs, thereby considerably reducing the size requirements of training sets.

9. PCA and LDA are two well-known techniques for reducing a large number of features down to a smaller number without losing their discriminating power. PCA uncorrelates the new features and maximizes their variance, whereas LDA maximizes the ability of the features to discriminate among the classes.

10. An ANN classifier has the advantages that it is not necessary to know the statistics of the features in order to function, and the decision surfaces it can implement in feature space are more complex than the second-order surfaces that the parametric Bayes classifier generates. However, its disadvantages are that it is a "black box" and it is difficult to prove optimality or to predict error rates. It also lacks the rich analytical underpinning that supports the design of statistical classifiers.

# References

1. BS White and KR Castleman, "Estimating Cell Populations," *Pattern Recognition*, **13**(5):365–370, 1981.
2. R Duda, P Hart, and D Stork, *Pattern Classification*, Wiley, 2001.

3. KR Castleman, *Digital Image Processing*, Prentice-Hall, 1996.

4. W Meisel, *Computer-Oriented Approaches to Pattern Recognition*, Academic Press, 1972.

5. R Schalkoff, *Pattern Recognition—Statistical, Structural and Neural Approaches*, John Wiley & Sons, New York, 1992.

6. L Ott and W Mendenhall, *Understanding Statistics*, 5th ed., PWS-Kent, 1990.

7. A Hyvärinen, J Karhunen, and E Oja, *Independent Component Analysis*, John Wiley & Sons, 2001.

8. R Fisher, "The Statistical Utilization of Multiple Measurements," *Annals of Eugenics*, **8**:376–386, 1938.

9. IT Young, "Further Considerations of Sample Size and Feature Size," *IEEE Transactions*, **IT-24**(6):773–775, 1978.

10. AK Jain and B Chandrasekaran, "Dimensionality and Sample Size Considerations in Pattern Recognition Practice," in *Handbook of Statistics*, Vol. 2, pp. 835–855, North Holland, 1982.

11. L Kanal and B Chandrasekaran, "On Dimensionality and Sample Size in Statistical Pattern Recognition," *Pattern Recognition*, **3**:225–234, 1971.

# 12

# Fluorescence Imaging

Fatima A. Merchant and Ammasi Periasamy

## 12.1 Introduction

Fluorescence microscopy is one of the most basic tools used in biological sciences for the visualization of cells and tissues. The popularity of fluorescence microscopy for the examination of biological specimens, both fixed and live, stems from its inherent ability to target fluorescent probes to molecules at low concentrations with high selectivity and specificity (and relatively high signal-to-noise ratios (SNRs) due to separation of the excitation light from the recorded fluorescence image).

Modernization of imaging techniques, robotic instrumentation, development of new fluorescent tagging proteins and synthetic fluorophores, and the rapid growth in computer and informatics technology have only compounded its utilization in the observation of the temporal and spatial dynamics of cellular components and activity. The past decade has witnessed a renaissance of fluorescence microscopy, with digital imaging playing a pivotal role in automated detection and analysis of molecular and cellular processes, resulting in a shift of paradigm from qualitative to quantitative biology. The current emphasis in biology is now on quantitative analysis of information so that observations can be integrated and their significance understood. Digital image processing can provide numerical data to quantify and substantiate biological processes observed by fluorescence microscopy. This chapter covers the principles of fluorescence and highlights problems inherent to fluorescence microscopy and methods to correct them digitally. In subsequent sections, various fluorescence

microscopy techniques are introduced, with an emphasis on the image processing and image analysis algorithms used for enhancing and analyzing fluorescence images.

## 12.2 Basics of Fluorescence Imaging

Electrons in certain types of molecules can absorb light, reach excited higher-energy states, and then decay back to their ground state by losing energy in the form of heat and emitted light. If the electron's spin is unchanged, the excited state is called the *singlet state*, whereas if the spin is altered by the excitation, the electron enters the *triplet state*. Decay from the singlet excited state results in *fluorescence* emission, whereas decay from the triplet state is known as *phosphorescence*. The phenomenon of fluorescence occurs when certain molecules (called *fluorophores, fluorochromes,* or *fluorescent dyes*) absorb light and reach an excited, unstable electronic singlet state ($S_1$). Under normal conditions, an unexcited molecule typically resides in the stable ground state $S_0$, at its lowest vibrational or rotational energy level. The absorption of a photon moves a molecule to one of the vibrational or rotational energy levels of a higher-energy state ($S_1$). Internal energy conversions (time on the order of $\sim 1$ ps) then force the molecule to relax back to the lowest-energy level of $S_1$. From here, they transition back to the singlet ground state ($S_0$), following the emission of fluorescent light at a characteristic wavelength (time order of $\sim 1$–10 ns). Internal conversion again relaxes the molecule back to the lowest-energy level of $S_0$.

Fluorescence emission always occurs due to decay from the lowest-energy level of $S_1$ to some level of the ground state, regardless of the initial state of excitation. Thus the energy of excitation is greater than the energy of emission, and the emission spectrum is independent of the energy of the exciting photon. The energy of the emitted photon is the difference between the energy levels of the excitation and emission states, and it determines the wavelength of the emitted light $\lambda_{EM}$ as follows

$$\lambda_{EM} = hc/E_{EM} \tag{12.1}$$

where $E_{EM}$ is the difference between the energy levels of the two states during emission (EM) of light, $h$ is Planck's constant, and $c$ is the speed of light. The wavelength of emission is always longer than that of excitation, and the difference between the two is known as the *Stokes shift*.

The emitted fluorescence can be expressed as

$$I_{EM} = I_{EX} \cdot \varepsilon \cdot c \cdot x \cdot \phi \tag{12.2}$$

where $I_{EX}$ is the intensity of the illuminating light, $\varepsilon$ is the extinction coefficient of the fluorophore, $c$ is the concentration of the fluorophore, $x$ is the optical path

length, and $\phi$ is the quantum efficiency, which reflects the fluorophore's ability to convert absorbed light into emitted fluorescence (i.e., the ratio of the number of photons emitted to the number of photons absorbed). The level of intensity, or brightness, of the emission produced by a fluorophore depends on its ability to absorb light at a particular wavelength (i.e., its extinction coefficient, $\varepsilon$) and on the quantum efficiency. Typical values of $\varepsilon$ for fluorophores at their characteristic absorption wavelength are in the range of tens of thousands, whereas the $\phi$ may range from 0 (no fluorescence) to 1 (100% efficiency). Fluorescence intensity is also influenced by the intensity of the incident illumination; that is, with an increase in illumination intensity, a larger number of fluorophore molecules are excited, and the number of emitted photons increases. Under conditions of constant illumination wavelength and intensity and low fluorophore concentrations, the emitted fluorescence is a linear function of the number of fluorophore molecules present. Nonlinearity typically results at very high fluorophore concentrations, partly due to reabsorption of the emitted light.

In fluorescence imaging, specimens are labeled with fluorophores. The distribution of fluorescence is then observed under exciting illumination and captured by photosensitive detectors that measure the intensity of the emitted light and create a digital image of the sample. Conventional wide-field microscopy (epifluorescence mode) is most commonly used for fluorescence microscopy of thin fixed samples, whereas confocal and two-photon fluorescence microscopy are more appropriate for thicker samples and for dynamic live cell imaging [1–3].

## 12.2.1 Image Formation in Fluorescence Imaging

Fluorescence microscopy is an incoherent imaging process. Each point in the specimen contributes independently to the light intensity distribution in the observed image. Each fluorophore molecule in the sample acts as a light source, and image formation occurs by the integration of these secondary light sources in the specimen. Thus the principle of linear superposition applies in fluorescence microscopy, such that the combination of multiple sources generates an image that is the sum of the individual responses of the point sources. Most fluorescence microscopes are *epifluorescence* systems [2], in which both sample illumination and the collection of emitted light from the sample occur through the same objective lens. Imaging in a fluorescence microscope can be modeled as a space-invariant linear system [4], where the intensity distribution is given by [1]

$$I(x, y, z) \propto \int_{R^3} \left| h_{\lambda_{em}} \left( \frac{x}{M} - u, \frac{y}{M} - v, \frac{z}{M^2} - w \right) \right|^2 \chi(u, v, w) \, du \, dv \, dw \quad (12.3)$$

where $M$ is the magnification of the objective, $\chi$ is an object-dependent function related to the fluorophore concentration that describes the specimen's ability to emit light at $\lambda_{em}$. The incoherent point spread function (Chapter 2), denoted by $|h_{\lambda_{em}}|^2$, is the impulse response that defines the image of an ideal point object and is given by the two-dimensional (2-D) Fourier transform of the pupil function [1],

$$h_\lambda(x, y, z) = \int_{R^2} P(u,v) \exp\left(i2\pi z \frac{u^2 + v^2}{2\lambda f^2}\right) \exp\left(-i2\pi \frac{xu + yv}{\lambda f}\right) du\, dv \quad (12.4)$$

where $f$ is the focal length of the objective and $P$ is the pupil function representing the circular aperture of the objective. The focal length, $f$, is related to the radius of the circular aperture of the objective as $f = r/\text{NA}$, where NA is the numerical aperture. NA is a measure of the angular dimension of the light cone emerging from the sample that is collected by the objective, and it affects both resolution and depth of field. Fluorescence intensity typically increases with an increase in the NA. The light intensity at the detector is approximately proportional to $\text{NA}^4$ [5]. Detailed descriptions of image formation, imaging resolution, and sampling concepts can be found in other publications [Chapters 1–3 this book, 6–8].

## 12.3  Optics in Fluorescence Imaging

Wide-field, confocal, and two-photon microscopes can be used to perform single- and/or multidimensional fluorescence microscopy [3]. The key requirement is that the microscope be appropriately equipped to allow (1) illumination at the required excitation wavelength, (2) separation and effective removal of the excitation light from the emitted fluorescence, and (3) detection of the emitted light. Mercury or xenon lamps that produce "white light" (i.e., visible spectrum, with peaks at certain characteristic wavelengths) are used as the light source in wide-field microscopy, whereas lasers are used for illumination in confocal and two-photon imaging. The selection of light of a particular wavelength is achieved by inserting an excitation filter in the illumination path and an emission filter (also known as a *barrier filter*) in the fluorescence emission path. Separation of reflected excitation light from the emitted light is accomplished by a dichroic mirror, which reflects or transmits light depending on wavelength (e.g., reflects excitation and transmits emission wavelengths). Information regarding fluorescence microscopes, filters, and objectives can be found in other publications [9–11].

Finally, it is critical to choose an appropriate detector. In fluorescence microscopy, CCD (charge-coupled device) cameras and image-intensified

systems are often used. For detailed information on detector selection and performance evaluation, see [12–16].

## 12.4 Limitations in Fluorescence Imaging

Most modern microscopy equipment is constructed to minimize phase distortion and optical aberrations. Nevertheless, no optical system is completely free of distortion, and, in practice, aberrations are always present to some extent. For a detailed description of the sources of aberrations in fluorescence microscopy, see [17]. The sources of aberrations in fluorescence microscopy broadly fall into two categories; instrumentation based and sample based. In addition, sample preparation and microscope handling also constitute important and frequent sources of inhomogeneity observed in fluorescence images.

### 12.4.1 Instrumentation-Based Aberrations

The choice and configuration of a fluorescence microscopy system has a profound effect on the quality of the acquired image. The illumination source, type of microscope, objectives, excitation and emission filters, and photosensitive detector must all be carefully and appropriately chosen and adjusted to achieve sharp images with high SNR [15, 16]. Illumination sources should be stable and should generate reliable, reproducible, and uniform field illumination with proper spectral separation and registration. The quality and performance of the objective lens are related directly to the system resolution, and the objective lens must be chosen to fit the application requirements. Similarly, detectors should be chosen to satisfy the Nyquist sampling criteria, linearity of photometric response, high SNR, and sensitivity (Chapters 2–4). Photomultiplier tubes (PMTs) and CCDs when used properly are linear detectors and are thus used in most fluorescence microscopy applications. Despite appropriately chosen instrumentation for performance optimization, certain limitations inherent to the equipment may result in measurement noise in images [7, 14, 18]. Common sources of noise and related image processing algorithms for correction are described in the following sections.

#### 12.4.1.1 Photon Shot Noise

Apart from the diffraction-limited spatial resolution inherent in light microscopy, the major source of aberration introduced by the imaging process is intrinsic photon noise. In fluorescence imaging, the quantum nature of light gives rise to a fundamental limitation of any photodetector, known as *photon shot noise*, which results from the random nature of photon emission.

The absorption of a photon by the CCD creates a photoelectron in the CCD well, and during readout the accumulated photoelectrons are counted. The number of photons collected by the detector determines the image amplitude at any given point in the image. Photon shot noise is random, with a Poisson distribution of the number of detected photons, given by [19]

$$p(N) = \prod_{i=1}^{M} \frac{\mu^N \exp(-\mu)}{N!} \qquad (12.5)$$

where $N$ is the number of detected photons and $\mu$ is the mean of the Poisson process. Although other factors, such as the integration time and quantum efficiency of the detector, influence photon shot noise [20], its intrinsically random nature make it impossible to avoid. Thus, even in the absence of other noise sources, photon noise leads to the finite SNR of detectors [7]. This limiting SNR is given by [7]

$$SNR_{\text{photon}} = 10\ \log_{10}(\mu) \qquad (12.6)$$

Thus photon shot noise is independent of the detector electronics and can be reduced only by increasing the light intensity or the exposure time. Consequently, the SNR can only be improved by increasing the exposure of specimens to light.

### 12.4.1.2 Dark Current

Dark current is another intrinsic source of noise present in photodetectors. It is the number of induced electrons per pixel that arise from sources such as thermal agitation [12]. Thermal energy is mostly responsible for the generation of dark current, with higher temperatures resulting in higher kinetic energy of the electrons and stronger dark current. For CCD detectors, dark current tends to charge the CCD pixel wells when the integration time or the temperature is too high. For PMTs, thermal energy often results in spontaneous electron emissions and, consequently, dark current as well. Dark current also follows the Poisson distribution for the number of thermal electrons produced over a given time interval. The presence of dark current introduces an offset in the pixel value, resulting in noise and a reduced dynamic range. The most effective method to alleviate dark current noise is to cool the detector. Consequently, most modern high-sensitivity scientific-grade cameras are available as cooled device detectors that have reduced thermal noise, even at long integration times.

### 12.4.1.3 Auxiliary Noise Sources

Electronics associated with CCD cameras are also responsible for generating noise during readout. Similarly, fluctuations in the internal gain of PMT devices

also result in noise. This type of noise is called *readout noise*, and its amplitude depends on the camera's readout rate [7, 19]. Readout noise is inversely related to the pixel readout frequency, with the power spectral density of the noise decreasing as $1/f$. Scientific-grade CCD cameras that operate in the frequency range of 20–500 kHz typically have low readout noise that can be ignored. For higher readout frequencies, the readout noise appears as additive, Gaussian distributed noise that can be problematic.

### 12.4.1.4 Quantization Noise

All digital detectors produce quantization noise. The digitization of the CCD image into a collection of integer values (i.e., the digital image) introduces a form of noise that is not band-limited. Quantization noise is inherent in the amplitude quantization process that occurs in the analog-to-digital converter (ADC). It is independent of the signal and can be modeled as additive noise when the dynamic range has intensity levels $\geq 2^4$ (equivalent to bit depth, $B$, of 4 ). For a digitized image, if the ADC is adjusted so that 0 corresponds to the minimum video signal value, and $2B-1$ corresponds to the maximum video value, then the SNR for quantization, $S_Q$, is given by [19]

$$S_Q = 6 \times B + 11 \tag{12.7}$$

measured in decibels. It is good practice to keep the quantization noise level to one-half the RMS noise level due to other sources.

### 12.4.1.5 Other Noise Sources

Finally, the ambient radiation, especially in the infrared domain, can also be a source of background noise in images. With recent advances in imaging hardware, most detectors are manufactured such that noise from other sources is negligible, and detector noise is essentially limited to only photon shot noise. Most state-of-the-art photodetectors have high quantum efficiency, low dark current (especially for cooled devices), high sensitivity, and excellent linearity.

## 12.4.2 Sample-Based Aberrations

The optical characteristics of a sample not only are important for image formation, but also play a role in introducing image aberrations. The sample-based aberrations most often observed in fluorescence images include effects of photobleaching, autofluorescence, absorption, and scattering.

### 12.4.2.1 Photobleaching

*Photobleaching* is an inherent phenomenon in fluorophores, and it has a damaging effect in fluorescence microscopy. Specifically, it causes an effective

reduction in and, ultimately, a complete elimination of fluorescence emission. The term *bleaching* covers all of the processes that cause the fluorescent signal to fade permanently [11], due to photon-induced chemical damage and covalent modification. This is different from the process of *quenching* (reduction in the excited-state lifetime and quantum yield), which is the reversible loss of fluorescence that occurs due to noncovalent interactions between a fluorophore and its molecular environment.

At the molecular level, photobleaching occurs when an excited electron reaches the triplet state. This state is long-lived, allowing more time for the fluorophores to react with another molecule to produce an irreversible covalent chemical modification. For example, in the presence of oxygen, a fluorophore molecule can transfer its energy to oxygen molecules, exciting them to a reactive singlet state. Chemical reactions with singlet oxygen molecules then covalently alter the fluorophore. This leads to permanent changes by which the molecule loses its ability to fluoresce or becomes nonabsorbent at the excitation wavelength. The kinetics of bleaching vary among fluorophores, since the number of excitation and emission cycles for each fluorophore depends on its molecular structure and the local milieu. Overall, bleaching is an irreversible process that has a collective effect; that is, a reduction in exposure time or excitation intensity does not prevent bleaching, but only reduces the rate at which it occurs.

Another detrimental side effect of the process is phototoxicity, which may result from the interaction of the radical singlet oxygen species with other organic molecules. In fluorescence imaging, bleaching limits the total intensity of light and the exposure time in all samples, and in dynamic studies it may decrease viability of living tissue over time. On a positive note, the photobleaching phenomenon has been the basis of many fluorescence measurement techniques (described in Section 12.7.7). Sample preparation and experimental methods to reduce photobleaching are described in detail elsewhere [11], whereas image processing–based correction is described in Section 12.5.9.

### 12.4.2.2 Autofluorescence

*Autofluorescence* is the term used to describe the emission of fluorescence from organic or inorganic molecules that are naturally fluorescent. In fluorescence imaging, molecules that emit fluorescence in the visible domain can be visualized, even in unstained samples. Autofluorescence is a significant source of background noise in fluorescence images. In quantitative fluorescence imaging, background signals due to autofluorescence become problematic when there is an overlap with the emission of a target fluorophore, and more so when the latter is sparsely expressed or exhibits weak fluorescence. Autofluorescence is observed in both plant and animal tissue. For example, the fluorescent pigment

lipofuscin is found in the cytoplasm of mammalian cells and in chloroplasts of plant cells. The mounting and embedding material may also exhibit low amounts of autofluorescence. Although sample preparation methods are available to reduce autofluorescence [21], computational background subtraction, described later, can prove to be a very effective method for correction.

### 12.4.2.3 Absorption and Scattering

Absorption and scattering of light are the most common causes of optical aberrations observed in fluorescence imaging. Light at both the excitation and emission wavelengths can be scattered due to particles, refracted due to interfaces, or absorbed by the specimen material itself. This typically occurs due to (1) the presence of particles in the specimen with sizes comparable to the wavelength of light and (2) a mismatch in the refractive indices of the specimen and the immersion layers. The optical aberration introduced is observed as a reduction in the intensity of light with increasing depth into the specimen. In light microscopy, the effect is manifested as both a reduction in the intensity of illumination with increasing depth and a limitation on the depth within the specimen from which an emitted light signal can be detected. These effects are apparent as a reduction in image contrast when imaging deep within the specimen, and they are most obvious in wide-field and confocal microscopy. The problems are somewhat alleviated in two-photon imaging, in which excitation at a longer wavelength allows imaging deeper within the sample. Methods to correct for depth-dependent signal attenuation are described in Section 12.5.10.

### 12.4.3 Sample and Instrumentation Handling-Based Aberrations

Variability in sample preparation and improper illumination alignment are the two most common and frequently observed sources of light intensity inhomogeneity in fluorescence images. Sample preparation can result in variation of light intensity across the image due to inconsistent staining and nonspecific fluorescence probe binding. Besides sample handling problems, uneven illumination of the specimen due to improper centering of the lamp contributes to further degradation of the image signal. Both halogen (transmitted light) and mercury (fluorescence light) lamps must be adjusted for uniform illumination of the field of view prior to use. Moreover, microscope optics and cameras can also introduce vignetting, in which the corners of the image are darker than the center. Depending on the nature of the intensity variation observed, digital image correction can be implemented to remove brightness variations as described next.

# 12.5 Image Corrections in Fluorescence Microscopy

In modern biological microscopy, fluorescence imaging is used to record and quantify location, functional status, and abundance of a tagged target molecule. This requires the application of image correction techniques and calibration methods for both image visualization and quantitative analysis. Digital image processing algorithms for correction and calibration strategies are discussed in the following sections.

## 12.5.1 Background Shading Correction

The process of eliminating nonuniformity of image background intensity by application of image processing to facilitate visualization and segmentation or to obtain accurate quantitative intensity measurements is known as *background correction, background flattening, flat-field correction*, or *shading correction*. These brightness variations in images are typically observed as intensity shadings across the field of view. In microscopy, image shading may occur due to nonuniform illumination, inhomogeneous detector sensitivity, dirt particles in the optics, nonspecific sample staining, or autofluorescence. Some of the most frequently used methods for correction or elimination of background shading are described here.

For fluorescence imaging, intensity shading can be described by the following model [19]

$$b(x, y) = I_{ill}(x, y) \cdot a(x, y) \tag{12.8}$$

where $b(x, y)$ is the image produced by the interaction of the illumination $I_{ill}(x, y)$ with the sample $a(x, y)$ and $(x, y)$ represents the spatial coordinates. Assuming low fluorophore concentrations, $c(x, y)$, for fluorescence imaging, the sample can be denoted as $a(x, y) = c(x, y)$.

Incorporation of the effects of the detector gain and offset gives the following discrete expression in integer coordinates [19]

$$c[m, n] = \text{gain}[m, n] \cdot b[m, n] + \text{offset}[m, n] \tag{12.9}$$

where $b[m, n]$ is the digital image that would have been recorded if there were no shading (Eq. 12.8) in the image. Equation 12.9 can then be expressed as

$$c[m, n] = \text{gain}[m, n] \cdot I_{ill}[m, n] \cdot a[m, n] + \text{offset}[m, n] \tag{12.10}$$

The goal of all correction algorithms is to determine $a[m, n]$ given $c[m, n]$. Algorithms used to correct shading effects are described next.

## 12.5.2 Correction Using the Recorded Image

In the first approach, the recorded digital image $c[m, n]$ is used to estimate the background shading pattern. Three different methods can be used to estimate the shading pattern. In the first, low-pass filtering is applied to smooth $c[m, n]$, where the smoothing effect is larger than the size of objects in the image. The choice of the low-pass filter requires that the spatial frequencies where the shading persists be known. The corrected image, $\hat{a}[m, n]$, is then estimated as follows [19]

$$\hat{a}[m, n] = c[m, n] - \text{LowPass}\{c[m, n]\} + \text{constant} \qquad (12.11)$$

Second, instead of low-pass filtering $c[m, n]$, smoothing can be performed by using morphological filtering (Chapter 8). Morphological filtering is used when the background variation is irregular and cannot be estimated by surface fitting (Section 12.5.4). The assumptions behind this method are that foreground objects are limited in size and are smaller than the scale of background variations and that the intensity of the background differs from that of the features. The approach is to use an appropriate structuring element to describe the foreground objects. Neighborhood operations are used to compare each pixel to its neighbors. Regions larger than the structuring element are taken as background. This operation is performed for each pixel in the image, producing a new image. The result of applying this operation to the entire image is to shrink the foreground objects by the radius of the structuring element and to extend the local background brightness values into the area previously occupied by the objects. The choice of the appropriate structuring element for smoothing depends on the size of the largest object of interest in the image. For example, an opening operation can be used to estimate the shape of the background. The corrected image, $\hat{a}[m, n]$, is then estimated as [19]

$$\hat{a}[m, n] = c[m, n] - \text{Sm}\{c[m, n]\} + \text{constant} \qquad (12.12)$$

where $\text{Sm}\{c[m, n]\}$ is a morphological smoothing operation.

Finally, homomorphic filtering can be used to estimate the shading [22]. The logarithm of Eq. 12.10 is taken, assuming the offset $[m, n]$ to be zero, the term $\{\text{gain}[m, n] \cdot I_{\text{ill}}[m, n]\}$ to be slowly varying (low frequency), and $a[m, n]$ to be rapidly changing (high frequency). Thus, high-pass filtering can effectively attenuate any shading. The background is characterized as low intensity and as having low spatial frequency content. The corrected image can be computed by taking the exponent (i.e., the inverse logarithm) [19]

$$\hat{a}[m, n] = \exp\{\text{HighPass}\{\ln\{c[m, n]\}\}\} \qquad (12.13)$$

This approach, also known as *frequency domain filtering*, assumes that the background variation in the image is a low-frequency signal and can be separated in frequency space from the higher frequencies that define the objects of interest in the image. The high-pass filter removes the low-frequency background components. This approach is typically used to remove shading due to nonuniform illumination or staining, and it is most appropriate when no information is available about the imaging system used to acquire the data. When implemented by convolution, the kernels tend to be quite large.

## 12.5.3 Correction Using Calibration Images

In this approach, calibration images are acquired in advance using the imaging system. Although several different algorithms are involved, the underlying principle is to use previously acquired calibration or test images. A few such algorithms are described here.

### 12.5.3.1 Two-Image Calibration

One approach is to record two calibration images using the microscope [19]. First, a black image is acquired by blocking all light to the detector (i.e., $b[m, n] = 0$ in Eq. 12.9). The recorded image is then $\text{BLACK}[m, n] = \text{offset}[m, n]$. A second calibration image is then recorded using a white reflecting surface or uniformly fluorescing glass, with no specimen in the light path, such that $a[m, n] = 1$, giving $\text{WHITE}[m, n] = \text{gain}[m, n] \cdot I_{\text{ill}}[m, n] + \text{offset}[m, n]$. The corrected image is then computed as follows [19]

$$\hat{a}[m, n] = \text{constant} \cdot \frac{c[m, n] - \text{BLACK}[m, n]}{\text{WHITE}[m, n] - \text{BLACK}[m, n]} \tag{12.14}$$

where the term *constant* determines the dynamic range. The choice of the parameter *constant* is important, since the corrected image will have integer values obtained by rounding real numbers. If small values are chosen for *constant* the dynamic range will be limited, whereas if large values are chosen, image display can become problematic. The exposure time (or integration time) has to be the same when acquiring the images in Eq. 12.14. The black image is also known as the *dark-current image*. This approach corrects images for shading due to uneven illumination and dark-current effects.

### 12.5.3.2 Background Subtraction

Another approach is to use a single calibration image. One "background" image is acquired in which a uniform reference surface or specimen is inserted in place

of actual samples to be viewed, and an image of the field of view is recorded. The image thus acquired is the background image. It represents the intensity variations that occur without a specimen in the light path, leaving only those due to any inhomogeneity in illumination source, system optics, or camera. It can then be used to correct all subsequently recorded images. When the background image is subtracted from a given image, areas that are similar to the background will be replaced with values close to the mean background intensity. The process, called *background subtraction*, is applied to even out the background intensity variations in a microscope image. It should be noted that, if the camera is logarithmic with a gamma of 1.0, then the background image should be subtracted. However, if the camera is linear, then the acquired image should be divided by the background image. Background subtraction can be used to produce a flat background and compensate for nonuniform lighting, nonuniform camera response, or minor optic artifacts (such as dust specks that mar the background of images captured from a microscope). In the process of subtracting (or dividing) one image by another, some of the dynamic range of the original data will be lost.

## 12.5.4 Correction Using Surface Fitting

This approach also uses a recorded image, but instead of using a smoothed version of the recorded image, it uses the process of surface fitting to estimate the background image (i.e., devoid of any objects). This method is especially useful when a reference specimen or the imaging system is not available to acquire a background image experimentally. Typically, a polynomial function is used to estimate variations of background brightness as a function of location. The process involves an initial determination of an appropriate grid of background sample points. To be accurate, the fit must be done through background pixels only. In particular, it is critical that the points selected for surface fitting represent true background areas in the image, and that no foreground (or object) pixels are included. If a foreground pixel is included in the fitting process, the surface fit will be biased, resulting in an overestimation of the background. In some cases it is practical to locate the points automatically for background fitting. This is feasible when working with images that have distinct objects that are well distributed throughout the image area and contain the darkest (or lightest) pixels present. The image can then be subdivided into a grid of smaller squares or rectangles. The darkest (or lightest) pixels in each subregion are located, and these points are used for the fitting [23].

Another issue comprises the spatial distribution and number of the sample points. The greater the number of valid points that are uniformly spread over the entire image, the greater will be the accuracy of the estimated surface fit. A least-squares fitting approach may then be used to determine the coefficients

of the polynomial function. For a third-order (cubic) polynomial, the functional form of the fitted background is

$$B(x, y) = a_0 + a_1 \cdot x + a_2 \cdot y + a_3 \cdot xy + a_4 \cdot x^2 + a_5 \cdot y^2 + a_6 \cdot x^2 y$$
$$+ a_7 \cdot xy^2 + a_8 \cdot x^3 + a_9 \cdot y^3$$

(12.15)

This polynomial has 10 $(a_0, \ldots, a_9)$ fitted constants. In order to get a good fit and to diminish sensitivity to minor fluctuations in individual pixels, it is usual to require several times the minimum number of points. We have found it effective to use about three times the total number of coefficients to be estimated. Figure 12.1 demonstrates the process of background fitting. Panel a shows the original image, panel b presents its 2-D intensity distribution as a surface plot, panel c shows the background surface estimated via the surface fitting algorithm, panel d shows the background subtracted image, and panel e presents its 2-D intensity distribution as a surface plot.

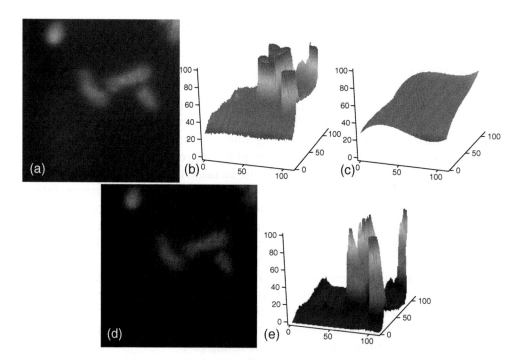

**FIGURE 12.1**    Background subtraction via surface fitting. (a) shows the original image; (b) presents its 2-D intensity distribution as a surface plot; (c) shows the background surface estimated via the surface fitting algorithm; (d) shows the background subtracted image; and (e) presents its 2-D intensity distribution as a surface plot. (Reproduced with permission from [10].)

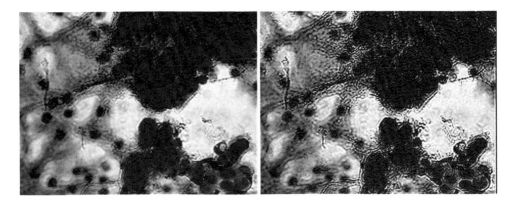

**FIGURE 6.8**

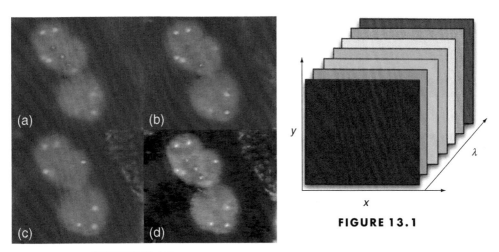

(a)　(b)

(c)　(d)

**FIGURE 7.16**

**FIGURE 13.1**

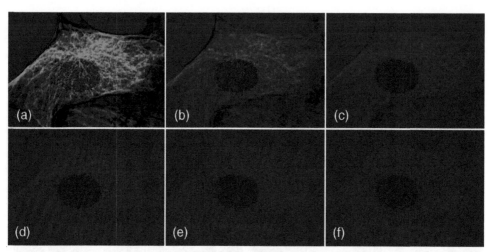

**FIGURE 12.2**

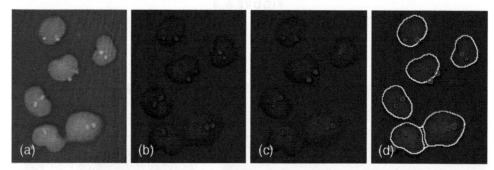

**FIGURE 12.6**

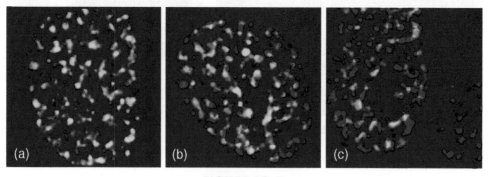

**FIGURE 12.7**

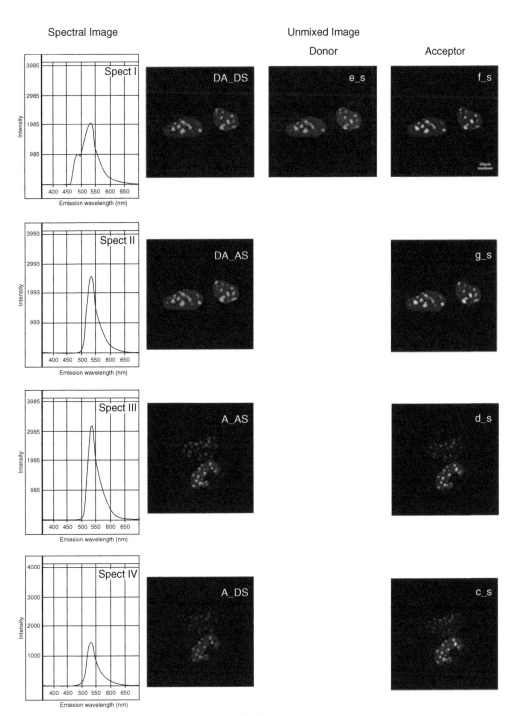

**FIGURE 12.8**

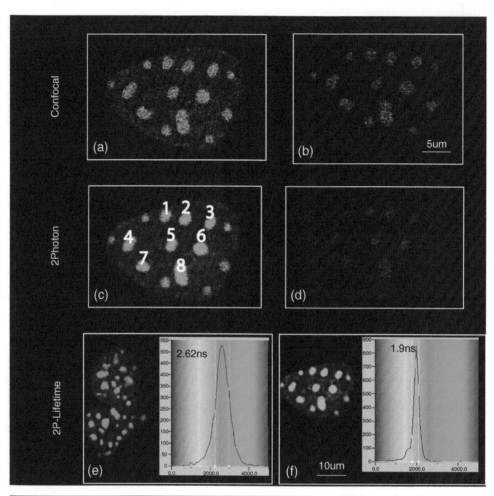

| Protein | Confocal | | 2Photon | | 2P-Lifetime | |
|---------|----------|----------|---------|----------|------------|----------|
| Complex | E (%) | r (Å) | E (%) | r (Å) | E (%) | r (Å) |
| Mean | 24.7 ± 1.95 | 63.59 ± 1.15 | 15.08 ± 0.53 | 70.38 ± 0.49 | 15 to 73 | 44.58 to 70.55 |

**FIGURE 12.10**

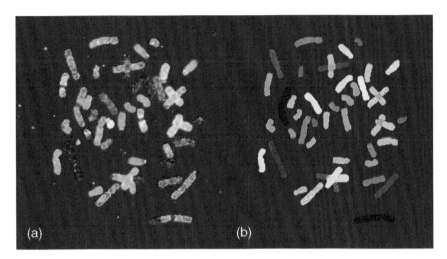

**FIGURE 13.9**

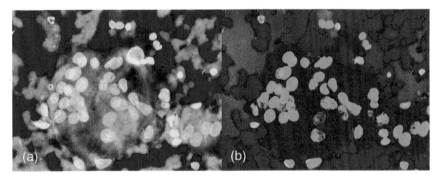

**FIGURE 13.10**

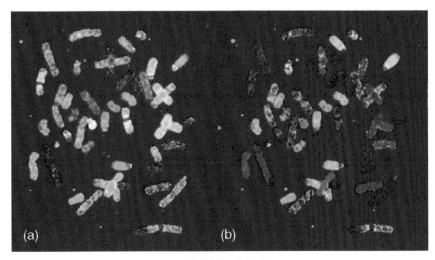

**FIGURE 13.11**

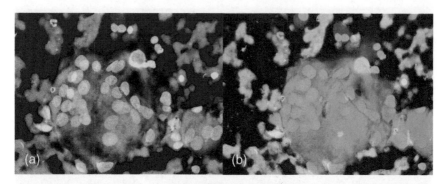

**FIGURE 13.12**

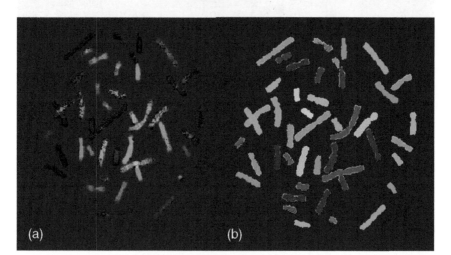

**FIGURE 13.13**

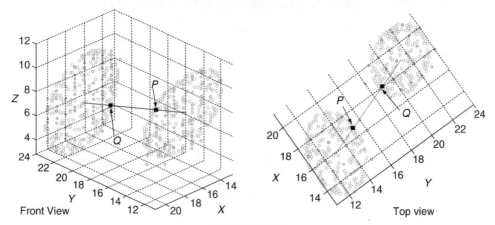

**FIGURE 14.5**

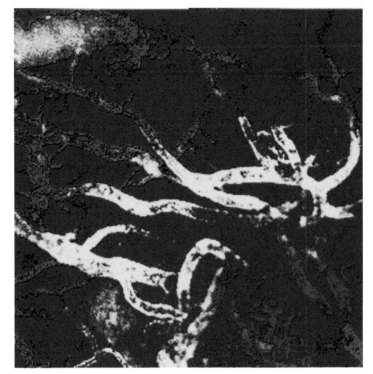

**FIGURE 14.7**

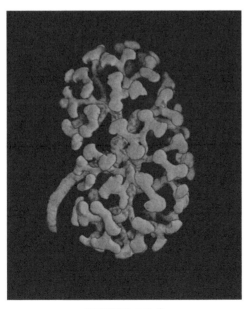

**FIGURE 14.8**

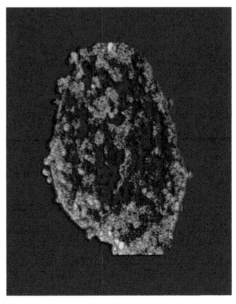

**FIGURE 14.10**

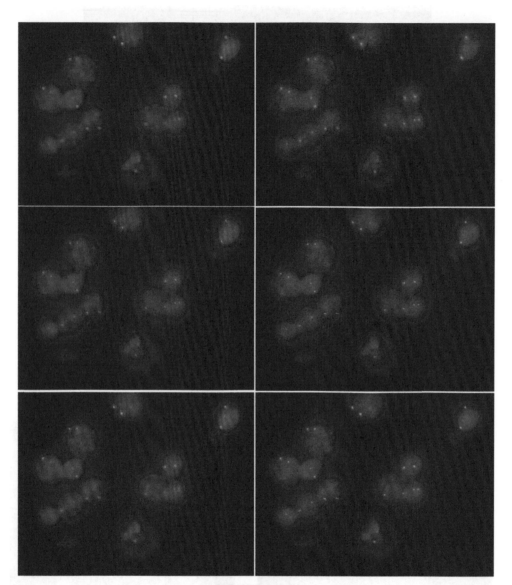

**FIGURE 16.8**

## 12.5.5 Histogram-Based Background Correction

Another simple histogram-based approach is used for background estimation in biological images of sparse objects, where the majority of the pixels are background pixels. This method is based on the assumption that the distribution of the dominant noise source in the image is unbiased and unimodal (which holds for Poisson noise) [24]. The background is estimated by fitting a parabola through the maximum values in the histogram. The corrected image is computed by subtracting the estimated background image from the recorded image.

## 12.5.6 Other Approaches for Background Correction

Several other approaches for shading correction have been published. For example, the variation of illumination intensity can be determined on the basis of the uniform bleaching characteristics of standardized uniformly fluorescing reference slides. This can be used for shading correction and image comparison in quantitative fluorescence microscopy [25]. One can also estimate the temporal variability of signal and noise in microscopic imaging, which separates monotonic, periodic, and random components of every pixel intensity change in time and allows the simultaneous determination of dark, photonic, and multiplicative components of noise [26].

Reducing brightness variations by subtracting a background image, whether obtained by experimental measurement, mathematical fitting, or image processing, is not a cost-free process. Subtraction reduces the dynamic range of the image, and clipping must be avoided in the subtraction process or it might interfere with subsequent analysis of the image. In general, given the huge diversity of biological samples being imaged with fluorescence microscopy, no single background-estimation algorithm is suitable universally for shading correction. The choice of the correction technique is application dependent.

## 12.5.7 Autofluorescence Correction

The background correction methods just described are also effective in attenuating shading effects due to autofluorescence. In another approach to remove autofluorescence effects, two images are recorded, one illuminated at the excitation wavelength of the fluorophore of interest and the other at the excitation wavelength of the autofluorescence [27]. Subtraction of the latter (i.e., autofluorescence-only image) from the former (representing the total fluorescence image, that is, the specific fluorophore plus the autofluorescence) results in an autofluorescence-free image. This technique assumes the autofluorescence image can be captured

using appropriate narrow-band excitation filters such that the autofluorescence excitation wavelength lies outside the excitation spectrum of the target fluorophore. If this is not the case, an additional correction factor can be used. This factor is computed by recording images of an unstained sample at both the autofluorescence and target fluorophore excitation wavelengths. The ratio $R$ of the two images at the desired emission wavelength of the target fluorophore is then used to compute the specific fluorescence as [27]

$$SF = TF - (R \times AF) \tag{12.16}$$

where SF is the specific fluorescence, TF is the total fluorescence, and AF is the autofluorescence. An alternative method based on time-delayed fluorescence imaging can also be used to eliminate autofluorescence effects [28, 29].

## 12.5.8  Spectral Overlap Correction

The most common problem encountered in multicolor fluorescence imaging (i.e., when two or more different-colored fluorophores are used) stems from the unavoidable overlap among fluorophore emission spectra and among camera sensitivity spectra. The result is that the individual colors, rather than being confined to one color channel, are smeared across all the channels. Intensity overlap between various color channels is problematic for both visualization and quantification. Examples include studies involving measuring concentrations of tagged molecules, colocalization of multiple target molecules, and segmentation of components in color images. A method called *color compensation* effectively isolates three fluorophores by separating them into three color channels (RGB) of the digitized color image [30]. This technique can account for black-level offset and unequal integration times [31]. Color compensation and other advanced signal processing methods for spectral unmixing are described in Chapter 13.

## 12.5.9  Photobleaching Correction

Photobleaching causes an overall decrease in intensity during intermittent or constant illumination over a period of time and can present barriers for both visualization and quantification in fluorescence imaging. Thus it is often necessary to analyze the kinetics of photobleaching of fluorophores objectively and make corrections. In fluorescence imaging, photobleaching manifests itself either as a first-, a second-, or a higher-order exponential decay in the average intensity of the image series as a function of time.

For a monoexponential bleaching process, the average intensity of an image at time $t$ is given by [32]

$$\langle i(x, y, t) \rangle_t = \langle i(x, y, t_0) \rangle_0 \exp[-kt] \tag{12.17}$$

where $\langle i(x, y, t_0)\rangle_0$ is the average intensity of the first image in the time series and $k$ is the bleaching decay constant, having reciprocal time units. The angular brackets in Eq. 12.17 indicate spatial averaging over the entire image or a region of interest.

For a biexponential bleaching process, the average intensity of an image at time $t$ is given by [32]

$$\langle i(x, y, t)\rangle_t = A \exp[-kt] + B \exp[-jt] \qquad (12.18)$$

where $j$ is a second bleaching rate and $A$ and $B$ are amplitude constants. Similarly, higher-order exponential decay functions can be expressed as

$$\langle i(x, y, t)\rangle_t = \sum_i D_i \exp[-k_i t] \qquad (12.19)$$

Using the appropriate photobleaching process model (Eq. 12.17, 12.18, or 12.19), it is possible to characterize empirically the intensity decay from the image (or region of interest) time series data. The decay curves can be obtained by fitting the appropriate exponential function to the data. To perform the exponential fitting, the average intensity values of the image or region of interest is determined for all the images of a bleaching series. The photobleaching decay curves are generated by plotting these intensity values as a function of time (in arbitrary units). Figure 12.2 presents an example of photobleaching observed in a time series of images captured for a triple-stained slide of bovine pulmonary artery endothelial cells. The cells were probed with anti–bovine-tubulin mouse

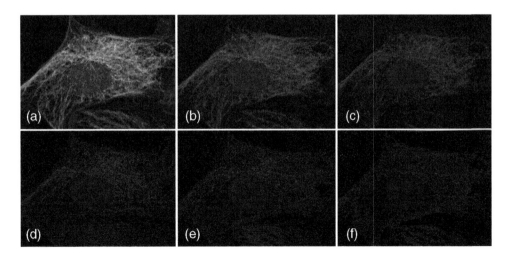

**FIGURE 12.2** Photobleaching of DAPI, fluorescein, and Texas Red. Time points were taken in 2-min intervals over 10 min. (a–f) Time = 0, 2, 4, 6, 8, and 10 min, respectively. This figure may be seen in color in the four-color insert.

monoclonal antibody and visualized with bodipy fluorescein goat anti-mouse immunoglobulin. The actin filaments are labeled with Texas Red-X phalloidin, and the nuclei are counterstained with DAPI (4′,6-diamidino-2-phenyl indole dihydrochloride). The images were acquired using a triple bandpass filter appropriate for Texas Red dye, fluorescein, and DAPI. The images in Fig. 12.2 were taken at 2-min intervals to excite the three fluorophores simultaneously while also recording the combined emission signals. The integration time for each image was 2.5 s. Note that all three fluorophores have a relatively high intensity in Fig. 12.2a, but the Texas Red intensity starts to drop rapidly at 2 min and is almost completely gone at 4 min (Fig. 12.2c). Similarly, the intensity of the green fluorescence drops dramatically over the course of the timed sequence (10 min). The photobleaching decay curves were generated by plotting these intensity values as a function of time (Fig. 12.3).

Nonlinear fitting methods, such as the Levenberg–Marquardt algorithm, can be used to determine the best-fit parameters [33]. Typically the fitting procedure minimizes a merit function with nonlinear dependencies to find the best-fit parameters. The minimization proceeds iteratively by giving trial values for the parameters, and the algorithm improves the trial solution until the value for the merit function stops (or effectively stops) decreasing. Generally, the estimated parameters are constrained to be positive so that the exponential function does not become negative [34]. Finally, for correction, every pixel is multiplied by the ratio of the fitted value at time 0 to the fitted value at the time the image was recorded.

Alternatively, several other functions have been defined to model the photobleaching process. For example, a stretched exponential decay [25] and a single

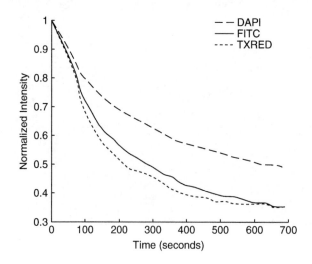

**FIGURE 12.3**   Photobleaching decay curves for DAPI, fluorescein, and Texas Red.

exponential function plus a constant term [35] provide much better fits to the photobleaching kinetics than a monoexponential function.

## 12.5.10 Correction of Fluorescence Attenuation in Depth

Attenuation of the fluorescence emission intensity with increasing depth due to absorption and scattering is a common problem encountered in fluorescence microscopy. This effect is most specifically relevant to three-dimensional (3-D) fluorescence imaging (see Chapter 14), where serial optical sections are acquired along the axial plane to obtain volumetric data stacks. Correction of loss of intensity with depth is essential for both visualization and quantitative analysis of data. However, correction of intensity loss is an inverse problem that has no unique solution [36]. Consequently, various empirical methods have been developed to model the effects of the intensity loss with depth, and several methods have been published for the correction of sections in a 3-D volumetric stack. These methods can be broadly classified into two major types, statistical and geometrical. Statistical approaches of attenuation correction employ empirical parametric functions to model the decay of light intensity with depth [37–45].

The geometrical approaches rely on the optical characteristics of the specimen. They model the distribution of light based on the underlying optical path traveled by the light, and they compute the attenuation of light with depth by integrating all light paths within the specimen [46–51].

The statistical methods are computationally simpler and take intensity decay due to photobleaching into account, though they are limited to specimens with nearly homogeneous fluorophore distribution. The geometrical approaches, on the other hand, are computationally complex and do not account for photobleaching effects. They do not, however, require the fluorophore distribution to be homogeneous. Instead, image intensity is a function of fluorophore density. Typically attenuation information at the previous slice is used to calculate the attenuation coefficients at the current slice.

Some work has been done on reducing the complexity of geometrical approaches [48, 50], and on correcting for spherical aberration in addition to scattering and absorption [51]. Also, a fully automated parameter-setting approach based on maximum entropy can be applied to both the statistical and the geometrical methods [36]. A drawback of both methods is the lack of improvement in SNR.

The overall correction algorithm is similar in both approaches. The fitted curve is obtained based on the underlying model (statistical or geometrical) and then used for the calculation of correction factors. First a one-dimensional (along the $z$-axis) spatial correction factor based on the statistical or geometric model is computed. The light intensity at the current $z$-position (slice) is then

adjusted with a multiplicative correction factor, and a new compensated series is computed. For example, if the loss of intensity with depth is modeled to follow the exponential decay law, then the procedure for attenuation correction is as follows [52]. A reference 3-D stack of $N$ images is taken of a representative area in the target specimen at a similar position, depth, and exposure as for each slice in the sample 3-D image. The sequence number of each image ($k = 1, \ldots,$ N) is proportional to the total integration time. The images in the reference stack are background corrected. An exponential decay curve, $\ln(I_k) = \ln(I_1) - \lambda k$, where $\lambda$ is the decay rate and $I_1$ and $I_k$ are the fluorescence intensities of the first and the $k$th image, respectively, is fitted to the reference data, and the value of $\lambda$ is estimated. The correction is implemented by multiplying the background-corrected signal in each slice $k$ of the sample image by $\exp(\lambda k)$ [52].

## 12.6    Quantifying Fluorescence

In modern biological microscopy, fluorescence imaging of live and fixed tissue is now used routinely. Quantitative analysis of fluorescence images allows measurements of (1) amounts or concentrations of cellular components and their interactions and (2) dynamics of cellular processes in space and time, at the subcellular, cellular, and tissue levels. The use of sophisticated imaging systems in conjunction with the image correction methods described earlier allows a direct correlation between the distribution of fluorescence and the digitally measured fluorescence signal, such that quantitative analysis can be performed. A key to quantitative analysis is (1) to take into account critical details of the entire protocol, starting with the optical properties of both the microscope and the specimen, (2) applying the appropriate corrections as needed, and (3) computing numerical values based on the properties of the fluorophores and the imaging parameters.

### 12.6.1    Fluorescence Intensity Versus Fluorophore Concentration

The amount of fluorescence emitted, $I_{EM}$, is proportional to the light absorbed. Given that $I_{EX}$ is the intensity of the light that illuminates a sample and $I$ is the amount of light that passes through the sample, then the portion of light absorbed is $I_{EX} - I$. The intensity of the emitted fluorescence can then be denoted by [9]

$$I_{EM} = \phi(I_{EX} - I) \qquad \text{where} \qquad (I_{EX} - I) \approx I_{EX} \cdot \varepsilon \cdot c \cdot x \qquad (12.20)$$

as defined earlier in Eq. 12.2. According to the Beer–Lambert law, the relationship between the exciting, emitted, and absorbed light can be expressed as [9]

$$I_A = -\log(I/I_{EX}), \quad \text{or} \quad I = I_{EX}e^{-I_A} \tag{12.21}$$

Thus Eq. 12.20 can be rewritten as [9]

$$I_{EM} = \phi I_{EX}\left(1 - e^{-I_A}\right) \tag{12.22}$$

From Eq. 12.22, it can be seen that when the absorption, $I_A$, is zero, $I_{EM}$ is zero. When $I_A$ approaches infinity, $I_{EM} = \phi I_{EX}$. Thus, when $I_A$ is small, the term $(1 - e^{-I_A})$ approaches $I_A$ and $I_{EM} = I_A\phi I_{EX}$. That is, the amount of light absorbed by the fluorophore is related to the concentration of the fluorophore, with $I_A \propto kc$, where $k$ is a constant and $c$ is the fluorophore concentration. Thus, at low concentrations, the fluorescence intensity is directly proportional to the concentration of the fluorophore, with $I_{EM} = kc\phi I_{EX}$, and at high concentrations $I_{EM} = \phi I_{EX}$, which is independent of the concentration. The linear relationship between absorbance and fluorescence holds at low absorbance values ($\sim \leq 0.2$) [9]. This linear relationship of fluorescence to excitation intensity enables quantitative measurements of concentration or amounts using fluorescence microscopy. It should be noted that fluorescence is a relative quantity, and a large number of factors can affect fluorescence measurements (discussed earlier, in Section 12.4). Thus careful calibration of the instrumentation, standards, and image correction methods are required for accurate quantification. Several quantitative microscopy techniques based on fluorescence imaging and the associated image analysis approaches are described next.

## 12.7 Fluorescence Imaging Techniques

The choice of the fluorescence imaging method used depends on the application. While the simplest form of fluorescence imaging involves the use of single-color fluorescence microscopy to measure the amounts and localization of cellular components, dual-color imaging is used for colocalization analysis, and more sophisticated approaches, such as fluorescence resonance energy transfer, are used to study protein interactions and for the dynamic investigation of molecular processes.

### 12.7.1 Immunofluorescence

Immunofluorescence is extensively used for the visualization and quantitation of the distribution of specific cellular components (such as proteins) in cells

or tissue. There are two major types of immunofluorescence techniques. In direct immunofluorescence, the primary antibody is labeled with a fluorescent dye and binds directly to the appropriate antigen. The specificity of this method is high, but the overall fluorescence signal is weak. In indirect immunofluorescence, a secondary antibody labeled with a fluorophore is used to recognize a primary antibody. This approach allows an increase of the fluorescence intensity, due to the larger number of antigenic sites available for binding the fluorescently labeled antibody.

Immunofluorescence microscopy is used to image the expression of proteins such as receptors, ion channels, and enzymes. This technique is useful for visualization of proteins but has two inherent limitations. The processing of tissue sections for mounting and staining may introduce artifacts, and, more importantly, structure and function cannot be studied in real time.

The most commonly observed problems in immunofluorescence microscopy are (1) nonspecific fluorescence due to cross-reactivity and background fluorescence and (2) photobleaching of the labeled target. Image preprocessing procedures typically involve the use of background correction, minimization of autofluorescence, and estimation of photobleaching characteristics. Analysis procedures include specific algorithms for localization of the spatial distribution of the target molecules and quantitative estimation of the relative amounts.

Figure 12.4 presents an image of the cytoskeletal architecture of mouse fibroblasts determined via direct immunofluorescence labeling and imaging of the rhodamine phalloidan–stained filamentous actin network. Images of the cytoskeletal architecture were acquired using a laser scanning confocal microscope [53]. The cytoskeletal morphology of the filamentous actin network was

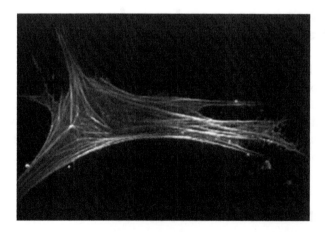

**FIGURE 12.4** Image of the cytoskeletal architecture of mouse fibroblasts determined via direct immunofluorescence labeling and imaging of the rhodamine phalloidan–stained actin network. (After [53].)

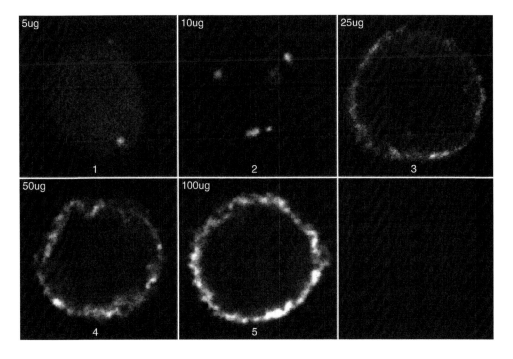

**FIGURE 12.5** Montage showing immunofluorescently labeled molecules of a genetically modified *Staphylococcus aureus* alpha toxin protein interacting with mouse fibroblasts. Panels 1, 2, 3, 4, and 5 show single-optical-section confocal micrographs of cells treated with 5, 10, 25, 50, and 100 μg/ml of H5, respectively, for 20 minutes.

evaluated. The cells are of stellate form, with a round or oval cell body and intact, long filopodial processes.

Figure 12.5 presents an image of fluorescently labeled molecules of a genetically modified bacterial protein, H5, interacting with NIH/3T3 mouse fibroblasts [54]. The interaction of H5 with cell membranes was studied by visualization and quantitation of the toxin molecules via indirect immunofluorescence labeling and confocal imaging. The labeled cells were imaged, and the relative amounts of the interacting protein and its spatial distribution in cells were determined by digital image analysis. The 3-D spatial distribution of the immunofluorescently labeled H5 was generated by determining the distance of each nonzero voxel from the center of mass of the cell. The total amount of H5 interacting with cell membranes was determined in terms of the volume of immunofluorescently labeled H5 normalized with respect to the cell volume. Image analysis algorithms included preprocessing of the acquired images using median filtering followed by segmentation using adaptive gray-level thresholding and 3-D region labeling. Surface modeling estimation using superquadric surfaces was used to identify the localization of the toxin molecules [55].

## 12.7.2  Fluorescence in situ Hybridization (FISH)

*Fluorescence in situ hybridization* (FISH) is a molecular cytogenetic technique that is very similar to immunofluorescence. It is used specifically for the visualization and localization of deoxyribonucleic acid (DNA) and ribonucleic acid (RNA) sequences. It has been widely applied in many areas of diagnosis and research, including prenatal and postnatal screening of genetic aberrations, pre-implantation genetic diagnosis, cancer genetics, and developmental molecular biology. FISH allows the microscopic analysis of chromosomal abnormalities such as an increase or reduction in the number of chromosomes and a translocation of part of one chromosome onto another.

The basic principle of the method is that a DNA probe for a specific chromosomal region will recognize and hybridize to its complementary sequence. Similar to immunofluorescence, two approaches are used for staining, direct and indirect. For direct labeling, the probe is tagged with a fluorescent dye, whereas in indirect labeling it is chemically modified by the addition of hapten molecules (biotin or digoxigenin) and then fluorescently labeled. The target DNA is stained with a fluorophore of complementary color. A fluorescence microscope equipped with filters specific for the fluorescently labeled probe and the counterstain is used to visualize the target. Normally, in interphase cells, the nucleus is counterstained using DAPI, and chromosome-specific DNA probes are directly or indirectly labeled with green (e.g., fluorescein) or red (e.g., Texas Red) dyes to visualize blue nuclei with colored dots (red, green, aqua, orange, etc.) [56]. Typically, multilabel (two-, three-, or four-color) FISH analysis is performed for cytogenetic analysis. The number of detected chromosomes or genes can be increased using combinatorial labeling, where the number of targets is $2^{n-1}$, with $n$ colors used for labeling (see multispectral FISH, discussed in Chapter 13).

Analysis of an interphase FISH specimen consists of determining the number of dots of each color, per cell [57]. Dot counting accuracy depends not only upon the hybridization efficiency, but also on the spatial location of chromosomes within the nucleus. Automated image analysis has been used to address most of these issues. Effective and efficient algorithms based on optical section deblurring and image fusion and gaussian modeling are used to differentiate between overlapping dots, split dots, and duplicated dots [10].

An example algorithm for automated image analysis is described here. Preprocessing is usually performed using background subtraction (Section 12.5.3.2) and color compensation (Chapter 13). Automated gray-level thresholding (generally, blue for the DAPI counterstain) is used to obtain binary images of cells. The cells are then uniquely identified using a region-labeling procedure

(Chapter 9). The 8-connected pixel neighborhood is used to determine the pixel belonging to a certain object. Each pixel in the connected neighborhood is then assigned a unique number so that all the pixels belonging to an object will have the same unique label. The number of pixels in each object is computed and used as a measure of cell size. Subsequently, shape analysis is used to discard large cell clusters and noncircular objects. Further, a morphological technique is used for automatically cutting touching cells apart (Chapter 8). The morphological algorithm shrinks the objects until they separate, and then it thins the background to define cutting lines. An exclusive-OR operation then separates the cells. Cell boundaries are smoothed by a series of erosions and dilations, and the smoothed boundary is used to obtain an estimate of the cellular perimeter. Performing a binary AND operation on the thresholded image and the morphologically processed mask with the other two red and green planes of the color-compensated image yields grayscale images containing only dots that lie within the cells. Objects are then located by thresholding in the probe color channels, using smoothed boundaries as masks. A minimum size criterion is used to eliminate noise spikes, and shape analysis is used to flag noncompact dots. The remaining objects are counted. The spatial location of each isolated dot is compared with the cell masks to associate each chromosomal dot with its corresponding cell.

Statistical modeling approaches may be applied to determine unbiased estimates of the proportion of cells having a given number of dots. For example, the befuddlement theory provides guidelines for dot-counting algorithm development by establishing the point at which further reduction of dot-counting errors will not materially improve the estimate [58]. This occurs when statistical sampling error outweighs dot-counting error. FISH-labeled interphase cells processed via automated image analysis are illustrated in Fig. 12.6. The image shows six female (XX) cells. Cells are counterstained blue (DAPI); X chromosomes are labeled in red (Texas Red). Panels a-d in Fig. 12.6 shows the results of automated image analysis. Panel a is the original image, panel b shows the background subtracted image, panel c shows the color compensated image, and panel d presents results of automated cell and dot finding. As seen in the figure, automated image analysis, correctly finds single cells, separates touching cells, and detects the red dots in individual cells.

## 12.7.3 Quantitative Colocalization Analysis

Colocalization studies are used to identify functionally related molecules. They involve the simultaneous analysis of the location and expression of multiple target molecules. The most common application is to determine the spatial

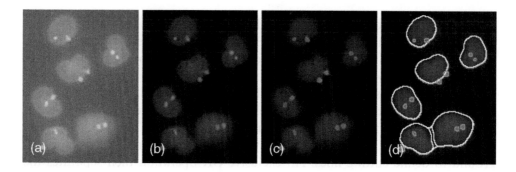

**FIGURE 12.6** FISH image of six female (XX) cells. Cells are counterstained blue (DAPI); X chromosomes are labeled in red (Texas Red). Results of automated image analysis: (a) original image, (b) background-subtracted image, (c) color-compensated image, and (d) results of automated cell and dot finding. This figure may be seen in color in the four-color insert.

colocalization between two fluorescently labeled proteins. Quantitative colocalization analysis allows estimation of the extent to which two or more proteins occur routinely at the same physical location in a cell or tissue region. This enables the mapping of potential protein-to-protein interactions with subcellular precision, thereby providing a better understanding of how intracellular mechanisms are regulated. In terms of image analysis, this involves the quantification of overlapping signals in multiple channels.

As described earlier, it is essential to correct the fluorescence images for background staining, spectral bleed-through, and other influences, such as lamp alignment and camera exposure settings, before colocalization can be quantified. Several approaches have been proposed for colocalization analysis. Techniques such as cross-correlation analysis [59] and cluster analysis of the 2-D histogram [60] have been applied to prove the existence of colocalization. Generally, given two proteins labeled using antibody (Ab) 1, colored red, and Ab 2, colored green, colocalization is based on the fact that the superimposition of the two proteins appears yellow. Figure 12.7 presents colocalization images of nascent DNA labeled with CldUrd (green) and IdUrd (red). Optical sections through the center of double-labeled nuclei (Chinise Hamster V79 cells) showing two early S-phase DNA replication patterns are presented in the figure. Nascent DNA was labeled with CldUrd (green) and IdUrd (red) at two different times. Time between the labels was 0 min in the control experiment (a), showing virtually complete colocalization, 25 and 45 min in (b) and (c), respectively, leading to less colocalization. This experiment shows that the DNA replication machinery moves through the nucleus.

Pearson's correlation coefficient, $r_p$, provides a nonlinear estimate of the amount of colocalized signals in the red and green channels [61]:

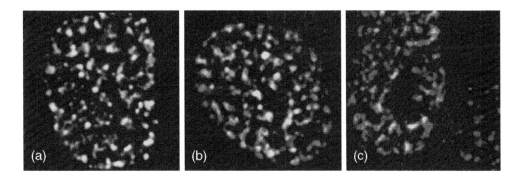

**FIGURE 12.7** Images of double-labeled nuclei (Chinese Hamster V79 cells) with nascent DNA labeled with CldUrd (green) and IdUrd (red) at two different times. Time between the labels was 0 min in the control experiment (a), showing virtually complete colocalization, 25 and 45 min in (b) and (c), respectively, leading to less colocalization. This figure may be seen in color in the four-color insert. (Images courtesy of Erik Manders.)

$$r_p = \frac{\sum_i (R_i - R_{av}) \cdot (G_i - G_{av})}{\sqrt{\sum_i (R_i - R_{av})^2 \cdot \sum_i (G_i - G_{av})^2}} \qquad (12.23)$$

where $R_i$ and $G_i$ are the values of pixel $i$ of the red and green components of a dual-color image, respectively, and $R_{av}$ and $G_{av}$ are the average values of $R_i$ and $G_i$, respectively. $r_p$ provides information on the similarity of shape independent of the average intensity of the signals. Its value ranges from $-1$ to $1$, and interpretation of the degree of overlap of the two signals may be ambiguous when negative values are encountered. Alternatively, an overlap coefficient can be computed as follows [62]

$$r = \frac{\sum_i R_i \cdot G_i}{\sqrt{\sum_i (R_i)^2 \cdot \sum_i (G_i)^2}} \qquad (12.24)$$

The value of $r$ ranges from 0 to 1, and it is independent of differences in signal intensities, when compared to $r_p$. The fraction of colocalizing regions in each component of dual-color images can be computed by dividing $r$ into two different coefficients [63], as

$$r_1 = \frac{\sum_i R_i \cdot G_i}{\sum_i R_i^2} \qquad \text{and} \qquad r_2 = \frac{\sum_i R_i \cdot G_i}{\sum_i G_i^2} \qquad (12.25)$$

The coefficients $r_1$ and $r_2$ are dependent on the intensities of the red and green signals, respectively. Two other coefficients, known as the Mander's

co-localization coefficients, can be defined to be independent of the signal intensities as follows [63]

$$M_1 = \frac{\sum\limits_i R_{i,\text{coloc}}}{\sum\limits_i R_i}, \qquad \text{where} \quad R_{i,\text{coloc}} = R_i \quad \text{if} \quad G_i > 0 \quad \text{and}$$
$$R_{i,\text{coloc}} = 0 \quad \text{if} \quad G_i = 0$$

$$M_2 = \frac{\sum\limits_i G_{i,\text{coloc}}}{\sum\limits_i G_i}, \qquad \text{where} \quad G_{i,\text{coloc}} = G_i \quad \text{if} \quad R_i > 0 \quad \text{and}$$
$$G_{i,\text{coloc}} = 0 \quad \text{if} \quad R_i = 0 \qquad (12.26)$$

Mander's colocalization coefficients are proportional to the amount of fluorescence of the colocalizing objects in each component of the image, relative to the total fluorescence in that component. The significance of Mander's coefficients can be assessed by a comparison with an expected random pattern obtained by repeatedly randomizing the pixel distribution in one of the channels [64]. Although these coefficients provide an indication of the coexistence of two proteins, they provide no information about whether the intensity of staining for the two proteins varies in synchrony (i.e., whether the two target proteins are structural elements of a common complex).

Intensity correlation analysis can be used to determine whether the staining intensities in the dual-color images are associated in a random, a dependent, or a segregated manner [65]. If $N$ is the number of pixels, $R_i$ and $G_i$ are the intensities in the red and green channels, and $R_{av}$ and $G_{av}$ the mean values of the red and green distributions, respectively, then we compute the sum of products of the differences between the pixel values and their means as follows [65]

$$\sum_i^N (R_i - R_{av})(G_i - G_{av}) \qquad (12.27)$$

The intensity correlation analysis technique involves generating scatter plots of the red dye or green dye against the product of the differences of each pixel in red and green intensities from their respective means (Eq. 12.27). The resulting plots emphasize the high-intensity-stained pixels, allowing the identification of protein pairs based on the variations in protein concentrations across the cell and not simply on their locations. If the two proteins are randomly distributed, then the value of Eq. 12.27 will tend toward zero, whereas if they are dependent the value will be positive, and if they are segregated the value tends to be negative. The polarity of each $(R_i - R_{av})(G_i - G_{av})$ value can be used to compute the intensity correlation quotient (ICQ), which provides a statistically

testable, single-value assessment of the relationship between the stained protein pairs. The ratio of the number of positive values to the total number of pixel pairs is first computed, and then the ICQ is determined by subtracting 0.5 from this value to distribute the quotients in the range $-0.5$ to $+0.5$. With random (or mixed) staining, $ICQ \approx 0$; with dependent staining, $0 < ICQ \le +0.5$; and for segregated staining, $0 > ICQ \ge -0.5$ [65]. The intensity correlation ICQ analysis allows identification of potential low-affinity protein complexes while retaining information on the cellular and subcellular locations.

## 12.7.4 Fluorescence Ratio Imaging (RI)

In fluorescence imaging, ratio imaging has three major applications: combinatorial ratio labeling, comparative genome hybridization (CGH), and ion ratio imaging. Combinatorial ratio labeling is used in multispectral fluorescence in situ hybridization (MFISH), in which the ratio between the intensities of different fluorophores is used to expand the number of colored labels. This number is typically limited by the number of fluorophores that can be spectrally separated (Chapter 13). In CGH, an estimate of the DNA sequence copy number as a function of position on the chromosome is obtained by measuring the ratio between sample DNA and the reference/control DNA to detect gene amplifications and deletions. Finally, ion ratio imaging is also used to measure either absolute or relative changes in spatial and temporal ion concentrations within living cells. This is achieved by measuring the fluorescence emission of special dyes that have been designed to change their spectral properties or emission intensities on binding to the ion of interest.

The principle underlying fluorescence ratio imaging is that the ratio of intensities at two or more wavelengths, computed for a single pixel or a region of interest, avoids the major problems associated with intensity variations in single-wavelength images. Gray-level changes in fluorescence images are very difficult to interpret, because of (1) variations in the intensity of the peak absorption or emission signals, (2) variations in local dye concentration, (3) photon shot noise, (4) fluctuations in the excitation light intensity, and (5) variations in detector gain. These intensity variations can be misinterpreted as a change in the concentration of the target. Moreover, specimen thickness may be problematic in single-wavelength images that display the amount of fluorescence only, with thicker portions of the sample looking brighter than smaller regions. The calculation of a ratio between the two channels corrects the result for intensity fluctuations and specimen thickness [66].

The protocol for ratio imaging is as follows. The ion-sensitive fluorescent dye is introduced into the cell, and two images are captured. The first image is acquired at the characteristic emission wavelength for binding, and the second at a reference wavelength (unbound). A ratio is then taken of the gray-level

changes at the same location at the two different wavelengths. This normalizes changes in the cell that are independent of a change in target concentration, such as the distance through a cell. Ratio imaging thus allows detection of ion transport and binding sites in living cells with relatively short optical path lengths (a few micrometers). It requires that the sources of measurement error (Section 12.4) be understood and appropriately corrected (Section 12.5) before quantitative measurement of concentration.

There is a wide range of fluorophores, with different spectral properties for numerous different ions. Intracellular calcium is the most widely imaged ion since it is involved in many different physiological processes, including muscle contraction, the release of neurotransmitters, ion channel gating, and second messenger pathways. Two types of fluorescence indicators are available for the measurement of intracellular calcium: (1) fluorescent dyes (Fluo-4, Fura-2, calcium green, etc.) and (2) fluorescent proteins (aequorin, derivatives of the green fluorescence protein (GFP) such as yellow camaleons, etc.). An advantage of the fluorescent proteins is that they can be targeted to different cell compartments while most dyes cannot.

The procedure for ratio imaging is relatively straightforward. For example, for analysis of $Ca^{+2}$ concentration using Fura-2 fluorescence dye, two excitation wavelengths are used, 340 nm and 380 nm. In the absence of any stimulus, in Fura-2-loaded cells, the $Ca^{+2}$ is bound in cell compartments. When excited at 380 nm, the Fura-2 molecules show strong fluorescence at an emission of 510 nm, whereas an excitation at 340 nm produces only weak fluorescence. On stimulation, the cell releases $Ca^{+2}$ from storage compartments and the Fura-2 molecules form complexes with the released $Ca^{+2}$ ions. The emitted signal now increases when excited with 340 nm and decreases when excited with 380 nm. The images are corrected for background variations, and the ratio between the signals of the two excitation channels is used to quantify the change of intensity. The ratio images can also be calibrated so that ratio values correspond to concentrations as [67]

$$[Ca^{+2}] = K_D \beta (R - R_{min})/(R_{max} - R) \tag{12.28}$$

where $R$ is the ratio of fura-2 fluorescence with 340-nm excitation divided by the fluorescence with 389-nm excitation at a given point in time. $R_{max}$ is the ratio when all the Fura-2 is bound to $Ca^{+2}$, $R_{min}$ is the ratio when all the Fura-2 is in the free acid form, $\beta$ is the ratio of fluorescence of free Fura-2 to the fluorescence of $Ca^{+2}$-bound Fura-2 with 380-nm excitation, and $K_D$ is the dissociation constant for Fura-2 and $Ca^{+2}$ binding. Typically, the values of $R_{max}$, $R_{min}$, and $\beta$ for intracellular $Ca^{+2}$ concentration calibration are determined as follows. Following the recording of $Ca^{+2}$ dynamics during an experiment, a calcium ionophore, such as ionomycin, is introduced into a cellular buffer solution that has a high free $[Ca^{+2}]$ to raise the intracellular $[Ca^{+2}]$. Recording images

after the cytosol reaches equilibrium allows the determination of $R_{max}$, because the 340-nm excitation signal is at its highest and the 380-nm excitation signal is at its lowest. Subsequently, a calcium chelator (e.g., ethylene glycol tetraacetic acid) is added to drop the intracellular $[Ca^{+2}]$, and, at equilibrium, images are acquired to measure $R_{min}$. The value of $K_D$ is fluorophore specific and can be obtained from the manufacturer. Ratio imaging can be performed using wide-field, confocal, or two-photon microscopy, with the most critical requirement being the simultaneous or near-simultaneous acquisition of two images at different excitation or emission wavelengths [68].

## 12.7.5 Fluorescence Resonance Energy Transfer (FRET)

Fluorescence resonance energy transfer (FRET) is a relatively new technique in fluorescence imaging that can be used to obtain information on the immediate environment (in the nanometer range) of a labeled molecule, to detect macromolecular interactions, and to determine the intra- and intermolecular proximity of two appropriately paired fluorophores. Protein-to-protein interactions mediate the majority of cellular processes. Identification of a protein's interacting partners is critical in understanding its function, placing it in a biochemical pathway, and thereby establishing its relationship to important disease processes.

Fluorescence resonance energy transfer is a process involving the radiation-less transfer of energy from a donor fluorophore to an appropriately positioned acceptor fluorophore [69, 70]. FRET can occur when the emission spectrum of a donor fluorophore significantly overlaps (>30%) the absorption spectrum of an acceptor. In the absence of spectrum overlap, FRET cannot occur. For FRET, the emission dipole of the donor and the acceptor absorption dipole should be oriented nonperpendicular to each other. A dipole is an electromagnetic field that exists in a molecule with two oppositely charged regions. With overlapping spectra, the donor's oscillating emission dipole looks for a matching absorption dipole of the acceptor to oscillate in synchrony. The magnitude of the relative orientation of the dipole–dipole coupling values ranges between 1 and 4, and the efficiency of energy transfer varies inversely with the sixth power of the distance separating the donor and acceptor fluorophores. Thus, the distance over which FRET can occur is limited to in the range of 1–10 nm. When the spectral, dipole orientation, and distance criteria are satisfied, excitation of the donor fluorophore results in sensitized fluorescence emission of the acceptor, indicating that the tagged proteins are separated by <10 nm. This FRET-inferred proximity between two labeled cellular components considerably surpasses the resolution of normal light microscopy, which can resolve distances of ~200 nm at best. The most commonly used fluorophore pairs for

FRET can be found in the literature along with their respective spectra and filter combinations [71, 72].

FRET has been implemented using wide-field, confocal, and two-photon fluorescence microscopy [72]. Wide-field FRET (W-FRET) imaging provides the 2-D spatial distribution of steady-state protein-to-protein interactions [73]. An advantage of W-FRET is that it allows the use of any excitation of wavelength using interference filters for various fluorophore pairs. A disadvantage of W-FRET is that it contains out-of-focus information in the FRET signal. However, this low-cost system is used widely to monitor protein associations in living specimens where confocality is not an issue, such as following events in the nucleus. In confocal FRET (C-FRET) and two-photon (2p) excitation FRET (2p-FRET) microscopy, one can discriminate the out-of-focus information to obtain the FRET signal at the selected focal plane [74]. Moreover, 2p-FRET microscopy uses infrared (IR) laser light as an excitation wavelength and has the ability to excite most of the selected fluorophore pairs as compared to the confocal systems, where fixed laser lines are available at a few limited excitation wavelengths. It is important to choose 2p-FRET fluorophore pairs with different 2p absorption cross sections to avoid simultaneous excitation by one wavelength. The use of infrared laser light excitation instead of ultraviolet laser light also reduces phototoxicity in living cells. In general, 2p-FRET microscopy is superior for deep-tissue FRET imaging [74]. Also, spectral imaging, either by confocal or two-photon systems, is an intensity-based imaging technique, which provides an excellent way to obtain a FRET signal (see Figs. 12.8 and 12.9) [75].

Figure 12.8 presents images of GHFT1 cells expressing alpha enhancer binding protein (C/EBPα) either with YFP, yellow fluorescent protein, (acceptor) alone or CFP, Cyan fluorescent protein (donor) or with both. The same optical settings were used for imaging both single- and double-labeled cells. These images were unmixed, based on the reference spectra of donor and acceptor using a spectral unmixing algorithm provided by the Zeiss Company. The experimental details regarding data acquisition and processing is described in the literature [75, 76]. We used a Carl Zeiss laser scanning 510 confocal/multiphoton/spectral imaging system to collect the data. The following is shown in Fig. 12.8: Spect I panel—DA_DS is the spectral image from the double-labeled specimen under donor excitation; e_s and f_s are unmixed from DA_DS; Spect II panel—DA_AS is the spectral image from the same double-labeled specimen but under acceptor excitation; g_s is unmixed from DA_AS; Spect III panel—A_AS is the spectral image from the single-labeled acceptor specimen under the same acceptor excitation as that from the double-labeled specimen; d_s is unmixed from A_AS; Spect IV panel—A_DS is the spectral image from the single-labeled acceptor specimen under the same donor excitation as that from the double-labeled specimen; c_s is unmixed from A_DS, which is only

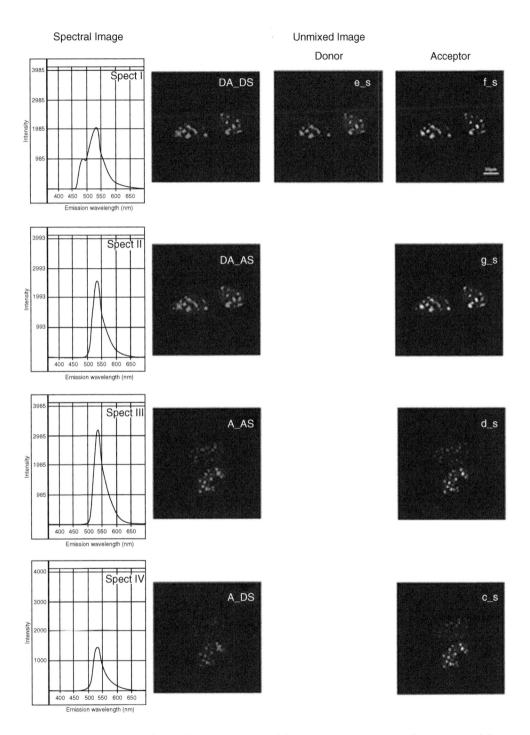

**FIGURE 12.8** Spectral FRET data acquisition and linear unmixing. GHFT1 cells expressing alpha enhancer binding protein (C/EBPα) either with yellow fluorescent protein (acceptor) alone or cyan fluorescent protein (donor) or with both. Same optical settings were used for imaging both single- and double-labeled cells. These images were unmixed, based on the reference spectra of donor and acceptor using spectral unmixing algorithm provided by the Zeiss Company. This figure may be seen in color in the four-color insert.

acceptor bleed-through. There are donor components from unmixing for DA_AS, A_DS, and A_AS; they are blank images in the figure and are not required for the data analysis. CFP and YFP fingerprints were obtained from single-labeled donor and single-labeled acceptor to use for linear unmixing. All the linear unmixing was implemented using CFP, YFP, and background spectra.

Figure 12.9 illustrates the results of the implementation of the processed spectral FRET (psFRET) algorithm [76] on the spectrally unmixed images. The f_s image in the panel Spect I (Fig. 12.8) contains the FRET signal and the acceptor spectral bleed-through signal. The bleed-through signal was analyzed and removed using the algorithm described in the literature [75, 76], and shown in Fig. 12.9 as a histogram for both conditions. The localization of C/EBPα protein in the living cell nucleus is clearly shown as a spot in the image.

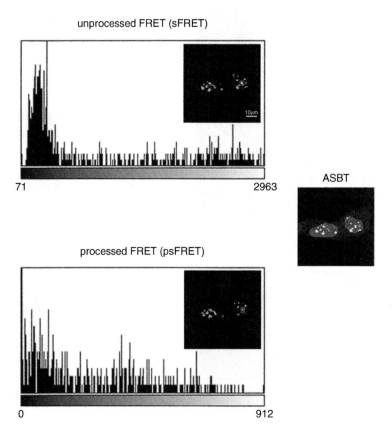

**FIGURE 12.9**    The f_s image in the panel Spect I (Fig. 12.8) contains the FRET signal and the acceptor spectral bleed-through signal. The bleed-through signal was analyzed and removed using the algorithm as described in the literature [76] and is shown in the figure as histogram for both conditions.

Förster's basic rate equation for a donor and acceptor pair at a distance $d$ from each other, is

$$k_\tau = 1/\tau_D (R_0/d)^6 \tag{12.29}$$

where $k_\tau$ is the rate of energy transfer, $\tau_D$ is the donor excited state lifetime in the absence of the acceptor, and $R_0$ is the Förster distance (a distance at which coupling efficiency reaches 50%). The energy transfer efficiency ($E$) is represented by the equation

$$E = R_0/(R_0^6 + d^6) \tag{12.30}$$

Typically, the efficiency drops if the distance between donor ($D$) and acceptor ($A$) molecules change from the Förster distance. The energy transfer efficiency ($E$) and the distance ($d$) measurement between donor and acceptor can also be calculated using the following equations

$$d = R_0 \{(1/E) - 1\}^{1/6} \tag{12.31}$$

$$R_0 = 0.211 \{\kappa^2 n^{-4} Q_D J(\lambda)\}^{1/6} \tag{12.32}$$

where $Q_D$ is the quantum efficiency of the donor molecule, $J$ is the spectral overlap between the donor emission and acceptor absorption power spectrum ($cm^2\ s^4/mol$), $n$ is the refractive index of the energy transfer medium, and $\kappa^2$ is orientation factor, which varies between 0 and 4. The overlap integral $J$, which expresses the degree of spectral overlap between the donor emission fluorescence and the acceptor absorption, is given as

$$J(\lambda) = \int_0^\infty f_D(\lambda)\varepsilon_A(\lambda)\lambda^4\ d\lambda \tag{12.33}$$

where $\lambda$ is the wavelength of the light, $\varepsilon_A(\lambda)$ is the molar extinction coefficient of the acceptor at that wavelength, and $f_D(\lambda)$ is the normalized fluorescence intensity at that wavelength. The energy transfer efficiency may also be calculated by ratioing the donor image in the presence and absence of the acceptor

$$E = 1 - [I_{DA}/I_D] \tag{12.34}$$

where $I_{DA}$ and $I_D$ are the fluorescence intensities in the presence and the absence of acceptor, respectively.

As described earlier, all these techniques require the removal of certain signal contaminations, such as camera insensitivities and background fluorescence [75, 76]. One of the important conditions for FRET to occur is the overlap

of the emission spectrum of the donor with the absorption spectrum of the acceptor. As a result of spectral overlap, the FRET signal is always contaminated by donor emission into the acceptor channel and by the excitation of acceptor molecules by the donor excitation wavelength. Both of these signals are termed *spectral bleed-through* (SBT) of signal into the acceptor channel. There are various methods to assess the SBT contamination in FRET image acquisition [77–80]. One approach eliminates both the donor and acceptor SBT problems and corrects the variation in fluorophore expression level (FEL), using the same cell as used for FRET imaging [74, 81, 82]. The letters $D$, $A$, and $DA$ are used to denote donor, acceptor, and donor–acceptor pairs, respectively. Seven images (denoted by a, b, c, d, e, f, g) are acquired as follows: double-labeled (three images; donor excitation/donor "e" and acceptor "f" channel; acceptor excitation/acceptor channel "g"), single-labeled donor (two images: donor excitation/donor "a" and acceptor "b" channel), and single-labeled acceptor (two images; donor excitation/acceptor "c" channel; acceptor excitation/acceptor channel "d"). This approach works on the assumption that the double-labeled cells and single-labeled donor and acceptor cells, imaged under the same conditions exhibit the same SBT dynamics [82]. A practical impediment to implementation arises from the fact that there are three different cells (D, A, and D + A), where individual pixel locations cannot be compared. Instead, comparison of pixels with matching fluorescence levels is performed. The algorithm follows fluorescence levels pixel by pixel to establish the level of SBT in the single-labeled cells and then applies these values as a correction factor to the appropriate matching pixels of the double-labeled cell. The following equations are used to remove the spectral bleed-through signal from the FRET channel image. The corrected FRET signal image, denoted as PFRET (precision FRET) is computed as [83]

$$PFRET = UFRET - DSBT - ASBT \qquad (12.35)$$

where UFRET (image "f") is uncorrected FRET, ASBT is the acceptor spectral bleed-through signal, and DSBT is the donor spectral bleed-through signal, computed as follows. To correct the DSBT, three images are required (one double-labeled "e" and two single-labeled donor images "a" and "b"). To obtain the DSBT values, the following equations are used [83]

$$rd_{(j)} = \frac{\sum\limits_{i=1}^{m} b_i}{\sum\limits_{i=1}^{m} a_i}, \qquad DSBT_{(j)} = \sum\limits_{p=1}^{n} \left( e_p * rd_{(j)} \right), \qquad DSBT = \sum\limits_{j=1}^{k} DSBT_{(j)} \qquad (12.36)$$

where $j$ is the $j$th range of intensity, $rd_{(j)}$ is the donor bleed-through ratio for the $j$th intensity range, $m$ is the number of pixels in "a" for the $j$th range, $a_i$ is the intensity of pixel $i$, $DSBT_{(j)}$ is the donor bleed-through factor for the range $j$, $n$ is

the number of pixels in "e" for the $j$th range, $e_p$ is the intensity of pixel $p$, $k$ is the number of the range, and DSBT is the total donor bleed-through.

The ASBT correction follows the same approach as DSBT, using three images (one double-labeled "g" and two single-labeled acceptor images "c" and "d"). To obtain the ASBT values, the following equations are used [83]

$$ra_{(j)} = \frac{\sum_{i=1}^{m} c_i}{\sum_{i=1}^{m} d_i}, \qquad \text{ASBT}_{(j)} = \sum_{p=1}^{n} \left( g_p * ra_{(j)} \right), \qquad \text{ASBT} = \sum_{j=1}^{k} \text{ASBT}_{(j)} \quad (12.37)$$

where $j$ is the $j$th range of intensity, $ra_{(j)}$ is the acceptor bleed-through ratio for the $j$th intensity range, $m$ is the number of pixels in "d" for the $j$th range, $d_i$ is the intensity of pixel $i$, $\text{ASBT}_{(j)}$ is the acceptor bleed-through factor for the range $j$, $n$ is the number of pixels in "g" for the $j$th range, $g_p$ is the intensity of pixel $p$, $k$ is the number of the range, and ASBT is the total acceptor bleed-through.

The PFRET image is then used for further data analysis, such as estimation of the distance between donor and acceptor molecules and the energy transfer efficiency $E\%$, as follows. The sensitized emission in the acceptor channel is due to the quenching of the donor or energy transferred signal from the donor molecule in the presence of acceptor. Adding the PFRET to the intensity of the donor in the presence of acceptor gives $I_D$. This $I_D$ is from the same cell used to obtain the $I_{DA}$. Then from Eq. 12.34 and Eq. 12.35, we have

$$E_n = 1 - [I_{DA}/I_{DA} + \text{PFRET}], \quad \text{where} \quad I_D = I_{DA} + \text{PFRET} \quad (12.38)$$

It is important to note that a number of processes are involved in the excited state during energy transfer. The equation for energy transfer efficiency $E_n$ (see [83] for details) is thus calculated by generating a new $I_D$ image and by including the detector spectral sensitivity for donor and acceptor channel images and the donor quantum yield, with the PFRET signal as follows [83]

$$E_n = 1 - \{I_{DA}/[I_{DA} + \text{PFRET} \times (\psi_{dd}/\psi_{aa}) \times (Q_d/Q_a)]\} \quad (12.39)$$

where

$$\frac{\psi_{dd}}{\psi_{aa}} = \left[ \left( \frac{\text{PMT gain of donor channel}}{\text{PMT gain of acceptor channel}} \right) \times \left( \frac{\text{spectral sensitivity of donor channel}}{\text{spectral sensitivity of donor channel}} \right) \right] \quad (12.40)$$

where $\psi_{dd}$ and $\psi_{aa}$ are collection efficiency in the donor and acceptor channel, $Q_d$ is the donor quantum yield and $Q_a$ is the acceptor quantum yield. Using $R_0$ defined in Eq. 12.32, the distance, $d_n$, between donor and acceptor, is computed as [83]

$$d_n = R_0\{(1/E_n) - 1\}^{1/6} \qquad (12.41)$$

An alternative approach for measuring FRET is to determine the fluorescent lifetime of the donor in the presence and absence of the acceptor. The advantages of this approach are that it is dependent directly on excited-state reactions and independent of the fluorophore concentration and light path length (and consequently photobleaching), thus allowing the donor–acceptor distance to be mapped more accurately.

## 12.7.6 Fluorescence Lifetime Imaging (FLIM)

The fluorescence lifetime, $\tau$, of a fluorophore is the average time, in the picosecond-to-nanosecond range, that a fluorophore spends in the excited state following photon absorption. Decay from the excited state occurs through spontaneous emission of fluorescence, internal conversion, photobleaching, and FRET. Thus, the measurement of the lifetime of the donor excited state by fluorescence lifetime imaging (FLIM) can also be used for studying FRET. It can be detected as a decrease in the fluorescence lifetime of the donor fluorophore. However, FLIM can be technically challenging, for it requires specialized equipment [84, 85], is difficult to apply in live cells, and is computationally complex [82]. In practice, the fluorescence lifetime is defined as the time in which the fluorescence intensity decays to $1/e$ of the intensity immediately following excitation.

In FLIM measurements, several time-resolved fluorescence images of a sample are obtained at various delay times (nanosecond). Typically, gated detection is performed following pulsed laser excitation of the field of view or region of interest. The effective fluorescence lifetime is calculated pixel by pixel by assuming a single exponential decay using time-resolved images taken at different delay times (typically 2–8 ns). Curve fitting is performed, and the lifetimes are determined by an iterative least-squares analysis. For a monoexponential decay, provided the pulse duration $\ll \tau$, the emitted fluorescent intensity can be written as [85]

$$I(t) = I_0 \cdot \exp\left(\frac{-t}{\tau}\right) \qquad (12.42)$$

where $I(t)$ is the fluorescent intensity as a function of time, $I_0$ is the fluorescent intensity immediately after the pulse, $t$ is the time after the light pulse, and $\tau$ is the excited-state lifetime. For example, if two delay times are used, $\tau$ can be measured as [85]

$$\tau = \frac{t_1 - t_2}{\ln(D_1 - D_2)} \qquad (12.43)$$

where $t_1$ and $t_2$ are the time delay between the excitation pulse and the start of detection interval 1 and 2, respectively, and $D_1$ and $D_2$ are the integrated intensities in intervals 1 and 2, respectively. Figure 12.10 presents representative

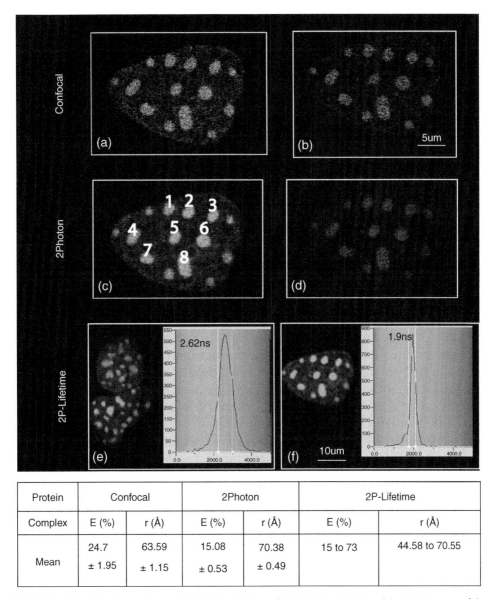

| Protein | Confocal | | 2Photon | | 2P-Lifetime | |
|---------|----------|---------|---------|---------|-------------|---------|
| Complex | E (%) | r (Å) | E (%) | r (Å) | E (%) | r (Å) |
| Mean | 24.7 ± 1.95 | 63.59 ± 1.15 | 15.08 ± 0.53 | 70.38 ± 0.49 | 15 to 73 | 44.58 to 70.55 |

**FIGURE 12.10** Comparison of C-FRET, 2p-FRET, and FLIM-FRET. C-FRET and 2p-FRET images of the quenched donor (a, c) and the PFRET images (b, d) are shown. The respective efficiency (E) and the distance (r) are shown in the table below the figure. For the same cell, the donor lifetime images were acquired in the absence (e) and the presence (f) of the acceptor. This figure may be seen in color in the four-color insert. (Reproduced with permission from [82].)

images for measuring the donor quenching or donor lifetime for estimating energy transfer efficiency ($E\%$) [86, 87]. The figure illustrates images comparing C-FRET, 2p-FRET, and FLIM-FRET. C-FRET and 2p-FRET images of the quenched donor (a, c) and the PFRET images (b, d) are shown. The respective efficiency ($E$) and the distance ($r$) are shown in the table below the figure. The distance between donor and acceptor molecules appears to be higher for 2p-FRET than for C-FRET. This may be due to the difference in methodology of acquisition of photons. Both C-FRET and 2p-FRET signals were collected in the same cell and optics using the Biorad Radiance2100 confocal/multiphoton microscopy system. For the same cell, the donor lifetime images were acquired in the absence (e) and the presence (f) of acceptor. As stated in the text, the natural lifetime of the donor (2.62 ns) was reduced to 1.9 ns (mean value) due to FRET. Lifetime measurements are the accurate values of the distance distribution of the dimerization of C/EBP$\Delta$244 protein molecules in mouse pituitary GHFT1-5 cell nucleus [82].

In summary, FRET-FLIM is an important technique for investigating a variety of phenomena that produce changes in molecular proximity and for monitoring intermolecular interactions and localization of proteins in cells and tissues [73].

## 12.7.7   Fluorescence Recovery After Photobleaching (FRAP)

Fluorescence recovery after photobleaching is used for studying the dynamic behavior of labeled molecules, specifically the behavior of proteins in living cells. The process involves photobleaching a region of interest, thereby allowing the temporal study of the consequent fluorescent recovery in that bleached region as a result of the movement of nonbleached fluorescent molecules from the surrounding area. The extent to which this recovery occurs and the speed at which it occurs are measures for the fraction of mobile molecules and the speed at which they move, respectively [88]. The basic FRAP experiment is straightforward. First, a region of limited dimensions within a larger volume is illuminated with a short pulse of an intense laser beam at the excitation wavelength of the dye to be bleached. Subsequently the molecules in the exposed region are no longer fluorescent. If the target labeled molecule is fixed, the region will remain dark. However, if the target molecules are mobile, they diffuse, with new fluorescent molecules from the surrounding unbleached regions moving into the bleached region and mixing with the bleached molecules. This leads to a continuous increase of fluorescence in the bleached region until the bleached and new fluorescent molecules have been completely redistributed over the entire volume. If the bleached area is relatively large compared to the total volume in which the target molecules reside, the final recovery of fluorescence will be less than the prebleaching level. This process can be followed on a microscope by visualizing

the fluorescence either in the bleached region or in the total volume. After a statistically relevant number of cells or regions have been sampled, the average mobility of the fluorescent molecules can be determined by averaging the normalized fluorescence intensity of the individual regions.

One approach to normalizing FRAP data is to express the data relative to the prebleaching value [88]

$$I_{norm,t} = \left(I_t - I_{background}\right)/\left(I_{prebleach} - I_{background}\right) \qquad (12.44)$$

where $I_{prebleach}$ is the measurement before bleaching (or the average of a number of recordings before bleaching) and $I_{background}$ is the signal level in the absence of any fluorescence [88]. Alternatively, normalization can be performed by fitting the data to the analytically derived descriptions of diffusion, as follows [88]

$$I_{norm,t} = (I_t - I_0)/(I_{final} - I_0) \qquad (12.45)$$

where $I_{final}$ is the final value at the completion of fluorescence recovery. This process yields a curve that starts at zero immediately after bleaching and reaches unity at recovery. The curve fit can be performed using any equation that represents the diffusion process and with any fitting algorithm, such as the least-squares method. A variety of analytical functions representing 2-D and 3-D diffusion models and the Monte Carlo simulation approach to generating FRAP curves are covered in the literature [88–91].

Another application of FRAP is to determine quantitatively the immobile fraction of the labeled molecule under investigation. This is achieved as [88]

$$I_{norm,t} = (I_t - I_0)(I_{prebleach} - I_0) \qquad (12.46)$$

where $I_0$ is the intensity immediately after bleaching. This approach yields a curve for which the prebleaching value is unity and the fluorescence level immediately after bleaching is zero [88, 89]. If the fraction of mobile bleached molecules is negligible, compared to the total amount of fluorescence molecules, that is, if the FRAP curve would return to prebleaching levels when no immobile fraction was present, then the immobile fraction can be estimated as $1 - I_{norm,final}$.

The confocal laser scanning microscope is ideal for performing FRAP experiments because the laser illumination can be limited to defined coordinates, allowing any region to be selected for bleaching. Applications of FRAP include the study of exchange between cells or organelles, diffusion of proteins within membranes or organelles, and determination of protein turnover in complexes. To aid in localization of the target molecule postbleaching, sometimes a second fluorophore that remains visible throughout the time course of the experiment is introduced to the target. This process is termed *fluorescence localization after photobleaching* (FLAP) [92]. Another complementary technique is

*fluorescence loss in photobleaching* (FLIP), which involves repeated photobleaching of a region of fluorescence within the cell [92]. Over time, this repeated bleaching leads to permanent loss of fluorescent signal throughout the cell. This indicates that free exchange of molecules occurs between the photobleached region and the rest of the cellular compartments. Thus, nonbleaching of molecules within the cell indicates where molecules are isolated and specifically localized in distinct cellular compartments.

## 12.7.8 Total Internal Reflectance Fluorescence Microscopy (TIRFM)

Total internal reflectance fluorescence microscopy (TIRFM) is used to monitor the behavior of biomolecules directly at the single-molecule level, both in vitro and in living cells. It is most suited to image events occurring at or close to the plasma membrane of live cells. This technique is based on the principle that when the excitation light is incident above a "critical angle" on the glass/water interface, the light is totally reflected internally, and it generates a thin electromagnetic field (called the *evanescent field*) with the same wavelength as the incident light [93]. The evanescent field that decreases exponentially is created at a depth of ~150 nm below the glass/water interface [94, 95]. The intensity of the evanescent field decays exponentially with distance from the glass surface; thus it is only able to excite molecules near the glass surface. This has the advantage that fluorophores further from the surface are not excited, resulting in a reduction of background noise. The constant of the exponential spatial decay of the field is the penetration depth, $d_p$, which depends on the physical parameters of the total internal reflection setup and the incident light.

In TIRF microscopy the field penetrates from the cover glass to the liquid in which the specimen is mounted. The penetrating energy is used as excitation to image a thin slice in the liquid substrate. The image intensity of a pixel depends on its depth $z(x, y)$ above the interface, given by [94, 95]

$$I_z(x, y) = I_{max} \exp^{\left(-(z(x, y) - z_{min})/d_p\right)} \tag{12.47}$$

where $I_{max}$ is the maximum intensity and $z_{min}$ is the corresponding height, whose value is an experimental constant depending on the thickness of the region under observation.

TIRFM is used to measure the time course, trajectory, and distribution of molecular properties for individual biomolecules in vitro and in living cells [93, 96]. Specific applications include examination of plasma membrane events, such as endocytosis and exocytosis, spatial and quantitative analyses of receptor–ligand binding interactions, mobility of plasma membrane components, dynamics of cytoskeletal filaments, and the monitoring of chemical reactions. Image processing

and analysis algorithms are typically dictated by the application, and most are customized to analyze quantitatively the parameters of interest.

## 12.7.9 Fluorescence Correlation Spectroscopy (FCS)

Fluorescence correlation spectroscopy (FCS) imaging is a highly sensitive method that provides fast temporal and high spatial resolution for single-molecule imaging. The basis of this technique is monitoring the fluorescence fluctuations that arise from molecule diffusion within a small optically defined volume (on the order of femtoliters), following excitation by a focused laser beam. These fluctuations in fluorescence may arise as a result of flow, chemical reaction, and Brownian diffusion. In conventional imaging, fluctuations in intensity are problematic and constitute noise. However, in FCS the fluctuations constitute the signal. The imaging approach is to record the fluctuations in fluorescence intensity as a function of time. FCS is based on correlation analysis, comparing time signals for a series of lag times $\tau$. The decrease in the autocorrelation function of the time series provides a measure of the diffusion coefficient of the fluorophore.

The most commonly used normalized autocorrelation function, relating the fluorescence intensity $I(t)$ at time $t$ to that $\tau$ seconds later, $I(t + \tau)$, is [97]

$$G(\tau) = 1 + \frac{\langle \delta I(0) \delta I(\tau) \rangle}{\langle I \rangle^2} \tag{12.48}$$

In FCS, for the evaluation of experimental data, the following analytical expression is used [97]

$$G(\tau) = 1 + \frac{1}{N} \left( 1 + \frac{\tau}{\tau_D} \right)^{-1} \left( 1 + \frac{\tau}{R^2 \tau_D} \right)^{-1/2}, \quad \text{where} \quad R = \omega_z / \omega_{xy} \tag{12.49}$$

Equation 12.49 gives the correlation function for translational diffusion. The function is time dependent and represents the fluorescence fluctuation that occurs due to Brownian motion. Assuming that the molecules within the observed volume element follow Poisson statistics, $N$ is the average number of molecules in the sample volume. The number of molecules is inversely proportional to the amplitude of the autocorrelation curve, $\tau_D$ is the average time the molecules take to move across the observation volume in the radial direction, and $R$ is the ratio of the axial half-axis to the lateral half-axis of the observation volume [97].

The autocorrelation curve resulting from processing FCS data is interpreted by fitting equations to it. Typically, mathematical functions that represent different diffusion models (such as Eq. 12.49) are fitted to the autocorrelation

curve. Parameters such as the translational diffusion time, which characterizes the average residence time of the fluorescent molecule in the defined excitation volume, and the average number of fluorescent molecules in the volume can then be determined. FCS has been used to measure the location, accumulation, and mobility of fluorescently tagged molecules in membranes and the cell wall from very low-bulk concentrations. Also, *fluorescence cross-correlation spectroscopy* (FCCS) has been used to measure protein-to-protein interaction between two fluorescently tagged targets. The reader is referred to other publications for a comprehensive review on FCS [98–100].

# 12.8   Summary of Important Points

1. Fluorescence imaging provides an incomparable degree of flexibility, given its ability to maintain a "molecular" resolution with high specificity in a tremendously complex biological background.

2. Fluorescence occurs when a molecule absorbs a photon and then emits a photon as it returns to a lower state.

3. Fluorescence microscopy is an incoherent imaging process; that is, each point of the object or sample contributes independently to the light intensity distribution in the observed image.

4. Wide-field, confocal, and two-photon microscopes can be used to perform single- and multidimensional fluorescence microscopy. The key requirements are illumination at the required wavelength and effective blocking of the excitation light during detection of the emitted light.

5. In practice, instrument- and sample-based aberrations are always present in fluorescence microscopy. It is critical that the sources of noise be identified and appropriately corrected.

6. Fluoresence images can be corrected easily for background inhomogeneity, dark current, autofluorescence, photobleaching, and intensity attenuation with depth.

7. The linear relationship between fluorescence and excitation intensity enables quantitative measurements of concentration using fluorescence microscopy.

8. Fluorescence is a relative quantity, and a large number of factors can affect fluorescence measurements, requiring calibration of instrumentation, standards, and image correction methods for accurate quantification.

9. Several techniques are available for fluorescence microscopy. The choice of the fluorescence microscopy method used depends on the application.

10. Immunofluorescence is extensively used for the visualization and quantitation of the distribution of specific cellular components (such as proteins) in cells or tissue.

11. Fluorescence in situ hybridization is a molecular cytogenetic technique that is used specifically for the visualization and localization of DNA and RNA sequences.

12. Colocalization studies are performed to identify functionally related molecules, and they involve the simultaneous analysis of the location and expression of multiple target molecules.

13. Ratio imaging is most widely used to measure either absolute or relative changes in spatial and temporal ion concentrations within living cells.

14. FRET can be used to obtain information on the immediate environment (in the nanometer range) of a labeled molecule, to detect macromolecular interactions, and to determine the intramolecular and intermolecular proximity between two appropriately paired fluorophores.

15. FLIM can be used for studying FRET by detecting the decrease in the fluorescence lifetime of the donor fluorophore.

16. FRAP, FLIP, and FLAP are used for studying the dynamic behavior of labeled molecules, specifically the behavior of proteins in living cells.

17. TIRFM is used to monitor the behavior of biomolecules directly at the single-molecule level, both in vitro and in living cells.

18. FCS is a highly sensitive method for single-molecule imaging.

# References

1. C Vonesch et al., "An Introduction to Fluorescence Microscopy," *IEEE Signal Processing Magazine*, **May**:20–31, 2006.
2. FD Rost, *Fluorescence Microscopy*, Cambridge University Press, 1992.
3. P Andrews, I Harper, and J Swedlow, "To 5D and Beyond: Quantitative Fluorescence Microscopy in the Postgenomic Era," *Traffic*, **3**:29–36, 2002.
4. IT Young, "Image Fidelity: Characterizing the Imaging Transfer Function," in *Methods in Cell Biology*, DL Taylor and YL Wang, eds., **30**:1–45, 1989.
5. M Abramowitz et al., "Basic Principles of Microscope Objectives," *Biotechniques*, **33**:772–781, 2002.

6. EK Stelzer, "Contrast, Resolution, Pixelation, Dynamic Range and Signal-to-Noise Ratio: Fundamental Limits to Resolution in Fluorescence Light Microscopy," *Journal of Microscopy*, **189**(1):15–24, 1998.

7. IT Young, "Quantitative Microscopy," *IEEE Engineering in Medicine and Biology*, **15**(1):59–66, 1996.

8. R Heintzmann and CR Sheppard, "The Sampling Limit in Fluorescence Microscopy," *Micron*, **38**:145–149, 2007.

9. B Herman, *Fluorescence Microscopy*, 2nd ed., BIOS Scientific, 1998.

10. FA Merchant and KR Castleman, "Computer-Assisted Microscopy," in *Handbook of Image and Video Processing*, AC Bovik, ed., Academic Press, 2005.

11. JW Lichtman and JA Conchello, "Fluorescence Microscopy," *Nature Methods*, **2**(12): 910–919, 2005.

12. KR Castleman, "Camera Technologies," in *Emerging Tools for Cell Analysis: Advances in Optical Measurement*, G Durack and JP Robinson, eds., John Wiley & Sons, 1999.

13. JC Mullikin et al., "Methods for CCD Camera Characterization," in SPIE, *Image Acquisition and Scientific Imaging Systems*, HC Titus and A Waks, eds., **2173**:73–84, 1994.

14. LR Van Den Doel et al., "Quantitative Evaluation of Light Microscopes Based on Image Processing Techniques," *Bioimaging*, **6**:138–149, 1998.

15. RM Zucker, "Evaluation of Confocal Microscopy System Performance," *Methods in Molecular Biology*, **319**:77–135, 2006.

16. RM Zucker, "Quality Assessment of Confocal Microscopy Slide Based Systems: Instability," *Cytometry A*, **69A**(7):677–690, 2006.

17. JB Pawley, "The Sources of Noise in Three-Dimensional Microscopical Data Sets," in *Three-Dimensional Confocal Microscopy: Volume Investigation of Biological Specimens*, JK Stevens, LR Mills, and JE Trogadis, eds., Academic Press, 1994.

18. Z Jericevic et al., "Validation of an Imaging System: Steps to Evaluate and Validate a Microscope Imaging System for Quantitative Studies," *Methods in Cellular Biology*, **30**:47–83, 1989.

19. IT Young, JJ Gerbrands, and LJ van Vliet, *Fundamentals in Image Processing*, Delft University Press, 1998.

20. TM Jovin and DJ Arndt-Jovin, "Luminescence Digital Imaging Microscopy," *Annual Review of Biophysics and Biophysical Chemistry*, **18**:271–308, 1989.

21. M Neumann and D Gabel, "Simple Method for Reduction of Autofluorescence in Fluorescence Microscopy," *Journal of Histochemistry and Cytochemistry*, **50**(3): 437–439, 2002.

22. AV Oppenheim, RW Schafer, and TG Stockham, "Non-Linear Filtering of Multiplied and Convolved Signals," *Proceedings of the IEEE*, **56**(8):1264–1291, 1968.

23. JC Russ, *The Image Processing Handbook*, CRC Press, 1994.

24. GP van Kempen, *Image Restoration in Fluorescence Microscopy*, PhD thesis, Delft University, 1999.

25. JM Zwier et al., "Image Calibration in Fluorescence Microscopy," *Journal of Microscopy*, **216**(1):15–24, 2004.

26. T Bernas et al., "Precision of Light Intensity Measurement in Biological Optical Microscopy," *Journal of Microscopy*, **226**(2):163–174, 2007.

27. CA van De Lest et al., "Elimination of Autofluorescence in Immunofluorescence Microscopy with Digital Image Processing," *Journal of Histochemistry and Cytochemistry*, **43** (7):727–730, 1995.

28. G Marriott et al., "Time-Resolved Imaging Microscopy: Phosphorescence and Delayed Fluorescence Imaging," *Biophysics Journal*, **60**(6):1374–1387, 1991.

29. L Seveus et al., "Time-Resolved Fluorescence Imaging of Europium Chelate Label in Immunohistochemistry and in-situ Hybridization," *Cytometry*, **13**(4):329–338, 1992.

30. KR Castleman, "Color Compensation for Digitized FISH Images," *Bioimaging*, **1**:159–163, 1993.

31. KR Castleman, "Digital Image Color Compensation with Unequal Integration Periods," *Bioimaging*, **2**:160–162, 1994.

32. DL Kolin, S Costantino, and PW Wiseman, "Sampling Effects, Noise and Photobleaching in Temporal Image Correlation Spectroscopy," *Biophysics Journal*, **90**:628–639, 2006.

33. LE Scales, *Introduction to Non-Linear Optimization*, Springer, 1985.

34. J Markham and JA Conchello, "Artefacts in Restored Images Due to Intensity Loss in Three-Dimensional Fluorescence Microscopy," *Journal of Microscopy*, **204**(2):93–98, 2001.

35. J Murray, "Evaluating the Performance of Fluorescence Microscopes," *Journal of Microscopy*, **191**:128–134, 1998.

36. HX Wu and L Ji, "Fully Automated Intensity Compensation for Confocal Microscope Images," *Journal of Microscopy*, **220**(1):9–19, 2005.

37. JP Rigaut and J Vassy, "High-Resolution Three-Dimensional Images from Confocal Scanning Laser Microscopy," *Analysis of Quantitative Cytology and Histology*, **13**:223–232, 1991.

38. JP Rigaut et al., "Three-Dimensional DNA Image Cytometry by Confocal Scanning Laser Microscopy in Thick Tissue Blocks," *Cytometry*, **12**:511–524, 1991.

39. J Conchello, "Fluorescence Photobleaching Correction for Expectation Maximization Algorithm," *SPIE Proceedings*, **2412**:138–146, 1995.

40. A Liljeborg, M Czader, and A Porwit, "A Method to Compensate for Light Attenuation with Depth in Three-Dimensional DNA Image Cytometry using Confocal Scanning Laser Microscope," *Journal of Microscopy,* **177**:108–114, 1995.

41. TA Nagelhus et al., "Fading Correction for Fluorescence Quantitation in Confocal Microscopy," *Cytometry*, **23**:187–195, 1996.

42. PU Adiga and BB Chaudhuri, "Some Efficient Methods to Correct Confocal Images for Easy Interpretation," *Micron*, **32**:363–370, 2001.

43. K Rodenacker et al., "Depth Intensity Correction of Biofilm Volume Data from Confocal Laser Scanning Microscopes," *Image Analysis and Stereology*, **20**(1):556–560, 2001.

44. CL Wang, *Three-Dimensional Blind Deconvolution for Light Microscopy: Fundamental Studies and Practical Implementations*, PhD thesis, Renssenlaer Polytechnic Institute, 2002.

45. C Kervrann, D Legland, and L Pardini, "Robust Incremental Compensation of the Light Attenuation with Depth in 3D Fluorescence Microscopy," *Journal of Microscopy*, **214**:297–314, 2004.

46. TD Visser, FA Groen, and GJ Brakenhoff, "Absorption and Scattering Correction in Fluorescence Confocal Microscopy," *Journal of Microscopy*, **163**:189–200, 1991.

47. JM Roerdink and M Bakker, "An FFT-Based Method for Attenuation Correction in Fluorescence Confocal Microscopy," *Journal of Microscopy*, **169**:3–14, 1993.

48. JM Roerdink, "FFT-Based Methods for Nonlinear Image Restoration in Confocal Microscopy," *Journal of Mathematical Imaging and Vision*, **4**:199–207, 1994.

49. KC Strasters et al., "Fast-Attenuation Correction in Fluorescence Confocal Imaging: A Recursive Approach," *Bioimaging*, **2**:78–92, 1994.

50. F Margadant, T Leemann, and P Niederer, "A Precise Light Attenuation Correction for Confocal Scanning Microscopy with O(N4/3) Computing Time and O(N) Memory Requirements for N Voxels," *Journal of Microscopy*, **182**:121–132, 1996.

51. A Can et al., "Attenuation Correction in Confocal Laser Microscopes: A Novel Two-View Approach," *Journal of Microscopy*, **211**:67–79, 2003.

52. SJ Lockett, "Three-Dimensional Image Visualization and Analysis," in *Current Protocols in Cytometry*, JP Robinson et al., eds., John Wiley & Sons, 1999.

53. FA Merchant et al., "Poloxamer 188 Enhances Functional Recovery of Heat-Shocked Fibroblasts," *Journal of Surgical Research*, **74**:131–140, 1998.

54. FA Merchant and M Toner, "Spatial and Dynamic Characterization of the Interaction of *Staphylococcal aureus* $\alpha$-Toxin with Cell Membranes," *Advances in Heat and Mass Transfer in Biotechnology HTV 355 / BED*, **37**:3–8, 1997.

55. FA Merchant, "Confocal Microscopy," in *Handbook of Image and Video Processing*, AC Bovik, ed., Academic Press, 2005.

56. RR Swiger and JD Tucker, "Fluorescence in situ Hybridization: A Brief Review," *Environ. Mol. Mutagen,* **27**(4):245–254, 1996.

57. FA Merchant and KR Castleman, "Strategies for Automated Fetal Cell Screening," *Human Reproduction Update*, **8**(6):509–521, 2002.

58. KR Castleman and BS White, "Dot-Count Proportion Estimation in FISH Specimens," *Bioimaging*, **3**:88–93, 1995.

59. B van Steensel et al., "Partial Colocalization of Glucocorticoid and Mineralocorticoid Receptors in Discrete Compartments in Nuclei of Rat Hippocampus Neurons," *Journal of Cell Science*, **109**:787–792, 1996.

60. D Demandolx and J Davoust, "Multicolour Analysis and Local Image Correlation in Confocal Microscopy," *Journal of Microscopy*, **185**:21–36, 1997.

61. RC Gonzalez and P Wintz, *Digital Image Processing*, Addison-Wesley, 1992.

62. EM Manders et al., "Dynamics of Three-Dimensional Replication Patterns During the S-Phase, Analyzed by Double Labeling of DNA and Confocal Microscopy," *Journal of Cell Science*, **103**:857–862, 1992.

63. EM Manders, FJ Verbeek, and J. Aten, "Measurement of Colocalization of Objects in Dual-Color Confocal Images," *Journal of Microscopy*, **169**:375–382, 1993.

64. SV Costes et al., "Automatic and Quantitative Measurement of Protein–Protein Colocalization in Live Cells," *Biophysical Journal*, **86**:3993–4003, 2004.

65. Q Li et al., "A Syntaxin 1, $G\alpha_o$, and N-type Calcium Channel Complex at a Presynaptic Nerve Terminal: Analysis by Quantitative Immunocolocalization," *Journal of Neuroscience*, **24**(61):4070–4081, 2004.

66. R Wegerhoff, O Weidlich, and M Kassens, "Basics of Light Microscopy and Imaging," in *Imaging and Research*, Git Verlag Gmbh, http://www.gitverlag.com/.

67. G Grynkiewicz, M Poenie, and RY Tsien, "A New Generation of $Ca^{2+}$ Indicators with Greatly Improved Fluorescent Properties," *Journal of Biological Chemistry*, **260**: 3440–3450, 1985.

68. MB Cannell, AC McMorland, and C Soeller, "Imaging Microscopic Calcium Signals in Excitable Cells," in *Imaging in Neuroscience and Development: A Laboratory Manual*, R Yuste, and A Konnerth, eds., Cold Spring Harbor Laboratory Press, 2005.

69 T Förster, "Delocalized Excitation and Excitation Transfer," in *Modern Quantum Chemistry Part III: Action of Light and Organic Crystals*, O Sinanoglu, ed., Academic Press, 1965.

70. JR Lakowicz, *Principles of Fluorescence Spectroscopy*, 2nd ed., Plenum Press, 1999.

71. A Periasamy, "Fluorescence Resonance Energy Transfer Microscopy: A Mini Review," *Journal of Biomedical Optics*, **6**(3):287–291, 2001.

72. A. Periasamy et al., "Wide-Field, Confocal, Two-Photon and Lifetime Resonance Energy Transfer Imaging Microscopy," in *Methods in Cellular Imaging*, A. Periasamy, ed., Oxford University Press, 2001.

73. H Wallrabe and A Periasamy, "FRET-FLIM Microscopy and Spectroscopy in the Biomedical Sciences," *Current Opinion in Biotechnology*, **16**(1):19–27, 2005.

74. JD Mills et al., "Illuminating Protein Interactions in Tissue Using Confocal and Two-Photon Excitation Fluorescent Resonance Energy Transfer (FRET) Microscopy," *Journal of Biomedical Optics*, **8**:347–356, 2003.

75. Y Chen and A Periasamy, "Localization of Protein–Protein Interactions in Live Cells Using Confocal and Spectral Imaging FRET Microscopy," *Indian Journal of Experimental Biology*, **45**(1):48–57, 2007.

76. Y Chen et al., "Characterization of Spectral FRET Imaging Microscopy for Monitoring the Nuclear Protein Interactions," *Journal of Microscopy*, **228**:139–152, 2007.

77. GW Gordon et al., "Quantitative Fluorescence Resonance Energy Transfer Measurements Using Fluorescence Microscopy," *Biophysical Journal*, **74**:2702–2713, 1998.

78. VS Kraynov et al., "Localized Rac Activation Dynamics Visualized in Living Cells," *Science*, **290**:333–337, 2000.

79. FS Wouters et al., "FRET Microscopy Demonstrates Molecular Association of Nonspecific Lipid Transfer Protein (nsL-TP) with Fatty Acid Oxidation Enzymes in Peroxisomes," *EMBO Journal*, **17**:7179–7189, 1998.

80. Z Xia and Y Liu, "Reliable and Global Measurement of Fluorescence Resonance Energy Transfer Using Fluorescence Microscopes," *Biophysical Journal*, **81**:2395–2402, 2001.

81. M Elangovan et al., "Characterization of One- and Two-Photon Excitation Energy Transfer Microscopy," *Methods*, **29**:58–73, 2003.

82. Y Chen, JD Mills, and A Periasamy, "Protein Interactions in Cells and Tissues Using FLIM and FRET," *Differentiation*, **71**:528–541, 2003.

83. Y Chen, M Elangovan, and A Periasamy, "FRET Data Analysis—The Algorithm," in *Molecular Imaging: FRET Microscopy and Spectroscopy*, A Periasamy and RN Day, eds., Oxford University Press, 2005.

84. A Kusumi et al., "Development of Time-Resolved Microfluorimetry and Its Application to Studies of Cellular Membranes," in *Time-Resolved Laser Spectroscopy in Biochemistry II*, JR Lakowicz, ed., SPIE Press, 1990.

85. EB van Munster and TW Gadella, "Fluorescence Lifetime Imaging Microscopy," *Advances in Biochemical Engineering Biotechnology*, **95**:143–175, 2005.

86. RV Krishnan et al., "Quantitative Imaging of Protein–Protein Interactions by Multiphoton Fluorescence Lifetime Imaging Microscopy Using a Streak Camera," *Journal of Biomedical Optics*, **8**:362, 2003.

87. Y Chen and A Periasamy, "Characterization of Two-Photon Excitation Fluorescence Lifetime Imaging Microscopy for Protein Localization," *Microscope Research Techniques*, **63**:72, 2004.

88. AB Houtsmuller, "Fluorescence Recovery after Photobleaching: Application to Nuclear Proteins," *Advances in Biochemical Engineering Biotechnology*, **95**:177–199, 2005.

89. AB Houtsmuller et al., "Action of DNA Repair Endonuclease ERCC1/XPF in Living Cells," *Science*, **284**:958–961, 1999.

90. G Carrero et al., "Using FRAP and Mathematical Modeling to Determine the *in vivo* Kinetics of Nuclear Proteins," *Methods*, 14–28, 2003.

91. JG Blonk et al., "Fluorescence Photobleaching Recovery in the Confocal Scanning Light Microscope," *Journal of Microscopy*, **169**:363–374, 1993.

92. TH Ward and F Brandizzi, "Dynamics of Proteins in Golgi Membranes: Comparisons Between Mammalian and Plant Cells Highlighted by Photobleaching Techniques," *Cellular and Molecular Life Sciences*, **61**:172–85, 2004.

93. T Wazawa and M Ueda, "Total Internal Reflection Fluorescence Microscopy in Single-Molecule Nanobioscience," *Advances in Biochemical Engineering Biotechnology*, **95**:77–106, 2005.

94. S Hadjidemetriou, D Toomre, and JS Duncan, "Segmentation and 3D Reconstruction of Microtubules in Total Internal Reflection Fluorescence Microscopy (TIRFM)," *Med. Image Comput. Comput. Assist Interv.*, **8**(1):761–769, 2005.

95. D Toomre and DJ Manstein, "Lighting Up the Cell Surface with Evanescent Wave Microscopy," *Trends in Cell Biology*, **11**(7):298–303, 2001.

96. Y Sako and T Yanagida, "Single-Molecule Visualization in Cell Biology," *Nature Reviews, Molecular Cell Biology*, SS1–SS5, 2003.

97. M Gosch and R Rigler, "Fluorescence Correlation Spectroscopy of Molecular Motions and Kinetics," *Advances in Drug Delivery Reviews*, **57**:169–190, 2005.

98. EL Elson, "Quick Tour of Fluorescence Correlation Spectroscopy from Its Inception," *Journal of Biomedical Optics*, **9**(5):857–864, 2004.

99. R Rigler and EL Elson, "Fluorescence Correlation Spectroscopy. Theory and Applications," in *Springer Series in Chemical Physics*, EP Schafer, JP Toennies, and W Zinth, eds., Springer-Verlag, 2001.

100. M Eigen and R Rigler "Sorting Single Molecules: Application to Diagnostics and Evolutionary Biotechnology," *Proceedings of the National Academy of Science*, **91**(13): 5740–5747, 1994.

# 13

# Multispectral Imaging

James Thigpen and Shishir K. Shah

## 13.1 Introduction

Spectral imaging methods have long been used in the fields of astronomy [1], remote sensing [2], and chemical compound analysis [3], to elucidate the composition and characteristics of terrestrial and atmospheric elements. In recent years, spectral imaging has found utility in microscopy applications ranging from spectral karyotyping [4], general cell visualization [5], and cell trafficking of variously colored fluorescent proteins [6].

Spectral imaging is the combination of two mature technologies: spectroscopy and imaging. In recent years, spectroscopy has found increased usage in analyzing biological samples, specifically for characterizing and delineating colorimetric and chemical stains, autofluorescence, and natural and man-made fluorophores, many of which may be present in the same sample. Due to its ability to identify the chemical composition of molecules, it has become one of the fastest-growing techniques in biosciences. The combined use of spectroscopy and imaging is a relatively new development, and its usage and benefits are less well understood. Spectral imaging results in the transformation of wavelength information over a spatial extent into a spectral image. In this chapter we discuss the principles of spectral imaging and several algorithms that are useful for the analysis of spectral images.

## 13.2   Principles of Multispectral Imaging

Spectral imaging combines spectroscopy and imaging to acquire a spectral image that specifies the complete wavelength spectrum of a sample at each point in the imaging plane. Spectral images are three-dimensional (3-D) cubes of data, $I_{x,y}(\lambda)$, composed of a series of two-dimensional (2-D) images, $I_{x,y}$, one for each value of $\lambda$. Just as an image is composed of pixels (grayscale or color) corresponding to each point in the spatial region of interest, spectral images are composed of *spectral pixels*, corresponding to a spectral signature of the corresponding imaged region. A spectral pixel is a pixel that stores not a grayscale or RGB value, but the entire measured spectrum of the corresponding spatial point. That is, each pixel location $(x,y)$ contains a spectral signature stored along the $\lambda$-axis corresponding to that spatial location in the image, as shown in Fig. 13.1. Each $I_{x,y}$, for a fixed $\lambda$, corresponds to a 2-D grayscale image.

This image can be stored in computer memory in several ways. One is *band-sequential* (BSQ), where each wavelength is stored as an image and the images are "stacked like a deck of cards" [7]. Other representation methods are *band-interleaved-pixel* (BIP) and *band-interleaved-line* (BIL). In BIP, the spectra for pixels are stored in a sequential fashion. Unlike BSQ representation, BIP has the advantage that a single spectral pixel may be accessed without accessing the entire image cube. Of course, a spectral image may be converted from any representation to any other.

Many different technologies have been used to generate spectral images [8]. To understand the process of image acquisition and the characteristics of

**FIGURE 13.1**   A three-dimensional stack representing data in spectral images. $x$ and $y$ dimensions represent the spatial information while $\lambda$ represents the spectral information. This figure may be seen in color in the four-color insert.

spectral imaging, we first briefly discuss the two elements of the imaging process: spectroscopy and imaging.

## 13.2.1 Spectroscopy

Spectroscopy is a broad and well-established science that has been used extensively to explain the spectral characteristics of matter. The first use of spectroscopy dates back to 1666, when Newton described the dispersion of white light into its constituent colors. Later, the same capability provided the spectrum of hydrogen, which was explained by Balmer in 1885, eventually leading to the Böhr model of the atom in 1913. The measured spectrum is related directly to the structure of the atoms and molecules under examination and is a measure of their energy levels. Energy, which is provided in microscopy applications by the brightfield and fluorescent illumination sources, is absorbed by the atoms in the molecule, which cause electrons to move to a higher energy level.

In typical use of fluorescence microscopy, either the sample to be observed is tagged with fluorescent molecules or the sample itself has fluorescing properties. On excitation from an external energy source, electrons jump to a higher metastable state and rapidly decay back to their ground state, releasing photons that are recorded as fluorescent intensity. The energy released by an excited molecule in returning to its ground state is unique for that molecule, and the measured spectrum provides a precise signature of the molecule [9]. Furthermore, the fluorescent intensity detected has a direct relationship to the concentration of the measured molecule. In most applications, the excitation light is many times stronger than the light emitted from the sample. The precise detection of emitted light requires the use of various filters that can provide maximum separation of the two light sources (Chapter 12).

In brightfield microscopy, the measured energy is related to the energy lost in exciting the electrons of the sample of interest. Hence, the measured spectrum is characteristic of a sample's ability to absorb or scatter the exciting light. Unlike intensity measurements using fluorescence microscopy, it has been found that, in a brightfield setup, the measured signal may be directly proportional not to the concentration of the observed molecules, but rather to its logarithm [9].

In typical spectroscopy configurations, the spectrum of a sample is measured by dispersing the exciting light into its constituent wavelengths, with the emitted intensity at each wavelength being detected. Many different methods of light dispersion are available, and each results in a different configuration in constructing a spectral imaging system. One of the common light dispersion systems is a monochromator, which uses a plane grating, concave holographic grating, or prism. Irrespective of the specific dispersing mechanism used, all spectral light sources operate as a function of the same geometric optics. To measure the

spectrum of a sample accurately, spectral analysis of the data must take into account the spectrum of the light source.

In a monochromator, wavelengths are sampled sequentially. If a diffraction grating is used as the dispersing mechanism, the broadband light emitting from the illumination source strikes the grating at an angle of incidence and is diffracted at an angle of diffraction. The angle of diffraction varies with wavelength, and hence manipulating the angle of light incidence can vary the wavelength of light emitted from the monochromator. The theory behind dispersion mechanisms, specifically diffraction gratings and prisms, is well covered in the literature [10]. Some key characteristics of a spectroscope are (1) its spectral resolution, which determines how close the wavelengths can be and still be detected and measured independently; (2) the spectral range, which determines the range of the spectra that can be measured; (3) the signal-to-noise ratio (SNR); and (4) the dynamic range, which determines the smallest measurable signal and the number of distinct levels in a measurement.

These parameters depend on both the characteristics of the light source and the detector used to measure a spectrum. The spectral resolution, or resolving power, $R$, of a spectroscope is given by

$$R = \lambda/d\lambda \tag{13.1}$$

where $d\lambda$ is the smallest difference in wavelengths that can be detected at wavelength $\lambda$. It can be interpreted as the minimum distance in the spectral dimension by which two spectral measurements must be separated in order to be discretely detected by the spectrograph. The Rayleigh criterion defines the resolvability of two values as being when the maximum of one falls on the first minimum of the other. In spectrometers that use diffraction gratings, it has been shown that

$$R = \lambda/d\lambda = kN \tag{13.2}$$

where $k$ is the refraction order and $N$ is the number of grooves on the illuminated width of the grating. Actual spectral resolution, also referred to as bandpass, also depends on the width of the entrance aperture and the focal length of the system. So the numerical resolution, $R$, should not be confused with the observed resolution or bandpass of the illumination source. For most real systems, the reported resolution is dominated by the bandpass determined by the slit width and the natural spectral bandwidth of the natural emission spectrum. For a detailed treatment of the fundamentals of spectrometers, one can consult the excellent review by Lerner [10].

## 13.2.2  Imaging

Imaging is the science and technology of acquiring multidimensional data with the primary emphasis on extracting spatial and temporal information from

samples. The most advanced and applicable method of acquiring data is digital imaging. Digital imaging captures data using a sensor such as a charged couple device (CCD) camera, complementary metal oxide semiconductor (CMOS) camera, photomultiplier tube (PMT), or any other light-detecting device. The process of imaging and the quality of detector define the characteristics of the recorded image data. The amount of information that can be extracted from an image is determined by the following common parameters that characterize the acquired images [11]: (1) *Spatial resolution*, which depends on the wavelength ($\lambda$), the numerical aperture (NA) of the objective lens, the magnification, and the pixel size of the detector, determines the closest distinguishable feature in the object; (2) the magnification and pixel size determine the sampling frequency, which must be equal to or greater than the Nyquist frequency (see Chapter 3) to achieve full optical resolution [11]; and (3) the quantum efficiency of the detector defines the lowest detectable signal. Other factors that affect the signal are the illumination power spectrum, the NA and quality of the optics, and the noise level of the system. All these should be optimized to obtain the best signal possible, especially in applications such as fluorescence imaging and live-cell imaging, where the number of photons is limited.

The *dynamic range* of the acquired data typically depends on the ratio of the maximum number of electrons at each pixel to the lowest detectable signal. Hence the dynamic range defines the number of unique intensity levels that can be measured in an image. *Field of view* (FOV) is dependent on the physical dimension of the detector and determines the maximal area that can be imaged.

Modern detectors also provide control of parameters such as exposure time and the binning of CCD pixels to gain sensitivity by trading off dynamic range or spatial resolution. Appropriate settings should be dictated by the application. CCD-based detectors are commonly used in quantitative optical microscopy due to their high sensitivity in detecting photons. CCD pixel wells operate fundamentally as capacitors whose charge is proportional to the number of photons that reach the detector [12, 13]. The ability of a CCD detector to measure the number of photons is specified by its quantum efficiency, which is the ratio of the number of photons sensed to the number of incident photons. Modern CCD detectors come in various configurations, including front-illuminated, back-illuminated, back-thinned, and intensified. Each configuration has its advantages and disadvantages, mostly varying in their quantum efficiencies. CCD detectors also offer different modes of data transfer, dependent on the construction of the electronics associated with the photosensitive element and the registers used to transfer the charge from each sensing element. These include full-frame, frame transfer, and interline transfer mechanisms [14–19]. The main difference among the transfer modes is mostly in the time taken to read out the image. For example, standard RS-170 CCD chips take less than 10 $\mu$s to acquire two video fields [15]. Scientific-grade interline transfer

cameras are even faster and take as little as 200 ns to transfer a frame. Each of the foregoing characteristics should be considered in making a final choice of the detector to be used for imaging and specifically for spectral imaging.

## 13.2.3 Multispectral Microscopy

Multispectral microscopy has generally been explored in the context of fluorescence or brightfield microscopy. In either mode of microscopy there are a number of options that result in the ability to acquire spectral data sets, each having its own set of advantages and disadvantages. Traditional use of multispectral imaging has been coupled to fluorescence microscopy and, in turn, based on multiposition filter wheels. Other methods include tunable illumination (as with monochromators), Fourier transform imaging spectroscopy, and various forms of tunable bandpass filtering. A variety of detectors has also been used for acquiring spectral images, the more common ones being CCDs and photomultipliers.

## 13.2.4 Spectral Image Acquisition Methods

There is a fundamental challenge in acquiring a spectral image, due to the fact that a spectral image is multidimensional, and typical image detectors are either 2-D or lower. This challenge has led to the development of different approaches for spectral image acquisition. Spectral imaging methods can be divided into the following methods, as defined in [9]: (1) wavelength-scan methods, which acquire the spectral image as a stack of images, measured one wavelength at a time, (2) spatial-scan methods, which acquire the spectral image one portion at a time (e.g., line by line) while measuring the whole spectrum of each portion and simultaneously scanning the image, and (3) time-scan methods, which acquire the spectral image based on data transform techniques such as the Fourier transform, where the data itself is a set of images, each one being a superposition of spectral or spatial image information.

### 13.2.4.1 Wavelength-Scan Methods

Spectral imaging using wavelength-scanning methods is based on acquiring a series of 2-D images, one for each wavelength of interest. This populates the data cube one planar image at a time and corresponds directly to the BSQ image representation. The simplest method of achieving spectral imaging is to use color filters. Most modern microscopes are equipped with filter wheels that can accommodate a range of optical filters. Spectral images can be acquired by simply capturing a set of images, changing the filter position between each image. This approach, however, is useful only when measuring a small number

of wavelengths, because the number of slots in the filter wheel limits the number of wavelength bands that can be measured. In addition, measuring new wavelengths of interest requires replacing the filters in the filter wheel with a new set. Optical filters may also present additional problems, in that their transmission spectra may decay unpredictably with time.

A more convenient method of capturing spectral data is through the use of tunable filters. There exist several types of such filters, circular-variable filters (CVFs) [20], liquid-crystal tunable filters (LCTFs) [21], and acousto-optical tunable filters (AOTFs) [22, 23]. A CVF is a continuous circular filter with narrow bands defined spatially along its surface. Wavelengths are selected by positioning the illumination source at a certain point along the filter surface. However, due to the continuous nature of the filter and the nonuniform nature of all illumination sources, a spectral gradient will be present in any imaged field. AOTFs and LCTFs are electro-optical components having no moving parts. With these systems, changing wavelengths is a very fast operation, which can occur on the order of microseconds for AOTFs or milliseconds for LCTFs [24]. These filters typically have relatively low transmittance, and their spectral resolution is hardware dependent and fixed for a given wavelength [24].

The monochromator provides another method for scanning wavelengths. A monochromator has many moving parts, so changing wavelengths is several orders of magnitude slower than with AOTFs or LCTFs. The bandwidth is adjustable, however, via entrance and exit slits on the monochromator. Decreasing the bandwidth results in a lower spectral resolution, but it also increases the light output of the system, which may be beneficial for imaging systems with low sensitivity [25].

Irrespective of the filters chosen, the major advantage of this approach is that the wavelengths are user selectable, and images can be acquired with the flexibility of choosing an optimal exposure time for each wavelength. On the other hand, the spectral resolution is usually hardware dependent and, for a given system, cannot be changed. A comprehensive review is presented by Gat [24]. The use of filters and the wavelength-scan method of spectral image acquisition can be adapted for both fluorescence and brightfield microscopy. This method benefits from simplicity, relatively low cost, and minimal image degradation, since no additional optical or mechanical elements are interposed in the imaging light path.

### 13.2.4.2 Spatial-Scan Methods

In this method, a prism or grating is placed in the emission path before the detector so that light from a slit can be spread onto a 2-D imaging sensor such as a CCD. In this configuration, all columns of the detector are measuring the same row of pixels from the sample, but each column sees a different wavelength.

Images are captured as $I(x,y)$ and scanned across the second spatial dimension, $y$ [26]. This approach is commonly used with confocal microscopy [27]. For most applications, the number of wavelengths to be measured is much smaller than the spatial dimension of the sample, and hence the detector requires a significantly smaller number of detector elements for the acquisition, relative to CCD-based methods. This results in a much longer acquisition time in comparison to the CCD-based systems in order to achieve the same SNR. This method is most commonly used for brightfield microscopy, but it is applicable for fluorescence microscopy as well.

### 13.2.4.3 Time-Scan Methods

Time-scan approaches rely on the use of data transformation techniques to acquire spectral images. The measured data itself is a superposition of the spectral or spatial information. One approach that uses this method is Fourier spectroscopy [28, 29]. This approach uses principles of light interference, instead of filters, to measure the spectrum. The key component of this approach is an interferometer, which splits a beam of light into two beams, creating an *optical path difference* (OPD). When the two beams join back to interfere at the detector, intensity is measured by the detector as a function of many OPDs, resulting in a pattern known as the *interferogram*. This pattern is specific to a tested spectrum. The Fourier transform of the interferogram provides the spectrum. Michelson or Sagnac interferometers are the ones commonly used in microscopic applications [28, 29]. Another method used more recently is based on the Hadamard transform [30].

These methods can also be used for both brightfield and fluorescence microscopy. The advantage of this approach includes the ability to tune acquisition parameters, such as spectral resolution, without any changes to the hardware. On the other hand, the major drawbacks of these approaches is computational complexity, due to the data transformations required, as well as an inability to select specific wavelengths of interest, since the entire spectrum must be captured to acquire any portion of it.

## 13.3 Multispectral Image Processing

A spectral image usually contains thousands of spectral pixels. The data files generated are large and multidimensional, making visual interpretation difficult at best. This necessitates a comprehensive set of tools for acquisition, analysis, visualization, and presentation of the results [31]. Many modern image processing methods and algorithms are capable of analyzing multidimensional images. These are, in general, adequate and relevant for spectral image processing.

For a review, see [32]. Specific applications require the design of image analysis algorithms, some of which may require the use of both spectral and image features [33, 34]. Spectral image analysis, in itself, is a growing field, and some of the basic algorithms are described here.

## 13.3.1 Calibration for Multispectral Image Acquisition

A key utility of multispectral microscopy is its ability to characterize the inherent chemical properties of a sample. This is achieved by measuring the sample's spectral response. In imaging any composite biological material, the interpretation of the spectra is a complicated problem. A primary reason for this is that any detector used for data acquisition does not have uniform quantum efficiency across the excitation spectrum, and this leads to interference effects. These interference effects necessitate the use of effective calibration algorithms before quantitative analysis of any specimen can be meaningful. Interference effects are introduced by nonhomogenous illumination, attenuation of the illumination at the shorter wavelengths vs. longer wavelengths, and variations in the SNR, due to a decreased quantum efficiency (QE) of the detector at the shorter wavelengths (i.e., the blue part of the spectrum). The observed spectrum of a sample depends on the spectral power distribution of the light source.

In brightfield multispectral microscopy, gray-level image intensities may be used to determine the proportion of light transmitted by each particle across the exciting spectra. The transmission factor, $T$, is defined as

$$T = \frac{I_t}{I_i} \tag{13.3}$$

where $I_t$ is the intensity of the transmitted radiation by the sample and $I_i$ is the intensity of the incident light. The incident light intensity can be approximated by measuring the average intensity of the background or the media surrounding the sample. The radiation transmitted by the sample is measured as the integrated intensity of the sample divided by the size of the sample. Thus, one can compute the absorption parameter for the sample, a measure of the sample's spectrum, using the Beer–Lambert law [35–37] as

$$A = \log\left(\frac{1}{T}\right) \tag{13.4}$$

For each sample to be analyzed, one can measure the absorption parameter across all wavelengths to generate a spectral signature.

Figure 13.2 shows images of white blood cells (WBCs) obtained at 450 nm, 550 nm, and 650 nm at three constant exposures. The corresponding profile of

Wavelength vs. Exposure

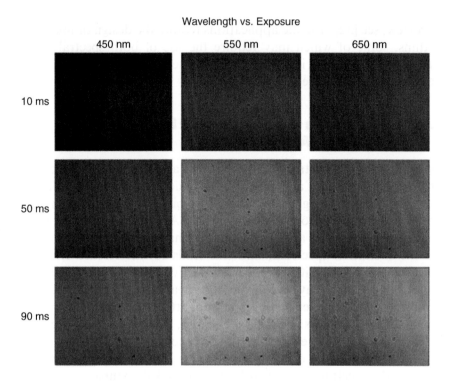

**FIGURE 13.2** White blood cells imaged at three different wavelengths (450 nm, 550 nm, and 650 nm) using three separate exposures (10 ms, 50 ms, and 90 ms) showing the variability in both the illumination source and the quantum efficiency of the detector.

the mean background intensity and the transmission factor, a spectral characteristic for a WBC, is shown in Fig. 13.3. The background intensity is highly varying across wavelengths, and hence a true spectral signature would not be quantifiable from these raw images. This shows that it is critical to calibrate for the spectral balance of the imaging system before accurate spectral signatures can be measured. This problem is similar to that of achieving white balance in color imaging, where one expects equal amplitude in the red, green, and blue channels. If one were to use a fixed gain and exposure setting for a camera and acquire images across the wavelengths, it would be difficult to separate the true spectral signature of the sample from the response of the imaging system.

A system configuration for brightfield multispectral microscopy is shown in Fig. 13.4. The system uses a grating-based spectral light source coupled to a standard optical microscope allowing 2-D image acquisition by a high-resolution cooled CCD camera. A quarter-meter class, Czerny–Turner type monochromator (Photon Technology International, Inc., NJ) provides a tunable light emission spectrum at 10-nm resolution (marked as a). The wavelength range used is 400–700 nm. The monochromator is connected to an

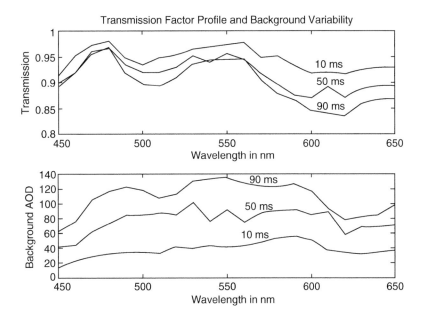

**FIGURE 13.3** Transmission factor profile of white blood cells and the respective image background across the spectra for the uncalibrated system.

**FIGURE 13.4** A multispectral imaging system for brightfield imaging based on the use of a monochromator coupled to an upright light microscope. (a) camera, (b) microscope, (c) monochrometer.

Olympus (Olympus America, Inc., PA) BX-51 upright optical microscope (marked as c) in such a way that the light output from the monochromator passes into the transmitted light path of the microscope. This allows for the use of conventional optical microscopy to acquire brightfield images at any desired wavelength (transmitted light). An Olympus UPlanApo 20X NA 0.7 objective is used for imaging. A SenSys™ (Photometrics, AZ) CCD camera (marked as b),

having $768 \times 512$ pixels of size $9\,\mu\text{m} \times 9\,\mu\text{m}$ and 8-bit digitization, provides for high-resolution, low-light image acquisition. The illumination from the mono-chromator is adjusted for Köhler illumination to obtain uniform excitation of the specimen. The condenser, aperture diaphragm, and field stop are held constant during the measurements. Focusing can be done at the central wave-length of 550 nm or at each wavelength separately before image acquisition, to minimize chromatic aberration.

One approach to calibrating the variations due to illumination effects and varying quantum efficiency of CCD cameras at different wavelengths is to normalize the camera exposure for each wavelength. This must be done in such a way as to avoid saturation. The goal is to have the incident light intensity uniform across the wavelengths. Since average background intensity is a measure of illumination strength, the problem of calibration is to adjust the exposure for each wavelength so that the average background intensity is uniform. This problem is formulated as one of similarity matching. Measures of similarity generally use the *average optical density* (AOD) and gray-level histograms of images taken at different wavelength and exposure. A least-squares error solution can be used to determine the final exposure value at each wavelength.

To initialize the calibration procedure, a reference image is selected to serve as the template for matching exposure across the wavelengths. One choice is to use an image at 550 nm as the reference, since most CCDs offer uniform quantum efficiency in the wavelength band 500–600 nm. The exposure value for this wavelength is selected so that the average optical density for the chosen wavelength–exposure image is close to the middle of the grayscale dynamic range. For 8-bit images, for example, the value could be 128, which allows for a broad dynamic range for measuring transmission factors. Let $I_{(\lambda,\,e)}$ denote one wavelength–exposure image pair, where $\lambda$ is the wavelength and $e$ signifies the exposure value in milliseconds. Thus, the reference image is denoted as $I_{\text{ref}}$ such that

$$I_{\text{ref}} = I_{(550,\, e_{\text{ref}})} \qquad (13.5)$$

where

$$e_{\text{ref}} = \arg\min_{e}\left(AOD\left(I_{(550,\, e)}\right) - 128\right)^{2} \qquad (13.6)$$

and

$$\text{AOD}\left(I_{(550,\, e)}\right) = \frac{1}{X * Y}\sum_{x}^{X}\sum_{y}^{Y} I_{(550,\, e)}(x,\, y) \qquad (13.7)$$

The first calibration approach is AOD equalization. This procedure chooses the exposure for each wavelength so that the AOD is equal to the AOD of the reference image. Then the spectral image set should have uniform background intensity across all wavelengths. The required exposures are given by

$$e_\lambda = \arg\min_e \left( \text{AOD}(I_{(\lambda, e)}) - \text{AOD}(I_{\text{ref}}) \right)^2 \qquad (13.8)$$

Other similarity measures are based on *histogram matching* (see Chapter 6). This approach preserves the ordinal relationship among pixels, and the spatial structure of the image is not affected. Histogram matching transforms an image so that its histogram matches that of another image. A distance measure is computed between the histogram of the reference image and each image across all the exposures for each wavelength. The exposure producing the smallest distance is chosen at each wavelength. Four different distance measures, drawn from signal processing and statistics, are presented here.

For two histograms, $H_{I_{\text{ref}}}$ and $H_{I_{(\lambda, e)}}$, with entries $h_{I_{\text{ref}}}$ and $h_{I_{(\lambda, e)}}$, the most common distance measure is based on the Minkowski metric, which has the form

$$d_M \left( H_{I_{\text{ref}}}, H_{I_{(\lambda, e)}} \right) = \sqrt{\sum_{m=0}^{M-1} \left( h_{I_{(\lambda, e)}}[m] - h_{I_{\text{ref}}}[m] \right)^2} \qquad (13.9)$$

Another metric that has been found to work well for histogram matching is the Jeffrey divergence [38]. For this case, the divergence is given as

$$d_J \left( H_{I_{\text{ref}}}, H_{I_{(\lambda, e)}} \right) = \sum_{m=0}^{M-1} h_{I_{\text{ref}}}[m] \log \left( \frac{2 h_{I_{\text{ref}}}[m]}{h_{I_{\text{ref}}}[m] + h_{I_{(\lambda, e)}}[m]} \right)$$
$$+ h_{I_{(\lambda, e)}}[m] \log \left( \frac{2 h_{I_{(\lambda, e)}}[m]}{h_{I_{\text{ref}}}[m] + h_{I_{(\lambda, e)}}[m]} \right) \qquad (13.10)$$

Various other distance metrics have been proposed to evaluate the similarity of two histograms [39]. Two different calculations of the $\chi^2$ distance metric [40, 41] can be used. One would use $\chi^2_{H_{I_{\text{ref}}}}$ when the theoretical distribution is known. Even though this is not known, in practice one can approximate the continuous distribution from the image. The distance measure can be computed as

$$\chi^2_{H_{I_{\text{ref}}}} \left( H_{I_{\text{ref}}}, H_{I_{(\lambda, e)}} \right) = \sum_{m-0}^{M-1} \frac{\left( h_{I_{(\lambda, e)}}[m] - h_{I_{\text{ref}}}[m] \right)^2}{h_{I_{\text{ref}}}[m]} \qquad (13.11)$$

Images from Calibrated Spectral System

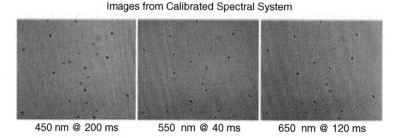

450 nm @ 200 ms        550  nm @ 40 ms        650  nm @ 120 ms

**FIGURE 13.5**   An image of white blood cells imaged at three different wavelengths (450 nm, 550 nm, and 650 nm) on the calibrated multispectral microscope.

The second distance measure, $\chi^2_{H_{I_{\text{ref}}} H_{I_{(\lambda, e)}}}$, is meant to compare two real histograms. It is computed as

$$\chi^2_{H_{I_{\text{ref}}} H_{I_{(\lambda, e)}}} \left( H_{I_{\text{ref}}}, H_{I_{(\lambda, e)}} \right) = \sum_{m-0}^{M-1} \frac{\left( h_{I_{(\lambda, e)}}[m] - h_{I_{\text{ref}}}[m] \right)^2}{h_{I_{\text{ref}}}[m] + h_{I_{(\lambda, e)}}[m]} \qquad (13.12)$$

Any of the foregoing metrics can be used to compute the distance measure for every exposure at each of the wavelengths. The exposure value that minimizes the metric is chosen for each wavelength; that is

$$e_\lambda = \arg \min_e D(\lambda, e) \qquad (13.13)$$

where $D$ is one of the distance measures described earlier.

In a recent study comparing the preceding metrics, it is shown that AOD equalization provided the best set of exposure values [42]. Images acquired by the calibrated system at the same three wavelengths (450 nm, 550 nm, and 650 nm) are shown in Fig. 13.5. The average background intensity across the wavelengths for exposure values chosen based on three of the distance metrics is plotted in Fig. 13.6. The profile across the wavelengths is relatively flat, as would be expected if the camera is color balanced across the wavelengths.

Furthermore, to evaluate the result of nonuniform illumination compensation, Fig. 13.7 shows the measured transmission factor of WBCs that are distributed spatially in the image. The transmission factors are overlaid next to the corresponding cell in the image. The values are similar and show minimal variance. The overall spectral profile for WBCs in a commercial blood standard, as imaged under the calibrated system, is shown in Fig. 13.8.

## 13.3.2  Spectral Unmixing

In brightfield and fluorescence microscopy, cellular components are stained with absorbing dyes or labeled with fluorophores. Spectral information from these

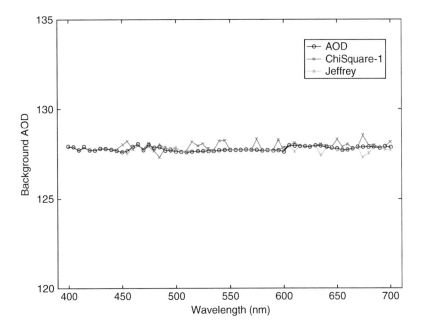

**FIGURE 13.6** Average background intensity profile across all the wavelengths for exposures computed using three of the defined distance measures.

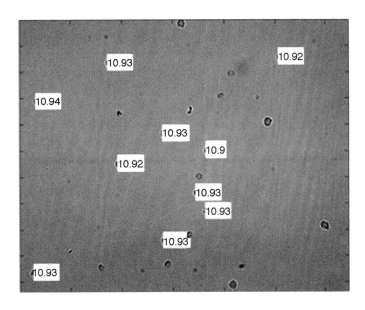

**FIGURE 13.7** Transmission factor for white blood cells located across the spatial extent of the calibrated spectral image.

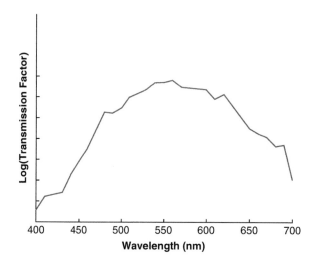

**FIGURE 13.8** Transmission profile of white blood cells in a commercial blood standard measured from the spectral image acquired after calibration of the multispectral brightfield microscope.

chemical components in the specimen can become confused due to overlap in the spectra of the dyes or labels used. Spectral unmixing is the process of unraveling that confusion.

In multispectral fluorescence applications, $N$ fluorophores are used to label $N$ different cellular components, and each fluorophore has a characteristic emission spectrum. Typically an $N$-channel multispectral image acquisition system is designed to isolate the images of the different fluorophores so that only one appears in each of the color channels. This way the spectral image is simply an overlay of the $N$ different fluorophore concentration images, and analysis of colocalization and structural interactions is straightforward.

When using a small number of fluorophores whose emission spectra are well separated, bandpass filters centered on the emission peak of each fluorophore can isolate each fluorophore image to one of the color channels. However, the fluorophore emission spectra tend to overlap. Thus, when imaging $N$ fluorophores simultaneously, the image recorded in each channel contains contributions from several fluorophores due to the overlap of emission spectra. Thus one of the fundamental processing requirements in analyzing such multispectral images is that of spectral unmixing.

In multispectral brightfield applications, the signal to be measured is the absorption spectrum of a molecule, which is related to the concentration of the molecule present in the sample. If the sample is stained with several different dye molecules, each with different absorption spectra, the resulting measured absorption spectrum is an overlap of the individual molecule spectra. Thus the problem here is similar to that of overlapping spectra in the case of

multispectral fluorescence applications. Spectral unmixing is the method used to separate mixed contributions to a pixel, for both colocalized fluorophores and absorbing dyes [43–46]. Spectral unmixing is simple to implement, but it requires that the emission spectrum of each fluorophore (or the absorbance profile of each stain) be known in advance.

### 13.3.2.1 Fluorescence Unmixing

Spectral unmixing algorithms for fluorescence assume that the measured signal at each pixel is a linear combination of the overlapping spectra at that point [46]. Further, these algorithms also assume that the measured signal is linearly proportional to the concentration of the fluorophore or dye at that point. This assumption holds true when the absorption and fluorophore concentrations are low but may be disrupted by energy transfer between colocalized fluorophores [45], and in such cases appropriate correction terms are necessary (see Chapter 12).

For fluorescence-based applications, assume that $N$ fluorophores are used, each one labeling a different cellular component, and that a spectral imaging camera produces an $L$-channel multispectral image, where $L \geq N$. The emission spectrum of each fluorophore, under the same imaging conditions, is known prior to actual analysis of the sample. The unmixing algorithm processes the spectral image so that each fluorophore is isolated to a single channel. If $L > N$, then the problem is overconstrained, and $L - N$ of the channels in the processed image will be empty.

At a single pixel, the recorded intensity is a vector, $\mathbf{I} = [I_j]$, where $j = 1, \ldots, L$ indexes the spectral channels. The actual intensity observed is a function of the fluorophore concentrations at any given pixel. If $\mathbf{C} = [C_i]$ is the vector of fluorophore concentrations, $C_i$, where $i = 1, \ldots, N$ is the index of fluorophores, the measured intensity at each pixel is given in matrix form as

$$
\begin{bmatrix} I_1 \\ I_2 \\ \vdots \\ I_L \end{bmatrix} = \begin{bmatrix} s_{1,1} & s_{1,2} & \cdots & s_{1,N} \\ s_{2,1} & s_{2,2} & & \\ \vdots & \vdots & \ddots & \vdots \\ s_{L,1} & \cdots & & s_{L,N} \end{bmatrix} \times \begin{bmatrix} C_1 \\ C_2 \\ \vdots \\ C_N \end{bmatrix} \quad (13.14)
$$

The $L \times N$ matrix, $\mathbf{S} = [s_{j,i}]$, called the *smear matrix*, represents the set of sensitivities of each color channel to the spectrum of each fluorophore. The measured intensity is simply

$$
\mathbf{I} = \mathbf{S} \times \mathbf{C} \quad (13.15)
$$

If $L = N$ and if S is known and invertible, then the inverse matrix, $\mathbf{S}^{-1}$, can be used to calculate the fluorophore concentrations at each pixel by

$$\begin{bmatrix} C_1 \\ C_2 \\ \vdots \\ C_N \end{bmatrix} = \mathbf{S}^{-1} \times \begin{bmatrix} I_1 \\ I_2 \\ \vdots \\ I_L \end{bmatrix} \qquad\qquad (13.16)$$

Ideally, the smear matrix, $\mathbf{S}$ has all positive elements and is approximately equal to the identity matrix, so matrix inversion is not problematic. The problem becomes one of determining $\mathbf{S}$. This is readily done if images of known specimens labeled with single fluorophores are available. In each such case, only one element of $\mathbf{C}$ is nonzero, and digitizing each such image yields one row of $\mathbf{S}$ [11, 48]. One must account for background brightness levels and, if different, for exposure times in each channel [11, 49].

If suitable training samples are not available, one can solve for $\mathbf{S}$ in several other ways, discussed later. However, such a solution may produce negative elements in $\mathbf{S}$, due to noise, and this does not correspond to reality, since negative concentrations are impossible. Possible solutions to this problem include modification of the foregoing formulation based on nonnegative constraints [47] as discussed later.

**M-FISH Example**  One application that benefits from the foregoing unmixing algorithm is *multispectral fluorescence in situ hybridization* (M-FISH) for chromosomal analysis. The 46 chromosomes in a human cell are known to occur as 22 homologous pairs plus two sex-determinant chromosomes, yielding 24 distinct types. Cytogeneticists examine chromosome "spreads" to look for extra, missing, or altered chromosomes. In M-FISH, combinations of five different fluorophores are used to label each of the 24 chromosome types, and a sixth is used as a counterstain. There are $2^5 - 1 = 31$ possible combinations of five fluorophores, so each of the 24 human chromosome types can be labeled with a unique combination. Identification of each chromosome in the acquired images is simple if the combination of fluorophores on each chromosome can be determined. Typically a six-channel spectral imaging system is used, with the color channels matched to the emission spectra of the six fluorophores. In reality, however, each pixel's intensity is a weighted combination of the six individual fluorophore brightnesses.

An example of an M-FISH chromosome spread image is shown in Fig. 13.9a. The image was acquired over a spectral range of 450–780 nm, with 10-nm spectral resolution (i.e., $L = 34$). The 34 spectral channels have been projected into the 3-D RGB color space for purposes of visualization. The spectral image has been processed according to the algorithm described earlier, unmixing each of the fluorophore images into a single spectral channel. The resulting 6-channel spectral image has been segmented, and each pixel has been

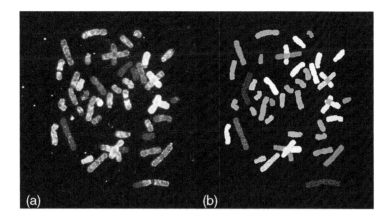

**FIGURE 13.9** (a) A six-color M-FISH image acquired using multispectral fluorescence microscopy based on a filter-wheel configuration. (b) The result of spectral unmixing using the linear decomposition method. This figure may be seen in color in the four-color insert.

classified by comparing the computed combination of labels to a table of standard labeling based on the known combinations of the five fluorophores used in the sample preparation. The classification results are displayed in Fig. 13.9b, in which each color represents a different chromosome type. This approach results in accurate classification with high specificity in the vast majority of specimens, even on complex samples [50, 51]. Similar applications, called *spectral karyotyping* (SKY) and *COBRA-FISH*, also use spectral unmixing [28, 52]. Various other applications have been enabled by this technique as well, both for immunofluorescence detection and elimination of autofluorescence [53–56].

### 13.3.2.2 Brightfield Unmixing

In the case of multispectral brightfield imaging, spectral unmixing is somewhat more complex because the relevant information is contained in the absorption of specific wavelength energy at each pixel. The absorption spectrum of a dye molecule is given by the Beer–Lambert law

$$I(\lambda) = I_t(\lambda) \cdot 10^{-\varepsilon(\lambda) \cdot c \cdot l} \tag{13.17}$$

where $I(\lambda)$ is the measured transmission through the sample at wavelength $\lambda$, $I_t(\lambda)$ is the spectrum of the light source, $c$ is the concentration of the molecules, $l$ is the light path length in the sample, and $\varepsilon(\lambda)$ is the extinction coefficient that specifies the probability that light of wavelength $\lambda$ will be absorbed by a molecule. The spectrum of the light source, $I_t(\lambda)$, can be determined by recording an image under the same conditions but without a sample present. The *absorbance* is given by the exponent of Eq. 13.17, which is

$$A(\lambda) = \varepsilon(\lambda) \cdot c \cdot l \tag{13.18}$$

Multiple absorbing molecules, indexed by $i$, have extinction coefficients $\varepsilon_i(\lambda)$. Absorbance is linear with the number of molecules along the optical path and can be expressed as a linear combination of the different wavelength contributions. The total absorbance due to all absorbing molecules present can be written as

$$A(\lambda) = \sum_i \varepsilon_i(\lambda) \cdot c_i \cdot l_i$$

If $l$ is assumed to be constant for the given sample, this reduces to a case similar to spectral unmixing in fluorescence images. The absorption spectrum of each individual dye can be measured in advance, and the measurement of total absorbance at each point in the image is expressed as

$$A(\lambda) = -\log(I(\lambda)/I_t(\lambda))$$

In general, when the sample contains more than a few absorbing dyes, the transmission spectrum has a more complex structure [57]. Several applications have been developed, including analysis of histological sections and cell smears [35, 58].

One common application of multispectral brightfield imaging is the analysis of stained histological samples. When multiple cellular components are to be detected, each stained with a different chromogen, spectral unmixing can allow measurement of their individual concentrations. It allows the separation of multiple stains, leading to visualization of the image as if it were stained with a set of single stains. Colocalization of proteins and relevant cell structures can be analyzed by correlating the resulting single-stain distributions.

In the example shown in Fig. 13.10a, a cytological smear of thyroid cancer was treated with Papanicolaou stain (hematoxylin and cytostain). Spectral images were captured with a calibrated system (see Section 13.3.1) covering the wavelength range of 400–700 nm with a spectral resolution of 10 nm. Figure 13.10b shows a color image that is re-created from the spectral image, in which the separate cellular components are labeled in different colors.

### 13.3.2.3 Unsupervised Unmixing

The spectral unmixing algorithm described earlier requires prior knowledge of the fluorophore or stain spectra and thus belongs to a class of algorithms called *supervised* classification methods. Specifically, the smear matrix **S** (Eq. 13.15) must be known. In contrast, algorithms categorized as *unsupervised* operate without any knowledge of the spectra but rely on "blind decomposition" of the measured signal to determine **S**, using the constraint that the signal is known to be a linear combination of spectral components. These methods are normally

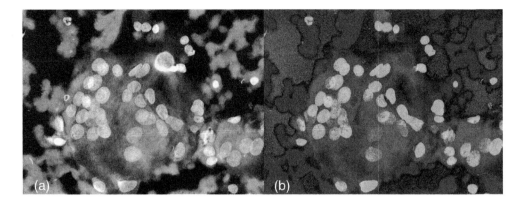

**FIGURE 13.10** A brightfield image of a Papanicolaou-stained thyroid cell smear (40× objective lens, NA = 0.90). (a) The spectral image acquired using multispectral brightfield microscopy. (b) The result of spectral unmixing based on the linear decomposition method. This figure may be seen in color in the four-color insert.

couched in terms of clustering or matrix factorization, and they require minimal input from the user, such as the number of fluorophores or stains that have been used.

***Principal Component Analysis*** *Principal component analysis* (PCA) is one such unsupervised unmixing method. It relies on a statistical analysis of the whole data set (i.e., spectra of all the pixels in the image) to find meaningful explanations for the similarities and differences in the data. PCA, also known as the *Karhunen–Loeve transform*, creates a linear transformation of an *L*-dimensional space that maximizes the variance of the data along each of its new axes. A data set may be reduced in dimensionality by eliminating low-variance components [59]. To use PCA to estimate **S** for spectral unmixing, we must assume that the gray-level values have a normal distribution (i.e., Gaussian pdf).

In the M-FISH application, for example, PCA can be used to estimate a smear matrix, **S**, that will map the six fluorophores into six color channels. Each pixel in the spectral image is considered to be a vector, and PCA is performed to identify a transform that minimizes the variance along each new axis while maximizing the variance between the axes. The image shown in Fig. 13.11a is an RGB projection of a six-channel M-FISH image. PCA was used to develop a linear transformation similar to Eq. 13.15. Figure 13.11b shows an RGB projection of the transformed image. Notice that pairs of similar chromosomes take on similar coloring. Classification of the pixels in the transformed (unmixed) image is more accurate, since the label combinations are more evident.

In the case of multispectral brightfield microscopy, the same procedure is followed. Figure 13.12a shows the brightfield image associated with the

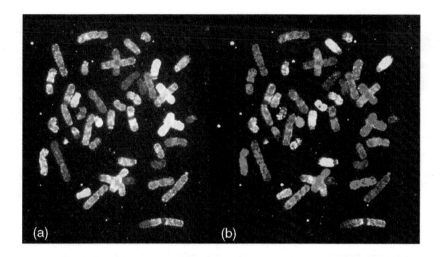

**FIGURE 13.11**  (a) A six-color M-FISH image acquired using multispectral fluorescence microscopy based on a filter-wheel configuration, and (b) the result of spectral unmixing using principal component analysis. This figure may be seen in color in the four-color insert.

spectral image acquired for a thyroid cancer smear stained with Papanicolaou stain. The spectral image has 31 channels, each acquired between the wavelengths of 400 nm and 700 nm at 10-nm intervals. The PCA transform of the spectral image was computed, and the dimensionality was reduced to the first three principal components, representing the maximum difference between axes. That is, PCA was used both to decorrelate the spectral data and to

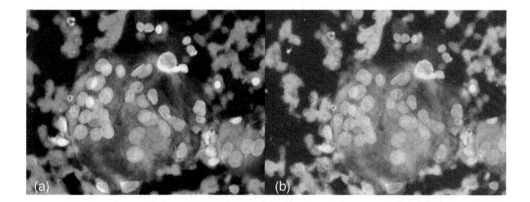

**FIGURE 13.12**  (a) A brightfield image of a Papanicolaou-stained thyroid cell smear corresponding to the spectral image acquired using multispectral brightfield microscopy, and (b) the result of spectral unmixing and dimensionality reduction based on principal component analysis. This figure may be seen in color in the four-color insert.

reduce the total dimensionality of the transformed image from 31 to 3. Figure 13.12b shows the transformed image, where the three PCA variables are mapped to the RGB color space.

**Independent Component Analysis** Another unsupervised unmixing approach to extract linearly independent signals from images is *independent component analysis* (ICA). Like PCA, ICA develops a linear transformation to project the data onto a different set of axes. But while PCA attempts to decorrelate the data, ICA searches all possible projections of the data to realize independence across all statistical orders. ICA can extract each signal from the mixture as long as the recorded image is a linear combination of independent signals. Two key assumptions required for ICA are that the signals are statistically independent and that they are not Gaussian distributed. Successful use of ICA has been demonstrated in several spectral microscopy applications [60].

**Nonnegative Matrix Factorization** Another approach to solve the unmixing problem (i.e., to estimate **S**) is *nonnegative matrix factorization* (NMF). The differences between PCA, ICA, and NMF arise from different constraints imposed on the smear matrix, **S**, and the vector of signal concentrations, **C**. Both PCA and ICA allow the entries of the two matrices to be of arbitrary sign, where cancellations between positive and negative numbers realize the required linear combination of signals. Since individual stains or fluorophores actually cannot have a negative concentration, this decomposition fails to duplicate reality. NMF does not allow negative entries and thus permits only additive combinations. It is an iterative technique that produces a nonnegative smear matrix. In addition, NMF does not impose the assumption of signals being statistically independent, and this is more realistic for most applications [61].

## 13.3.3 Spectral Image Segmentation

Segmentation of the sample under study is a necessary precursor to measurement and classification of the objects in a spectral image (see Chapter 9). For biological samples, this is a significant problem due to the complex nature of the samples and to inherent limitations in microscopy. Spectral images share the following characteristics: (1) poor contrast, (2) many cluttered cells, particles, and debris in a single view, (3) inhomogeneity of staining and labeling, and (4) spectral variability, in that the gray levels of the structures change as a function of wavelength. A number of techniques, such as wavelets, entropy, probability, fuzzy sets, and neural networks, have been used [64]. Here we

discuss one approach that has proved useful in segmenting multispectral microscopy images.

### 13.3.3.1 Combining Segmentation with Classification

Traditional image analysis methods view segmentation as a low-level operation decoupled from higher-level analysis such as measurement and classification (see Chapter 9). Each pixel has a scalar gray-level value, and the objects are first isolated from the background based on gray level and then identified based on a set of measurements reflecting their morphology. With spectral imaging, however, each pixel is a vector of intensity values, and the identity of an object, in addition to its mere presence, is encoded in that vector. Thus segmentation and classification are more closely related and can be integrated into a single operation. The process then becomes one of "pixel classification," where "background" is just another class to which a pixel might belong. This approach has been used with success in chromosome analysis and in optical character recognition [62, 63].

### 13.3.3.2 M-FISH Pixel Classification

We illustrate this approach for the M-FISH application discussed earlier. The objective in segmenting M-FISH images is to classify individual pixels to determine to which of the chromosome types each one belongs. It is important to do this on a pixel-by-pixel basis because pieces of one chromosome can become translocated onto other chromosomes, and this has clinical significance.

In M-FISH, five fluorophores attach to the various chromosomes in different combinations, and a sixth, the counterstain, labels all chromosomes. The traditional approach is to segment the image, after unmixing, using the counterstain channel alone, and then to classify each interior pixel based on its brightness in the other five color channels. This second step is a standard 24-class, five-feature classification problem that can be approached using the techniques outlined in Chapter 11. An alternative, however, is to include the counterstain channel intensity as a feature and to include "background" as a class. Then it becomes a six-feature, 25-class problem, with image segmentation and pixel classification integrated into a single step. Segmentation is implicit, in that the background class contains all nonchromosome pixels.

An example of a typical M-FISH image is shown in Fig. 13.13a, and the result of pixel-by-pixel segmentation combined with classification appears in Fig. 13.13b. Overall, this approach provides over 96% accuracy in detecting pixels for each of the 24 chromosomes.

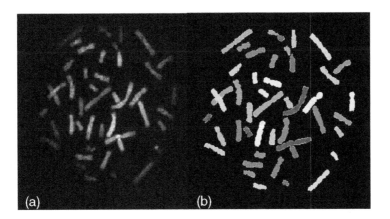

**FIGURE 13.13** (a) A six-color M-FISH image acquired using multispectral fluorescence microscopy based on a filter-wheel configuration, and (b) the result of segmentation based on pixel classification. This figure may be seen in color in the four-color insert.

# 13.4 Summary of Important Points

1. Multispectral imaging is the acquisition of spectral information at each pixel of a sample.

2. Multispectral imaging involves the combined use of spectroscopy and imaging.

3. Multispectral imaging is a relatively new technique that is being explored for many applications in both brightfield and fluorescence microscopy.

4. Spectral resolution refers to the closest wavelengths that can be distinguished.

5. A key utility of multispectral microscopy is the ability to characterize inherent chemical constituents of a sample.

6. Multispectral image acquisition can be achieved via three different methods: wavelength-scan methods, spatial-scan methods, and time-scan methods.

7. Multispectral image analysis is often necessary because spectral images are too big and complex to be interpreted visually.

8. Most standard image processing methods and algorithms can be generalized to spectral image analysis.

9. Interference effects due to varying quantum efficiency of detector, variable attenuation of illumination, and nonhomogenous illumination necessitate the use of effective calibration algorithms to ensure the accuracy of acquired spectral images.

10. Spectral unmixing isolates the light from one stain or fluorophore to a single color channel.

11. Multispectral pixel classification combines segmentation and classification into one step.

# References

1. E Kim et al., "A High-Resolution Multispectral Imaging System for Small Satellites," *Acta Astronautica*, **52**:813–818, 2003.
2. J Kerekes and J Baum, "Spectral Imaging System Analytical Model for Subpixel Object Detection," *IEEE Transactions on Geoscience and Remote Sensing*, **40**(5):1088–1101, 2002.
3. A Kulcke et al., "On-Line Classification of Synthetic Polymers Using Near-Infrared Spectral Imaging," *Journal of Near-Infrared Spectroscopy*, **11**(1):71–81, 2003.
4. HG Weier et al., "Fluorescence in situ Hybridization and Spectral Imaging Analysis of Human Oocytes and First Polar Bodies," *Journal of Histochemistry and Cytochemistry*, **53**(3):269–272, 2005.
5. D Maiti, S Sennoune, and R Martinez-Zaguilan, "Proton Gradients in Human Breast Cancer Cells Determined by Confocal, Multiphoton, and Spectral Imaging Microscopy," *FASEB Journal*, **17**(4):A467, 2003.
6. T Haraguchi et al., "Spectral Imaging Fluorescence Spectroscopy," *Genes to Cells*, **7**(9): 881–887, 2002.
7. RG Bearman, "Biological Imaging Spectroscopy," in *Biomedical Photonics Handbook*, T Vo-Dinh, ed., CRC Press, 2003.
8. RM Levenson and JR Mansfield, "Multispectral Imaging in Biology and Medicine: Slices of Life," *Cytometry A*, **69**(8):748–758, 2006.
9. Y Garini, IT Young, and G McNamara, "Spectral Imaging: Principles and Applications," *Cytometry A*, **69**(8):735–747, 2006.
10. JM Lerner, "Imaging Spectrometer Fundamentals for Researchers in the Biosciences— A Tutorial," *Cytometry A*, **69**(8):712–734, 2006.
11. KR Castleman, *Digital Image Processing*, Prentice-Hall, 1998.
12. E Hecht, *Optics*, Addison-Wesley, 1998.
13. S McLean, *Electronic Imaging in Astronomy: Detectors and Instrumentation*, John Wiley & Sons, 1997.
14. RW Waynant and EN Marwood, *Electro-Optics Handbook*, McGraw-Hill, 2000.

15. RS Aikens, DA Agard, and JW Sedat, "Solid-State Imagers for Microscopy," *Methods in Cell Biology*, **29**:291–313, 1989.

16. JW Smith, *Modern Optical Engineering: The Design of Optical Systems*, McGraw-Hill, 1990.

17. IT Young, "Image Fidelity: Characterizing the Imaging Transfer Function," in *Methods in Cell Biology*, DL Taylor and YL Wang, eds., Academic Press, 1989.

18. JC Mullikin et al., "Methods for CCD Camera Characterization," in *SPIE Proceedings: Image Acquisition and Scientific Imaging Systems*, HC Titus, and A Waks, eds., **2173**: 73–84, 1994.

19. TL Williams, *The Optical Transfer Function of Imaging Systems*, Institute of Physics Publishing, 1999.

20. CL Wyatt, "Infrared Spectrometer. Liquid-helium-cooled Rocketborne Circular-Variable Filter," *Applied Optics*, **14**:3086–3091, 1975.

21. PJ Miller, "Use of Tunable Liquid Crystal Filters to Link Radiometric and Photometric Standards," *Metrologia*, **28**:145–149, 1991.

22. X Gao et al., "In vivo Cancer Targeting and Imaging with Semiconductor Quantum Dots," *Nature Biotechnology*, **22**:969–976, 2004.

23. R Shonat et al., "Near-Simultaneous Hemoglobin Saturation and Oxygen Tension Maps in Mouse Brain Using an AOTF Microscope," *Journal of Biophysics*, **73**:1223–1231, 1997.

24. N Gat, "Imaging Spectroscopy Using Tunable Flters: A Review," *Proceedings of SPIE*, **4056**:50–64, 2000.

25. RH Levenson and CC Hoyt, "Spectral Imaging and Microscopy," *American Laboratory*, **32**(22):26–33, 2000.

26. MB Sinclair et al., "Design Construction Characterization and Application of a Hyperspectral Microarray Scanner," *Applied Optics*, **43**:2079–2088, 2004.

27. ME Dickinson et al., "Multispectral Imaging and Linear Unmixing Add a Whole New Dimension to Laser Scanning Fluorescence Microscopy," *Biotechniques*, **31**:1272–1278, 2001.

28. J Bayani and JA Squire, "Spectral Karyotyping," *Methods in Molecular Biology*, **204**:85–104, 2002.

29. Z Malik et al., "Fourier Transform Multipixel Spectroscopy for Quantitative Cytology," *Journal of Microscopy*, **182**:133–140, 1996.

30. QS Hanley et al., "Three-Dimensional Spectral Imaging by Hadamard Transform Spectroscopy in a Programmable Array Microscope," *Journal of Microscopy*, **197**(1):5–14, 2000.

31. Y Garini et al., *Fluorescence Imaging Spectroscopy and Microscopy*, John Wiley & Sons, 1996.

32. RA Cardullo, "Fundamentals of Image Processing in Light Microscopy," *Methods in Cell Biology*, **72**:217–242, 2003.

33. WC Schwartzkopf, AC Bovik, and BL Evans, "Maximum-Likelihood Techniques for Joint Segmentation–Classification of Multispectral Chromosome Images," *IEEE Transactions on Medical Imaging*, **24**(12):1593–1610, 2005.

34. S Shah, "Multispectral Integration for Segmentation of Chromosome Images," in *Lecture Notes in Computer Science: Proceedings 11th International Conference on Computer Analysis of Images and Patterns*, **3691**:506–513, 2005.

35. R Ornberg, M Woerner, and D Edwards, "Analysis of Stained Objects in Histopathological Sections by Spectral Imaging and Differential Absorption," *Journal of Histochemistry and Cytochemistry*, **47**(10):1307–1313, 1999.

36. C Rothmann, I Bar-Am, and Z Malik, "Spectral Imaging for Quantitative Histology and Cytogenetics," *Histology and Histopathology*, **13**:921–926, 1998.

37. C Rothmann, A Cohen, and Z Malik, "Chromatin Condensation in Erythropoiesis Resolved by Multipixel Spectral Imaging: Differentiation versus Apoptosis," *Journal of Histochemistry and Cytochemistry*, **45**(8):1097–1108, 1997.

38. I Ulrich and I Nourbakhsh. "Appearance-Based Place Recognition for Topological Localization," in *Proceeding of the IEEE International Conference on Robotics and Automation*, **2**:1023–1029, 2000.

39. M Swain and D Ballard, "Color Indexing," *International Journal of Computer Vision*, **7**(1):11–32, 1991.

40. W Press et al., *Numerical Recipes in C*, Cambridge University Press, 1992.

41. B Schiele and J Crowley, "Object Recognition Using Multidimensional Receptive Field Histograms," in *Proceeding of Fourth European Conference on Computer Vision*, **1064**(1):610–619, 1996.

42. S Shah et al., *Photometric Calibration for Automated Multispectral Imaging of Biological Samples*. Proceeding of International Conference on Medical Image Computing and Computer-Aided Intervention: Workshop on Microscopy Image Analysis, 2006.

43. D Chorvat et al., "Spectral Unmixing of Flavin Autofluorescence Components in Cardiac Myocytes," *Biophysical Journal*, **89**(6):L55–L57, 2005.

44. ST Gammon et al., "Spectral unmixing of multicolored bioluminescence emitted from heterogeneous biological sources.," *Analytical Chemistry*, **78**(5):1520–1527, 2006.

45. C Thaler and SS Vogel, "Quantitative Linear Unmixing of CFP and YFP from Spectral Images Acquired with Two-Photon Excitation," *Cytometry A*, **69**(8):904–911, 2006.

46. T Zimmermann, "Spectral Imaging and Linear Unmixing in Light Microscopy," *Advances in Biochemical Engineering/Biotechnology*, **95**:245–265, 2005.

47. CI Lawson and RJ Hanson, *Solving Least-Squares Problems*, Prentice-Hall, 1974.

48. KR Castleman, "Color Compensation for Digitized FISH Images," *Bioimaging*, **1**:159–163, 1993.

49. KR Castleman, "Digital Image Color Compensation with Unequal Integration Periods," *Bioimaging*, **2**:160–162, 1994.

50. C Rubio et al., "FISH Screening of Aneuploidies in Preimplantation Embryos to Improve IVF Outcome," *Reproductive Biomedicine Online*, **11**(4):497–506, 2005.

51. MR Speicher, SG Ballard, and DC Ward, "Karyotyping Human Chromosomes by Combinatorial Multifluor FISH," *Nature Genetics*, **12**:368–375, 1996.

52. AK Raap and HJ Tanke, "COmbined Binary RAtio Fluorescence in situ Hybridiziation (COBRA-FISH): Development and Applications," *Cytogenetic and Genome Research*, **114**(3–4):222–226, 2006.

53. T Haraguchi et al., "Spectral Imaging Fluorescence Microscopy," *Genes to Cells*, **7**(9): 881–887, 2002.

54. Y Hiraoka, T Shimi, and T Haraguchi, "Multispectral Imaging Fluorescence Microscopy for Living Cells," *Cell Structure and Function*, **27**(5):367–374, 2002.

55. L Rigacci et al., "Multispectral Imaging Autofluorescence Microscopy for the Analysis of Lymph-Node Tissues," *Photochemistry and Photobiology*, **71**(6):737–742, 2000.

56. S Sanchez-Armass et al., "Spectral Imaging Microscopy Demonstrates Cytoplasmic pH Oscillations in Glial Cells," *American Journal of Physiology—Cell Physiology*, **290**(2): C524–538, 2006.

57. R Zhou, EH Hammond, and DL Parker, "A Multiple-Wavelength Algorithm in Color Image Analysis and Its Applications in Stain Decomposition in Microscopy Images," *Medical Physics*, **23**(12):1977–1986, 1996.

58. MV Macville et al., "Spectral Imaging of Multi-Color Chromogenic Dyes in Pathological Specimens," *Analytical Cell Pathology*, **22**(3):133–142, 2001.

59. RO Duda, PE Hart, and DG Stork, *Pattern Classification*, John Wiley & Sons, 2001.

60. A Rabinovich et al., "Unsupervised Color Decomposition of Histologically Stained Tissue Samples," in *Advances in Neural Information Processing Systems 16*, S Thrun, L Saul, and B Scholkopf, eds., MIT Press, 2004.

61. JP Brunet et al., "Metagenes and Molecular Pattern Discovery Using Matrix Factorization," *PNAS*, **101**(12):4164–4169, 2004.

62. G Agam and I Dinstein, "Geometric Separation of Partially Overlapping Nonrigid Objects Applied to Automatic Chromosome Classification.," *IEEE Transactions on Pattern Analysis and Machine Intelligence*, **19**(11):1212–1222, 1997.

63. G Martin, "Centered-Object Integrated Segmentation and Recognition of Overlapping Handprinted Characters," *Neural Computation*, **5**(3):419–429, 1993.

64. K Fu and J Mui, "A Survey on Image Segmentation," *Pattern Recognition*, **13**:3–16, 1981.

# 14

# Three-Dimensional Imaging

Fatima A. Merchant

## 14.1 Introduction

Cells and tissues are three-dimensional (3-D) entities, and most cellular activities occur in 3-D space. Thus 3-D imaging techniques are needed to improve our ability to study them. Three-dimensional light microscopy offers a noninvasive, minimally destructive option for obtaining spatial and volumetric information about the structure and function of cells and tissues. The last decade has seen both an increase in the development of methods for 3-D imaging and a consequent growth in techniques for 3-D image processing and analysis. In this chapter we describe commonly used microscopy methods for the acquisition of 3-D data and related image processing and analysis algorithms.

## 14.2 Image Acquisition

The techniques available for 3-D microscopy include electron microscope tomography and optical sectioning light microscopy. An advantage of optical microscopy is that it is nondestructive; that is, it involves no physical manipulation of the specimen, allowing imaging of intact cells and tissues. The focus of this book is image analysis in optical microscopy, so other microscopy methods, such as electron microscopy, are not covered.

There are two major approaches for 3-D optical microscopy: far-field and near-field imaging. Far-field methods rely on light diffraction from specimens for image formation, and their resolution is thus limited by the wavelength of visible light. Conventional light microscopy is a far-field technique. Near-field methods utilize a solid mechanical probe to examine the specimen surface and are not limited by the Abbe equation (see Chapter 2). The near-field optical microscope, scanning tunneling microscope, and the atomic force microscope all employ near-field optics. Near-field microscopy methods are slower, and there is danger of mechanical damage to the specimen when compared to the far-field techniques such as light microscopy.

Here we address the most popular and widely commercialized approaches to 3-D microscopy, which include the far-field techniques of wide-field, confocal, and multiphoton microscopy. Other high-resolution 3-D microscopy methods that are newly developed and not yet commercially available are described only briefly.

## 14.2.1   Wide-Field Three-Dimensional Microscopy

Conventional wide-field light microscopy can be used to collect 3-D information from a specimen in the form of a series of two-dimensional (2-D) images taken at different focal planes. When used to collect 3-D data, wide-field microscopy is referred to as *computational optical sectioning microscopy* or *deconvolution microscopy* [1]. The drawback of this method is that light emitted from planes above and below the in-focus regions is also captured in each optical section. This occurs because the entire specimen is flooded with light, such that all parts of the specimen, throughout the optical path, are illuminated, and all of the radiated light is detected by a camera. This also reduces both lateral resolution and depth discrimination. Computational deconvolution, based on the physics of image formation and recording, can be used to remove the out-of-focus information from each 2-D image in the series.

## 14.2.2   Confocal Microscopy

Confocal imaging is a microscopy technique that provides increased resolution and increased depth discrimination ability over the conventional wide-field microscopes. Confocal microscopy achieves a theoretical improvement in axial resolution of $\sim 1/\sqrt{2}$ as compared to conventional wide-field microscopy. The confocal microscope has three important features that give it advantages over conventional microscopes. First, the lateral resolution can be as much as one and a half times better than that of a conventional microscope. Second, and most importantly, the confocal microscope has the ability to remove

out-of-focus information and thus produce an image of a very thin section of a specimen. Third, because of the absence of out-of-focus information, much higher-contrast images are obtained.

The confocal microscope, developed in 1957, uses point illumination and a pinhole in front of the detector to eliminate out-of-focus information [2]. Only the light within the plane of focus is detected, so the image quality is much better than that of wide-field images. In contrast to wide-field microscopy, in most confocal microscopes the illumination light is focused to the smallest possible spot in the plane of focus, using a coherent light source such as a collimated laser beam.

Confocal microscopes are categorized into two major types, depending on the imaging instrument design. The scanning confocal microscope scans the specimen by physically moving either the stage or the illumination beam. By contrast, the spinning-disk (Nipkow disk) confocal microscope employs a stationary stage and light source. Generally speaking, confocal laser scanning microscopy yields better image quality, but the imaging frame rate is quite slow (less than three frames/second), whereas spinning-disk confocal microscopes can achieve imaging at video rates, which is desirable for dynamic observations. Detailed reviews of the concepts, advantages, and aberrations of confocal microscopy are available [3].

Although live-cell imaging is possible with confocal microscopy, phototoxicity and photobleaching from repeated exposures to visible light limit its practical application. In conventional *one-photon* confocal fluorescence microscopy, the total excitation, which depends linearly on incident illumination intensity, is constant in each plane throughout the specimen. Confocal microscopy exposes the entire sample to high-energy photons every time an optical section is generated. Since fluorophores are bleached when excited, photobleaching occurs throughout the thickness of a sample when collecting a series of images. This limits not only the maximum time for image collection, but also the amount of time that living tissues can be observed because of photodamage due to the production of toxic by-products. Photodamage and photobleaching can be minimized by using *multiphoton microscopy* optical sectioning, in which excitation is confined to the optical section being observed by the process of *two-photon absorption*.

## 14.2.3 Multiphoton Microscopy

Two-photon microscopy is probably the most important development in fluorescence microscopy since the introduction of confocal imaging. Two-photon laser scanning microscopy is a nonlinear process that retains the optical sectioning ability of confocal microscopy while improving on its ability to image live cells [4]. It involves exciting the fluorophore by the simultaneous absorption

of two photons. The combined effect of two low-energy photons is to raise the fluorophore from the ground state to the same excited state as would be caused by a single photon of half the wavelength (i.e., twice the energy). The fluorophore then relaxes back to the ground state, emitting the absorbed energy as fluorescence, just as if it had been excited by a single photon. Unlike linear fluorescence excitation, the emission wavelength is shorter than the excitation wavelength.

Because a fluorophore must absorb two photons for excitation, fluorescence depends on the square of the incident beam intensity. Moreover, the intensity of the exciting light falls off as $1/z^2$ (where $z$ is the distance from the focal plane) above and below the focal plane. Thus, the probability of exciting a fluorophore falls off as $1/z^4$. This highly nonlinear behavior limits the excitation to a high-intensity region near the focal plane of the focused laser beam. The extremely high intensities near the focal plane confine 80% of the fluorescence excitation to a $10^{-10}\mu l$ volume when a high-numerical-aperture (NA) objective is used. This process uniquely localizes the excitation to the diffraction-limited spot of the focused beam, giving rise to the intrinsic optical sectioning ability of two-photon microscopy. Its high 3-D resolution is due to the confinement of absorption and, consequently, excitation, to the focal volume. Therefore out-of-focus photobleaching and photodamage and the attenuation of the excitation beam by out-of-focus absorption are avoided. Photodamage at the focal plane does occur, as with conventional confocal microscopy, but damage above and below the plane of focus is greatly reduced [5].

Two-photon imaging is also useful with ultraviolet excitable dyes in live cells because the excitation is achieved with infrared light, and the cells are never exposed to the more damaging ultraviolet excitation. Moreover, the infrared excitation used in two-photon imaging penetrates into tissue more efficiently than shorter wavelengths, allowing for imaging of thicker specimens. Since the probability of absorbing two photons depends on the square of the illumination intensity, infrared lasers that compress all of their output into very short ($\sim 10^{-13}$ s) high-energy pulses ($\sim 2kW$) are used. It is possible to produce these very short, intense light pulses with a "mode-locked" laser light source. Mode-locked lasers generate pulses relatively far apart ($\sim 10^{-8}$ s), so a peak power in the kilowatt range is reduced to a mean power of only a few tens of milliwatts at the specimen, and these moderate mean power levels do not damage the specimen. The laser most commonly employed to date is a tunable titanium-doped sapphire (Ti:sapphire) laser that operates in the range of 690–1000 nm. This allows two-photon excitation of fluorophores that are normally excited by single ultraviolet, blue, or green light photons.

The theoretical resolution of two-photon microscopy is typically up to 1.3-fold better (lower resolution) than that of conventional fluorescence microscopy because of the longer excitation wavelength used [6, 7]. When maximum

resolution is required, two-photon microscopy is often coupled with confocal detection (by a pinhole) [8], or two-beam interference illumination is combined with confocal detection [9].

## 14.2.4 Other Three-Dimensional Microscopy Techniques

Recent years have seen the development of several other methods for three-dimensional microscopy. Optical coherence tomography (OCT) is a 3-D microscopy technique in which axial resolution is improved by interferometric measurement of the time-of-flight of short-coherence light [10]. Typically, a Michelson-type interferometer is illuminated by a femtosecond laser pulse or superluminescent light-emitting diode (LED) light, and the reference arm is dithered to generate a heterodyne signal by the interference with the backscattered light from the sample point. The 3-D image is constructed via mechanical scanning over the sample volume.

Another technique is optical projection tomography (OPT), which is based on the transmission and detection of visible light through a $360°$-step-rotated specimen. Data are collected at each angular position, and the 3-D image is reconstructed by a back-projection algorithm. OPT has the advantage over confocal microscopy and OCT of increased depth penetration [11]. An alternative is multiple imaging axis microscopy, where wide-field images (2-D projections) are taken of a stationary sample using several objective lenses mounted at different angles, and the recorded images are then combined to reconstruct a 3-D image [12].

Single-plane illumination microscopy (SPIM) is another technique used for optical sectioning [13]. Here the sample is illuminated, rotated about a vertical axis, and observed in a direction perpendicular to the illumination plane. An advantage of SPIM is that only those parts of the sample that are being observed are illuminated, so out-of focus light is not generated. The sample is attached to a stage that can be rotated and translated. This allows 3-D data stacks to be recorded along different directions.

Other methods that offer improved 3-D resolution include interference and structured illumination methods, such as (1) 4-pi-confocal [9], (2) $I^{n}M$ (e.g., incoherent interference illumination microscopy) [14], and (3) HELM (harmonic excitation light microscopy) [15]. In interference microscopy two or more light sources are used to generate a periodic pattern of light at the sample plane. When these patterns are used to excite fluorescence, they interact with the sample structure, and the recorded emission carries higher-resolution information than what can be achieved by conventional microscopy. Typically two objective lenses are used at the front and rear of the sample, and the emitted fluorescence is collected from both objectives and combined to interfere at the image plane. Structured illumination microscopy is covered in Chapter 17.

# 14.3   Three-Dimensional Image Data

Three-dimensional data obtained from microscopes consists of a stack of optical sections, referred to as the *z-series* (see Fig. 14.1). The optical sections are obtained at fixed intervals along the *z*-axis. Each 2-D image is called an *optical slice* or *optical section*, and all the slices together comprise a volume data set. Building up the *z*-series in depth allows the 3-D specimen to be reconstructed.

## 14.3.1   Three-Dimensional Image Representation

For image processing and analysis purposes, a 3-D digital image is represented as a 3-D array whose elements are called *volume elements*, or *voxels*. Other terms used to refer to 3-D images include *3-D data set, 3-D volume, volumetric image,* and *z-stack*. Many 3-D image processing techniques are simply extensions of the corresponding 2-D image processing algorithms. A few of the truly 3-D algorithms that operate on volume data sets are discussed next.

### 14.3.1.1   Three-Dimensional Image Notation

A 3-D image, $f(x, y, z)$, is represented as a 3-D matrix of dimensions $L \times M \times N$, where $x$, $y$, $z$ denote column, row, and slice coordinates, respectively. Each voxel has a physical size $D_x \times D_y \times D_z$ in units that are typically millimeters or micrometers. Ideally, a voxel is a cube with the same dimension in depth as in lateral spacing, but in practice (especially in 3-D microscopy) this is

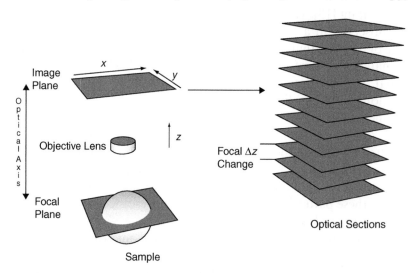

**FIGURE 14.1**   A schematic representation of 3-D image acquisition in optical sectioning microscopy.

rarely achieved, and the $z$ dimension is much thicker. In the following sections we describe the methods for deblurring and restoration of images obtained via optical sectioning. Then we describe some 3-D image processing, analysis, and display techniques.

# 14.4 Image Restoration and Deblurring

The aim of image restoration is to bring an image as close as possible to what it would have been if it had been recorded without degradation. Typically, restoration encompasses the processes of noise removal and image deblurring via deconvolution. The primary task of deblurring is to remove or reduce the out-of-focus haze arising from objects located above and below the plane of focus. In order to achieve this, the deconvolution process estimates the amount of out-of-focus light characterizing the particular microscope optics in use and then attempts either to subtract out this light or to redistribute it back to its point of origin in the specimen volume. In other words, the goal is to recover the function $f(x, y, z)$ from a series of images $g(x, y, z)$ taken at different focal plane levels $z$. While this approach faces theoretical limitations it can be done well enough to make it an important tool in biological research, particularly in microscopy.

## 14.4.1 The Point Spread Function

The out-of-focus light can be characterized by the 3-D *point spread function* (psf), which is the image of a point source of light. The psf is the basic unit that makes up any image (see Chapter 2). For example, fluorescent molecules in a specimen can be likened to point sources of light, where their intensity is proportional to the concentration of the fluorophore at that point. A copy of the 3-D psf is produced by each of these sources, and the 3-D summation of these is the 3-D image. Thus the out-of-focus light in the image arises from the summed contributions of many psfs. This process can be modeled mathematically as a convolution operation, whereby light emitted from out-of-focus points in the specimen is convolved with the defocus psf, and it appears as a blurred region in the image. Deconvolution is used to reverse the process and deblur the image. Typically the entire stack of 2-D images is processed in order to deblur each optical slice in the $z$ series.

The first step in any 3-D deconvolution algorithm design is to determine the 3-D psf. Three methods are commonly used for estimating the psf of a microscope: experimental, theoretical, and analytical. Experimentally, images of one or more pointlike objects (typically fluorescent beads smaller than the resolution of the microscope) are collected and used to estimate the psf [16, 17].

The recommended bead diameter is one-third of the Rayleigh resolution value, or $0.41\lambda/\text{NA}$ [18]. For an $\text{NA} = 1.4$ objective operating with green fluorescence (500 nm), a bead diameter of $0.15\,\mu\text{m}$ is recommended. It is important to emulate the microscopy conditions of the planned experiment as closely as possible. For example, the same mounting medium should be used, and the optical system should have the same objective lens, relay lenses, and detectors. Typically an experimentally measured psf closely matches the actual psf for that experimental setup. An experimentally measured psf, however, may exhibit low signal-to-noise ratio (SNR), with symmetric features in radial planes but asymmetry along the axial plane due to spherical aberration. Typically, high-quality optical components that are precisely aligned are used to produce psfs that are symmetrical.

In the theoretical method, the psf is computed using a mathematical model from diffraction theory (see Eq. 14.1). A theoretically determined psf will have axial and radial symmetry. Figure 14.2 presents cross-sections through theoretically determined psf's for wide-field and confocal microscope systems. The psf's were determined using a 1.4-NA oil-immersion lens and a wavelength of 630 nm. Both psf's were calculated via the XCOSM software [1, 17]. As seen in the figure, the psf for the wide-field system, which exhibits an Airy disk pattern, clearly shows the central disk and side lobes (first row, second column

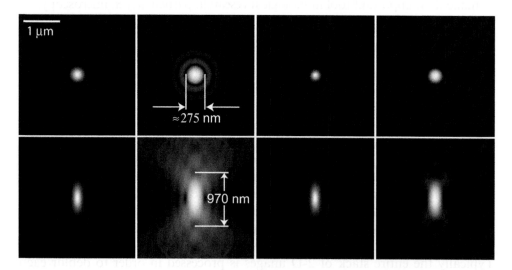

**FIGURE 14.2** Cross sections through the point spread function (psf). Top row: *xy*, or horizontal, sections at the plane of best focus. Bottom row: *xz*, or vertical, sections at the center of the psf. The two leftmost columns illustrate the psf of a wide-field microscope. The leftmost column is displayed using a linear brightness scale, and the second column from the left is displayed using a logarithmic brightness scale of four decades. The two rightmost columns illustrate the psf of a confocal microscope. The second column from the right is displayed using a linear brightness scale, and the rightmost column is displayed using a logarithmic brightness scale of four decades. (Image courtesy of José-Angel Conchello.)

from the left). The confocal psf, which is equal to the square of the Airy disk, exhibits a narrower central disk with very weak side lobes (first row, rightmost column).

The third method for determining the psf is analytical. In this case, the psf is determined by computationally extracting it directly from recorded 3-D image data. Section 14.4.3.6 discusses doing this by means of blind deconvolution.

### 14.4.1.1 Theoretical Model of the Point Spread Function

The psf may be calculated theoretically using a diffraction-based model [19, 20], as

$$h(x, y, z; \psi) = \left| \int_0^1 J_0\left(\frac{KN_a\rho\sqrt{x^2 + y^2}}{M}\right) \exp\{jK\phi(z, \psi)\}\rho \, d\rho \right|^2 \quad (14.1)$$

where $J_0$ is the first order Bessel function, $K$ is the wave number, $N_a$ is the numerical aperture, $M$ is the magnification, and $j$ is the square root of $-1$. The vector $\psi$ denotes the measurement setup parameters (i.e., refractive index of the immersion oil, thickness of the coverslip and specimen, and the microscope tube length), and $\rho$ denotes the normalized radius in the back focal plane. The distance from the in-focus plane to the point of evaluation is $z$, and $\phi(\cdot)$ denotes the phase aberration. When more than one or two physical parameters are unknown in Eq. 14.1, the psf can be modeled in terms of purely mathematical parameters by replacing the phase term, $\exp\{jK\phi(z, \psi)\}$, with $A(\rho) \exp\{jW(\rho, z)\}$, where [20, 21]

$$W(\rho, z) = zC(\rho) + B(\rho)$$

$$A(\rho) = \sum_{k=0}^{K_a} a_k\chi_k(\rho)$$

$$B(\rho) = \sum_{k=0}^{K_b} b_k\vartheta_k(\rho)$$

$$C(\rho) = \sum_{k=0}^{K_c} c_k\nu_k(\rho)$$

The unknown parameters $a_k$, $b_k$, $c_k$, and $\chi_k(\cdot)$, $\vartheta_k(\cdot)$, $\nu_k(\cdot)$, are suitably chosen bases. It is possible to represent $A(\rho)$, $B(\rho)$, and $C(\rho)$ either as power series expansions or in terms of radial Zernike polynomials [22]. Several articles that provide tutorial information on the psf are recommended for an in-depth review [1, 3, 17, 23, 24].

### 14.4.2  Models for Microscope Image Formation

Most microscopes can be assumed to be shift-invariant linear systems with a position-independent psf, where point sources located anywhere in the sample create psf's of constant shape at the detector. In its simplest form, then, the formula for microscope image formation incorporates two known quantities, the psf, $h(x, y, z)$, and the recorded 3-D image, $g(x, y, z)$, and one unknown quantity, the actual distribution of light in the 3-D specimen, $f(x, y, z)$. These terms are related by the imaging equation

$$g(x, y, z) = f(x, y, z) * h(x, y, z) \qquad (14.2)$$

where $*$ indicates 3-D convolution. In practice, however, image recording is corrupted by intrinsic and extrinsic noise. Intrinsic noise obeys a Poisson model and is introduced when each photon hits the detector, thus creating a random number of photoelectrons. Other sources introduce random extrinsic noise that can be modeled as additive Gaussian noise. Mathematical models for 3-D fluorescence microscopy imaging based on the Poisson and Gaussian noise statistics are commonly used [20].

#### 14.4.2.1  Poisson Noise

Poisson modeling [20] of both the signal emitted by the specimen and the background noise can be represented mathematically as follows [20]

$$og(x, y, z) = P(o[f(x, y, z) * h(x, y, z)]) + P(o[b(x, y, z)]) \qquad x, y, z \in R \quad (14.3)$$

where $o$ is the reciprocal of the photon-conversion factor, $og(x, y, z)$ is the number of measured photons, $P$ is a Poisson process, and $b(x, y, z)$ is the background noise. In fluorescence microscopy, the photon-conversion factor depends on several physical parameters, such as the exposure time and the quantum efficiency of the detector. Both

$$P(o[f(x, y, z) * h(x, y, z)]) \qquad \text{and} \qquad P(o[b(x, y, z)])$$

are independent Poisson random variables; hence, the measured output is a Poisson random variable [20].

#### 14.4.2.2  Gaussian Noise

The Gaussian noise model [20] is given by

$$g(x, y, z) = f(x, y, z) * h(x, y, z) + w(x, y, z) \qquad x, y, z \in R \qquad (14.4)$$

where $w(x, y, z)$ represents the additive Gaussian noise. The background term is omitted because it can be estimated and then removed. For the Poisson noise model, the background term cannot be incorporated in a term that is independent of $(f(x, y, z) * h(x, y, z))$ and thus must be explicitly defined. As explained earlier, deconvolution recovers an estimate of $f(x, y, z)$ from $g(x, y, z)$, given a knowledge of $h(x, y, z)$. The following section describes some of the commonly used algorithms for deconvolution.

### 14.4.3 Algorithms for Deblurring and Restoration

On the basis of their mode of implementation (2-D or 3-D), deconvolution algorithms can be broadly divided into two classes, *deblurring* and *image restoration*. Algorithms that are applied sequentially to each 2-D plane of a 3-D image stack, one at a time, are classified as *deblurring* procedures. Appropriately, they are not really deconvolution methods because they do not use the imaging formula and are not based on an estimation of $f(x, y, z)$ as outlined in Eq. 14.2. On the other hand, image *restoration* (or deconvolution) algorithms operate simultaneously on every voxel in a 3-D image stack and are truly implemented in 3-D to restore the actual distribution of light in the specimen by determining $f(x, y, z)$. In this chapter, the term *deconvolution* is used to refer to both deblurring and restoration.

Different deconvolution methods solve for $f(x, y, z)$ in different ways, and six major categories of deconvolution algorithms have evolved so far. These approaches differ in the type of mathematical model used to emulate image formation and recording and in the underlying assumptions used in the simulation to reduce complexity. This section describes the following approaches to deconvolution: (1) the no-neighbor methods, (2) neighboring plane methods, (3) linear methods, (4) nonlinear methods, (5) statistical methods, and (6) blind deconvolution. Prior to deconvolution, the 3-D image data recorded from a microscope should be preprocessed (or corrected) to remove background inhomogenities, such as those due to spatially nonuniform illumination, uneven sensitivity of the detector, and intensity attenuation with depth (Chapter 12). Other image preprocessing algorithms and enhancement methods are described in Chapter 6.

### 14.4.3.1 No-Neighbor Methods

The no-neighbor processing scheme is a 2-D method for deblurring an individual section through the object from a single image [25]. It is based on the principle that in-focus structures in the image are "sharper" than out-of-focus

ones, which tend to blur or flatten out. While sharpness is typically represented by higher spatial frequencies, the out-of-focus components tend to be composed of lower spatial frequencies (i.e., the light intensity varies more slowly over the field of view). The idea is that removing lower spatial frequencies will remove mainly out-of-focus structures and leave behind the in-focus objects of interest. Retaining the higher frequencies also tends to improve the picture by sharpening edges of structures. This approach, then, is simply a sharpening (high-pass) filter [26] that can be implemented by convolution. This approach is applicable for specimens that tend to be composed mostly of higher-spatial-frequency components, i.e., small structures such as pointlike objects and filaments [25]. A significant advantage of this approach is its computational simplicity and the resulting speed of processing. A disadvantage is that most specimens are actually a complex mixture of low and high spatial frequencies, and there is the danger of filtering out components of interest.

### 14.4.3.2  Nearest-Neighbor Method

This method also falls under the category of deblurring algorithms, which were first introduced in 1971 for deblurring light microscope image stacks [27]. Each 2-D image in a 3-D stack contains information from the corresponding in-focus specimen plane plus a sum of defocused adjacent specimen planes. The diffraction-limited transfer function (Chapter 2) tends to discriminate against high spatial frequencies but passes low-frequency content. It is thus possible to partially remove defocused structures by subtracting adjacent plane images that have been blurred by convolution with the appropriate defocus psf. In the nearest-neighbor method only two immediately adjacent planes are used, one above the plane of focus and the other below. While the image taken at any one focal plane actually contains out-of-focus light from all specimen planes, the nearest-neighbor method assumes that the strongest contributions come from the nearest two adjacent planes. For example, as shown in Eq. 14.5, the nearest-neighbor algorithm operates on a plane $k$ by blurring its neighboring planes $k \pm 1$, using a digital blurring filter, and then subtracting the blurred planes from $k$ [28]

$$\hat{f}_k(x, y) = g_k(x, y) - c[g_{k-1}(x, y) * h_{k-1}(x, y) + g_{k+1}(x, y) * h_{k+1}(x, y)] \quad (14.5)$$

where the subscript $k$ indicates the optical slice number. One 2-D image is sharpened at a time, with the neighboring images immediately above and below it blurred, and a fraction $c$ of them subtracted out. Figure 14.3 shows the effect of deblurring using the nearest-neighbor method [29]. Panels a–c show three optical slices taken from May-Giemsa-stained blood cells. The images were obtained at a $z$ interval of $0.5\,\mu\text{m}$. The centermost slice (panel b) was deblurred, using neighboring slices, immediately above (panel a), and below (panel c). The deblurred image is shown in panel d.

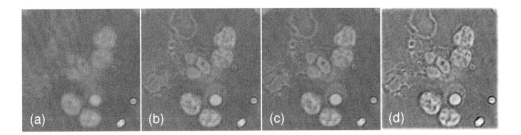

**FIGURE 14.3** Deblurring using the nearest-neighbor method. Panels a–c show three optical slices taken from May-Giemsa-stained blood cells. The images were obtained at a z interval of 0.5 μm. The optical section in b was deblurred, using neighboring slices, immediately above a and below c. The resulting deblurred image is shown in d. (Image reproduced with permission from [29].)

Multineighbor methods extend this concept to a user-selectable number of planes. The entire 3-D stack is processed by applying the algorithm to each image in the stack to remove blurring from that plane. Not only does increasing the number of planes used for deblurring increase the computational load of the technique, but the amount of improvement also falls off rapidly as more planes are used. The deblurred images can be sharpened further with a Wiener inverse filter (Chapter 6) to reduce the remaining blur. After processing, the content of each image corresponds predominantly to the in-focus information from the corresponding specimen plane.

Nearest-neighbor methods work best when the amount of blur from one plane to the next is significant, that is, when the planes are relatively far apart. They are most applicable to specimens containing sparse structures distributed through a transparent or nonfluorescing tissue, such as thin filaments. Since the algorithms involve relatively simple calculations on single image planes, they are also most useful in situations when quick image sharpening is needed and computing power is limited. The advantages of this approach include computational speed, improved contrast, and sharpening of features in each optical slice. There are also several disadvantages to this approach. These methods are sensitive to noise and may produce noisier images, since noise from several planes tends to get added together. They also tend to introduce structural artifacts because each optical slice can contain diffraction rings or light from other structures that may be sharpened as if it were in that focal plane. Contrast is also reduced by the deblurring process, because intensities are removed rather than redistributed. Therefore it is better to use these methods for visualization rather than prior to quantitative analysis. For specimens containing structures that fluoresce over large areas or volumes, these simple methods do not perform well, and some of the approaches described next may be more applicable.

### 14.4.3.3  *Linear Methods*

Linear methods fall under the category of image restoration techniques and represent one of the simplest 3-D methods for deconvolution. With linear methods, the deconvolution algorithm is implemented in the frequency domain. This is because convolution in the spatial domain corresponds to multiplication in the frequency domain. These methods employ Eq. 14.2 to recover an estimate of $f(x, y, z)$ from $g(x, y, z)$, and they require knowledge of the 3-D psf. Transforming Eq. 14.2 into the frequency domain yields

$$G(u, v, w) = F(u, v, w)H(u, v, w) \tag{14.6}$$

where $u$, $v$, and $w$ are frequency variables in the $x$, $y$, and $z$ directions, respectively. The spectrum of the specimen function is

$$F(u, v, w) = G(u, v, w)H'(u, v, w) \tag{14.7}$$

where $H'(u, v, w)$ is the inverse 3-D optical transfer function (OTF), given by

$$H'(u, v, w) = \frac{1}{H(u, v, w)} \tag{14.8}$$

The OTF, $H(u, v, w)$, which is the Fourier transform of the psf of the microscope, describes mathematically how the system treats periodic structures (Chapter 2). Essentially, the OTF drops off at higher frequencies and goes to zero at $f_c = 2NA/\lambda$, the optical cutoff frequency. Frequencies above the cutoff are not recorded in the microscope image. As seen in Eqs. 14.2–14.8, division in the Fourier domain is equivalent to deconvolution in the spatial domain. This inverse filtering is the simplest way to remove the effects of the psf, and it forms the basis of all linear methods of deconvolution. Most linear methods thus involve Fourier transforming an image and then dividing by the Fourier transform of the psf.

In linear methods, noise in the measured data becomes a problem, particularly at frequencies where the denominator, $H(u, v, w)$, is small or even zero. As discussed in Chapter 2, the OTF is almost always small at high spatial frequencies. Further, the specimen typically contains little energy at the high frequencies, so noise can dominate the upper part of the frequency spectrum. To address this problem, linear deconvolution methods often adopt some noise-reduction strategy. The goal is to strike a balance by reducing the contribution of high-spatial-frequency noise while retaining sharpness in the image. Several algorithms for linear deconvolution have been described, including (1) inverse filtering, (2) Wiener deconvolution, (3) regularized least squares, (4) linear least-squares restoration, and (5) Tikhonov–Miller regularization.

*Inverse Filtering* An inverse filter uses an approximate direct linear inversion of the imaging equation, Eq. 14.7, as

$$\hat{f}(x, y, z) = F^{-1} \left[ \frac{G(u, v, w)}{H(u, v, w)} \right] \tag{14.9}$$

The main drawback of this method is that $H(u, v, w)$ is usually a low-pass filter, and therefore $1/H(u, v, w)$ is a high-pass filter that takes on large values at the higher frequencies. Thus, Eq. 14.9 becomes numerically unstable for small values of $H(u, v, w)$, and this greatly increases the high-frequency noise contribution. This makes simple inverse filtering very sensitive to noise. One method to combat this is to limit the inverse OTF as follows [20]

$$\hat{f}(x, y, z) = \begin{cases} F^{-1} \left\{ \dfrac{G(u, v, w)}{H(u, v, w)} \right\} & \text{if } |H(u, v, w)| \geq \varepsilon \\ 0 & \text{if } |H(u, v, w)| \leq \varepsilon \end{cases} \tag{14.10}$$

where $\varepsilon$ is a small positive constant. The choice of $\varepsilon$ balances resolution versus noise in the resulting image estimate. For example, small $\varepsilon$ results in sharper images with finer resolution but more noise.

Another approach for reducing noise is to apply an adjustable smoothing operation. The inverse filtering algorithm is most useful when a known low-pass filter has blurred the image, since it is theoretically possible to recover that image via inverse filtering. In microscopy, these algorithms use either a theoretical or a measured psf to remove image blurring rapidly and effectively. The results are usually qualitative and generally better than the no- and nearest-neighbor methods. However, as discussed earlier, inverse filtering is very sensitive to additive noise. The Wiener filtering approach, described next, implements an optimal trade-off between inverse filtering and noise smoothing.

*Wiener Deconvolution* One of the most widely used image-restoration techniques is Wiener deconvolution. Unlike simple inverse filtering, this method attempts to reduce noise while restoring the original signal. It implements a balance between inverse filtering and noise smoothing that is optimal in the mean square error (MSE) sense. Assuming the white Gaussian noise model described in Eq. 14.4, the orthogonality principle implies that the Wiener filter can be expressed in the Fourier domain as [20, 28]

$$\hat{H}(u, v, w) = \frac{H^*(u, v, w)}{\left\{ |H(u, v, w)|^2 + \left( \frac{P_w(u, v, w)}{P_f(u, v, w)} \right) \right\}} \tag{14.11}$$

where $\hat{H}(u, v, w)$ is the 3-D Fourier transform of $\hat{h}(x, y, z)$, "$*$" is the complex conjugation operation, and $P_w(u, v, w)$ and $P_f(u, v, w)$ are the power spectral densities of the noise and the specimen, respectively [30]. Equation 14.11 can be rewritten as

$$\hat{H}(u, v, w) = \frac{1}{H(u, v, w)}\left[\frac{|H(u, v, w)|^2}{|H(u, v, w)|^2 + \frac{1}{\text{SNR}(u, v, w)}}\right] \qquad (14.12)$$

where

$$\text{SNR}(u, v, w) = \frac{P_f(u, v, w)}{P_w(u, v, w)}$$

Equation 14.12 can be interpreted as two filters in cascade in the frequency domain, where $1/H(u, v, w)$ is the inverse filter and the term in brackets is the Wiener filter. The term $\text{SNR}(u, v, w)$ is the signal-to-noise ratio as a function of frequency. In the absence of noise, (i.e., infinite SNR), the Wiener deconvolution filter reduces to the standard inverse filter. However, as noise is added, the SNR decreases, and the term in square brackets decreases as well. The Wiener filter attenuates certain frequencies according to their SNR. It not only performs deconvolution, which is a high-pass filtering operation, but it also reduces noise with low-pass filtering. Wiener deconvolution performs well in the presence of noise, but it has other problems that limit its effectiveness. First, the MSE criterion of optimality is not a particularly good one for human observation. It tends to smooth the image more than the eye would like. Second, it weighs all errors equally, regardless of their location in the image. Finally, classical Wiener deconvolution cannot handle a spatially variant microscope psf.

**Linear Least Squares**    The linear least-squares (LLS) method is also used to restore images corrupted with additive white Gaussian noise [31]. This approach is based on linear algebra. The Gaussian noise imaging model in Eq. 14.4 can be rewritten in discrete form as a matrix-vector equation [32],

$$\mathbf{G} = \mathbf{HF} + \mathbf{W} \qquad (14.13)$$

where $\mathbf{G}$ is the recorded image, $\mathbf{F}$ is the specimen object, $\mathbf{W}$ is the noise, and $\mathbf{H}$ is the matrix representing the psf. In this formulation $\mathbf{F}$, $\mathbf{G}$, and $\mathbf{W}$ are vectors formed by stacking the columns of the respective images. If $\mathbf{W} = 0$ or if we know nothing about the noise, we can set up the restoration as a least-squares minimization problem in the following way. We wish to select $\hat{\mathbf{F}}$ so that, if it is blurred by $\mathbf{H}$, the result will differ from the observed image $\mathbf{G}$, in the mean square sense, by as little as possible. Since $\mathbf{G}$ itself is simply $\mathbf{F}$ blurred by $\mathbf{H}$, this is a satisfying approach. If $\mathbf{F}$ and $\hat{\mathbf{F}}$, both having been blurred by $\mathbf{H}$, are nearly

equal, then hopefully $\hat{\mathbf{F}}$ is a good approximation to $\mathbf{F}$. This formulation is distinctly different from that used in the Wiener filter. There we sought to minimize the difference between the restored signal and the original. Here we are satisfied to minimize the difference between the blurred original and a similarly blurred estimate of the original. We cannot expect the results of these two formulations to be the same.

Let $e(\hat{\mathbf{F}})$ be a vector of residual errors that results from using $\hat{\mathbf{F}}$ as an approximation to $\mathbf{F}$. Equation 14.13 then becomes

$$\mathbf{G} = \mathbf{HF} = \mathbf{H}\hat{\mathbf{F}} + e(\hat{\mathbf{F}}), \qquad \text{or} \qquad e(\hat{\mathbf{F}}) = \mathbf{G} - \mathbf{H}\hat{\mathbf{F}} \qquad (14.14)$$

and we seek to minimize the function

$$\phi(\hat{\mathbf{F}}) = \|e(\hat{\mathbf{F}})\|^2 = \|\mathbf{G} - \mathbf{H}\hat{\mathbf{F}}\|^2 = (\mathbf{G} - \mathbf{H}\hat{\mathbf{F}})^T(\mathbf{G} - \mathbf{H}\hat{\mathbf{F}}) \qquad (14.15)$$

where $\|a\| = \sqrt{a^T a}$ denotes the Euclidean norm of a vector, that is, the square root of the sum of the squares of its elements. Then, setting to zero the derivative of $\phi(\hat{\mathbf{F}})$ with respect to $\hat{\mathbf{F}}$ and solving for $\hat{\mathbf{F}}$ gives [32]

$$\hat{\mathbf{F}} = [\mathbf{H}^T\mathbf{H}]^{-1}\mathbf{H}^T\mathbf{G} \qquad (14.16)$$

where the matrix $\mathbf{H}$ can be constructed from the discrete psf and has a Toeplitz structure. The variance and the error depend on the eigenvalues, which are used for the matrix-inversion operation. The algorithm searches the optimal number of eigenvalues to be used in the inversion process by discarding the lowest eigenvalues. The estimate $\hat{\mathbf{F}}$ of the 3-D image is obtained in a single pass. One drawback is that, since the OTF of a microscope gives rise to a singular or quasi-singular matrix, the inversion of such a matrix system is an ill-posed problem [32].

**Regularization** A "well-posed" estimation problem is one in which (1) a solution exists, (2) that solution is unique, and (3) it depends on the input data in a continuous fashion. The deconvolution of $\mathbf{G}$, i.e., Eq. 14.13, is often an ill-posed problem. This means, in particular, that a large, uncontrolled amplification of the noise can be expected, and the resulting solution of the inverse problem is useless. Regularization helps one find a useful solution. It seeks a solution that approaches the true input distribution as the amount of noise is reduced [18]. It provides additional information for solving the ill-posed problem. For example, additional constraints on the image to be restored are utilized, such as nonnegativity, statistical properties of the image; or even information about the degree of smoothness of the image. Mostly this results in a trade-off between the smoothness of the reconstruction (with less noise)

and the degree of the deblurring. A regularized filter typically imposes certain constraints on the estimate, allowing the algorithm to select the most reasonable estimate from the large number of solutions that might arise because of the noise. Moreover, the result is usually smoothed by the elimination of higher frequencies that are well beyond the resolution limit of the microscope [33].

***Tikohnov Regularization***   Tikhonov regularization is the most commonly used method for regularization of ill-posed problems. Here the same image distortion model is assumed as in the linear least-squares method. The approach involves minimizing the Tikhonov functional, which is given by [33]

$$\phi(\hat{\mathbf{F}}) = \|\mathbf{H}\hat{\mathbf{F}} - \mathbf{G}\|^2 + \lambda \|\mathbf{C}\hat{\mathbf{F}}\|^2 \tag{14.17}$$

where $\lambda$ is the regularization parameter and $\mathbf{C}$ is the regularization matrix. The matrix $\mathbf{C}$ penalizes the solution of $\hat{\mathbf{F}}$ in the regions where it oscillates due to the noise. In matrix notation $\hat{\mathbf{F}}$ is given as [20]

$$\hat{\mathbf{F}} = \left(\mathbf{H}^T\mathbf{H} + \lambda \mathbf{C}^T\mathbf{C}\right)^{-1}\mathbf{H}^T\mathbf{G} \tag{14.18}$$

Regularization can be applied in one step within an inverse filter (discussed earlier), or it can be applied iteratively as discussed next.

### 14.4.3.4  Nonlinear Methods

The linear methods just described are quick to compute, but they have several drawbacks. These include the inability to incorporate prior knowledge about the true image, the fact that negative intensities might occur in the deconvolved image, and ringing artifacts that may be created near edges. Artifacts result from an inability to estimate the high-frequency components that are cut off by the diffraction-limited objective. Because these frequency components are not in the recorded image, it is difficult to obtain a correct estimate of the specimen. One method to address this problem is to use algorithms that incorporate a priori information about the specimen, such as nonnegativity, finite support, and smoothness. This may be used to enforce regularization constraints that the specimen estimate must satisfy. Nonlinear methods are usually iterative, involving operations that are performed repetitively until certain criteria are satisfied. Thus, these methods are also called *constrained iterative algorithms*. The constraints minimize noise or other distortions, consequently improving the restoration of the blurred image. The drawback is that iterative methods require more computational time. Some of the most widely used nonlinear

methods are described in the following sections. They provide a way to impose constraints on the restored image, after each iteration step, to avoid convergence to an infeasible solution.

**Jansson–van Cittert Method**   The Jansson–van Cittert (JVC) method of repeated convolution has been applied to digital microscope images [34–37]. It is an iterative spatial domain transform that generates successive approximations of the specimen image. The JVC method is most useful for image reconstruction in microscopy, where a consistent blurring function, (i.e., the psf) has degraded an image. The effects of blurring are attenuated using the following iterative process

$$\hat{f}_{k+1} = \hat{f}_k + r(g - h * \hat{f}_k) \tag{14.19}$$

where $g$ is the recorded image (typically a version that has been smoothed to reduce noise), $\hat{f}_k$ is the $k$th iteration image estimate, and $h$ is the microscope psf. The relaxation function, $r$, controls, during the iteration, voxel-specific constraints and image convergence constraints. The method proceeds by repeatedly adding a high-pass filtered version, $(g - h * \hat{f}_k)$, scaled by $r$, of the current image iteration, $k$, to itself. Typically, $r$ is a finite weight function that is defined over a positive intensity range. It is used to prevent unusually bright intensities in the estimated image and negative intensities, because a specimen cannot have negative fluorescence. Thus any voxel value in the estimate that becomes negative during the computation is automatically set to zero. Convergence is achieved when the difference between the image estimate at iteration $k$, $\hat{f}_k$, and the smoothed image, $g$, approaches zero.

A critical factor in reconstruction quality is the mitigation of noise. As iterations proceed, noise is amplified. Most implementations suppress this with a smoothing filter (e.g., Gaussian), which simultaneously attenuates both signal and noise. Residual structures are then amplified by a high-pass filter. Most often, the smoothing operation does not work well for low-SNR images.

**Constrained Least-Squares Method**   In the nonlinear least-squares (NLS) approach, the sum of the squared difference between the distorted recorded image and the estimated image is minimized. That is, the NLS method aims iteratively to find the specimen function $\hat{f}(x, y, z)$ that minimizes

$$\sum_{i, j, k} \left| g_{i, j, k} - \left[ \hat{f} * h \right]_{i, j, k} \right|^2 \tag{14.20}$$

where $i$, $j$, and $k$ are the voxel coordinates of the recorded 3-D image and $*$ represents 3-D convolution. In contrast to the linear least-squares method, the function $\hat{f}(x, y, z)$ is refined iteratively until the MSE is minimized. High-frequency noise imposes the same challenges as described earlier. The recorded image may contain components that do not correspond to any (blurred) physically possible component of the specimen. This situation can force the iterative process to include artificial high-frequency components in the reconstructed specimen. Impulse noise in $g(x, y, z)$, for example, might correspond to physically impossible high-frequency components in $\hat{f}(x, y, z)$. Combined with truncation (and often undersampling), particularly in the $z$ direction, least-squares reconstruction can lead to inaccurate results. Remedies for these problems include smoothing $\hat{f}(x, y, z)$ between iterations [37] and terminating the reconstruction process before the high-frequency artifacts build up.

**The Carrington Algorithm**    Carrington proposed a regularization method based on a minimization with constraints in the least-squares sense. The Carrington algorithm seeks the nonnegative function $\hat{f}(x, y, z)$ that minimizes [32, 38, 39]

$$
\min_{\{\hat{f} \geq 0\}} \sum \left| g(x, y, z) - \int \int \int h(x, y, z) \hat{f}(x, y, z) \, dx \, dy \, dz \right|^2
$$
$$
+ \alpha \int \int \int \left| \hat{f}(x, y, z) \right|^2 dx \, dy \, dz \tag{14.21}
$$

where $\alpha$ is a constant. The first term in the equation represents the difference between the original and the restored images. The second term enforces smoothness on $\hat{f}(x, y, z)$ to prevent noise in $g(x, y, z)$ from introducing unwarranted oscillations. The value of $\alpha$ determines the amount of smoothing that is enforced on $\hat{f}(x, y, z)$. If $\alpha$ is too small, we face the same problems as with least-squares deconvolution. If $\alpha$ is too large, $\hat{f}(x, y, z)$ will be too smooth to show details of interest.

**Iterative Constrained Tikhonov–Miller Algorithm**    The Tikhonov–Miller algorithm is the linear restoration filter that minimizes the Tikhonov functional from Eq. 14.17. The iterative constrained Tikhonov–Miller (ICTM) algorithm [40, 41] is a nonlinear algorithm that iteratively minimizes the Tikhonov functional. In this method, regularization is achieved by imposing the nonnegativity constraint by clipping to zero the negative intensities at each iteration step. This algorithm finds the minimum of the

Tikhonov functional using the method of conjugate gradients [42]. The conjugate gradient direction is given by [33]

$$d_k = r_k + \xi_k d_{k-1} \tag{14.22}$$

where for the $k^{\text{th}}$ iteration $\xi_k = \|r_k\|^2 / \|r_{k-1}\|^2$ and $r_k$ is the steepest descent direction, given by

$$r_k = \left(-\frac{1}{2}\right) \nabla_{\hat{f}} \phi\left(\hat{f}\right) = \left(\mathbf{H}^T\mathbf{H} + \lambda\mathbf{C}^T\mathbf{C}\right)\hat{f}_k - \mathbf{H}^T\mathbf{G}$$

The next new conjugate gradient estimate is found by [33]

$$\hat{f}_{k+1} = \begin{cases} \hat{f}_k + \beta_k d_k & \hat{f}_k + \beta_k d_k \geq 0 \\ 0 & \text{otherwise} \end{cases} \tag{14.23}$$

where $\beta_k$ is the optimal step size, which can also be analytically determined [33]. Values for $\beta$ can be found using an iterative one-dimensional minimization algorithm, such as the golden section rule [42, 43], or by using a first-order Taylor series expansion of Eq. 14.23 with respect to $\beta$. Although the ICTM algorithm used with a nonnegativity constraint is less sensitive to errors than noniterative TM restoration, it is more computationally expensive.

### 14.4.3.5 Maximum-Likelihood Restoration

Most of the constrained deconvolution methods just described are based on the assumption that the noise statistics follow a Gaussian distribution and can be modeled as additive noise. However, this assumption is not always valid, especially in the case of photon-limited imaging. In these situations, when the noise component is either large or dominated by Poisson noise, statistical processing methods are typically used to improve the deconvolution process. They incorporate information about the statistics of the noise and impose necessary constraints. Statistical methods are usually based on the premise that, given the probability distribution of the observed image for a known specimen and a known microscope psf, one can statistically estimate the true specimen image that best satisfies not only the mathematical description of image formation and recording but also the original recorded image [44]. These methods are also capable of recovering certain information that is not passed by the objective lens [44]. The algorithms are iterative and computationally more expensive than the constrained iterative methods.

Maximum-likelihood (ML) restoration has been applied to optical section deblurring [45]. If the psf, $h$, of the microscope is known, the *probability density function* (pdf) $\Pr(g|f)$, which is the likelihood of the recorded image $g$, is a function of the true specimen image $f$. Then the problem of image restoration is to estimate the unknown parameters $f(X)$, $\forall X \in S_f$, where $S_f$ is the support of $f$. Using the log-likelihood function, the ML solution for the image estimate $\hat{f}$, which is most likely to give rise to the observed image $g$, is found by solving [46]

$$\hat{f} = \arg\ \min_{f}\ -\log \Pr(g|f, h) \tag{14.24}$$

In the case of Gaussian noise, the probability density function is given by [46]

$$\Pr(g|f) = \frac{1}{(2\pi)^{N/2\sigma N}} \exp\left(\frac{-\|g - Hf\|^2}{2\sigma^2}\right) \tag{14.25}$$

where $N$ is the number of voxels in the image and $\sigma^2$ is the noise variance. Equation 14.24 can now be written as

$$\hat{f} = \arg\min_{f} \frac{\|g - Hf\|^2}{2\sigma^2}$$

which is similar to the least-squares solution. Iterative techniques, such as the steepest-descent method, may then be used for minimization [46]

$$\hat{f}_{k+1} = \hat{f}_k + \eta \mathbf{H}^T(g - Hf) \tag{14.26}$$

where $T$ denotes matrix transpose, subscript $k$ denotes the $k$th iteration, and $\eta$ is a predetermined parameter such that $0 < \eta < 2/\sigma_1^2$, where $\sigma_1$ is the largest singular value of the matrix $\mathbf{H}$. This method is usually referred to as the *Landweber method* [47]. For large values for $\eta$, convergence to the optimal image is rapid, but may be unstable, whereas smaller values for $\eta$, although slower, afford more stability. It is important to have a criterion for stopping the iterations. For example, the discrepancy error, $e^k = \|Hf^k - g\|_2^2$, is widely used for stopping the iterations when it is less than a predetermined threshold [47]. The number of iterations also allows regularization, and the process can be stopped to avoid overfitting the noise. Other constraints, such as nonnegativity and band-limitedness, can also be applied after each iteration step.

**The EM-ML Algorithm**    In the case of Poisson noise, if $A$ represents the mean of the number of photons counted at all the image voxels, then the probability of counting exactly $n$ photons during the exposure time of one voxel is Poisson distributed, with density [46]

$$\Pr(n) = \frac{A^n}{n!} \exp(-A) \tag{14.27}$$

This uncertainty in the number of photons appears as Poisson noise in the observed image, and it is correlated with intensity. The pdf can be written as [46]

$$\Pr(g|f, h) - \frac{(\mathbf{H}f)^g}{g!} \exp(-\mathbf{II}f) \tag{14.28}$$

The maximum-likelihood solution is then found by setting $\partial \log(\Pr(g|f))/\partial f$ to zero, which is the *expectation maximization–maximum likelihood* (EM-ML) algorithm [44, 48, 49].

The expectation-maximization (EM) algorithm is an iterative procedure to compute the maximum-likelihood (ML) estimate in the presence of missing or hidden data. The aim is to estimate the model parameters (specimen function, $\hat{f}$) for which the observed data are the most likely. In microscopy, the recorded (diffraction-limited) image $g(x, y, z)$ represents an incomplete data set, whereas the specimen image $f(x, y, z)$ is the image to be estimated. Details of the implementation are given in the references [44, 45, 48, 49]. The EM algorithm has a slow convergence rate and is quite computationally intensive.

**The Richardson–Lucy Algorithm**  The Richardson–Lucy (RL) algorithm is similar to the maximum-likelihood algorithm for Poisson noise [50, 51]. The maximization of $\Pr(g|f, h)$ with respect to $f$ leads to the iterative form [46]

$$\hat{f}_{k+1} = \left( \mathbf{H}^T \frac{g}{\mathbf{H}f} \right) \hat{f}_k \tag{14.29}$$

where $k$ is the iteration number and $\mathbf{H}^T$ denotes the transpose of the convolution matrix corresponding to the psf. As long as the initial guess for the estimated image $\hat{f}_0$ is nonnegative, the estimate at the $k$th iteration will remain nonnegative. This makes the algorithm sensitive to the initial guess and influences its performance. Typically, a smooth initial solution is used to avoid the amplification of high-frequency noise. The Richardson–Lucy algorithm is constrained but not regularized. The number of iterations is used to stop the computations. The MSE (between the estimated image and the true solution) decreases with the number iterations until it reaches a minimum, it increases again when noise overfitting begins. At this point, the algorithm is usually stopped to avoid noise amplification.

**Maximum-Penalized-Likelihood (MPL) Method**  Typically in ML restoration, it is difficult to determine the optimal number of iterations.

Regularization can be applied as a penalty function added to the likelihood function. This is known as the *maximum-penalized-likelihood (MPL) method* [44, 48]. In MPL, the likelihood function is modified such that it decreases when the noise increases. That is, the log-likelihood function can be modified by subtracting a penalty term that increases with unwanted characteristics, such as high-frequency content and intensity saturation. For example, an "intensity penalty" is applied to address problems associated with very bright spots in the images, and a "roughness penalty" is applied to prevent high-frequency noise, in which large changes between neighboring voxels are encountered [44, 48].

***Maximum a Posteriori (MAP) Method*** Alternatively, Bayesian statistics can be used for regularization in the form of a prior probability distribution, known as the *maximum a posteriori (MAP)* methods. In this approach, prior knowledge about the true image, i.e., the image to be estimated, is taken in the form of a prior pdf. For example, if the pdf $\Pr(f)$ represents prior knowledge about the true image, then using Bayes' theorem, this prior distribution can be modified, based on the recorded image, into the a posteriori distribution [28]. According to Bayes' theorem, the posterior probability can be calculated as (see Chapter 11)

$$\Pr(f|g) = \frac{\Pr(g|f)\,\Pr(f)}{\Pr(g)} \tag{14.30}$$

where $\Pr(g)$ depends on the observed image only and can be regarded as a normalizing constant and the likelihood $\Pr(g|f)$ denotes the conditional pdf of $g$ given $f$. The mode of the posterior distribution is often selected to be the estimated true image. In this case, it is known as the MAP solution and is obtained by maximizing $\Pr(g|f)\,\Pr(f)$. The $\Pr(f)$ can be regarded as a penalty function that penalizes undesired features of the solution. The maximization of the penalized likelihood can be interpreted as the maximization of the posterior probability [46]

$$\hat{f} = \arg\,\max_{f}\,\Pr(g|f)\,\Pr(f) \tag{14.31}$$

The selection of the prior probability distribution is difficult. A prior distribution that performs well for one class of images might not be suitable for another. Several forms of the prior distribution have been published, including the Gibbs distribution [46], the Good's roughness penalty [52], and the total variations penalty function [53]. Alternatively, when information about the true image (other than nonnegativity) is not available, the probability $\Pr(f)$ can be based on the entropy of $f$ [54].

The difference between MAP and MPL is that in MPL methods only the undesired characteristics of the true image need to be known, whereas in MAP the probability distribution of the specimen must be known a priori [44]. MPL reduces to MAP if the penalty function is taken to be the prior pdf.

### 14.4.3.6 Blind Deconvolution

Given an inaccurate psf, all of the image restoration methods described earlier are ineffective in estimating the true specimen image. In practice, a truly accurate determination of the psf is difficult to obtain. Noise is always present in an experimentally measured psf, and a theoretical psf cannot completely account for the aberrations present in the microscope optics. Blind deconvolution algorithms do not require knowledge of the psf. Instead, they estimate the microscope psf and the original 3-D specimen image simultaneously from the acquired image.

Several authors have described blind deconvolution algorithms [21, 55, 56]. One approach is to constrain the psf to be circularly symmetric and band-limited [55]. Another approach is to apply a quadratic parameterization to enforce nonnegativity on $f$ and use a psf parameterization based on phase aberrations in the pupil plane for $h$ [56].

A parametric blind deconvolution algorithm based on a mathematical model of the psf is described as follows. In general, an iterative estimate of the object is computed as [20, 21]

$$\hat{f}_{i+1}^k(x, y, z) = \left\{ \left[ \frac{g(x, y, z)}{\hat{f}_i^k(x, y, z) * \hat{h}^{k-1}(x, y, z)} \right] * \hat{h}^{k-1}(-x, -y, -z) \right\} \hat{f}_i^k(x, y, z) \quad (14.32)$$

and the psf is estimated as

$$\hat{h}_{i+1}^k(x, y, z) = \left\{ \left[ \frac{g(x, y, z)}{\hat{h}_i^k(x, y, z) * \hat{f}^{k-1}(x, y, z)} \right] * \hat{f}^{k-1}(-x, -y, -z) \right\} \hat{h}_i^k(x, y, z) \quad (14.33)$$

In the first iteration step, the object estimate is simply the recorded image, which is convolved with a theoretical psf calculated from the optical parameters of the imaging system. The resulting blurred specimen estimate is compared with the raw image, and a correction is computed. This correction is used to generate the next estimate. The same correction is also applied to the psf, generating a new psf estimate. In further iterations, the psf estimate and the object estimate are updated together using Eqs. 14.32 and 14.33. Constraints, such as axial circular symmetry and band-limitedness, can be imposed on the psf. These constraints are imposed at each iteration step, after the computation of each

new estimate. Circular symmetry can be enforced on the psf by averaging the values equidistant from the optical axis. The frequency band-limit constraint is imposed by setting to zero all values of the Fourier transform of $\hat{h}_{k+1}(x, y, z)$ that lie above the cutoff frequency.

In 3-D microscopy, lateral and axial resolutions are usually different, and the psf can be adjusted accordingly. Blind deconvolution methods take twice as long per iteration as the ML technique because two functions (i.e., object and psf) are being estimated. They can produce better results than using a theoretical psf, especially if unpredicted aberrations are present. The algorithm adjusts the psf to fit the data and can thus partially correct for spherical aberration. Blind deconvolution is used when the psf is unknown.

### 14.4.3.7 Interpretation of Deconvolved Images

Deconvolution techniques can be applied to wide-field and even confocal and two-photon microscope images. Generally, of all the deconvolution algorithms described here, the methods that model the image formation characteristics most precisely lead to the best results. Depending on the imaging modality being used (wide-field, confocal, two-photon, etc.) and the system optics, the psf can have a different shape. The results obtained from deconvolution procedures also depend heavily on image quality, specifically signal-to-noise ratio and sampling density. Finely sampled, low-noise images yield the best results. Artifacts often arise due to the noise sensitivity of the algorithm, a poor choice of algorithm regularization parameters, inaccurate psf estimation, and coarse data sampling. Interpretation of deconvolved images typically requires some knowledge of the processing methods so that the user can recognize artifacts and identify real features. For a discussion of interpreting deconvolved images, refer to [17, 24]. Figure 14.4 presents deconvolution results using linear and nonlinear methods. Deconvolution using a Wiener filter (linear, noniterative method) is compared with a constrained maximum-likelihood iterative (nonlinear) method.

### 14.4.3.8 Commercial Deconvolution Packages

Commercial deconvolution software packages are available from Media Cybernetics, VayTek, Scanalytics, Intelligent Imaging Innovations, and Applied Precision and from most major microscope manufacturers, such as Zeiss, Olympus, Leica, and Nikon. Most of these packages include features for 3-D psf generation in addition to image deblurring algorithms. The linear methods of inverse filtering and Weiner deconvolution are available in most commercial

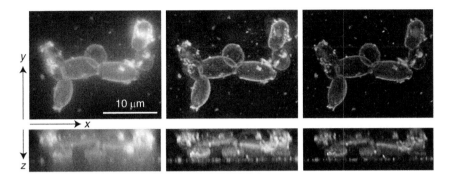

**FIGURE 14.4** Linear versus nonlinear deconvolution. Deconvolution using a Wiener filter is compared with a constrained maximum-likelihood iterative method. The results are presented using maximum intensity projection. The top row presents the *xy* projection (horizontal), and the bottom row presents the *xz* projection (vertical). The leftmost column shows an image of hystoplasma capsulatum collected with a 100×/1.3 NA oil-immersion objective at a fluorescent wavelength of 570 nm. The center column presents deconvolution results obtained with a Wiener filter (linear noniterative method), and the right column shows results obtained with a constrained maximum-likelihood iterative (nonlinear) method. Scale bar = 10 μm, with a 0.1-μm pixel size along all axes. (Image courtesy of José-Angel Conchello. Original image contributed by W. Goldman.)

software packages. The key commercial vendors in this field market different implementations of the nonlinear algorithms. For example, Vaytek, Intelligent Imaging Innovations, Applied Precision, Carl Zeiss, and Bitplane market an implementation of the modified JVC algorithm [36, 37]. Scanalytics and Vaytek also market a reconstruction algorithm based on Carrington's regularized least-squares minimization method [38, 39]. Various implementations of the maximum-likelihood estimation (MLE) and expectation maximization (EM) algorithms have been commercialized by SVI, Bitplane, ImproVision, Carl Zeiss, and Media Cybernetics. Freely available deconvolution packages include XCOSM [17] and plugins for ImageJ [57].

## 14.5 Image Fusion

Image fusion is an approach frequently used in 3-D microscopy to combine a set of optical section images into a single 2-D image containing the detail from each optical section in the stack. This simulates a microscope with much larger depth of field. One effective method uses the wavelet transform (see Chapter 7) for image fusion. See Chapter 16 for a thorough description of this technique. Image fusion involves combining multiple images into one image such that the fused image contains the interesting components collected from all of the input images.

## 14.6  Three-Dimensional Image Processing

Three-dimensional image processing can be performed using three different approaches. The first approach involves performing 2-D image processing operations on the individual optical sections of the image stack. This approach does not take into account the 3-D nature of the data set and may be suboptimal in certain situations. The second approach is to perform image processing using the entire 3-D data set, treating the voxel (volume element) as the basic unit of brightness in three dimensions. In this approach, all operations are performed on cubic voxel arrays. Finally, the fused image of a stack can be processed by 2-D techniques. For most image processing techniques, the 2-D counterpart can easily be extended to 3-D. The following sections discuss several image processing algorithms useful in 3-D microscopy.

## 14.7  Geometric Transformations

Transformations for 3-D images, such as translation and reflection, are direct extensions of the corresponding 2-D image transforms (Chapter 5). Image translation by a vector $(dx, dy, dz)$ is given by [58]

$$
\begin{bmatrix} x' \\ y' \\ z' \end{bmatrix} = \begin{bmatrix} x \\ y \\ z \end{bmatrix} + \begin{bmatrix} dx \\ dy \\ dz \end{bmatrix}
\tag{14.34}
$$

where $x$, $y$, and $z$ are the original coordinates and $x'$, $y'$, and $z'$ are the corresponding translated voxel elements. The translation operation can be formulated as [58]

$$
a(x, y, z) = b(x + dx, y + dy, z + dz)
\tag{14.35}
$$

Similarly, reflection about the $z$-axis can be formulated as

$$
a(x, y, z) = b(x, y, D_z - z)
\tag{14.36}
$$

where $D_z$ is the image dimension in the $z$ direction, that is, the total number of optical slices. Reflection along the $x$ and $y$ directions can be computed in a similar fashion. Rotation is another operation that is often applied to 3-D images to enable visualization of the data set from different viewpoints. This operation requires each voxel, $(x, y, z)$, in the original volume to be mapped into a new position, $(xx, yy, zz)$. The computation can be performed as [58]

$$\begin{bmatrix} x - x_c \\ y - y_c \\ z - z_c \end{bmatrix} = \begin{bmatrix} \cos\theta & -\sin\theta\cos\phi & \sin\theta\sin\phi \\ \sin\theta & \cos\theta\cos\phi & -\cos\theta\sin\phi \\ 0 & \sin\phi & \cos\phi \end{bmatrix} \begin{bmatrix} xx - xx_c \\ yy - yy_c \\ zz - zz_c \end{bmatrix} \quad (14.37)$$

where $(x_c, y_c, z_c)$, $(xx_c, yy_c, zz_c)$ are the rotation centers in the input and output images, and $\theta$ and $\phi$ are the rotation angles about the $z$- and $x$- axis, respectively. Typically, such computations result in noninteger values for the coordinates that need to be truncated or rounded. This may result in more than one voxel's being mapped to the same position, which leaves holes in the rotated image (see Chapter 5). This can be avoided by using an inverse implementation, where, for each voxel $(xx, yy, zz)$ of the output image, the corresponding input voxel $(x, y, z)$ value is evaluated [58]. Both translation and rotation are rigid-body transforms, in which lengths and angles are preserved. Scaling is an affine transformation, where lengths are changed. It can be computed as [58]

$$\begin{bmatrix} x' \\ y' \\ z' \end{bmatrix} = \begin{bmatrix} s_x & 0 & 0 \\ 0 & s_y & 0 \\ 0 & 0 & s_z \end{bmatrix} \begin{bmatrix} x \\ y \\ z \end{bmatrix} \quad (14.38)$$

where $s_x$, $s_y$, $s_z$ are the scaling factors in the $x$, $y$, and $z$ directions, respectively.

## 14.8  Pointwise Operations

Pointwise operations that are performed in 2-D can also be applied in 3-D on a voxel-by-voxel basis. For example, gray-level mathematical operations such as subtraction and addition and binary operations such as OR, XOR, and AND can be expressed for 3-D images as follows [58]

$$\begin{aligned} addition&: c(x, y, z) = a(x, y, z) + b(x, y, z) \\ subtraction&: c(x, y, z) = a(x, y, z) - b(x, y, z) \qquad (14.39) \\ binary\ OR&: c(x, y, z) = a(x, y, z) \parallel b(x, y, z) \end{aligned}$$

## 14.9  Histogram Operations

The gray-level histogram is a function showing, for each gray level, the number of voxels in the image that have the same gray level. In other words, the pdf of the voxel intensities is called the *histogram*. For a 3-D image of dimensions $D_x \times D_y \times D_z$ having $K$ discrete intensity levels $i_1, \ldots, i_K$, the histogram value at a certain intensity is given by the frequency of occurrence of that intensity [58]

$$p(i_k) = \frac{n_k}{D_x D_y D_z} \tag{14.40}$$

where $n_k$ is the number of voxels having intensity $i_k$. A histogram is plotted as a display of the frequencies at each intensity value, where the gray-level intensity is the abscissa and the ordinate is the frequency of occurrence. The cumulative histogram is a variation of the histogram in which the vertical axis represents not just the counts for a single gray level, but, rather, denotes the counts for the intensity in consideration plus all values less than that intensity. The cumulative density function (cdf) is given by [58]

$$P(i_k) = \frac{1}{D_x D_y D_z} \sum_{l=1}^{K} n_l \tag{14.41}$$

The histogram contains important information about image quality and can be used for image enhancement (Chapter 6). A popular histogram-based enhancement operation is *histogram equalization*, in which the histogram of the output image is made to be uniform (flat) such that it has an equal number of voxels at every gray level. Histogram equalization for an input image $f(x, y, z)$ to generate the output $g(x, y, z)$ can be achieved using a pointwise intensity transformation function as follows [58]

$$g(x, y, z) = T(f(x, y, z)) \qquad \text{such that} \qquad g = T(f) = \int_0^f p_f(w)\, dw \tag{14.42}$$

where $p_f$ is the histogram of the input image and image intensities are normalized to the [0, 1] range. Although image contrast is improved, histogram equalization tends to enhance noise, and image smoothing is often applied prior to histogram equalization for improved performance.

Histogram equalization is not appropriate for interactive image enhancement applications because it generates only one result, an approximation to a uniform histogram. In situations where a particular histogram shape, capable of highlighting certain gray-level ranges, is desired, another method, known as *histogram specification*, can be used. This transforms an image so that its histogram more closely resembles a given histogram. An image $f(x, y, z)$ with a histogram function $p_f$ can be transformed into a new image $g(x, y, z)$, having a given histogram, $p_g$, by [58]

$$g(x, y, z) = P_g^{-1}\left[P_f(f(x, y, z))\right] \tag{14.43}$$

where $P_f$ and $P_g$ are the cumulative histograms for the 3-D images $f(x, y, z)$ and $g(x, y, z)$, respectively, and $P_g^{-1}$ is the inverse function of $P_g$.

# 14.10 Filtering

Image filtering operations are typically used either to reduce noise by smoothing or to emphasize edges. Analogous to their 2-D counterparts (Chapter 6), 3-D filters can be defined as operators that map one 3-D image into another 3-D image as $b(x, y, z) = f(a(x, y, z))$, where $b(x, y, z)$ is the output (filtered) image that results from processing the input image $a(x, y, z)$. Each voxel in the output image is computed as a function of one or several voxels located in its neighborhood in the input image. Depending on the nature of the filter function $f$, the operation can be classified as linear or nonlinear. Digital convolution filters are linear, since the output voxel values are linear combinations of the input image voxels, but other types of filters are nonlinear.

## 14.10.1 Linear Filters

Linear filters can be implemented either as convolution operations in real space or as multiplication operations in Fourier space. A linear filter can be specified either by its convolution kernel, or by its transfer function. The kernel and the transfer function form a Fourier transform pair.

### 14.10.1.1 Finite Impulse Response (FIR) Filter

A finite impulse response (FIR) filter has a kernel (matrix of filter coefficients) that is zero outside a relatively small region near the origin. It is implemented as a convolution of the kernel with the input image $a(x, y, z)$ as [58]

$$b(x, y, z) = h(x, y, z) * a(x, y, z)$$

$$= \sum_{i=0}^{L-1} \sum_{j=0}^{M-1} \sum_{k=0}^{N-1} h(i, j, k) a(x - i, y - j, z - k) \qquad (14.44)$$

where $h(x, y, z)$ is the filter kernel, defined over $0 \leq x < L$, $0 \leq y < M$, and $0 \leq z < N$.

This moving-average filter is also known as the arithmetic-mean filter, where the values of all the filter coefficients in the kernel are equal to $1/LMN$ for a kernel of dimensions $L \times M \times N$. From this definition, one can see that if a voxel value is noise, taking the average gray level of the voxels surrounding it tends to normalize its gray level. Thus an averaging filter smooths areas of high frequency and only subtly changes constant areas. While it is useful for reducing random noise, it is not as effective against impulse noise like the nonlinear filters described next. With a less restricted kernel, Eq. 14.44 can be used to implement a variety of linear filters for low-pass, or high-pass filtering simply by selecting an appropriate kernel or transfer function (see Chapter 6).

## 14.10.2 Nonlinear Filters

Nonlinear filters can also be implemented by $b(x, y, z) = f(a(x, y, z))$, as earlier, except that $f$ is no longer a linear function. They are more general and can be designed to preserve edge information and remove impulse noise. Some representative nonlinear 3-D filters are discussed next.

### 14.10.2.1 Median Filter

A median filter belongs to the class of order-statistic filters, i.e., filters based on a rank ordering of the input voxel values. Most implementations use a square kernel of neighborhood pixels (e.g., $3 \times 3$, $5 \times 5$) as the filter window. Consider the voxels $X_1, X_2, \ldots, X_W$, where $W$ is an odd number, within a filter window of size $W = L \times M \times N$. Then the rank-ordered voxel values can be expressed as $X_1 < X_2 < \cdots < X_i \cdots < X_W$, and the median is defined as the middle voxel value, given by $X_{med} = X_{((W+1)/2)}$, and the median filter is defined as the value that minimizes [58]

$$\sum_{i=1}^{W} |X_i - X_{med}| \tag{14.45}$$

The median filter is implemented by moving the filter window over the 3-D data set. At each window position, the central voxel is replaced by the value of $X_{med}$ inside the window neighborhood. This process is slow, especially in 3-D, due to the requirement of sorting all the voxels in each neighborhood based on their gray level. One approach for reducing the computational complexity is to apply successive 1-D median filtering along the rows, columns, and sections (image planes). This process is called a *separable median filter*, and the resulting output image differs from that of the 3-D median filter.

### 14.10.2.2 Weighted Median Filter

The weighted median filter is a variation of the median filter that incorporates spatial information of the voxels when computing the median value. A weighted 3-D median filter is implemented as follows [58]

$$b(x, y, z) = \text{median}\{w_1 \square X_1, \ldots, w_N \square X_N\} \tag{14.46}$$

where $X_1, \ldots, X_N$ are the voxel values inside a window centered at $(x, y, z)$ and $w \square X$ denotes replication of $X$, $w$ times. The advantage of this approach is that, by applying larger weight values on certain voxels, spatial or structural information can be incorporated into the filtering process.

### 14.10.2.3 Minimum and Maximum Filters

Another set of widely used nonlinear filters are the minimum and maximum filters. Like the median filter, these two are also order-statistic filters. The maximum filter fills the central voxel of the 3-D window with the maximum $X_N$ among the ordered set of voxel intensities, whereas the minimum filter replaces it with the minimum value, $X_1$. Unlike the median filter, these filters have much reduced computational complexity. The implementation of these filters is also speeded up by performing three successive 1-D filtering operations along the three axis directions. Maximum filters are used to suppress negative impulses and to brighten up the image, whereas minimum filters reduce positive impulses and tend to darken the image.

### 14.10.2.4 α-Trimmed Mean Filters

α-trimmed mean filters are widely used for the restoration of signals and images corrupted by additive symmetric noise. The filter rejects a certain percentage of outlying voxels (extremely high and low values) and then averages the remaining voxels within the filter window. The filter is implemented as follows [58]

$$b(x, y, z) = \frac{1}{(1 - 2\alpha)N} \sum_{i=\alpha N+1}^{(1-\alpha)N} X_i \qquad 0 \leq \alpha \leq 0.5 \qquad (14.47)$$

where $N$ is the number of voxels within a filter window centered at $(x, y, z)$. The approach involves ordering the voxels within the filter window and then rejecting a percentage (specified by $\alpha$) of the lower- and upper-rank voxels. The filter output is the average of the remaining voxels. The rejection parameter, $\alpha$, is selected in relation to the noise statistics. The filters are simple to implement and can be applied iteratively for optimizing $\alpha$ and thereby controlling the filtering effects. These filters are generally used to eliminate spike noise without smearing the image.

An extension of the trimmed filter is the modified trimmed mean filter. This filter sets a threshold $T$ and averages only those voxels' values where the difference from the mean or median value is less than the threshold. This process is written as [58]

$$b(x, y, z) = \frac{\sum_i a_i X_i}{\sum_i a_i} \qquad \text{where} \quad a_i = \begin{cases} 1 & \text{if } |X_i - \bar{X}| \leq T \\ 0 & \text{otherwise} \end{cases} \qquad (14.48)$$

where $\bar{X}$ is either the mean or the median value within the filter window. The threshold is determined based on the noise statistics.

### 14.10.3 Edge-Detection Filters

Similar to boundaries in 2-D images, the surfaces of the different 3-D regions are represented by intensity changes in the data volume and can be detected using

specialized linear filters that highlight edges. Three-dimensional edge operators are direct extensions of the 2-D edge-based operators (Chapter 9), and 3-D edges (or, more appropriately, surfaces) represent discontinuities in image intensity. The intensity gradient can be expressed in 3-D as [58]

$$\nabla f(x,\, y,\, z) = \left( \frac{\partial f}{\partial x},\, \frac{\partial f}{\partial y},\, \frac{\partial f}{\partial z} \right) \tag{14.49}$$

Edge activity can then be detected by computing the gradient magnitude or the $L_1$ norm as follows [58]

$$\text{edge}(x,\, y,\, z) = \sqrt{ \left( \frac{\partial f}{\partial x} \right)^2 + \left( \frac{\partial f}{\partial y} \right)^2 + \left( \frac{\partial f}{\partial z} \right)^2 }$$

$$\text{or} \quad \text{edge}(x,\, y,\, z) = \left| \frac{\partial f}{\partial x} \right| + \left| \frac{\partial f}{\partial y} \right| + \left| \frac{\partial f}{\partial z} \right| \tag{14.50}$$

The algorithm for edge detection involves convolution with a kernel that creates an approximation of the partial derivative in a given direction. Thus, for 3-D edge detection, three masks are used, one for each direction. For example, the Sobel edge detector (Chapter 9) can be generalized for 3-D processing as a set of three 3-D masks, one for each of three directions [58]. For the $y$ direction (vertical edges), this $3 \times 3 \times 3$ matrix is

$$\begin{bmatrix} -1 & 0 & 1 \\ -2 & 0 & 2 \\ -1 & 0 & 1 \end{bmatrix} \quad \begin{bmatrix} -2 & 0 & 2 \\ -3 & 0 & 3 \\ -2 & 0 & 2 \end{bmatrix} \quad \begin{bmatrix} -1 & 0 & 1 \\ -2 & 0 & 2 \\ -1 & 0 & 1 \end{bmatrix} \tag{14.51}$$

The other two operators are obtained via $90°$ rotations of the one shown in Eq. 14.51. Edge-detection filters are commonly used for image segmentation. For the most part, 3-D filtering is an extension of the 2-D filtering process described in Chapter 6, but with somewhat increased computational complexity due to the added third dimension. For a more complete description of filters, the reader should consult a textbook on image processing [28, 58].

## 14.11   Morphological Operators

Mathematical morphological operators are a subclass of nonlinear filters that are used for shape and structure analysis and for filtering in binary and grayscale images. Three-dimensional morphological operators are straightforward extensions of their 2-D counterparts (as described in Chapter 8), with sets and functions defined in the 3-D Euclidean grid $Z^3$. In this section we extend the

concepts introduced in Chapter 8 to three dimensions. An in-depth description of the mathematical basis of morphological operators is presented in [58–60].

## 14.11.1 Binary Morphology

Mathematical morphological operators are based on set theory. An object $O$ in a binary 3-D image can be denoted as

$$O = \{\mathbf{v}: f(\mathbf{v}) = 1, \mathbf{v} = (x, y, z) \in \mathbf{Z}^3\} \tag{14.52}$$

where $f$ is called the characteristic function of $O$. Similarly, the object background, $O^c$, can be defined as follows [58]

$$O^c = \{\mathbf{v}: f(\mathbf{v}) = 0, \mathbf{v} = (x, y, z) \in \mathbf{Z}^3\} \tag{14.53}$$

All morphological operations utilize a structuring element (also known as the *kernel*), which determines the precise details of the effect that the operator has on the input image. In 3-D morphology, the structuring element is a small cluster of voxels, arranged in a geometric pattern (sphere, cube, octahedron, etc.) relative to some origin. Normally, Cartesian coordinates are used to represent each voxel, and the origin is typically at the center of the cluster. The origin of the structuring element is typically translated to each voxel position in the input image in turn, and the points within the translated structuring element are compared with the underlying image voxel values. The details of the operation and the effect of the outcome depend on which morphological operator is being used. The two basic mathematical operations of dilation and erosion are denoted as [58]

$$
\begin{aligned}
\textit{dilation:} \quad & O \oplus B^S = \{\mathbf{v} \in \mathbf{Z}^3 : B_\mathbf{v} \cap O \neq 0\} \\
\textit{erosion:} \quad & O \ominus B^S = \{\mathbf{v} \in \mathbf{Z}^3 : B_\mathbf{v} \subset O\}
\end{aligned}
\tag{14.54}
$$

where $B^S$ is the symmetric of $B$ with respect to the origin $(0, 0, 0)$. Dilation is an expanding operation, whereas erosion has a shrinking effect. The successive application of erosion and dilation is opening; dilation followed by erosion is closing [58]

$$
\begin{aligned}
\textit{opening:} \quad & \left(X \ominus B^S\right) \oplus B \\
\textit{closing:} \quad & \left(X \oplus B^S\right) \ominus B
\end{aligned}
\tag{14.55}
$$

Opening smooths the surface and typically smears sharp spurs on the object boundary, whereas closing fills small holes and typically unites objects that are close to each other. Note that applying either opening or closing more then once produces no further effect.

## 14.11.2 Grayscale Morphology

Grayscale images can be denoted as functions, $f$, whose domain $D$ is a subset of the Euclidean grid $\mathbf{Z}^3$ [58]

$$f(\mathbf{v}), \mathbf{v} = (x, y, z) \in D \subset \mathbf{Z}^3 \qquad (14.56)$$

The structuring element can also be denoted as a function $g$ within domain $G$ [58]

$$g(\mathbf{v}), \mathbf{v} = (x, y, z) \in G \subset \mathbf{Z}^3 \qquad \text{and the symmetric of } g \text{ is}$$
$$g^s(\mathbf{v}) = g(-\mathbf{v}) \qquad (14.57)$$

The operations of dilation, erosion, opening, and closing are then defined as follows [58]

$$
\begin{aligned}
\textit{dilation:} \quad & [f \oplus g^s](\mathbf{v}) = \max_{\mathbf{v} \in D, \mathbf{v} - \mathbf{d} \in G} \{f(\mathbf{v}) + g(\mathbf{v} - \mathbf{d})\} \\
\textit{erosion:} \quad & [f \ominus g^s](\mathbf{v}) = \min_{\mathbf{v} \in D, \mathbf{v} - \mathbf{d} \in G} \{f(\mathbf{v}) - g(\mathbf{v} - \mathbf{d})\} \\
\textit{opening:} \quad & [(f \ominus g^s) \oplus g](\mathbf{v}) \\
\textit{closing:} \quad & [(f \oplus g^s) \ominus g](\mathbf{v})
\end{aligned}
\qquad (14.58)
$$

where $\mathbf{d}$ is a vector that defines the translation. Grayscale opening suppresses positive impulses but enhances negative ones, whereas closing does the converse. Additionally, opening and closing can be combined to create filters such as the close–open and open–close filters, which suppress both negative and positive impulses. Another morphological operator of interest is the top-hat transform, which is very similar to a high-pass filter. It can be applied to 3-D images to produce peaks of the object features. The top-hat transform is denoted as [58]

$$g(\mathbf{v}) = f(\mathbf{v}) - f_{kB}(\mathbf{v}) \qquad (14.59)$$

where $kB = B \oplus B \oplus B \oplus \cdots \oplus B$, $k$ times.

Finally, mathematical operators can also be used as edge detector as follows [58]

$$e(\mathbf{v}) = f(\mathbf{v}) - [f \ominus kB](\mathbf{v}) \qquad (14.60)$$

where $e$ is the output edge image.

Three-D image stacks are usually anisotropic; that is, the sampling interval along the axial dimension is larger than in the radial dimension. For this reason the structuring element should be chosen as an anisotropic 3-D kernel.

For example, the quasi-spherical structuring element of size $3 \times 7 \times 7$ shown in Eq. 14.61 has been used for a 3-D morphological opening operation [61]

$$
\begin{array}{ccc}
\begin{bmatrix}
0 & 0 & 0 & 0 & 0 & 0 & 0 \\
0 & 0 & 1 & 1 & 1 & 0 & 0 \\
0 & 1 & 1 & 1 & 1 & 1 & 0 \\
0 & 1 & 1 & 1 & 1 & 1 & 0 \\
0 & 1 & 1 & 1 & 1 & 1 & 0 \\
0 & 0 & 1 & 1 & 1 & 0 & 0 \\
0 & 0 & 0 & 0 & 0 & 0 & 0
\end{bmatrix}
&
\begin{bmatrix}
0 & 0 & 1 & 1 & 1 & 0 & 0 \\
0 & 1 & 1 & 1 & 1 & 1 & 0 \\
1 & 1 & 1 & 1 & 1 & 1 & 1 \\
1 & 1 & 1 & 1 & 1 & 1 & 1 \\
1 & 1 & 1 & 1 & 1 & 1 & 1 \\
0 & 1 & 1 & 1 & 1 & 1 & 0 \\
0 & 0 & 1 & 1 & 1 & 0 & 0
\end{bmatrix}
&
\begin{bmatrix}
0 & 0 & 0 & 0 & 0 & 0 & 0 \\
0 & 0 & 1 & 1 & 1 & 0 & 0 \\
0 & 1 & 1 & 1 & 1 & 1 & 0 \\
0 & 1 & 1 & 1 & 1 & 1 & 0 \\
0 & 1 & 1 & 1 & 1 & 1 & 0 \\
0 & 0 & 1 & 1 & 1 & 0 & 0 \\
0 & 0 & 0 & 0 & 0 & 0 & 0
\end{bmatrix}
\\
\text{(a)} & \text{(b)} & \text{(c)}
\end{array}
\tag{14.61}
$$

From Eq. 14.61, the kernel (b) is applied to the optical slice in the middle, whereas (a) and (c) are applied to slices above and below [61].

Other widely used 3-D morphological techniques include the watershed algorithm and skeletonization (see Chapter 8). The interested reader is directed to other publications for information on these techniques [58–61].

# 14.12 Segmentation

Segmentation is a procedure that classifies all the voxels in an image to divide the image up into regions ultimately, each of which corresponds to a different object. Two-dimensional segmentation is discussed in Chapter 9. Here we generalize those concepts to 3-D. The segmentation process is based on the notion that voxels belonging to a certain region share some similar characteristics, such as intensity, texture, and spatial position. Segmentation algorithms may be applied either to unprocessed images or after the application of certain transformations or filters, and they may be automated, or interactive, that is, requiring human input.

Segmentation is often the most challenging step in image analysis. If segmentation is done improperly, then all subsequent stages of image analysis are incorrect. The challenges of segmentation are further confounded when processing 3-D microscopy images. The difficulty in segmenting regions of volumetric images arises from several factors. Regions are often touching each other or overlapping and irregularly arranged, with no definite shape. Illumination variations are also common in thick specimens, with intensity falling off with increasing depth due to factors such as absorption, scattering, and diffraction of the light by structures located above and below the focal plane (Chapter 12).

There are two methods to implement segmentation of 3-D images. The first approach is slice by slice, in which the 2-D images in the 3-D stack are individually processed, and the 3-D regions are extracted when the processed 2-D slices are stacked. The disadvantage of this implementation is that discontinuities of volume between the slices may occur, and thus it is not possible to derive accurate 3D-volumetric morphology. Object boundaries that lie parallel to the focal plane cannot be extracted accurately.

The second approach is the volume-oriented approach, which is based on processing the complete set of consecutive slices, in its entirety, as a single 3-D image. The trade-off here is that volumetric information is retained but computational complexity is increased. Regardless of the implementation chosen, there are three general approaches to segmentation: point-based, edge-based, and region-based methods.

## 14.12.1   Point-Based Segmentation

In thresholding, which is also known as *point-based segmentation*, voxels are allocated to categories according to the range of intensity in which a voxel value lies. For example, if voxels that form a certain object fall within a specific intensity range that is different from the intensity of the background voxels and from the intensity range of other objects in the image, then the object can be segmented using a pair of intensity thresholds. Given a pair of thresholds $t_1$ and $t_2$, the voxel located at position $(x, y, z)$ with grayscale value $f(x, y, z)$ is allocated to a category $C_1$ if $t_1 < f(x, y, z) \leq t_2$. Otherwise, the voxel is allocated to a different category.

The success of thresholding algorithms depends heavily on the selected threshold, for which selection is challenging and often subjective. Several automatic threshold selection methods have been developed, but very often the procedure requires some user interaction. Reviews of automated threshold selection methods for 2-D images are available [62, 63]. While most algorithms simply use the histogram, others make use of contextual information, such as gray-level occurrences in adjacent pixels. Most of these methods are applicable to 3-D images and require use of the image's 3-D gray-level histogram. A representative iterative algorithm for automated threshold selection for 3-D images, often referred to as the *intermeans algorithm*, is presented here [64]. An initial guess, typically the median intensity value, is used for the threshold at the start. This threshold is used to generate two categories, and the mean values of voxels in the two categories are calculated as [65]

$$\mu_1 = \frac{\sum_{k=0}^{T} kh_k}{\sum_{k=0}^{T} h_k} \quad \text{and} \quad \mu_2 = \frac{\sum_{k=T+1}^{N} kh_k}{\sum_{k=T+1}^{N} h_k} \tag{14.62}$$

where $T$ is the median voxel value chosen such that $\sum_{k=0}^{T} h_k \geq n^2/2 > \sum_{k=0}^{T-1} h_k$ and $h_k$ specifies the number of voxels in the image with gray-level value $k$, $N$ is the maximum voxel value (typically 255), and $n$ is the total number of voxels, i.e., $D_x \times D_y \times D_z$. Next, the threshold is computed to lie exactly halfway between the two means

$$T = \left] \frac{\mu_1 + \mu_2}{2} \right[ \tag{14.63}$$

where $]$ $[$ indicates only integer values. The mean values are then calculated again, and the process is repeated to compute a new threshold, and so on, until the threshold stops changing value between consecutive computations.

There are other methods that use recursive or iterative thresholding as well [66, 67]. Most iterative methods split the image iteratively into regions by finding the peaks in the histogram due to each region or by dividing the histogram based on specific criteria to pick the threshold. Another common segmentation approach is to determine multilevel thresholds, whereby different objects are segmented in different threshold bands. This is done by determining multiple threshold values by searching the global intensity histogram for peaks or by using specific criteria to divide the histogram [68].

Thresholding is most suitable for images in which the objects display homogeneous intensity values against a high-contrast uniform background. If the objects have large internal variation in brightness, thresholding will not produce the desired segmentation. In 3-D images, intensity typically falls off deep within the specimen due to diffraction, scattering, and absorption of light, and a single threshold value is not applicable for the entire stack. Multilevel thresholding methods with localized threshold determination for individual 2-D slices in the stack are typically more appropriate. Moreover, thresholding algorithms that are based solely on gray level and do not incorporate spatial information result in segmented images in which objects are not necessarily connected. Most often the outcome of a thresholding operation is not used as the final result; rather, refinement procedures such as morphological processing and region-based segmentation algorithms are applied to delineate regions further.

## 14.12.2 Edge-Based Segmentation

In 2-D edge-based segmentation, an edge filter is applied to the image, and pixels are classified as edge or nonedge, depending on the filter output (Chapter 9). Typical edge filters produce images in which pixels near rapid intensity changes are highlighted. For 3-D data, surfaces represent object edges or boundaries, and edge detection in 2-D can be extended to 3-D surface detection.

For example, the Marr–Hildreth operator for 3-D surface detection operates as follows [58, 69]

$$C(x, y, z) = \nabla^2(I(x, y, z) * G(x, y, z, \sigma)) \tag{14.64}$$

where

$$G(x, y, z, \sigma) = \frac{1}{\sqrt{(2\pi)^3 \cdot \sigma^3}} \cdot e^{-(x^2+y^2+z^2)/2\sigma^2}$$

$I(x, y, z)$ is the 3-D image, $G(x, y, z, \sigma)$ is the Gaussian function, $C(x, y, z)$ is the resulting contour (surface) image, and $\nabla^2$ is the Laplacian operator. Equation 14.64 can be written as [58]

$$C(x, y, z) = I(x, y, z) * \nabla^2 G(x, y, z, \sigma) \tag{14.65}$$

where $\nabla^2 G$ is the Laplacian of a Gaussian operator. An implementation of the *difference of Gaussians* (DOG) operator is shown in Eq. 14.66. The DOG operator is separable and can be implemented as [58]

$$\nabla^2 G(x, y, z, \sigma) \approx G(x, y, z, \sigma_e) - G(x, y, z, \sigma_i)$$
$$\approx G(x, \sigma_e) * G(y, \sigma_e) * G(z, \sigma_e) - G(x, \sigma_i) * G(y, \sigma_i) * G(z, \sigma_i) \tag{14.66}$$

In order for the DOG operator to approximate the $\nabla^2 G$ operator, the values for $\sigma_e$ and $\sigma_i$ must be [69]

$$\sigma_e = \sigma \cdot \sqrt{\frac{1 - (1/r^2)}{2 \ln r}} \quad \text{and} \quad \sigma_i = r \cdot \sigma_e \tag{14.67}$$

where $r$ is the ratio $\sigma_i : \sigma_e$.

The values of $\sigma_e$ and $\sigma_i$ are determined such that the bandwidth of the filter is small and the sensitivity is high. As seen in Eq. 14.64, this edge-detection filter uses a Gaussian filter to smooth the data and remove high-frequency components. The amount of smoothing can be controlled by varying the value of $\sigma$, which is the standard deviation (i.e., width) of the Gaussian filter. Moreover, the Laplacian component is rotationally invariant and allows the detection of edges at any orientation.

Overall, surface-based segmentation is most useful for images with "good boundaries," that is, the intensity value varies sharply across the surface, is homogeneous along the surface, and the objects that the surfaces separate are smooth and have an uniform surface [70]. Generally, special surfaces, such as those that are planar, spherical, or ellipsoidal, are detected as the boundaries between

objects [71, 72]. The medical imaging field offers a number of promising algorithms that seek to optimize the surface of the object by balancing edge/region parameters measured from the image with a priori information about the shape of the object [73]. Despite their success in medical image analysis, boundary detection methods are seldom optimal for microscopy data where the intensity changes are typically gradual and heterogeneous along the surface. A major disadvantage of the edge-based algorithms is that they can result in noisy, discontinuous edges that require complex postprocessing to generate closed boundaries. Typically, discontinuous boundaries are subsequently joined using morphological matching or energy optimization techniques to find the surface that best matches the gradient map [74]. An advantage of edge detection is the relative simplicity of computational processing. This is due to the significant decrease in the number of voxels that must be classified and stored when considering only the voxels of the surface, as opposed to all the voxels in the volume of interest.

## 14.12.3 Region-Based Segmentation

Region-based methods are further classified into region-growing, region-splitting, and region-merging methods. These algorithms operate iteratively by grouping together adjacent voxels that are connected as neighbors and have similar values or by splitting groups of voxels that are dissimilar in value. Grouping of voxels is determined based on their connectivity.

### 14.12.3.1 Connectivity

For 3-D images there are three widely used definitions of connectivity: 6-neighborhood, 18-neighborhood, and 26-neighborhood connectivity. Given a voxel $\mathbf{v} = (x, y, z)$, the 6-neighborhood $N_6(\mathbf{v})$ of $\mathbf{v}$ consists of the six voxels whose positions in the 3-D space differ from $\mathbf{v}$ by $\pm 1$ in only one coordinate. These voxels are called 6-neighbors of $\mathbf{v}$, and their coordinates $(x', y', z')$ satisfy the following condition [58]

$$N_6(\mathbf{v}) = \{(x', y', z'): |x - x'| + |y - y'| + |z - z'| = 1\} \qquad (14.68)$$

Similarly, the 18-neighborhood, $N_{18}(\mathbf{v})$, and 26-neighborhood, $N_{26}(\mathbf{v})$, voxels satisfy the following conditions [58]

$$N_{18}(\mathbf{v}) = \{(x', y', z'): \ 1 \le |x - x'| + |y - y'| + |z - z'| \le 2 \text{ and}$$
$$\max(|x - x'|, |y - y'|, |z - z'|) = 1\} \qquad (14.69)$$
$$N_{26}(\mathbf{v}) = \{(x', y', z'): \ \max(|x - x'|, |y - y'|, |z - z'|) = 1\}$$

Any voxel $p$ in the 6-neighborhood of a voxel $x$ shares one face, in the 18-neighborhood shares at least one edge, and in the 26-neighborhood shares

at least one vertex with the voxel $x$. As in the 2-D case, connectivity in 3-D is defined in terms of the following adjacency pairs: (6, 26), (26, 6), (18, 6), and (6, 18), where the first component represents connectivity of the foreground and the second component represents connectivity of the background. Region-based methods typically utilize some characteristic, such as connectivity, intensity value, structural property, probabilistic correlation (e.g., Markow random field models), or correlation between voxels in a neighborhood, to attribute voxels to different objects or to the background.

### 14.12.3.2  Region Growing

*Region-growing* segmentation techniques start with marked voxels, or small regions (called *seeds*), that have near-uniform properties based on chosen criteria. The seeds can be placed automatically or interactively. Then, moving along the boundary of each seed, neighboring (connected) unassigned voxels are examined sequentially to determine if each should be incorporated into the region. The procedure is repeated and the region grows until no further neighboring voxels qualify for incorporation. Notice that this procedure produces a segmentation in which no regions overlap, and many voxels may remain unassigned to any region.

### 14.12.3.3  Region Splitting and Region Merging

Region-splitting methods start from a segmented region and proceed recursively toward smaller regions through a series of successive splits. Each region is checked for homogeneity based on some predefined criteria, and, if found to be nonhomogenous, it is tentatively split into eight octant regions. These are examined, and octants with different properties remain as separate new regions, while similar octants are remerged. The splitting procedure is repeated for the newly created regions. The procedure will stop when (1) all of the split regions remerge, (2) no more regions qualify for splitting, or (3) a minimum region size has been reached.

R*egion merging* acts to merge touching regions that have similar properties based on predefined criteria. The process terminates when no further region merging is possible. This process can correct oversegmentation.

Region splitting and region merging can be performed together as a single algorithm known as the *split-and-merge* technique. This recursive method starts with the entire image as a single region and uses the splitting technique to divide nonhomogenous regions based on predefined similarity criteria. Splitting continues until no further splitting is allowed. Then merging is used until it terminates. The resulting regions then constitute the segmentation results. This approach usually yields better segmentation results than the region-splitting or

region-merging methods alone. The region-growing method frequently results in oversegmentation, and split-and-merge operations can be applied to improve the results.

## 14.12.4 Deformable Models

Deformable models, popularly known as *active contours* or *snakes* in 2-D image processing (see Chapter 9), can be extended to 3-D image processing, where they are referred to as *active surfaces* or *balloons* [74]. These models represent geometric forms such as surfaces that are designed to simulate elastic sheets so that when they are placed close to an object's boundary the models will deform under the influence of internal and external forces to conform to the shape of the object boundary. External forces, also known as *image forces*, are driven by image attributes and pull the active surface toward strong edges in the image. Internal forces typically enforce regularity based on specified properties of elasticity or rigidity that the surface must maintain.

There are two major classes of 3-D deformable models, explicit [73] and implicit [75], and they differ at the implementation level. The surface of explicit deformable models is defined in a parametric form that uses global and local parameters. The surface $S$ is defined in a parametric form. The two parameters $s$ and $r$ specify points that are on the surface as follows [58, 73]

$$u(s, r) = (u_1(s, r), u_2(s, r), u_3(s, r)) \qquad s, r \in [0, 1] \qquad (14.70)$$

For every pair $(s, r)$, $u_1$, $u_2$, and $u_3$ define the $(x, y, z)$ coordinates of a point on the surface. The following energy functional, $E$, is associated with the surface [58]:

$$E(u) = \int_\Omega \left( w_{10} \left\| \frac{\partial u}{\partial s} \right\|^2 + w_{01} \left\| \frac{\partial u}{\partial r} \right\|^2 + 2w_{11} \left\| \frac{\partial^2 u}{\partial s \partial r} \right\|^2 \right.$$
$$\left. + w_{20} \left\| \frac{\partial^2 u}{\partial s^2} \right\|^2 + w_{02} \left\| \frac{\partial^2 u}{\partial r^2} \right\|^2 + P(u(s, r)) \right) ds \, dr \qquad (14.71)$$

where $\Omega = [0,1] \times [0,1]$, and $w_{10}$, $w_{01}$ represent surface elasticity, $w_{20}$, $w_{02}$ represent surface rigidity, and $w_{11}$ represents its resistance to twist. The internal or image force, $P(u)$, which drives the surface toward the local gradient maxima, is given by [58]

$$P(u) = -\| \nabla I(u) \|^2 \qquad (14.72)$$

The deformation process can be controlled by changing the values of the elasticity, rigidity, and resistance parameters or by using user-defined external

forces, such as a pressure to drive the initial estimates until an edge is detected or a weight that pulls the surface down until an object surface is detected. The Euler–LaGrange equation can be used to represent the local minimum of the energy functional $E$ as [58]

$$
-\frac{\partial}{\partial s}\left(w_{10}\frac{\partial u}{\partial s}\right) - \frac{\partial}{\partial r}\left(w_{01}\frac{\partial u}{\partial r}\right) + 2\frac{\partial^2}{\partial s\partial r}\left(w_{11}\frac{\partial^2 u}{\partial s\partial r}\right)
$$
$$
+\frac{\partial^2}{\partial s^2}\left(w_{20}\frac{\partial^2 u}{\partial s^2}\right) + \frac{\partial^2}{\partial r^2}\left(w_{02}\frac{\partial^2 u}{\partial r^2}\right) = F(u)
$$
(14.73)

where $F(u)$ is the sum of all forces acting on the surface. Typically, initial estimates are used to solve the following equation and compute the local minima [58]

$$
\frac{\partial u}{\partial t} - \frac{\partial}{\partial s}\left(w_{10}\frac{\partial u}{\partial s}\right) - \frac{\partial}{\partial r}\left(w_{01}\frac{\partial u}{\partial r}\right) + 2\frac{\partial^2}{\partial s\partial r}\left(w_{11}\frac{\partial^2 u}{\partial s\partial r}\right)
$$
$$
+\frac{\partial^2}{\partial s^2}\left(w_{20}\frac{\partial^2 u}{\partial s^2}\right) + \frac{\partial^2}{\partial r^2}\left(w_{02}\frac{\partial^2 u}{\partial r^2}\right) = F(u)
$$
(14.74)

Equation 14.74 is solved using the finite difference and finite element methods. This formulation of the explicit deformable model is also known as the *energy-minimization formulation* [76].

An alternative, known as the *dynamic force formulation* [74], provides the flexibility of applying different types of external forces to the deformable model. For example, the deformable model can start as a sphere inside the object and then use balloon force to push the model out to the boundary by adding a constant inflation pressure inside the sphere [74]. In general, explicit deformable models are easy to represent and have a fast implementation but do not adapt easily to topology. Topological changes occurring during deformation are better handled by implicit deformable models [77], which represent the curves and surfaces implicitly as a level set of higher-dimensional scalar function [78]. However, the implicit models' descriptions are not intuitive, and their implementations are computationally expensive.

## 14.12.5 Three-Dimensional Segmentation Methods in the Literature

Several composite algorithms for 3-D image segmentation of microscopy data have been published. The overall consensus is that no single method can be generalized adequately to be applicable to a variety of images and that most methods must be customized to solve a particular problem in a specific set of images from a given system. Both interactive and automatic algorithms are used

to perform 3-D segmentation. Interactive methods, based on manually tracing regions with a mouse in a sequence of images, are typically superior to automatic algorithms in performance, based on visual judgment of the results, and they constitute the gold standard. Although interactive segmentation is simple and generally applicable, it is very time consuming and monotonous, and it demands constant precision from the operator. In contrast, automatic segmentation techniques offer the advantages of high speed, robustness, and a lack of bias. Many methods for automated image segmentation have been proposed, but completely automatic 3-D image segmentation is still not reliable. It is difficult to quantify and measure the quality of segmentation due to the inherently subjective nature of the process and the large variances in manual segmentation, which continues to be used as the ground truth. Most applications still rely on semiautomated or manual methods. For 3-D segmentation, the most popular approaches have combined region-based, edge-based, and morphological methods to achieve the desired results. A description of all the published literature in the area of 3-D segmentation is beyond our scope, but a few examples of 3-D segmentation algorithms for microscopy are mentioned here.

One 3-D segmentation method integrates several morphological image processing algorithms, including gray-level opening, top-hat transformation, geodesic reconstruction, particle deagglomeration by the watershed algorithm, and a final discrimination by adaptive thresholding to segment nuclei in 3-D tissue samples of normal rat liver and in situ carcinoma of the esophagus [79]. The automated algorithm worked well for detecting nuclei in the liver samples, but interactive user intervention was required for the cancerous tissue, where nuclei were tightly clustered.

Another 3-D approach combines initial thresholding with a split-and-merge algorithm to identify volumes, followed by a final watershed algorithm to divide clusters of overlapping nuclei. Images are preprocessed with gradient filters and then globally thresholded, followed by local adaptive thresholding. Segmented regions are processed further to separate connected regions using 3-D watershed or a cluster analysis algorithm [80–82].

Other methods have utilized a combination of global thresholding followed by processing of individual slices in 3-D data sets to segment images [83]. The segmentation results from global thresholding are optimized by further processing using morphological filtering and segregation by the watershed algorithm to segment each 2-D slice of the 3-D image. Shape-based criteria, such as convexity, are then applied to the segmented object's contours to perform nuclei deagglomeration in the z direction (depth). Four different types of samples, including hyperplasia of a prostatic lesion, prostatic intraepithelial neoplastia, and well-differentiated and poorly differentiated carcinoma, were used for testing the algorithms.

A semiautomated method for 3-D segmentation incorporates automated thresholding followed by 3-D volume visualization and interactive division of

clusters of nuclei by a seeded region-growing technique [84]. The seeding is performed manually by marking the centers of nuclei, and this is followed by automatic region growing from the markers. Predefined criteria of size and shape are used to restrict the region-growing process. Finally, parametric modeling based on an ellipsoidal model is used to aid interactive refinement, allowing further optimization of the segmentation of nuclei.

Iterative multilevel thresholding followed by region splitting has also been applied to automate 3-D segmentation [85]. This approach allows segmentation of images where objects have varying levels of brightness and heterogeneity. Iterative multilevel thresholding and splitting (IMTS) initially splits a region by iterative thresholding to segment the 3-D images into volumes, and then it splits larger volumes into smaller volumes using intensity homogeneity and volume size criteria. The volumes are finally extracted via a slice-merging method, where each 2-D optical slice is processed and the segmented volumes are merged based on the connectivity of adjacent image planes.

Another semiautomated approach for segmentation utilizes an adaptive algorithm to determine the gradient-weighted average threshold, followed by interactive classification of each object. Objects classified as clusters are divided iteratively into subcomponents using the distance transform and a watershed algorithm [86]. Postprocessing techniques, such as partial-differential-equation–based filters, can also be used to improve the segmentation results [87].

Segmentation methods can also combine automation with manual intervention at several interim stages to achieve optimal results [88]. For example, automatic algorithms based on the Hough transform (see Chapter 9) and an autofocusing algorithm (see Chapter 16) have been used to estimate the size of nuclei and to separate regions of fluorescence-stained nuclei and unstained background. Subsequent manual review is then used to classify the segmented regions as individual nucleus, a cluster of multiple nuclei, a partial nucleus, or debris. Next, automated analysis, based on morphological reconstruction and the watershed algorithm, is used to divide clusters into smaller objects. These are again manually reclassified, and the procedure is repeated until all the clusters have been analyzed, at which point the analyst indicates which partial nuclei should be joined to form complete nuclei.

The watershed algorithm (Chapter 8) is commonly used for separating touching objects [89]. Region-based segmentation methods are combined with the watershed algorithm to separate clustered objects. Region merging can then be used to effect the final segmentation.

Alternatively, edge-based segmentation is used to split clustered objects. For example, contour-based methods can split clustered objects based on indentations along their boundaries [90]. One strategy is to use the restricted convex hull computation to achieve slicewise segmentation and then to join the information obtained per slice to construct the 3-D objects.

Finally, mathematical modeling methods can be used extract objects. For example, Gaussian Markov random fields can be used to segment nuclei by modeling the local dependencies of the nuclei within predefined neighborhoods [91, 92].

Overall, several different approaches have been developed for 3-D segmentation, and the most popular approaches have combined region-based, edge-based, and morphological methods to achieve the desired results. The general consensus is that most applications require a customized set of specific segmentation algorithms and that most images require tuned parameters for optimal results.

## 14.13 Comparing Three-Dimensional Images

In some applications it is necessary to determine the similarity between two images or to find the position of the best match between an image and a 3-D template. The similarity between two three-dimensional images can be determined by computing the 3-D correlation between them [58]

$$R_{ab}(x', y', z') = \sum_{x=0}^{P_1-1} \sum_{y=0}^{P_2-1} \sum_{z=0}^{P_3-1} a(x, y, z)\, b(x + x', y + y', z + z') \qquad (14.75)$$

where the input images $a$ and $b$ have regions of support $R_{P1,\,P2,\,P3}$ and $R_{Q1,\,Q2,\,Q3}$, respectively. The correlation is defined in the region $(-Q_1, P_1) \times (-Q_2, P_2) \times (-Q_3, P_3)$. Correlation of two different images is called *cross-correlation*, whereas correlation of an image with itself is *autocorrelation*. The position of the peak in the cross-correlation function specifies the shift required for alignment, and the strength of that peak gives the degree of similarity.

## 14.14 Registration

In optical sectioning microscopy, where the sample is stationary during image acquisition (except in live-cell imaging), all of the sections in the 3-D optical stack are well aligned. Thus registration of the image slices is not required. For physically sectioned samples, however, the process of cutting the sections and fixing them to the glass slide creates distortion, and registration of the section images is required to form a 3-D image. Cross-correlation, just described, can be used to determine the offset between adjacent section images. Another popular method to register images is based on the concept of *mutual information content* (or *relative entropy*) from the field of information theory. This has been used for

multimodal images in medical imaging and is also effective for optical sections in a $z$ stack [93]. Mutual information content is a measure of the statistical dependence, or information redundancy, between the image intensities of corresponding voxels in adjacent optical slices. Maximal values are obtained if the images are geometrically aligned. The main advantage of this method is that feature calculation is straightforward, since only gray-level values are used, and the accuracy of the methods is thus not limited by segmentation errors.

## 14.15   Object Measurements in Three Dimensions

The ultimate objective of most microscopy investigations is to evaluate a sample in terms of features that convey essential information about the structure and function of the specimen. Image analysis algorithms are typically applied to measure object features such as topology, shape, contrast, and brightness. Intensity-based measurements for objects in 3-D are similar to those described in Chapter 10 for 2-D objects. Morphological and topological measurements for 3-D objects are specialized, since the third dimension is required, and some of the algorithms for performing these measurements are described here. Topological features convey information about the structure of objects, and they refer to those properties that are preserved through any deformation. Typically, the definitions of adjacency and connectivity given in Section 14.12.3.1 are the most common topological notions used in 3-D image analysis. Another topological characteristic commonly measured for 3-D objects is the Euler number, which is based on the number of cavities and tunnels in the object. Structural features include measures such as surface area, volume, curvature, and center of mass.

### 14.15.1   Euler Number

A *cavity* is the 3-D analog of a hole in a 2-D object, and it is defined as a background component that is totally enclosed within a foreground component [58]. The number of cavities is determined by applying the region-growing algorithm (Section 14.12.3.2) to the background voxels in the image. This gives a count of the total number of background components, and the total number of cavities in the image is 1 less, since the background is also counted. Tunnels in 3-D objects are more difficult to compute, since a tunnel is not a separate background object. The first Betti number of the object is used to estimate of the number of tunnels in an object. The first Betti number equals the number of nonseparating cuts one can make in an object without changing the number

of connected components [58]. The Euler number of a 3-D object is then defined as [58]

$$\chi(S) = (\text{components}) - (\text{tunnels}) + (\text{cavities}) \qquad (14.76)$$

The Euler number corresponds to the topology of a closed surface rather than the topology of an object, and thus it cannot differentiate between surfaces from distinct objects and surfaces originating from the same object, such as an object with a hole. The Euler number is used as a topology test in 3-D skeletonization algorithms [94].

## 14.15.2 Bounding Box

The simplest method to measure the size of an object is to estimate the dimensions of its bounding box, that is, the smallest parallelepiped that contains the object. This can be done by scanning the 3-D volume and finding the object voxels with the minimum and maximum coordinates along each dimension [58] as follows

$$x = x_{max} - x_{min}, \qquad y = y_{max} - y_{min}, \qquad z = z_{max} - z_{min} \qquad (14.77)$$

## 14.15.3 Center of Mass

The *centroid* of an object may be defined as the center of mass of an object of the same shape with constant mass per unit volume. The center of mass is, in turn, defined as that point where all the mass of the object could be concentrated without changing the first moment of the object about any axis [95]. In the 3-D case the moments about the $x$-, $y$-, and $z$-axes are

$$X_c \iint_I f(x, y, z) \, dx \, dy \, dz = \iint_I x f(x, y, z) \, dx \, dy \, dz$$

$$Y_c \iint_I f(x, y, z) \, dx \, dy \, dz = \iint_I y f(x, y, z) \, dx \, dy \, dz \qquad (14.78)$$

$$Z_c \iint_I f(x, y, z) \, dx \, dy \, dz = \iint_I z f(x, y, z) \, dx \, dy \, dz$$

where $f(x, y, z)$ is the value of the voxel at $(x, y, z)$, and $(X_c, Y_c, Z_c)$ is the position of the center of mass. The integral appearing on the left side of these equations is the total mass, with integration taken over the entire image. For discrete binary images, the integrals become sums, and the center of mass for a 3-D binary image can be computed as

$$X_c = \frac{\sum_i \sum_j \sum_k i f(i,j,k)}{\sum_i \sum_j \sum_k f(i,j,k)}, \qquad Y_c = \frac{\sum_i \sum_j \sum_k j f(i,j,k)}{\sum_i \sum_j \sum_k f(i,j,k)},$$

$$Z_c = \frac{\sum_i \sum_j \sum_k k f(i,j,k)}{\sum_i \sum_j \sum_k f(i,j,k)}$$

(14.79)

where $f(i,j,k)$ is the value of the 3-D binary image (i.e., the intensity) at the point in the $i$th row, $j$th column, and $k$th section of the 3-D image (i.e., at voxel $(i,j,k)$). Intensities are assumed to be analogous to mass, so zero intensity represents zero mass.

### 14.15.4  Surface Area Estimation

The surface area of 3-D objects can be estimated by examining voxel connectivity in the 26-connected voxel neighborhoods of foreground voxels. A foreground voxel is considered to be a surface voxel if at least one of its 6-neighbors belongs to the background. The algorithm to find boundary voxels examines all object voxels to determine if there are any background voxels in their 6-neighborhood. The number of border voxels found is used as an estimate of the object's surface area. Other methods to estimate the surface have also been described [96].

A parametric modeling method popular in the field of computer graphics can also be employed in digital image analysis for estimating the 3-D surface area. This approach uses superquadric primitives with deformations to compute the 3-D surface area. Superquadrics are a family of parametric shapes that are used as primitives for shape representation in computer graphics and computer vision. An advantage of these geometric modeling primitives is that they allow complex solids and surfaces to be constructed and altered easily from a few interactive parameters. Superquadric solids are based on the parametric forms of quadric surfaces such as the superellipse and the superhyperbola, in which each trigonometric function is raised to a power. The spherical product of pairs of such curves produces a uniform mathematical representation for the superquadric. This function is referred to as the *inside–outside function* of the superquadric, or the *cost function*. The cost function represents the surface of the superquadric that divides the 3-D space into three distinct regions: inside, outside, and surface boundary. Model recovery may be implemented by using 3-D data points as input. The cost function is defined such that its value depends on the distance of points from the model's surface and on the overall size of the model. A least-squares minimization method is used to recover model parameters, with initial estimates for minimization obtained from the rough position, orientation, and size of the object. During minimization, all the model

parameters are adjusted iteratively to deform the model surface so that most of the input 3-D data points are near the surface.

To summarize, a superquadric surface is defined by a single analytic function that can be used to model a large set of structures such as spheres, cylinders, parallelepipeds, and shapes in between. Further, superquadric parameters can be adjusted to include such deformations as tapering, bending, and cavity deformation [97]. For example, superellipsoids may be used to estimate the 3-D bounding surface of biological cells. The inside–outside cost function $F(x, y, z)$ of a superellipsoid surface is defined by

$$F(x, y, z) = \left( \left( \left( \frac{x}{a_1} \right)^{2/\varepsilon_2} + \left( \frac{y}{a_2} \right)^{2/\varepsilon_2} \right)^{\varepsilon_2/\varepsilon_1} + \left( \frac{z}{a_3} \right)^{2/\varepsilon_1} \right)^{\varepsilon_1} \qquad (14.80)$$

where $x$, $y$, and $z$ are the position coordinates in 3-D space, $a_1$, $a_2$, $a_3$ define the superquadric size, and $\varepsilon_1$ and $\varepsilon_2$ are the shape parameters. The superquadric cost function is defined as [98]

$$F(x_W, y_W, z_W) = F(x_W, y_W, z_W : a_1, a_2, a_3, \varepsilon_1, \varepsilon_2, \phi, \theta, \psi, c_1, c_2, c_3) \qquad (14.81)$$

where $a_1$, $a_2$, $a_3$, $\varepsilon_1$, and $\varepsilon_2$ are as just described, $\varphi$, $\theta$, $\psi$ are orientation angles, and $c_1$, $c_2$, $c_3$ define the position in space of the center of mass. To recover a 3-D surface it is necessary to vary these 11 parameters to define a set of values such that most of the outermost 3-D input data points lie on or near the surface. The orientation, the size, and the shape parameters are varied, and the cost function is minimized using an algorithm such as the Levenberg–Marquardt method [95]. Typically, severe constraints are essential during minimization to obtain a unique solution, since different sets of parameter values can produce almost identical shapes. Figure 14.5 presents an application of this approach for determining the separation distance in 3-D between the fluorescent in situ hybridization (FISH) dots (i.e., signals) of a duplicated gene. Optical sections were obtained through FISH-labeled cells at a $z$ interval of 0.1 μm. Object boundary points were determined for each of the two FISH dots, in each optical section of the $z$ stack, and used to estimate the 3-D surface for each dot using Eq. 14.81. In the figure, the green symbols represent points on the estimated 3-D surface for the two dots. The two dots are shown using blue and red symbols. The line segment $PQ$ shows the separation distance between the two dots [29].

## 14.15.5 Length Estimation

Length measurement in 3-D can be performed via two different approaches. The first is a straightforward extension of the chain code–based length estimator

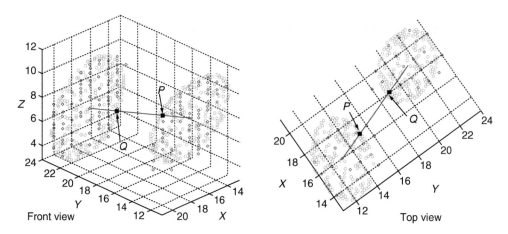

**FIGURE 14.5** Surface estimation using superquadric modeling primitives. This figure may be seen in color in the four-color insert.

for 2-D images described in Chapters 9 and 10. In this method, connected voxels along a straight line of $N$ elements are segregated into three types: grid parallel, square diagonal, and cube diagonal. The numbers of elements in each class $(n_{grid}, n_{square}, n_{cube})$ are scaled using predefined weight coefficients $(\alpha, \beta, \gamma)$ to determine the 3-D length as follows [99]

$$L = \alpha n_{grid} + \beta n_{square} + \gamma n_{cube} \tag{14.82}$$

Several different values for the weight parameters, such as $\alpha = 0.9016$, $\beta = 1.289$, $\gamma = 1.615$, have been published [100–102].

The second method for measuring length in 3-D is based on techniques from stereology. This approach works best for long curves or on sets of curves, yielding an estimate of the total length. The length is estimated by counting the number of intersections between the projection of the original curve onto a plane and a few equidistantly spaced straight lines in that plane [103].

### 14.15.6 Curvature Estimation

Curvature is increasingly used as a feature in object recognition and classification applications. The definitions of normal, Gaussian, and mean curvature are as follows. If $\vec{u}$ and $\vec{n}$ are the tangent and normal vectors, respectively, to any surface $M$ at a point $P$, then the *normal curvature* of $M$ at $P$, in the direction of $\vec{u}$, is the curvature of the space curve $C$ formed by the intersection of $M$ with the plane $N$ spanned by $\vec{u}$ and $\vec{n}$. The minimum and maximum values of the normal curvature are known as the *principal curvatures*, $p_1$ and $p_2$, respectively. The *Gaussian curvature K* of a surface $M$ at a point $P$ is computed as the product of the two principal curvatures (i.e., $K = p_1 p_2$). Finally, the *mean curvature H* is the

mean of the two principal curvatures, $H = 1/2[p_1 + p_2]$. Several techniques are available for curvature estimation [104]. Two approaches, surface triangulation and the cross-patch method, are described next [104].

### 14.15.6.1 Surface Triangulation Method

In this method, a surface patch is approximated by a series of adjacent triangles. Since each triangle is flat, the Gaussian curvature is estimated at the common vertex of the triangles (the center of the patch). The Gaussian curvature, $K = \Delta\theta/A$, where $\Delta\theta = 2\pi - \sum_i \theta_i$, is a quantity called the *angle deficit*, $\theta_i$ is the vertex angle of the individual triangles in the series, and $A$ is the sum of the areas of the triangles [104].

### 14.15.6.2 Cross-Patch Method

In this method, a discreet surface patch consisting of a cross-shaped (+) set of points is modeled as a sampling of a continuous patch, $\vec{S}(u, v)$, such that [104]

$$\vec{S}(u, v) = [x(u, v)\ y(u, v)\ z(u, v)]^T \tag{14.83}$$

where $x(u, v)$, $y(u, v)$, and $z(u, v)$ are polynomial functions whose coefficients are determined from the input data points using least-squares fitting [104]. The parameters $u$ and $v$ represent traces along the surface in two orthogonal planes (the cross). These planes (1) must contain the inspection point at which curvature is to be estimated, (2) must be parallel to the coordinate planes (the x-y, x-z, and y-z planes), and (3) must be the two such planes (out of three) that are most coincident with the surface normal at the inspection point, as indicated by the magnitude of the 2-D vector resulting from projection of the normal onto the plane. The result of fitting coefficients for the $x(u, v)$, $y(u, v)$, and $z(u, v)$ polynomials is used to estimate the original continuous surface, and the parameters are used to determine the surface area and its curvature.

## 14.15.7 Volume Estimation

The simplest approach to obtain an estimate of the volume of a 3-D object is an extension of the 2-D procedure for measuring area. The region of interest is initially outlined on each of the individual sections, and then the area of each segmented region on each section is multiplied by the section thickness (the $z$ interval). The total volume is then the sum of the volumes from each individual section. Alternatively, complex computer graphics models are estimated for the 3-D surface of the region of interest, and the enclosed volume can be determined mathematically [95–97]. For example, polyhedral and curved surface representations allow piecewise integration to be used for volume measurement.

## 14.15.8  Texture

Three-dimensional texture measures are used to describe the variations of image intensity value and contrast within the image. For example, a cell can contain directional texture indicative of the formation of fibers. Texture can be measured in 3-D by simply extending work done in 2-D analysis of textures to 3-D images. A description of 2-D texture measures is presented in Chapter 10.

# 14.16    Three-Dimensional Image Display

One of the greatest challenges in 3-D imaging is the final step, that of visual representation and display of the images. Given the vast amount of information that exists in 3-D data sets, it is difficult to extract useful information from the raw data, and well-designed visualization methods are essential to understand the 3-D structures and their spatial relationships truly. Volumetric data may be displayed using techniques such as surface rendering, volume rendering, and maximum intensity projection. A projection technique is almost always required to move data from higher dimensions to 2-D for viewing on a screen or print. Traditional display methods, such as the computer monitor and paper prints, are inherently 2-D, while the data is inherently 3-D. Thus various perceptual cues, such as shading and rotating a projection of the image volume are needed to impart a sense of depth when displaying 3-D data. Here we describe some of the popular techniques used to display microscopy data: as a montage of a series of 2-D slices, as a 2-D projection image, and as a 3-D rendering with stereo pairs and anaglyphs.

## 14.16.1  Montage

A montage is typically used to display a series of images. These images may be (1) the sequence of serial optical sections in a 3-D image stack, (2) a series of projected images, each of which is created by rotating the 3-D image to a specific angle, or (3) images from a time-lapse experiment. A montage display is a composite image created by combining several separate images. The images are tiled on the composite image, in a grid pattern, typically with the name of the image optionally appearing just below the individual tile. Each individual image in the montage is scaled to fit a predefined maximum tile size.

In 3-D microscopy, because we are optically sectioning the specimen volume, a montage is the appropriate way to visualize all the serial cross sections through the specimen simultaneously, rather than visualizing sequential presentations of single sections. The simultaneous presentation of images in a montage allows

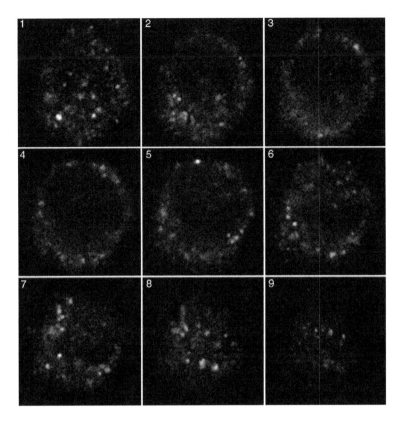

**FIGURE 14.6** A montage of a series of optical sections through a mouse 3T3 fibroblast. The images were obtained using a z interval of 1.8 μm for optical sectioning. The labels 1–8 represent cell depths ranging from 0 to 14.4 μm. Panel 1 shows the top of the cell, at 0 μm, panel 5 is the center of the cell, at a depth of 7.2 μm, and panel 8 shows the bottom of the cell, at a depth of 14.4 μm. The cell was treated with bacterial toxin H5 prior to immunofluorescence labeling.

a visualization of the continuity of image features in depth and other spatial relationships.

Figure 14.6 shows a montage of serial sections through a mouse 3T3 fibroblast obtained at an optical sectioning, z interval of 1.8 μm. The labels 1–8 in Fig. 14.6 represent cell depths ranging from 0 to 14.4 μm. Panel 1 shows the top of the cell at 0 μm, panel 5 is the center of the cell at a depth of 7.2 μm, and panel 8 shows the bottom of the cell at a depth of 14.4 μm. The cell was treated with bacterial toxin H5 prior to immunofluorescence labeling. The bacterial toxin interacts only with cell membranes. The montage display allows the 3-D image data to be viewed simultaneously, thus permitting direct visualization of the peripheral localization of the toxin without cellular internalization.

## 14.16.2  Projected Images

A projected image offers a 2-D view of a 3-D image. It is created by projecting the 3-D image data onto a plane. This is done by suitably combining the voxel intensity values along a given set of rays extending through the image volume and onto the plane. Different algorithms are available for generating such projections, two of which are discussed here: ray casting and voxel projection. *Ray casting* consists of tracing a line perpendicular to the viewing plane from every pixel in the serial sections into the 2-D projection image. *Voxel projection* involves projecting voxels encountered along the projection line from the 3-D image directly onto the 2-D projection image. Of the two methods, voxel projection is computationally faster.

### 14.16.2.1  Voxel Projection

The most straightforward and computationally simple approach to perform image projection is to use the maximum intensity projection (MIP) algorithm [105]. This algorithm works for a projection path that is orthogonal to the slices (2-D image planes) in a 3-D data set. The MIP algorithm picks up the brightest voxel along a projection ray and displays it on the projected 2-D image. The projected image is the same size as the slice images. MPI is most effective when the objects of interest in the 3-D image have relatively simple structures with uniformly bright voxels. It produces images that have a particularly high contrast for small structures, but it does not represent fluorescence concentrations quantitatively and thus cannot be used prior to further numerical analysis.

Alternatively, but at the risk of losing image sharpness, average (mean) intensity projection (AIP) can be used when quantification is required. AIP can be useful for measuring relative fluorophore concentrations and their dynamic changes [106]. The ranged-intensity projection (RIP) method allows the user to select a range of intensity values that are of most interest in a specific application [107]. It works like AIP, except only those voxel intensities that are within the specified range are accumulated during projection. A major advantage of these methods is that they do not require segmentation. Their main drawback is their poor performance in noisy images. Figure 14.7 presents a maximum-intensity projection image of microvasculature at an islet transplant site in the rat kidney.

### 14.16.2.2  Ray Casting

Ray casting requires segmented image data. It models the process of viewing the 3-D object in space. Rays from a virtual light source are simulated as reflecting off the surface of the objects in the 3-D image. The reflected rays are modeled to intersect a virtual screen between the data set and the observer. The intensity

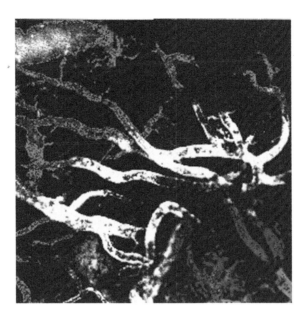

**FIGURE 14.7** Maximum-intensity projection image of the microvasculature of an islet graft at the renal subcapsular site. The image is color coded to denote depth. The blood vessels appearing in the lower portion (blue) are at a depth of 30 μm, whereas those in the middle and upper portions of the image are at a depth of ~85 μm (yellow) and 135 μm (violet), respectively. This figure may be seen in color in the four-color insert.

and color of each reflected ray determine the intensity and color of the corresponding pixel on this screen. When this is done for all pixels in the output image, it becomes a 3-D view of the object. A view from another direction can be calculated by moving the screen to another point in the virtual space of the data set. Views from several different viewing angles can be grouped together as sequential frames to form a movie of the object rotating in space.

## 14.16.3 Surface and Volume Rendering

Three-dimensional graphical rendering is popularly used in the field of computer graphics for displaying 3-D objects. Volume-rendering algorithms can be used to create 2-D projection images showing stacks of 2-D cross-sectional images from various points of view. Two algorithms for rendering are described briefly here, and the reader is directed to published texts for an in-depth description [108, 109].

### 14.16.3.1 Surface Rendering

Object surfaces in a segmented 3-D image are portrayed by the surface-rendering process. Standard 3-D graphics techniques are used to render objects, in which

their surfaces are approximated by a list of polygons. Several algorithms are available to generate the polygons that represent an object's surface. The most widely used method to triangulate a 3-D surface is known as the *marching cube algorithm* [110]. Following triangulation, the desired viewing angle is selected, and the object is displayed by projecting the polygons onto a plane perpendicular to the viewing direction. The object can be viewed from any desired angle, either by applying a rotation matrix to the polygon list or by changing the viewing direction used in the projection process. Shading or changing the transparency of the rendered objects can be used to improve the aesthetics and enhance the 3-D viewing effect. The quality of a display made using surface triangulation is highly dependent on the accuracy of the prior segmentation process, which, if poorly done, can result in a loss of detail in the rendered object.

### *14.16.3.2  Volume Rendering*

An alternative approach that does not require defining the surface geometry with polygons is to render the entire volume by projecting colored, semitransparent voxels onto a chosen projection plane. There are three steps in volume rendering: classification, shading (also known as *compositing*), and projection. In the classification step, each voxel is assigned an opacity value ranging from zero (transparent) to 1 (opaque) based on its intensity value. In order to avoid uneven transitions between transparency and opacity, a hyperbolic tangent mapping of voxel intensities is often applied. Every voxel is then considered to reflect light, with the goal of determining the total amount of light it directs to the viewing screen. Shading is used to simulate the object's surface, including both the surface's position and orientation with respect to the light source and the observer. An illumination model is used to implement the shading function [111], and the color and opacity of each voxel is computed [112].

The final stage is the projection step. Here the colored, semitransparent voxels are projected onto a plane perpendicular to the observer's viewing direction. Ray casting is used to project the data, as before. It involves tracing a line perpendicular to the viewing plane into the object volume. For each grid point $(m, n)$ in the projection plane, a ray is cast into the volume, and the color and opacity are computed at evenly spaced sample locations. Compositing (shading) is applied in a back-to-front order to yield a single pixel color $C(m, n)$. A detailed description of this approach is given in [112, 113].

Most of the major commercial imaging programs for microscopy include a volume-rendering module, and specialized software for 3-D visualization is also available. For a comprehensive listing of available software, see [108]. There are also several free volume-rendering programs available, but only a few of them (e.g., Voxx, VisBio) can import the 3-D image files produced by microscopy systems [114, 115]. Free volume-rendering plug-ins are also available for the

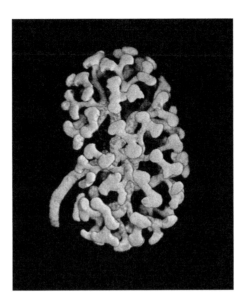

**FIGURE 14.8** Volume rendering of the ureteric tree of a fetal mouse kidney. This figure may be seen in color in the four-color insert. (Image courtesy of Deborah Hyink.)

ImageJ software package [57]. Figure 14.8 shows an example of volume rendering of the ureteric tree of a fetal mouse kidney. Optical sections of an E13 Hoxb7/GFP kidney were collected using a laser scanning confocal microscope and volume rendered using the Volocity software (Improvision, Inc., Waltham, MA).

## 14.16.4 Stereo Pairs

Stereoscopic techniques are used to retain the depth information when mapping 3-D data into a 2-D view for visualization. One method is to present the observer simultaneously with "left eye" and "right eye" views differing by a small parallax angle of about $6°$. Stereo pairs can be generated from volumetric data in two ways. The first method is to rotate the full 3-D data set anywhere from $\pm 3°$ to $\pm 10°$ and then to project each of these rotated views onto a 2-D plane [108]. Alternatively, instead of rotating the image data, the projection images can be created simply by summing the stack of serial images with an appropriate constant horizontal offset between the adjacent sections, to generate a top-down view. This can be described by the stereo "pixel shift" function [108]

$$x_v = x_i + \delta x * z_v, \qquad y_v = y_i, \qquad z_v = z_i \qquad (14.84)$$

where $\phi_s$ is the parallax angle, $\delta x_{\text{left}} = \tan(0.5 * \phi_s)$, and $\delta x_{\text{right}} = -\delta x_{\text{left}}$. Alternatively, the optimal pixel shift can be computed using [108, 116]

$$\delta_p = 2 * nz_{\text{calib}} * M * \sin(\arctan(\delta x * nz_i/nz_{\text{calib}})) \qquad (14.85)$$

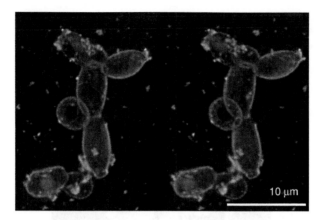

**FIGURE 14.9**   Maximum-intensity stereo pair image of the of *Histoplasma capsulatum*. (Image courtesy of José-Angel Conchello.)

where $\delta_p$ is the parallax shift between equivalent points in the two views, $nz_{calib}$ is the calibrated $z$ size of the data (thickness of the specimen), and $M$ is the magnification. The left view is made by shifting each image in the stack sequentially to the left, progressing from the farthest to the nearest section. The number of pixels to be shifted depends on the pixel size and the distance between sections.

The resulting left and right views are known as a *stereo pair*. They must be visually "fused" into a 3-D representation by positioning each view in front of the corresponding eye. The observer then perceives a single 3-D view at the appropriate viewing distance. Alternatively, side-by-side stereo pairs can be viewed with a horizontal prismatic viewer that appropriately presents the images to each eye. Figure 14.9, shows a maximum-intensity stereo pair image of *Histoplasma capsulatum*.

## 14.16.5   Color Anaglyphs

Anaglyphing [117] is a method of presenting a stereo pair to the viewer's eyes. The anaglyph is a stereo pair in which the left eye image is printed in red and the right eye image in blue (or cyan). It is viewed through a special pair of glasses having a red lens over the left eye and a blue lens over the right eye. The two images combine to create the perception of a three-dimensional image. Figure 14.10 shows a red–cyan anaglyph of a pancreatic islet.

## 14.16.6   Animations

Animations make use of the temporal display space for visualization. This technique involves the sequential display, in rapid succession, of rotated views

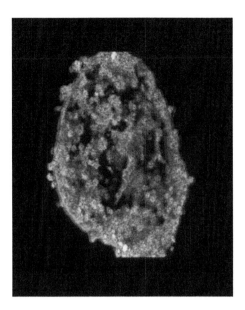

**FIGURE 14.10** Red–cyan anaglyph image of a pancreatic islet. This figure may be seen in color in the four-color insert.

of the object. The rotation angle is successively increased, and a rendered image is created at each angle. When the different views are presented in sequential frames, the result is a movie of the spinning object. The requirements for creating smooth animations are (1) fine rotation steps, (2) a short-persistence noninterlaced monitor, and (3) a display frame rate greater than 10 Hz [108]. Animations have proven to be a valuable support tool, especially for the assessment of the shape and relative position of 3-D structures. A complex structure is generally easier to comprehend in a moving animation than in a series of cross-sectional images.

## 14.17 Summary of Important Points

1. Three-dimensional light microscopy offers a noninvasive, minimally destructive option for obtaining spatial and volumetric information about the structure and function of cells and tissues.

2. The most popular and widely commercialized approaches to 3-D microscopy include the far-field techniques of wide-field, confocal, and multi-photon microscopy.

3. New methods for 3-D microscopy that offer improved resolution, include 4-pi-confocal, $I^nM$, HELM, OCT, OPT, and SPIM.

4. Three-dimensional data obtained from microscopes consists of a stack of 2-D images (optical sections), referred to as the $z$ stack, 3D-stack, or volumetric data.

5. In 3-D imaging, light emitted from planes above and below the in-focus regions is also captured in each optical section, and it appears as out-of-focus blurring.

6. The out-of-focus light can be characterized by the point spread function (psf), which is the 3-D image of a point source of light.

7. Three methods are commonly used for estimating the psf of a microscope: experimental, theoretical, and analytical.

8. Image formation can be modeled mathematically as a convolution operation, whereby light emitted from each defocused point in the specimen is convolved with the psf and appears as a blurred region in the image.

9. The deconvolution process (deblurring or restoration) estimates the amount of out-of-focus light characterizing the particular microscope optics in use (i.e., psf) and then attempts either to subtract out this light or to redistribute it back to its point of origin in the specimen volume.

10. Algorithms that are applied sequentially to each 2-D plane of a 3-D image stack, one at a time, are classified as deblurring procedures.

11. Image restoration algorithms operate simultaneously on every voxel in a 3-D image stack and are implemented in 3-D space to restore the actual distribution of light in the specimen.

12. There are six major categories of deconvolution algorithms: (1) no-neighbor methods, (2) neighboring plane methods, (3) linear methods, (4) nonlinear methods, (5) statistical methods, and (6) blind deconvolution.

13. The choice of the deconvolution procedure used is often dictated by the imaging system, experimental conditions, and the specific application.

14. The results obtained from deconvolution procedures depend heavily on image quality, specifically the signal-to-noise ratio, and the sampling density.

15. Deconvolution software is available both commercially and as freeware.

16. Image fusion is an approach frequently used in 3-D microscopy to combine a set of optical section images into a single 2-D image containing the detail from each optical section in the stack.

17. Three-dimensional image processing can be performed via three different approaches: (1) by performing 2-D image processing operations on the individual optical sections, (2) by performing operations using the entire 3-D data set, and (3) by performing 2-D operations on the fused image of a stack.

18. For most image processing techniques, the 2-D counterpart can easily be extended to 3-D.

19. Gray-level mathematical operations, such as subtraction and addition, and binary operations, such as OR, XOR, and AND, can be expressed for 3-D images, using the voxel as the brightness unit.

20. Image transformations, such as translation, reflection, rotation, and scaling, can also be expressed in 3-D.

21. Image filtering operations are typically used either to reduce noise by smoothing or to emphasize edges.

22. Digital convolution filters are linear, since the output pixel values are linear combinations of the input image pixels, but other types of filters are nonlinear.

23. Edge-detection filters are commonly used for segmentation based on surface detection in 3-D.

24. Mathematical morphological operators are a subclass of nonlinear filters that are used for shape and structure analysis and for filtering in binary and grayscale images.

25. Three-dimensional morphological operators are straightforward extensions of their 2-D counterparts, with sets and functions defined in the 3-D Euclidean grid $\mathbf{Z}^3$.

26. Three-dimensional image stacks are usually anisotropic; that is, the sampling interval is larger along the axial dimension than in the lateral dimension. For this reason, the structuring element should be chosen as an anisotropic 3-D kernel.

27. Segmenting regions of volumetric images is challenging, because, in 3-D, regions are often touching each other or overlapping and irregularly arranged, with no definite shape, and intensity typically falls off deep within the specimen due to diffraction, scattering, and absorption of light.

28. There are three general approaches to segmentation: point-based, edge-based, and region-based methods.

29. For 3-D segmentation the most popular approaches have combined region-based, edge-based, and morphological methods to achieve the desired results.

30. Two 3-D images can be compared by computing the 3-D correlation between them.

31. One popular method for registering images in an optical stack is based on the concept of mutual information content (or relative entropy).

32. Intensity-based measurements for objects in 3-D are similar to those for 2-D objects.

33. Morphological and topological measurements, such as surface area, volume, curvature, length, Euler number, and center of mass for 3-D objects, are different from their 2-D counterparts since the third dimension is required.

34. Traditional display methods are inherently 2-D, so well-designed visualization methods are essential to display and understand 3-D structures and their spatial relationships.

35. Typically perceptual cues, such as shading and rotating a projection of the image volume, are needed to impart a sense of depth when displaying 3-D data.

36. Popular techniques used to display 3-D microscopy data include a montage of a series of 2-D slices, 2-D projection images, and 3-D rendering with stereo pairs and anaglyphs.

# References

1. JA Conchello and JW Lichtman, "Optical Sectioning Microscopy," *Nature Methods*, **2**(12):920–931.
2. M Minsky, "Microscopy Apparatus," United States Patent No. 3,013,467. Filed Nov. 7, 1957; granted Dec. 19, 1961.
3. JB Pawley, *Handbook of Confocal Microscopy*, Plenum Press, 2006.
4. W Denk, JH Strickler, and WW Webb, "Two-Photon Laser Scanning Fluorescence Microscopy," *Science* **248**:73–76, 1990.
5. RM Williams, DW Piston, and WW Webb, "Two-Photon Molecular Excitation Provides Intrinsic 3-Dimensional Resolution for Laser-Based Microscopy and Microphotochemistry," *FASEB J*, **8**:804–813, 1994.
6. JA Ridsdale and WW Webb, "The Viability of Cultured Cells under 2-Photon Laser Scanning Confocal Microscopy," *Biophysics* **64**:A109, 1993.

7. M Gu and CR Sheppard, "Comparison of 3-Dimensional Imaging Properties Between 2-Photon and Single-Photon Fluorescence Microscopy," Journal of *Microscopy*, **177**: 128–137, 1995.

8. CR Sheppard and M Gu, "Image Formation in 2-Photon Fluorescence Microscopy," *Optik*, **86**:104–106, 1990.

9. S Hell and EK Stelzer, "Fundamental Improvement of Resolution with a 4Pi-Confocal Fluorescence Microscope Using Two-Photon Excitation," *Optical Communications*, **93**:277–282, 1992.

10. L Yu and MK Kim, "Full-Color 3-D Microscopy by Wide-Field Optical Coherence Tomography," *Optics Express*, **12**(26):6632–6641, 2004.

11. J Sharpe et al., "Optical Projection Tomography as a Tool for 3-D Microscopy and Gene Expression Studies," *Science*, **296**:541–545, 2002.

12. J Swoger, J Huisken, and EK Stelzer, "Multiple Imaging Axis Microscopy Improves Resolution for Thick-Sample Applications," *Optics Letters*, **28**(18):1654–1656, 2003.

13. J Huisken et al., "Optical Sectioning Deep Inside Live Embryos by Selective Plane Illumination Microscopy," *Science*, **305**:1007–1009, 2004.

14. ML Gustafsson, DA Agard, and JW Sedat, "I$^5$M: 3D Wide-Field Light Microscopy with Better Than 100-nm Axial Resolution," *Journal of Microscopy*, **195**:10–16, 1999.

15. JT Frohn, HF Knapp, and A Stemmer, "Three-Dimensional Resolution Enhancement in Fluorescence Microscopy by Harmonic Excitation," *Optics Letters*, **26**:828–830, 2001.

16. Y Hiraoka, JW Sedat, and DA Agard, "Determination of the 3-D Imaging Properties of a Light Microscope System," *Biophysical Journal*, **57**:325–333, 1990.

17. JG McNally, T Karpova, J Cooper, and JA Conchello, "Three-Dimensional Imaging by Deconvolution Microscopy," *Methods*, **19**:373–385, 1999.

18. C Preza et al., "Regularized Linear Method for Reconstruction of 3-D Microscopic Objects from Optical Sections," *Journal of the Optical Society of America A*, **9**:219–228, 1992.

19. SF Gibson and F Lanni, "Experimental Test of an Analytical Model of Aberration in an Oil-Immersion Objective Lens Used in 3-D Light Microscopy," *Journal of the Optical Society of America A*, **8**(10):1601–1612, 1991.

20. P Sarder and A Nehorai, "Deconvolution Methods for 3-D Fluorescence Microscopy Images," *IEEE Signal Processing Magazine*, **May**:32–45, 2006.

21. J Markham and J Conchello, "Parametric Blind Deconvolution: A Robust Method for the Simultaneous Estimation of Image and Blur," *Journal of the Optical Society of America A*, **16**(10):2377–2391, 1999.

22. VN Mahajan, "Zernike Circle Polynomials and Optical Aberrations of Systems with Circular Pupils," *Engineering Laboratory Notes*, **17**:S21–S24, 1994.

23. PJ Shaw and DJ Rawlins, "The Point Spread of a Confocal Microscope: Its Measurement and Use in Deconvolution of 3-D Data," *Journal of Microscopy*, **163**:151–165, 1991.

24. W Wallace, LH Schaefer, and JR Swedlow, "A Workingperson's Guide to Deconvolution in Light Microscopy," *Biotechniques*, **31**:1076–1097, 2001.

25. JR Monck et al., "Thin-Section Ratiometric $Ca^{2+}$ Images Obtained by Optical Sectioning of fura-2 Loaded Mast Cells," *Journal of Cell Biology*, **116**(3):745–759, 1992.

26. JC Russ, *The Image Processing Handbook*, CRC Press, 1994.

27. M Weinstein and KR Castleman, "Reconstructing 3-D Specimens from 2-D Section Images," *Proceedings of the Society for Photo-Optical Instrument Engineering*, **26**: 131–138, 1971.

28. KR Castleman, *Digital Image Processing*, Prentice-Hall, 1996.

29. FA Merchant and KR Castleman, "Coomputerized Microscopy," in *Handbook of Image and Video Processing*, AC Bovik, ed., Academic Press, 2005.

30. A Erhardt et al., "Reconstructing 3-D Light Microscopic Images by Digital Image Processing," *Applied Optics*, **24**(2):194–200, 1985.

31. HC Andrews and BR Hunt, *Digital Image Restoration*, Prentice-Hall, 1977.

32. A Chomik et al., "Quantification in Optical Sectioning Microscopy: A Comparison of Some Deconvolution Algorithms in View of 3D Image Segmentation," *Journal of Optics*, **28**:225–233, 1997.

33. GP van Kempen, *Image Restoration in Fluorescence Microscopy*, PhD thesis, Delft University Press, 1999.

34. PH van Cittert, "Zum Einflub der Spaltbreite auf die Intensitatsverteilung in Spektrallinien (On the influence of slit width on the intensity distribution in spectral lines)," *Zeitschrift für Physik*, **65**:547, 1930.

35. PA Jansson, RH Hunt, and EK Plyler, "Resolution of Enhancement of Spectra," *Journal of the Optical Society of America*, **60**:596–599, 1976.

36. DA Agard, "Optical Sectioning Microscopy," *Annual Review of Biophysics and Bioengineering*, **13**:191–219, 1984.

37. DA Agard et al., "Fluorescence Microscopy in Three Dimensions," *Methods in Cell Biology*, **30**:353–377, 1989.

38. WA Carrington, "Image Restoration in 3D Microscopy with Limited Data," *Bioimaging and Two-Dimensional Spectroscopy, Proceedings SPIE*, **1205**:72–83, 1990.

39. WA Carrington et al., "Superresolution Three-Dimensional Images of Fluorescence in Cells with Minimal Light Exposure," *Science*, **268**:1483–1487, 1995.

40. RL Lagendijk and J Biemond, *Iterative Identification and Restoration of Images,* Kluwer Academic, 1991.

41. HM van der Voort and KC Strasters, "Restoration of Confocal Images for Quantitative Image Analysis," *Journal of Microscopy*, **178**:165–181, 1995.

42. WH Press, SA Teukolsky, and WT Vetterling, *Numerical Recipes in C*, Cambridge University Press, 1992.

43. PJ Verveer and TM Jovin, "Acceleration of the ICTM Image Restoration Algorithm," *Journal of Microscopy*, **188**:191–195, 1997.

44. JA Conchello, "An Overview of 3-D and 4-D Microscopy by Computational Deconvolution," in *Cell Imaging: Methods Express*, D Stephens, ed., Scion, 2006.

45. TJ Holmes, "Maximum-Likelihood Image Restoration Adapted for Noncoherent Optical Imaging," *Journal of the Optical Society of America A*, **5**:666–673, 1988.

46. NM Lashin, *Restoration Methods for Biomedical Images in Confocal Microscopy*, Thesis, Technical University Berlin, 2005.

47. L Liang and Y Xu, "Adaptive Landweber Method to Deblur Images," *IEEE Signal Processing Letters*, **10**(5):129–132, 2003.

48. J Markham and JA Conchello, "Tradeoffs in Regulated Maximum-Likelihood Image Restoration," in *3D Microscopy: Image Acquisition and Processing IV, Proc. SPIE BIOS97*, CJ Cogswel, JA Conchello, and T Wilson, eds., SPIE Press (2984-18), 1997.

49. JA Conchello and EW Hansen, "Enhanced 3D Reconstruction from Confocal Scanning Microscope Images I: Deterministic and Maximum-Likelihood Reconstructions," *Applied Optics*, **29**:3795–3804, 1990.

50. WH Richardson, "Bayesian-Based Iterative Method of Image Restoration," *Journal of the Optical Society of America*, **62**:55–59, 1972.

51. TJ Holmes and YH Liu, "Richardson–Lucy Maximum-Likelihood Image Restoration Algorithm for Fluorescence Microscopy: Further Testing," *Applied Optics*, **28**: 4930–4938, 1989.

52. S Joshi and MI Miller, "Maximum a posteriori Estimation with Good's Roughness for Optical-Sectioning Microscopy," *Journal of the Optical Society of America*, **10**(5): 1078–1085, 1993.

53. LI Rudin, S Osher, and E Fatemi, "Nonlinear Total Variation-Based Noise Removal Algorithm," *Physica D*, **60**:259–268, 1992.

54. BR Frieden, "Restoring with Maximum Likelihood and Maximum Entropy," *Journal of the Optical Society of America*, **62**:511–518, 1972.

55. TJ Holmes, "Blind Deconvolution of Quantum-Limited Incoherent Imagery: Maximum-Likelihood Approach," *Journal of the Optical Society of America A*, **9**:1052–1061, 1992.

56. E Thiebaut and JM Conan, "Strict a priori Constraints for Maximum-Likelihood Blind Deconvolution," *Journal of the Optical Society of America A*, **12**(3):485–492, 1995.

57. WS Rasband, ImageJ, U.S. National Institutes of Health, Bethesda, Maryland, http://rsb.info.nih.gov/ij/, 1997–2007.

58. N Nikolaidis and I Pitas, *3-D Image Processing Algorithms*, John Wiley & Sons, 2001.

59. J Serra, *Image Analysis and Mathematical Morphology*, Academic Press, 1998.

60. F Meyer, "Mathematical Morphology: From Two Dimensions to Three Dimensions," *Journal of Microscopy*, **165**:5–28, 1992.

61. G Lin et al., "A hybrid 3D Watershed Algorithm Incorporating Gradient Cues and Object Models for Automatic Segmentation of Nuclei in Confocal Image Stacks," *Cytometry A*, **56A**:23–36, 2003.

62. CA Glasbey, "An Analysis of Histogram-Based Thresholding Operations," *CVGIP: Graphical Models and Image Processing*, **55**:532–537, 1993.

63. PK Sahoo, S Soltani, and KC Wong, "A Survey of Thresholding Techniques," *Computer Vision Graphics and Image Processing*, **41**:233–260, 1988.

64. TW Ridler and S Calvard, "Picture Thresholding Using an Iterative Selection Method," *IEEE Transactions on Systems, Man and Cybernetics*, **8**(8):630–632, 1978.

65. CA Glasbey and GW Horgan, *Image Analysis for the Biological Sciences*, John Wiley & Sons, 1995.

66. R Ohlander, K Price, and R Reddy, "Picture Segmentation by a Recursive Region-Splitting Method," *Computer Graphics and Image Processing,* **26**:269–279, 1978.

67. SH Kwok and AG Constantinides, "A Fast Recursive Shortest Spanning Tree for Image Segmentation and Edge Detection," *IEEE Transactions on Image Processing*, **6**:328–332, 1997.

68. FJ Chang, JC Yen, and S Chang, "A New Criterion for Automatic Multilevel Thresholding," *IEEE Transactions on Image Processing*, **4**:370–378, 1995.

69. M Bomans et al., "3D Segmentation of MR Images of the Head for 3D Display," *IEEE Transactions on Medical Imaging*, **12**:153–166, 1990.

70. HR Singleton and GM Pohost, "Automatic Cardiac MR Image Segmentation Using Edge Detection by Tissue Classification in Pixel Neighborhoods," *Magnetic Resonance in Medicine*, **37**:418–424, 1997.

71. LH Chen and WC Lin, "Visual Surface Segmentation from Stereo," *Image and Vision Computing*, **15**:95–106, 1997.

72. A Hoover et al., "An Experimental Comparison of Range Image Segmentation Algorithms," *IEEE Transactions on Pattern Analysis and Machine Intelligence*, **18**: 673–689, 1996.

73. T McInerney and D Terzopoulos, "Medical Image Segmentation Using Topologically Adaptable Surfaces," in *Proceeding of the 1st Joint Conference, Computer Visualization, Virtual Reality, and Robotics in Medicine and Medical Robotics and Computer-Assisted Surgery,* 23–32, 1997.

74. LD Cohen and I Cohen, "Finite-Element Methods for Active Contour Models and Balloons for 2D and 3D Images," *IEEE Transactions on Pattern Analysis and Machine Intelligence*, **15**:1131–1147, 1993.

75. T Chan and L Vese, "Active Contours Without Edges," *IEEE Transactions on Image Processing*, **10**(2):266–277, 2001.

76. M Kass, A Witkin, and D. Terzopoulos, "Snakes: Active Contour Models," *International Journal of Computer Vision*, **1**:321–331, 1987.

77. R Malladi, J Sethian, and BC Vemuri, "Shape Modeling with Front Propagation: A Level Set Approach," *IEEE Transactions on Pattern Analysis and Machine Intelligence*, **17**(2):158–175, 1995.

78. S Osher and N Paragios, *Geometric Level Set Method in Imaging, Vision and Graphics*, Springer, 2002.

79. JP Rigaut et al., "3-D DNA Image Cytometry by Confocal Scanning Laser Microscopy in Thick Tissue Blocks," *Cytometry*, **12**:511–524.

80. B Roysam et al., "Algorithms for Automated Characterization of Cell Populations in Thick Specimens from 3-D Confocal Fluorescence Microscopy Data," *Journal of Microscopy*, **173**:115–126, 1994.

81. H Ancin et al., "Advances in Automated 3-D Image Analysis of Cell Populations Imaged by Confocal Microscopy," *Cytometry*, **25**:221–234, 1996.

82. RW Mackin et al., "Advances in High-Speed, Three-Dimensional Imaging and Automated Segmentation Algorithms for Thick and Overlappped Clusters in Cytologic Preparations—Application to Cervical Smears," *Analytical and Quantitative Cytology and Histology*, **20**:105–121, 1998.

83. T Irinopoulou et al., "Three-Dimensional DNA Image Cytometry by Confocal Scanning Laser Microscopy in Thick Tissue Blocks of Prostatic Lesions," *Cytometry*, **27**: 99–105, 1997.

84. K Rodenacker et al., "Groping for Quantitative Digital 3-D Image Analysis: An Approach to Quantitative Fluorescence in situ Hybridization in Thick Tissue Sections of Prostate Carcinoma," *Analytical Cellular Pathology*, **15**:19–29, 1997.

85. D Luo et al., "Iterative Multilevel Thresholding and Splitting for 3-D Segmentation of Live-Cell Nuclei Using Laser Scanning Confocal Microscopy," *Journal of Computer-Assisted Microscopy*, **10**(4):151–162, 1998.

86. SJ Lockett et al., "Efficient Interactive 3D Segmentation of Cell Nuclei in Thick Tissue Sections," *Cytometry*, **31**:275–286, 1998.

87. A Sarti et al., "A Geometric Model for 3-D Confocal Image Analysis," *IEEE Transactions on Biomedical Engineering*, **47**:1600–1609, 2000.

88. CO de Solorzano et al., "Segmentation of Confocal Microscope Images of Cell Nuclei in Thick Tissue Sections," *Journal of Microscopy*, **193**:212–226, 1999.

89. PU Adiga and BB Chaudhuri, "An Efficient Method Based on Watershed and Rule-Based Merging for Segmentation of 3-D Histopathological Images," *Pattern Recognition*, **34**:1449–1458, 2001.

90. JM Belien et al., "Confocal DNA Cytometry: A Contour-Based Segmentation Algorithm for Automated 3D Image Segmentation," *Cytometry*, **49**:12–21, 2002.

91. BL Luck, KC Carlson, AC Bovik, and RR Richards-Kortum, "An Image Model and Segmentation Algorithm for Reflectance Confocal Images of in-vivo Cervical Tissue," *IEEE Transactions on Image Processing*, **14**(9):1265–1276, 2005.

92. T Collier et al., "Real-Time Reflectance Confocal Microscopy: Comparison of 2D Images and 3D Image Stacks for Detection of Cervical Precancer," *Journal of Biomedical Optics*, **12**(2):024021(1–7), 2007.

93. F Maes et al., "Multimodality Image Registration by Maximization of Mutual Information," *IEEE Transactions on Medical Imaging*, **16**(2):187–198, 1997.

94. S Lobregt, PW Verbeek, and FA Groen, "3D Skeletonization: Principal and Algorithm," *IEEE Transactions on Pattern Analysis and Machine Intelligence*, **2**:75–77.

95. FA Merchant et al., "Confocal Microscopy," in *Handbook of Image and Video Processing*, AC Bovik, ed., Academic Press, 2005.

96. D Gordon and JK Udupa, "Fast Surface Tracking in 3D Binary Images," *Computer Vision, Graphics and Image Processing*, **45**(2):196–214, 1989.

97. F Solina and R Bajcsy, "Recovery of Parametric Models from Range Images: The Case for Superquadrics with Global Deformations," *IEEE Transactions on Pattern Analysis and Machine Intelligence*, **12**:131–147, 1990.

98. TE Boult and AD Gross, "Recovery of Superquadrics from Depth Information," *Proceeding of the Spatial Reasoning Multi-Sensor Fusion Workshop*, 128–137, 1987.

99. LJ Van Vliet, *Grayscale Measurements in Multidimensional Digitized Images*, PhD thesis, Delft University, 1993.

100. AD Beckers and AM Smeulders, "Optimization of Length Measurements for Isotropic Distance Transformations in 3D," *CVGIP Image Understanding*, **55**(3):296–306, 1992.

101. BH Verwer, "Local Distances for Distance Transformations in Two and Three Dimensions," *Pattern Recognition Letters*, **12**(11):671–682, 1991.

102. N Kiryati and O Kubler, "On Chain Code Probabilities and Length Estimators for Digitized 3D curves," *Pattern Recognition, Conference A: Computer Vision and Applications,* **1**:259–262, 1992.

103. LM Cruz-Orive and CV Howard, "Estimating the Length of a Bounded Curve in 3D Using Total Vertical Projections," *Journal of Microscopy*, **163**(1):101–113, 1991.

104. MH Davis, A Khotanzad, DP Flamig, SE Harms, "Curvature Measurement of 3D objects: Evaluation and Comparison of Three Methods," *IEEE Proceedings ICIP 95*, **2**:627–630, 1995.

105. S Rossnick, G Laub, R Braeckle, et al., "Three-dimensional Display of Blood Vessels in MRI," *Proceedings of the IEEE Computers in Cardiology Conference*, 193–196, 1986.

106. W Schroeder and MK Lorensen, *The Visualization Toolkit: An Object-Oriented Approach to Computer Graphics*, Prentice-Hall, 1998.

107. Y Sun, B Rajwa, and JP Robinson, "Adaptive Image Processing Technique and Effective Visualization of Confocal Microscopy images," *Microscopy Research and Technique*, **64**:156–163, 2004.

108. NS White, "Visualization Systems for Multidimensional CLSM Images," in *Handbook of Biological Confocal Microscopy*, JB Pawley, ed., Plenum Press, 1995.

109. RA Drebin, L Carpenter, and P Hanrahan, "Volume Rendering," *Computer Graphics*, **22**(4):65–74, 1988.

110. WE Lorensen and HE Cline, "Marching Cubes: A High-Resolution 3D Surface Reconstruction Algorithm," *International Conference on Computer Graphics and Interactive Techniques*, 163–169, 1987.

111. BT Phong, "Illumination for Computer-Generated Pictures," *Communications of the ACM*, **18**(6):311–317, 1975.

112. H Chen et al., "The Collection, Processing, and Display of Digital Three-Dimensional Images of Biological Specimens," in *Handbook of Biological Confocal Microscopy*, JB Pawley, ed., Plenum Press, 1995.

113. A Kaufman, *Volume Visualization*, IEEE Computer Society Press, 1991.

114. J Clendenon et al., "Voxx: A PC-Based, Near Real-Time Volume Rendering System for Biological Microscopy," *American Journal of Physiology: Cell Physiology*, **282**: C213–C218, 2002.

115. C. Rueden, K Eliceiri, and J White, "VisBio: A Computational Tool for Visualization of Multidimensional Biological Image Data," *Traffic*, **5**:411–417, 2004.

116. PC Cheng et al., "3D Image Analysis and Visualization in Light Microscopy and X-Ray Micro-Tomography," in *Visualization in Biomedical Microscopies*, A Kriete, ed., VCH, 1992.

117. R Turnnidge and D Pizzanelli, "Methods of Previsualizing Temporal Parallax Suitable for Making Multiplex Holograms. Part II: Greyscale and Color Anaglyphs Made in Photoshop," *Imaging Science Journal*, **45**:43–44, 1997.

# 15

# Time-Lapse Imaging

Erik Meijering, Ihor Smal, Oleh Dzyubachyk,
and Jean-Christophe Olivo-Marin

## 15.1 Introduction

By their very nature, biological systems are dynamic, and a proper understanding of the cellular and molecular processes underlying living organisms and how to manipulate them is a prerequisite to combating diseases and improving human health care. One of the major challenges of current biomedical research, therefore, is to unravel not just the spatial organization of these complex systems, but their *spatiotemporal* relationships as well [1]. Catalyzed by substantial improvements in optics hardware, electronic imaging sensors, and a wealth of fluorescent probes and labeling methods, light microscopy has, over the past decades, matured to the point that it enables sensitive time-lapse imaging of cells and even of single molecules [2–5]. These developments have had a profound impact on how research is conducted in the life sciences.

An inevitable consequence of the new opportunities offered by these developments is that the size and complexity of image data are ever increasing. Data sets generated in time-lapse experiments commonly contain hundreds to thousands of images, each containing hundreds to thousands of objects to be analyzed. Figure 15.1 shows examples of frames from image sequences acquired for specific time-lapse imaging studies containing large numbers of cells or subcellular particles to be tracked over time. These examples illustrate the complexity of typical time-lapse imaging data and the need for automated image analysis, but they also show the difficulty of the problem.

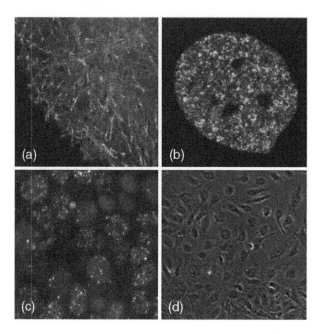

**FIGURE 15.1** Sample frames from image sequences acquired for specific time-lapse imaging studies. The sequences contain large numbers of cells or subcellular particles to be tracked over time. (a) Single frame (36 × 36 μm) from a fluorescence microscopy image sequence (1 s between frames) showing labeled microtubule plus-ends moving in the cytoplasm of a single COS-7 cell (only partly visible). (b) Single frame (30 × 30 μm) from a fluorescence microscopy image sequence (about 12 s between frames) showing labeled androgen receptors moving in the nucleus of a Hep3B cell. (c) Single frame (73 × 73 μm) from a fluorescence microscopy image sequence (about 16 min between frames) showing labeled Rad54 proteins in the nuclei of mouse embryonic stem cells. (d) Single frame (about 500 × 500 μm) from a phase contrast microscopy image sequence (12 min between frames) showing migrating human umbilical vein endothelial cells in a wound-healing assay. Together, these examples show the complexity of typical time-lapse imaging data and the need for automated image analysis. But at the same time they illustrate the difficulty of the problem. (Images a through d courtesy of N Galjart, A Houtsmuller, J Essers, and T ten Hagen, respectively.)

Such huge amounts of data cannot be digested by visual inspection or manual processing within any reasonable amount of time. It is now generally recognized that automated methods are necessary, not only to handle the growing rate at which images are acquired, but also to provide a level of sensitivity and objectivity that human observers cannot match [6].

Roughly speaking, time-lapse imaging studies consist of four successive steps: (1) planning the experiment and acquisition of the image data, (2) preprocessing the data to correct for systemic and random errors and to enhance relevant features, (3) analysis of the data by detecting and tracking the objects relevant to the biological questions underlying the study, and (4) analysis of the resulting trajectories to test predefined hypotheses or to detect new phenomena. Figure 15.2 gives a topical overview of the process. The circular structure of the diagram reflects the

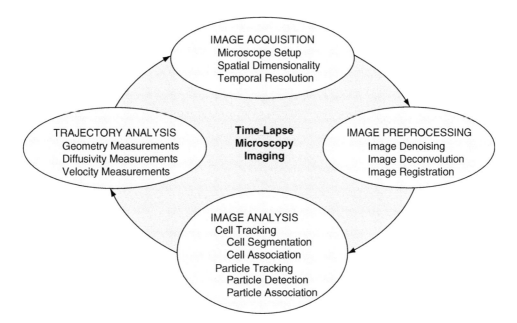

**FIGURE 15.2** The circle of life in time-lapse microscopy imaging. The diagram depicts the successive steps in the imaging process and, at the same time, gives an overview of the topics addressed in this chapter. Following image acquisition, preprocessing is often required to increase the success of subsequent automated analysis of the images and, eventually, of the resulting trajectories. The circular structure of the diagram reflects the iterative nature of the imaging process: The results of previous experiments usually trigger the planning of new experiments.

iterative nature of the imaging process, in that the results of previous experiments usually trigger the planning of new studies.

This chapter addresses each of these issues from an informatics perspective. It focuses on methodological, rather than hardware or software, aspects. It gives examples of image processing and analysis methods that have been used successfully for specific applications. The ultimate goal of this chapter is to prepare the reader to select methods intelligently.

## 15.2 Image Acquisition

Time-lapse imaging experiments involve the acquisition of not only spatial information, but also temporal information and often spectral information as well, resulting in up to five-dimensional $(x, y, z, t, s)$ image data sets. Figure 15.3 shows different configurations and dimensionalities in time-lapse microscopy imaging. Notice that dimensionality, as used here, does not necessarily describe the image configuration unambiguously. For example, 4-D imaging may refer either to spatially 2-D multispectral time-lapse imaging or to spatially 3-D

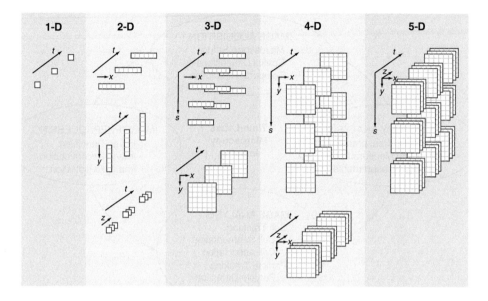

**FIGURE 15.3** Possible image configurations and dimensionalities in time-lapse microscopy imaging. Each dimension corresponds to an independent physical parameter or coordinate: $x$ and $y$ commonly denote the in-plane spatial coordinates, $z$ the depth or axial coordinate, and $t$ the time coordinate, and here $s$ denotes any spectral parameter, such as wavelength. Notice that dimensionality, as used here, does not necessarily describe the image configuration unambiguously. For example, 4-D imaging may refer either to spatially 2-D multispectral time-lapse imaging or to spatially 3-D time-lapse imaging. To avoid confusion, it is better to use the abbreviations 2-D and 3-D to refer to spatial dimensionality only and to indicate explicitly whether the data also involves a temporal or spectral coordinate. Therefore, in this chapter we indicate spatially 2-D and 3-D time-lapse imaging by 2-D+t and 3-D+t respectively, rather than by 3-D and 4-D.

time-lapse imaging. To avoid confusion, it is better to use the abbreviations 2-D and 3-D to refer to spatial dimensionality only and to indicate explicitly whether the data also involves a temporal or spectral coordinate. Therefore, in this chapter we indicate spatially 2-D and 3-D time-lapse imaging by 2-D+t and 3-D+t, respectively, rather than by 3-D and 4-D.

Regardless of the imaging technique being used, a careful design of the microscope setup is imperative, because shortcomings may require additional pre- or postprocessing of the resulting image data or may even lead to artifacts that cannot be removed and that hamper data analysis. We include here a few general remarks concerning the choice of microscopy, spatial dimensionality, and temporal resolution from the perspective of subsequent data analysis.

## 15.2.1  Microscope Setup

Time-lapse imaging experiments generally involve living cells and organisms. A fundamental concern is keeping the specimen alive during the acquisition of hundreds or thousands of images over a period of time that may range from

minutes to hours. This not only calls for a suitable environment with controlled temperature, humidity, and a stably buffered culture medium [7], but it also requires economizing light exposure, since living cells are subject to photo-damage [8]. In fluorescence microscopy, excessive illumination bleaches fluor-ophores, and this limits their emission time span and generates free radicals that are toxic for living cells.

Two very important factors determine whether automated methods can be applied successfully, and they strongly affect accuracy. They are *signal contrast* (the intensity difference between objects and background) and *noise*, which, in light microscopy, is signal dependent. These two factors are usually combined into a single measure, the signal-to-noise ratio (SNR), calculated as the differ-ence in mean intensity between the object, $I_o$, and the background, $I_b$, divided by a representative noise level, $\sigma$, that is, $SNR = (I_o - I_b)/\sigma$. Ideally, experiments should be designed so as to maximize SNR to allow robust and accurate automated image analysis, and the only way to accomplish this is with high light exposure levels.

These contradictory requirements call for a careful choice of the type of micro-scopy to be used. This also depends on the type of objects to be studied, their dimensions, motility, and viability. Living cells in culture medium, for example, produce poor contrast with standard brightfield illumination, and they often require contrast-enhancing imaging techniques, such as phase contrast and differ-ential interference contrast microscopy. Intracellular particles are hardly visible without contrast enhancement and are better studied using fluorescence micro-scopy (cf. Tables 15.1 and 15.2). In all cases the system should make the best use of the available light, implying the use of high-numerical-aperture objectives in con-junction with highly sensitive detectors. In many cases this may also mean that wide-field microscopy is preferable over confocal microscopy [7–9], with the pro-viso that 3-D wide-field microscopy requires images to be deconvolved.

In practice, for any biological application, there is often no single best microscope setup. This means that a compromise must be found between sufficient (but not toxic) illumination and (spatial and temporal) resolution so that the maximum number of acceptable images (optical slices and time frames) can be acquired before the specimen is completely photobleached or damaged [7]. Here *acceptable* means having the minimum SNR required by automated image analysis techniques (discussed later in this chapter). To this end, a good understanding of different microscope systems is needed, for which we refer to excellent introductory texts [5].

## 15.2.2 Spatial Dimensionality

One of the fundamental questions to be addressed when setting up an experi-ment is whether imaging needs to be performed in two or in three spatial

**TABLE 15.1**   Selected cell-tracking methods and some of their features and applications

| Ref. | Dim. | Segmentation | Association | Microscopy | Application | Auto. |
|---|---|---|---|---|---|---|
| [22] | 2D+t | Manual indication | Template matching | PC | Leukocytes | MI |
| [46] | 3D+t | Multiple thresholding | Template matching | F | *Dictyostelium discoideum* | FA |
| [64] | 2D+t | Otsu thresholding + watersheds | Distance + area + overlap | F | HeLa cells | FA |
| [100] | 2D+t | Manual indication + edges | Monte Carlo tracking | PC | Leukocytes | MI |
| [54] | 2D+t | Manual indication + active contours | Active contour evolution | PC | Endothelial cells | MI |
| [67] | 2D+t | Manual indication | Coupled mean shift processes | PC | Cancer and endothelial cells | MI |
| [44] | 3D+t | Thresholding | Nearest cell | HMC | Cancer cells | FA |
| [55] | 2D+t | Active contours | Active contour evolution | F | *Dictyostelium* cells | FA |
| [56] | 3D+t | Multiple level sets | Level set evolution | F | *Entamoeba histolytica* and epithelial cells | FA |
| [51] | 2D+t | Manual outlining + watersheds | Unknown matching algorithm | PC | PC-3 cells | MI |
| [48] | 2D+t | Template matching | Probabilistic association | PC | Hematopoietic stem cells | FA |
| [65] | 2D+t | Manual indication | Template matching | PC | HSB-2 T-cells | MI |
| [68] | 2D+t | Manual outlining | Active contour evolution | BF | Fibroblasts | MI |
| [57] | 2D+t | Level sets | Level set evolution | PC | Leukocytes | FA |
| [58] | 2D+t | Manual indication | Contour evolution + Kalman filtering | PC | Leukocytes | MI |

| | | | | | | |
|---|---|---|---|---|---|---|
| [30] | 2D+t | Space-time filtering + thresholding | Space-time trace angle + distance | PC | Leukocytes | FA |
| [60] | 2D+t | Active contours | Monte Carlo tracking | F | HeLa cells | FA |
| [66] | 2D+t | Manual outlining + active contour | Fourier-based template matching | PC | Keratocytes | MI |
| [53] | 2D+t | Marker-controlled watersheds | Mean shift + Kalman filtering | F | HeLa cells | FA |
| [61] | 2D+t | Manual outlining | Active contour evolution | PC | Entamoeba histolytica | MI |

From left to right the columns indicate the reference number describing the method, the dimensionality of the data for which the method was designed, the main features of spatial segmentation and temporal association used by the method, the type of microscopy used and the applications considered in the described experiments, and the level of automation of the method.
BF = brightfield; F = fluorescence; FA = fully automatic, meaning that in principle no user interaction is required, other than parameter tuning; HMC = Hoffman modulation contrast; MI = manual initialization, meaning that more user interaction is required than parameter tuning; PC = phase contrast.

**TABLE 15.2**  Selected particle-tracking methods and some of their features and applications

| Ref. | Dim. | Detection | Association | Microscopy | Application | Auto. |
|---|---|---|---|---|---|---|
| [77] | 2D+t | Gaussian fitting | Distance + intensity | F | Lipoproteins, influenza viruses | FA |
| [72] | 2D+t | Thresholding + centroid | Nearest particle | F | Microspheres, actin filaments | FA |
| [31] | 3D+t | Pyramid linking | Intensity + velocity + acceleration | F | Microspheres, vimentin | FA |
| [87] | 2D+t | Template matching | Minimum-cost paths | F | Quantum dots, glycine receptors | FA |
| [18] | 3D+t | Thresholding + centroid | Template matching | F | Subchromosomal foci | FA |
| [11] | 3D+t | Gaussian mixture fitting | Template matching | F | Kinetochore microtubules | FA |
| [28] | 2D+t | Artificial neural networks | Velocity and virtual flow | F | Microspheres | FA |
| [81] | 3D+t | Multiscale products | Interacting multiple models | F | Quantum dots, endocytic vesicles | FA |
| [36] | 3D+t | Thresholding | Fuzzy logic | F | Chromosomes, centrosomes | FA |
| [73] | 2D+t | Thresholding + centroid | Nearest particle | F | Low-density lipoprotein receptors | FA |
| [15] | 2D+t | Local maxima | Nearest particle | F | R-phycoerythrin | FA |
| [78] | 2D+t | Gaussian fitting | Nearest particle | F | P4K proteins | FA |
| [9] | 3D+t | Thresholding + centroid | Nearest particle | F | Secretory granules | FA |
| [85] | 2D+t | Thresholding + centroid | Nearest particle | F | Actin filaments | FA |

| Ref | Dim | Spatial detection | Temporal association | Microscopy | Applications | Automation |
|---|---|---|---|---|---|---|
| [33] | 3D+t | Laplacian of Gaussian | Dynamic programming | F | Telomeres | FA |
| [86] | 2D+t | Local maxima | Distance + intensity moments | TIRF | Lipoproteins, adenovirus-2, quantum dots | FA |
| [80] | 3D+t | Gaussian mixture fitting | Global weighted-distance minimization | F | Chromosomes, spindle pole body | FA |
| [20] | 2D+t | Gradient magnitude + tracing | Fuzzy logic | F | Secretory vesicles, speckles | FA |
| [88] | 2D+t | Local maxima selection | Multilayered graphs | F | Actin and tubulin fluorescent speckles | FA |
| [74] | 2D+t | Thresholding + centroid | Area + major/minor axes + distance | F | Actin filaments | FA |

From left to right the columns indicate the reference number describing the method, the dimensionality of the data for which the method was designed, the main features of spatial detection and temporal association used by the method, the type of microscopy used and the applications considered in the described experiments, and the level of automation of the method.
F = fluorescence; FA = fully automatic, meaning that in principle no user interaction is required, other than parameter tuning; TIRF = total internal reflection fluorescence.

dimensions over time (denoted as 2-D+t and 3-D+t, respectively, and the latter is also referred to as 4-D). Despite the amount of 4-D imaging reported in the literature, the vast majority of experiments today are still performed in 2-D+t (cf. Tables 15.1 and 15.2). Often this is due to limitations imposed by photobleaching and phototoxicity, which preclude wasting light, as one can in confocal microscopy imaging. In other studies, in particular those addressing intracellular dynamic processes, acquiring multiple optical slices would simply take too much time relative to the motions of interest, resulting in intrascan motion artifacts. In cases, for example, when studying cell migration in monolayers or microtubule dynamics in neurons, the structures of interest may be sufficiently flat to allow 2-D+t imaging by wide-field microscopy to give a good understanding of a process. The improved light collection and the lower number of optical slices in such cases yields a better SNR and allows for a higher temporal resolution.

Most cellular and intracellular processes, however, occur in three dimensions over time, and they require 3-D+t imaging to fully characterize cell morphodynamics [8]. It is known, for example, that tumor cells treated with drugs that block migration on 2-D substrates can still move inside an artificial 3-D collagen matrix by means of a very different type of motility [4, 10]. Regarding intracellular processes, studies into kinetochore microtubule dynamics [11] have recently revealed that trajectories obtained from 2-D+t imaging may differ significantly from those obtained from 3-D+t imaging and may lead to severe misinterpretation of the underlying processes. These findings suggest that a paradigm shift may be necessary, in that 2-D+t imaging studies should always be preceded by experiments confirming the validity of that approach. This could be as important as making sure that fluorescent probes, in fluorescence microscopy imaging, do not alter physiology.

## 15.2.3  Temporal Resolution

Another issue of great importance in time-lapse experiments is the rate at which images should be acquired over time, also referred to as the *temporal sampling rate* or *temporal resolution*. Ideally, this should be sufficiently high to capture the relevant details of object motion. However, similar to spatial resolution, the temporal sampling rate is not an independent parameter that can be fixed to any desired value; it is constrained by the limited viability of living cells under illumination.

From sampling theory it is known that, in order to be able to reconstruct a continuous signal from a set of samples, the sampling rate must be at least twice the highest frequency at which a component is present in the signal (see Chapter 2). This minimum sampling rate, often called the *Nyquist rate*, also applies to sampling in time. Object position as a function of time is a continuous

signal, and high-fidelity reconstruction of this signal and any derived motion parameters, such as velocity and acceleration, is possible only if temporal sampling is done at a rate that complies with the theory.

Establishing this rate, however, is a chicken-and-egg problem. Before sampling, one must have knowledge of the expected velocities to be estimated, which can only be obtained by sampling at or above the proper rate in the first place. In practice, a series of experiments at different sampling rates is often necessary to arrive at the optimal setting. Several studies can be found in the literature [11–13] that discuss temporal resolution for specific applications. They clearly demonstrate how undersampling may have a significant effect on velocity estimation. From the point of view of image analysis it should also be realized that many automated cell-tracking algorithms (cf. Table 15.1) fail if the displacement between time frames is larger than the cell diameter [4], especially in the cases involving cell contact. Similar limitations exist for particle-tracking algorithms (*cf.* Table 15.2), particularly in cases of high particle densities or when trying to characterize Brownian motion.

## 15.3 Image Preprocessing

During image acquisition there are many factors that may cause image quality degradation (see Chapter 3). Since illumination levels must be kept to a minimum to avoid photobleaching and photodamage in fluorescence microscopy, the SNR in the acquired images is often rather low. Further, any optical imaging device has limited resolution due to diffraction phenomena, and this manifests itself as blurring. In addition, out-of-focus light causes a loss of contrast for in-focus objects, especially in wide-field microscopy imaging. Finally, even if the microscope setup is perfectly stable, unwanted motion may occur in the specimen. This is the case, for example, when studying intracellular dynamic processes while the cells themselves are migrating. In this section we discuss methods developed specifically for reducing these artifacts. A more in-depth discussion of these methods can be found elsewhere in this volume and in other works [5].

### 15.3.1 Image Denoising

Any image acquired with a physical device will be contaminated with noise. For the purposes of this chapter we refer to *noise* as any random fluctuation in image intensity, as distinct from systematic distortions, such as hot or cold pixels in charge-coupled devices (CCDs), or background shading, which can be compensated by other methods. In optical microscopy imaging, noise originates from sources that fall into four categories: (1) the quantum nature of light, which

gives rise to *photon shot noise*, (2) random electron generation due to thermal vibrations, called *thermal noise*, (3) random fluctuations in the analog electric signals in the imaging sensors before digitization, referred to as *readout noise*, and (4) round-off error introduced by converting the analog signal into digital form, known as *quantization noise*. Whereas thermal, readout, and quantization noise can be controlled by careful electronic design and proper operating conditions, photon shot noise is inherent to optical imaging and can only be reduced by increasing exposure [14].

Although noise cannot be avoided during acquisition, it can be reduced afterwards, to some degree, by image processing. A wide variety of "denoising" techniques are available for this purpose, and they can be divided into linear and nonlinear filtering methods. The linear methods are typically implemented by convolution filtering (see Chapter 6). Examples include uniform local averaging [15] and Gaussian smoothing [16]. While effective in reducing noise, these methods also blur relevant image structures. This can be avoided by using nonlinear methods. The most common of these is median filtering [17, 18]. More sophisticated methods that are increasingly being used in time-lapse imaging [17, 19, 20] are based on the principle of anisotropic diffusion filtering [21]. By avoiding blurring near object edges, these methods usually yield superior results. Methods based on gray-level morphology (see Chapter 8) have also been used to remove not only noise, but small-scale image structures as well [22].

## 15.3.2  Image Deconvolution

Conventional wide-field microscopes are designed to image specimens at the focal plane of the objective lens, but they also collect light emanating from out-of-focus planes. This reduces the contrast of in-focus image structures. In confocal microscopes, this out-of-focus light is largely rejected by the use of pinholes, resulting in clearer images and increased resolution, both laterally and axially [5]. In either case, however, diffraction occurs as the light passes through the finite-aperture optics of the microscope, introducing a blurring effect. For a well-designed imaging system, this blurring can be modeled mathematically as a convolution of the true incident light distribution with the point spread function (psf) of the system [23]. If the psf is known, it is possible, in principle, to reverse this operation, at least partially. This process is called *deconvolution* (see Chapter 14).

A number of methods are available for deconvolution, and these vary greatly in computational demand, the requirement for accurate knowledge of the psf, and their ability to reduce blur, improve contrast, increase resolution, and suppress noise [23–25]. Similar to denoising, they can be divided into linear and nonlinear methods. The former category includes the *nearest-neighbor* and Fourier-based *inverse filtering* algorithms, which are conceptually simple and

computationally fast but have the tendency to amplify noise and can even introduce artifacts. Generally they are not successful when studying small, intracellular structures and dynamic processes. More sophisticated, nonlinear methods involve *iterative constrained* algorithms, which allow enforcement of specific constraints. The nonlinear category also includes *blind deconvolution* algorithms [25], which do not require knowledge of the psf, for it is estimated from the data during the process. Time-lapse imaging of thick samples may require even more sophisticated, space-variant deconvolution methods.

While some authors have advocated always to deconvolve image data if possible [23], the question of whether deconvolution, as a separate preprocessing step, is really necessary or beneficial depends on the application. Particularly in studies requiring tracking of subresolution particles, explicit deconvolution seems less relevant, except perhaps when wide-field microscopes are used [7, 9]. This is because the localization of such particles, which appear in the images as diffraction-limited spots, can be done with much higher accuracy and precision than the resolution of the imaging system [26, 27]. Indeed, when the detection and localization algorithm involves fitting (a model) of the psf, this is, in fact, deconvolution to some degree, carried out implicitly.

### 15.3.3 Image Registration

One of the difficulties frequently encountered in quantitative motion analysis is the presence of unwanted movements confounding the movements of interest. In time-lapse imaging of living specimens, the observed movements are often a combination of global displacements and deformations of the specimen as a whole, superposed on the local movements of the structures of interest [7, 17]. For example, in intravital microscopy studies, which involve living animals, the image sequences may show cardiac, respiratory, or other types of global motion artifacts [28–30]. But even in the case of imaging live-cell cultures, the dynamics of intracellular structures may be obscured by cell migration, deformation, or division [18, 31–33]. In these situations, prior motion correction is necessary. This can be achieved by global or local image alignment, also referred to as *image registration*.

Many image registration methods have been developed over the past decade for a wide variety of applications (see Chapter 14), notably in clinical medical imaging [34, 35]. The aspects of a registration method that determine its suitability for a specific registration problem include (1) the type of information (extrinsic or intrinsic), (2) the measure (such as cross-correlation or mutual information) used to quantify the similarity of images, (3) the type of geometrical transformations supported (rigid, i.e., translation and rotation, versus nonrigid, which also includes scaling, affine, and elastic deformations), and (4) various implementation issues (such as the interpolation, optimization, and

discretization strategies used). From the large body of literature on the subject, it was recently concluded [35] that the currently popular mutual-information-based methods are suitable for numerous clinical applications, but that they may not be a universal cure for all registration problems. Also, specific implementation choices may have a large influence on the results.

In biological imaging, image registration methods are less common than in clinical medical imaging, but a variety of techniques are increasingly used in both 3-D and time-lapse microscopy. For tracking leukocytes in phase-contrast images, for example, normalized cross-correlation of edge information has been used to achieve translational background registration [22, 29, 30]. By contrast, tracking of intracellular particles in fluorescence microscopy usually requires correction for translation and rotation or even for more complex deformations. This can be done by intensity-based cross-correlation [18] or by using the labeled proteins as landmarks in an iterative point-based registration scheme [34, 36]. In fluorescence microscopy, large parts of the images often bear no relevant information, so the use of landmarks can improve the robustness and accuracy of registration [37]. At present, no clear consensus about which method works best has emerged.

## 15.4    Image Analysis

The ultimate goal of time-lapse imaging experiments is to gain insight into cellular and intracellular dynamic processes. Inevitably this requires quantitative analysis of motion patterns. Approaches to this problem fall into three categories. The first consists of real-time, single-target tracking techniques. These usually involve a microscope setup containing an image-based feedback loop controlling the positioning and focusing of the system to keep the object of interest in the center of the field of view [38, 39]. Only a small portion of the specimen is illuminated this way, which reduces photodamage and allows imaging to be done faster or over a longer time. The second category consists of ensemble tracking approaches, such as fluorescence recovery after photobleaching (FRAP) and fluorescence loss in photobleaching (FLIP) [8] (see Chapter 12). While useful for assessing specific dynamic parameters (e.g., diffusion coefficients and association and dissociation rates of labeled proteins), they are limited to yielding averages over larger populations. The third category, on which we focus here, consists of approaches that aim to track all individual objects of interest present in the data. These are usually performed off-line.

Different possible levels of computerization range from simply facilitating image browsing and manual analysis, to manual initialization followed by automated tracking, to full automation (cf. Tables 15.1 and 15.2). In the interest of efficiency, objectivity, and reproducibility, full automation is to be preferred. However, given the large variety of imaging techniques and cellular components

of interest, the objects to be tracked have widely differing and even time-varying appearances. As a consequence, full automation usually can be achieved only by developing very dedicated algorithms that are tuned for the specific application. This explains why existing commercial tracking software tools, which are developed for broad, general applicability, often fail to yield satisfactory results for specific tracking tasks.

In this section we discuss published approaches to automated object tracking in time-lapse microscopy images. A distinction is made between *cell tracking* and *particle tracking*. Two different strategies exist for both problems. The first consists of the identification of the objects of interest in the entire image sequence, separately for each frame, followed by temporal association, which tries to relate identified objects either globally over the entire sequence or from frame to frame. In the second strategy, objects of interest are identified only in a first frame and are subsequently followed in time by image matching or by model evolution. In either case, the algorithms usually include a detection or segmentation stage and a temporal association stage. Both are essential to performing motion analysis of individual objects. Alternative approaches based on optic flow have also been studied [17, 19, 40, 41], but these are limited to computing collective cell motion and intracellular particle flows, unless additional detection algorithms are applied.

## 15.4.1  Cell Tracking

Cell motility and migration are of fundamental importance to many biological processes [4, 10, 42, 43]. In embryonic development, for example, cells migrate and differentiate into specific cell types to form different organs. Failures in this process may result in severe congenital defects and diseases. In adult organisms as well, cell movement plays a crucial role. In wound healing, for example, several interrelated cell migration processes are essential in regenerating damaged tissue. The immune system consists of many different proteins and cells interacting in a dynamic network to identify and destroy infectious agents. Many disease processes, most notably cancer metastasis, depend heavily on the ability of cells to migrate through tissue and reach the bloodstream. Because of its importance for basic cell biology and its medical implications, cell migration is a very active field of research. Automated methods for segmenting cells and following them over time (Table 15.1) are becoming essential in quantifying cell movement and interaction under normal and perturbed conditions.

### 15.4.1.1  Cell Segmentation

The simplest approach for separating cells from the background is intensity thresholding (see Chapter 9). This involves a single threshold parameter that can

be set manually or derived automatically from the data, based on the intensity histogram. Although used in many cell-tracking algorithms [13, 44, 45], this approach is successful only if cells are well separated and their intensity levels differ markedly and consistently from that of the background. In practice, however, this condition is rarely met. In phase-contrast microscopy, for example, cells may appear as dark regions surrounded by a bright halo, or vice versa, depending on their position relative to the focal plane. In the case of fluorescence microscopy, image intensity may fall off as a function of time due to photobleaching. While the situation may be improved by using adaptive thresholding or some sort of texture filtering [46, 47], thresholding based on image intensity alone is generally inadequate.

A fundamentally different approach to cell detection and segmentation that is particularly relevant to phase-contrast and differential-interference-contrast microscopy is to use a predefined cell intensity profile, also referred to as a *template*, to be matched to the image data. This works well for cells that do not change shape significantly, such as certain blood cells and algal cells [48, 49]. However, most cell types are highly plastic and move by actively changing shape. Keeping track of such morphodynamic changes would require the use of a very large number of different templates, which is impractical from both algorithm design and computational considerations.

Another well-known approach to image segmentation is to apply the watershed transform [50] (see Chapter 9). By considering the image as a topographic relief map and by flooding it from its local minima, this transform completely subdivides the image into regions (*catchment basins*) with delimiting contours (*watersheds*). Fast implementations exist for this intuitively sensible method, which is easily parallelized. The basic algorithm has several drawbacks, however, such as sensitivity to noise and a tendency toward oversegmentation [50]. Carefully designed pre- and postprocessing strategies are required for acceptable results. By using marking, gradient-weighted distance transformation, and model-based merging methods (see Chapter 9), several authors have successfully applied the watershed transform to cell segmentation in microscopy [16, 51–53].

Currently there is increasing interest in the use of deformable models for cell segmentation [4, 54–61]. These usually take the form of parametric *active contours*, or "snakes" [62], in 2-D and implicit active surfaces or level sets [63] in 3-D. They begin with an approximate boundary and iteratively evolve in the image domain to optimize a predefined energy functional. Typically this functional consists of both image-dependent and boundary-related terms. The former may contain statistical measures of intensity and texture in the region enclosed by the developing boundary or gradient magnitude information along the boundary. Image-independent terms concern properties of the boundary shape itself represented by the front, such as boundary length, surface area, and curvature, and the similarity to reference shapes. It is this mixture of terms,

enabling flexible incorporation of both image information and prior knowledge, that makes deformable models easily adaptable to specific applications [4, 56]. This approach is discussed in more detail in Chapter 9.

### 15.4.1.2 Cell Association

Several strategies exist for performing interframe cell association. The simplest is to associate each segmented cell in one frame with the nearest cell in a subsequent frame, where *nearest* may not only refer to spatial distance between boundary points or centroid positions [12, 44, 47]. It may refer to similarity in terms of average intensity, area or volume, perimeter or surface area, major and minor axis orientation, boundary curvature, angle or velocity smoothness, and other features [28, 64]. Generally, the more features involved, the lower is the risk of ambiguity. However, matching a large number of features may be as restrictive as template matching, since cell shape changes between frames are less easily accommodated [22, 46, 65, 66]. Some applications may not require keeping track of cell shape features, so robust tracking of only cell center position may be achieved by mean-shift processes [53, 67].

In addition to boundary delineation, deformable model approaches lend themselves naturally to capturing cell migration and cell shape changes over time [4]. At any point in an image sequence, the contours or surfaces obtained in the current frame can be used as initialization for the segmentation process in the next frame [56, 57, 61, 68]. With standard algorithms, however, this usually works well only if cell displacements are limited to no more than one cell diameter from frame to frame [56, 59]. Otherwise, more algorithm sophistication is required, such as the use of gradient-vector flows [58, 59, 61] or the incorporation of known or estimated dynamics [54, 60].

Rather than using explicitly defined models (parametric active contours), recent research efforts have shown a preference toward implicitly defined models (through level sets), since they can easily handle topological changes, such as cell division, and can be extended readily to deal with higher-dimensional image data [56]. In either case, however, several adaptations of the standard algorithms are usually necessary to be able to track multiple cells simultaneously and to handle cell appearances, disappearances, and touches. While this is certainly feasible [56–58, 61], it usually introduces a number of additional parameters that must be tuned empirically for each specific application. This increases the risk of errors and reduces reproducibility. This, in turn, may require postprocessing to validate tracking results [69].

### 15.4.2 Particle Tracking

The ability of cells to migrate, perform a variety of specialized functions, and reproduce is the result of a large number of intracellular processes involving

thousands of different-sized biomolecular complexes, collectively termed *particles* in this chapter. Since many diseases originate from a disturbance or failure of one or more of these processes, they have become the subject of intense current research by academic institutes and pharmaceutical companies. Fluorescent probes permit visualization of intracellular particles [70]. Combined with time-lapse optical microscopy, they enable studying the dynamics of virtually any protein in living cells. Automated image analysis methods for detecting and following fluorescently labeled particles over time (Table 15.2) are becoming indispensable in order to take full advantage of the image data acquired from such studies [3].

### 15.4.2.1 Particle Detection

In fluorescence microscopy imaging, the particles of interest are never observed directly, but their position is revealed indirectly by the fluorescent molecules attached to them. Typically these fluorophores are cylindrically shaped molecules having a length and diameter on the order of a few nanometers. In most experimental cases it is unknown how many fluorescent molecules are actually attached to the particles of interest. Commonly, however, a fluorescently labeled particle will be much smaller than the optical resolution of the imaging system. Even though recent advances in light microscopy have led to significantly improved resolution [71], most confocal microscopes currently in use today can resolve about 200 nm laterally and around 600 nm axially. Therefore, fluorescently labeled particles effectively act as point sources of light, and they appear in the images as diffraction-limited spots, also called *foci*.

From several recent studies [26, 27] it follows that localization accuracy of single particles and the resolvability of multiple particles depend on a number of factors. If magnification and spatial sampling are properly matched to satisfy the Nyquist sampling criterion, the limiting factor is the SNR, or effectively the photon count, with higher photon counts yielding greater accuracy and resolvability. The consensus emerging from these studies is that a localization accuracy for single particles of around 10 nm is achievable in practice. Estimation of the distance between two particles is possible with reasonable levels of accuracy for distances of about 50 nm and larger. Smaller distances can be resolved, but with rapidly decreasing accuracy. In order to improve accuracy in such cases, the number of detected photons would have to be increased substantially, which typically is not possible in time-lapse imaging experiments without causing excessive photobleaching.

A number of approaches to particle detection and localization exist. Similar to cell segmentation, the simplest approach to discriminate between objects and background is to apply intensity thresholding. The localization of a particle is often accomplished by computing the local centroid, or center of intensity,

of image elements with intensity values above a certain threshold [9, 18, 72–74]. Clearly such threshold-based detection and localization will be successful only in cases of very limited photobleaching, unless some form of time-adaptive thresholding is used. More robustness can be expected from using the intensity profile of an imaged particle in one frame in a template-matching process to detect the same particle in subsequent frames [75, 76]. This approach can be taken one step further by using a fixed template representing the theoretical profile of a particle. In the case of diffraction-limited particles, this profile is simply the psf of the microscope, which is often approximated in practice by the Gaussian function [77–79]. Extensions of this approach involving Gaussian mixture model fitting has been used for detecting multiple closely spaced particles simultaneously [11, 80]. For larger particles with varying shapes and sizes, detection schemes using wavelet-based multiscale products have been used successfully [81, 82].

In a recent study [83], several common algorithms to particle detection and localization were compared quantitatively, as a function of SNR and object diameter, in terms of both accuracy (determinate errors or bias) and precision (indeterminate errors). The algorithms included two threshold-based centroid detection schemes, Gaussian fitting, and template matching using normalized cross-correlation or the sum of absolute differences as similarity measures. It was concluded that for particles with diameter less than the illumination wavelength, Gaussian fitting is the best approach, by several criteria. For particles having much larger diameter, cross-correlation-based template matching appears to be the best choice. It was also concluded that the SNR constitutes the limiting factor of algorithm performance. As a rule of thumb, the SNR should be at least 5 in order to achieve satisfactory results using these algorithms. Subsequent evaluation studies [84] even mentioned SNR values of 10 and higher. Since such levels are quite optimistic in practice, especially in time-lapse imaging experiments, the quest for more robust detection schemes is likely to continue for some time to come.

### 15.4.2.2  Particle Association

Similar to cell association, the simplest approach to particle association is to use a nearest-neighbor criterion, based on spatial distance [9, 15, 72, 73, 78, 85]. While this may work well in specimens containing very limited numbers of well-spaced particles, it will fail to yield unambiguous results in cases of higher particle densities. In order to establish the identity of particles from frame to frame in such cases, additional cues are required. When tracking subresolution particles, for example, the identification may be improved by taking into account intensity and spatiotemporal features (such as velocity and acceleration) that have been estimated in previous frames [77, 31, 86]. Larger particles may also be distinguished by using spatial features such as size, shape, and

orientation [74]. In the limit, matching a large number of spatial features is similar to performing template matching [11, 18].

Rather than finding the optimal match for each particle on a frame-by-frame basis, the temporal association problem can also be solved in a more global fashion. Such an approach is especially favorable in more complex situations of incomplete or ambiguous data. For example, particles may temporarily disappear, either because they move out of focus for some time or (as in the case of quantum dots) because the fluorescence of the probe is intermittent. For single or well-spaced particles, this problem has been solved by translating the tracking task into a spatiotemporal segmentation task and finding optimal paths through the entire data [33, 87].

The problem becomes more complicated, however, with high particle densities and the possibility of particle interaction. For example, two or more subresolution particles may approach each other so closely at some point in time that they appear as a single spot that cannot be resolved by any detector. Then they may separate at some later time to form multiple spots again. Keeping track of all particles in such cases requires some form of simultaneous association and optimization. Several authors have proposed to solve the problem using graph-theoretic approaches, in which the detected particles and all possible correspondences and their likelihoods together constitute a weighted graph [76, 80, 86, 88]. The subgraph representing the best overall solution is obtained by applying a global optimization algorithm.

Most particle-tracking algorithms published to date are deterministic, in that they make hard decisions about the presence or absence of particles in each image frame and the correspondence of particles between frames. There is now increasing interest in the use of probabilistic approaches to reflect the uncertainty present in the image data [81, 89]. Typically these approaches consist of a Bayesian filtering framework and involve models of object dynamics, to be matched to the data. It has been argued that incorporating assumptions about the kinematics of object motion is risky in biological tracking since little is known about the laws governing that motion, and the purpose of tracking is to deduce this [46]. However, biological investigation is an iterative endeavor, leading to more and more refined models of cellular and molecular structure and function, so it makes sense at each iteration to take advantage of knowledge previously acquired.

## 15.5  Trajectory Analysis

The final stage in any time-lapse microscopy imaging experiment is the analysis of the trajectories resulting from cell or particle tracking, to confirm or reject predefined hypotheses about object dynamics, or to discover new phenomena.

Qualitative analysis by visual inspection of computed trajectories may already give hints about trends in the data, but it usually does not provide much more information than can be obtained by looking directly at the image data itself or projections thereof. Quantitative analyses of the trajectories are required in order to achieve higher sensitivity in data interpretation and to be able to perform statistical tests. Of course, which parameters to measure and analyze depends very much on the research questions underlying a specific experiment. Here we briefly discuss examples of measurements frequently reported in the literature.

## 15.5.1 Geometry Measurements

Once the objects of interest in an image sequence are detected, segmented, and associated, a multitude of measures concerning the geometry of the resulting trajectories as well as of the objects themselves can readily be computed. An example is the maximum relative distance from the initial position that was reached by the object [51, 54, 67]. Other examples are the length of the trajectory (the total distance traveled by the object) and the distance between starting point and end point (the net distance traveled). The latter measures relate to the so-called *McCutcheon index* [47], which is often used in chemotaxis studies to quantify the efficiency of cell movements. It is defined as the ratio between the net distance moved in the direction of increasing chemoattractant concentration and the total distance moved. Derived parameters, such as the directional change per time interval and its autocorrelation [43], are indicative of the directional persistence and memory of a translocating cell. Information about the cell contour or surface at each time point allows the computation of a variety of shape features, such as diameter, perimeter or surface area, area or volume, circularity or sphericity, convexity or concavity [43], and elongation or dispersion [55], and how they change over time.

## 15.5.2 Diffusivity Measurements

A frequently studied parameter, especially in particle-tracking experiments, is the mean square displacement (MSD) [9, 11, 15, 18, 33, 72, 77, 90]. It is a convenient measure to study the diffusion characteristics of individual particles [91–93], and it allows assessment of the viscoelastic properties of the media in which they move [93, 94]. By definition, the MSD is a function of time lag, and the shape of the MSD–time curve for a given trajectory is indicative of the mode of motion of the corresponding particle (Fig 15.4). For example, in the case of normal diffusion by pure thermally driven Brownian motion, the MSD will increase linearly as a function of time, where the diffusion constant determines the slope of the line. In the case of flow or active transport, on the other hand, the MSD will

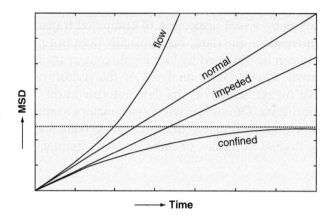

**FIGURE 15.4** Different types of diffusivity characterized by the MSD as a function of time lag. The idealized curves apply to the case of noise-free measurements and consistent object motion. In the case of localization errors and nonconsistent motion, the curves will show offsets and irregularities.

increase more rapidly, and in a nonlinear fashion. The contrary case of anomalous subdiffusion, characterized by a lagging MSD–time curve compared to normal diffusion, occurs if the motion is impeded by obstacles. Confined motion, caused by corrals or tethering or other restrictions, manifests itself by a converging curve, where the limiting MSD value is proportional to the size of the region accessible for diffusion. Mathematically, the MSD is the second-order moment of displacement. A more complete characterization of a diffusion process is obtained by computing higher-order moments of displacement [86, 95].

Some prudence is called for in diffusivity measurements. In isotropic media, where the displacements in each of the three spatial dimensions may be assumed to be uncorrelated, the 2-D diffusion coefficient is equal to the 3-D diffusion coefficient [93]. In practical situations, however, it may be unknown in advance whether isotropy can be assumed. In this context we stress again the importance of experimental verification of one's assumptions [4, 10, 11]. Furthermore, the diffusivity of a particle may depend on its diameter relative to the microstructure of the biological fluid in which it moves. Here, a distinction must be made between microscopic, mesoscopic, and macroscopic diffusion [93]. Also, in the case of normal diffusion, the relation between the slope of the MSD–time line and the diffusion constant strictly holds only for infinite trajectories [91]. The shorter the trajectories, the larger the statistical fluctuations in the diffusivity measurements and the higher the relevance of studying distributions of diffusion constants rather than single values. But even for very long trajectories, apparent subdiffusion patterns may arise at short time scales, caused solely by the uncertainty in particle localization in noisy images [90]. Finally, care must be taken in computing the MSD over an entire trajectory, for it may obscure transitions between diffusive and nondiffusive parts [92].

### 15.5.3 Velocity Measurements

Another commonly studied parameter in time-lapse imaging experiments is velocity [44, 47, 51]. It is computed simply as distance over time. Instantaneous object velocity can be estimated as the distance traveled from one frame to the next divided by the time interval. Average velocity, also referred to as *curvilinear velocity*, is then computed as the sum of the frame-to-frame distances traveled, divided by the total time elapsed. If the temporal sampling rate is constant, this is the same as averaging the instantaneous velocities. The so-called *straight-line velocity*, another type of average velocity, is computed as the distance between the first and last trajectory positions divided by the total elapsed time. The ratio between the latter and the former, known as the *linearity of forward progression* [12, 13, 45], is reminiscent of the McCutcheon index mentioned earlier. Histograms of velocity [19, 47, 85, 88, 91] are often helpful in gaining insight into motion statistics. Object acceleration can also be estimated from velocity, but it is rarely studied [43].

Several cautions are in order regarding velocity estimation. In the case of cell tracking, motion analysis is tricky, due to the possibility of morphological changes over time. Often, to circumvent the problem, a center position is tracked [12, 13, 44, 45]. In the case of highly plastic cells, however, centroid-based velocity measurements can be very deceptive [43]. For example, an anchored cell may extend and retract pseudopods, thereby continuously changing its centroid position and generating significant centroid velocity while the cell is not actually translocating. In the contrary case, a cell may spread in all directions at high velocity in response to some stimulant while the cell centroid position remains essentially unchanged. Another caution concerns the accuracy of velocity estimation in relation to the temporal sampling rate [43]. The higher this rate, the more detailed are the movements captured and the closer will the velocity estimates approach the true values. Statistically speaking, as the sampling rate decreases, velocities will, on average, be increasingly underestimated.

## 15.6 Sample Algorithms

In the previous section we discussed existing methodologies for cell and particle tracking. In order to illustrate the intricacies of the tracking problem and some of the solutions that have been proposed, we now describe two specific algorithms in more detail, one for cell-tracking and one for particle-tracking applications. Both are based on the use of models, and they represent the currently most promising, but necessarily more involved, cell- and particle-tracking approaches.

## 15.6.1   Cell Tracking

Possibly the most extensively studied approach to image segmentation in recent years is the use of level-set methods [63]. These methods have also been explored for cell segmentation and tracking [56, 57, 96], with promising results. Most classical model–based approaches involve cumbersome explicit representations of objects by marker points and parametric contours or surfaces [62, 97]. In contrast, level-set methods conveniently define object boundaries, in an implicit way, as the zero level set of a scalar function, denoted by $\varphi(.)$ here. This level-set function is defined such that $\varphi(\mathbf{x}) > 0$ when $\mathbf{x}$ lies inside the object, $\varphi(\mathbf{x}) < 0$ when $\mathbf{x}$ is outside the object, and $\varphi(\mathbf{x}) = 0$ at the object boundary, where $\mathbf{x}$ denotes position within the image domain. The important advantages of this representation over explicit representations are its topological flexibility and its ability to handle data of any dimensionality without the need for dedicated modifications.

The idea of level-set-based image segmentation is to evolve the level-set function $\varphi(.)$ iteratively so as to minimize a predefined energy functional. In principle, it is possible to define $\varphi(.)$ in such a way that its zero level includes the boundaries of all objects of interest in the image and to evolve these boundaries concurrently by evolving this single function. However, in order to have better control over the interaction between object boundaries when segmenting multiple cells and to conveniently keep track of individual cells, it is advisable to define a separate level-set function, $\varphi_i(.)$, for each object, $i = 1, \ldots, N$. Using this approach, we can define the energy functional as

$$
\begin{aligned}
E(\varphi_1, \ldots, \varphi_N) = \int_\Omega \sum_{i=1}^{N} &\left[ \alpha\delta(\varphi_i(\mathbf{x}))|\nabla\varphi_i(\mathbf{x})| + H(\varphi_i(\mathbf{x}))e_i(\mathbf{x}) \right. \\
&\left. + e_0(\mathbf{x})\frac{1}{N}\prod_{j=1}^{N}(1 - H(\varphi_j(\mathbf{x}))) + \gamma\sum_{i<j} H(\varphi_i(\mathbf{x}))H(\varphi_j(\mathbf{x})) \right] d\mathbf{x}
\end{aligned}
$$

$$(15.1)$$

where $\delta(.)$ is the Dirac delta function, $H(.)$ denotes the Heaviside step function, $\alpha$ and $\gamma$ are positive parameters, the integral is over the entire image domain, denoted by $\Omega$, and the $e_i(.)$ are object energy functions, with $e_0(.)$ denoting the background energy function. The model-based aspect of the level-set approach lies primarily in the latter functions.

The core of this equation consists of four terms, each with an intuitive meaning. The first, with weight $\alpha$, boils down to the size of the object boundary (contour length in 2-D and surface area in 3-D). The second term adds energy values for positions inside the boundary, the third is the total background energy, and the fourth, with weight $\gamma$, is a penalty term for overlapping

boundaries. The formula for iterative evolution of the level-set functions corresponding to the $N$ objects follows from the Euler–Lagrange equations associated with the minimization of the functional in Eq. 15.1:

$$\partial\varphi_i(\mathbf{x}) = \delta(\varphi_i(\mathbf{x}))\left[\alpha\nabla\cdot\frac{\nabla\varphi_i(\mathbf{x})}{|\nabla\varphi_i(\mathbf{x})|} - e_i(\mathbf{x}) + e_0(\mathbf{x})\prod_{j\neq i}(1 - H(\varphi_j(\mathbf{x})))\right.$$

$$\left. - \gamma\sum_{j\neq i}H(\varphi_j(\mathbf{x}))\right]\partial\tau \qquad\qquad (15.2)$$

where $\partial\tau$ denotes the step size in artificial (evolution) time, that is, for segmentation carried out within a single image frame, not to be confused with the real-time interval between image frames. Once the energy functional is minimized, and thus a segmentation (boundary) has been obtained for a given image frame, the resulting level-set functions can be used to compute any morphological feature of interest and can also serve as initialization for the minimization procedure for the next image frame.

In summary, the main steps of a level-set-based tracking algorithm and the associated points of attention concerning its application to multiple cell tracking in time-lapse microscopy are:

1. Define the object and background energy functions, $e_i(.)$ and $e_0(.)$, respectively. These functions mathematically describe the deviation of object and background features from their desired values. This allows one to incorporate prior knowledge about cell and background appearance. In practice, it often suffices to model appearance in terms of simple image statistics, such as the deviation from the mean intensity within the cell or background, and intensity variance.

2. Specify the parameters $\alpha$ and $\gamma$. These determine the influence of the boundary-magnitude and overlap-penalty terms, respectively, relative to the object and background energy terms in the total energy functional (Eq. 15.1), and are necessarily application dependent. Optimal values for these parameters will have to be obtained by experimentation.

3. Segment the first image of the sequence. This is done by defining a single level-set function $\varphi(.)$ and evolving it according to the single-object version of Eq. 15.2 until it converges. Since proper initialization is crucial to achieving fast convergence and arriving at the global optimum, the initial level-set function chosen must be as close as possible to the true boundaries. For example, one could apply a simple segmentation scheme and initialize $\varphi(.)$ based on that outcome.

4. Initialize the level-set functions in the first image of the sequence. Cell objects are obtained by finding connected components in the segmentation resulting from step 3. For each detected object $O_i$, a level-set function $\varphi_i(.)$ is computed from the signed distance function applied to the boundaries of $O_i$, with positive values inside and negative values outside $O_i$.

5. Evolve the level-set functions $\varphi_i(.)$ concurrently according to Eq. 15.2 until convergence. The time step $\partial\tau > 0$ in the discretized version of the evolution equation should be chosen with care. Values too small may cause unnecessarily slow convergence. Conversely, values too large may cause object boundaries to be missed. In practice, values between 0.01 and 0.1 give satisfactory results. To speed up the computations, one could choose to update the level-set functions only for positions $\mathbf{x}$ in a narrow band around the current zero level sets, for which $\varphi_i(\mathbf{x}) = 0$.

6. Detect incoming and dividing cells. An additional level-set function could be used to detect cells that enter the field of view from the boundaries of the image. Cell division could be detected by monitoring cell shape over time. Drastic morphological changes are indicative of approaching division. If, just after such an event, a level-set function contains two disconnected components, one could decide to replace the function with two new level-set functions.

7. Initialize the level-set functions for the next frame of the sequence. This can be done simply by taking the functions from the previous frame. Notice that in order for this approach to work in practice, cells should not move more than their diameter from one frame to the next. To prevent the level-set functions from becoming too flat, it may be advantageous to reinitialize them to the signed distance to their zero level after a fixed number of iterations.

8. Repeat steps 5–7 until all frames of the image sequence are processed. The resulting level-set functions $\varphi_i(.)$ as a function of real time enable estimation of the position and morphology of the corresponding cells for each frame in the sequence.

Sample results with specific implementations of this cell-tracking algorithm [56, 96] applied to the tracking of the nuclei of proliferating HeLa and Madin–Darby canine kidney (MDCK) cells are shown in Fig. 15.5. The examples illustrate the ability of the algorithm to yield plausible contours even in the presence of considerable object noise and strongly varying intensities, as caused, for example, by photobleaching in the case of FRAP experiments. The renderings demonstrate the ability of the algorithm to keep track of cell division.

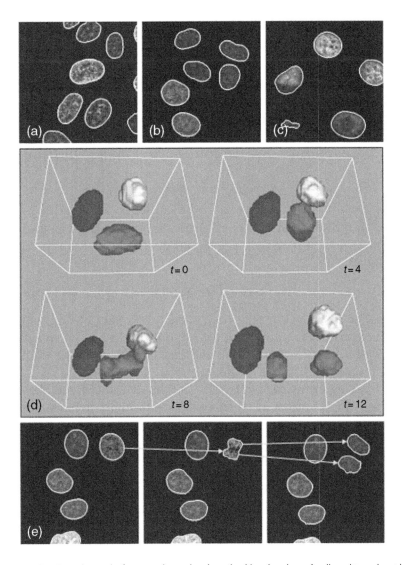

**FIGURE 15.5** Sample results from applying the described level set based cell-tracking algorithm. (a–c) Segmentations (white contours) for arbitrary frames taken from three different 2-D+t image sequences. The examples illustrate the ability of the algorithm to yield plausible contours even in the presence of considerable object noise and strongly varying intensities, as caused, for example, by photobleaching in the case of FRAP experiments. (d) Visualization of segmented surfaces of cell nuclei in four frames of a 3-D+t image sequence. The renderings demonstrate the ability of the algorithm to keep track of cell division. (e) Illustration of tracking cell division in a 2-D+t image sequence. (Images a, b, c, e courtesy of G van Cappellen.)

## 15.6.2 Particle Tracking

An interesting and promising approach to particle tracking is to cast the temporal association problem into a Bayesian estimation problem [81, 89]. In general, Bayesian tracking deals with the problem of inferring knowledge

about the true state of a dynamic system based on a sequence of noisy measurements or observations. The state vector, denoted by $\mathbf{x}_t$, contains all relevant information about the system at any time $t$, such as position, velocity, acceleration, intensity, and shape features. Bayesian filtering consists of recursive estimation of the time-evolving posterior probability distribution $p(\mathbf{x}_t \mid \mathbf{z}_{1:t})$ of the state $\mathbf{x}_t$, given all measurements up to time $t$, denoted as $\mathbf{z}_{1:t}$. Starting with an initial prior distribution, $p(\mathbf{x}_0 \mid \mathbf{z}_0)$, with $\mathbf{z}_0 = \mathbf{z}_{1:0}$ being the set of no measurements, the filtering first predicts the distribution at the next time step:

$$p(\mathbf{x}_t \mid \mathbf{z}_{1:t-1}) = \int D(\mathbf{x}_t \mid \mathbf{x}_{t-1}) p(\mathbf{x}_{t-1} \mid \mathbf{z}_{1:t-1}) d\mathbf{x}_{t-1} \qquad (15.3)$$

based on a Markovian model, $D(\mathbf{x}_t \mid \mathbf{x}_{t-1})$, for the evolution of the state from time $t-1$ to time $t$. Next, it updates the posterior distribution of the current state by applying Bayes' rule,

$$p(\mathbf{x}_t \mid \mathbf{z}_{1:t}) \propto L(\mathbf{z}_t \mid \mathbf{x}_t) p(\mathbf{x}_t \mid \mathbf{z}_{1:t-1}) \qquad (15.4)$$

using a likelihood, $L(\mathbf{z}_t \mid \mathbf{x}_t)$, that models the probability of observing $\mathbf{z}_t$ given state $\mathbf{x}_t$. The power of this approach lies not only in the use of explicit dynamics and observation models, but also in the fact that at any time $t$, all available information up to that time is exploited.

The foregoing recurrence relations are analytically tractable only in a restricted set of cases, such as when dealing with linear dynamic systems and Gaussian noise, for which an optimal solution is provided by the so-called *Kalman filter*. In most biological imaging applications, where the dynamics and noise can be expected to be nonlinear and non-Gaussian, efficient numerical approximations are provided by sequential Monte Carlo (SMC) methods, such as the *condensation algorithm* [98]. In that case, the posterior distribution is represented by $N_s$ random state samples and associated weights:

$$p(\mathbf{x}_t \mid \mathbf{z}_{1:t}) \approx \sum_{i=1}^{N_s} w_t^{(i)} \delta\left(\mathbf{x}_t - \mathbf{x}_t^{(i)}\right) \qquad (15.5)$$

where $\delta(.)$ is the Dirac delta function and the weights $w_t^{(i)}$ of the state samples $\mathbf{x}_t^{(i)}$ sum to 1. The problem of tracking large numbers of objects using this framework is conveniently solved by representing the filtering distribution by an $M$-component mixture model:

$$p(\mathbf{x}_t \mid \mathbf{z}_{1:t}) = \sum_{m=1}^{M} \omega_{m,t} p_m(\mathbf{x}_t \mid \mathbf{z}_{1:t}) \qquad (15.6)$$

where the weights $\omega_{m,t}$ of the components $p_m$ sum to 1, the total number of samples is $N = MN_s$, and each sample is augmented with a component label denoted by $c_t^{(i)}$, with $c_t^{(i)} = m$ if state sample $i$ belongs to mixture component $m$. This representation is updated in the same fashion as the single-object case. At each time step, statistical inferences about the state, such as the expected value or the maximum a posteriori (MAP) or minimum mean square error (MMSE) values, can easily be approximated from the weighted state samples for each object.

In summary, the main steps of an SMC-based tracking algorithm and the associated points of attention concerning its application to multiple particle tracking in time-lapse microscopy are:

1. Define the state vector $\mathbf{x}_t$. In most experimental situations it will be sufficient to include position $(x_t, y_t, z_t)$, velocity $(v_{x,t}, v_{y,t}, v_{z,t})$, acceleration $(a_{x,t}, a_{y,t}, a_{z,t})$, and intensity $(I_t)$.

2. Define the state evolution model $D(\mathbf{x}_t \,|\, \mathbf{x}_{t-1})$. This model mathematically describes the probability of a particle to jump from the previous state $\mathbf{x}_{t-1}$ to state $\mathbf{x}_t$. It allows one to incorporate prior knowledge about the dynamics of the objects to be tracked and is therefore necessarily application dependent. An example of such a model is the Gaussian weighted deviation of $\mathbf{x}_t$ from the expected state at time $t$ based on $\mathbf{x}_{t-1}$ (for instance, expected position at time $t$ based on velocity at time $t-1$ and expected velocity at $t$ based on acceleration at $t-1$). This framework also permits the use of multiple interacting models to deal with different types of motion concurrently (such as random walk, or directed movement, with constant or changing velocity). Notice that having $I_t$ as part of the state vector also allows one to model the evolution of particle intensity (photobleaching).

3. Define the observation model $L(\mathbf{z}_t \,|\, \mathbf{x}_t)$. This model mathematically describes the likelihood or probability of measuring state $\mathbf{z}_t$ from the data, given the true state $\mathbf{x}_t$. It allows one to incorporate knowledge about the imaging system, in particular the psf, as well as additional, static object information, such as morphology. Such a model could, for example, be defined as the Gaussian weighted deviation of the total measured intensity in a neighborhood around $\mathbf{x}_t$, from the expected total intensity based on a shape model of the imaged objects and from the background intensity, taking into account the noise levels in the object and the background.

4. Specify the prior state distribution $p(\mathbf{x}_0 \,|\, \mathbf{z}_0)$. This can be based on information available in the first frame. For example, one could apply

a suitable detection scheme to localize the most prominent particles and, for each detected particle, add a Gaussian-shaped mixture component $p_m$ with weight $\omega_{m,0}$ proportional to size or intensity. Each component is then sampled $N_s$ times to obtain state samples $\mathbf{x}_t^{(i)}$ and associated weights $w_t^{(i)}$ for that component. The detection step does not need to be very accurate because false positives will be filtered out rapidly as the system evolves.

5. Use the posterior state distribution $p(\mathbf{x}_{t-1} \mid \mathbf{z}_{1:t-1})$ at time $t-1$ to compute the predicted state distribution $p(\mathbf{x}_t \mid \mathbf{z}_{1:t-1})$ at time $t$ according to Eq. 15.3, and subsequently use this prediction to compute the updated posterior state distribution $p(\mathbf{x}_t \mid \mathbf{z}_{1:t})$ according to Eq. 15.4. Effectively this is done by inserting each sample $\mathbf{x}_{t-1}^{(i)}$, $i = 1, \ldots, N$, into the state evolution model, taking a new sample from the resulting probability density function to obtain $\mathbf{x}_t^{(i)}$, and computing the associated weight $w_t^{(i)}$ from $w_{t-1}^{(i)}$ based on the likelihood and dynamics models and an auxiliary importance function. A penalty function can be used to regulate particle coincidence.

6. Update the sample component labels $c_t^{(i)}$. This step is necessary if particle-merging and -splitting events are to be captured. It involves the application of a procedure to recluster the state samples from the $M$ mixture components to yield $M'$ new components. This procedure can be implemented in any convenient way, and it allows one to incorporate prior knowledge about merging and splitting events. In the simplest case one could apply a $K$-means clustering algorithm.

7. Update the mixture component set and the corresponding weights $\omega_{m,t}$. To determine whether particles have appeared or disappeared at any time $t$, one could apply some detection scheme as in step 4 to obtain a particle probability map and compare this map to the current particle distribution, as follows from the posterior $p(\mathbf{x}_t \mid \mathbf{z}_{1:t})$. For each appearing particle, a new mixture component is added with predefined initial weight $\omega_b$. Components with weights below some threshold $\omega_d$ are assumed to correspond to disappearing particles and are removed from the mixture. The weights $\omega_{m,t}$ are computed from the $\omega_{m,t-1}$ and the weights $w_t^{(i)}$ of the state samples.

8. Repeat steps 5–7 until all frames of the image sequence are processed. The resulting posterior state distributions $p_m(\mathbf{x}_t \mid \mathbf{z}_{1:t})$ enable estimation of the states of the corresponding particles at any $t$.

Sample results with a specific implementation of this algorithm [89] applied to the tracking of microtubule plus-ends in the cytoplasm and androgen receptor proteins in the cell nucleus are shown in Fig. 15.6. This example illustrates the ability of the algorithm to deal with photobleaching, to capture newly appearing

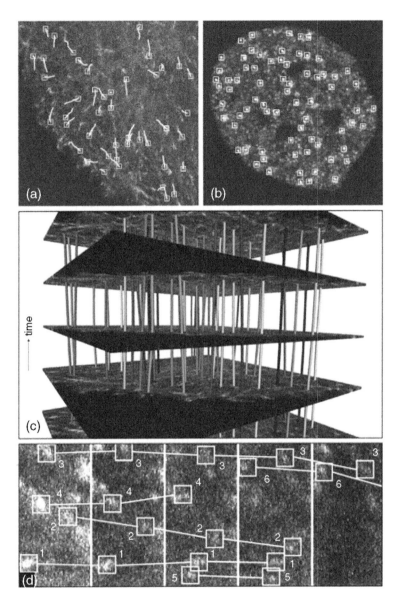

**FIGURE 15.6** Sample results from applying the described SMC-based particle-tracking algorithm. (a and b) Estimated current locations (white squares) and trajectories (white curves) up to the current time, for the most prominent particles in an arbitrary frame from the 2-D+t image sequences shown in Figs. 15.1a and 15.1b, respectively. The trajectories in B are due to Brownian motion and are therefore strongly confined. (c) Artistic rendering of the trajectories linking multiple frames of data set (a). (d) Illustration of the capability of the algorithm to deal with photobleaching, to capture newly appearing particles, to detect particle disappearance, and to handle closely passing particles.

particles, to detect particle disappearance, and to handle closely passing particles. Experiences with an alternative but related Bayesian filtering algorithm [81] applied to the tracking of cytoplasmic and nuclear HIV-1 complexes can be found in [99].

## 15.7  Summary of Important Points

In this chapter we have sketched the current state of the art in time-lapse microscopy imaging, in particular cell and particle tracking, from the perspective of automated image processing and analysis. While it is clear that biological investigation is relying increasingly on computerized methods, it also follows that such methods are still very much in their infancy. Although there is a growing consensus about the strengths and weaknesses of specific approaches, there is currently no single best solution to the problem in general. On the contrary, the main conclusion emerging from the literature is that, with currently available image processing and analysis methodologies, any given tracking application requires its own dedicated algorithms to achieve acceptable results.

1. Living cells are sensitive to photodamage and require economizing of the light exposure.

2. Success rates of automated image analysis generally increase with increasing SNR.

3. Time-lapse microscopy requires trading off SNR against spatial and temporal resolution.

4. Biological processes occur in 3-D+t and should preferably be studied as such.

5. Studies in 2-D + t should be accompanied by 3-D + t experiments to confirm their validity.

6. Sampling theory applies not only to sampling in space but also to sampling in time.

7. Nonlinear filtering methods allow reducing noise while preserving strong gradients (edges).

8. Deconvolution of time-lapse microscopy imaging data is not always necessary.

9. Object motion is often a superposition of global and local displacements.

10. Global motion can be corrected by image registration.

11. Object tracking requires dedicated detection, segmentation, and association methods.

12. Optic flow methods can be used to compute collective cell motion and particle flows.

13. Image intensity thresholding alone is generally not adequate for segmentation.

14. Template matching works best for objects that do not change shape significantly as they move.

15. Watershed-based segmentation requires careful pre- and postprocessing strategies.

16. Deformable models allow easy use of both image information and prior knowledge.

17. By design, deformable models are very suitable for capturing morphodynamics.

18. Implicitly defined models are generally more flexible than explicitly defined models.

19. In fluorescence microscopy, objects are observed only indirectly, via fluorescent probes.

20. Fluorescent (nano)particles act as point light sources and appear as psf-shaped spots.

21. Particle localization accuracy and resolvability depend strongly on photon count.

22. For single particles, a localization accuracy of about 10 nm is achievable in practice.

23. Two particles are resolvable with reasonable accuracy for separation distances greater than 50 nm.

24. Gaussian fitting is most suitable for detecting particles with diameter less than one wavelength.

25. Template matching is most suitable for detecting particles with diameter of several wavelengths.

26. For most particle detection methods, the SNR must be greater than 5 to achieve satisfactory results.

27. Reliable temporal association usually requires the use of more criteria than just spatial distance.

28. Tracking of many closely spaced particles requires some form of joint association.

29. Probabilistic tracking methods reflect the uncertainty in the image data.

30. Models of object dynamics are helpful in tracking but should be used with care.

31. Displacement moments provide detailed information about diffusion characteristics.

32. The shape of the MSD–time curve of an object is indicative of its mode of motion.

33. In isotropic media, the 2-D diffusion coefficient is equal to the 3-D diffusion coefficient.

34. Distinction must be made between microscopic, mesoscopic, and macroscopic diffusion.

35. Short trajectories show large statistical fluctuations in diffusivity measurements.

36. Subdiffusive patterns at short time scales may be due to noise in particle localization.

37. Computing the MSD over entire trajectories may obscure transitions in diffusivity.

38. Different velocity measures result from considering different distance measures.

39. Centroid-based velocity measurements can be very deceptive in cell tracking.

40. Velocities are increasingly underestimated with decreasing temporal resolution.

# References

1. RY Tsien, "Imagining Imaging's Future," *Nature Cell Biology* **5**:S16–S21, 2003.
2. C Vonesch et al., "The Colored Revolution of Bioimaging," *IEEE Signal Processing Magazine*, **23**(3):20–31, 2006.

3. E Meijering, I Smal, and G Danuser, "Tracking in Molecular Bioimaging," *IEEE Signal Processing Magazine*, **23**(3):46–53, 2006.

4. C Zimmer et al., "On the Digital Trail of Mobile Cells," *IEEE Signal Processing Magazine*, **23**(3):54–62, 2006.

5. JB Pawley (ed.), *Handbook of Biological Confocal Microscopy*, 3rd ed., Springer, 2006.

6. RF Murphy, E Meijering, and G Danuser, "Special Issue on Molecular and Cellular Bioimaging," *IEEE Transactions on Image Processing*, **14**(9):1233–1236, 2005.

7. D Gerlich and J Ellenberg, "4-D Imaging to Assay Complex Dynamics in Live Specimens," *Nature Cell Biology,* **5**:S14–S19, 2003.

8. D J Stephens and VJ Allan, "Light Microscopy Techniques for Live-Cell Imaging," *Science*, **300**(5616):82–86, 2003.

9. D Li et al., "Three-Dimensional Tracking of Single Secretory Granules in Live PC12 Cells," *Biophysical Journal*, **87**(3):1991–2001, 2004.

10. DJ Webb and AF Horwitz, "New Dimensions in Cell Migration," *Nature Cell Biology*, **5**(8):690–692, 2003.

11. JF Dorn et al., "Yeast Kinetochore Microtubule Dynamics Analyzed by High-Resolution Three-Dimensional Microscopy," *Biophysical Journal*, **89**(4):2835–2854, 2005.

12. DF Katz et al., "Real-Time Analysis of Sperm Motion Using Automatic Video Image Digitization," *Computer Methods and Programs in Biomedicine*, **21**(3):173–182, 1985.

13. SO Mack, DP Wolf, and JS Tash, "Quantitation of Specific Parameters of Motility in Large Numbers of Human Sperm by Digital Image Processing," *Biology of Reproduction*, **38**(2):270–281, 1988.

14. LJ van Vliet, D Sudar, and IT Young, "Digital Fluorescence Imaging Using Cooled CCD Array Cameras," in *Cell Biology: A Laboratory Handbook*, vol. III, J. E. Celis, ed., Academic Press, pp. 109–120, 1998.

15. M Goulian and SM Simon, "Tracking Single Proteins within Cells," *Biophysical Journal*, **79**(4):2188–2198, 2000.

16. C Wählby et al., "Combining Intensity, Edge and Shape Information for 2-D and 3-D Segmentation of Cell Nuclei in Tissue Sections," *Journal of Microscopy*, **215**(1):67–76, 2004.

17. D Gerlich, J Mattes, and R Eils, "Quantitative Motion Analysis and Visualization of Cellular Structures," *Methods*, **29**(1):3–13, 2003.

18. H Bornfleth et al., "Quantitative Motion Analysis of Subchromosomal Foci in Living Cells Using Four-Dimensional Microscopy," *Biophysical Journal*, **77**(5):2871–2886, 1999.

19. D Uttenweiler et al., "Spatiotemporal Anisotropic Diffusion Filtering to Improve Signal-to-Noise Ratios and Object Restoration in Fluorescence Microscopic Image Sequences," *Journal of Biomedical Optics*, **8**(1):40–47, 2003.

20. W Tvaruskó et al., "Time-Resolved Analysis and Visualization of Dynamic Processes in Living Cells," *Proceedings of the National Academy of Sciences of the United States of America*, **96**(14):7950–7955, 1999.

21. P Perona and J Malik, "Scale-Space and Edge Detection Using Anisotropic Diffusion," *IEEE Transactions on Pattern Analysis and Machine Intelligence*, **12**(7):629–639, 1990.

22. ST Acton, K Wethmar, and K Ley, "Automatic Tracking of Rolling Leukocytes in vivo," *Microvascular Research*, **63**(1):139–148, 2002.

23. MB Cannell, A McMorland, and C Soeller, "Image Enhancement by Deconvolution," in *Handbook of Biological Confocal Microscopy*, JB Pawley, ed., Springer, 2006.

24. P Sarder and A Nehorai, "Deconvolution Methods for 3-D Fluorescence Microscopy Images," *IEEE Signal Processing Magazine*, **23**(3):32–45, 2006.

25. TJ Holmes, D Biggs, and A Abu-Tarif, "Blind Deconvolution," in *Handbook of Biological Confocal Microscopy*, Ch. 24, JB Pawley, ed., pp. 468–487, 2006.

26. F Aguet, D Van De Ville, and M Unser, "A Maximum-Likelihood Formalism for Subresolution Axial Localization of Fluorescent Nanoparticles," *Optics Express*, **13**(26):10503–10522, 2005.

27. S Ram, ES Ward, and RJ Ober, "Beyond Rayleigh's Criterion: A Resolution Measure with Application to Single-Molecule Microscopy," *Proceedings of the National Academy of Sciences of the United States of America*, **103**(12):4457–4462, 2006.

28. E Eden et al., "An Automated Method for Analysis of Flow Characteristics of Circulating Particles from in vivo Video Microscopy," *IEEE Transactions on Medical Imaging*, **24**(8):1011–1024, 2005.

29. AP Goobic, J Tang, and ST Acton, "Image Stabilization and Registration for Tracking Cells in the Microvasculature," *IEEE Transactions on Biomedical Engineering*, **52**(2): 287–299, 2005.

30. Y Sato et al., "Automatic Extraction and Measurement of Leukocyte Motion in Microvessels Using Spatiotemporal Image Analysis," *IEEE Transactions on Biomedical Engineering*, **44**(4):225–236, 1997.

31. CP Bacher et al., "4-D Single Particle Tracking of Synthetic and Proteinaceous Microspheres Reveals Preferential Movement of Nuclear Particles Along Chromatin-Poor Tracks," *BMC Cell Biology*, **5**(45):1–14, 2004.

32. B Rieger et al., "Alignment of the Cell Nucleus from Labeled Proteins only for 4-D in vivo Imaging," *Microscopy Research and Technique*, **64**(2):142–150, 2004.

33. D Sage et al., "Automatic Tracking of Individual Fluorescence Particles: Application to the Study of Chromosome Dynamics," *IEEE Transactions on Image Processing*, **14**(9): 1372–1383, 2005.

34. JV Hajnal, DLG Hill, and DJ Hawkes, *Medical Image Registration*, CRC Press, 2001.

35. JPW Pluim, JBA Maintz, and MA Viergever, "Mutual-Information-Based Registration of Medical Images: A Survey," *IEEE Transactions on Medical Imaging*, **22**(8):986–1004, 2003.

36. D Gerlich et al., "Four-Dimensional Imaging and Quantitative Reconstruction to Analyze Complex Spatiotemporal Processes in Live Cells," *Nature Cell Biology*, **3**(9): 852–855, 2001.

37. CÓS Sorzano, P Thévenaz, and M Unser, "Elastic Registration of Biological Images Using Vector-Spline Regularization," *IEEE Transactions on Biomedical Engineering*, **52**(4):652–663, 2005.

38. G Rabut and J Ellenberg, "Automatic Real-Time Three-Dimensional Cell Tracking by Fluorescence Microscopy," *Journal of Microscopy*, **216**(2):131–137, 2004.

39. T Ragan et al., "3-D Particle Tracking on a Two-Photon Microscope," *Journal of Fluorescence*, **16**(3):325–336, 2006.

40. F Germain et al., "Characterization of Cell Deformation and Migration Using a Parametric Estimation of Image Motion," *IEEE Transactions on Biomedical Engineering*, **46**(5):584–600, 1999.

41. K Miura, "Tracking Movement in Cell Biology," in *Advances in Biochemical Engineering/Biotechnology: Microscopy Techniques*, J. Rietdorf, ed., Springer-Verlag, Berlin, 2005.

42. D Dormann and CJ Weijer, "Imaging of Cell Migration," *EMBO Journal*, **25**(15):3480–3493, 2006.

43. DR Soll, "The Use of Computers in Understanding How Animal Cells Crawl," *International Review of Cytology*, **163**:43–104, 1995.

44. ZN Demou and LV McIntire, "Fully Automated Three-Dimensional Tracking of Cancer Cells in Collagen Gels: Determination of Motility Phenotypes at the Cellular Level," *Cancer Research*, **62**(18):5301–5307, 2002.

45. ST Young et al., "Real-Time Tracing of Spermatozoa," *IEEE Engineering in Medicine and Biology Magazine*, **15**(6):117–120, 1996.

46. V Awasthi et al., "Cell Tracking Using a Distributed Algorithm for 3-D Image Segmentation," *Bioimaging*, **2**(2):98–112, 1994.

47. RM Donovan et al., "A Quantitative Method for the Analysis of Cell Shape and Locomotion," *Histochemistry*, **84**(4–6):525–529, 1986.

48. NN Kachouie et al., "Probabilistic Model-Based Cell Tracking," *International Journal of Biomedical Imaging*, **2006**(12186):1–10, 2006.

49. D Young et al., "Towards Automatic Cell Identification in DIC Microscopy," *Journal of Microscopy*, **192**(2):186–193, 1998.

50. V Grau et al., "Improved Watershed Transform for Medical Image Segmentation Using Prior Information," *IEEE Transactions on Medical Imaging*, **23**(4):447–458, 2004.

51. C De Hauwer et al., "In vitro Motility Evaluation of Aggregated Cancer Cells by Means of Automatic Image Processing," *Cytometry*, **36**(1):1–10, 1999.

52. G Lin et al., "A Hybrid 3D Watershed Algorithm Incorporating Gradient Cues and Object Models for Automatic Segmentation of Nuclei in Confocal Image Stacks," *Cytometry*, **56A**(1):23–36, 2003.

53. X Yang, H Li, and X Zhou, "Nuclei Segmentation Using Marker-Controlled Watershed, Tracking Using Mean-Shift, and Kalman Filter in Time-Lapse Microscopy," *IEEE Transactions on Circuits and Systems I: Regular Papers*, **53**(11):2405–2414, 2006.

54. O Debeir et al., "A Model-Based Approach for Automated in vitro Cell Tracking and Chemotaxis Analyses," *Cytometry*, **60A**(1):29–40, 2004.

55. D Dormann et al., "Simultaneous Quantification of Cell Motility and Protein-Membrane-Association Using Active Contours," *Cell Motility and the Cytoskeleton*, **52**(4): 221–230, 2002.

56. A Dufour et al., "Segmenting and Tracking Fluorescent Cells in Dynamic 3-D Microscopy with Coupled Active Surfaces," *IEEE Transactions on Image Processing*, **14**(9): 1396–1410, 2005.

57. DP Mukherjee, N Ray, and ST Acton, "Level-Set Analysis for Leukocyte Detection and Tracking," *IEEE Transactions on Medical Imaging*, **13**(4):562–572, 2004.

58. N Ray, ST Acton, and K Ley, "Tracking Leukocytes in vivo with Shape and Size Constrained Active Contours," *IEEE Transactions on Medical Imaging*, **21**(10):1222–1235, 2002.

59. N Ray and ST Acton, "Motion Gradient Vector Flow: An External Force for Tracking Rolling Leukocytes with Shape and Size Constrained Active Contours," *IEEE Transactions on Medical Imaging*, **23**(12):1466–1478, 2004.

60. H Shen et al., "Automatic Tracking of Biological Cells and Compartments Using Particle Filters and Active Contours," *Chemometrics and Intelligent Laboratory Systems*, **82**(1–2):276–282, 2006.

61. C Zimmer et al., "Segmentation and Tracking of Migrating Cells in Videomicroscopy with Parametric Active Contours: A Tool for Cell-Based Drug Testing," *IEEE Transactions on Medical Imaging*, **21**(10):1212–1221, 2002.

62. M Kass, A Witkin, and D Terzopoulos, "Snakes: Active Contour Models," *International Journal of Computer Vision*, **1**(4):321–331, 1988.

63. JA Sethian, *Level-Set Methods and Fast Marching Methods: Evolving Interfaces in Computational Geometry, Fluid Mechanics, Computer Vision, and Materials Science*, Cambridge University Press, 1999.

64. X Chen, X Zhou, and STC Wong, "Automated Segmentation, Classification, and Tracking of Cancer Cell Nuclei in Time-Lapse Microscopy," *IEEE Transactions on Biomedical Engineering*, **53**(4):762–766, 2006.

65. DJEB Krooshoop et al., "An Automated MultiWell Cell Track System to Study Leukocyte Migration," *Journal of Immunological Methods*, **280**(1–2):89–102, 2003.

66. CA Wilson and JA Theriot, "A Correlation-Based Approach to Calculate Rotation and Translation of Moving Cells," *IEEE Transactions on Image Processing*, **15**(7):1939–1951, 2006.

67. O Debeir et al., "Tracking of Migrating Cells Under Phase-Contrast Video Microscopy with Combined Mean-Shift Processes," *IEEE Transactions on Medical Imaging*, **24**(6): 697–711, 2005.

68. F Leymarie and MD Levine, "Tracking Deformable Objects in the Plane Using an Active Contour Model," *IEEE Transactions on Pattern Analysis and Machine Intelligence*, **15**(6):617–634, 1993.

69. N Ray and ST Acton, "Data Acceptance for Automated Leukocyte Tracking Through Segmentation of Spatiotemporal Images," *IEEE Transactions on Biomedical Engineering*, **52**(10):1702–1712, 2005.

70. J Lippincott-Schwartz and GH Patterson, "Development and Use of Fluorescent Protein Markers in Living Cells," *Science*, **300**(5616):87–91, 2003.

71. SW Hell, M Dyba, and S Jakobs, "Concepts for Nanoscale Resolution in Fluorescence Microscopy," *Current Opinion in Neurobiology*, **14**(5):599–609, 2004.

72. J Apgar et al., "Multiple-Particle Tracking Measurements of Heterogeneities in Solutions of Actin Filaments and Actin Bundles," *Biophysical Journal*, **79**(2):1095–1106, 2000.

73. RN Ghosh and WW Webb, "Automated Detection and Tracking of Individual and Clustered Cell Surface Low-Density Lipoprotein Receptor Molecules," *Biophysical Journal*, **66**(5):1301–1318, 1994.

74. SS Work and DM Warshaw, "Computer-Assisted Tracking of Actin Filament Motility," *Analytical Biochemistry*, **202**(2):275–285, 1992.

75. J Gelles, BJ Schnapp, and MP Sheetz, "Tracking Kinesin-Driven Movements with Nanometre-Scale Precision," *Nature*, **331**(6155):450–453, 1988.

76. D Thomann et al., "Automatic Fluorescent Tag Localization II: Improvement in Super-Resolution by Relative Tracking," *Journal of Microscopy*, **211**(3):230–248, 2003.

77. CM Anderson et al., "Tracking of Cell Surface Receptors by Fluoresence Digital Imaging Microscopy Using a Charge-Coupled Device Camera," *Journal of Cell Science*, **101**(2):415–425, 1992.

78. T Kues, R Peters, and U Kubitscheck, "Visualization and Tracking of Single Protein Molecules in the Cell Nucleus," *Biophysical Journal*, **80**(6):2954–2967, 2001.

79. B Zhang, J Zerubia, and JC Olivo-Marin, "Gaussian Approximations of Fluorescence Microscope Point-Spread Function Models," *Applied Optics*, **46**(10):1819–1829, 2007.

80. D Thomann et al., "Automatic Fluorescent Tag Detection in 3-D with Super-Resolution: Application to the Analysis of Chromosome Movement," *Journal of Microscopy*, **208**(1):49–64, 2002.

81. A Genovesio et al., "Multiple Particle Tracking in 3-D+t Microscopy: Method and Application to the Tracking of Endocytosed Quantum Dots," *IEEE Transactions on Image Processing*, **15**(5):1062–1070, 2006.

82. JC Olivo-Marin, "Extraction of Spots in Biological Images Using Multiscale Products," *Pattern Recognition*, **35**(9):1989–1996, 2002.

83. MK Cheezum, WF Walker, and WH Guilford, "Quantitative Comparison of Algorithms for Tracking Single Fluorescent Particles," *Biophysical Journal*, **81**(4):2378–2388, 2001.

84. BC Carter, GT Shubeita, and SP Gross, "Tracking Single Particles: A User-Friendly Quantitative Evaluation," *Physical Biology*, **2**(1):60–72, 2005.

85. SB Marston et al., "A Simple Method for Automatic Tracking of Actin Filaments in the Motility Assay," *Journal of Muscle Research and Cell Motility*, **17**(4):497–506, 1996.

86. IF Sbalzarini and P Koumoutsakos, "Feature Point Tracking and Trajectory Analysis for Video Imaging in Cell Biology," *Journal of Structural Biology*, **151**(2):182–195, 2005.

87. S Bonneau, M Dahan, and L D. Cohen, "Single Quantum Dot Tracking Based on Perceptual Grouping Using Minimal Paths in a Spatiotemporal Volume," *IEEE Transactions on Image Processing*, **14**(9):1384–1395, 2005.

88. P Vallotton et al., "Recovery, Visualization, and Analysis of Actin and Tubulin Polymer Flow in Live Cells: A Fluorescent Speckle Microscopy Study," *Biophysical Journal*, **85**(2):1289–1306, 2003.

89. I Smal, W Niessen, and E Meijering, "Advanced Particle Filtering for Multiple Object Tracking in Dynamic Fluorescence Microscopy Images," *Proceedings of the IEEE International Symposium on Biomedical Imaging: From Nano to Macro*, IEEE, 2007.

90. DS Martin, MB Forstner, and JA Käs, "Apparent Subdiffusion Inherent to Single Particle Tracking," *Biophysical Journal*, **83**(4):2109–2117, 2002.

91. H Qian, MP Sheetz, and EL Elson, "Single Particle Tracking: Analysis of Diffusion and Flow in Two-Dimensional Systems," *Biophysical Journal*, **60**(4):910–921, 1991.

92. MJ Saxton and K Jacobson, "Single-Particle Tracking: Applications to Membrane Dynamics," *Annual Review of Biophysics and Biomolecular Structure*, **26**:373–399, 1997.

93. J Suh, M Dawson, and J Hanes, "Real-Time Multiple-Particle Tracking: Application to Drug and Gene Delivery," *Advanced Drug Delivery Reviews*, **57**(1):63–78, 2005.

94. Y Tseng et al., "Micro-Organization and Visco-Elasticity of the Interphase Nucleus Revealed by Particle Nanotracking," *Journal of Cell Science*, **117**(10):2159–2167, 2004.

95. R Ferrari, AJ Manfroi, and WR Young, "Strongly and Weakly Self-Similar Diffusion," *Physica D*, **154**(1):111–137, 2001.

96. O Dzyubachyk et al., "A Variational Model for Level-Set Based Cell Tracking in Time-Lapse Fluorescence Microscopy Images," in *Proceedings of the IEEE International Symposium on Biomedical Imaging: From Nano to Macro*, IEEE, 2007.

97. T McInerney and D Terzopoulos, "Deformable Models in Medical Image Analysis: A Survey," *Medical Image Analysis*, **1**(2):91–108, 1996.

98. M Isard and A Blake, "CONDENSATION—Conditional Density Propagation for Visual Tracking," *International Journal of Computer Vision*, **29**(1):5–28, 1998.

99. N Arhel et al., "Quantitative Four-Dimensional Tracking of Cytoplasmic and Nuclear HIV-1 Complexes," *Nature Methods* **3**(10):817–824, 2006.

100. J Cui, ST Acton, and Z Lin, "A Monte Carlo Approach to Rolling Leukocyte Tracking in vivo," *Medical Image Analysis,* **10**(4):598–610, 2006.

# 16

# Autofocusing

Qiang Wu

## 16.1 Introduction

With the rapid development in cellular and molecular technology at micro- and nanoscale levels, there is a growing need for high-throughput automatic "walk-away" instruments for microscope imaging. Automated microscopy is used in a wide range of biomedical applications where automatic acquisition of specimen images in unattended operation is required. An essential and indispensable component of automated microscopy is automatic focusing of the microscope. In addition to facilitating automation of imaging, microscope autofocusing enables objective, accurate, and consistent image measurements for quantitative analysis. Fast, accurate, and reliable autofocusing is crucial to high-throughput scanning microscopy applications, where large numbers of specimens must be imaged and analyzed routinely.

### 16.1.1 Autofocus Methods

There are two primary types of autofocus techniques used in automated microscopy instruments. The first type, known as *active focusing*, utilizes active surface sensing of the specimen by directing energy, such as a laser beam, toward the object. These methods measure distance to the object independent of the optics and automatically adjust the optical system for accurate focus. They are fast and can be used for real-time imaging because multiple image captures are not required [1]. However, active methods generally require calibration of the in-focus imaging position with a single surface from which the light

beam is reflected. These requirements are impractical for many biological applications, since specimens typically exhibit variable depth and multiple reflective surfaces [2].

The second type is known as *passive focusing* because it is based only on the analysis of the content of captured images. The in-focus position is determined by searching for the maximum of an autofocus function using measurements from a series of images captured at different focal planes. The passive autofocus methods, albeit slower due to the acquisition time required for capturing multiple images, are not affected by the reflective surfaces of a specimen and therefore are often more suitable for biomedical microscopy applications. In this chapter, we limit our discussion to passive autofocusing methods, since those involve image processing algorithms. Interested readers are referred to [1] for further information on active techniques.

## 16.1.2   Passive Autofocusing

The objective of autofocusing is to locate the $z$-axis position of best image focus. In passive autofocusing this is done by computing an autofocus function at several values of $z$ and taking the position of the largest one. There are a number of ways to compute a value that reflects focal sharpness, and these are discussed here. Similarly there are several different ways to select particular $z$-axis positions at which the focus values are to be computed. It is frequently useful to begin with a coarse search over a wide range and to follow that with a finer search over a narrower range. This process can be facilitated by curve fitting or multiresolution methods. The final selection of the in-focus position can be done by curve fitting, exhaustive search, or using an optimal search technique, such as hill climbing.

## 16.2   Principles of Microscope Autofocusing

Generally, a microscope autofocusing system determines the in-focus position of a given field of view by searching for the maximum of an autofocus function over a range of $z$-axis positions. An autofocus function, computed on images captured at various $z$-axis positions, provides a quantitative measure of focal sharpness at each position for a particular field of view (see Fig. 16.1). By searching along the $z$-axis and comparing the autofocus function values obtained, the in-focus position can be located as the one where the autofocus function is maximized.

In the following sections we discuss autofocusing techniques based on single-channel grayscale images. For microscope systems using RGB color images, the

**FIGURE 16.1** The autofocus function is defined over a range of focal distance encompassing the in-focus imaging position.

images are usually converted to grayscale by computing the luminance. The resulting monochrome images are then used to compute the autofocus function, since most of the focus-relevant information is encoded in the luminance rather than in the chrominance components of a color image.

## 16.2.1 Fluorescence and Brightfield Autofocusing

Fluorescence and brightfield microscopy, which are the two major modalities used in biomedical applications, employ different illumination sources and imaging conditions. The fluorescence microscope is used to analyze specimens labeled with fluorescent dyes, while brightfield microscopy is used on specimens prepared with light-absorbing stains.

In fluorescence microscopy, specimens are treated with special reagents that make their individual molecules absorb and emit light at different wavelengths (see Chapter 12). The fluorescence image can be used directly for autofocusing. However, due to photobleaching and the formation of destructive by-products, light exposure of photosensitive specimens should be kept to a minimum [3]. This places a stringent requirement on the speed of autofocusing algorithms. In brightfield microscopy, the autofocus function is typically unimodal, with tails that extend over a broad depth range. By contrast, fluorescence images typically have a low signal-to-noise ratio (SNR), and the assumptions mentioned above do not always hold true.

In brightfield microscopy, specimens are illuminated with transmitted light, concentrated by a substage condenser. The specimens appear dark against a bright background, typically with a high SNR. Further, the specimens usually do not deteriorate as rapidly as fluorescently labeled samples. Hence most existing autofocusing methods work better for brightfield microscopy than for its fluorescence counterpart.

## 16.2.2  Autofocus Functions

The autofocus function and its computation are crucial to the accuracy and efficiency of a microscope autofocusing system. Research on the subject dates back more than a quarter of a century, and many methods have been developed [4–17].

A comprehensive comparative study of 11 autofocus functions for brightfield microscopy established a set of criteria for the design of a microscope autofocusing system [5], and these have been widely applied [2, 9, 11]. This study used metaphase chromosome spreads and electron microscopy grids as the specimens. The conclusions drawn from this study were that autofocus functions based on intensity gradients or variance yielded the best performance. Another study tested a number of autofocus functions on brightfield images of lymph node tissue and synthetic images [8]. It concluded that autofocus functions based on the image power performed better than those based on cellular logic and spectral moments, while histogram-based functions performed the worst.

Autofocusing for tissue specimens has also been investigated [12]. Four categories of autofocus functions were evaluated: (1) frequency domain functions, (2) gradient functions, (3) information content functions, and (4) gray-level variance functions. They observed that the gray-level variance functions performed best in the presence of noise but were less accurate in determining the in-focus position.

As an alternative, to reduce photo damage and bleaching of fluorescently labeled specimens, autofocusing with phase-contrast microscopy has been evaluated [2], using the same set of 11 autofocus functions mentioned earlier [5]. A significant difference was observed between the two in the best in-focus position. Nevertheless, the difference was sufficiently constant to allow for correction.

A theoretical study of autofocusing in brightfield microscopy [9] found that the signal power in the middle frequencies, instead of that at the high-frequency end, is most affected by defocus and should be used in the autofocus function. They also found that the signal-sampling density significantly influences the performance of autofocus algorithms.

A recently published algorithm uses signal power computed after convolving the image with a first-order derivative of Gaussian (DoG) filter. This technique is intended to be generally applicable to several light microscopy modalities, including fluorescence, brightfield, and phase-contrast microscopy, and on a large variety of specimen types and preparation methods. However, the algorithm utilizes an exhaustive search method for finding the in-focus position, presumably to circumvent problems caused by noise in the computed autofocus function values.

Another study systematically evaluated 13 autofocus functions for FISH studies of counterstained nuclei [14]. Using a proposed figure-of-merit criterion that weighs five different characteristics of an autofocus function, it reported that functions based on correlation measures have the best performance for the specific images studied.

The autofocus functions just mentioned can be categorized into methods based on (1) edge strength, (2) contrast, (3) autocorrelation, and (4) the Fourier spectrum of an image. Table 16.1 tabulates these functions along with their definition and references. In this table the image is represented by $g_{i,j}$, where $i$ and $j$ are the spatial coordinates, $g$ is the pixel intensity, $G_x$ and $G_y$ are the first-order derivative of Gaussian filters in the $x$ and $y$ directions, $n$ is the number of pixels in the image, $H(k)$ is the gray-level histogram at level $k$, the superscript $T$ indicates the matrix transpose, and $*$ indicates the convolution operation. Several of the listed autofocus functions have been patented, including $F_4$, $F_6$, $F_7$, and $F_9$. According to previously published studies, the best-performing autofocus function for fluorescence microscopy is $F_4$. For brightfield microscopy however, $F_1$, $F_2$, $F_3$, and $F_5$ are recommended, although $F_7$ performs best in the presence of noise but suffers from lower accuracy. The recently patented autofocus function $F_6$ reportedly achieved very good performance on several light microscopy modalities, including fluorescence, brightfield, and phase-contrast microscopy, when performed with an exhaustive $z$-axis search.

In general, one observes that there are a number of approaches to computing an autofocus function, and one that works well for a particular imaging modality, sampling density, and specimen type might not work well for another configuration.

## 16.2.3 Autofocus Function Sampling and Approximation

In order to locate the in-focus position, one needs to find the $z$-axis position where the autofocus function reaches its maximum. The brute-force approach is to search exhaustively over the $z$-axis range that is known to include the maximum autofocus function value. In many applications, however, due to speed considerations and time constraints for limiting specimen light exposure, the search is better done in stages. The autofocus function is first coarsely sampled at sparse intervals over a wide range along the $z$-axis. The search is then narrowed to a smaller range with finer sampling. At each stage, a unimodal curve, such as a parabola, is fitted to the set of autofocus function values. This allows one to identify a smaller $z$-axis interval that contains the maximum autofocus value. In the finest iteration, the peak of the fitted curve is taken as the point of focus. One advantage of curve fitting is that it tends to smooth out irregularities in the autofocus function values. Two such techniques are discussed next.

**TABLE 16.1**  Summary of existing microscope autofocus functions

| Autofocus Function | Description | References |
|---|---|---|
| $F_1 = \sum_{ij}([-1, 2, -1] * g_{i,j})^2$ | Laplacian | [5] |
| $F_2 = \sum_{ij}([1, 0, -1] * g_{i,j})^2$ | Brenner's function | [2, 7–9, 13, 14] |
| $F_3 = \sum_{ij}([1, -1] * g_{i,j})^2$ | Squared gradient | [2, 5, 9, 13, 14] |
| $F_4 = \sum_{ij} g_{i,j}g_{i+1,j} - \sum_{ij} g_{i,j}g_{i+2,j}$ | Autocorrelation | [2, 7, 14] |
| $F_5 = \sum_{ij}\left(\begin{bmatrix} -1 & 0 & 1 \\ -2 & 0 & 2 \\ -1 & 0 & 1 \end{bmatrix} * g_{i,j}\right)^2 + \sum_{ij}\left(\begin{bmatrix} 1 & 2 & 1 \\ 0 & 0 & 0 \\ -1 & -2 & -1 \end{bmatrix} * g_{i,j}\right)^2$ | Tenengrad function | [12, 14] |
| $F_6 = \sum_{ij}[(G_x * g_{i,j})^2 + (G_y * g_{i,j})^2]$ | Derivative of Gaussian | [11, 13] |
| $F_7 = \sum_{ij}(g_{i,j} - \bar{g})^2$ | Variance | [5, 8, 12, 14] |
| $F_8 = \frac{1}{\bar{g}}\sum_{ij}(g_{i,j} - \bar{g})^2$ | Normalized variance | [5, 14] |
| $F_9 = \frac{1}{n(n-1)}\left(n\sum_{ij}p_{i,j}^2 - \left(\sum_{ij}p_{i,j}\right)^2\right)$ | Contrast | [2] |

where

$$p_{i,j} = \begin{bmatrix} -1 & -1 & -1 \\ -1 & 9 & -1 \\ -1 & -1 & -1 \end{bmatrix} * g_{i,j}$$

| | | |
|---|---|---|
| $F_{10} = \max\{k \mid H_k > 0\} - \min\{k \mid H_k > 0\}$, $H_k$ denotes the number of pixels with gray level $k$. | Range of maximum and minimum gray levels | [8, 14] |
| $F_{11} = \sum_k P_k \log_{10}(k)$, | Fourier spectral moment | [8] |

$P_k$ is the percent power in the $k$th spectral component.

### 16.2.3.1  Gaussian Fitting

The properties of the Gaussian function make it useful for fitting the autofocus function data. Suppose $f_1$, $f_2$, and $f_3$ are the autofocus function values measured at $z_1$, $z_2$, and $z_3$, respectively:

$$f_1 = f(z_1), \qquad f_2 = f(z_2), \qquad f_3 = f(z_3), \qquad z_1 \neq z_2 \neq z_3 \tag{16.1}$$

Then the fitted Gaussian and its maximum value are

$$f(z) = A \, \exp\left(-\frac{(z - \mu)^2}{2\sigma^2}\right) \qquad \text{and} \qquad f_{\max}(z) = f(\mu) = A \tag{16.2}$$

The problem is to find $\mu$, which is the $z$ coordinate that corresponds to $f_{\max}$. Since we have

$$\ln(f_i) = \ln(A) - \frac{(z_i - \mu)^2}{2\sigma^2} \qquad \text{where} \quad i = 1, 2, 3 \tag{16.3}$$

and

$$\ln(f_2) - \ln(f_1) = \frac{(z_1 - \mu)^2 - (z_2 - \mu)^2}{2\sigma^2}$$
$$\ln(f_3) - \ln(f_2) = \frac{(z_2 - \mu)^2 - (z_3 - \mu)^2}{2\sigma^2} \tag{16.4}$$

The solution can be derived as

$$\mu = \begin{cases} \dfrac{1}{2}\dfrac{B \cdot (z_3 + z_2) - (z_2 + z_1)}{B - 1}, & \text{if } (z_3 - z_2) = (z_2 - z_1) \\[2ex] \dfrac{1}{2}\dfrac{B \cdot (z_3^2 - z_2^2) - (z_2^2 - z_1^2)}{B \cdot (z_3 - z_2) - (z_2 - z_1)}, & \text{otherwise} \end{cases} \tag{16.5}$$

$$\text{where } B = \frac{\ln(f_2) - \ln(f_1)}{\ln(f_3) - \ln(f_2)}$$

### 16.2.3.2  Parabola Fitting

For broadly shaped autofocus function curves, using a parabola-fitting approximation may be more appropriate. Again assuming $f_1$, $f_2$, and $f_3$ are sampled autofocus function values, a best-fitting parabola function and its maximum value can be defined by

$$f(z) = -C(z - v)^2 + D, \qquad f_{\max}(z) = f(v) = D, \qquad C > 0 \tag{16.6}$$

where $C$ and $D$ are constants and $v$ is the $z$ coordinate corresponding to $f_{\max}$. Since we have the relationships

$$f_3 - f_2 = C[(z_2 - v)^2 - (z_3 - v)^2] \tag{16.7}$$

and

$$f_2 - f_1 = C[(z_1 - v)^2 - (z_2 - v)^2] \tag{16.8}$$

we can derive the solution to the problem as

$$v = \begin{cases} \dfrac{1}{2} \dfrac{E \cdot (z_3 + z_2) - (z_2 + z_1)}{E - 1}, & \text{if } (z_3 - z_2) = (z_2 - z_1) \\[2ex] \dfrac{1}{2} \dfrac{E \cdot (z_3^2 - z_2^2) - (z_2^2 - z_1^2)}{E \cdot (z_3 - z_2) - (z_2 - z_1)}, & \text{otherwise} \end{cases}, \tag{16.9}$$

$$\text{where } E = \frac{f_2 - f_1}{f_3 - f_2}$$

## 16.2.4   Finding the In-Focus Imaging Position

As discussed earlier, autofocus function approximation by curve fitting can expedite finding the in-focus position by narrowing the search to a smaller $z$-axis range within which the maximum of the fitted curve is located. This way an exhaustive search [11, 13] over the entire focal range is avoided. However, the fitted curve is based on a small number of sampled points and thus provides only a coarse approximation of the underlying autofocus function. Thus the peak of the fitted unimodal curve may not coincide with the maximum of the autofocus function. To improve accuracy, one can perform a secondary sampling and refined curve fitting over a reduced focal range. Determination of the actual in-focus position can be achieved by searching around the area where the maximum autofocus function value is predicted to be. As an alternative to curve fitting, the position of the maximum autofocus function value can be found via an optimal search algorithm. For example, the hill-climbing method has been used to speed up the process for finding the in-focus position [9]. Fast search algorithms, such as the Fibonacci method, have also been used to speed up the autofocusing process [12]. While the hill-climbing algorithm is known for its simplicity and speed, it is not always accurate. The Fibonacci search algorithm has been shown to be optimal, with guaranteed precision for unimodal curves.

## 16.3   Multiresolution Autofocusing

A common attribute of the autofocusing methods described earlier is that the measurement and search procedures are performed based on image analysis

done only at the resolution of the captured images. There are several shortcomings associated with single-resolution techniques. First, noise in microscope images largely manifests itself at the higher frequencies. Computing focus measures on images at full resolution can produce a noisy autofocus function and may lead to inaccurate determination of the in-focus position. Second, due to the possibility of multiple peaks on noisy autofocus functions, fast search algorithms may find a local maximum rather than the global maximum. To avoid this, exhaustive search would have to be performed, and this requires capturing and processing considerably more images along the z-axis. Such a solution is unacceptable in exposure-sensitive applications. Photobleaching, for example, poses stringent constraints on exposure time, prohibiting excessively repeated imaging of fluorescence specimens. Third, the processing speed of an autofocusing algorithm depends primarily on the number of pixels involved in the computations. Calculating autofocus function values always at full resolution involves a much larger number of pixels than computing them at a lower image resolution.

To address these issues, a new approach, based on multiresolution image analysis, has been introduced for microscope autofocusing [18]. Unlike the single-resolution counterparts, the multiresolution approach seeks to exploit salient image features from image representations not just at one particular resolution, but across multiple resolutions. The image features and autofocus functions associated with different resolutions are utilized to facilitate highly flexible and efficient multiresolution autofocusing methods.

## 16.3.1 Multiresolution Image Representations

Many known image transforms, such as the Laplacian pyramid, B-splines, and wavelet transforms (Chapter 7), can be used to generate multiresolution representations of microscope images. Multiresolution analysis has the following characteristics: (1) Salient image features are preserved and are correlated across multiple resolutions, whereas the noise is not; (2) it yields generally smoother autofocus function curves at lower resolutions than at full resolution; and (3) if the autofocus measurement and search are carried out at lower resolutions, the computation can be reduced exponentially.

These characteristics are illustrated by the examples given here. Figure 16.2 shows an in-focus (left) and an out-of-focus (right) image of a DAPI-counterstained FISH specimen represented at three different resolutions using a wavelet transform. The differences between the in-focus and out-of-focus images are remarkable and can be observed even at the lowest resolution. It is clear from these images that, in order to determine whether the images are in focus or not, the use of the high-resolution image is unnecessary because the lower-resolution

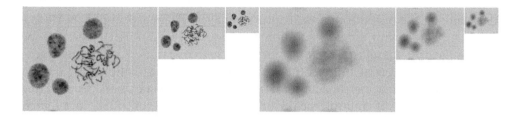

**FIGURE 16.2**   An in-focus (left) and an out-of-focus (right) view of a DAPI-counterstained FISH specimen represented at three different resolutions.

images provide just as much information to arrive at the same decision. This observation can lead to a substantial saving of autofocusing time because the computation of the autofocus function value can be carried out on images of exponentially smaller size. Furthermore, the autofocus function curves measured from lower-resolution images also appear to behave better than those measured at full resolution. Figure 16.3 shows a 3-D plot of a wavelet-based autofocus function measured along the $z$-axis and across different image resolutions. Clearly the lower the image resolution is (i.e., at higher image scale), the less noisy the autofocus curve becomes. Such a characteristic property of autofocus function can be exploited to design highly efficient multiresolution autofocusing algorithms.

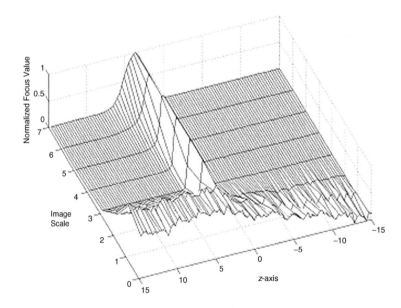

**FIGURE 16.3**   Three-dimensional illustration of a wavelet-based autofocus function measured along the $z$-axis (in micrometers) and across different image resolutions. Image scale from 0 to 7 corresponds to images from high to low resolution.

## 16.3.2 Wavelet-Based Multiresolution Autofocus Functions

A wavelet-transform-based method to compute autofocus functions at multiple resolutions is described here [18]. If we denote the 2-D wavelet transform as

$$W_{2^j}^k I(x, y) = (I * \psi_{2^j}^k)(x, y), \qquad j = 0, 1, \dots, J, \qquad k = 1, 2, 3 \qquad (16.10)$$

where $W_{2^j}^k I(x, y)$ is the wavelet transform of an image $I(x, y)$ at resolution $j$ and in subband $k$, $\psi_{2^j}^k$ is the corresponding wavelet, and $J$ is the minimum resolution (i.e., maximum decomposition) level to be computed, then the wavelet-based autofocus function at resolution $j$ is computed as the sum of the squared values of the wavelet coefficients at resolution $j$; that is,

$$f = \sum_k \sum_x \sum_y \left[ W_{2^j}^k I(x, y) \right]^2, \qquad \text{while} \qquad \left| W_{2^j}^k I(x, y) \right| \geq \Theta \qquad (16.11)$$

Here $\Theta$ is a threshold value that can be determined empirically. Depending on which wavelet filters are used in the wavelet transform, different multiresolution autofocus function measurements can be obtained with this computation procedure.

## 16.3.3 Multiresolution Search for In-Focus Position

To some extent, the multiresolution microscope autofocusing method resembles the process that experienced microscopists use to focus a microscope manually. In general, a technician will switch between different magnification objective lenses to look for and focus on specimen objects more quickly, rather than using a single objective lens.

With multiresolution autofocus function measurements, the sampling and approximation techniques discussed in Section 16.2.3 are applied to search more efficiently for the in-focus imaging position. The multiresolution search algorithm described next combines hill climbing with the Gaussian approximation to locate the in-focus position at a coarse scale (i.e., low resolution) and combines the Fibonacci algorithm with the parabola approximation to determine the best in-focus position at a fine scale (i.e., high resolution). The steps are:

1. Compute the autofocus function, $f$, using Eq. 16.11 from the wavelet coefficients at a coarse scale (low resolution) of an image captured at an initial position $z_0$.

2. Apply the hill-climbing algorithm to locate three reference $z$-axis positions where $f_1$, $f_2$, and $f_3$ cover a wide range encompassing the peak

of the autofocus function curve. That is, the middle value is larger than either of the endpoints.

3. Use these three points to compute the Gaussian approximation to predict the coarse-scale in-focus position, $\mu$, using Eq. 16.5, and capture an image there.

4. Compute the autofocus function, $f$, using Eq. 16.11, but this time use the wavelet coefficients at a fine scale (high resolution) of the image captured in step 3.

5. Apply the Fibonacci algorithm at high resolution to locate three new reference $z$-axis positions, where $f_1$, $f_2$, and $f_3$ are now closer together but still cover the in-focus peak of the autofocus function curve.

6. Use these three points to compute the parabola approximation to find the fine-scale in-focus position, $v$, using Eq. 16.9.

Figures 16.4 and 16.5 demonstrate the multiresolution autofocusing technique just described. Figure 16.4a shows the result of the Gaussian fitting (dashed line), based on the $f_1$, $f_2$, and $f_3$ that are computed from three low-resolution images shown in Figs. 16.4b, 16.4c, and 16.4d, respectively. Correspondingly, Fig. 16.4e shows the result of the parabola fitting (dashed line) based on the $f_1$, $f_2$, and $f_3$ computed from three high-resolution images shown in Figs. 16.4f, 16.4g, and 16.4h, respectively. Figure 16.5a illustrates the process of multiresolution search for the in-focus $z$-axis position, and Fig. 16.5b displays the image acquired at the predicted fine-scale in-focus position $v$.

Because only low-resolution images are used in the coarse search, the computational cost for the autofocus function is significantly reduced. Besides, during the coarse search, the hill-climbing algorithm is applied to a smoother curve, and this avoids the problems with local maxima. During the fine search, however, the autofocus function is computed from high-resolution images to ensure focusing accuracy, and the Fibonacci search is conducted over the near-focus region of the autofocus function curve, which is typically unimodal.

# 16.4  Autofocusing for Scanning Microscopy

Scanning microscopy is frequently used for high-throughput screening applications, where a large number of specimens must be imaged and analyzed. For slide-based scanning microscopy, it is important to take into consideration stage- and sample-based focus variations as the system scans across multiple fields of view on the microscope slide. Experience has shown that it is impossible

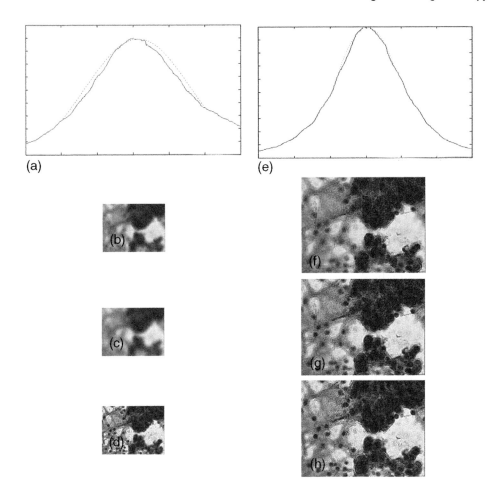

**FIGURE 16.4** Sampling and curve fitting of the autofocus function at both coarse and fine scale. (a) Result of the Gaussian fitting (dashed line) based on the three sampled autofocus function values that are computed from the low-resolution images shown in (b), (c), and (d), respectively. (e) Result of the parabola fitting (dashed line) based on the three sampled autofocus function values computed from the high-resolution images shown in (f), (g), and (h), respectively.

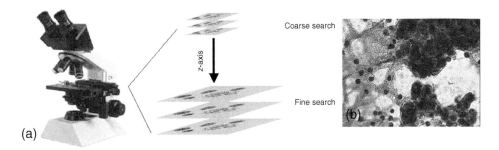

**FIGURE 16.5** (a) Illustration of a multiresolution search for the in-focus position. (b) The image acquired at the predicted fine-scale in-focus position.

to maintain focus by relying on the in-focus position of any one location or simply by finding the in-focus positions at two locations on a slide and scanning along the line between them [2]. Even with careful microscope stage calibration, variations in focus over a scan area will still exist, due to such factors as mechanical instability of the microscope, irregularity of glass slide surfaces, and presence of artifacts and debris.

Moving between adjacent fields of view normally requires only a slight change of focus. This can be exploited in the design of an efficient autofocusing algorithm for scanning microscopy. After finding the in-focus position for one field of view, it can be taken as the starting position for the adjacent field of view because it is unlikely to be very different. If, for some reason, a large discrepancy occurs between the in-focus positions of adjacent fields, it signals what is likely to be a focusing error that needs to be corrected.

Another practical issue concerning the efficiency of an automated scanning microscope is the detection and handling of empty, or "blank" fields that contain no material. It is a waste of time and resources to attempt to focus on these fields or even to record their images. These empty fields can be identified by their narrow histogram and low focus function value. If the first image captured at a particular location indicated a blank field, then no further processing is done at that location. It is sometimes possible to identify "junk" fields by their histograms and focus values as well.

## 16.5    Extended Depth-of-Field Microscope Imaging

One of the fundamental problems that plagues automated microscopy originates from specimens thicker than the depth-of-field (DOF) of the microscope objective lens. Images acquired under these circumstances are usually of low quality because the objects cannot be brought completely into focus. Blurring introduced by objects that lie outside the in-focus plane affects the accuracy of image segmentation and measurement. Quantitative analysis is prone to error due to the presence of blurred image information.

A number of techniques have been developed to overcome the inherent limitations caused by out-of-focus objects in a three-dimensional specimen that is imaged with a two-dimensional system. These include both hardware- and software-based methods for extended DOF imaging. Extended DOF images increase the amount of accessible structural information available in microscope images of thick specimens.

A well-known hardware-based method, referred to as *wavefront coding*, incorporates both optical modifications to the microscope and subsequent digital image processing. A custom-made optical component, known as the

*cubic-phase plate*, is inserted into the optical path. An image captured with this modified microscope appears distorted. It can be modeled as a filtered image, where the filter kernel is approximately invariant to defocus. A digital inverse filter is applied to the captured image to produce the effect of extended DOF [19].

By contrast, software-based methods generally resort to digital image fusion to generate a single composite image from a set of optical section images that have been captured across a range of focal distances around the best in-focus position. These optical section images are usually captured along the $z$-axis, with a translation step $\Delta z$ no larger than the DOF of the objective lens. Each image is intended to contain some portions of the specimen in focus, and the whole set of images covers the desired range of focal depth. The following sections discuss software-based methods. Readers interested in hardware-based methods are referred to [19, 20] for further information.

## 16.5.1 Digital Image Fusion

Digital image fusion is the technique of combining information from multiple images into one composite image. An implicit assumption used by most image fusion techniques is that all input images are registered, which means that each physical component is aligned to the same location in all of the images. For extended DOF microscope imaging, since all optical section images are captured from the same field of view, albeit at different focal planes, such an assumption can be easily met.

The central idea of image fusion methods for extended DOF microscope imaging is to select, from different optical section images, those pixels or regions that contain the most in-focus information, because in-focus components contain more structural information than out-of-focus components. The amount of information in a region or component of an image is usually estimated by a quantitative focus measure, which is now a 2-D function of $(x, y)$ location in the image. Notice that this differs from the autofocus functions discussed in previous sections, which are 1-D functions of $z$ alone and are computed from the entire image. A 2-D fusion map is generated to indicate, at each $(x, y)$ position, which one of the optical section images has the highest focus measure. This fusion map is used to determine from which optical section image that component in the composite image should be gathered. Finally the selected components from all corresponding optical section images are assembled, according to the fusion map, to form the extended DOF image.

Given a set of $N$ optical section images, as $I_1(x, y), I_2(x, y), \ldots, I_N(x, y)$, the component focus measure for each of these images at location $(x, y)$ is $R_n(x, y), n = 1, 2, \ldots, N$. The fusion map is then defined as

$$M(x, y) = \arg \max_n |R_n(x, y)|, \qquad n = 1, 2, \ldots, N \qquad (16.12)$$

which is an index function with integer value ranging from 1 to $N$. The composite image resulting from image fusion is given by

$$I'(x, y) = \bigcup_{n=M(x, y)} \{I_n(x, y)\} \qquad (16.13)$$

The preceding discussion assumes single-channel grayscale images. For RGB images, a color-space transformation should first be performed to convert the images from RGB to another space, such as the YUV or principal component analysis (PCA) space. Then the component focus measure, $R_n(x, y)$, is computed using only one grayscale image from the transformed space (such as the luminance or the first principal component), since this image encodes most focus-relevant information. Subsequently, the fusion map is generated based on this grayscale image, and it is used to assemble the fused image from the stack of RGB images. In the following sections, three different image fusion schemes for extended DOF microscope imaging are described.

## 16.5.2 Pixel-Based Image Fusion

In pixel-based image fusion schemes, the component focus measure $R_n(x, y)$ is computed at each pixel coordinate $(x, y)$ and then compared among all optical section images $I_n(x, y)$, $n = 1, 2, \ldots, N$. A representative approach [21] is described here. Pixels are selected out of different optical section images based on a maximum or minimum selection rule and fused together to form the composite image. Specifically,

$$R_n(x, y) = |I_n(x, y) - I_{\text{mean}}(x, y)| \qquad (16.14)$$

$$Q(x, y) = |I_{\text{max}}(x, y) - I_{\text{mean}}(x, y)| - |I_{\text{min}}(x, y) - I_{\text{mean}}(x, y)| \qquad (16.15)$$

where

$$I_{\text{max}}(x, y) = \max\{I_1(x, y), I_2(x, y), \ldots, I_N(x, y)\},$$
$$I_{\text{min}}(x, y) = \min\{I_1(x, y), I_2(x, y), \ldots, I_N(x, y)\}$$

$$I_{\text{mean}}(x, y) = \frac{1}{N} \sum_{k=1}^{N} I_k(x, y)$$

For each pixel, the composite image $I'(x, y)$ is assembled with either $I_{\text{max}}(x, y)$ or $I_{\text{min}}(x, y)$, depending on whether $Q(x, y) \geq 0$ or $Q(x, y) < 0$. This simple approach has been widely used over the years. However, pixel-based methods have the problem that they ignore the context of the underlying physical structure of objects when fusing the images. For instance, neighboring pixels are likely to correspond to portions of the same object. Therefore, these portions

normally should come from the same or neighboring planes. However, a pixel-based method might choose adjacent pixels from widely separated planes and thus generate an inaccurate image.

### 16.5.3 Neighborhood-Based Image Fusion

With neighborhood-based image fusion schemes, the component focus measure $R_n(x, y)$ is computed based on a set of neighboring pixels [22] instead of individual pixels as in the pixel-based schemes. Several such methods have been studied in the past. The first type of methods uses differential or gradient operations to process the images and characterize their focus measure. For example a $3 \times 3$ differential operator has been used [21]. Each optical section image is convolved with this operator to generate the component focus measure:

$$R_n(x, y) = I_n(x, y) * \begin{bmatrix} -1 & 1 & 1 \\ -1 & 0 & 1 \\ -1 & -1 & 1 \end{bmatrix} \qquad (16.16)$$

Since the differential operation detects abrupt image intensity changes such as edges, the value of $R_n(x, y)$ is closely related to the strength of image edges. The assembly of the composite image is straightforward using Eqs. 16.12 and 16.13.

The second type of neighborhood-based schemes takes into consideration some form of image variance in a neighborhood of every pixel when the optical section images are fused. One algorithm uses the regional coefficient of variance of a $5 \times 5$ area [22]. The component focus measure in this case is defined as the squared coefficient of variance based on the values of the pixels in the area. It is computed by

$$R_n(x, y) = \frac{\sum\limits_{i=-2}^{2} \sum\limits_{j=-2}^{2} \left( I_n(x+i, y+j) - \bar{I}_n(x, y)^2 \right)}{\bar{I}_n(x, y)^2} \qquad (16.17)$$

where

$$\bar{I}_n(x, y) = \frac{1}{25} \sum\limits_{i=-2}^{2} \sum\limits_{j=-2}^{2} I_n(x+i, y+j)$$

Thus the pixels with the maximum regional variance over the entire stack of optical section images contribute to the formation of the resultant composite image.

While the preceding neighborhood-based schemes take into consideration the information in the surrounding region of pixels, the rectangular spatial

context models are still somewhat restrictive. A good neighborhood-based image fusion scheme requires knowledge about the physical structure of the objects in the specimen in order to determine their boundaries. However, to incorporate segmentation of image regions into the fusion process significantly increases the complexity of the algorithm.

### 16.5.4    Multiresolution Image Fusion

Multiresolution-based image fusion schemes employ multiscale image transforms and have an intermediate level of complexity between the pixel-based and the neighborhood-based approaches [23–25]. Unlike the pixel-based approach, a fusion decision made on a transform coefficient in the low-resolution representation can affect a number of pixels instead of just one. On the other hand, contrary to the neighborhood-based approach, defining precise boundaries of neighborhoods is rarely required in order to obtain good performance. The early studies of multiresolution image fusion were based on pyramid transforms [26, 27]. More recently, however, discrete wavelet transforms have gained popularity because of their sound underlying mathematical theory and the availability of fast algorithms [28, 29]. Image fusion methodology based on the wavelet transform has been described [24], in which a wavelet transform was performed on each of the images to be fused. The coefficient of maximum absolute value was selected at each pixel, and these were combined into one transform coefficient image. An inverse wavelet transform then generated the fused image. The results were found to be better and more stable than techniques based on the Laplacian pyramid transform [24]. One disadvantage of discrete wavelet transforms, though, is shift variance. To overcome this problem, the use of overcomplete wavelet transforms with shift invariance has been introduced [23]. More recently, the study using complex wavelet transforms for the same purpose was also reported [25].

Generally, a multiresolution image fusion scheme can be summarized by the block diagram shown in Fig. 16.6. Unlike previously discussed single-resolution techniques, with a multiresolution scheme the computations of the component

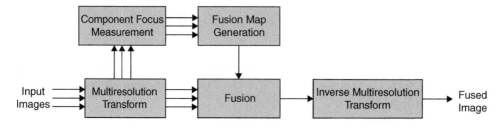

**FIGURE 16.6**    Block diagram of a general scheme for multiresolution image fusion.

focus measure, the fusion map, and the composite image are all carried out on the coefficient data resulting from the multiresolution transform. For image fusion based on the wavelet transform, we denote the 2-D wavelet transform as

$$
\begin{cases}
S_{2^j} I(x, y) = (I * \phi_{2^j})(x, y) \\
W_{2^j}^k I(x, y) = (I * \psi_{2^j}^k)(x, y)
\end{cases}, \quad j = 0, 1, \ldots, J, \quad k = 1, 2, 3 \quad (16.18)
$$

where $S_{2^j} I(x, y)$ is the scaling component of the transform, $\phi_{2^j}$ is the corresponding scaling function, $W_{2^j}^k I(x, y)$ is the wavelet component of the transform on image $I(x, y)$ at resolution $j$ and in subband $k$, $\psi_{2^j}^k$ is the corresponding wavelet, and $J$ is the minimum resolution (i.e., maximum decomposition) level to be computed. The component focus measure at $(x, y)$ based on the wavelet transform of the $n$th optical section image at resolution $j$ and in subband $k$ is computed as

$$
R_n(x, y, 2^j, k) = \begin{cases}
|W_{2^j}^k I_n(x, y)|, & k = 1, 2, 3 \\
|S_{2^j} I_n(x, y)|, & k = 0
\end{cases} \quad (16.19)
$$

where $j = 1, 2, \ldots, J$ and $n = 1, 2, \ldots, N$. Correspondingly, the fusion map is

$$
M(x, y, 2^j, k) = \arg\max_n \left\{ R_n(x, y, 2^j, k) \right\}, \quad j = 0, 1, \ldots, J,
$$
$$
k = 1, 2, 3, \quad n = 1, 2, \ldots, N \quad (16.20)
$$

The actual image fusion is carried out by assigning the $j$th-level, $k$th-subband component of the fused wavelet transform coefficient image as

$$
\begin{cases}
S_{2^j} I'(x, y) = S_{2^j} I_n(x, y) \\
W_{2^j}^k I'(x, y) = W_{2^j}^k I_n(x, y)
\end{cases}, \quad j = 0, 1, \ldots, J, \quad k = 1, 2, 3,
$$
$$
n = M(x, y, 2^j, k) \quad (16.21)
$$

Finally the fused composite image $I'(x, y)$ is obtained via an inverse wavelet transform.

## 16.5.5 Noise and Artifact Control in Image Fusion

Most image fusion methods are formulated based on the underlying assumption that the important information content of an image corresponds to abrupt changes in the image. Thus, almost all focus measures represent various estimates of the strength of high-frequency components in the image. In practice, however, such an assumption and any estimates derived using it are prone to error because

noise tends to weigh significantly in the high-frequency end of the image spectrum. As a result these methods tend to boost image noise and artifacts.

### 16.5.5.1   Multiscale Pointwise Product

A new image fusion scheme for extended DOF microscope imaging that responds well to image signals but is insensitive to noise has been described [30]. Similar to the schemes described in Section 16.5.4, this form of image fusion is performed in the wavelet domain. However, the component focus measure in this case is not just a simple estimate of the strength of high-frequency energy, but an adaptive measure constrained by a multiscale pointwise product (MPP, defined shortly) criterion. This technique enables filtering of the high-frequency wavelet transform coefficients so that image signals, rather than noise, are included in the focus measure. This originates from the fact that the MPP criterion naturally discourages the selection of noise components while enforcing the selection of image signal components.

Specifically, the MPP approach uses an overcomplete cubic spline wavelet transform to decompose the optical section images into their multiresolution image representations that are shift invariant [30]. The forward and inverse transforms can be implemented very efficiently, for only additions and bit shift operations are required [31]. Given an optical section image $I(x, y)$, the $j$th-level decomposition of the forward transform is defined as

$$\begin{cases} S_{2^j}I(x, y) & = & S_{2^{j-1}}I(x, y) * (h, h)_{\uparrow 2^{j-1}} \\ W_{2^j}^1 I(x, y) & = & S_{2^{j-1}}I(x, y) * (g^{(2)}, d)_{\uparrow 2^{j-1}} \\ W_{2^j}^2 I(x, y) & = & S_{2^{j-1}}I(x, y) * (d, g^{(2)})_{\uparrow 2^{j-1}} \\ W_{2^j}^3 I(x, y) & = & S_{2^{j-1}}I(x, y) * (g^{(1)}, g^{(1)})_{\uparrow 2^{j-1}} \end{cases} \tag{16.22}$$

where $S_1 I(x, y) = I(x, y)$ and $*(h, g)_{\uparrow 2^{j-1}}$ represents the separable convolution of the rows and columns of the image with 1-D filters $[h]_{\uparrow 2^{j-1}}$ and $[g]_{\uparrow 2^{j-1}}$, respectively; $[h]_{\uparrow m}$ represents the up-sampled sequence of the filter $\{h(n)\}$ by an integer factor $m$ in general; and the symbol $d$ denotes the Dirac delta function with value 1 at the origin and zero elsewhere. The image can be recovered with the following reconstruction formula of the inverse transform:

$$\begin{aligned} S_{2^{j-1}}I(x, y) & = W_{2^j}^1 I(x, y) * (\tilde{g}^{(2)}, u)_{\uparrow 2^{j-1}} + W_{2^j}^2 I(x, y) * (u, \tilde{g}^{(2)})_{\uparrow 2^{j-1}} \\ & \quad + W_{2^j}^3 I(x, y) * (\tilde{g}^{(1)}, \tilde{g}^{(1)})_{\uparrow 2^{j-1}} + S_{2^j}I(x, y) * (\tilde{h}, \tilde{h})_{\uparrow 2^{j-1}} \end{aligned} \tag{16.23}$$

Details on the filters used for decomposition and reconstruction in the cubic spline wavelet transform can be found in [31]. Under wavelet-based multiresolution representations, image signals of specimen objects are observed generally to have strong correlation across multiple scales, whereas noise components

do not. This observation has motivated the introduction of MPP [32], which is defined as

$$
\mathrm{MPP}(x,\,y,\,k) = \begin{cases} \displaystyle\prod_{j=1}^{J} S_{2^j} I(x,\,y), & k = 0 \\ \displaystyle\prod_{j=1}^{J} W_{2^j}^k I(x,\,y), & k = 1,\,2,\,3 \end{cases} \tag{16.24}
$$

where $\mathrm{MPP}(x,\,y,\,k)$ represents the MPP for the wavelet transform at $(x,\,y)$ in subband $k$ and $J$ is the number of wavelet decomposition levels computed. Since the MPP only reinforces the responses from image signals, its magnitude is small for noise components. Thus its absolute value naturally becomes a desired component focus measure for image fusion. To fuse a set of $N$ optical section images $I_1(x,\,y),\,I_2(x,\,y),\,\ldots,\,I_N(x,\,y)$, the MPP-based fusion map can be generated as

$$
M(x,\,y,\,k) = \arg\max_{n}\,\{|MPP_n(x,\,y,\,k)|\}, \qquad k = 0,\,1,\,2,\,3 \tag{16.25}
$$

The image fusion is carried out by assigning the $j$th-level, $k$th-subband component of the fused wavelet transform coefficient image as

$$
\begin{cases} S_{2^j} I'(x,\,y) = S_{2^j} I_n(x,\,y) \\ W_{2^j}^k I'(x,\,y) = W_{2^j}^k I_n(x,\,y) \end{cases},\qquad \begin{aligned} & j = 0,\,1,\,\ldots,\,J, \\ & k = 1,\,2,\,3, \qquad n = M(x,\,y,\,k) \end{aligned} \tag{16.26}
$$

With the MPP focus measure incorporating a thresholding mechanism into the fusion process, it can easily accommodate further denoising. Since a low MPP does not represent an image signal, high-frequency coefficients from the optical section images are not included if the corresponding MPP value is too low [32]. We can achieve greater denoising by replacing Eq. 16.26 with

$$
\begin{cases} S_{2^j} I'(x,\,y) = S_{2^j} I_n(x,\,y) \\ W_{2^j}^k I'(x,\,y) = \begin{cases} W_{2^j}^k I_n(x,\,y), & \max\limits_{n}\,\{|MPP_n(x,\,y,\,k)|\} > T \\ 0, & \text{otherwise} \end{cases} \end{cases} \tag{16.27}
$$

where $j = 0,\,1,\,\ldots,\,J$, $k = 1,\,2,\,3$, $n = M(x,\,y,\,k)$, and $T$ is a threshold parameter that can be empirically determined based on the number of decomposition levels computed and the wavelet filter kernel used.

### 16.5.5.2 Consistency Checking

Since most object structures in the image are larger than one pixel, the pixel-based maximum selection rule for generating the fusion map may lead to unnatural results or even artifacts. It is intuitively more appealing to have pixels

within a certain part of an object coming from the same image rather than from different images. *Consistency checking* can be applied to refine the fusion map for this purpose. For example, a simple majority filter with different kernel sizes can improve image fusion performance [23]. The fusion map can be smoothed by repeatedly applying a $3 \times 3$ median filter until it no longer changes [33].

### 16.5.5.3  Reassignment

On the other hand, as a consequence of selecting maximum absolute value coefficients in the wavelet domain, the fusion may yield results that are "non-convex" combinations of the pixel values of the input images [25]. In such a case the resulting composite image will have pixels with values outside the dynamic range of all the input images. The increased dynamic range is likely to cause saturation and can boost energy and noise. To address this problem, a reassignment algorithm as a postprocessing step was introduced in [25], where outliers are eliminated and the closest available values from the input images are selected instead. Computationally, the reassignment algorithm can be expressed as

$$I''(x, y) = \bigcup_{k} \{I_k(x, y)\}, \qquad k = \arg \min_{n}\{|I'(x, y) - I_n(x, y)|\} \qquad (16.28)$$

In this case the final composite image $I''(x, y)$ is reassigned with the pixel values present in the input data that are closest to the pixel values of the fused image $I'(x, y)$.

## 16.6   Examples

This section presents examples of extended DOF microscope images based on the digital image fusion methods described in this chapter. Figure 16.7 shows the extended DOF images of a brightfield microscope specimen. The top left picture is the original image, selected as the most in-focus image from a stack of optical sections. The remaining pictures display the results of various image fusion methods. In Fig. 16.8, extended DOF images of a fluorescence microscope specimen are shown. Again the top left is the selected most in-focus image of an optical section stack, whereas the image fusion results are shown for comparison in the remaining pictures.

## 16.7   Summary of Important Points

1. In addition to facilitating automation of imaging, microscope autofocusing enables objective, accurate, and consistent image measurements for quantitative analysis.

**FIGURE 16.7** Examples of extended DOF images generated by the digital image fusion methods described in the text. The top left is the original image of a brightfield microscope specimen, selected as the most in-focus image from a stack of optical section images. The top right is the result of pixel-based image fusion. The middle left is the result of neighborhood-based image fusion using a $3 \times 3$ nondirectional differential operator. The middle right is the result of neighborhood-based image fusion using a $5 \times 5$ coefficient of variance operator. The bottom left is the result of wavelet-based multiresolution image fusion. The bottom right is the result of MPP multiresolution image fusion.

2. A microscope autofocusing system determines the in-focus imaging position of a given field of view by searching for the maximum of an autofocus function.

3. Autofocus function approximation by curve fitting can expedite the search for the in-focus position by narrowing down the search to a smaller focal range within which the maximum of the fitted curve is located.

4. To expedite the search for the in-focus position, one can use a fast search method, such as the hill-climbing or the Fibonacci algorithm, to carry out the search efficiently instead of relying on an exhaustive search method.

**FIGURE 16.8**    More examples of extended DOF images generated by the digital image fusion methods described in the text. The top left is the original image of a fluorescence microscope specimen, selected as the most in-focus image from a stack of optical section images. The top right is the result of pixel-based image fusion. The middle left is the result of neighborhood-based image fusion using a $3 \times 3$ nondirectional differential operator. The middle right is the result of neighborhood-based image fusion using a $5 \times 5$ coefficient of variance operator. The bottom left is the result of wavelet-based multiresolution image fusion. The bottom right is the result of MPP multiresolution image fusion. This figure may be seen in color in the four-color insert.

5. Compared with single-resolution methods, an multiresolution approach utilizes salient image features and autofocus functions across multiple resolutions to enable autofocusing. The process facilitates a highly flexible search algorithm operating at an exponentially reduced computational cost.

6. For slide-based scanning microscopy, it is important to take into consideration stage- and sample-based variations as the system scans across multiple fields of view on the microscope slide. The spatial constraints of specimen objects that extend across adjacent fields of view can be exploited in the design of an efficient autofocusing algorithm and for detection of focus errors.

7. A fundamental problem in microscopy originates from imaging specimens thicker than the DOF of microscope objective lens. Digital image fusion provides an effective software-based solution by generating extended DOF images that maximize the amount of accessible structural information available in microscope images.

8. The central idea of applying digital image fusion to generate an extended DOF microscope image is to assemble from different optical section images the components that contain the most in-focus information into a composite image. These optical section images should be captured along the $z$-axis, with a translation step $\Delta z$ that is no larger than the DOF of the imaging system, and the whole set of images covers approximately the desired focal depth of a specimen.

9. Pixel-based image fusion schemes are simple and do not make use of any contextual information when fusing the images.

10. Neighborhood-based image fusion schemes take into consideration the information in a surrounding region of each pixel.

11. Multiresolution-based image fusion schemes have an intermediate level of complexity because fusion decisions are made on multiresolution transform coefficients and can affect a number of pixels; therefore, defining regions of neighborhoods is unnecessary.

12. One potential side effect of digital image fusion is the possible increase in noise and artifacts in the fused image. These problems can be effectively handled by incorporating denoising and consistency checking into the fusion process. Furthermore, postprocessing steps can be taken to refine the fused images by enforcing physical constraints.

# References

1. Y Liron et al., "Laser Autofocusing System for High-Resolution Cell Biological Imaging," *Journal of Microscopy*, **221**:145–151, 2006.
2. JH Price and DA Gough, "Comparison of Phase-Contrast and Fluorescence Digital Autofocus for Scanning Microscopy," *Cytometry*, **16**:283–297, 1994.
3. LB Chen, "Fluorescent Labeling of Mitochondria," in *Fluorescence Microscopy of Living Cells in Culture: Part A*, YL Wang and DL Taylor, eds., Academic Press, 1989.
4. ML Mendelsohn and BH Mayall, "Computer-Oriented Analysis of Human Chromosomes—III focus," *Computers in Biology and Medicine*, **2**:137–150, 1972.
5. FA Groen, IT Young, and G Ligthart, "A Comparison of Different Focus Functions for Use in Autofocus Algorithms," *Cytometry*, **6**:81–91, 1985.

6. D Vollath, "Automatic Focusing by Correlative Methods," *Journal of Microscopy*, **147**:27–288, 1987.

7. D Vollath, "The Influence of the Scene Parameters and of Noise on the Behavior of Automatic Focusing Algorithms," *Journal of Microscopy*, **152**(2):133–146, 1988.

8. L Firestone et al., "Comparison of Autofocus Methods for Automated Microscopy," *Cytometry*, **12**:195–206, 1991.

9. FR Boddeke et al., "Autofocusing in Microscopy Based on the OTF and Sampling," *Bioimaging*, **2**(4):193–203, 1994.

10. HS Whu, J Barbara, and J Gil, "A Focusing Algorithm for High-Magnification Cell Imaging," *Journal of Microscopy*, **184**:133–142, 1996.

11. JM Geusebroek et al., "Robust Autofocusing in Microscopy," *Cytometry*, **39**:1–9, 2000.

12. TE Yeo et al., "Autofocusing for Tissue Microscopy," *Image and Vision Computing*, **11**(10):628–639, 1993.

13. JM Geusebroek, "Robust Autofocus System for a Microscope," EP1190271 filed May 30, 2000, WO0075709, published December 14, 2000.

14. A Santos et al., "Evaluation of autofocus functions in molecular cytogenetic analysis," *Journal of Microscopy*, **188**:264–272, 1997.

15. Carl-Zeiss-Stiftung: Method of and Device for the Automatic Focusing of Microscopes, Patent specification 1314313, London, 1973.

16. Kernforschungszentrum Karlsruhe GMBH: Verfahren und Einrichtung zur automatischen Scharfeinstellung eines jeden Bildpunktes eines Bildes. Patent specification PLA 7907 Karlsruhe, 1979.

17. D Vollath, Verfahren und Einrichtung zur automatischen Scharfein-stellung eines jeden Punktes eines Bildes. German Patent DE 2,910,875 C 2, U.S. Patent 4,350,884, 1982, European Patent 0017726.

18. Q Wu et al., "A Multiresolution Autofocusing Method for Automated Microscopy," *Proceedings of Microscopy and Microanalysis*, 2003.

19. ER Dowski and WT Cathey, "Extended Depth of Field through Wavefront Coding," *Applied Optics,* **34**(11):1859–1866, 1995.

20. P Prabhat et al., "Simultaneous Imaging of Several Focal Planes in Fluorescence Microscopy for the Study of Cellular Dynamics in 3D," *Proceedings of the Society of Photo-Optical Instrumentation Engineers*, **6090**:0L1–0L7, 2006.

21. RJ Pieper and A Korpel, "Image Processing for Extended Depth of Field," *Applied Optics*, **22**:1449–1453, 1983.

22. V Tympel, "A New High-Level Image Capture System for Conventional Light Microscopy," in *Proceedings of the SPIE*, **2707**:529–536, 1996.

23. Z Zhang and RS Blum, "A Categorization of Multiscale-Decomposition-Based Image Fusion Schemes with a Performance Study for a Digital Camera Application," *Proceedings of the IEEE*, **87**(8):1315–1326, 1999.

24. H Li, BS Manjunath, and SK Mitra, "Multisensor Image Fusion Using the Wavelet Transform," in *Proceedings of the ICIP'94*, **1**:51–55, 1994.

25. B Forster et al., "Complex Wavelets for Extended Depth of Field: A New Method for the Fusion of Multichannel Microscopy Images," *Microscopy Research and Technique*, **65**(1–2):33–42, 2004.

26. A Toet, LJ van Ruyven, and JM Valeton, "Merging Thermal and Visual Images by a Contrast Pyramid," *Optical Engineering*, **28**(7):789–792, 1989.

27. PJ Burt and RJ Kolczynski, "Enhanced Image Capture Through Fusion," *Proceedings of the 4th International Conference on Computer Vision*, 173–182, 1993.

28. T Huntsberger and B Jawerth, "Wavelet-Based Sensor Fusion," *Proceedings of the SPIE*, **2059**:448–498, 1993.

29. T Ranchin, L Wald, and M Mangolini, "Efficient Data Fusion Using Wavelet Transform: The Case of Spot Satellite Images," *Proceedings of the SPIE*, **2934**:171–178, 1993.

30. S Cheng et al., "An Improved Method of Wavelet Image Fusion for Extended Depth-of-Field Microscope Imaging," *Proceedings of the SPIE Medical Imaging*, 6144, 2006.

31. Y Wang, et al., "Chromosome Image Enhancement Using Multiscale Differential Operators," *IEEE Trans. on Medical Imaging*, **22**(5):685–693, 2003.

32. DL Donoho, "Denoising by soft thresholding," *IEEE Trans. Information Theory*, **41**(3):613–627, 1995.

33. NT Goldsmith, "Deep Focus: A Digital Image Processing Technique to Produce Improved Focal Depth in Light Microscopy," *Image Anal. Stereol.*, **19**:163–167, 2000.

# 17

# Structured Illumination Imaging

Leo G. Krzewina and Myung K. Kim

## 17.1 Introduction

In this chapter we explore the rich subset of light microscopy known as *structured illumination microscopy* (SIM). In general, a SIM setup is one in which the specimen is illuminated with a specific spatial pattern rather than with uniform illumination. This is typically accomplished by a mask placed in the optical path or by interference of one or more coherent sources. The structured light pattern encodes additional information into the image beyond what is available under full illumination. This comes at the cost of requiring multiple exposures for full coverage of the specimen. Image processing is a key component of SIM since it is essential to the process of decoding the information in the image. SIM has proven to be highly successful, and it has rapidly expanded, in both usage and variety. This chapter reviews one important SIM illumination structure, the linear sinusoid, which illustrates the advantages and limitations of SIM.

### 17.1.1 Conventional Light Microscope

Use of the conventional light microscope (CLM) is constrained to objects having a size scale no smaller than microns, due to the wavelength of visible light. The lateral resolution of a diffraction-limited system depends on its numerical aperture (NA) and the wavelength of the illumination (see Chapter 2). The resolution at the focal plane is approximated by the Abbe distance,

$$r_0 \approx \frac{\lambda}{2\mathrm{NA}} \qquad (17.1)$$

For example, with a central wavelength of $\lambda = 550\,\mathrm{nm}$ and an NA of 1.4, the lateral resolving power is about $0.2\,\mu\mathrm{m}$. This diffraction limit, however, can be surpassed by using structured illumination [1, 2]. In theory at least, a SIM microscope could approach unlimited lateral resolution [3].

When three-dimensional objects are examined, we must also consider resolution along the optical axis. If the optical axis is along the $z$ direction, the in-focus region (the depth of field, DOF) is given approximately by

$$\Delta z_{\mathrm{field}} \approx \frac{n\lambda}{\mathrm{NA}^2} \qquad (17.2)$$

where $n$ is the index of refraction of the medium in which the object is immersed (Chapter 2). As with lateral resolution, this is the diffraction-limited case. Thus, to maintain focus throughout a thick object, a large DOF is required, and this implies a lower NA. This is in conflict with high lateral resolution, as one can see by comparing Eq. 17.1 and Eq. 17.2.

## 17.1.2 Sectioning the Specimen

One way to circumvent the problem of limited depth of field is by *physical sectioning*, that is, cutting the object into slices thin enough to fit entirely within the DOF, as shown in Fig. 17.1. This method, however, is destructive of the

**FIGURE 17.1**   In physical sectioning, the object is sliced into sections thinner than the DOF to maintain focus. With optical sectioning, there is no need to destroy the specimen. (Rendering courtesy of Kratos Productions.)

specimen. For the same parameters used in the preceding example and with $n = 1$, the slices, or *sections*, should not be thicker than about $0.28\,\mu$m. The technique of *optical sectioning* (see Chapter 14) accomplishes the same result but is implemented by optical means. Besides being physically nondestructive, it avoids the inconvenience of slicing and preparing sample slides. Optical sectioning can be done using only the inherently limited DOF of the objective lens, but it can be made considerably more effective with SIM. Optical sectioning with structured illumination offers other benefits besides improving axial and lateral resolution. By including feedback and iteration, light structure can be optimized to correct for uneven illumination [4].

## 17.1.3 Structured Illumination

Three basic approaches are employed in structured illumination microscopy to improve specific characteristics of the microscope image.

1. Array confocal microscopy (ACM) illuminates the specimen with a rectangular array of pinholes and senses the image with a CCD camera [5]. This approach obtains a narrow-depth-of-field image in a much shorter time than a (single pinhole) confocal microscope requires.

2. A Ronchi ruling (one-dimensional grid) forms the illumination mask for linear SIM [2, 3].

3. Dynamic speckle illumination (DSI) microscopy uses the speckle pattern produced by two interfering coherent beams [1, 6].

Each of these methods requires digital processing of the image for its implementation. We now describe two forms of linear structured illumination. These typically offer trade-offs in terms of speed of image acquisition, resolution, cost, difficulty of implementation, and complexity of image processing.

In the late 1990s, the use of a linear sinusoidal light pattern for improved resolution in both the axial and lateral directions was proven experimentally. These both require a minimum of three frame acquisitions per image, along with substantial image processing. This technique is addressed in more detail later.

The seemingly random form of light structure known as *speckle* can be used in SIM to discriminate depth in microscopic imaging. A speckle pattern is composed of high-contrast light and dark areas and can be generated by either incoherent or coherent illumination [6, 7]. The dynamic speckle illumination approach exploits the speckle pattern that arises from constructive and destructive interference of a laser beam passing through thick objects [6]. This has the advantage of being less susceptible to noise due to scattering within the object than is linear structured illumination, and it maintains a wide field of view.

It is also simple and inexpensive in comparison with confocal microscopes. However, in order to obtain complete coverage of the object with good signal strength, one must calculate the root mean square (RMS) of a large number of images—up to 100 or more. Therefore, in fluorescence, DSI is most suitable for thick specimens that are not highly susceptible to photobleaching.

## 17.2   Linear SIM Instrumentation

Figure 17.2 shows a schematic of a typical microscope setup for linearly sinusoidal SIM. A light-emitting diode (LED) illuminates a mask (GRID), which adds structure to the beam. The structured light passes through a beam splitter (BS) and is focused by a microscope objective (MO) on a plane conjugate to the mask at the object or sample (S). Light scattered by the object passes back through the microscope objective and beam splitter to be imaged on the camera, often a charge coupled device (CCD), which is also in a plane conjugate to the object. The camera is connected to a personal computer (PC), where image processing is performed.

In other arrangements, the LED can be replaced by a different incoherent source or by a coherent light source. In the latter case, a diffraction grating generates a linear sinusoidal pattern with high light efficiency. This is significant since the linear sinusoid is the most common structure used in SIM. The same structure may be added under incoherent illumination by using a sinusoidal mask in place of the GRID. The addition of structured illumination to fluorescence microscopes is another variation that has shown excellent results [8].

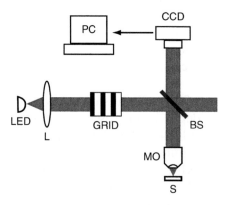

**FIGURE 17.2**   A sample structured illumination microscope setup.

## 17.2.1  Spatial Light Modulator

A particularly versatile type of mask is the spatial light modulator (SLM). This is an array of pixels that allows modulation of the phase or intensity of the light over specific microscopic regions. Spatial light modulators are available in both transmittance and reflectance modes. They are based on a variety of technologies, including microarrays of liquid crystals, mirror arrays, and light-emitting diodes. For example, a micro-pixel array of light-emitting diodes has demonstrated effectiveness for structured illumination [9]. For our purposes the important feature is that generating a mask with the SLM is no more difficult than displaying a bitmap image on a computer monitor. The flexibility and precise pixelwise control provided by the SLM have contributed to its widespread use in optical systems. Spatial light modulators vary widely in quality and cost, but they provide a solid-state alternative to mechanical moving parts such as the Nipkow disk (see Chapter 14).

Another use is to correct for an uneven, but stable, illumination pattern [4]. If the result of image processing is directed back through a feedback loop to the SLM, the light structure can be adapted in an iterative process until it becomes flat. To do so it is only necessary to measure the intensity from a planar mirror object and then to use its inverted pattern to control the SLM. Minor adjustments are required to maximize total light throughput.

## 17.3  The Process of Structured Illumination Imaging

Perhaps the most common use of structured illumination is in optical sectioning microscopy. While the conventional light microscope is an invaluable tool in the physical and life sciences, it is limited when viewing thick objects because light from out-of-focus regions pollutes the image from the focal plane. This problem occurs especially when a high-NA objective is used to obtain good lateral resolution, per Eqs. 17.1 and 17.2, and so is most problematic at high magnification, where the DOF may well be thinner than the specimen.

Toward the end of the 20th century, a number of instruments capable of rejecting defocused light were developed to overcome this limitation. The confocal scanning microscope (CSM) is the best-known example. However, it requires time-consuming scanning in both lateral and axial directions, and the CSM device is more complicated and expensive than a conventional microscope [10]. Linearly sinusoidal SIM is a fast optical sectioning tool that requires only simple modification to the conventional light microscope (see Fig. 17.2), followed by a bit of image processing [11]. A mechanical actuator attached to a linear sinusoidal grating is used in place of the grid, along with a coherent

light source. This yields an illumination pattern of fringes $S_i(y)$ having the approximate form

$$S_i(y) = 1 + m\cos\left(\frac{2\pi y}{T} + \phi_i\right) \tag{17.3}$$

The spatial period of the grid that illuminates the object is given by

$$T = \frac{T_0}{\beta} \tag{17.4}$$

where $T_0$ is the spatial period of the grid mask itself, $\phi$ is the phase offset of the grid pattern, and $\beta$ is the magnification from the specimen plane to the grid plane. The amplitude factor $m$ is the *modulation depth*. It depends on how well the optical transfer function (OTF) of the microscope transmits the frequency of the grid.

Images having intensity $I_i(x, y)$ are captured for three different phase offsets, $\phi_1 = 0$, $\phi_2 = 2\pi/3$, and $\phi_3 = 4\pi/3$. These are obtained by physically sliding the grid with the actuator. Figure 17.3 shows an ideal (computer-simulated) struc-ture imposed on the illumination under these conditions. If an in-focus planar mirror were to be used for the object, the CCD would capture images similar to Fig. 17.3, only slightly blurred, due to the point spread function (psf) of the microscope (Chapter 2). The frequency shown is chosen for illustration, since an actual grid would use as high a frequency as possible. It is shown later that the axial resolution improves with increasing spatial frequency, $\nu = T^{-1}$.

After the three images $I_i(x, y)$ have been obtained, image processing is used to extract the optical section. Mathematically the processing, at each pixel position $(x, y)$, is expressed as

$$I_{\text{sectioned}} = \left[(I_1 - I_2)^2 + (I_2 - I_3)^2 + (I_1 - I_3)^2\right]^{1/2} \tag{17.5}$$

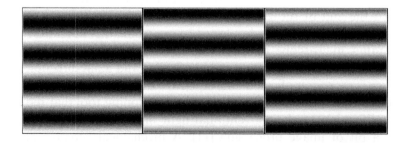

**FIGURE 17.3**    Linear sinusoidal light structure offset by 1/3 spatial period between each frame.

This is simply the RMS of the three images. Although the CCD camera converts the optical image into a digital image, we reference position in both images as $x$ and $y$, implicitly assuming real numbers in the former and integers in the latter. To compute an $M \times N$-pixel optical section image, Eq. 17.5 is applied on a pixel-by-pixel basis for all positions, $(x, y)$, with $0 \le x < M$ and $0 \le y < N$.

At this stage care must be taken to avoid loss of information. The sectioned image should be computed with high numerical precision (e.g., double-precision floating point). Then one can apply further image processing if necessary. If so, high precision should be used there as well. The values resulting from the floating point calculations must be scaled to the integer range of the final output file. For example, for 8-bit precision, the overall range would be scaled from 0 to 255. But this is not completely straightforward. Usually a series of optical sections is gathered at regular intervals along the $z$-axis to cover a three-dimensional specimen fully. The entire set of images must be considered when scaling gray-level values, since all sections should be scaled consistently. This can be done by finding a global $I_{max}$ and $I_{min}$ from the set and then scaling to the maximum grayscale bitmap value $G_{max}$ using

$$I(x, y)_{gray} = [G_{max}/(I_{max} - I_{min})] \cdot [I(x, y) - I_{min}] \qquad (17.6)$$

Equation 17.6 is written this way to emphasize that the constant factor $G_{max}/(I_{max} - I_{min})$ can be precalculated.

## 17.3.1 Extended-Depth-of-Field Image

In order to view a thick object all at once, the sections can be combined into an *extended-depth-of-field* (EDOF) *image* (see Chapter 16). The most in-focus pixels at each $(x, y)$ position along the entire axial range of sections are compiled into a single composite image. Since SIM strongly suppresses defocused light, the most in-focus pixels will likely also be the brightest. Thus the brightest pixel along the $z$-axis, at each position $(x, y)$, is selected as the most in-focus one [11].

## 17.3.2 SIM for Optical Sectioning

Light gathered by the objective, after passing through the object, has a focused component and a defocused component. Structured illumination microscopy suppresses the defocused component. It is easy to verify, by algebra or direct substitution, that, if the three intensities in Eq. 17.5 take on the sinusoidal form of Eq. 17.3, then the resulting $I_{sectioned}$ is maximized. For a planar mirror, it would be constant (an evenly illuminated field), as one would expect. Under defocusing, the $I_i$ also contain a low-frequency blurred component that is

canceled out in the computation of $I_{sectioned}$. Note that any constant that is added to all three $I_i$ is subtracted out in Eq. 17.5.

The following simulated example illustrates the process. The image in Fig. 17.4a is a picture of Turtox captured by conventional wide-field microscopy. In Fig. 17.4b the image is tilted so that it becomes increasingly out of focus toward the bottom. This is simulated as follows. A grayscale depth map (not shown) is created, where zero gray level at the top corresponds to the focal plane, and it has a smooth transition to 255 at the bottom, which is most distant from the focal plane. Thus this specifies that the top of the image is in focus and the bottom is the most out of focus, as is apparent in Fig. 17.4b, which is a simulation of one image from a stack of optical sections. To compute Fig. 17.4b from Fig. 17.4a and the depth map, the weighting function

$$w(r) = e^{(-r/r_0)} \qquad (17.7)$$

is used as a convolution filter kernel to blur the image to simulate the defocus that is specified by the depth map. The width of the blurring kernel, $r_0$, is proportional to the distance of the pixel from the focal plane, as given by the depth map.

Once it is known how the object blurs with distance, it can be illuminated virtually. A grid like that of Fig. 17.3 but with higher frequency was multiplied

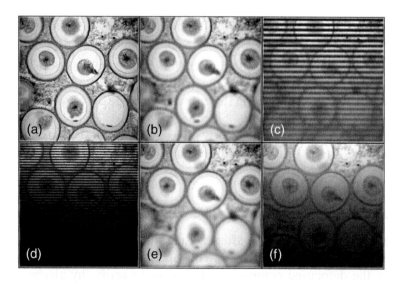

**FIGURE 17.4** Simulation of SIM to obtain an optical section. The image in (a) is tilted in (b) so that it becomes increasingly out of focus toward the bottom, as viewed in a conventional microscope. One of the three phase-offset illumination patterns is applied in (c). The difference from Eq. 17.5 in (d) shows how overlapping, defocused light is removed. In (e) the conventional image of (b) has been reconstructed by Eq. 17.8. Finally, (f) shows the section where only the focused component of the light has been retained.

by the focused image Fig. 17.4a for each of the three phases. Figure 17.4c shows illumination for one phase after the blurring for depth has been simulated. The square of the difference between two depth-blurred illuminations, corresponding to $(I_1 - I_2)^2$ in Eq. 17.5, is shown in Fig. 17.4d. When three such results are combined, as in Eq. 17.5, the optical section of Fig. 17.4f results. It is also possible to construct the conventional image, shown in Fig. 17.4e, from the three phase images by computing

$$I_{\text{conventional}} = I_1 + I_2 + I_3 \qquad (17.8)$$

The earlier statement about the image containing a focused component and a defocused one can be substantiated by comparing Figs. 17.4b and 17.4f. Due to increased blurring toward the bottom, much of the image has been eliminated. What remains near the bottom is dim but better focused. Near the top, the image is bright. Notice that if the depth map were inverted, bringing the bottom into focus, the bottom portion of the computed image would be bright. This suggests that the EDOF image would be composed with uniform brightness if enough intermediate frames were processed.

### 17.3.3 Sectioning Strength

A common way to quantify the improvement in axial resolution that is obtained via SIM is by determining the *sectioning strength* of the microscope. This is a measure of how effectively light outside the focal DOF is rejected. For SIM, the measurement may be performed by using a planar mirror as the object and stepping its position along the optical $z$-axis. When the mirror is outside the DOF in either direction, the response should be small due to the suppression of defocused light. At the focal plane, the response should be maximal.

As a baseline for comparison, we calculate the theoretical best response. A good approximation for monochromatic light is [12]

$$I(z) \sim \left| \frac{2J_1(\gamma)}{\gamma} \right| \qquad (17.9)$$

This includes the Bessel function of the first kind, $J_1(\gamma)$, and the parameter $\gamma$ defined by

$$\gamma = u\hat{v}(1 - \hat{v}/2) \qquad (17.10)$$

Equation 17.10 is expressed in optical coordinates for convenience. The axial coordinate is

$$u = 8\pi z\lambda^{-1} \sin^2(\alpha/2) \qquad (17.11)$$

and the dimensionless frequency is

$$\hat{v} = \beta \lambda v \sin^{-1}(\alpha) \tag{17.12}$$

These make use of the grid spatial frequency $v = 1/T_0$, magnification $\beta$, from Eq. 17.4, and $\alpha$ obtainable from the index of refraction $n$ and numerical aperture by $NA = n \sin(\alpha)$.

A plot of the theoretical response of Eq. 17.9 is shown in Fig. 17.5 for parameters $\lambda = 550$ nm, $\beta = 40$, $NA = 0.65$, and $T_0 = 100$ μm ($v = 10$ mm$^{-1}$). This represents the best response that can be expected when using these values. This limit is practically attainable [11, 13] and the response curves exhibit the correct shape, including the side lobes. When the magnification or grid spatial frequency is high, aberrations can cause some discrepancy. The effects that result from chromatic aberration, and their corrections, are discussed later.

It is also of interest to examine how sectioning strength changes with grid spatial period. This is plotted in Fig. 17.6. The result is approximately linear, but it begins to curve slightly for a fine grid of high $v$ (low $T_0$). If the optical transfer function is such that little light is passed at high $v$, a trade-off of lower axial resolution might be justified. If the microscope employs a spatial light modulator for the grid, one can measure the modulation transfer function (MTF) and adjust the grid period as desired. The digital nature inherent to the SLM must be considered, though, when it is used to display high-frequency grids.

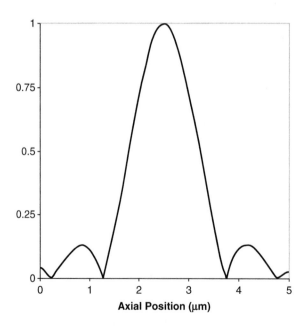

**FIGURE 17.5**   Theoretical best axial response for $\lambda = 550$ nm, $\beta = 40$, $NA = 0.65$, and $T_0 = 100$ μm.

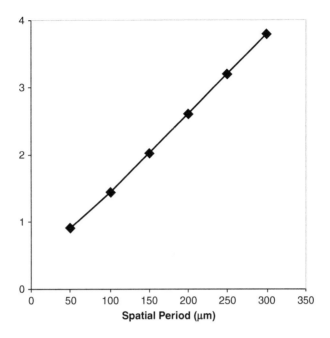

**FIGURE 17.6** Full width at half maximum (FWHM) of axial response curves versus (minified) spatial period $T$, with other parameters the same as in Fig. 17.5.

Since a phase shift of 1/3 period is needed between successive frames, the minimum $T_0$ for an SLM is three pixels wide. Obviously, a sine wave is not precisely represented by so few pixels. The alternatives include (1) increasing $\beta$, since this is equivalent to narrowing $T_0$ in terms of sectioning strength, (2) using a fixed mechanical grid, and (3) suffering increased artifacts (see later).

# 17.4 Limitations of Optical Sectioning with SIM

Structured illumination is fairly easy to use, provides good optical sectioning strength, and has a faster acquisition rate than its leading competitor, CSM, but it has two main disadvantages. The first is that it requires three frame captures per section, which makes it inapplicable for moving objects. However, two ways to overcome this problem have been demonstrated. The first uses "smart pixel" detector arrays to allow the three phases to be applied and processed in about a millisecond [13]. This approach is relatively expensive due to its requirement for special hardware. The second approach to improve the speed of SIM is *color structured illumination microscopy* (CSIM), which substitutes a single RGB exposure with three colors. This approach is detailed later.

**FIGURE 17.7** Pigeon feather in field size $240 \times 180\,\mu m^2$. The conventional image on the left has a DOF too narrow to focus the entire three-dimensional surface. The SIM EDOF image on the right succeeds in focusing over the axial range of 279 μm but exhibits serious vertical linear artifacts.

The other, more serious problem encountered with SIM occurs when remnants of the illumination grid structure propagate into the final processed image, where they appear as artifacts. To illustrate, a sample region of size $240 \times 180\,\mu m^2$ of a pigeon feather is shown in Fig. 17.7. The image on the left was taken by a conventional microscope set so that the rightmost area is in focus. The other image is the EDOF compilation from 11 sections separated by steps of $\Delta z = 25.4\,\mu m$. Structures in the EDOF image appear in focus, but object structures are obscured by linear artifacts. In this case, a vertical grid was used, resulting in vertical artifacts.

There are numerous causes for these artifacts. One often encountered is when the light source fluctuates in intensity between frames. It is also seen in fluorescence SIM applications when saturation or photobleaching of the fluorophores occurs. Another cause is the presence of errors in the grid position due to imprecisely timed camera triggering or to uncertainty in the mechanical actuator. It is sometimes advantageous to use a square rather than sinusoidal grid pattern to increase light efficiency, but the higher harmonics present in this pattern produce high-frequency artifacts.

## 17.4.1 Artifact Reduction via Image Processing

When artifacts cannot be avoided by improving the microscope setup, it is necessary to reduce them with image processing. Some of these techniques are reviewed here.

### 17.4.1.1 Intensity Normalization

The simplest artifact reduction approach is *uniform intensity normalization* (UIN) [14]. It compensates for fluctuations in lighting between image acquisitions.

The simulation of SIM with the Turtox sample, introduced earlier, is now extended, as shown in Fig. 17.8. In Fig. 17.8a, the intensities $I_2$ and $I_3$ were multiplied by factors of 0.9 and 0.8, respectively, before the section was computed according to Eq. 17.5. Since such a uniform intensity change can be completely reversed by UIN, the problem is fully corrected, as shown in Fig. 17.8b. To perform UIN, first the sums of pixel intensities for each frame are computed:

$$I_{\text{total},i} = \sum_{y=1}^{N-1} \sum_{x=1}^{M-1} I_i(x, y) \tag{17.13}$$

Next, the maximum of the three sums, $I_{\text{total,max}} = \max\left(I_{\text{total},1}, I_{\text{total},2}, I_{\text{total},3}\right)$, is determined. The scale factor for each frame is then

$$\kappa_i = I_{\text{total,max}}/I_{\text{total},i} \tag{17.14}$$

Replacing all $I_i(x, y)$ with $\kappa_i I_i(x, y)$ implements the UIN procedure. The most intense image of the three will have $\kappa_i = 1$, and it does not need to be scaled.

Saturation of fluorophores is a similar intensity adjustment, leading to the artifacts in Fig. 17.8c, where $I_2$ and $I_3$ are multiplied by factors 1.2 and 1.4,

**FIGURE 17.8** Simulated artifacts and correction by uniform intensity normalization. (a) $I_2$ and $I_3$ were decreased by factors of 0.9 and 0.8, respectively. The normalization applied in (b) fully corrects this. When $I_2$ and $I_3$ are saturated in (c) by factors 1.2 and 1.4, respectively, uniform normalization is only partially effective (d).

respectively. This clips the sine profile, making it more like a square wave, and higher harmonics are then seen in the artifacts. Uniform intensity normalization does improve on this, as shown in Fig. 17.8d, but residual structure is still visible. The effectiveness of UIN is reduced when the object contains the same frequency as the projected grid [15]. This is because UIN assumes that the structure is evenly distributed over the three illumination patterns and that any fluctuations in overall intensity are due to source variations, which will not hold if one of the frames happens to align with object structure having the same frequency. This is a rare occurrence that can be avoided by rotating either the object or the grid.

If the source intensity varies nonuniformly over the field between frames, further steps must be taken to correct artifacts. An error-minimization procedure is discussed later in Section 17.4.1.4. Some fluctuations can be corrected by modifying UIN to operate over subdivided images. The initial $M \times N$ images are partitioned into $(M/M_\delta) \times (N/N_\delta)$ cells of size $M_\delta \times N_\delta$ in which UIN is applied individually. Then, pixelwise intensity scale factors are interpolated from the resulting lattice of scale factors. The size of the cells along the grid direction should be at least as large as $T_{CCD}$, the period in pixels at the camera. If this condition is not met, the subdivided UIN technique does not correct the artifacts.

### 17.4.1.2   Grid Position Error

Artifacts resulting from grid misalignment are shown in Fig. 17.9. In the left half of this figure, the first and third grids are positioned correctly at $\phi_1 = 0$ and $\phi_3 = 4\pi/3$, but the second grid is offset from its correct position by 2% of the grid period, or $0.04\pi$. The section created using Eq. 17.5 results in minor but noticeable artifacts. Two grid positions are perturbed in the right half of Fig. 17.9, and the artifacts are more obvious. Here the grid positions used

**FIGURE 17.9**   Simulated grid position errors. On the left, the second grid was offset by a position error of 2% of the grid period. On the right, the second and third grids were offset by 2% in opposite directions.

were $\phi_1 = 0$, $\phi_2 = 2\pi/3 + \delta\phi$, and $\phi_3 = 4\pi/3 - \delta\phi$, again with $\delta\phi = 0.04\pi$ radians.

It is clear that a small amount of grid position error can lead to significant artifacts. A general result for predicting the sectioning strength reduction due to grid position errors is straightforward to obtain. If we use a pristine grid such as the one shown in Fig. 17.3, the section resulting from application of Eq. 17.5 has maximum intensity. If grid position errors are introduced between the three frames, a lower intensity results. We define the fractional grid position error as

$$\varepsilon_\phi = \frac{1}{3} \sum_{i \neq j} \left| \frac{\phi_i - \phi_j - 2\pi/3}{2\pi/3} \right| \tag{17.15}$$

and the fractional intensity error as

$$\varepsilon_I = \frac{\sum\limits_i (I_{\max} - \bar{I}_i)}{3 I_{\max}} \tag{17.16}$$

A plot of $\varepsilon_I$ versus $\varepsilon_\phi$ is shown in Fig. 17.10, where it can be seen that a breakdown occurs when the grid position errors exceed 20%. Normally one would not expect such large grid position fluctuations in a microscope, but the graph does indicate how critical these errors are, even when they are small. Note also that the simulation used here does not include any blurring. Even so, these results should be more accurate than those of Fig. 17.4.

**Detection**   Fortunately, the problem of grid position error is not difficult to detect and correct with image processing. The key to correcting grid

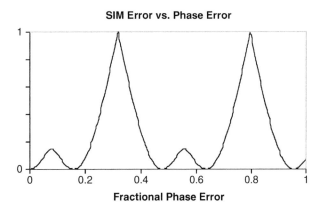

**FIGURE 17.10**   Fractional intensity error in SIM versus average fractional grid position error between frames. Notice that a large error produces heavy artifacts.

misalignment error is first to determine the amount of error present. To do so, we compute the Fourier transform (FT) $\Im(I_i)$ of each frame. Normally the strong periodic pattern of the grid will dominate the FT at its frequency, making it simple to find the phase difference between each pair of frames. Consider the example here, in which the grid is in the $y$ direction. The size of the image along the grid direction is $N$ pixels, and the spatial period of the grid, measured directly from the image, is $T_{\text{grid}}$ pixels. Then the frequency component of the grid in the FT is $\nu_{\text{grid}} = N/T_{\text{grid}}$. So if the FT is represented by an array of complex numbers as $z_{\text{FT}}(k_x, k_y)$, where $k_x$ and $k_y$ are integer grid positions in the Fourier domain, the value associated with the grid period is $z_{\text{FT}}(0, \nu_{\text{grid}})$. From this complex number, the phase of the grid is simply $\phi = \tan^{-1}\left[\text{Im}(z)/\text{Re}(z)\right]$. This technique is generally useful, but it is subject to error if the object has a strong component at the grid frequency. Under this circumstance, the phase error can still be estimated and optimized, as described later in Section 17.4.1.4.

**Correction**    After $\phi_i$ is found for each frame $i$, there are two approaches for correcting the phases. One is simply to note that a phase shift is equivalent to sliding the image along the direction of the grid. Shifting the image by an amount $\Delta y$ changes the phase by $\Delta \phi = 2\pi \, \Delta y / T_{\text{grid}}$. So if, for example, $\phi_1 = 0$ and $\phi_2 = 2\pi/3 + \delta$, a downward shift of pixels in $I_2$ of $\Delta y = (\delta/2\pi) T_{\text{grid}}$ would correct the error in grid position between the first two images. Similarly, the third image would be shifted to minimize the overall phase error and allow Eq. 17.5 to be used. Note that the images might need to be scaled to a larger size to increase the pixel resolution or interpolation used for noninteger pixel shift.

Another way to compensate for grid position error is to use a more general expression than Eq. 17.5. A knowledge of the phase differences between frames allows the sectioned image to be calculated [14] from $I_{\text{sectioned}} = |I_{S0}|$, where

$$
I_{S0} = (I_3 - I_1) + j\left[ \frac{I_1 - I_2}{\tan\left(\frac{\phi_1 - \phi_2}{2}\right)} + \frac{I_2 - I_3}{\tan\left(\frac{\phi_2 - \phi_3}{2}\right)} \right] \tag{17.17}
$$

Equation 17.17 is readily applied, but the tangent and division operations increase computation time. Thus, the choice of whether to correct grid position error by image shifting or by use of Eq. 17.17 is a matter of preference.

### 17.4.1.3    *Statistical Waveform Compensation*

We now address the saturation-induced artifacts illustrated in Fig. 17.8c. The profile of one period of the intensity waveform $I(y)$ for the most saturated of the three frames is shown by the dashed line in Fig. 17.11. The approach is to use

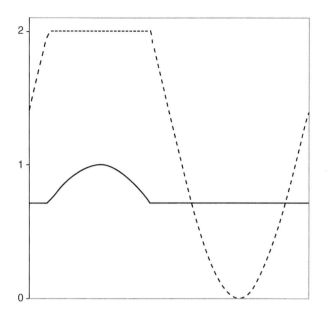

**FIGURE 17.11** Waveform compensation. The improper waveform of the dashed line will become sinusoidal when multiplied by the compensation curve of the solid line.

a nonlinear grayscale transformation to restore the shape of the grid profile. The goal is to find a compensation function $\varsigma(y)$ such that $\varsigma(y)I(y) = S(y)$ is sinusoidal, where $S(y)$ is from Eq. 17.3. In this case $S(y)$ and $I(y)$ are known, so $\varsigma(y)$ may be calculated. It is plotted as the solid curve in Fig. 17.11.

The waveform $I(y)$ can be observed directly if a mirror is used for the object. When a nontrivial object is illuminated, however, its image is likely to be so complicated that the grid profile of the illumination pattern is not obvious. Yet if a substantial fraction of the field of view is in focus, one can obtain the pattern by averaging individual grid lines together.

In experimental data, obstacles commonly encountered include a grid not aligned with a lateral axis and insufficiently large focused areas. An image can be rotated so that a grid that is oriented at an arbitrary angle aligns with the $x$- or $y$-axis. If there is too little focused area, waveform compensation will fail because the grid profile waveform is not estimated accurately.

### 17.4.1.4 Parameter Optimization

The final artifact correction procedure to be discussed is that of parameter optimization [15]. If the source illumination fluctuates or if there is imprecise grid alignment between frames, the projected light structure of Eq. 17.3 is more properly modeled by

$$S_i(y) = k_i \left[ 1 + m \cos\left( \frac{2\pi y}{T} + \phi_i + \delta\phi_i \right) \right] \qquad (17.18)$$

The factor $k_i$ accounts for intensity fluctuations, and $\delta\phi_i$ accounts for the phase errors. When the section is constructed, artifacts result for nonzero $k_i$ and $\delta\phi_i$. The values of these parameters can be adjusted in the sectioning calculation to minimize artifacts. Therefore, after the section is calculated it is evaluated by a merit function that rewards a lack of artifacts.

The two parameters can be determined iteratively as follows. For grid frequency $\nu_0 = 1/T$, the artifacts are most prominent at frequencies $\nu_0$ and $2\nu_0$ in the FT. Accordingly, these components are to be minimized in the reconstructed image (Eq. 17.5). The optical section is first computed for some $k_i$ and $\delta\phi_i$. A Fourier transform of the section is computed, and its values at the artifact frequencies are input into an appropriate merit function [15]. This process is repeated by varying $k_i$ and $\delta\phi_i$ until the merit function is minimized.

Parameter optimization shows improved quality in both simulated and experimental data. Its merit function can be tailored to specific cases. On the negative side, it is computationally intensive, so a fast search routine for parameter space is needed.

## 17.5 Color Structured Illumination

While optical sectioning by SIM is a relatively fast technique for wide-field microscopy, it may still be too slow in live-cell imaging applications. Specifically, assuming that a fractional phase error between frames of $\eta$ is acceptable, the maximum velocity of a moving object in the direction of the grid is $\nu_{obj}$:

$$\nu_{obj} = \frac{\eta T}{t_{frame}} \qquad (17.19)$$

As an example, for a grid period (at the specimen) of $T = 20\,\mu m$, a 10% phase error ($\eta = 0.1$), and frame time of $t_{frame} = 0.01\,s$, the object velocity must not exceed $200\,\mu m/s$. Living specimens could exceed this limit, producing motion blur and reducing sectioning strength. The frame time $t_{frame}$ can be divided into the exposure time $t_{exp}$ and the recovery time $t_{rest}$. Typically $t_{exp}$ is much smaller than the recovery time needed for the hardware to transfer the charge out of the CCD pixel wells. Therefore if all three phases can be recorded in a single exposure, structured illumination would allow optical sectioning of more rapidly moving objects. Even for static objects, the time required to obtain a section would be reduced by at least a factor of 3.

A color CCD camera has three channels: red (R), green (G), and blue (B). The separate subimages $I_1$, $I_2$, and $I_3$ can be collected in a single exposure as

**FIGURE 17.12** Combination of red (R), green (G), and blue (B) grids to make a magenta (M), R, yellow (Y), G, cyan (C), and B grid. The MRYGCB stripes are one-third as large as those of R, G, or B.

$I_R$, $I_G$, and $I_B$ [16]. The experimental setup for this is the same as that in Fig. 17.2. The grid is polychromatic, and the illumination source must have strong components at the RGB wavelengths. Alternatively, three monochromatic sources projecting sinusoidal interference patterns might be used.

Figure 17.12 shows the construction of the polychromatic color grid. The first three columns show adjacent grids offset by $T/3$. The combination color grid in the rightmost column is the addition of these three subgrids. This assumes that R + B = magenta (M), R + G = yellow (Y), and G + B = cyan (C). The final color grid has the same period as the original and takes the form of a repeated MRYGCB stripe pattern. A square, rather than sinusoidal, grid is used for increased light efficiency and because it is much easier to manufacture. The higher-frequency components included in this pattern lead to minor artifacts [14].

## 17.5.1 Processing Technique

In CSIM the image processing and grid fabrication are intertwined because different CCD cameras vary in their response to any particular grid. To find the relationship, test grids or other patterns can be made and adjusted to optimize the result. It is much simpler to calibrate the system when spectral information is available. Given the camera sensitivity $S(\lambda)$, the fractional emissivity of the lamp $E(\lambda)$, and the transmissivity of a grid stripe $T(\lambda)$, the expected net measured intensity is

$$I(\lambda) = ETS \qquad (17.20)$$

In this expression we neglect the reflectivity of the object, which will be accounted for with postprocessing, as in the artifact corrections already discussed. Figure 17.13 illustrates a spectrum measured by a CCD camera when light from a white fluorescent lamp passes though a red thin-film filter.

The total response in each RGB channel in Fig. 17.13 is the area under the respective curve. Although the R channel is dominant, the G and B components

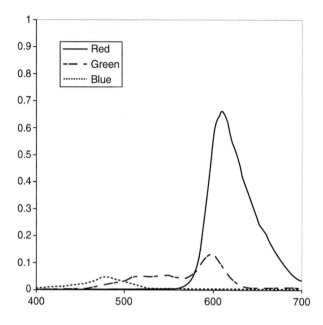

**FIGURE 17.13** Calculated response of a CCD camera to a broadband spectrum passed through a red dielectric thin-film filter.

are too large to be ignored. The main image processing that CSIM adds to SIM is to apply a first-order correction to this color blending. For measured $I_R^0$, $I_G^0$, and $I_B^0$, the corrected $I_R$, $I_G$, and $I_B$ are computed using decoupling parameters $\alpha_{XY} \geq 0$:

$$I_R = +\alpha_{RR}I_R^0 - \alpha_{RG}I_G^0 - \alpha_{RB}I_B^0$$
$$I_G = -\alpha_{GR}I_R^0 + \alpha_{GG}I_G^0 - \alpha_{GB}I_B^0 \qquad (17.21)$$
$$I_B = -\alpha_{BR}I_R^0 - \alpha_{BG}I_G^0 + \alpha_{BB}I_B^0$$

The $\alpha_{XY}$ are found from the ratio the areas of the response curves. For example,

$$\alpha_{RG} = \frac{\int I(R)}{\int G(R)} \qquad (17.22)$$

## 17.5.2  Chromatic Aberration

After Eq. 17.21 has been applied, the remaining image processing proceeds as with three-phase SIM, but with one difference. Because polychromatic light is used, there might be side effects due to chromatic aberration. Specifically, longitudinal chromatic aberration (LCA) may cause the R, G, and B light to focus at different positions along the optical axis. In order to check whether or

not this is a problem for any given microscope configuration, the sectioning strength is measured as usual by stepping a planar mirror through focus. This was done for a setup using 35-mm slides for a grid with period $T_0 = 254.4\,\mu m$, magnification $\beta = 15.5$, and NA = 0.25. The result is plotted in Fig. 17.14 along with the theoretically ideal response for monochromatic light.

The sectioning strength of this experiment is clearly inferior to the expected value. It is straightforward to model LCA by extending the use of Eq. 17.9 over a range of wavelengths and summing the individual terms to predict a broadband sectioning strength. One only needs additional data of chromatic aberration for the microscope objective versus wavelength to calculate a best-case outcome (ignoring aberration due to other components). This way, LCA is found to account for the observed reduction in sectioning strength.

The best way to eliminate the complications arising from LCA is to use a plan-apochromat microscope objective, stopped down (reduced NA) if necessary. Alternatively, if a set of images is taken in many steps along the optical axis to form the EDOF image, the R, G, and B image subsets can be taken from different positions along the $z$-axis, relative to one another to best compensate for the difference in focal positions due to LCA. The step size $\Delta z$ must be smaller than these differences in order for this approach to succeed, and this is only practical for static objects.

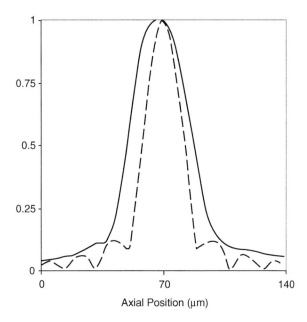

**FIGURE 17.14** Measured sectioning strength of a CSIM setup exhibiting longitudinal chromatic aberration (solid lines). The theoretical monochromatic response of Eq. 17.9 is shown for comparison (dashed lines).

### 17.5.3  SIM Example

We now illustrate optical sectioning by structured illumination as a three-dimensional imaging tool. Figure 17.15 shows Spanish moss images acquired with a color structured illumination microscope. The conventional view in Fig. 17.15a is well focused at the starting $z$ position, but the more distant region is completely out of focus. After collecting sections from six steps along the $z$-axis, the EDOF image is compiled in Fig. 17.15b. Although the entire field is now in focus, it is difficult to discern any depth information. A depth map has been constructed in Fig. 17.15c. This is a by-product of the EDOF image; since the brightest pixels from all sections are chosen, the depth for each such pixel is given by the $z$ position of its section. This is stored as a grayscale image having as many levels as there are steps along the $z$-axis. Visualization software can be used to combine Figs. 17.15b and 17.15c into a surface image appearing truly three-dimensional. However, due to noise in the depth map, particularly in low-brightness regions, the three-dimensional view may contain discontinuities. Use of a low-pass filter is one way to diminish this effect, as shown in the relatively smooth version Fig. 17.15d.

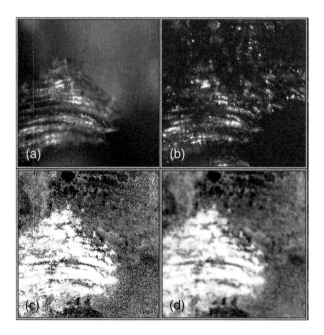

**FIGURE 17.15**   Spanish moss in a field width of 240 μm. (a) Single conventional image of the foremost structure with completely defocused background area; (b) the EDOF image is composed of six frames separated by $\Delta z = 25.4$ μm and shows the entire field in focus but lacks depth information; (c) the depth map, which provides the information along the optical axis, but is noisy in regions of low light level; and (d) a smoother depth map obtained by applying a low-pass filter to (c).

## 17.6  Lateral Superresolution

When the lateral resolution of a light microscope exceeds the diffraction limit of Eq. 17.1, it is said to exhibit *superresolution*. Several forms of light microscopy are able to surpass the Rayleigh limit and achieve superresolution. Some of them utilize structured illumination [1, 17, 18], while others do not [19]. This section follows the linear sinusoidal SIM approach and achieves a factor of 2 improvement in lateral resolution [2, 3].

### 17.6.1  Bypassing the Optical Transfer Function

Optical systems pass a limited range of frequencies (see Chapter 2), as defined by the optical transfer function (OTF). The highest frequency that is not completely attenuated is known as the *cutoff frequency*. Because finer details of the object are encoded in higher-frequency components, higher resolution could be attained if the cutoff frequency were increased. The leftmost strip in Fig. 17.16 is a linear sinusoidal pattern having a period of $T_{\text{left}} = 20$ units. The rightmost strip is inclined relative to the left by $10°$ and has a period of 18 units. The center strip results from multiplying these two, and it shows distinctive Moiré fringes of period measured to be about 96 units. Suppose that the OTF allows the leftmost pattern to be transmitted but not the right, which falls above the cutoff frequency. The rightmost strip, then, represents structure that would normally be

**FIGURE 17.16**  The Moiré fringes of the center strip show the low-frequency pattern resulting from multiplication of two patterns having higher frequencies and different directions (left and right).

attenuated completely. The much lower frequency of the Moiré fringes is easily within the passband, and that component carries information about the pattern on the right that is unobservable directly. What is needed is a way to extract this information, which can be done by shifting the phase of the illumination grid over a few frame captures and solving a set of algebraic equations. This is the basis of using SIM to extend lateral resolution.

## 17.6.2  Mathematical Foundation

A deeper understanding of this method follows from its mathematical analysis, which relies on Fourier theory [20]. By the convolution theorem, the FT of the convolution of two functions $g(x, y)$ and $h(x, y)$ in real space is equal to the pointwise product of their FTs in frequency space, and vice-versa; that is,

$$\Im[g \otimes h] = \Im[g] \times \Im[h] \quad \text{and} \quad \Im[g \times h] = \Im[g] \otimes \Im[h] \quad (17.23)$$

where $\otimes$ denotes the convolution operator, $\Im$ denotes the FT, and $\times$ is pointwise multiplication. Also recall, from the shift theorem,

$$\Im\left(e^{i\mathbf{k}_0 \cdot \mathbf{r}}\right) = \delta(\mathbf{k} - \mathbf{k}_0) \quad (17.24)$$

In two dimensions, the vectors are $\mathbf{r} = (x, y)$ and $\mathbf{k} = (k_x, k_y)$. The exponential representation of the cosine is

$$\cos(\mathbf{k} \cdot \mathbf{r}) = \frac{\left(e^{i\mathbf{k} \cdot \mathbf{r}} + e^{-i\mathbf{k} \cdot \mathbf{r}}\right)}{2} \quad (17.25)$$

and the final preliminary expression we will need is

$$f(\mathbf{k}) \otimes \delta(\mathbf{k} - \mathbf{k}_0) = f(\mathbf{k} - \mathbf{k}_0) \quad (17.26)$$

### 17.6.2.1  Shifting Frequency Space

Assume the source illumination projects a cosine grid pattern at orientation $\mathbf{k}_g$ and phase $\phi_m$:

$$S_m(\mathbf{r}) = 1 + A \, \cos(\mathbf{k}_g \cdot \mathbf{r} + \phi_m) \quad \text{and} \quad m = 1, \dots, 3 \quad (17.27)$$

A series of frames for some grid orientation $\mathbf{k}_g = (2\pi/T)(\cos\theta_{\text{grid}}, \, \sin\theta_{\text{grid}})$ are taken with several different phases $\phi_m$. This is equivalent to Eq. 17.3 when $\mathbf{k}_g = (0, 2\pi/T)$. Given that the fluorophores have a distribution over the object plane of $R(\mathbf{r}) = R(x, y)$, then the light measured at the detector is

$$I_m(\mathbf{r}) = (R(\mathbf{r})S_m(\mathbf{r})) \otimes P \quad (17.28)$$

The convolution by $P$ in Eq. 17.28 is the effect of the psf of the microscope. Taking the FT of Eq. 17.28 and applying the convolution theorem results in

$$\Im[I_m] = \tilde{I}_m = \Im[(RS_m) \otimes P] = \Im(RS_m) \times \Im(P) \qquad (17.29)$$

We use the tilde over a variable to denote its FT. The FT of the psf, $\tilde{P}$, is the optical transfer function (OTF) and is referred to as $\tilde{P} \equiv O(k_x, k_y)$. Observe that $\Im(RS_m)$ can be simplified further by once again applying the convolution theorem

$$\Im[RS_m] = \tilde{R} \otimes \tilde{S}_m \qquad (17.30)$$

along with Eq. 17.25 to obtain

$$\tilde{S}_m = \Im[1 + A\cos(\mathbf{k}_g \cdot \mathbf{r} + \phi_m)] = \Im\left[\frac{1 + A\left(e^{i(\mathbf{k}_g \cdot \mathbf{r} + \phi_m)} + e^{-i(\mathbf{k}_g \cdot \mathbf{r} + \phi_m)}\right)}{2}\right]$$
$$= \Im\left[e^{i0} + \frac{Ae^{i\phi_m}}{2}e^{i\mathbf{k}_g \cdot r} + \frac{Ae^{-i\phi_m}}{2}e^{-i\mathbf{k}_g \cdot \mathbf{r}}\right] \qquad (17.31)$$

Finally, after using Eq. 17.24, the expression for $\Im[S_m]$ reduces to

$$\tilde{S}_m = \delta(\mathbf{k}) + \frac{Ae^{i\phi_m}}{2}\delta(\mathbf{k} - \mathbf{k}_g) + \frac{Ae^{-i\phi_m}}{2}\delta(\mathbf{k} + \mathbf{k}_g) \qquad (17.32)$$

By substituting Eq. 17.32 into Eq. 17.30 and applying Eq. 17.26, we find that

$$\Im[RS_m] = \tilde{R}(\mathbf{k}) + \frac{Ae^{i\phi_m}}{2}\tilde{R}(\mathbf{k} - \mathbf{k}_g) + \frac{Ae^{-i\phi_m}}{2}\tilde{R}(\mathbf{k} + \mathbf{k}_g) \qquad (17.33)$$

Thus, from Eq. 17.29, when the FT of the CCD image is computed, it will be equal to

$$\tilde{I}_m = \left[\tilde{R}(\mathbf{k}) + \frac{Ae^{i\phi_m}}{2}\tilde{R}(\mathbf{k} - \mathbf{k}_g) + \frac{Ae^{-i\phi_m}}{2}\tilde{R}(\mathbf{k} + \mathbf{k}_g)\right] \times O(\mathbf{k}) \qquad (17.34)$$

The two terms that are shifted by $\pm\mathbf{k}_g$ contain information that is inaccessible under full-field illumination. With Eq. 17.34 and some image processing, enhanced lateral resolution will result.

### 17.6.2.2 Extracting the Enhanced Image

To make use of Eq. 17.34, one must identify the known quantities and solve for the unknowns. Assuming we know the grid direction and its spatial period $T$, $\mathbf{k}_g$ is known. The modulation amplitude, $A$, can be estimated from image data. It is also possible to fit $\mathbf{k}_g$, $A$, and the initial phase, $\phi_1$, more precisely via parameter

optimization (Section 17.4.1.4 earlier). The remaining $\phi_m = \phi_1 + (m-1) \times \Delta\phi$ are known because the phase steps $\Delta\phi$ are determined by the hardware. The OTF and CCD image $I_m$ are measured. Thus the three $\tilde{R}$ terms are the only unknowns in the system, so only three linearly independent equations are needed to solve for them. These can be obtained by capturing three images ($m = 1, 2, 3$) that are offset from each other in phase by $\Delta\phi = 2\pi/3$.

By rewriting Eq. 17.34 as

$$Z_m = \tilde{R}_0 + C_m \tilde{R}_- + D_m \tilde{R}_+ \qquad (17.35)$$

where $Z_m = \tilde{I}_m O^{-1}$, $\tilde{R}_0 = \tilde{R}(\mathbf{k})$, $\tilde{R}_- = \tilde{R}(\mathbf{k} - \mathbf{k}_g)$, $\tilde{R}_+ = \tilde{R}(\mathbf{k} + \mathbf{k}_g)$, $C_m = \frac{Ae^{i\phi_m}}{2}$, and $D_m = \frac{Ae^{-i\phi_m}}{2}$, we find the complex solution

$$\tilde{R}_- = \frac{(Z_3 - Z_1)(D_2 - D_1) - (Z_2 - Z_1)(D_3 - D_1)}{(C_3 - C_1)(D_2 - D_1) - (C_2 - C_1)(D_3 - D_1)} \qquad (17.36)$$

$$\tilde{R}_+ = \frac{Z_3 - Z_1 - \tilde{R}_-(C_3 - C_1)}{D_3 - D_1} \qquad (17.37)$$

$$\tilde{R}_0 = Z_1 - C_1 \tilde{R}_- - D_1 \tilde{R}_+ \qquad (17.38)$$

Each grid orientation and accompanying set of three images expands the sampling of frequency space in the grid direction, as shown in Fig. 17.17. The number of grid orientations used depends on how fully one wishes to span the available space. If $n$ denotes the number of grid orientations, then the minimum number of frame captures is $3 + 2(n-1)$, though it might be procedurally simpler to capture $n$ three-phase sets, for a total of $3n$ images.

(a)    (b)    (c)

**FIGURE 17.17**  Extending frequency space. The dark, center circle encloses the area conventionally passed by the OTF. Additional circular regions centered at $(0, \pm k_y)$ are sampled by applying structured illumination with a pattern having $k_1 = (0, k_y)$ as in (a). In (b), another set of three phase-offset images is taken with $k_2 = (k_x, 0)$. Three directions at relative rotations of $120°$ provide good coverage in seven to nine frame captures, effectively expanding the lateral resolution by a factor of 2.

### 17.6.3 Lateral Resolution Enhancement Simulation

The following simulation shows this method in use. The "object" was the focused two-dimensional image of Turtox from Fig. 17.4a. The effect of the microscope OTF was modeled by a low-pass filter. Next, a set of three phase-offset grids having period of 32 units was made for both the $x$ and $y$ directions to expand the resolution, as in Fig. 17.17b. These grids were multiplied by the unfiltered object and then operated on by the low-pass filter. This models the structured light fluorescing from the object and then being filtered by the OTF of the microscope. The $Z_m$ in Eqs. 17.36 through 17.38 resulted from the FT of these images.

Since this is a simulation, $A$ and $\phi_1$ were known a priori, and solving for $\tilde{R}_0$, $\tilde{R}_-$, and $\tilde{R}_+$ is direct. The Fourier transforms of these for the $y$-shifted set are shown in Fig. 17.18. The middle frame is what the conventional microscope would pass. Some of this information is repeated in the left and right frames, but shifted up and down, respectively. This can be matched to the middle frame to find $A$ and $\phi_1$, if they are not already known. The amount of shifting necessary to align them determines $\mathbf{k}_g$. The extra information in the left and right frames is the high-frequency information that has been shifted into the observable region.

Equations 17.36 through 17.38 were solved for both directions. The $\tilde{R}$ values were combined by first shifting them to their proper positions in frequency space and then forming a composite image by collecting the brightest pixels from each at any given $(k_x, k_y)$. The inverse FT of this composite image, shown in the right side of Fig. 17.19, exhibits the desired resolution enhancement. On careful inspection of the end product in Fig. 17.19, one can see a faint grid pattern due to "ringing" introduced by the low-pass filter.

**FIGURE 17.18** Frequency space views $\tilde{R}_-$, $\tilde{R}_0$, and $\tilde{R}_+$ for the $k_1 = (0, k_y)$ grid direction. The bright regions in the left and right frames must be shifted to align with that in the middle frame to move them to their position of origination. The inverse FT of the combined image gives resolution improvement in one dimension. By adding $\mathbf{k}_g$ in other directions, resolution is enhanced in two dimensions.

**FIGURE 17.19**  The Turtox image, simulating the object, after processing by a low-pass filter (left). The enhanced-resolution image (right) after application of SIM in the *x* and *y* directions.

## 17.7   Summary of Important Points

1. In structured illumination, a pattern is imposed on the incident light via a mask, such as a Ronchi ruling, or interference of one or more coherent sources.

2. In most cases the entire field is not illuminated, making several camera acquisitions necessary per axial position.

3. Optical sectioning is a nondestructive way to obtain a 3-D image of a specimen.

4. Using three image acquisitions, SIM is capable of matching the axial resolution of the confocal microscope.

5. All forms of SIM are dependent on computer processing to compose a final image from several separate acquired images.

6. Remnants of the illumination grid structure often persist as artifacts in the image, and additional processing may be necessary to minimize these.

7. The spatial light modulator is a flexible type of pattern generator that is convenient for SIM, and it makes real-time adaptive illumination possible.

8. The various forms of structured illumination microscopy are more complex and expensive than conventional light microscopy. SIM nevertheless has applications in such fields as medicine and the biosciences.

## References

1. R Heintzmann and G Ficz, "Breaking the Resolution Limit in Light Microscopy," *Briefings in Functional Genomics and Proteomics* **5**:289–301, 2006.

2. ML Gustafsson, "Surpassing the Lateral Resolution Limit by a Factor of 2 Using Structured Illumination Microscopy," *Journal of Microscopy*, **198**:82–87, 2000.

3. ML Gustafsson, "Nonlinear Structured-Illumination Microscopy: Wide-Field Fluorescence Imaging with Theoretically Unlimited Resolution," *Proceedings of the National Academy of Sciences of the USA*, **102**(37):13081–13086, 2005.

4. KP Proll, JM Nivet, C Voland, and HJ Tiziani, "Application of a Liquid-Crystal Spatial Light Modulator for Brightness Adaptation in Microscopic Topometry," *Applied Optics*, **39**:6430–6435, 2000.

5. HJ Tiziani and HM Uhde, "Three-Dimensional Analysis by a Microlens-Array Confocal Arrangement," *Applied Optics*, **33**:567–572, 1994.

6. C Ventalon and J Mertz, "Quasi-confocal Fluorescence Sectioning with Dynamic Speckle Illumination," *Optics Letters*, **30**:3350–3352, 2005.

7. JW Goodman, "Statistical Properties of Laser Speckle Patterns," in *Laser Speckle and Related Phenomena*, JC Dainty, ed., Springer-Verlag, 1976.

8. H Bauch, "Structured Illumination in Fluorescence Microscopy," *Bioscience Technology*, 2003.

9. HX Zhang et al., "Microstripe-Array InGaN Light-Emitting Diodes with Individually Addressable Elements," *IEEE Photonics Technology Letters*, **18**:1681–1683, 2006.

10. JB Pawley, *Handbook of Biological Confocal Microscopy*, Plenum Press, 2006.

11. MA Neil, R Juskaitis, and T Wilson, "Method of Obtaining Optical Sectioning by Using Structured Light in a Conventional Microscope," *Optics Letters*, **22**:1905–1907, 1997.

12. PA Stokseth, "Properties of Defocused Optical Systems," *Journal of the Optical Society of America*, **59**:1314, 1969.

13. J Mitic et al., "Optical Sectioning in Wide-Field Microscopy Obtained by Dynamic Structured Light Illumination and Detection Based on a Smart Pixel Detector Array," *Optics Letters*, **28**:698–700, 2003.

14. MJ Cole et al., "Time-Domain Whole-Field Fluorescence Lifetime Imaging with Optical Sectioning," *Journal of Microscopy*, **203**:246–257, 2001.

15. LH Schaefer, D Schuster, and J Schaffer, "Structured Illumination Microscopy: Artifact Analysis and Reduction Utilizing a Parameter Optimization Approach," *Journal of Microscopy*, **216**:165–174, 2004.

16. L Krzewina and MK Kim, "Single-Exposure Optical Sectioning by Color Structured Illumination Microscopy," *Optics Letters*, **31**:477–479, 2006.

17. C Pitris and P Eracleous, "Transillumination Spatially Modulated Illumination Microscopy," *Optics Letters*, **30**:2590–2592, 2005.

18. E Ben-Eliezer, N Konforti, and E Maron, "Superresolution Imaging with Noise Reduction and Aberration Elimination via Random Structured Illumination and Processing," *Optics Express*, **15**:3849–3863, 2007.

19. PC So et al., "Two-Photon Excitation Fluorescence Microscopy," *Annual Review of Biomedical Engineering*, **2**:399–429, 2000.

20. JW Goodman, *Introduction to Fourier Optics*, 3rd ed., Roberts and Company, 2004.

# 18

# Image Data and Workflow Management

Tomasz Macura and Ilya Goldberg

## 18.1  Introduction

Proteomics, genetics, and pharmaceutical therapeutic agent screens are spearheading a new approach to biomedical microscopy that is based on *high-content cellular screens (HCS)*. A *cellular screen* refers to any assay involving living cells. In HCS, changes in staining or fluorescence markers are monitored to observe how compounds or genetic manipulations affect cellular activities or morphology. These are high-throughput screens because whole classes of compounds (~150,000 chemicals) or genes (up to 20,000) need to be investigated exhaustively in a systematic manner. The dataset size further increases when additional experimental variables are examined, such as varying concentration levels and different imaging markers.

Robots are used in HCS for sample preparation, fluid handling, and image acquisition. The rate-limiting factor in high-throughput microscopy experiments is the qualitative, manual image analysis performed after data collection [1]. To alleviate this bottleneck, image informatics platforms are being developed to enable image analysis to be performed using quantitative, automated computer vision algorithms.

A microscopy image informatics platform is software that interacts with a database to store images, structured meta-data, descriptor annotations, numerical analysis outputs, and provenance information. Platforms enable researchers to organize, annotate, browse, search, and analyze their datasets manually and

algorithmically. Informatics solutions benefit microscopy projects of all scales, from modest projects involving only dozens of images to high-throughput screens with multiple experiments and collaborators.

### 18.1.1   Open Microscopy Environment

The open microscopy environment (OME) is a publicly available, open-source informatics platform for scientific images [2]. It has been in release since 2001 [3, 4] and is the most high-profile and full-featured system of its kind. We cite OME throughout this chapter as an example for illustrating concepts.

### 18.1.2   Image Management in Other Fields

Image management software is being developed for applications besides microscopy. For example, Apple and Google market, respectively, the iPhoto and Picassa programs for organizing and editing photographs from consumer digital cameras. In hospitals, radiology departments are storing patient diagnostic images digitally in picture archiving and communication systems (PACS) [5]. The remote-sensing community has been making aerial, satellite, and topographic images available to the pubic through programs such as NASA WorldWind, Google Earth, and Microsoft TerraServer [6]. Finally, astronomy has the most extreme high-throughput, high-content imaging requirements of all. The planned Large Synoptic Surgery Telescope (LSST) will be robotically aimed and will image the whole sky daily with a 3.8-gigapixel camera. When LSST becomes operational in 2013, it is projected to produce up to 30 terabytes of image data per day [7].

### 18.1.3   Requirements for Microscopy Image Management Systems

A single high-throughput experiment can produce tens of thousands of images, where each image can potentially be over 100MB, with multiple focal planes, channels, and time points. Microscopy platforms must support hundreds of thousands of such images comprising terabytes of disk space.

Microscopy has many different modes (light, fluorescence, phase contrast) as well as many different types of staining and markers. There are 20–30 common microscopy formats [8]. Software has to be designed to accommodate in a single system all of the vastly different microscopy images.

Organizational containers, whether albums (iPhoto and Picassa), patients (PACS), or datasets (microscopy), are applicable to all types of image management. Free-text descriptions, numerical measurements, ontological references,

and other annotations are absolutely crucial to scientific and medical images, where the content, unlike that in consumer photographs, cannot be gleaned from cursory inspection.

One feature that sets apart research microscopy from other kinds of image management is that the structure of information is not known a priori. Rather, when the system is used in a discovery process, the process leads to new information that needs to be stored in the same system. Predefined annotations and hierarchies are inadequate for all experiments. This motivates the development of a specification language for defining new information and an extensible platform architecture that will be able dynamically to support the new data types.

The second distinct feature in microscopy is the tight coupling between large datasets and automated quantitative image analysis via computer vision algorithms. The systematic computer-based quantitative analysis of high-throughput microscopy experiments involves thousands of images and a handful of algorithms, with parameters, that produce thousands of analysis results along with execution logs. It is advantageous to store information about algorithm execution within the informatics platform.

## 18.2   Architecture of Microscopy Image/Data/Workflow Systems

For an informatics platform to support microscopy experiments effectively, it must manage not only images, but also related data and image analysis workflows. Thus the platform needs a unified system architecture, based on an extensible data model (see Fig. 18.1).

### 18.2.1   Client–Server Architecture

Scientific image informatics platforms follow the standard *client–server architecture*, in which a single instance functions as a shared resource for a community of users. In microscopy, that community is often an entire laboratory or department.

System administrators install and maintain the platform, while users connect to it with either a web browser or dedicated thick clients (e.g., Java programs). The centralized design confers several advantages. Dedicated hardware and hosting provide large-capacity redundant storage and guaranteed up-time. Administrators handle system install, update, and maintenance. Users only need to point their browser or download a simple client. A web-based interface can be accessed from any computer; on the other hand, thick remote clients (a thick or fat client is capable of processing data, which it then passes on to the

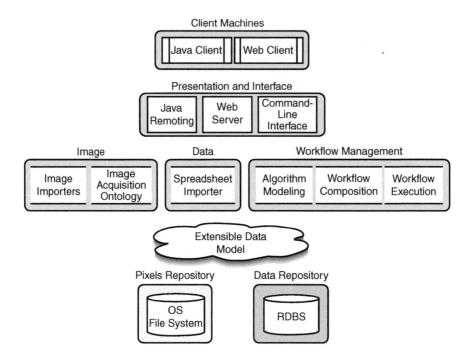

**FIGURE 18.1**   Schematic illustrating a unified image, data, and workflow management system based on an extensible data model.

server for communications and/or storage) need to be installed separately on each client computer, but they provide more advanced visualization and interaction than a browser.

Web interfaces and thick remote clients are complementary, so most platforms, including OME, support both. Command-line interfaces are handy because they can be used with shell scripting to automate tasks, e.g., to perform scheduled backups or import images without user intervention directly from the microscope. Documented application programming interface's (APIs) give the most flexibility by permitting users to develop their own views on managed data, and they are available with most scientific image management software.

## 18.2.2   Image and Data Servers

Relational databases are built for storing structured collections of data that will be queried in a random fashion. Thus databases are the logical location where informatics platforms record annotations and other meta-information. On the other hand, pixels and other large files (binary large objects, BLOBs) are sequentially accessed in whole blocks, e.g., per image plane, making it more efficient to store BLOBs on the file system [9].

The OME image server (OMEIS) is an http interface to the OME repository where image pixels and original image files are stored on the file system using dynamically generated, balanced directory trees. Files and pixels are accessed using 64-bit integer identifiers (IDs) that OMEIS can decode into file paths. The OME meta-information database stores the Uniform Resource Locator (URL) to the OMEIS repository and the OMEIS IDs as foreign keys for each file or image pixels.

Images' pixels data is typically orders of magnitude larger than their meta-data. Separating the pixels data from meta-data gives more options for systems administration. OMEIS can be run from high-capacity drives separate from the database's fast-access drives or on a different computer all together. OMEIS has been designed to work directly off the file system in a way that is compatible with general system-administration utilities for file compression and archiving.

## 18.2.3 Users, Ownership, Permissions

Platforms need user accounts to support multiple people adding or editing data. Programs for organizing digital photographs don't use accounts because they are single-user applications running on personal computers; and aerial photography and astronomy programs typically display only data, so every user is a "guest."

A user account has a username and password for authentication along with identification details: the person's name, titles, and email address. Many IT departments are already using Lightweight Directory Access Protocol (LDAP) to store address book information and manage email/computer accounts. To manage passwords and other user details centrally, OME can use LDAP for authentication and lookup. User accounts are also handy for storing user-state and customization parameters such as layout.

Importantly, user accounts enable the platform to link each image and annotation to the user that imported or created it. This turns out to be very useful if questions arise about a particular piece of data: There is always a data owner to ask for explanations. OME places users into groups. Users in a group are considered collaborators, and one user in a group is marked as group leader. Usually groups are set up to mimic departmental organizational structure.

Permissions are layered on top of the data-ownership framework. In OME, data that is visible is data owned by the user, data owned by groups to which the user belongs, data owned by groups led by the user, or data owned by members of the groups led by the user. A consequence of permissions is that there needs to be at least one superuser or administrator account that has unconstrained access. OME's permissions are implemented by injecting Structured Query Language (SQL) at the lowest layer, so higher layers, including presentation code, do not have to worry about permissions because data that the user is not permitted to view is not retrieved from the database.

Most people spend the majority of their time analyzing their own data. OME utilizes ownership information to provide default views where only a user's or user collaborators' data is presented. By limiting what data is presented, ownership and permissions perform an important role in maintaining performance on large-scale deployments.

## 18.3  Microscopy Image Management

### 18.3.1  *XYZCT* Five-Dimensional Imaging Model

The "image" internal representation is a key component of image management software. Images produced with consumer cameras are clearly two-dimensional (2-D) RGB pixel lattices. However, representing microscopy images is more complex, due to the numerous types of optical light microscopy, including brightfield, differential interference contrast, and phase contrast, fluorescent microscopy, and confocal microscopy.

The *XYZCT 5-D imaging model* [4] was designed to encompass all types of microscopy images. $XY$ denotes the spatial extents, same as in real-world images (2-D). $Z$ denotes the focal planes, cross-cutting the sample at regularly spaced intervals. $C$ denotes the channels; these can be a single channel in the case of phase contrast, the three red, green, blue channels in stained pathology images, or multiple fluorescence emission wavelengths. $T$ denotes the elapsed-time points that are relevant for live-cell imaging.

### 18.3.2  Image Viewers

The challenge with viewing five-dimensional microscopy images is that monitors are physically limited to displaying only two dimensions. Volume rendering can produce 2-D projections that users can rotate, pan, and manipulate to mimic a three-dimensional (3-D, i.e., $XYZ$) pixels stack. The VisBio Java client [10] (see Fig. 18.2) produces such visualizations. When the rendering can be performed in nearly real time, a movie of the 3-D pixels stack can be generated to show time-elapsed changes ($T$ dimension). An alternative to volume rendering that is utilized by thin clients (perform no processing activities, but only convey input and output between the user and the remote server), such as OME's SVG web image viewer, is to give users controls to iterate over the $Z$ and $T$ dimensions. The OME viewer can iterate over the dimensions automatically—to "play" $Z$ and $T$ fly-throughs.

Displaying multiple-channel images is tricky. Microscopy images, e.g., of histochemically stained slides, that were acquired with a color camera are

Display Transform

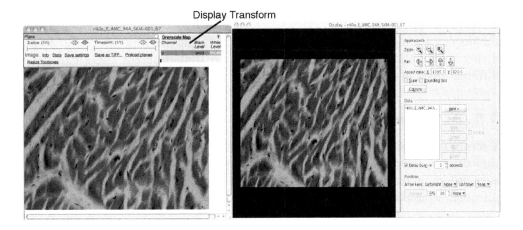

**FIGURE 18.2** Image viewers for *XYZCT* 5-D images. Left: OME SVG web interface. Right: VisBio Java client. Both viewers are displaying the same (postprocessed) image of H&E-stained mouse skeletal muscle acquired at 40×.

recorded as red, green, blue channels so that they can be displayed as color photographs. Other types of microscopy images can also be multichannel, but with each channel totally independent from the others. In fluorescence microscopy, each channel represents a different emission wavelength. Each channel can be viewed separately, or multiple channels can be viewed together using pseudo-color. In pseudo-color, each channel is arbitrarily assigned a color (e.g., red, green, or blue) and displayed pixels are combinations of coloring with channel intensity.

The digital cameras mounted on microscopes often sample photons at 10- to 12-bit quantization (1024–4048 levels), while monitors can only display 256 color intensities. Transfer functions resample the original pixel intensities into the 256 shades that will be displayed. There are many different ways to define such transfer functions, but all transfer functions share the property that they filter out data. Different images have different noise and signal characteristics and also are used for different purposes. It is important for users to be able to adjust the display transfer function for individual images. OME uses a simple uniform transfer function (marked on Fig. 18.2) that displays all pixels between the minimum and maximum thresholds.

Multiple parameters are involved with displaying images, which can be collectively referred as *display settings*. Selecting the proper display settings can be quite laborious and tedious to repeat every time the image is viewed. If consumer photographs are edited, e.g., contrast is improved with image management software, then the file is typically overwritten with the new pixel intensities. This is not appropriate for scientific image management. Instead, OME stores the raw pixel intensities from the image files and also stores the

display settings. The display views are regenerated every time by applying the display settings to the raw pixels. In OME, display settings are assigned an owner and thereby tied to individual users so that different users can have different display settings for the same image.

### 18.3.3    Image Hierarchies

Users have a much easier time navigating and maintaining large image datasets if they can put their images into groups. Much like files in folders on a file system, such groupings can be hierarchical. Images in a single group share some contextual information implicitly that can be made explicit by annotating the group.

#### 18.3.3.1    Predefined Containers

Nearly all image management software provides such predefined hierarchies. Software for digital camera photographs organizes images into *albums* or *events* that can be titled, labeled, or sorted. These groupings typically revolve around a particular time point, e.g., birthday party, or a particular activity, e.g., sailing. PACS, since they are geared toward a diagnostic workflow, organize images by patients. Patients are further subdivided into modalities and date of study. This organizational structure gives radiologists easy access to a patient's previous studies that may impact the current diagnosis.

Since OME is tailored to scientific experiments it provides a *project, dataset, and image object hierarchy*. Projects represent large, long-term investigations, usually by a single investigator or a small group of investigators. Each project contains a number of datasets, and each dataset contains a number of images. There is a many-to-many relationship between projects, datasets, and images: Images can belong to multiple datasets, and datasets can belong to multiple projects. Objects in the image object hierarchy carry very little state themselves, except for a name and textual description.

The Atlas of Gene Expression in Mouse Aging Project (AGEMAP) is a study by the National Institutes of Health, National Institute on Aging, involving 48 male and female mice, of four ages, on ad libidum or caloric-restriction diets. AGEMAP is investigating biomarkers of aging and diet in multiple organs by analyzing Hematoxylin & Eosin (H&E) stained tissue sections with quantitative pattern analysis algorithms. For each mouse, 50 images per organ were collected from liver, kidney, and skeletal muscle. As AGEMAP progresses, additional organs are going to be imaged, including brain, lungs, pancreas, thymus, and heart. Images from this project are managed and analyzed within OME.

AGEMAP (see Fig. 18.3 for a schematic) is organized as a single project that is divided into datasets by mouse organ. All people collecting images, such as

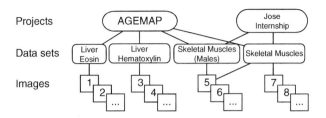

**FIGURE 18.3**   Example project/dataset/images hierarchy.

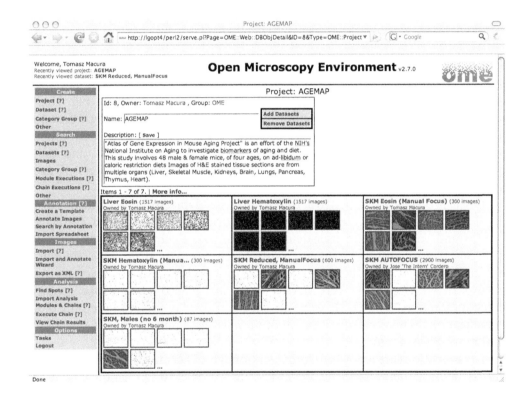

**FIGURE 18.4**   Screenshot showing 5000 images organized by projects and datasets.

Jose, who was a summer intern, have their images linked to their own projects. As can be seen in Fig. 18.4, organizing images into projects and datasets gives an overview of 5000 images that is much clearer that just randomly selected thumbnails.

### 18.3.3.2   User-Defined Containers

AGEMAP is similar to many other microscopy experiments, in that large groups of images are collected along multiple crosscutting axes of investigation,

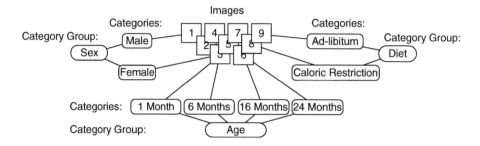

**FIGURE 18.5** Schematic illustrating how images are grouped into three independent category groups: age, sex, and diet.

where each axis could be the organizational hierarchy. The project/dataset/ images hierarchy is effective in grouping AGEMAP images by organ, but other groupings, based on individual mouse, age, sex, and diet (see Fig. 18.5), can also be organized. There is significant value in the other groupings. Viewing images by individual mice can help elucidate if there are staining variations in slides or any per-mouse outliers. Analyzing images in age-, sex-, and diet-matched groups makes it possible to look for structural biomarkers of age, sex, and diet, which is a key objective of AGEMAP.

OME provides a parallel structure to projects/datasets/images called *classi-fications*, based on the category groups/categories/images hierarchy. Category groups and cateogries are user-defined containers. Each category belongs to a single category group. An image cannot belong to two categories of the same category group but may belong to two categories of different category groups. Figure 18.5 shows how AGEMAP images are placed in category groups/ categories/images. The OME web interface can display images based on their classifications. This style of image annotation is very similar to image "tagging" in iPhoto, Picassa, etc.

Classifications are a powerful organizational tool because they enable images across multiple datasets to be assembled in a crosscutting fashion into user-defined groupings according to similar image content.

## 18.3.4  Browsing and Search

In consumer photography it is usually trivial to look at a small thumbnail and tell who is present in the picture and what is happening (e.g., cutting cake at a birthday party). For this reason, iPhoto and Picassa interfaces are based on browsing pages full of thumbnails. The only commonly used meta-data is the image acquisition time stamp.

This is diametrically opposite to scientific imaging, where image content is rarely obvious, and often misleading, without proper context. In AGEMAP it is

relatively easy to look at a thumbnail and know what organ was imaged, but not the mouse's age, sex, or diet. This all-crucial context can be recorded in a variety of ways: image name, description, dataset, or classifications. Users can exploit this context information using keyword matching to carve out image subsets in which they are interested. OME provides interfaces (Fig. 18.6) to search by image free-text annotations, structured meta-data, datasets, or classifications.

As the volume of managed images grows, the number of images that can be displayed becomes an even smaller fraction of all images stored. This is partially due to the computational overhead involved in presenting images and partially due to finite screen area, but the ultimate constraint is that people can concurrently process only a limited number of images. By allowing users to specify constraints as to what they are looking for, search interfaces can show only the most pertinent images.

In browsing interfaces, paging is important for maintaining stable performance as the volume of managed images scales up. The idea behind paging is that a user can analyze only a single page of information at once, so only a single page of images or data will be presented to the user, and therefore only that data will be retrieved from the database. A count of how many "pages" of data are available is also returned, so a user can go to the "next page" to continue browsing data.

## 18.3.5 Microscopy Image File Formats and OME-XML

After images have been captured by the microscope and written to the file system, they need to be imported before they can be manipulated with image management software. During import, the file format is detected, meta-data is extracted, and pixels are converted into the system's internal representation. In OME, the pixels are stored as a 5-D stack on the OME image server (OMEIS), a thumbnail is precomputed and cached by OMEIS, and information about the image is recorded in the OME database. It's an open question what to do with the original image file after the pixels and meta-data were extracted for it. OME stores the original file in OMEIS and links it to the image pixels, making it available to users on request.

Radiology has standardized on the *Digital Imaging and Communications in Medicine (DICOM)* image-file format [11]. Thus scanners made by different manufacturers for different radiological imaging modalities, e.g., computed tomography, magnetic resonance imaging, and ultrasound, all write images in the same file format. This made it possible to store, retrieve, and present radiological images of all types in a single system and was critical to the success of *picture archiving and communication systems (PACS)*.

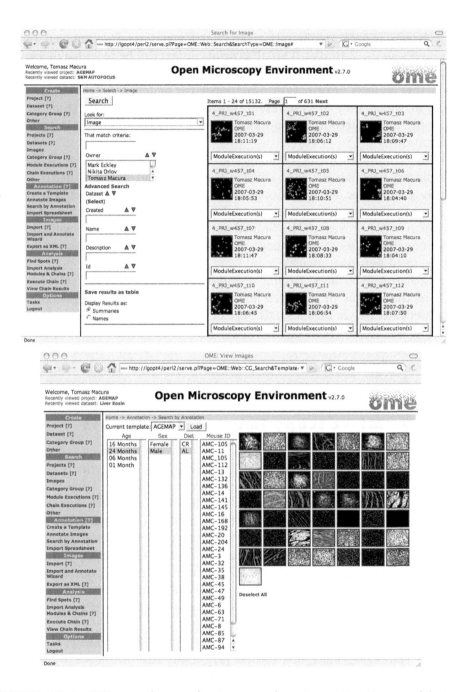

**FIGURE 18.6**   OME users utilize meta-data to retrieve relevant images. Top: Users search by image name, description, date, and experimenter. Bottom: Users find images based on image categorizations.

OME supports DICOM and was also designed to allow users to store all types of multidimensional microscopy and medical images in a single system. In microscopy, unfortunately, there are 20–30 common proprietary image-file formats [8]. Programming libraries, such as Bio-Formats , which is written in Java and is capable of reading and writing microscopy files in over 50 image formats, are bridging this fragmentation [12]. OME uses Bio-Formats to import images.

Before Bio-Formats was developed in 2005, most software for processing microscopy images would support only a select few image formats. In this environment TIFF became the de facto standard for sharing microcopy images. The TIFF standard allows for storing multiple two-dimensional image planes in a single file and has a mechanism of name–value pairs called *custom tags* for adding meta-data. In principle, TIFF can be used effectively for storing multidimensional microscopy images. In practice, microscope software encoded pixels and meta-data in TIFFs indiscriminately, thereby undermining interoperability.

Some software exported a single image as a whole directory of TIFFs, one file for each 2-D image plane. Splitting single images into multiple files is both a strength and a weakness: It requires lower overhead during processing than a single large file, but it also makes it easier for part of the image to get lost. Without detailed meta-data, stitching the files back into a single image becomes a matter of parsing filenames, which is far from robust since there was no convention on filenames. Others images were written as a single TIFF file with multiple 2-D planes without specifying explicitly whether the planes are focal sections, channels, or time points. Storing meta-data was an even bigger problem. If software wrote meta-data at all, it was often included in a separate file, with proprietary, binary, syntax. Or the meta-data was loaded into the TIFFs as custom tags, with no convention on tag names and structure. Either way, the meta-data was lost or ignored because it could not be understood. A great feature of Bio-Formats is that it extracts not only pixels from image formats, but also as much of the meta-data as possible.

### 18.3.5.1 OME-XML Image Acquisition Ontology

Converters for microscopy file formats such as Bio-Formats are only an interim solution. What is needed is agreement on meta-data, its structure, and how it will be stored along with the pixels.

*OME-XML* [13] is the ontology for describing microscopy images. It has components for specifying image dimensions; the hardware configuration used to acquire image planes, e.g., lenses, filters; settings used with the hardware (physical size of image planes in microns, channel configuration); and who

performed the image acquisition. The OME-XML Schema was released in January 2004, accepted by the European Light Microscopy Initiative as a standards recommendation in 2005, and is natively supported by several microscope manufacturers and software vendors.

OME-XML is not a new file format; it is a new set of meta-data. This meta-data is written in Extensible Markup Language (XML) using a format specified in XML Schema—a standard format-description language for XML documents.

XML is a powerful format for interchanging images because XML is not binary, but readable, plain text; the structure of XML documents is inherently open, so it is possible to understand a new XML format even without the governing schema; XML Schema provides an unambiguous description of the document's structure, which allows for validation with third-party tools; lastly, there is wide support for software for parsing XML for many computing languages and platforms. OME-XML files follow the meta-data specification in the OME Schema. Binary pixel data is encoded in base 64 in order to preserve the "plain text" characteristic of XML documents. Base-64 encoding stores a binary stream as a text series of 64 characters (52 uppercase and lowercase letters, 10 digits, and two punctuation characters).

OME-TIFF is a variant of OME-XML that maximizes the respective strengths of OME-XML and TIFF, taking advantage of the rich meta-data defined in OME-XML while retaining the pixels in the TIFF format for greater compatibility. A complete OME-XML meta-data block without the base64–encoded pixels is embedded in the TIFF file header using the "Description" tag. Thus OME-XML–compliant software can open the TIFF file, parse the OME-XML in the Description tag, and read the pixels using the standard TIFF encoding. Generic TIFF readers can still open OME-TIFF file, except they would ignore the OME-XML block and the meta-data it contains.

## 18.4    Data Management

In informatics platforms, image and data management is intertwined: Data associated with each image is the all-critical context for interpreting its pixels. This context is heavily utilized when searching for and organizing images. It also serves as historical documentation that makes the images more interpretable by colleagues. We have already discussed several ways of recording context information, such as by giving images names and descriptions, placing them into predefined hierarchies (e.g., datasets and categories), and recording their acquisition meta-data.

Predefined organizational hierarchies and free-text descriptions, however, are not suitable for describing all experiments. Instead, ontologies can be used

for creating hierarchies and structured meta-data specialized to new information types. Ontologies imbue data with a defined semantic meaning and a computable logical model that can later be used to visualize, query, and collate [14] the structured data in a way that is impossible with plain text.

## 18.4.1 Biomedical Ontologies

Ontologies have been applied to organizing facts and observations since the 17th century. An *ontology* can be defined simply as a controlled vocabulary. In the present day, the use of ontologies in biology and medicine has become so prevalent that it could be considered mainstream [15]. An ontology can describe how empirical data was generated. For example, the MIAME standard defines a minimal set of information about microarray experiments [16], similar to OME-XML's light-microscopy image acquisition parameters. Other ontologies represent knowledge objects and relationships from a given domain in a computable format. The Gene Ontology (GO) [17, 18] models relationships between gene product and function and is, to date, the most highly successful [19] example of an ontology in biology.

A particular ontology first needs to be adopted by the scientific community before it can serve as a unifying terminology for data and service interoperability. In an effort to build consensus, institutions and consortiums, such as NIH's National Cancer for Biomedical Ontology and the European Center for Ontological Research, are increasingly guiding ontology development. In a similar vein, there now exist common ontology descriptive languages (XML, RDF, OWL) and cross-discipline ontology editors, e.g., Protégé [20]. The current trend in ontologies is toward increased logical rigor and formalism [21].

Medicine is a discipline heavily dependent on specialized terminology. Systematized Nomenclature of Medicine—Clinical Terms (SNOMED-CT) and its predecessors have been in development since 1965 in an effort to systemize medical terminology in an electronic multiaxial, hierarchical classification system. SNOMED has 269,864 classes, named with 407,510 terms and subdivided into 18 top-level classes (e.g., body structure, environment, organism, pharmaceutical/biologic product) [22]. Creating and maintaining SNOMED is a massive undertaking involving a whole community of doctors and informaticians.

DICOM Structured Reporting (DICOM SR) [23] is leveraging the SNOMED ontology in an attempt to formalize, with coded or numerical content grouped in lists and hierarchical relationships, the patient information and diagnostic reports stored in radiology PACS. Patient information is data such as age, gender, weight, lifestyle (e.g., smoker), and past medical history. Reports are dictated and written by radiologists to specify study details, findings, interpretations, and differential diagnosis.

In microscopy, the visual content of images varies greatly, depending on the experiment, and experiments vary greatly between preceptors and laboratories. Thus there cannot exist a single complete ontology, such as SNOMED, for describing all information that can be extracted from a microscopy image. Instead, a standardized data model can exist that will allow researchers to define their own ontologies specific to an individual experiment or analysis. The image management software would parse the ontology definitions and adapt to the new information types. This is the approach undertaken with the OME "SemanticType" Data Model and OME platform [4].

## 18.4.2  Building Ontologies with OME SemanticTypes

OME *SemanticTypes* are an XML-based specification language for constructing ontological terms to define the meaning and structure of data. Instances of SemanticTypes, the actual data, are called attributes. A SemanticType's meaning comes from its name, description, and granularity. Names and descriptions are human interpretable and convey the common traits shared by attributes of that SemanticType. A SemanticType's *granularity* can either be "image," "dataset," or "global" and specifies whether the SemanticType is a property applicable to a specific image, e.g., cell count, a property applicable to a group of images, e.g., average number of cells per image, or a global fact, e.g., name of a cell line. The SemanticType's structure is specified with a list of named fields called *Semantic-Elements*. Each SemanticElement can be a simple data type, such as an integer, string, or floating-point number, or can be a reference to another SemanticType.

The property that SemanticTypes can reference other SemanticTypes is used for modeling *has-a* relationships. *Is-a* relationships can also be modeled: The SemanticType definition has an optional element to refer to the Semantic-Type of which it is a specialization. These has-a and is-a relationships are the mechanism by which SemanticType object definitions can be combined, like a network, into ontologies.

The OME-XML image acquisition ontology is defined by its Schema definition, but it is also completely modeled with SemanticTypes. Figure 18.7 shows two elements from this ontology. An "Instrument" is a global granularity SemanticType that describes a microscope. Its SemanticElements are "Manufacturer," "Model," "SerialNumber," and "Orientation"—all strings. Similarly "LightSource" is a global granularity SemanticType with string Semantic-Elements "Manufacturer," "Model," and "Serial Number." "LightSource" has one additional SemanticElement that is a reference to an "Instrument."

It is conceptually clear that an instrument is made up of (has-a) a light-source, detector, objective, and filter wheel with an optical transfer function (OTF). Conceivably an instrument could be modeled as a single SemanticType,

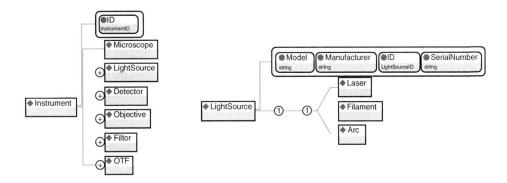

**FIGURE 18.7**  Instrument and Objective's schematic representations.

with SemanticElements defining all the attributes for objectives, filters, etc. Or another possibility is that the objective, filters, etc. are separate Semantic-Types that are referenced by the "Instrument" SemanticType. Both hypothetical modeling approaches are severely limited. First, a single microscope typically has multiple objectives with different magnifications; but referencing objectives in the instrument definition requires making assumptions as to how many objectives a microscope can have. Second, instruments are often regularly upgraded with new objectives or cameras. Hardware changes would require the creation of a new instrument, duplicating much of the old instrument's definition. These limitations can be avoided if the has-a relationship between the instrument and, e.g., objective is modeled with the objective's SemanticElement referencing the instrument SemanticType. Then there are no limits on how many, e.g., objectives an instrument has—when a new objective is purchased, a new objective SemanticType attribute is made referencing the old instrument.

Modeling OME-XML with SemanticTypes makes the ontology locally extensible. For example, some microscopes are placed on air tables for vibration abatement, but OME-XML lacks the meta-data to describe such air tables. It is easy to extend OME-XML by defining an "AirTable" SemanticType, with SemanticElements listing the air table's properties and a SemanticElement referencing the "Instrument" SemanticType. Such ontology extensions can be produced independently and immediately put to use in the lab. Subsequently they can be forwarded to the OME-XML standards committee, incorporated into the official Schema, and released.

A key element in the OME-XML ontology is the *Pixels* SemanticType. Although pixels are mathematically represented as a 5-D matrix, they are treated markedly different than a lattice of numbers: They are displayed rasterized on the screen rather than as a table of numerals. Some pixels are directly from a microscope, while others, the processed pixels, are by-products of image analysis such as segmentation. Computational pixels are stored and displayed in

a similar manner as raw pixels but have different semantic meanings. Utilizing SemanticTypes' support of specialization, each new type of computational pixels can be defined as its own new SemanticType that also "is-a" Pixels.

OME SemanticTypes are being used in other independent projects, including the Bio-Image Semantic Query User Environment [24] and the BioSig Imaging Bioinformatics Framework [25].

## 18.4.3 Data Management Software with Plug-in Ontologies

Informatics platforms store data with an inherent structure. This structure can be implicit and simple; for example, in software for managing consumer photographs, the data structure is something like: albums have images and images comprise name, pixels, and time stamp. Ontologies can be used to formalize software's complex data structures. In this way, SNOMED-CT is being integrated into PACS systems. But since SNOMED-CT is a single ontology, this integration can occur during software development. The challenge for microscopy platforms is that the structure of information is not known a priori; rather, the ontologies that model the scientific discovery process can be defined only by the software users. Platforms need a language for defining these ontologies, and an infrastructure for "plugging in" the ontologies so that they can be utilized for data management.

Ontologies defined as SemanticTypes in XML files can be imported into a running OME platform. Through the import process, the OME platform gains the capabilities to manage these new data objects. OME can support plug-in ontologies because (1) the OME database schema was designed to expand dynamically and (2) all of OME, from the database to the presentation layers, treats SemanticType attributes generically. The generic treatment that's provided by default can also be customized per SemanticType for presentation or other purposes, e.g., Pixels have specialized rendering.

In OME, each SemanticType is stored in its own table, with columns for each SemanticElement. This table is created when the SemanticType's XML definition is imported into OME. The SemanticElement's declared data type is the column data type of the new table. Each SemanticType attribute has its own row in the table and a key (attribute id). Tables for SemanticTypes that are of image or dataset granularity also contain a column with foreign keys into the images or dataset tables. This ties attributes to the container they describe. Similarly, SemanticElements that reference a SemanticType are foreign-key references to the referenced SemanticType's table.

OME maintains meta-tables that map SemanticTypes to table names and SemanticElements to columns names and data types. These meta-tables completely insulate data storage in OME. Data is accessed in terms of its ontology,

not how it's laid out in the database. Thus OME is not locked into maintaining this data layout format, and it could just as well be storing attributes as key/value pairs in a single long, skinny table. The one table per SemanticType data layout format was selected for performance reasons because it leads to significantly fewer rows and therefore significantly lower database overhead due to indices and storage than if using key/value pairs.

Leveraging OME's support for plug-in ontologies, many of OME's essential data structures are not hard-coded but, rather, defined using SemanticTypes and imported during the OME install process. These are called the OME *core types* and are fully compliant SemanticTypes defined in XML that are no different than user-defined ontologies [26]. The OME-XML image acquisition ontology and the category groups/categories/images hierarchies are built in to OME in this way. Thus the extensibility mechanism is used to build the entire system rather than just to extend it.

## 18.4.4 Storing Data with Ontological Structure

After the ontology has been defined and integrated into the informatics platform, data in the prescribed ontological structure can be loaded into the platform. This data can come from a variety of sources: It can be extracted from image files, entered via the web interface either individually or en masse, or imported from spreadsheets.

### 18.4.4.1 Image Acquisition Meta-Data

When images are imported into OME, as much of the meta-data as possible is extracted from the image files and converted into structured annotations. Some file formats (TIFF is a prominent example) store very little meta-data and so acquisition information has to be supplied manually. OME's web interface has a generic page for creating new attributes of any SemanticType. This page presents fields where users can enter values for all of a SemanticType's SemanticElements.

### 18.4.4.2 Mass Annotations

Some use cases, such as manually scoring high-content screens (HCS), call for marking up a large number of images en masse. The aforementioned web interfaces are effective for creating one-at-a-time SemanticType attributes that need to be made infrequently and without viewing image content but are cumbersome for annotating image datasets. After all, a microscope's properties have to be defined only once.

OME has a specialized web interface for mass annotations. In this interface, users first select which ontological terms they want to use for annotations and which images they want to annotate. Ontological terms can be any Semantic-Type or category group. Ontologies are often complex, and informatics platforms manage many images; hence focusing on terms and images of interest is important in increasing efficiency by eliminating distractions. After users have made their selections, they are presented each image, one at a time, along with meta-data including name, owner, and description, and other ontological terms. Users can change the image's annotations, click the "Save & Next" button, and move on to annotating the next image. This interface was designed to entail the least number of keystrokes and mouse movements so as to enable images to be annotated manually at maximal speed.

### 18.4.4.3  Spreadsheet Annotations

Many images that are managed by informatics platforms have already been annotated externally, with the annotations recorded in spreadsheets. This makes tools that can migrate a laboratory's extensive spreadsheet collections into the platform very valuable.

OME has support for converting spreadsheets in the Microsoft Excel and tab-delimited file formats into projects/datasets groupings, category group/category classifications, and SemanticType annotations. All the different annotations that can be made with the web interface, can also be made via spreadsheets. The spreadsheet's column headings dictate what type of annotations will take place.

Spreadsheets that define image annotations need to have one column named "Image.Name," "Image.FilePath," "Image.FileSHA1," or "Image.id." This column is how OME finds the correct image to annotate. Columns named "Dataset" or "Project" specify how the images need to be grouped into the projects/datasets/images hierarchy. Columns can also be names of category groups, and then all of its entries are categories into which the image will be classified. To annotate by SemanticType, the column headings should be of the form SemanticType.SemanticElement and the entry in the column will be used to set the SemanticElement's value.

Spreadsheet annotations were used to link AGEMAP images to the acquisition microscope's meta-data and to classify the images by age, sex, diet, and mouse. The AGEMAP spreadsheet was produced by a script and had thousands of rows across half a dozen columns. The script contained a hard-coded lookup table to map mouse identifiers to age, sex, and diet. When it scanned a directory of images, it extracted the mouse identifier from each filename and used the identifier to fill in the spreadsheet. Sample spreadsheet-generating scripts and a Perl programming toolkit are included in OME.

Many times scientists purposely group their images into directories on the file system based on an experimental variable. In AGEMAP the images are placed in directories based on which organ is imaged. OME "annotation wizards" can scan these directory structures and produce annotation spreadsheets to convert directory hierarchies into projects/datasets/images and category groups/categories/images hierarchies. Wizard-produced spreadsheets can be examined for accuracy and then used to create annotations.

# 18.5 Workflow Management

Analogous to ontologies that represent concepts and define data's semantic meaning, workflows model processes in order to define data's provenance. Provenance information records the procedure by which data was generated. This information is applicable to all data but is especially relevant in scientific image analysis, where results can be produced by computer algorithms such as in the systematic analysis of high-throughput microscopy experiments.

Workflows are data-flow descriptions; but they can also include execution instructions that specify how a workflow's algorithms ought to be run. The platform follows these instructions to enact the workflow and automatically record the algorithm results and provenance information. The platform can optionally distribute the analysis across networked computers to take advantage of parallelization or reuse previous results to avoid reexecuting algorithms with the same inputs.

## 18.5.1 Data Provenance

When an image is imported, recorded provenance information is the link between the original image file and the pixels and meta-data that were extracted from it. Similarly, spreadsheets used for mass annotations need to be marked as the sources of new classifications and attributes. Provenance information for analysis results includes a description of the algorithm used and its input values. Even if annotations were created spontaneously, e.g., with a web interface, it needs to be noted that annotations were produced with "Web Annotation."

Provenance is essential to differentiating data that could have been created in multiple ways. Data modeled with the same ontological terms but with different provenance has subtly different meanings. For example, in OME, DisplaySettings is the SemanticType defining the parameters used by the 5-D viewers for rendering images. Users create the majority of DisplaySettings attributes by manipulating the viewer's controls. Other DisplaySettings attributes are extracted during import from images if their file format (e.g., DICOM) includes meta-data about how pixels should be presented.

Data modeled with different ontological terms but with the same provenance share common properties that explain why the data was produced together. Formally recording provenance information enables these groupings to be exploited. The OME web interface can display the new classifications and attributes produced from a spreadsheet import.

Image analysis algorithms and other data creation processes, such as image import, spreadsheet mass annotations, and web interface manual annotations, can all be modeled as transformations that convert inputs into outputs. The transformations are defined a priori and are used by the platform to make the provenance links between actual input and output data values.

### 18.5.1.1   OME AnalysisModules

Transformations in OME are called *AnalysisModules* and are defined in XML. AnalysisModule definitions include the module's name, description, inputs and outputs. The module's name and description is text explaining how the module's outputs are generated. Inputs and outputs have informal names but are formally modeled by specifying the SemanticType and arity. *Arity* refers to the number of operands and can be "one," "optional," "one or more," or "zero or more." Some AnalysisModules, such as spreadsheet importers, instead of specifying the outputs' SemanticTypes, have "untyped" outputs that can produce any SemanticType.

OME maintains a meta-table where each *AnalysisModule execution (MEX)* is associated with meta-data, including an experimenter ID, time stamp, timing statistics, any error/warning messages, and a status flag that states if the execution was successful. An ActualInputs table maps MEXs to the attributes that were used to satisfy the modules' inputs. Every data attribute stored in OME is tied to the MEX that produced it. This is implemented by adding a column to each SemanticType table that is a not-null foreign-key reference into the MEX meta-table (see Fig. 18.7).

### 18.5.1.2   Editing and Deleting Data

Many data repositories are designed to be read-only. For example, PACS systems lack functionality to delete radiological studies or edit diagnostic reports. The images and radiologist's opinions are a matter of record. That they cannot be altered is an intended feature crucial to situations such as quality assessment and investigating possible malpractice. For similar reasons, the results of pharmaceutical experiments also often need to be preserved without alterations. Curation is necessary and inevitable for all large scientific datasets. Read-only repositories support curation by employing a mechanism by which old annotations are "invalidated," hidden, and replaced with new, "valid"

annotations. OME supports data deletion, but that is an administrative function not available to regular users. Deletion in OME is inaccessible by the web interface and is not intended to be performed regularly.

OME has three types of data annotations. The first type includes notes, such as image name and description or dataset name and description, that can be altered casually with the web interface and no record is kept that changes were made. The second type includes image annotations and classifications that can also be causally altered by the web interface, but where previous values are stored in the database with an invalidated status. Finally, the third type includes interrelated data, such as results produced as outputs of algorithms. This data cannot be edited with the web interfaces; it can only be deleted using administrative tools with all traces removed from the database.

Deleting and editing of interrelated data has to be performed in a manner that maintains the provenance chain in a valid state. Issues include: Can an algorithm's outputs be deleted if they have also been used as inputs to other algorithms? And is it permitted to delete some algorithm outputs while leaving the remaining outputs?

OME deletions are performed per module execution rather than per attribute. Deleting the MEX removes timing information and other MEX meta-data, all the attributes produced by the MEX, and all other MEXs that subsequently used this MEX's output attributes as inputs. OME does not allow cherry-picking output attributes. For example, even if only some of the annotations in a spreadsheet mass annotation are wrong, the whole annotation needs to be rolled back, the error in the spreadsheet fixed, and the spreadsheet reimported.

## 18.5.2 Modeling Quantitative Image Analysis

High-throughput microscopy experiments are producing large volumes of data that subsequently need to be systematically analyzed. Manual image analysis is laborious, qualitative, and not always objective. Analyzing images with algorithms is becoming popular for it offers automation and reproducibility and often has higher sensitivity than manual observers.

As part of the AGEMAP project, we ultimately expect to collect and analyze over 25,000 images, including all major tissues and organs, such as liver, skeletal muscles, kidney, brain, heart, and lungs. For analysis, we are using a multipurpose pattern analysis tool called WND-CHARM [27] that we've developed for comparing image morphology. WND-CHARM consists of two major components: feature extraction (CHARM) and classification (WND-5). CHARM stands for a Compound Hierarchy of Algorithms Representing Morphology. During feature extraction, each image is digested into a set of

1025 image content descriptions. The algorithms used to extract these features include polynomial decompositions, high-contrast features, pixel statistics, and textures. The features are computed from the raw image, transforms of the image, and transforms of transforms of the image. WND-CHARM is a complex workflow comprising 17 algorithms as 53 nodes with 189 links outputting 1025 numeric values modeled as 48 SemanticTypes. For a single $347 \times 260$ 12-bit image (175 Kb), CHARM feature computation takes 150 seconds and produces 2.5MB in intermediate pixels data due to results from the transforms and transforms of transforms.

In large-scale projects such as AGEMAP, systematic quantitative analysis involves thousands of images and a handful of algorithms arranged in a complex workflow. Executing the workflow requires multiple parameters, creates thousands of execution logs, and produces millions of analysis results. The meta-data, structured semantics, and provenance information recorded by informatics platforms are all crucial to organizing the data so that conclusions and results can be drawn from it.

### 18.5.2.1   Coupling Algorithms to Informatics Platforms

Microscopy image analysis algorithms are commonly implemented in a variety of ways, including as command-line compiled programs and interpreted scripts such as MATLAB$^{TM}$ (The MathWorks, Inc., Natick, MA), Octave (http://www.gnu.org/software/octave), and R (http://www.r-project.org). These implementations all have their unique requirements for specifying inputs and outputs. Before quantitative image analysis results can be managed by an informatics platform, the algorithms, inputs, and outputs all need to be defined using the platform's ontology. In OME, AnalysisModules are the algorithm representations, with the inputs and outputs modeled with SemanticTypes. After the algorithm is modeled, the coupling between its implementation and the informatics platform can be made.

**Pull vs. Push Paradigms**   This coupling can follow either the pull or push paradigm. Using *pull*, implementations can be linked to a platform API so that when algorithms are executed they initiate read/write transactions with the platform. This is a common paradigm in client–server architectures. In *push*, the platform is instructed a priori how to execute the algorithms, and it follows the instructions to present inputs to the algorithm, run the algorithm, and gather outputs. Pushing can also be implemented such that algorithm execution is initiated by the platform but the algorithm is responsible for reading and writing data. The key distinction is who initiates the transaction—the algorithm or the informatics platform. User-initiated analysis follows the pull

paradigm, but a platform that manages workflow and executions for the user must be constructed using the push paradigm.

To implement push, the platform requires significant machinery that will fire off algorithm executions, make sure the executions are running, and determine what algorithms need to be executed next. In pulling, all these features are provided by the algorithm implementation itself, and all the platform does is service read/write requests. The advantage of pushing is that the platform can provide organized features such as distributed analysis, results reuse, and execution management.

OME supports both pushing and pulling for algorithm execution. The OME analysis engine is the push infrastructure. Spreadsheet and image importers are implemented using pull, but complex image analysis workflows, such as WND-CHARM, are implemented using push—mainly to take advantage of parallelization and execution management.

### *Coupling Using APIs or Execution Instructions*   It is typically easier and more flexible to program using APIs written in the same language as the algorithm implementation than to write *execution instructions* in a specification language such as XML. On the other hand, execution instructions do not require editing implementation source code, which makes them better suited for wrapping legacy algorithms or proprietary programs. The function of APIs and execution instructions is to map the program's inputs, parameters, and outputs to the platform's ontological terms. APIs enable the algorithm to read/write the data when it needs to, while execution instructions specify how the inputs should be presented and outputs parsed. Execution instructions additionally need to specify how the program should be run.

APIs and execution instructions are language specific and need to accommodate many different types of image analysis. They can be designed in a general way to take advantage of language bindings for the APIs and polymorphism in the execution instruction interpreter to make it easier to support other programming and scripting languages. We strove to develop simple, flexible, and expressive instructions that would enable a wide variety of implementations to interact with OME without altering the programs' interfaces.

OME provides Perl APIs for connecting with the platform and execution instructions for command-line programs and MATLAB$^{TM}$ scripts. OME execution instructions are specified in XML as part of the AnalysisModule definition. In our experience, OME APIs and execution instructions are quite general. This API is used to implement all the web annotations, image importers, and spreadsheet importers. We developed the execution instructions concurrently with WND-CHARM. The execution instructions constructions have proven to be sufficiently general to allow us to add 11 substantially different feature extraction algorithms to CHARM without expanding the execution instruction set.

### 18.5.2.2   Composing Workflows

The data modeling section is the same for all AnalysisModules, regardless of the algorithm or manual annotation they represent. This makes them an implementation-independent, modular, algorithm representation. Each algorithm is intended to perform an atomic subset of a full image analysis. The algorithms can be collated into multifunction libraries or toolboxes and linked together in creative and novel ways to form complex workflows for new image analysis applications. Parts of the workflow can be implemented in different languages or using combinations of specialized newly developed modules and previously defined modules. The only strict limit is that connections be allowed only between inputs and outputs of the same SemanticType.

OME workflows, called *AnalysisChains*, are XML representations of computational experiments. In a valid AnalysisChain, the output of a given module can be used to feed multiple other modules, but each module's input must come from exactly one other module. Loops or conditionals are not supported. Also, there is currently no provision for ordering attributes, so multiple attributes that feed into inputs with multiple arity are treated as lists.

A module's output can be connected to the input of another only if the two connectors have the same SemanticType. Semantic typing ensures that connections between modules in a chain are more meaningful that just a storage-based correspondence. Strong semantic typing also serves as a form of "syntax checking," making sure that algorithms are used within their designed constraints.

The ChainBuilder GUI tool allows users interactively to compose AnalysisChains by dragging modules from a palette onto a canvas and clicking glyphs to form module connections (see Fig. 18.8). This enables ChainBuilder users to focus on the image analysis workflow while remaining agnostic to the details of algorithm implementations. Graphically composed AnalysisChains can be exported in the form of XML to be shared with colleagues.

### 18.5.2.3   Enacting Workflows

Workflows such as AnalysisChains are mathematically abstracted as directed acyclic graphs. The graph's nodes are its chain's AnalysisModules, and the graph's edges are its chain's input/output connections. Each node has in-degree 1 except for root nodes, which have in-degree zero. Nodes' out-degree is unconstrained.

The *OME Analysis Engine's* (AE) overarching functions are (1) to guide AnalysisChain execution by ensuring that modules are executed in the correct order and (2) to record provenance information for each module execution.

When presented an AnalysisChain, the Analysis Engine sorts the chain's graph topologically to reveal its data-dependency structure. Nodes at a particular topological level are executed only after nodes from previous levels have

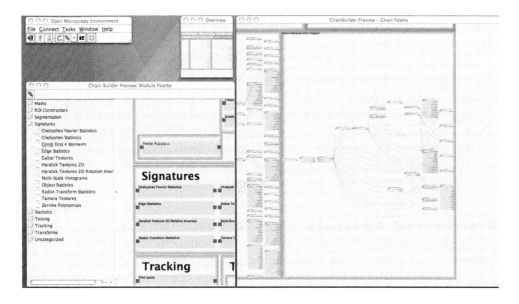

**FIGURE 18.8** The OME ChainBuilder tool enables users to compose workflows by graphically connecting AnalysisModules' inputs and outputs.

finished executing. However, nodes at the same topological level can be executed concurrently, supporting distributed computation. Data dependency is used by the AE to maintain an updated queue of all chain nodes that are ready for execution. Initially, the ready-module queue is composed entirely of root nodes. As nodes are executed, they are removed from the queue, and successor nodes are added once predecessor nodes have all successfully executed. This cycle continues until all the nodes in the chain have been executed or, because of errors in predecessor nodes, no further nodes can be executed. Executors access the AE's module queue and distribute ready modules to Handlers for the actual execution. As module executions finish successfully, status information is passed back through the handler and executor to the analysis engine. The engine uses successfully executed modules to satisfy inputs to downstream modules and thus to replenish the module-ready queue.

The OME analysis engine passes algorithm results through third-party APIs in C/Perl/SQL, possibly across the network, before finally storing the results in a database. This adds significant layers of complexity around the algorithm execution environment (e.g., MATLAB$^{TM}$). It was an important step to validate that the results of doing algorithm execution within OME, storing intermediary results in a database and middle layers, agrees to native algorithm execution results to seven significant figures, the precision expected with 32-bit floating-point precision. This level of precision occasionally requires modifications to algorithms to make them less prone to numerical noise. For example, Fourier

transforms need to be thus modified to ensure that "last digit" imprecision does not end up dominating results.

Algorithm models, workflow representations, and recording provenance information introduces overhead. Using the WND-CHARM workflow as an example, OME overhead was found to be minimal (5% increase) as compared to the algorithm execution time when executing the algorithms entirely outside of OME. Provenance information can improve execution time when it is used by the platform to distribute analysis across networked computers and to reuse previous results, thus taking advantage of parallelization and avoiding reexecuting algorithms with the same inputs.

***Distributed Analysis***   Often when quantitative analysis is applied to datasets with multiple images, each image's calculations can be performed independently, making the task embarrassingly parallel. Additionally, for complex AnalysisChains with parallel paths connecting modules, even though individual modules are single threaded, there exists higher-level parallelization. The analysis engine uses the recorded provenance information to exploit both types of parallelization and to distribute computations across a network of computers.

In a distributed analysis configuration, one running instance of OME we term the *master node*, because it hosts the database and image server. Additional computers, called *worker nodes*, can be configured to run separate instances of OME. The master node maintains a list of URLs to all worker nodes. When executing a workflow, the master node distributes individual AnalysisModule executions to its workers, which individually connect to the master node's database and image server to perform their calculations. When executing WND-CHARM using four dual-processor computers, one computer configured as the master node and three as workers, we measured $4\times$ speedup as compared to running the WND-CHARM in a single-threaded MATLAB$^{TM}$ environment.

***Results Reuse***   Quantitative microscopy requires optimization steps— commonly biologists will tweak parameters to a selected AnalysisModule without changing the rest of the workflow. To incorporate users' changes efficiently, the OME analysis engine performs results reuse, and only modules whose inputs have changed will be reexecuted.

Before executing a module, the analysis engine encodes the module's name and input attributes in a string called an "InputTag" and compares the new InputTag to previously executed modules' InputTags. If this check indicates a module has been successfully executed with matching inputs, the module is not reexecuted; rather, the analysis engine records the module execution as a virtual module execution, with references to the original module execution's attributes.

***Robust Execution Environment*** It is important to verify that any system that claims to support a workflow and execution management platform can be successfully applied to large-volume, long-duration, highly distributed workflows.

We've collected 48,000 images, each $347 \times 260$ with 12-bit quantization, for which we needed to compute WND-CHARM features. Beginning with 8GB of raw pixels, we generated 125GB of computational pixels and extracted 48 million WND-CHARM features over 2000 processor hours. OME was able to contend with such unexpected events as hard-disk failures, running out of disk space, unscheduled operating system upgrades triggered by update scripts, and intermittent web server restarts.

# 18.6 Summary of Important Points

1. The rate-limiting factor of high-throughput microscopy experiments is the image analysis that needs to be performed after image acquisition.

2. Image informatics software supports image analysis by providing an infrastructure of image management that scientists use to organize, browse, search, and view their datasets.

3. Informatics platforms are effective when based on a client–server architecture, where researchers access their data stored in a centralized repository using a web browser or other (e.g., Java) client.

4. Meta-data is stored in a database, and pixels data is stored in a specialized repository designed for large binary objects.

5. Users can better manage, navigate, and maintain large image datasets by grouping images into hierarchical containers, such as projects/ datasets/images and category group/category/images.

6. Predefined organizational hierarchies and standardized meta-data are not suitable for all microscopy experiments. It is essential that image informatics software be based on an extensible data model.

7. Image meta-data and annotations provide crucial context necessary for interpreting pixels. This context must be stored in image informatics platforms alongside the original images.

8. Search interfaces exploit this context information, using keyword matching, to help scientists find relevant images.

9. Image acquisition meta-data describes the microscope configuration and settings. OME-XML is the industry standard.

10. User-defined annotations can be either unstructured (free text) or structured (based on an ontology). Unstructured annotations are inherently more flexible, while data modeling annotation structure confers semantic interoperability.

11. Annotations can be either text summarizing human interpretations or numeric measurements produced by computer vision algorithms.

12. SemanticTypes are an XML-based specification language for defining new structured annotations. SemanticTypes are realized with an extensible database schema.

13. Laboratories already keep extensive records in the form of notebooks and spreadsheets. Platforms need to provide tools to migrate legacy spreadsheets into annotations.

14. The systematic computer-based quantitative analysis of high-throughput microscopy experiments involves thousands of images and a handful of algorithms, with parameters, that produce thousands of analysis results along with execution logs. It is advantageous to store information about algorithm execution within the informatics platform's data warehouse.

15. Defining algorithms' inputs and outputs using the data's ontological terms conveys the semantics and not merely the data structure of the data on which the algorithms operate.

16. Execution instructions describe how to present inputs, run the program or script implementing the algorithm, and parse outputs.

17. Algorithm inputs and outputs can be connected together to create recipes of computational experiments, called workflows. Workflows composed of algorithms with execution instructions can be enacted by the informatics platform.

18. Every piece of data is associated with provenance information, which records how the data was derived, e.g., the algorithm and inputs that produced it.

19. Provenance information can improve execution time when it is used by the platform to distribute analysis across networked computers and to reuse previous results, thus taking advantage of parallelization and avoiding reexecuting algorithms with same inputs.

20. Platforms exist at the hub of an ecosystem of scientific programs. They need to accept data in a variety of formats and they need exporters so that they can present data in common-denominator formats to external programs for specialized processing.

# References

1. X Zhou and SC Wong, "Informatics Challenges of High-Throughput Microscopy," *IEEE Signal Processing Magazine*, **23**(3):63–72, 2006.

2. www.open-microscopy.org.uk.

3. JR Swedlow et al., "Informatics and Quantitative Analysis in Biological Imaging," *Science*, **300**(5616):100–102, 2003.

4. IG Goldberg et al., "The Open Microscopy Environment (OME) Data Model and XML File: Open Tools for Informatics and Quantitative Analysis in Biological Imaging," *Genome Biology*, **6**(5):R47.1–R47.13, 2005.

5. HS Huang, *PACS: Basic Principles and Applications*, Wiley-Liss, 2004.

6. T Barclay, J Gray, and D Slutz, "Microsoft TerraServer: A Spatial Data Warehouse," *SIGMOD Record*, **29**(2):307–318, 2000.

7. JA Tyson, "Large Synoptic Survey Telescope: Overview," *Proceeding of SPIE*, **4836**: 10–20, 2002.

8. M Eisenstein, "Tower of Babel," *Nature*, **443**:1021–1021, 2006.

9. R Sears, C van Ingen, and J Gray, "To BLOB or Not to BLOB: Large Object Storage in a Database or a Filesystem?," *Microsoft Research Technical Report*, MSR-TR-2006–45, 2006.

10. C Rueden, KW Eliceiri, and JG White, "VisBio: A Computational Tool for Visualization of Multidimensional Biological Image Data," *Traffic*, **5**:411–417, 2004.

11. WD Bidgood et al., "Understanding and Using DICOM, the Data Interchange Standard for Biomedical Imaging," *Journal of American Medical Informatics Association*, **4**(3):299–313, 1997.

12. http://www.loci.wisc.edu/ome/formats.html.

13. http://www.ome-xml.org.

14. JR Swedlow, S Lewis, and IG Goldberg, "Modeling Data Across Labs, Genomes, Space and Time," *Nature Cell Biology*, **8**(11):1190–1194, 2006.

15. O Bodenreider and R Stevens, "Bio-ontologies: Current Trends and Future Directions," *Briefings in Bioinformatics*, **7**(3):256–274, 2006.

16. A Brazma et al., "Minimum Information About a Microarray Experiment (MIAME)—Towards Standards for Microarray Data," *Nature Genetics*, **29**:365–371, 2001.

17. M Ashburner et al., "Gene Ontology: Tool for the Unification of Biology," *Nature Genetics*, **25**:25–29, 2000.

18. Gene Ontology Consortium, "The Gene Ontology (GO) project in 2006," *Nucleic Acids Research*, **34**(Database issue):D322–D326, 2006.

19. M Bada et al., "A Short Study on the Success of the Gene Ontology," *Journal of Web Semantics*, **1**:235–240, 2004.

20. JH Gennari et al., "The Evolution of Protégé: An Environment for Knowledge-Based Systems Development," *International Journal of Human-Computer Studies*, **58**:89–123, 2003.

21. B Smith et al., "Relations in Biomedical Ontologies," *Genome Biology*, **6**(5):R46.1–R46.15, 2006.

22. O Bodenreider et al., "Investigating Subsumption in SNOMED CT: An Exploration into Large Description Logic-Based Biomedical Terminologies," *Artificial Intelligence in Medicine*, **39**(3):183–195, 2007.

23. D Clunie, *DICOM Structured Reporting*, PixelMed, 2000.

24. www.bioimage.ucsb.edu/projects/bisque.php.

25. B Parvin et al., "Integrated Imaging Informatics," in *Computational Systems Biology*, A. Kriete and R. Eilis, eds., Elsevier, 2006.

26. http://www.openmicroscopy.org.uk/api/xml/OME/ome-core.html.

27. N Orlov et al., "Computer Vision for Microscopy Applications," in *Vision Systems— Segmentation and Pattern Recognition*, G Obinata and A Dutta, eds., ARS, 2007.

# Glossary of Microscope Image Processing Terms

This glossary is meant to help the reader avoid confusion brought about by the use of ordinary words given specialized meaning in this book. These definitions conform roughly to common usage in microscope image processing but do not constitute a standard in the field.

**Algebraic operation**—an image processing operation involving the pixel-by-pixel sum, difference, product, or quotient of two images.

**Aliasing**—an artifact produced when the pixel spacing is too large in relation to the detail in an image (Chapter 3).

**Arc**—(1) a continuous portion of a circle; (2) a connected set of pixels representing a portion of a curve.

**Background shading correction**—the process of eliminating nonuniformity of image background intensity by application of image processing.

**Binary image**—a digital image having only two gray levels (usually 0 and 1, black and white).

**Blur**—a loss of image sharpness, introduced by defocus, low-pass filtering, camera motion, etc.

**Border**—the first and last row and column of a digital image.

**Boundary chain code**—a sequence of directions specifying the boundary of an object.

**Boundary pixel**—an interior pixel that is adjacent to at least one background pixel (contrast with *Interior pixel, Exterior pixel*).

**Boundary tracking**—an image segmentation technique in which arcs are detected by searching sequentially from one arc pixel to the next.

**Brightness**—the value associated with a point in an image, representing the amount of light emanating or reflected from that point.

**Change detection**—an image processing technique in which the pixels of two registered images are compared (e.g., by subtraction) to detect differences in the objects therein.

**Class**—one of a set of mutually exclusive, preestablished categories to which an object can be assigned.

**Closed curve**—a curve whose beginning and ending points are at the same location.

**Closing**—a binary or grayscale morphological operation consisting of a dilation followed by an erosion (Chapter 8).

**Cluster**—a set of points located close together in a space (e.g., in feature space).

**Cluster analysis**—the detection, measurement, and description of clusters in a space.

**Concave**—a characteristic of an object: at least one straight-line segment between two interior points of the object is not entirely contained within the object (contrast with *Convex*).

**Connected**—pertaining to the pixels of an object or curve: any two points within the object can be joined by an arc made up entirely of adjacent pixels that are also contained within the object.

**Contrast**—the amount of difference between the average brightness (or gray level) of an object and that of the surrounding background.

**Contrast stretch**—a linear grayscale transformation.

**Convex**—a characteristic of an object: all straight-line segments between two interior points of the object are entirely contained within the object (contrast with *Concave*).

**Convolution**—a mathematical process for combining two functions to produce a third function. It models the operation of a shift-invariant linear system.

**Convolution kernel**—(1) the two-dimensional array of numbers used in convolution filtering of a digital image; (2) the function with which a signal or image is convolved.

**Curve**—(1) a continuous path through space; (2) a connected set of pixels representing a path (see *Arc, Closed curve*).

**Curve fitting**—the process of estimating the best set of pararmeters for a mathematical function to approximate a curve.

**Deblurring**—(1) an image processing operation designed to reduce blurring and sharpen the detail in an image; (2) removing or reducing the blur in an image, often one step of image restoration.

**Decision rule**—in pattern recognition, a rule or algorithm used to assign an object in an image to a particular class. The assignment is based on measurements of its features.

**Digital image**—(1) an array of integers representing an image of a scene; (2) a sampled and quantized function of two or more dimensions, generated from and representing a continuous function of the same dimensionality; (3) an array generated by sampling a continuous function on a rectangular grid and quantizing its value at the sample points.

**Digital image processing**—the manipulation of pictorial information by computer.

**Digitization**—the process of converting an image of a scene into digital form.

**Dilation**—a binary or grayscale morphological operation that uniformly increases the size of objects in relation to the background (Chapter 8).

**Down-sampling**—making a digital image smaller by deleting pixels in the rows and columns. This process is also known as *decimation*.

**Edge**—(1) a region of an image in which the gray level changes significantly over a short distance; (2) a set of pixels belonging to an arc and having the property that pixels on opposite sides of the arc have significantly different gray levels.

**Edge detection**—an image segmentation technique in which edge pixels are identified by examining neighborhoods.

**Edge enhancement**—an image processing technique in which edges are made to appear sharper by increasing the contrast between pixels located on opposite sides of the edge.

**Edge image**—an image in which each pixel is labeled as either an edge pixel or a nonedge pixel.

**Edge operator**—a neighborhood operator that labels the edge pixels in an image.

**Edge pixel**—a pixel that lies on an edge.

**Emission filter**—a "physical" filter inserted in the emission path of a microscope to select light of a particular wavelength.

**Enhance**—to increase the contrast or subjective visibility of.

**Erosion**—a binary or grayscale morphological operation that uniformly reduces the size of bright objects in relation to the background (Chapter 8).

**Excitation filter**—a "physical" filter inserted in the illumination path of a microscope to select light of a particular wavelength.

**Exterior pixel**—a pixel that falls outside all the objects in a binary image (contrast with *Interior pixel*).

**False negative**—in two-class pattern recognition, a misclassification error in which a positive object is labeled as negative.

**False positive**—in two-class pattern recognition, a misclassification error in which a negative object is labeled as positive.

**Feature**—a characteristic of an object, something that can be measured and that assists classification of the object (e.g., size, texture, shape).

**Feature extraction**—a step in the pattern recognition process in which measurements of the objects are computed.

**Feature selection**—a step in the pattern recognition system development process in which measurements or observations are studied to identify those that can be used effectively to assign objects to classes.

**Feature space**—in pattern recognition, an $n$-dimensional vector space containing all possible measurement vectors.

**Fluorophore**—a molecule that absorbs light of a certain wavelength, reaches an excited, unstable electronic singlet state, and emits light at a longer wavelength.

**Fourier Transform**—a linear transform that decomposes an image into a set of sinusoidal frequency component functions.

**Geometric correction**—an image processing technique in which a geometric transformation is used to remove geometric distortion.

**Gray level**—the value associated with a pixel in a digital image, representing the brightness of the original scene at that point, (2) a quantized measurement of the local property of the image at a pixel location.

**Grayscale**—the set of all possible gray levels in a digital image.

**Grayscale transformation**—the function, employed in a point operation, that specifies the relationship between input and corresponding output gray-level values.

**Hankle transform**—similar to the Fourier transform, a linear transformation that relates the (one-dimensional) profile of a circularly symmetric function of two dimensions to the (one-dimensional) profile of its two-dimensional (circularly symmetric) Fourier transform.

**Hermite function**—a complex-valued function having an even real part and an odd imaginary part.

**High-pass filtering**—an image enhancement (usually convolution) operation in which the high-spatial-frequency components are emphasized relative to the low-frequency components.

**Histogram**—a graphical representation of the number of pixels in an image at each gray level.

**Hole**—in a binary image, a connected region of background points that is completely surrounded by interior points.

**Image**—any representation of a physical scene or of another image.

**Image coding**—translating image data into another form from which it can be recovered, as for compression.

**Image compression**—any process that eliminates redundancy from or approximates an image, in order to represent it in a more compact form.

**Image enhancement**—any process intended to improve the visual appearance of an image.

**Image matching**—any process involving quantitative comparison of two images in order to determine their degree of similarity.

**Image processing operation**—a series of steps that transforms an input image into an output image.

**Image reconstruction**—the process of constructing or recovering an image from data that occurs in nonimage form.

**Image registration**—a geometric operation intended to position one image of a scene with respect to another image of the same scene so that the objects in the two images coincide.

**Image restoration**—any process intended to return an image to its original condition by reversing the effects of prior degradations.

**Image segmentation**—(1) the process of detecting and delineating the objects of interest in an image; (2) the process of subdividing an image into disjoint regions. Normally these regions correspond to objects and the background on which they lie.

**Interior pixel**—in a binary image, a pixel that falls inside an object (contrast with *Boundary pixel, Exterior pixel*).

**Interpolation**—the process of determining the value of a sampled function between its sample points. It is normally done by convolution with an interpolation function.

**Kernel**—(1) the two-dimensional array of numbers used in convolution filtering of a digital image; (2) the function with which a signal or image is convolved.

**Local operation**—an image processing operation that assigns a gray level to each output pixel based on the gray levels of pixels located in a neighborhood of the corresponding input pixel. A neighborhood operation (contrast with *Point operation*).

**Local property**—the interesting characteristic that varies with position in an image. It may be brightness, optical density, or color for microscope images.

**Lossless image compression**—any image compression technique that permits exact reconstruction of the image.

**Lossy image compression**—any image compression technique that inherently involves approximation and does not permit exact reconstruction of the image.

**Low-pass filter**—a filter that attenuates the high-frequency detail in an image.

**Measurement space**—in pattern recognition, an $n$-dimensional vector space containing all possible measurement vectors.

**Median filter**—a nonlinear spatial filter that replaces the gray value of the center pixel with the median gray value of the input group of pixels, in order to remove noise spikes and other single-pixel anomalies.

**Misclassification**—in pattern recognition, the assignment of an object to any class other that its true class.

**Minimun enclosing rectangle (MER)**—for an object, its bounding box aligned such that it encloses all the points in the object, with the area minimized.

**Multispectral image**—a set of images of the same scene, each formed by radiation from a different wavelength band of the electromagnetic spectrum.

**Neighborhood**—a set of pixels located in close proximity.

**Neighborhood operation**—an image processing operation that assigns a gray level to each output pixel based on the gray levels of pixels located in a neighborhood of the corresponding input pixel (see *Local operation*, contrast with *Point operation*).

**Noise**—irrelevant components of an image that hinder recognition and interpretation of the data of interest.

**Noise reduction**—any process that reduces the undesirable effects of noise in an image.

**Object**—a connected set of pixels in a binary image, usually corresponding to a physical object in the scene.

**Object label map**—an image of size equal to an original image, in which the gray level of each pixel encodes the sequence number of the object to which the corresponding pixel in the original image belongs.

**Opening**—a binary or grayscale morphological operation consisting of an erosion followed by a dilation (Chapter 8).

**Optical image**—the result of projecting light emanating from a scene onto a surface, as with a lens.

**Optical sectioning**—a noninvasive method for obtaining optically (without physical sectioning), that is, via images along the axial axis, 3-D information about the structure of specimens.

**Pattern**—a meaningful regularity that members of a class express in common and that can be measured and used to assign objects to classes.

**Pattern class**—one of a set of mutually exclusive, preestablished categories to which an object can be assigned.

**Pattern classification**—the process of assigning objects to pattern classes.

**Pattern recognition**—the detection, measurement, and classification of objects in an image by automatic or semiautomatic means.

**Perimeter**—the circumferential distance around the boundary of an object.

**Photobleaching**—a phenomenon inherent in fluorophores that causes an effective reduction in, and ultimately a complete elimination of, fluorescence emission.

**Photon shot noise**—noise in photodetector devices resulting from the random nature of photon emission.

**Picture element**—the smallest element of a digital image. The basic unit of which a digital image is composed.

**Pixel**—contraction of *Picture element*.

**Point operation**—an image processing operation that assigns a gray level to each output pixel based only on the gray level of the corresponding input pixel (contrast with *Neighborhood operation*).

**Quantitative image analysis**—any process that extracts quantitative data from a digital image.

**Quantization**—the process by which the local property of an image, at each pixel, is assigned one of a finite set of gray levels.

**Ratio image**—an image obtained by dividing one image by another image.

**Readout noise**—noise generated by the electronics associated with photodetectors during readout.

**Region**—a connected subset of an image.

**Region growing**—an image segmentation technique in which regions are formed by repeatedly taking the union of subregions that are similar in gray level or texture.

**Registered**—(1) the condition of being in alignment; (2) when two or more images are in geometric alignment with each other and the objects therein coincide.

**Registered images**—two or more images of the same scene that have been positioned with respect to one another so that the objects in the scene occupy the same positions.

**Resolution**—(1) in optics, the minimum separation distance between distinguishable point objects; (2) in image processing, the degree to which closely spaced objects in an image can be distinguished from one another.

**Sampling**—the process of dividing an image into pixels (according to a sampling grid) and measuring the local property (e.g., brightness or color) at each pixel.

**Scene**—a particular arrangement of physical objects.

**Sharp**—pertaining to the detail in an image, well defined and readily discernible.

**Sharpening**—any image processing technique intended to enhance the detail in an image.

**Sinusoidal**—having the shape of the sine function.

**Skeletonization**—a binary operation that reduces the objects in an image to a single-pixel-wide skeleton representation.

**Smoothing**—any image processing technique intended to reduce the amplitude of small detail in an image. This is often used for noise reduction.

**Statistical pattern recognition**—an approach to pattern recognition that uses probability and statistical methods to assign objects to classes.

**Structural element**—A set of logical values (in the binary image case) or grey-level values (in the grayscale image case) defined in the nonlinear spatial filtering mask and used in binary and grayscale morphological operations.

**Surface fitting**—the process of estimating the best set of pararmeters for a mathematical function to approximate a surface.

**System**—anything that accepts an input and produces an output in response.

**Texture**—in image processing, an attribute representing the amplitude and spatial arrangement of the local variation of gray level in an image.

**Thinning**—a binary image processing technique that reduces objects to sets of thin (one-pixel-wide) curves.

**Threshold**—a specified gray level used for producing a binary image.

**Thresholding**—the process of producing a binary image from a grayscale image by assigning each output pixel the value 1 if the gray level of the corresponding input pixel is at or above the specified threshold gray level and the value 0 if the input pixel is below that threshold.

**Transfer function**—for a linear, shift-invariant system, the function of frequency that specifies the factor by which the amplitude of a sinusoidal input signal is multiplied to form the output signal.

**Up-sampling**—to make a digital image larger by adding pixels to the rows and columns, usually in an interleaved fashion.

**Voxel**—contraction of '*volume element*', that is, the extension of the pixel to 3-D.

# References

1. RM Haralick, "Glossary and Index to Remotely Sensed Image Pattern Recognition Concepts," *Pattern Recognition*, **5**:391–403, 1973.
2. IEEE Std 610.4-1990, *IEEE Standard Glossary of Image Processing and Pattern Recognition Terminology*, IEEE, 10017-2394, 1990.
3. RM Haralick and LG Shapiro, "Glossary of Computer Vision Terms," *Pattern Recognition*, **24**:69–93, 1991.

4. L Darcy and L Boston, *Webster's New World Dictionary of Computer Terms* (3rd ed.), Prentice-Hall, 1988.

5. B Pfaffenberger, *Que's Computer User's Dictionary* (2nd ed.), Que Corporation, Carmel, Indiana, 1991.

6. CJ Sippl and RJ Sippl, *Computer Dictionary* (3rd ed.), Howard W. Sams, Indianapolis, IN, 1980.

7. GA Baxes, *Digital Image Processing*, John Wiley & Sons, 1994.

8. KR Castleman, *Digital Image Processing*, Prentice-Hall, 1996.

# Index

Printed and bound by CPI Group (UK) Ltd, Croydon, CR0 4YY

03/10/2024

01040316-0007